W9-BVK-350

THE SCULPTURE OF AUGUSTE RODIN

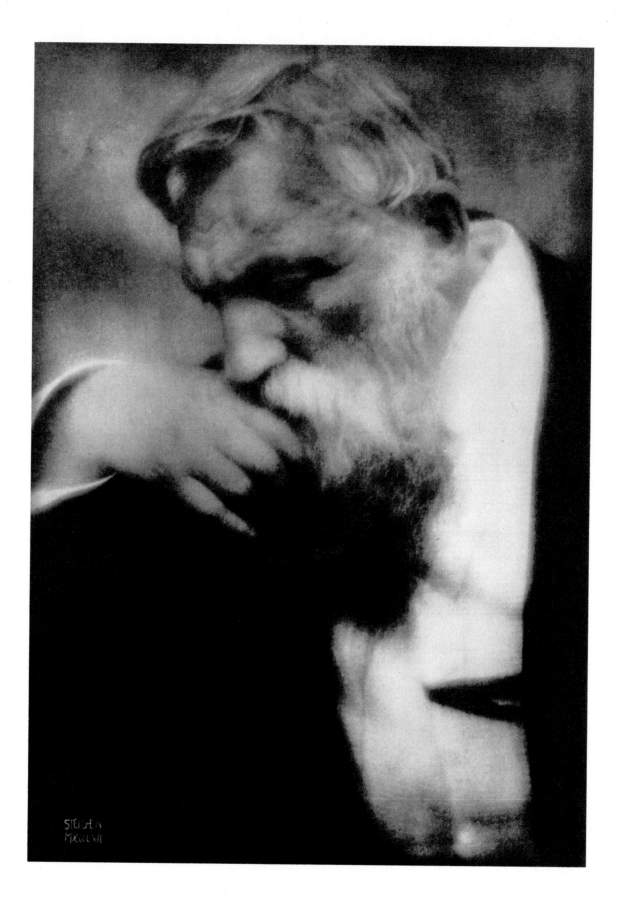

THE SCULPTURE OF AUGUSTE RODIN

THE COLLECTION
OF THE RODIN MUSEUM
PHILADELPHIA

JOHN L. TANCOCK

SPECIAL PHOTOGRAPHY
MURRAY WEISS

PHILADELPHIA MUSEUM OF ART

PHOTOGRAPHIC CREDITS

Photographs of sculpture in the Rodin Museum
by Murray Weiss unless otherwise indicated
ACL, Brussels, pl. 24; p. 65; fig. 101–2
Anderson, Rome, fig. 9–2
Annan, Glasgow, fig. 17–3
Archives Photographiques, Paris, pp. 69, 71, 75; figs. 6–1,
19–4, 19–7, 20–5, 24–2, 67–69–1, 67–69–3, 67–69–6,
67–69–7, 67–69–8, 67–69–9, 67–69–10, 67–69–11, 67–
69–12, 70–5, 71–1, 71–2, 71–5, 71–6, 71–7, 72–76–8,
72–76–9, 72–76–10, 77–2, 80,81–2, 80,81–3, 83–1, 85–1,
90–1, 91–1, 91–2, 99–2
R. Arsicaud & Fils, Tours, fig. 70–3
Berthold Beng, Vienna, fig. 97,98–5
Bernès, Marouteau, Paris, figs. 1–6, 47–1, 70–7
E. Irving Blomstrann, New Britain, Conn., fig. 24–1
Brunel, Lugano, pl. 22
Bulloz, Paris, p. 74; figs. 18–2, 24–5, 30–1, 65–3, 70–8,
87–6, 90–3, 108–6, 119,120–3
J. Camponogara, Lyons, pls. 13, 14; figs. 18–3, 36–6,
109–6
Choumoff, Paris, pp. 87, 88
Geoffrey Clements, New York, fig. 104–1
H. Shobbrook Collins, New York, fig. 14–16–1
Walter Drayer, Zurich, fig. 67–69–2
Albert E. Elsen, Stanford, Calif., figs. 72–76–5, 88–3
Foto-Koch, Frankfurt, fig. 34–1

Giraudon, Paris, figs. 5–3, 19–6, 21–1, 26–1, 32–2, 55–2,
56–1, 70–2, 71–4, 87–7
Bruno Jarret, Paris, figs. 3–1, 21–5
Laboratoire Studio Gérond, Lille, fig. 29–2
Elisabeth C. Loewenstein, New York, figs. 6–3a, b
Gilbert Mangin, Nancy, fig. 7–1
Barry Mason, Dublin, fig. 94–2
V. Pannelier, Paris, p. 62
Photopress, Grenoble, p. 67
Marco Pillot, Bordeaux, fig. 25–3
J. M. Renaud, Paris, fig. 7–3
Ritter-Jeppesen Photography Ltd., fig. 109–8
Roger-Viollet, Paris, pl. 27; p. 80; figs. 3–2, 4–1, 7–2, 8–1,
8–2, 8–3, 12, 13–1, 21–3, 45–4, 72–76–1, 72–76–12,
72–76–15, 87–1, 88–2, 89–1, 90–2, 94–1, 95–1, 99–1,
100–1, 101–1, 101–3, 102–1, 103–1, 104–2
Rudomine, Paris, figs. 10–4, 32–1, 36–2, 36–3, 43–4, 105–2,
108–5
Sakamoto Photo Research Laboratory, Tokyo, pl. 25
figs. 6–2, 11–3, 14–16–2, 20–1, 21–2, 61–2, 88–1
John Schiff, New York, fig. 79–3
Service de Documentation Photographique, Paris, p. 77
figs. 5–5, 11–1, 23–1, 26–2, 46–6, 64–2, 65–2, 70–6,
72–76–11, 72–76–13, 77–3, 89–2, 111–117–3
Stearn & Sons, Cambridge, England, fig. 57–1
Grete Stern, fig. 77–4a–c
Taylor & Dull, Inc., New York, fig. 17–4
Murray Weiss, pl. 23; figs. 18–1, 19–3, 108–4
Liselotte Witzel, Essen, fig. 41–1
A. J. Wyatt, Staff Photographer, Philadelphia Museum of
Art, figs. 1–3, 11–4, 20–2, 30, 57–2, 91–4, 97, 98–1

Frontispiece: Photograph of Auguste Rodin by Edward Steichen, 1908

Copyright © 1976 by the Philadelphia Museum of Art
All rights reserved. No part of this publication may be reproduced,
stored in a retrieval system, or transmitted in any form or by any means,
electronic, mechanical, photography, recording, or otherwise, without
the prior permission of the publishers.
Library of Congress Catalog Card Number: 75–5211
Museum edition: ISBN: 87633–018–9
Trade edition: ISBN: 0–87923–157–2
Printed and bound in Switzerland by Conzett + Huber AG

CONTENTS

FOREWORD

Rarely in its long history has Philadelphia been as firmly committed to the realization of a promising future as it was in 1872, the year that Jules E. Mastbaum was born. The city had seen the recent consolidation of the largest public park system in the country. There were plans for a new art museum, for the nation's first zoo, and for a major new building for the Pennsylvania Academy of the Fine Arts, the nation's leading art school. Most important of all, construction was under way for the great Exposition to celebrate the Centennial of America's independence. The fair, in proving to its vast numbers of visitors how much the young nation had achieved in its first century, gave the city and the nation an impetus to pursue new goals in the last quarter of the nineteenth century. Jules Mastbaum came of age in a proud period; and certainly, once he was established in his economic success, few citizens could match him in his great love for the city of Philadelphia and in his splendid generosity to its people and its causes.

A year before Mr. Mastbaum's birth, a small group of private citizens, united in their belief that Philadelphia's new park would be even more rewarding with the judicious placement of major sculptures, had gathered together to establish the Fairmount Park Art Association. In the following years, this association and other civic-minded groups commissioned considerable numbers of works from many of the better-known sculptors of the day; as the dedication of each successive work proved, their efforts aroused an astonishing degree of local enthusiasm. It was through these efforts that the names of such distinguished French masters of the day as Antoine Louis Barye, Auguste Cain, and Emmanuel Frémiet became well known in Philadelphia.

However, as so often happens when commissions are made as the result of committee action, for the most part the more conservative sculptors were chosen; even so it is remarkable that Auguste Rodin, the best known—although admittedly the most controversial—French artist at the turn of the century, was apparently never approached.

Perhaps it was not chance that a person as imaginative as Jules Mastbaum, who at an early date had recognized the great potential of the new "moving pictures," should have been so unexpectedly excited by and intensely involved in collecting the work of Auguste Rodin. A member of the family has suggested that Mr. Mastbaum's enthusiasm may have been promoted in part by a Philadelphia friend who shared his great love of sports, Samuel Stockton White, 3rd. Even in a city distinguished for seemingly conventional people having startling things happen in their lives, Mr. White stands out because as a young man he met

the great sculptor, who was impressed by the Philadelphian's beautifully developed physique and agreed that he should pose for a work. This experience produced one of Rodin's finest bronzes (no. 57). It also exposed Samuel White to the excitement of the Paris art world in the years immediately preceding World War I, an experience which influenced his own collecting in later years; and vicariously it may have nurtured Jules Mastbaum's fascination with a great master and, ultimately, with France.

In the years immediately preceding Mr. Mastbaum's discovery of Rodin, the city of Philadelphia had purchased the successive blocks of crowded housing between the recently completed City Hall and Fairmount in order to create a great new Parkway which would be a latter-day reflection of Baron Haussmann's urban planning for Second Empire Paris. With a characteristic concern for the betterment of life in Philadelphia, Mr. Mastbaum offered to build a fine small museum, reflecting the most elegant aspects of the Beaux-Arts tradition, to house what was rapidly becoming the second largest collection of the master's work, a collection surpassed only by the one Rodin bequeathed to the French nation. The early designers of the Parkway had planned that statues would be erected along its walks to enrich the strolling citizens. Because of Mr. Mastbaum's gesture, the new museum building was to become an extension of that concept since the entrance gateway, a replica of Rodin's tomb at Meudon, and the façade included major sculptures which exposed even the most casual wanderer to a great master's genius. Sadly, because of his premature death on December 7, 1926, this great donor never lived to see the realization of his fine plans.

Philadelphia's Rodin Museum was opened with appropriate fanfare to the public in 1929; yet the following twenty years were quiet ones for the museum. That this should be so was not entirely surprising because, as so often happens after the death of a powerful and revered personality such as Rodin, there was a period of intense reaction against his work. Instead, up-to-date taste favored a simplification and an understatement which was in sharp contrast to the great sculptor's passion. However, during these years one important emerging collector was greatly influenced by Mr. Mastbaum's collection; that man, R. Sturgis Ingersoll, had attended the dramatic dedication ceremonies of the Rodin Museum and subsequently returned again and again to the museum, always feeling that *The Gates of Hell* (no. 1) decorating its façade was one of the three greatest works of art in the city. Shortly before his own death, Mr. Ingersoll gave the nearby Philadelphia Museum of Art a splendid group of bronzes by such major masters as Maillol, Lipchitz, Matisse, and Picasso, all of whom had been influenced by Rodin. The museum that received them had, in part because of Mr. Ingersoll's own involvement, already been greatly enriched by handsome collections, containing exceedingly fine twentieth-century sculptures, from Louise and Walter Arensberg, A. E. Gallatin, and Louis E. Stern. These various gifts had made Philadelphia in less than forty years a major center in the United States for studying nineteenth- and twentieth-century French sculpture.

The intensity of the reaction against Rodin in the years before World War II was countered by the renewed fervor of public admiration occurring after 1950. No single person has played a greater role in this deserved revival than the scholar, Albert E. Elsen. Through his own vivid writings, including the distinguished catalogue he wrote for the exhibition of the master's work at New York's Museum of Modern Art in 1963, and through his influence upon students at Indiana University and at Stanford he has fostered a steadily broadening appreciation. He has been of immense help to Philadelphia's Rodin Museum. It was largely

as a result of his concern that the idea for this catalogue was first conceived. He advised in the initial planning; he suggested the young English art historian John Tancock as a possible author and as curator of the collection; and at every point since then he has been characteristically generous in providing information and suggesting leads.

During the past decade the Philadelphia Museum of Art, which has been responsible since 1939 for the administration of the Rodin Museum, has exerted considerable effort in seeing that Mr. Mastbaum's contribution becomes better known. The collection was re-installed for the first time in 1968, when a weak replica in marble of Rodin's most famous carving, *The Kiss,* was moved to Memorial Hall, while *The Burghers of Calais* (no. 67) and four other major figures were moved inside to protect them from the polluting atmosphere of a modern city. Special exhibitions of related material have been shown; for example, Edward Steichen's photographs of Rodin and his work and the complete graphic *œuvre* of Henry Moore, who was greatly influenced by Rodin. Funds were made available to purchase Rodin's last portrait, a bronze of *Etienne Clémentel* (no. 104), and a wax sketch (no. 30) which extends understanding of Rodin's technique in one of the few areas not suggested by Mr. Mastbaum's inclusive gathering. This choice museum is now seen as a major haven of calm in a Parkway which will be dominated by Bicentennial bustle in 1976.

But most important of all in showing the art museum's commitment to this splendid collection is the decision to publish this catalogue, the most ambitious and thorough publication of its kind produced to date by the museum. It is a monument to John Tancock's imagination and tenacity; it has been enriched by the brilliant work of one of Philadelphia's finest photographers, Murray Weiss; it has been achieved because of the dedication of the museum's Editor of Publications, George H. Marcus. The catalogue joins the august succession of important art museum catalogues made possible in the United States because of the imaginative program funded by the Ford Foundation. We owe them great thanks.

With the publication of this catalogue we believe that beyond doubt everyone will become fully aware of the great stature of Jules Mastbaum's commitment to the city that he loved.

Evan H. Turner
Director, Philadelphia Museum of Art

ACKNOWLEDGMENTS

To a certain extent, writing a catalogue is a collective effort. Without the cooperation of numerous individuals who own or are responsible for the maintenance of the works being studied, no progress is possible. How much more is this the case when, with a prolific sculptor like Rodin, the *œuvre* is immense and the individual works exist in sizable although frequently unlimited editions and in numerous versions.

For providing the initial impetus and much needed guidance through the intricacies of Rodin scholarship, my particular thanks go to Professor Albert Elsen, whose searching analysis of Rodin's work has done so much to clarify the issues that need to be debated. At various times in the compilation of the material that constitutes this catalogue, I have benefited greatly from direct and indirect contact with other Rodin enthusiasts. In recent years Kirk Varnedoe's work on Rodin's drawings and Athena Spear's cataloguing of the sculptures in the Cleveland Museum of Art have provided many valuable insights, and they have not been reluctant to share them. Elisabeth Geissbuhler's survey of Rodin's constantly growing passion for the Gothic art of France has provided much illumination, and my conversations with her have deepened my understanding of Rodin's genius.

While researching and writing this book I relied heavily on two invaluable assistants, Margaret Kline and Dorothy Headly, who coped with the vast amount of correspondence and the frequently tedious work that the project involved. Most importantly, their enthusiasm never waned. I also had the good fortune to work under Dr. Evan H. Turner, whose encouragement was invaluable to me as indeed was that of Mrs. Charles B. Grace, President of the Rodin Museum Committee.

I have relied heavily on the good will of museum officials and collectors throughout the world, too numerous to mention by name. I trust that my gratitude will be adequately expressed wherever their names or the institutions they represent are mentioned in the catalogue. Special mention must be made, however, of Mme Cécile Goldscheider, former Conservateur of the Musée Rodin, who allowed me access to certain documentary files in the archives of the Musée Rodin. Mme Monique Laurent, present Conservateur of the Musée Rodin, has provided a number of vitally important photographs, as has Professor Elsen, and Vera Green of the B.G. Cantor Art Foundation has been unfailingly helpful.

The organization of such a quantity of disparate material is an enormously complicated task, and I have been ably helped at various times by Nina Parris, who checked many of the bibliographical references, and by Janet Wilson, Pamela Scheinman, and Elizabeth Landreth, who assisted in the editing and proofreading. Special mention must also be made of Murray Weiss, whose fine photographs of the Rodin Museum's sculptures, exceptional in the manner in which they reveal new aspects of works frequently only too well known, are such an indispensable feature of the book. In addition, the design staff at Conzett and Huber has shown admirable perceptiveness and creativity in their layout of this book. Finally, I should like to express my gratitude for the extraordinary patience and attention to detail of George H. Marcus and Joanne Greenspun. In their hands, being edited was a pleasure and not an ordeal.

J.L.T.

NOTES FOR THE USE OF THE BOOK

All works in the Rodin Museum were the gift of Jules Mastbaum, unless otherwise stated in the Notes.

For each work, the date given is that of the original conception, not of the casting in bronze, carving in marble, enlargement, or reduction. Only when these dates are known or can be reasonably surmised have they too been included. In citing dimensions, height precedes width followed by depth. The numbers in brackets in the Notes and References sections refer to citations in the Bibliography.

In the Other Casts and Versions sections, works in the same dimension and medium as those in the Rodin Museum have been listed first. When no dimensions are given, they are the same as those in the immediately preceding listing. In compiling these lists, every attempt has been made to be as exhaustive as possible. However, since most of the works discussed have been cast in considerable numbers, the claim of completeness cannot justifiably be made. It is hoped that the publication of this catalogue will bring unknown casts to light.

THE RODIN MUSEUM

No one familiar with Jules E. Mastbaum's collection before 1923 would have been able to foretell that by the time of his premature death on December 7, 1926, he would have assembled a sufficient number of works of art to form a museum. Until 1923 when, in the company of the Michigan-born painter Gilbert White, he purchased his first sculpture by Rodin, his interests in the business and sports worlds kept him fully occupied. He was born in 1872 and attended the Philadelphia public schools. After graduating from the Wharton School of Business of the University of Pennsylvania, he became a buyer for Gimbel Brothers in Milwaukee. He returned to Philadelphia and entered the real estate business, but in the late 1890s he began to show an interest in the pioneer movie industry. The first Mastbaum theater opened in Philadelphia in 1905 at the southeast corner of Eighth and Market streets. After the death of his brother Stanley in 1918, Mr. Mastbaum organized the Stanley Company of America, which in a few years became the largest corporative operator of motion-picture houses in the nation. He was well known in sports circles, particularly racing and athletics, and took a lively interest in the breeding of thoroughbred dogs. It was as a philanthropist, however, that he won the respect of all who knew him.

In 1922 he commissioned Albert Rosenthal to purchase for him in Europe a selection of French bronzes of the nineteenth century. The following year he went to Paris himself, bought a bronze by Rodin, and developed what his agent in future negotiations with the Musée Rodin, Mr. Rosenthal, described as a "mania" for the great artist. Not content with merely owning works by Rodin, he felt the need to form a fully representative collection of his work and to make this available to the general public.

Rodin was already well known in America. As early as 1893 the Art Institute of Chicago had acquired a plaster of Jean d'Aire, one of *The Burghers of Calais (see* no. 67, Other Casts and Versions), and the Metropolitan Museum of Art had acquired a cast of the *Bust of St. John the Baptist* in the same year *(see* no. 65, Other Casts and Versions). Exhibitions of his work had been held at the National Arts Club in New York in 1903 and, together with Claude Monet, at the Copley Society of Boston in 1905, and important groups of drawings had been seen at Alfred Stieglitz's "291" Gallery in 1908 and at the Little Galleries at "291" in 1910. In 1912 a collection of thirty-two works acquired with funds given by Thomas Fortune Ryan and by gift from the artist had been opened to the public at the Metropolitan Museum of Art in New York. Important collections were also being formed by Alma de Bretteville Spreckels in San Francisco and by Samuel Hill in Maryhill, Washington.

Jules Mastbaum was unique, however, in the methodical manner in which he approached his self-appointed task. His agent made frequent trips to Paris and Meudon and, working with Léonce Bénédite, Director of the Musée Rodin, and with his successor Georges Grappe, selected pieces that represented Rodin in all of his aspects, as a sculptor on an intimate scale as well as the maker of great monuments. Certain major works, notably *The Gates of Hell*

(no. 1), had not been cast in bronze during Rodin's lifetime but clearly, to a man of Mr. Mastbaum's temperament, no collection of Rodin's art would be complete without a cast of his most important work. Toward the end of 1925 he ordered no less than two casts of *The Gates*, one for Philadelphia and one for the Musée Rodin in Paris, which was still in dire financial straits. Mr. Mastbaum's desire to further Rodin's reputation is amply demonstrated by this gesture, as it was by his decision to provide funds for the restoration of Rodin's house and studio at Meudon, which had rapidly been falling into disrepair since Rodin's death in 1917. With few exceptions, then—*Eternal Springtime* (no. 32b), *Youth Triumphant* (no. 26), and *The Hero* (no. 49)—the bronzes in the Rodin Museum are posthumous casts by Alexis Rudier. Executed shortly after the artist's death, however, and by the foundry that worked for Rodin during the latter part of his life, they are casts of the highest quality.

Mr. Mastbaum did not limit himself to the purchase of works from the Musée Rodin. Through his agent he established a close relationship with the well-known dealers F. and J. Tempelaere, and they were able to secure for him a number of unusual works in addition to several hundred drawings, some of which are of the greatest interest, documentary and ephemeral material, and books and reminiscences from some of Rodin's friends and collaborators. *The Zoubaloff Fauness* (no. 34), *La Lorraine* (no. 106), *Minerva* (no. 109), the *biscuit de Sèvres* bust of Albert Carrier-Belleuse (no. 85), a plaster study of Balzac (possibly no. 74), the plaster version of the bust of Victor Hugo dedicated to Henri Fantin-Latour (no. 87a), and two works dedicated to Léopold-Armand Hugo (nos. 23 and 42) came from this source. Judith Cladel, Rodin's great friend and biographer, also took the liveliest interest in the formation of the museum. As a token of her admiration for Mr. Mastbaum's espousal of the cause to which she had dedicated such a great part of her own life, she gave two drawings to the museum that were particularly precious to her since they had been gifts from Rodin.

Throughout 1925 and 1926 works by the hundred were arriving at the port of Philadelphia. *The Burghers of Calais* could be seen briefly on the Benjamin Franklin Parkway at Logan Square, and the greater part of the collection was exhibited under the title "Rodin Museum of Philadelphia, Jules E. Mastbaum Foundation" in the Department of Fine Arts at the Sesqui-Centennial Exposition in 1926. By this time plans for the future museum were well under way. In order to create an environment that was in keeping both with the spirit of the sculpture to be displayed there and with the Parkway itself, Mr. Mastbaum approached Jacques Gréber of Paris, who had conceived the overall design of Philadelphia's Benjamin Franklin Parkway, and persuaded him to collaborate with the local firm of Paul P. Cret.

On April 15, 1926, Mr. Mastbaum wrote to the Commissioners of Fairmount Park, stating that he had recently purchased a number of works by Rodin and that he wished to make them "freely available for the study an denjoyment of my fellow citizens of Philadelphia." He offered to erect an appropriate building on the Parkway, without cost to the city, which would then become its property. He further offered to maintain the building as well as the collection without cost to the city, as long as he was permitted to display his collection there. This beneficient offer was formally accepted by the Commissioners of Fairmount Park on May 12, 1926, the site allotted being the northeast portion of the Parkway gardens between Twenty-first and Twenty-second streets.

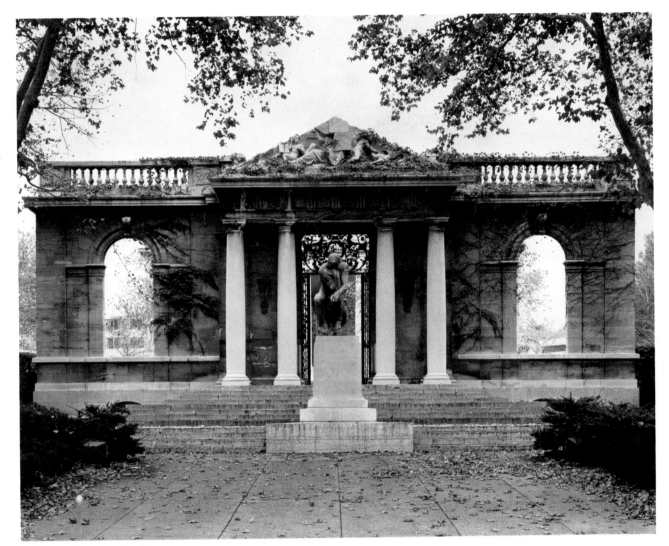

Gateway to the Rodin Museum.

This was the situation when Mr. Mastbaum died on December 7, 1926. The work of construction had not even begun, but fortunately provision had been made for the completion of the museum in the event of his sudden death. His executors and trustees were authorized to complete the building, provided that satisfactory arrangements were made with the city of Philadelphia for its proper care. Consequently on May 6, 1927, Mrs. Mastbaum wrote to the Commissioners, stating that it was her intention to proceed with the construction of the museum, but proposing that the entire collection forming part of Mr. Mastbaum's estate should be transferred outright to the city, in consideration of which the city was asked to assume the responsibility for the maintenance of the museum and its contents. These proposals were formally accepted on May 12, 1927, and ground-breaking ceremonies were held on December 7 of the same year. The work of construction was finished by the latter part of 1929, and the museum was formally handed over to the city and opened on November 29, 1929, in the presence of the mayors of Philadelphia and New York and of the French Ambassador, Paul Claudel. One further change in the status of the museum occurred in 1939. Agreement was reached between the Commissioners of Fairmount Park and the Philadelphia Museum of Art whereby the Commission authorized the museum as its agent to administer the Rodin Museum and to care for such objects of art belonging to the city as might be placed there.

The building that resulted from the collaboration between Gréber and Cret is an example of the Beaux-Arts style at its best and, housed as it is in a formal garden of no little charm, it still forms one of the most delightful enclaves on what is now a very busy highway. The museum is approached through a faithful reproduction of Rodin's tomb at Meudon, itself a reconstruction of the façade of the eighteenth-century Château d'Issy, which Rodin had purchased with the intention of reconstructing it in its entirety, although in the event only the façade was built.

After the initial excitement, interest in the museum waned. For a time, until Works Progress Administration funds came to the rescue, it was only open one day a week, and attendance was very poor. Unfortunately, too, some of the documentary material that had been gathered so carefully was dispersed, and no attempt was made to round out the collection in areas where the taste of the 1920s had left it somewhat weak. Only one work, the beautiful plaster of *Eternal Springtime* (no. 32a), was acquired between 1929, the year of the museum's founding, and 1968, when a bronze cast of Rodin's last portrait, the bust of Etienne Clémentel (no. 104) was obtained. In 1970 a very rare wax sketch entitled *Scene from the French Revolution* (no. 30) was purchased.

The American museum-going public owes more than it frequently realizes to the enthusiasms of private collectors and patrons of the arts. Many of these collections, of course, are ultimately bequeathed to museums. Jules Mastbaum's collecting habits were unique, however, insofar as from the very beginning it was his intention that his collection should be made available to the general public. It was not something jealously guarded and revealed only reluctantly but freely given for the enjoyment of his fellow citizens and the cultural improvement of the city in which he lived. Philadelphia owes a great deal to Mr. Mastbaum's passion for the modern sculptor of passion. How tragic that he did not live to see his creation.

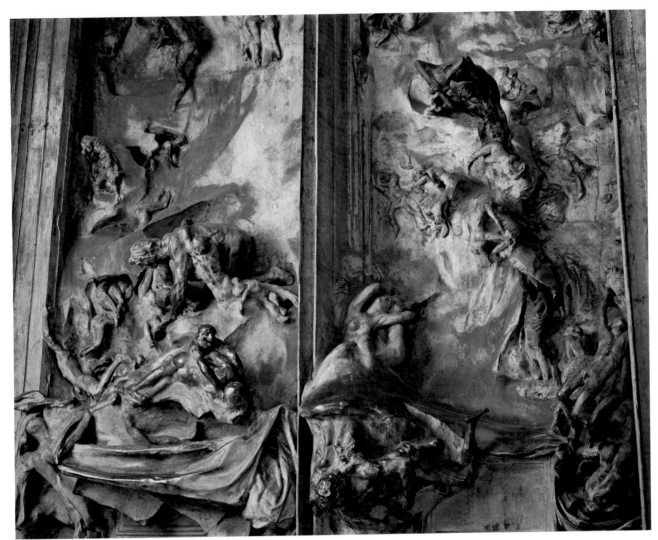

Detail of The Gates of Hell (no.1)

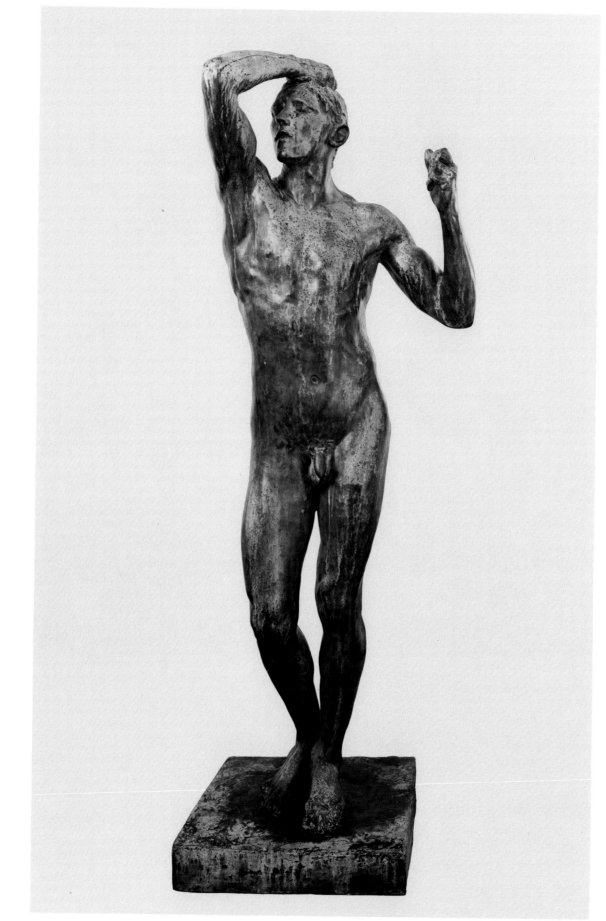

The Age of Bronze (no. 64)

INTRODUCTION

Rodin lived long enough to enjoy the considerable rewards bestowed upon him. His works were beginning to enter major museums on both sides of the Atlantic in significant quantities, and he died in the assurance that there would be a museum devoted to his work in Paris. He still did not have the satisfaction of seeing certain of his major pieces cast in bronze—notably the *Monument to Balzac (see* nos. 72–76) and *The Gates of Hell* (no. 1)—but his preeminence among living sculptors must have made it seem merely a matter of time before they would be. He was the subject of numerous monographs and countless articles, and his opinions were listened to with respect, not to say veneration. In the two books that were published under his name—*Art* in 1911 and *Cathedrals of France* in 1914—as well as in various published interviews, he found yet another way of reaching the public at large.

In the years of his greatest fame, however, he was already something of an anachronism. The old man who had met Delacroix as a youth lived long enough to converse with Matisse, Maillol, and Brancusi and even, in a surprising encounter worthy of some of his sculptural juxtapositions, to be photographed with Diego Rivera *(see* Chronology). To these men he was a survivor from another age whose work, omnipresent as it seemed, required a riposte. For while Rodin's work was acknowledged to be superior to almost everything else that was produced in the nineteenth century, its basic tenets were thought to be invalid. Artists like Matisse and Maillol, who were essentially modelers, found fault with Rodin's taste and with his inability to produce works that were finished and formally satisfying. Roger Fry went so far as to deny that his approach was sculptural,[1] and in a discussion of the "Rodin case," a later writer stated that "the worst thing is always the lack of doctrine, of discipline, the absence of monumental support."[2] Another significant group of younger sculptors, including Brancusi, Modigliani, Henry Moore, and, for a limited period in his career, Jacob Epstein, who saw the probity of sculpture in direct carving and "truth to material," were highly critical of Rodin's apparently rather distant relationship to the execution of his marbles and to what they regarded as his insufficient concern for the intrinsic qualities of materials.

Although David Smith's work derives in no way from Rodin, certain of his remarks summarize very aptly the difficulties encountered by the majority of early-twentieth-century sculptors in approaching Rodin's work. In an interview Smith was asked why he did not

employ assistants in view of the fact that he could well afford them. "I can't use studio assistants any more than Mondrian could have used assistants to paint in solid areas or any more than de Kooning or any of my friends can use somebody else to put backgrounds in, even though they might be pure white. They don't want the marks of another hand on their work. *Now that is twentieth century, too.*"[3] Discussing the value of uniqueness in sculpture, he made a further point that is relevant: "Sculpture is lightly considered because you see the same goddammed sculptures. They become common and that reduces the interest. The world is full of reproductions of sculpture and that is one of the defiling things about it."[4]

Through the accumulated observations of twentieth-century sculptors and critics and, of course, through the works themselves certain beliefs about the nature of sculpture became axiomatic, namely, that the sculptor should be entirely responsible for the execution of his work and that sculptures should be unique or at least issued in quite limited editions. Furthermore, it was widely believed that the size in which a work was originally conceived was one of its essential characteristics and should not be subject to change and that any content related to the human experience should be subordinate to the formal qualities of the sculpture as object. Although Rodin's work never lost its appeal on a popular level, and illustrated monographs continued to appear in abundance, his work went into critical oblivion almost immediately after his death as a result of the prevailing attitudes. A re-emergence of his work for serious consideration took place only in the early 1950s when, partly through the efforts of the dealer Curt Valentin, certain aspects of Rodin's art were found to have qualities that were not antithetical to the most cherished twentieth-century beliefs.

It was a new and severely depleted body of work that was found fit to qualify Rodin as a precursor of twentieth-century sculpture. In one of the finest essays written to make a case for the "new Rodin," the critic and art historian Leo Steinberg urged the viewer who wanted to rediscover Rodin's "relevance" to "begin by shelving the famous marbles and stones."[5] Referring to the "flatly anti-rhetorical" sympathies of the post-World War II public, he sympathized with their inability to "suffer and judge an art of Rodin's demonstrative humorless pathos" and saw a way out of the impasse by looking "to the plasters, the work in terra-cotta and wax, and the finest bronze casts."[6] The Rodin who finds favor is thus the author of the small unfinished studies and not the highly finished set pieces, the creator of bizarre encounters between unrelated fragments of his own work and not of the more immediately appealing romantic subjects. Rodin is accepted in his twentieth-century guise but rejected totally as an artist of the nineteenth century.

Yet with a renewed and growing interest on the part of younger art historians and critics in the more conservative aspects of the art of the last century it is perhaps finally possible to form a less dogmatic and narrowly defined sense of Rodin's multi-faceted genius. He can be seen once again not as a great proto-twentieth-century artist unhappily bogged down in the sentimental excesses and dubious sculptural practices of the nineteenth century, but as a figure firmly embedded in the century in which he lived, whose work happened to suggest many fruitful avenues of exploration to younger artists. Rodin must be seen in his diversity.

Rodin had no choice but to be stylistically versatile in his formative years. Before he began working on *The Age of Bronze* (no. 64) in 1875 only isolated works, notably *Man with the Broken Nose (see no. 79)* and *Mignon* (no. 80) and perhaps several others executed for his own personal satisfaction, strike one as being fully characteristic of Rodin at his most powerful. It was not, however, the late appearance of the creative urge that delayed the emergence of his first fully independent sequence of sculptures in the latter part of the 1870s. After he failed the entrance examination of the Ecole des Beaux-Arts for the third time in 1857, adverse financial circumstances obliged him to earn his living by working for other sculptors in what was frequently the humblest capacity. Rodin referred to these years in one of his conversations with Victor Frisch: "In addition to sculpture and design, I myself have worked at all sorts of things. I've cut down marbles, and pointed them; I've done etching, and lithography, bronze founding and patina; I've worked in stone, made ornaments, pottery, jewelry—perhaps even too long; but it all has served. It's the material itself that interested me. In short, I began as an artisan, to become an artist. That's the good, the only, method."[7]

As a result of this background, far removed from the official art world, Rodin's early sculptures show his ability to work in a wide variety of styles, from the classical as interpreted by David d'Angers in the bust of Jean-Baptiste Rodin (pl. 2) and Father Eymard (no. 78), to the Second Empire mode of the busts of M. Garnier (1870) and M. Saffrey (1871; pl. 1), highly detailed in the treatment of physiognomy and costume, and to the frankly decorative eighteenth-century manner of works like *Flora* (no. 105) and the *Head of a Young Girl with Flowers in Her Hair* (pl. 3). Carrier-Belleuse, whose works ranged in scale from small groups in porcelain, portraits and *bustes de fantaisie,* to monuments and decorative ensembles for public buildings, expected an equal versatility on the part of his employees, and there was no aspect of the sculptural profession to which Rodin could not turn his hand if the occasion arose. He was perhaps the last major sculptor to be trained as a polymath.

Although his rejection by the Ecole des Beaux-Arts was a crushing blow to him at the time, since the only way in which a younger sculptor could advance in his profession was through official channels, Rodin later recognized that this was a singularly fortunate event in his life. Instead of winning the Prix de Rome and having to satisfy his taskmasters in Paris and Rome, he was able, in the time he devoted to work for his own satisfaction, to focus exclusively on the living model and the works of art that interested him most deeply, not those that were officially approved. Thus it was not to immerse himself in the classical tradition that he went to Florence and Rome in 1875–76 but to see first-hand the artist that meant most to him at the time, Michelangelo. To earn his living he was obliged to conform to decorative schemes that were not of his devising, but in the privacy of his studio, primitive as this was, he could devote himself to the patient study of the model.

Against the background of almost twenty years of enforced hackwork, the extraordinary tenacity of *Man with the Broken Nose* and *The Age of Bronze* takes on a heroic dimension. Rodin sought to prove himself to the official art world that had ignored him by works that were as simple as nature itself, a portrait of an odd-job man and a full-length nude study of a young Belgian soldier. In the context of academic sculpture, however, the revolutionary nature of this gesture as far as sculpture was concerned was overlooked in the

furor caused by the accusations that Rodin had used casts taken directly from the model in making his *Age of Bronze.* Rodin was so successful in achieving his aims that his academic contemporaries could not believe their eyes. This was a very different type of criticism from that occasioned by the first exhibitions of the Impressionists, to whose opponents they were merely incompetent daubers. It was Rodin's honesty rather than his ability that was called into question, since the extraordinary fidelity of the figure could not be denied.

In summary, Rodin's views on art, which perhaps crystallized during the eighteen months he worked on *The Age of Bronze,* sound disarmingly simple. "I obey Nature in everything, and I never pretend to command her. My only ambition is to be servilely faithful to her," he said in his conversations with Paul Gsell.[8] He expressed the same idea in speaking with Henri Dujardin-Beaumetz: "I say plainly that I have no ideas when I don't have something to copy; but when nature shows me forms, at once I find something that is worth saying and even developing."[9] It was through the technique of contour modeling that this exact copying was achieved: "When I begin a figure, I first look at the front, the back, the two profiles of right and left, that is, their contours from four angles; then, with clay, I arrange the large mass as I see it and as exactly as possible. Then I do the intermediate perspectives, giving the three-quarter profiles; then, successively turning my clay and my model, I compare and refine them."[10]

Through the advice of an obscure sculptor named Constant Simon, Rodin learned never to "consider a surface except as the extremity of a volume"[11] with the result that "the truth of my figures, instead of being merely superficial, seems to blossom from within to the outside, like life itself."[12] This subservience to nature did not, however, result in an accumulation of detail in the manner of the Naturalists but in a more thorough comprehension of the human figure in all its aspects, both physical and spiritual, for he believed that "all is idea, all is symbol. So the form and the attitude of a human being reveal the emotions of its soul. The body always expresses the spirit whose envelope it is."[13]

Inner feelings were revealed through movement and a certain degree of exaggeration. In many statements Rodin refers to the crucial role of movement in his sculpture, even in the portrait busts, a movement not stopped, as in an instantaneous photograph, but represented from beginning to end and synthesized in one telling form. In no other sculptural *œuvre* is such a wide diversity of movements represented, from the merest tremor on a human brow to the athletic leaps of *Nijinsky* (pl. 4), from the earthbound and deliberate as in *St. John the Baptist Preaching* (no. 65) to the helpless and frenzied as in the majority of figures falling through space in *The Gates of Hell.*

There was as much variety in the degree to which the sculptural forms were accentuated for emotional effect. Discussing *The Prodigal Son* (pl. 5), Rodin explained how he accentuated the lines which best expressed the emotional state he wished to interpret;[14] referring to the *Monument to Balzac,* the crucial work of the 1890s, he stated that his principle was to imitate not only form but life. "I look for that life in nature, but in amplifying it, exaggerating the holes and the bumps so as to give them more light; then I look for a synthesis of the whole."[15] But if there are many works, including some of the greatest, such as *The Burghers of Calais* (no. 67) and the *Monument to Balzac,* in which the degree of exaggeration is pronounced in

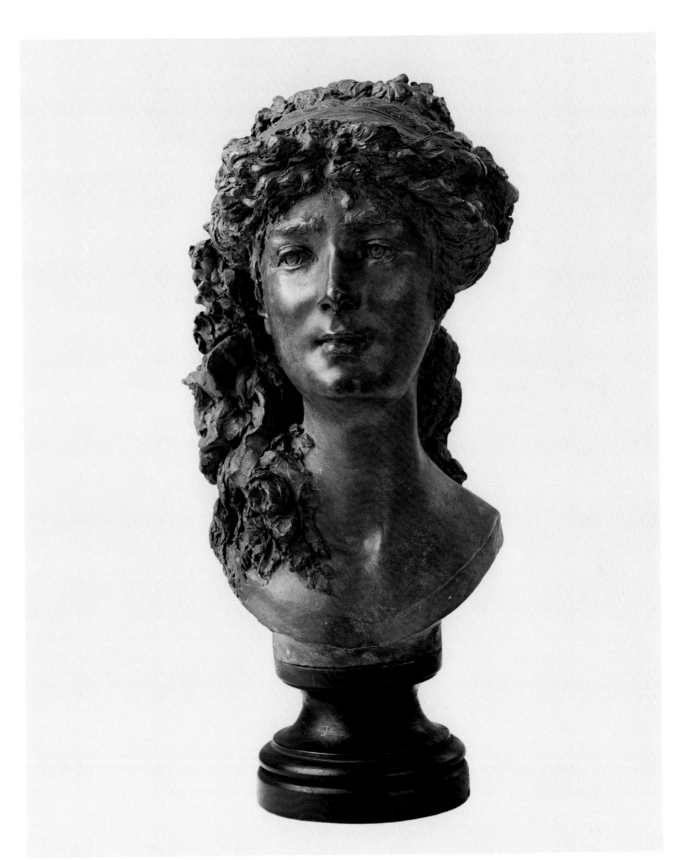

Flora (no.105)

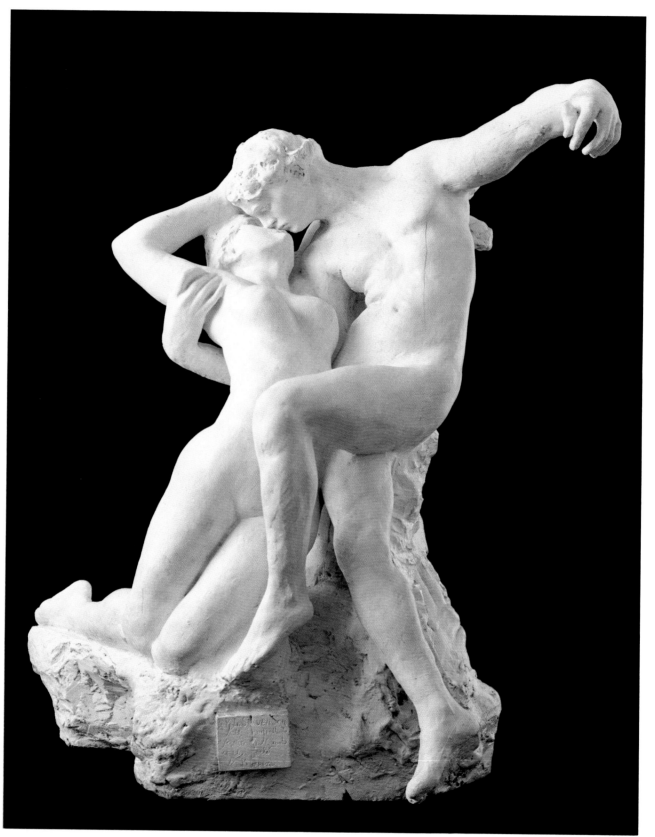

Eternal Springtime (no. 32a)

accordance with the elevated emotional state of the people depicted, there are as many, particularly in the marbles of the later years, in which the forms are dematerialized and to a certain extent idealized in keeping with the calmer state of mind that the artist cultivated.

In spite of his constant emphasis on movement and the judicious use of exaggeration, Rodin was not forgetful of the formal attributes of his works, although in his case the form was something that grew organically from the human body, even in movement, and not something imposed from outside. He allowed his models, chosen preferably from those who had never posed for other sculptors, to move freely, and he said to Frederick Lawton that if he made an exception he was sure to regret it. "Any dictated attitude is for the nonce unnatural, and is worse than useless to the student. It is the finite substituted for the infinite, isolation and interruption of the secret law of our being; the body loses its charm, and becomes absurd and ridiculous."[16] In spite of its mobility and fleshiness, the human body was seen as architecture of the most sophisticated kind, its forms balanced in a miraculous and constantly changing equilibrium, "a temple which moves and, like a temple, has a central point around which the volumes are situated and spread out. It is moving architecture."[17]

The highly personal nature of Rodin's theoretical position, formulated only in later years but based on the patient accumulation of a lifetime of experience, renders any discussion of his relationship to his contemporaries problematic in the extreme. He saw himself in relation to the Egyptians, the Greeks, the Romans, the Gothic sculptors, and Michelangelo and not to the Naturalists, the Impressionists, the Symbolists, and certainly not to the academic sculptors of his time. Nonetheless it is inevitable that there are certain affinities with his contemporaries, with many of whom he was on intimate terms, although the nature of his craft and its role in nineteenth-century society as well as Rodin's respect for tradition, "the real tradition of truth and liberty,"[18] account for the limited extent to which such comparisons are apt.

Like his immediate contemporaries, the Impressionists, Rodin was hostile to the academic ideal. "The ideal is a word invented by the bourgeois,"[19] he stated on one occasion and elsewhere, "at the Institute, they have stuffed the antique."[20] In his opinion the Ecole des Beaux-Arts had dispensed with tradition at the beginning of the nineteenth century and had ossified the beauties of nature. He rejected its views on composition for the same reason, claiming that Carpeaux's *Ugolino,* as great a sculpture as it is, is "static. There's too much striving after architectural composition; that keeps him from solving his problem."[21] And yet in his choice of themes, in his working methods, and in his attitude toward the materials of his craft, Rodin was much more closely related to the academic practice of his time than were the Impressionists.

By the time *The Age of Bronze* was exhibited at the Salon in 1877, Impressionism, with its focus on the modern world, on rapidity of execution *sur-le-motif,* and with its general informality, was fully developed. It was a revolution of subject matter, style, and technique and represented a clean break, not with the past, since the young painters learned a great deal from their immediate forebears, but with the prevailing academic style. The Impressionists simplified painting, rejecting literary and philosophical subject matter and complex compositions that necessitated elaborate preliminary studies and complicated technical proce-

dures, in favor of a direct response to the modern world, conveyed through a simple technique that concealed none of its methods. By contrast Rodin had studied his model for eighteen months, registering every contour with the greatest care; and his subject matter, a life-size standing male nude figure with identifiable attributes, was originally fully in keeping with academic ideas, although by the time it was exhibited it proved to be provoking for its lack of explicitness *(see no. 64)*.

Unlike the Impressionists, Rodin never abandoned his interest in literary and romantic subject matter, and it is this aspect of his sculpture that not only links him to his academic contemporaries but that also led Camille Mauclair to point to his affinities with Gustave Moreau, Puvis de Chavannes, Stéphane Mallarmé, and Félicien Rops. These artists, Mauclair said, "have chosen mythological subjects from the repertory of the Ecole, scrutinized ad nauseam, one would have thought; and yet, they have brought forth unknown sensations—Moreau by the accumulation of mysterious luxury and oriental symbolism, Puvis de Chavannes by the simplified serenity of a heroic and pure nudity, barely supported by a few accessories, Mallarmé by the eurythmy of the images and the knowing choice of rare epithets, Rops by his neurotic modernity. Rodin, for his part, finds these unknown sensations through a personal aesthetic of form and by a special feeling for gesture, by the strange psychological intensity of his heads, by the unexpectedness of his groupings."[22]

Thus Rodin's predilection for mythology and themes of the imagination removed him from the modern world of the Impressionists just as much as his firm commitment to the human body removed him from the rarefied, insubstantial world of so many of the Symbolists. It was his friendship with great Naturalist writers like the de Goncourt brothers and Emile Zola that undoubtedly led him to familiarize himself with all aspects of his subject matter, visual and documentary, before embarking on the execution of major works like *The Burghers of Calais* and the *Monument to Balzac,* but he still required a model who resembled the figure he was commemorating *(see nos. 67, 72–76)*. He was not satisfied merely with recording external characteristics, choosing instead to use these only insofar as they mirrored the soul. He was directly opposed to the "Jacques Louis David method,"[23] but by virtue of the fact that sculpture was a more public art than painting he was obliged to compete with his academic contemporaries for commissions and to enter works in the annual Salons in the hope that funds would be forthcoming to have the work cast in bronze or carved in marble. As the demand for his works increased, he required numerous assistants and a well-organized studio to meet all his commitments. In this respect his work is much more traditional than the sculptural *œuvre* of two painters, Honoré Daumier and Edgar Degas, who executed their sculptures themselves, although, of course, their three-dimensional work was a by-product of their painting and neither artist was capable of working on a monumental scale as was Rodin.

It was his firm commitment to nature that also accounted for his largely negative views on the more advanced tendencies of late-nineteenth-century art. In architecture he referred to "the penury of *modern style,* everything angular and irregular,"[24] which lacks the feeling for transitions between light and shade found in earlier architecture; elsewhere he spoke of the "Pre-Raphaelite"[25] tendencies which invaded France after having originated

24

in England and disfigured the environments in which modern collectors chose to live. He was also thoroughly out of sympathy with the aesthetic views that were being formulated by Maurice Denis, believing that "there does not perhaps exist a single work of art which owes its charm only to balance of line or tone, and which makes an appeal to the eyes alone."[26] Anything that detracted from the majesty of nature was anathema to Rodin, hence his refusal to adhere to any aesthetic doctrine that placed the stress on man's will or his imagination. In his words he was the servant of nature, but, in apparent contradiction, he was also the director of a large and flourishing sculptural studio organized along traditional lines.

Rodin was an immensely prolific artist. Distrusting inspiration and believing in the efficacy of work, he was seldom not modeling or, especially in later years, producing drawings by the hundreds. Unfortunately, although hardly surprisingly, only a relatively small amount of his work is widely known. The storage areas of the Musée Rodin have been inaccessible, and official publications have been sparse. In addition there are many works in private collections and museums throughout the world which have never been published. Partly as a result of an incomplete knowledge of the extent of his *œuvre*, most writers on Rodin have adopted what might be described as a linear approach, seeing the rhythm of his work in progress from monument to monument and portrait to portrait. Alternatively, his work has been broken down into categories ranging from the fully documented major pieces to the "inconnu." The traditional view sees Rodin as the maker of a number of more or less famous and identifiable works, while more adventurous taste tends to overlook these in favor of the nameless sketches and assemblages.

As more sculptures become known, however, the readily identifiable works begin to seem like the tips of icebergs emerging from a sea of closely interrelated studies and assemblages. Figures seen in one medium and size in one city are reencountered greatly diminished or enlarged and in a different material in another city. Well-known and well-loved sculptures are found in a different context, completely transformed by the addition or subtraction of parts, some of which may be familiar from elsewhere. The sexual identity of figures changes as do the titles, giving new ranges of associations to identical forms. The *œuvre* begins to slip from the grasp, to become less familiar and much stranger as more is known about it. There are some landmarks, perhaps, but they are more closely related than had been anticipated and are consequently more confusing to navigate by. Prolonged familiarity reveals not a fixed pattern in Rodin's *œuvre* but its deliquescence, as it melts away in the course of growth or decay or as it branches off in many divisions. It was from the basic sculptural event, however, the encounter between the sculptor with his clay and the naked model, that the complex network derived.

For Rodin sculpture and modeling were synonymous. Many of his statements on the nature of sculpture reflect his belief that the integrity of a piece of sculpture lies in direct ratio to the sculptor's ability to record all the contours of his model. Thus the initial working in clay, in direct response to the physical presence of the model, assumed a role of particular importance in Rodin's sculptural aesthetic. Regarding the clay as the medium through

which the sculptor's sensitivity to the slightest modulation in form was recorded, he had no time for any sculptural techniques which compromised the fidelity of his response. Thus Truman H. Bartlett recorded: "The practice, in and out of the school, of working with 'bullets' finds no favor with Rodin. The sculptor, instead of putting on the clay with a sweep of his thumb or fingers, and thus indicating, with his every touch, the ever-important fact of planes, rolls it out into a little ball, and carefully places it where he desires with a slight pressure of his finger. A figure thus made looks like a mass of flattened bullets. This method of modeling is not regarded as indicating a true sensibility of form, but a way of hiding an incapacity for serious modeling."[27]

Particularly important when working in clay is the ability to keep it at the right degree of softness or hardness, not so soft that it slides off the armature but not so hard that it is no longer susceptible to being manipulated with ease. Rodin's most skilled assistant in this particular area was the faithful Rose Beuret, who seemed to have an innate feeling for the variations in the performance of the clay. It was her job to keep the clay à point, and indeed this remained her job almost to the day she died. The letters Rodin wrote to her from Belgium and Italy between 1871 and 1877 are full of anxious inquiries as to the state of his clay models. "When you damp my figure," he wrote from Brussels in 1871, "do not do it too much, so that the legs won't get too soft."[28] "Look after the casts," he wrote in October of the same year, "wrap them all up in newspapers, handkerchiefs, or whatever you find."[29]

But however vigilant one is in caring for clay, its period of life is limited. If left untouched, it dries out, cracks, and eventually disintegrates. If, as happens more often, the decision is made to give the modeled form a more permanent life, whether in plaster, bronze, or marble, the clay probably disappears in the process. The most direct method of preserving the original clay form is simply to bake it and, in fact, if it is free from impurities the resulting terra-cotta is extremely strong. Until the early 1880s Rodin was not in a financial position to consider having his works cast in bronze. This fact, in addition to the fashion for terra-cotta, which was an aspect of the eighteenth-century revival of which Carrier-Belleuse was one of the main exponents, explains why most of Rodin's work before 1873 was not cast in bronze.[30] After this date he returned to terra-cotta from time to time,[31] and a considerable number of terra-cottas date from after 1900,[32] but in most cases the terra-cotta preserves a study for the final work that was later developed further and carved in marble or cast in bronze.

Among the most important of the many assistants employed by Rodin were the mouleurs, whose task it was to make casts from the clay studies both during and immediately after the execution of the work. The making of a plaster cast was not simply an essential step in preparation for the casting of a bronze. For Rodin plaster had an aesthetic of its own, and the plaster cast played an unusually important role in his working methods. Malvina Hoffman, who studied with Rodin in 1910 and 1911 and returned for a period in 1912, gave a description of the use Rodin made of the services of the mouleur while he was working: "Frequently I knew him to start a portrait, and after a few sittings, to call in a plaster-caster and have a mould made as a record; then he would make a 'squeeze,' that is, the fresh

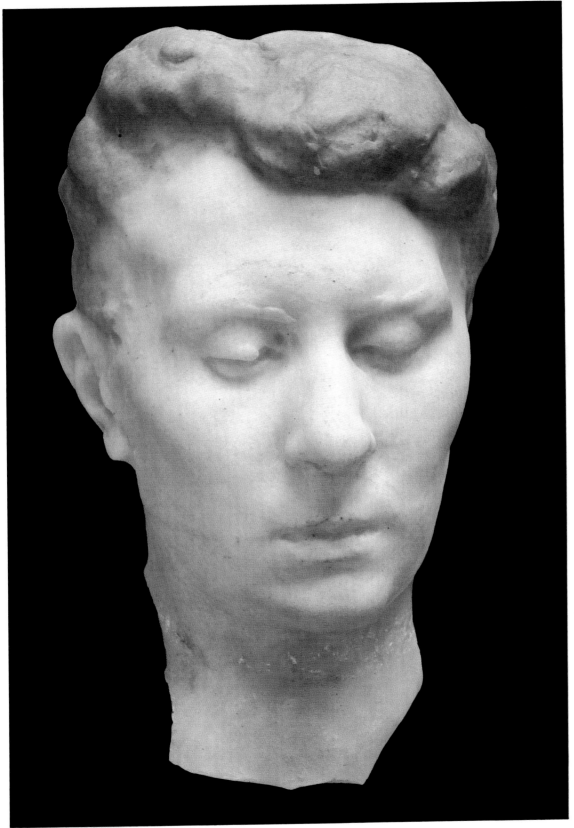

Mask of Mme Rodin (no. 81)

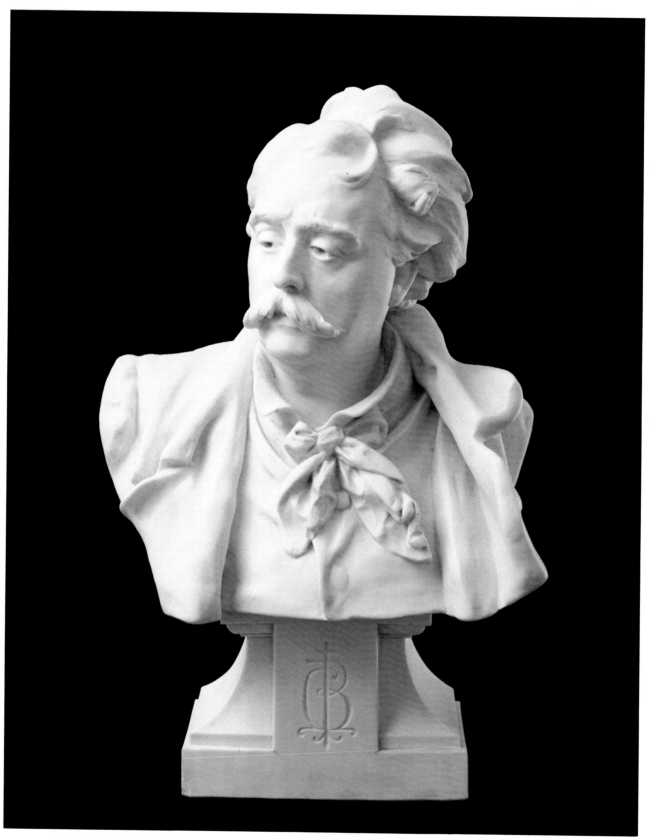

Albert–Ernest Carrier-Belleuse (no. 85)

clay would be pressed into the negative of the piece-mould and with this stage of the portrait safely registered, he would feel more free to make bold changes and experiments, without the fear of losing what had been achieved up to that point. The first plaster was a guide to which he could always refer if he felt himself in doubt during the subsequent sittings."[33]

Thus there are very often a number of original plasters of the same work which differ considerably in detail from one another. In the continuation of her description of Rodin's working methods, Miss Hoffman noted one of his most individual characteristics, namely, his habit of forming composite figures and groups from fragments of his own work: "He would hand me little plaster figures and ask me to cut off the arms and legs; then with white wax he would rearrange the groups, changing a gesture and adding action or some new suggestion of composition."[34]

As early as 1878, when Rodin was working on *St. John the Baptist Preaching,* it is apparent that he regarded the human figure not as an inviolable entity but as a sum of parts that were not necessarily related in a definitive way. He worked on the torso and legs separately and experimented endlessly with the relationship of the arms to the hands *(see no. 65).* Indeed, in view of his interest in the ceaseless flow of movement and of his dislike of static poses, his approach to the human figure and the depiction of movement could only have been a relativistic one. It was with *The Gates of Hell,* however, that his investigation of the full expressive potential of his modeled figures began in earnest. Roger Ballu gave an account of the dismantled state of *The Gates* in 1883, and Bartlett described how the small figures were cut off in pieces and sections until the time came to reassemble them *(see no. 1).* Gustave Geffroy arrived at the studio sometime in the mid 1880s and gave the following description of what he saw: "The key grates in the lock and the door opens. None of the sculptor's models is stretching his muscles or standing like statues of trembling flesh. Rodin is alone, working at the assembly of groups, looking for arrangements and harmonies."[35]

That is to say, the artist was discovered, not in the process of modeling or carving but in rearranging works that he had already created. Models were frequently present, but they were not the focus of activity in the studio. Through acting spontaneously they provided, as it were, a natural background for the sculptor's activities, one to which he could turn for inspiration if he felt so inclined. In his conversations with Gsell, Rodin referred to himself as a dramatist, since he believed that sculpture and painting, in their recreation of moments of past history, could be compared to theater and literature,[36] but he realized that it was his mastery of modeling that made this possible. As he said to Dujardin-Beaumetz: "When the figures are well modeled, they approach one another and group themselves by themselves. I copied two figures separately; I brought them together; that sufficed, and those two bodies united made 'Francesca da Rimini and Paolo' "[37] *(see pls. 6, 7, 8).*

In the numerous works that derive from *The Gates of Hell* and in the mythological subjects, there was thus never a question of imposing a composition on recalcitrant material but of discovering groupings that arose spontaneously. The participants in these sculptural dramas are the tangible results of Rodin's slavish devotion to nature in the form of the living

29

model, but the dramas themselves are as imaginary as the Dantesque scenes in the early "black" drawings.

Throughout the text of this catalogue, reference is made to the constant use of figures and parts of figures in new compositions and combinations, frequently over an extended period of time *(see nos. 5, 6, 8, 9, 18, 19, 25, 49–51)*. Two further examples will give an idea of the extent to which this creative principle was applied and of its curious ramifications with regard to the spectator's response to individual works. Familiarity with one element in a composition, perhaps heavily disguised by changes in scale or angle of vision, or the addition or subtraction of limbs, results in a disturbing sense of *déjà vu,* adding strongly to the mysterious appeal of the sculpture. The figures of Acis and Galatea, for example, in the work known as *Polyphemus, Acis, and Galatea* (no. 22), although diminutive in scale, are closely related to one of Rodin's most popular works, *The Eternal Idol,* a finely carved marble version of which is in the Fogg Art Museum (pl. 9). A plaster cast in the Fine Arts Museums of San Francisco (pl. 10) represents the germ of the idea. A roughly executed man, one hand behind his back and grasping his other arm, kneels before a standing female figure, his head just below the level of her breasts. In the marble, the gesture of the male figure has been refined, and he now places an adoring kiss beneath her breasts. Both figures were used again, together in one case and separately in another. With their positions altered and their loving contact broken, they were used in a little-known group most convincingly titled *The Creation,*[38] a bronze cast of which is in the Museum of Fine Arts in Boston (pl. 12). Another work in the Boston museum utilizes the female figure alone. With a new pair of arms she rests between the legs of a significantly larger male figure who leans over her in an attitude of extreme concentration. Here the title *Vulcan Creating Pandora* seems to be appropriate (pl. 11). Finally, in 1900, the male figure also appeared in a mythological guise, perched on the back of a lively marine creature together with a reclining female figure in the work known as *Triton and Nereid on a Dolphin* (pl. 13). Rodin gave this small plaster version to the Musée des Beaux-Arts in Lyons in 1903, while an enlarged marble version may be found in the Musée Rodin.

A further example of Rodin's inability to leave his figures alone, once he had created them, is provided by a little-known terra-cotta figure of a *Woman Seated on a Rock* (pl. 14). The slender, ungainly figure, pressing down on a rock with both hands, most probably dates from the mid 1880s and was used in the work known as *Two Women Embracing,* a bronze cast of which is in the St. Louis Art Museum collection (pl. 15). No changes were made in its position, but an equally slender female figure glides into her arms in an impassioned, consolatory embrace. In a bizarre plaster assemblage in the Musée Rodin, the tormented creature sits beneath the shade of a tree while a considerably smaller female nude peers from behind it and hovers over her (pl. 16).

Rodin certainly cherished the ambiguity of these groupings which, as he recognized, would not have been possible sculpturally had he not consistently envisaged each figure as a three-dimensional form immersed in space. His extended labor on *The Age of Bronze* had revealed to him that an exact equivalence between work and title tends to destroy the mystery of the work so that it runs the risk of becoming merely illustrative. Rodin

demonstrated this amusingly one afternoon when the sculptor Charles Despiau was present: "Every Sunday at Meudon numerous visitors came. On that day all the works were covered with cloth. One Sunday, however, a bust was uncovered. Each visitor stops to admire it. One of them, bolder than the rest, asks what the head is. 'It's Joan of Arc,' said Rodin. Everybody exclaims at the beauty and truth of the work. A new admirer comes up who stops in front of the statue and asks what it represents. 'It is the town of Nantes,' the master said. In this way the statue changed personality five times in one afternoon, much to the confusion of several awkward admirers."[39]

Dwelling so much in the realms of history, mythology, and literature, Rodin frequently saw analogies in the conjugations of his forms with given situations in the past, and the addition of a poetic title added an even greater aura of mystery to his groups. Nothing was fixed in this world, however, and Rodin remained perpetually alert to the possibility of new permutations as different aspects of his figures were revealed in new situations. He was as open to suggestion from the elements of his own work as he was from the forms of nature, hence the endless variations to which his works were submitted. But at the same time as they were investigated for their expressive potential through reuse in different contexts, they were also dismantled and broken down into their component parts and detached to facilitate contemplation. Heads and torsos, arms and legs, hands and feet were stored by the thousands in the studio, utilized when appropriate in the completion of a group or the modification of a figure, and ultimately presented as evidence of his devotion to the human form (see pls. 17, 18, 19). Stripped of all literary associations, they became independent sculptures in their own right. He gave minute studies of hands and feet to some of his admirers, including Mrs. John W. Simpson, as well as to public institutions like the Metropolitan Museum of Art. He had clearly come to the conclusion that, fragmentary and unassuming as these studies were, they were still valid sculptural statements in their own right. Tokens of his submission to the human form, they are touching in their humbleness and anonymity but bold in their redefinition of what sculpture might be.

Rodin matured at a time when there was an enormous and growing demand for sculpture of all kinds, from public monuments to decorative bronzes for the bourgeois mantelpiece. To accommodate the demand, vastly productive foundries sprang up all over Europe and, more than ever before, sculptors needed the collaboration of assistants and artisans to meet their commitments. Any sculptor who, like Antoine Louis Barye, endeavored to supervise the entire production of his work from the preliminary model in clay to the casting, chasing, and patination was likely to go bankrupt, as he did in 1848. Since, for obvious reasons, the capital outlay of the sculptor was much more considerable than that of the painter or engraver, he could not afford to have works cast in bronze or carved in marble unless he had received a commission or at least had very good hope of getting one, and he was therefore obliged to satisfy his clients both with regard to medium and size. He had to be totally flexible and willing to produce bronze or marble versions of the same work according to circumstances. Equally, adjustments in size might be required. The invention of the Collas Machine for the reduction of statues in the round by Achille Collas in 1836 greatly facilitated this under-

taking, and bronze reductions were produced by the thousands to satisfy the public appetite for small versions of contemporary works that had been well received at the annual Salons or of major works of antiquity and the Renaissance.

Rodin's approach to the methods of production and the dissemination of his art did not differ from that of his contemporaries. Versions of his most popular works exist in plaster, marble, and bronze, and in all dimensions. Until 1890, according to Stanislas Lami,[40] Rodin had always modeled his sculptures the size they were finally to be, but he seems gradually to have come to the conclusion that this method was too slow, preventing him from realizing on a large scale all but a few of the compositions that he was constantly assembling. For this reason he turned to the services of Henri Lebossé, whose profession it was to make enlargements and reductions of sculpture. From 1902 on he became one of Rodin's most indispensable assistants. While the majority of reductions were made after a work had gained sufficient popularity to warrant its production, as was the case with the reduced versions of five of *The Burghers of Calais* (see fig. 67–69–13), other works such as *Eve* (no. 8) were known in reduced scale before they were ever exhibited full scale.

It is as a bronze sculptor that Rodin is generally known and preferred today, although he himself did not distinguish between the relative merits of casting in bronze and carving in marble as ways of giving permanent form to his ideas. Moreover, his major works were nearly always exhibited in plaster before they were cast in bronze. *The Age of Bronze*, for example, exhibited in plaster at the Salon des Artistes Français in 1877, was not cast in bronze until 1880, when it was exhibited at the Salon again and purchased by the state. The same pattern of initial exhibition in plaster and later casting in bronze was followed in the case of most of the major works exhibited at the Salon by Rodin in his lifetime. Bronzes were cast as they were commissioned and according to demand, the contract being given to the firm that offered the best price. Thus some works may have been cast in bronze only once while others were cast in considerable numbers. In 1891 Rodin sold a bronze cast of *The Idyll* to the well-known collector, Antony Roux. On July 20 of that year he wrote: "The model is unique and can never be reproduced in any material. I undertake to break the plaster model which has served for the bronze casts, no others existing."[41] Other works, however, like *The Age of Bronze* and *Man with the Broken Nose,* ten casts of which had been sold in England alone by 1889,[42] were reproduced in considerable quantities. Since the question of making limited editions of individual works did not arise until after Rodin's death, none of these early casts was numbered, and many do not even bear a founder's mark.

The situation is further complicated by the fact that, in addition to those works for which the arrangements for the bronze casting were made by Rodin himself, bronze casts were frequently made by people to whom Rodin had sold plasters or given them as gifts. Various types of arrangements were reached with the owners of plasters. Thus on September 21, 1885, Rodin signed a receipt for *Iris* in which it was stated that this work was the "exclusive property"[43] of M. Antony Roux, thereby authorizing him to make as many casts as he liked. Six years later, however, he wrote to the same collector concerning *Glaucus,* forbidding the making of any reproductions whatsoever: "Received from M. Antony Roux

the sum of . . . for a statue, *Glaucus* . . . I undertake not to make any more, neither in bronze nor in marble, the original belonging to M. Roux. Neither is M. Roux permitted to have any reproductions made, in bronze or in marble."[44]

When works were given to friends, however, as in the case of the plasters that Rodin gave to the sculptor Camille Lefèvre, which are now in the Musée de Belfort, it is to be assumed that no formal agreement was reached regarding the casting of the bronzes. Many collectors, like Lefèvre, who had a bronze cast made from a plaster of *Polyphemus* (no. 23) that Rodin had dedicated to him, would have had the bronze made simply out of the desire to give more permanent form to an object that was relatively fragile,[45] while others probably acted from less commendable reasons.

Rodin was notoriously hard to please when it came to the finishing of his bronzes. Judith Cladel related that Jean Limet, who specialized in the patination of bronzes, gave three different patinas to *The Walking Man* (fig. 65-1) before Rodin was satisfied with it.[46] He loved richly colored, eventful patinas, even valuing the droppings of the birds which perched on his sculptures when displayed out of doors. When Rodin and Paul Gsell saw a cast of *The Thinker* (no. 3) which was destined for America left out in the open air, Rodin remarked: "The rain water brings out the parts in relief by oxidizing them, while the dust and dirt, lodging in the hollows, accentuate the depth. . . . It is not only due to the familiarities of the birds that bronzes and marbles left in the open air gain their rich patinas."[47]

Many references in the correspondence attest to the fact that it was frequently the achieving of a rich patina that caused delays in the delivery of works that were commissioned from him. In June 1907, for example, the Swedish collector Ernst Thiel commissioned a bronze cast of *The Shade* (no. 5) at a cost of 10,000 francs.[48] On March 25, 1908, Rodin wrote that he thought he would be able to send the bronze soon, perhaps in three weeks, but he conceded: "Work on it has taken a long time and is not quite finished, since it takes a long time to obtain the patina. But I want it to be beautiful, and I also want you to have a work that is remarkable from all points of view."[49] By June[50] he was ready to send it, and on August 25 he wrote to Thiel expressing his pleasure at the fact that his work was well received: "I am very pleased that my work has given you so much satisfaction and very flattered that you have given it the most prominent place in your admirable collection. In fact the patina is particularly successful. There is an infinite variety of methods; everybody has his own way. But a good patina requires, necessitates a long period of trial—and also a certain amount of chance."[51]

In the same year Prince Eugène of Sweden commissioned a bronze cast of *The Thinker* and once again the importance of the patina was stressed: "'The Thinker,' the same size as that outside the Panthéon, cast in bronze with a patina, ordered by Prince Eugène, at the price of 14,000 francs. 'The Thinker' will be executed and given its patina in the space of six or eight months, perhaps a little less, perhaps a little more—that depends on the patina."[52]

But the degree of attention accorded to the finishing and the patination of the casts by Rodin himself must have been in direct ratio to the pressures exerted on him. It also depended on the nature of the agreement with the founder responsible for the casting of the work, for in addition to the making of unique casts and to casting works in limited

numbers, according to demand, Rodin himself at various times in his life signed contracts with commercial foundries to cast works in extremely large editions over which he had no, or relatively little, control. Thus, in 1872, as a young and impoverished artist in Belgium, Rodin sold the copyright to two works, *Suzon* and *Dosia* (figs. 106-1, 106-2), to the Compagnie des Bronzes, and these were still being cast in 1939.[53] In 1895 the long-established and hugely productive firm of Leblanc-Barbédienne made the first cast of *The Burghers of Calais,* after much searching on Rodin's part for the best price. On July 6, 1898, he signed a contract with this foundry authorizing the production in various dimensions of two of his most popular works, *Eternal Springtime* (no. 32) and *The Kiss,* no limit being put on the number of casts that could be made. He did, however, reserve for himself the right to have casts made by the sand-casting method, with the result that there is a considerable difference in quality between the best and the worst casts of these works, the sensitive modeling of the originals disappearing completely in the commercial editions.

The foundry of Fumière et Gavignot was also employed by Rodin to cast editions of his works on a commercial scale. On April 4, 1898, a contract was signed giving this foundry the right to cast the figure of *St. John the Baptist Preaching* in four different sizes for a period of ten years. On October 24 of the same year Fumière et Gavignot was given the right to edit *Youth Triumphant* (no. 26). In the contract the foundry was authorized to make reductions in all sizes deemed fit for sale, the reductions to be executed under the supervision of Rodin himself. It was stipulated that at the end of ten years the foundry might extend the period for a further ten years, if it so desired.

After 1902, however, with few exceptions, Rodin's bronzes were cast by the foundry of Alexis Rudier, with whom he established a close personal relationship. Bronzes continued to be cast as they were required, and since at this time there was no question of limiting the number of casts of each work, no attempt was made to number them. This situation continued until Rodin's death in 1917. In his will he left his entire estate, including the molds of unedited works, to the French state. The Musée Rodin, as his legatee, was authorized to make casts from the original molds in editions limited to twelve. Henceforth all the bronzes issued by the Musée Rodin were cast by the foundry of Alexis Rudier.

Still according to demand, casts were now made of works that had already been cast during Rodin's lifetime and of works that, for whatever reason, had not. The Musée Rodin and not the artist himself was now responsible for deciding the aesthetic wisdom of casting unedited works in bronze. In some cases, for example *The Gates of Hell* and the *Balzac,* Rodin would undoubtedly have had bronze casts made, had circumstances permitted. In others it is equally certain that he had no intention whatsoever of doing so, as can be seen from a statement recorded by Sir William Rothenstein. Discussing his plaster figures with the distinguished English artist, Rodin expressed the fear that the friends to whom he gave these figures might have them recast and dispose of them as bronzes. "Rodin insisted that they were not suitable for casting," reported Rothenstein. "He expressed himself strongly on this subject, and begged me to keep his views in mind if ever I saw casts of this kind."[54]

Plaster, regarded by most previous sculptors as at best a poor substitute for bronze or marble, became for Rodin the ideal medium in which to preserve the various stages of his

"work in progress," plastic thoughts which deserved to be preserved, if not immortalized, in the more noble materials. There is no doubt that the decision to make bronze casts of works that were as important as *The Gates of Hell* or the *Balzac* was thoroughly justified. A number of the unedited works cast more recently, however, for the most part very minor pieces and preliminary studies, are sad testimony to Rodin's foresight.

Alexis Rudier died in 1922 but his son, Eugène, continued to run the foundry until his death in 1952, using the foundry mark of his father: Alexis Rudier/Fondeur Paris. Thus bronzes bearing this particular mark, certainly the most sought after by collectors, may have been cast at any time between 1902 and 1952. With rare exception none of the bronzes cast during this period is numbered.[55] In 1952 the Musée Rodin contract passed to Georges Rudier, nephew of Eugène, who established a new foundry that retained some of his uncle's employees. All bronzes manufactured by this foundry bear the foundry mark, Georges Rudier/Fondeur Paris, and are inscribed with the date of the casting. On works which were not cast during the artist's lifetime, the number of the cast from the edition of twelve is inscribed, while the new editions of works that had been cast previously are recorded but unnumbered. In recent years casts have also been issued by the founders Susse and Godard.

There is no doubt that Rodin's reputation has suffered from the inconsistent standards he applied to the quality of the bronzes to which he affixed his name. As has already been noted, these range from bronzes of the finest quality and finish, of which the perfectionist Barye would not have been ashamed, to commercial bronzes of no distinction at all. Rodin too was a perfectionist, but he was also extraordinarily popular in his later years, and he made full use of the commercial facilities that accompanied the huge expansion of the bronze-casting industry in the nineteenth century. As a result of this it is sometimes difficult to perceive the perfectionist through the plethora of inferior and suspect bronzes, authentic but poor quality posthumous casts, unfinished and rejected marbles, and conspicuously fake drawings that greatly expand while diluting the full impact of his *œuvre*. The strong beauty of his work is too often only barely glimpsed through inferior replicas and many, although by no means all, of the more recent posthumous casts bear the same kind of relationship to Rodin's original concept as do late Roman copies to the Greek originals from which they derive. The form is there but the spirit is missing.

Even during his lifetime Rodin was criticized for running a sculpture "factory," for farming out the work to numerous assistants and then signing the finished product with his own name. A song that used to be sung in the studios went as follows: "It is Desbois who makes the holes, it is Rodin who makes the projections."[56] It is indeed true that Rodin relied heavily on his assistants at every stage of the sculptural procedure, from the initial construction of a sturdy armature, through the making of plaster casts from the finished clay, to the enlargement and final execution in marble of many of his works. But there was nothing unusual in this. Most of the great Renaissance and Baroque artists had their "shops," without the assistance of which they would never have been able to complete the vast amount of work they left behind at their deaths. Typical of the attitude that prevailed until the Romantic notion of the artist-craftsman gained predominance in the nineteenth century was Jean-

Baptiste Colbert's request to Giovanni Lorenzo Bernini in a letter of December 6, 1669, to make an equestrian statue of Louis XIV similar to that of Constantine but not a replica. Bernini was asked to execute the head himself, using the students of the French Academy in Rome to do the rest of the work but to touch up the whole himself "so that one can truly say that it is a work by your hand."[57]

Sculptors still need to employ assistants, and their studios are still the breeding grounds of new talent, unlike the situation which prevails in most painters' studios, but Rodin's "shop," as perhaps the last great highly organized entity in the Renaissance sense of the word, became the archetype of sculptural production that was completely rejected by sculptors of the younger school. Thus the legend, propagated principally by his ex-assistants, became widespread that Rodin, born modeler though he was, was incapable of carving in stone. But this is not true. During his long apprenticeship to other sculptors, for whom he had to work to support himself and his family, Rodin learned all aspects of the sculptor's trade, including stone carving.

Between 1864 and 1870, when he worked for Carrier-Belleuse in Paris, Rodin was mainly employed in the making of small clay models that were then finished by his employer and sold as the work of Carrier-Belleuse. However, after 1871, when he joined Carrier-Belleuse in Brussels, Rodin's mastery of stone carving was demonstrated in the execution of a considerable number of large-scale works, including decorative sculpture for the Bourse in Brussels and the monument to Burgomaster J. F. Loos in Antwerp (see Chronology). Even after his return to Paris in 1877 Rodin did not entirely abandon this aspect of the sculptor's craft. In 1878, working for the architect Cordier, he carved two caryatids and a mask of Neptune *in situ* for the façade of the Villa Neptune in Nice.[58]

There is no doubt, then, that Rodin was perfectly capable of carving. While working for Carrier-Belleuse, however, he had the opportunity to see how a great *atelier* was organized. It seemed natural to him, as it had to countless European artists before him, that the various stages of the work should be left to specialists rather than that the artist should see the work through all the stages himself. Even as an impoverished young man in Brussels, Rodin had employed *praticiens* to execute in marble the clay and plaster models he had left behind in Paris.[59]

Rodin was aware of the dangers inherent in this division of labor, although his attitude toward them varied a great deal, ranging from resentment at the intrusion of another artistic personality between his original concept and the finished marble sculpture to delight at the added dimension that this gave to the work. Bartlett summarized Rodin's attitude toward the fine marble bust of Mme Vicuña (fig. 89-1) in the following words:

> Exquisitely charming as it is, the sculptor does not regard it as a fully satisfactory reproduction of his model, because it bears too much the impress of the character of the superior marblecutter who executed it. Rodin understands the fine fact, that just in proportion that a marble workman excels in his trade does he unconsciously give his work his own interpretation of the model which he copies. And this in spite of the most exacting means of mechanical measurement that he may employ. With a sensitive sculptor this is precisely what is not wanted, and the only way that he can insure the exact reproduction of his model in marble is to do the work himself. But this method is practically impossible, because he cannot afford to do it for the prices he receives.[60]

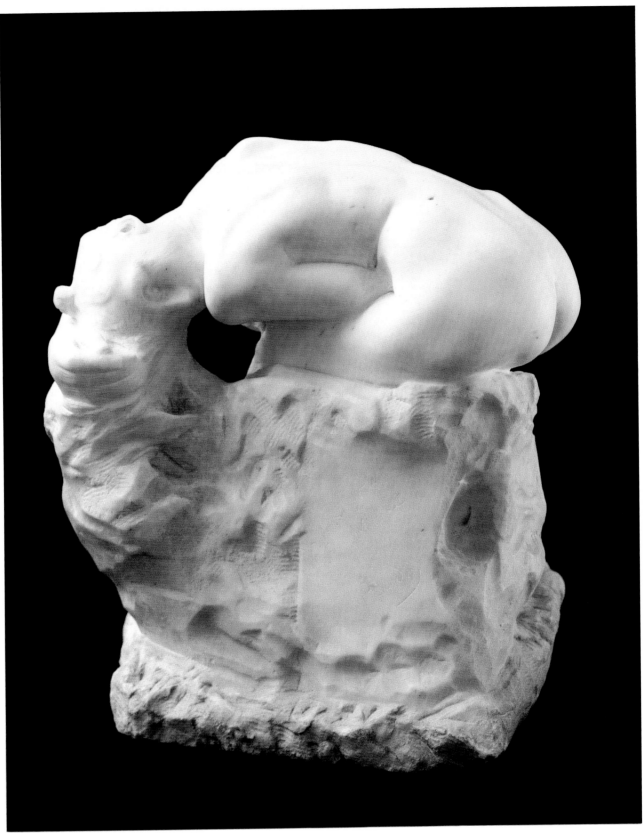

Andromeda (no. 35)

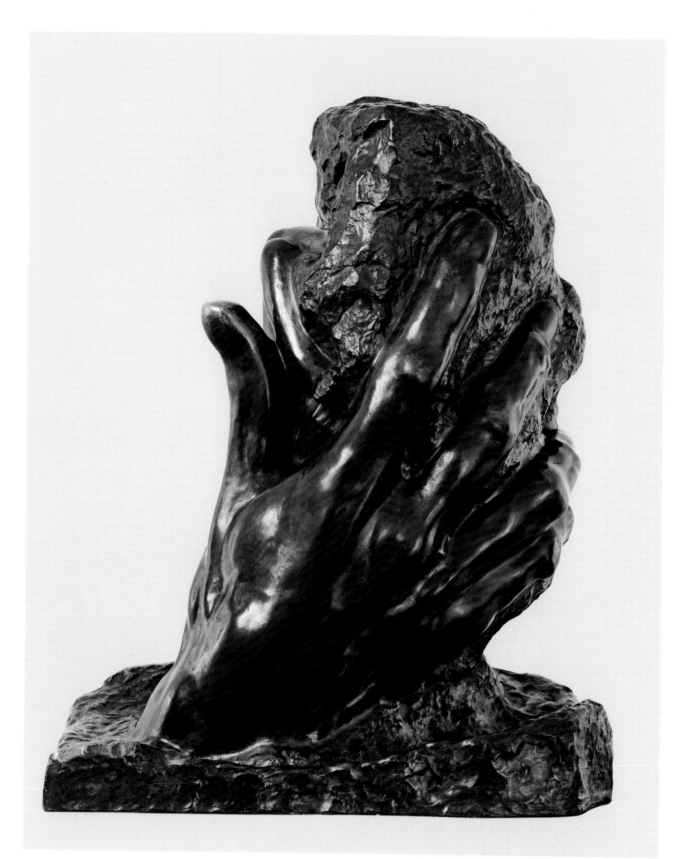

The Hand of God (no. 121)

Several years later Rodin expressed a diametrically opposite opinion to the young sculptor François Pompon, who had just started working for him. Judith Cladel gave the following account: "When he entered the studio, and Rodin gave him a figure to interpret in marble, Pompon said to him: 'I will go and ask Escoula to tell me how you like people to work for you.' 'But no,' replied the master, 'my works can be interpreted in different ways! You will do as you want, according to your temperament, and others will do as they want.'"[61]

The apparent dissimilarity in these two views on the role of the assistant in the creation of the finished work of art is perhaps less disturbing than it seems since, contrary to popular opinion, Rodin continued to do a certain amount of the carving himself, even in later years. Moreover, however great the freedom given to the individual *praticien,* the work was always executed under Rodin's constant supervision. One of Rodin's models described his energy as a marble carver in the early 1880s:

> He had a block of marble ready, with the outlines of a figure in crayon...Oh, he worked very fast. Chip-chip-chip and the marble flew everywhere. For a little man he was very strong and used a big mallett.
> Then to work he would go furiously. Chip, chip, chip, hours at a time....Then, I believe it was in 1897, he began two figures—a man and a woman. We sat upon a bench for hours. M. Rodin was more terrible than ever. He would never stop, but kept the chisel going every day....For weeks he kept us there....Then, of course, when he really became famous he was happy about it. But he never ceased to work. The only difference was that he brought in students to do the rough chiselling.[62]

Two witnesses of the sculptor at work in the very last years of his life reveal that, in spite of the increased demand for his marble sculptures, Rodin still managed to finish the works himself, if not to execute them entirely. Malvina Hoffman was very definite on this point:

> Many people have stated that Rodin never carved his own marble. He did engage several outside carvers and assistant sculptors. One of them was Despiau, who has since won international fame as a master sculptor. I have watched Rodin carving his own marbles at his studio in the rue de l'Université, and have marvelled at the way he could suggest soft feathers of a great broken wing, carving them directly in the block, without referring to the small plaster model. The pressure of an arm against another arm or the weight of a foot on the ground were certain problems which Rodin solved by himself, explaining to me just how the desired result was obtained in marble. He avoided any sharp edges, and used the light reflections almost as a painter would, to envelop his forms. He had a horror of deep holes or sharp outlines. He had a perfectly definite technique which is easily recognized, and he told me he had spent many hours identifying the strokes of certain tools, and just what effects they were capable of giving, in the collection of Michelangelo's sculptures in Florence.[63]

In his diary for March 15, 1921, René Gimpel recorded that Mrs. John W. Simpson, who posed for Rodin in 1901 and 1902, "vouches for the fact that Rodin finished all his marbles, which he used to cover with pencil marks—though certainly Bourdelle took some works very far, like an Eve in pinkish stone bought by Scandinavia, which Rodin called *'Bourdelle's Eve.'*"[64]

The dispersal of the myth that Rodin never touched the marble leaves the contemporary connoisseur in a better position to examine the marble sculptures for what they really are. Firstly, it should be pointed out that they vary considerably in quality, depending in part

on the skill of the *praticien* employed. Secondly, the majority of the marbles were commissioned, with the result that many of them are now in public and private collections throughout the world and not in the Musée Rodin. Although there are some excellent marbles in the Paris museum, for example, *Mme Rodin* (fig. 80, 81–2) and *The Little Water Sprite*,[65] many of them are either unfinished or of such poor quality that they were not sold. Georges Grappe recognized this himself in his discussion of the work *Constellation*.

> This bronze cast from the plaster shows decisively that the marble of the same subject, no. 320, is unfinished. This marble was found in Rodin's studio at his death, in the state it is now. This information is particularly relevant as the same is true of a certain number of marbles exhibited in the rooms of the museum; many visitors think that the haziness in which the figures are bathed was intentional on the part of the artist, who desired at one period in his life to treat his sculpture as Carrière did his painting, enveloping it in a kind of luminous mist. But this method was not systematic, as one can see by comparing the unfinished states of certain works with their *maquettes*.[66]

Rodin's earlier marbles, for example *Man with the Broken Nose* and *Mme Vicuña*, were direct translations of relatively simple forms that had first been modeled in clay. When he began to make marble versions of the complex figure groups that had first been conceived for *The Gates of Hell*, however, the direct reproduction possible in a simpler form became impossible. The closely entwined figures, with their complicated rhythms and subtle intervals and their frequently protruding limbs, would have defied the skill of even the most proficient marble carvers. Marble can only be undercut and hollowed out to a certain point. A comparison of the bronze and the marble versions of *The Death of Alcestes* of 1899 (pls. 20, 21) illustrates this quite clearly. The decision not to detach the figures completely from the matrix of the marble, the effect of which is to make it seem as if the figures are emerging from the inert matter, may at first have been determined by purely practical reasons. But for the artist, practical decisions are aesthetic decisions. To Rodin the technical proficiency of the academic sculptors, the evenness of finish of their works, detracted from the mystery of the sculpture, whereas Michelangelo's areas of *non-finito* contributed to it. At the same time these unfinished areas increased the strength of the mass of stone. Rodin's intuitive understanding of these matters, known only to the sculptor, was undoubtedly a more important factor in determining the styles of his marble sculptures than the influence of Medardo Rosso or Eugène Carrière. His admiration for these two artists is well-known, but the influence of Rosso's rarefied, small-scale art on the majestic art of Rodin has surely been overestimated, and there is certainly a limit to the amount Rodin the sculptor could have learned from Carrière the painter.

Further evidence of Rodin's heightened awareness of the far from simple relationship between bronze and marble is provided in his unpublished correspondence with Mme Dumon of Tournai, Belgium, who early in 1894 commissioned a stone version of *The Fallen Caryatid Carrying Her Stone* (pl. 22). The original figure, conceived in 1881, can be seen sheltered under a swathe of drapery at the top of the left pilaster of *The Gates of Hell* (no. 1, detail G). It soon became immensely popular, and a large number of replicas in bronze, marble, and stone were made in various dimensions. On January 24, 1894, Rodin informed Mme Dumon

that the execution of the stone had just commenced and that it ought to be finished in two months.[67] Six months later, however, work was still in progress, as was indicated in a letter of June 14: "I ought to have written to you to tell you that work on your caryatid is still going on and that I was very much mistaken in the lapse of time that I asked for its execution. However, I hope to send it to you from here in six weeks. The sculpture ought to have been done much more quickly, but it is like all sculpture, it is the modeling and not the material that prevents one from going quickly. Please excuse me and believe me when I say that I will be happy if it meets with your approval when it is finished.... The caryatid has not been left one day. Work on it has not ceased."[68]

On July 22 he was able to tell Mme Dumon that the stone was finished[69] and that she could call it whatever she wanted—"perhaps it is the translation of the sonnet of Arvers." He indicated that he had made a number of deliberate changes in the course of execution: "I have left the figure more unfinished for the effect of stone, and it has become much more expressive." He also gave her instructions as to the best way of displaying the sculpture—"keep the group in plenty of shadow, against the light."

Through the process of recreation from bronze to stone, the initial sculptural idea of *The Fallen Caryatid* has been completely transformed. No less than four examples were executed between 1894 and 1907, and a further marble version of a variant of this work, *The Fallen Caryatid Carrying an Urn,* was carved during this same period. Closest to the original concept is the exquisite marble version (pl. 23) commissioned by the well-known patron of the arts, Mme Eugenia Huici de Errazuriz. The main difference between the marble and the bronze (pl. 25) is in the size of the rocky outcrop on which the figure sits. Another marble was purchased by the Danish collector Carl Jacobsen in 1907. In this example the sinuous forms of the drapery have been amplified, and the incised lines on the base and the hair are strongly reminiscent of the stylistic characteristics of Art Nouveau (pl. 26). The two stone versions depart even further from the original form. He "left the figure more unfinished for the effect of stone" in the version commissioned by Mme Dumon in 1894, and he went even further in that direction in the stone that was purchased by the state for the Musées Royaux des Beaux-Arts de Belgique in 1899 (pl. 24). Here there are no transitions between the smooth forms of the body and the mass of roughly hewn stone, which seems to be on the point of engulfing the figure.

In his marbles as in his bronzes, Rodin offered a redefinition of the stage at which a sculpture might be said to be "finished." A work by the academic sculptor Jean Boucher (1870–1939) entitled *The Florentine Sculptor* (pl. 27) offers an amusing visual lesson regarding the traditional point of view on this subject. The slender youth, with chisel and mallet in hand, is portrayed carving a smiling head which, in its state of incompletion, looks amazingly like a marble sculpture by Rodin *(see* fig. 14–16–1). There is no doubt that, once completed, the work on the pedestal would have been as highly finished as the figure of the young sculptor himself. Boucher clearly regarded the mass of unfinished marble as so much inert material to be removed to enable the sculptured form to emerge with full clarity. All traces of the sculptor's hand and of the technical processes involved would have been concealed in the finished work.

Rodin, on the contrary, cherished the evidence of the processes that went into the making of a work, and in the plasters and bronzes he made no effort to conceal his methods of execution. Frequently the imprint of the fabrics used in keeping the clay damp is visible in the bronzes, and more often than not Rodin chose not to conceal the raised lines on the surface of the forms left by the piece molds. He did this so consistently that Henry Moore was undoubtedly correct when he stated his belief that this was done to "underline the form"[70] of the piece as much as for purely technical reasons. Likewise in the marbles he frequently left unfinished areas in which the marks of the tools are plainly visible.

It is doubtless true that a greater effort of sympathetic understanding is required of the contemporary viewer to respond to the marbles than to the bronzes. In the bronzes there is a direct communication with the artist, as immediate as his response to the model. The feeling of intense inner life that emanates from the bronzes is less apparent in the marbles, since they are more removed from the initial sculptural encounter between the artist and his model. They do, however, have a rarefied beauty that is unique to them and readily apparent to the unbiased eye.

Rodin's beginnings were humble and beset with difficulties. It was not until he was nearly forty that one of his major works, *The Age of Bronze,* attracted considerable public attention, distressing as the nature of this was to him. Between 1880 and 1890 he became famous and, after the "Balzac affair," notorious. His fame was extraordinary, far surpassing that of even his greatest contemporaries, and his dealings with the committees which commissioned the major monuments in the 1880s and 1890s were reported in considerable detail in the national press. Rodin was front-page news in the last years of his life. Curiously enough, the period of his greatest fame coincided with a certain decline in his productivity, no really major projects being undertaken in the years after the rejection of the statue of *Balzac* by the Société des Gens de Lettres in 1898 and his death in 1917. It seems that he lost the ability and even the desire to embark on projects that required the considerable powers of organization that had enabled him to complete or, at least, nearly complete the focal works of the previous two decades, *The Gates of Hell, The Burghers of Calais,* the *Monument to Balzac,* and the Victor Hugo monument *(see* no. 71). The monuments of these last years were either small-scale affairs like the *Monument to Barbey d'Aurevilly* (fig. 101-1), indecisive like the ill-fated *Monument to Whistler (see* Chronology), or never executed at all like the *Monument to Eugène Carrière (see* no. 63).

Not that there was any weakening of his abilities as a modeler. Some of his most radical works—the suite of seven dancers, for example, or *The Juggler* (pl. 28)—date from these years. He continued to produce portraits of extraordinary psychological penetration, such as those of Gustav Mahler (no. 99) and Pope Benedict XV (no. 103), and his last portrait, that of Etienne Clémentel (no. 104), executed when his mental faculties were already beginning to decline, is surely one of his most moving. Even as a society portraitist, with busts that included Mrs. John W. Simpson (pl. 29), Miss Eve Fairfax (pl. 30), Comtesse Mathieu de Noailles (pl. 31), and Mrs. Hunter, Rodin produced a body of work that rivals that of such artists as John Singer Sargeant and Giovanni Boldini, whose reputations were based on flattering

images like these. There is no doubt, however, that he was less prolific and less innovative after his great retrospective exhibition of 1900, although it was after that crucial event that the *œuvre* as we know it today began to take shape. Fewer new forms came from his hand, but more sculptures than ever before, for the most part versions of earlier works, were produced in the studio as the international demand for his works increased.

He had reached the period in his life when the preservation of what he had already created was a matter of greater urgency than the creation of new works. Enlargements were made and placed in prominent positions—*The Thinker* in front of the Panthéon in 1906 and *The Walking Man* in the courtyard of the Palazzo Farnese in 1912—and collectors such as the Dane Carl Jacobsen and the Americans Thomas Fortune Ryan and Mrs. John W. Simpson purchased representative selections of his work that included plaster sketches as well as bronzes and marbles of the highest quality. Rodin himself contributed to the international distribution of his work by presenting many important pieces to the Victoria and Albert Museum in 1914. Needless to say he was also deeply involved with the attempts to establish his own museum in his natal city.

It is sad that he did not live to see the moment of his triumph, even sadder that his last years were clouded by personal and professional intrigues that might have been conceived by Balzac. Scandals yet to be fully unraveled marred his dying days and almost immediately began to blur the outlines of his work. Spurious bronzes were sold in reputable galleries, marbles were completed after his death, and the abundance of patently fake drawings began to destroy the real sense of Rodin's mastery as a draftsman. Furthermore, his critical reputation, already questioned before World War I by the rising generation of young sculptors, suffered an almost total eclipse after the war. Only a true believer like Jules Mastbaum of Philadelphia thought highly enough of his work to establish a museum in his name. It is only now, perhaps, that a true sense of Rodin's multi-faceted personality is beginning to emerge. In order to bring him into the twentieth century it was necessary to reject a great deal, but now, as more is known about him, it is possible to respond to every facet of his work, from the momentary and informal to the highly finished and monumental, without a lowering of critical standards. It is not a tidy *œuvre,* and it is doubtful if a complete *catalogue raisonné* will ever be published. Indeed, insofar as bronzes are still being cast, Rodin's body of works is growing and changing. The decision to cast a previously uncast work in bronze changes the outlines of the entire *œuvre,* however imperceptibly. A greater knowledge of what Rodin did countenance during his lifetime is not only valuable for its own sake but will sharpen one's awareness of the appropriateness of what has been done in his name after his death. It is hoped that this catalogue will be effective in both areas.

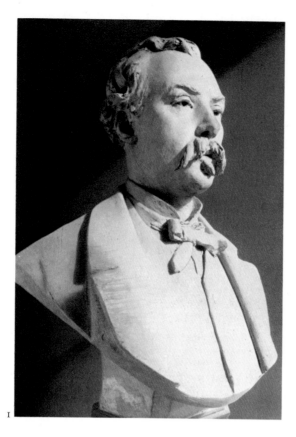

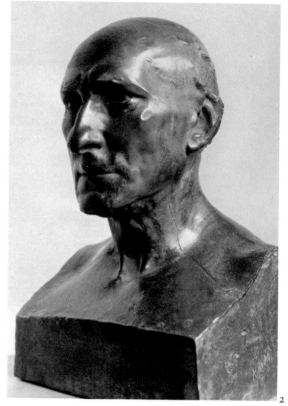

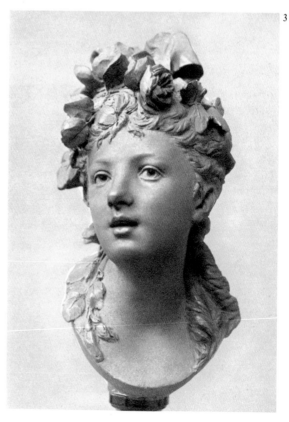

Plate 1
M. Saffrey
1871, terra-cotta, height 23 ¼ inches
Musée Rodin, Paris

Plate 2
Jean-Baptiste Rodin
1860, bronze, height 16 ¼ inches
Musée Rodin, Paris

Plate 3
Head of a Young Girl with Flowers in Her Hair
c. 1868?, terra-cotta?
Location unknown

44

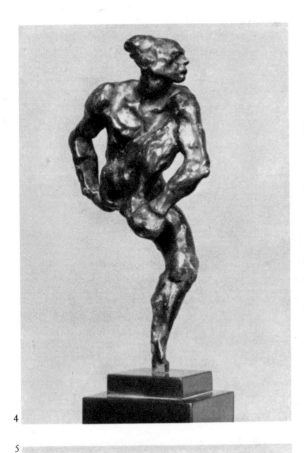

4

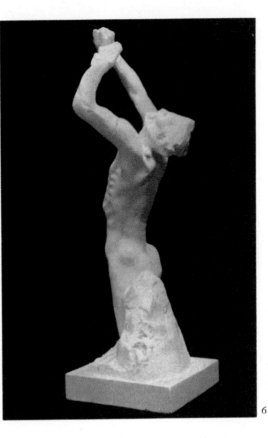

6

5

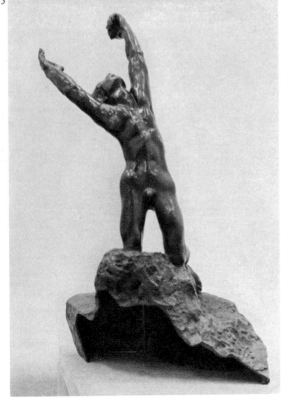

Plate 4
Nijinsky
1912, bronze, height 7¼ inches
Collection Mrs. Bertram Smith, New York

Plate 5
The Prodigal Son
c. 1885–87, bronze, height 55 inches
Tate Gallery, London

Plate 6
Despairing Youth
1882, plaster, height 15¾ inches
Musée Rodin, Paris

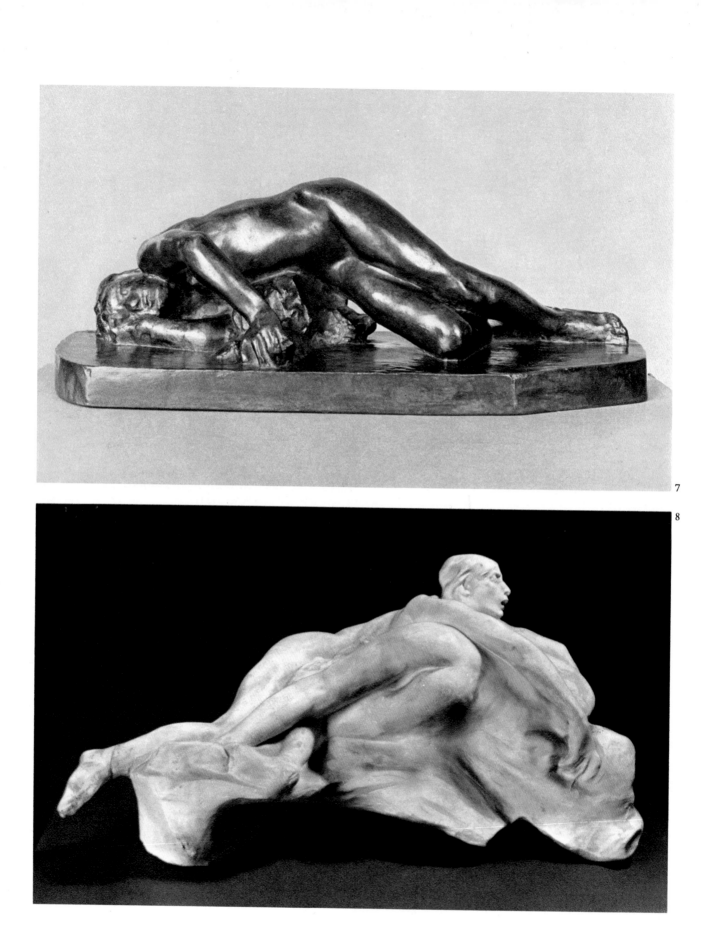

7

8

46

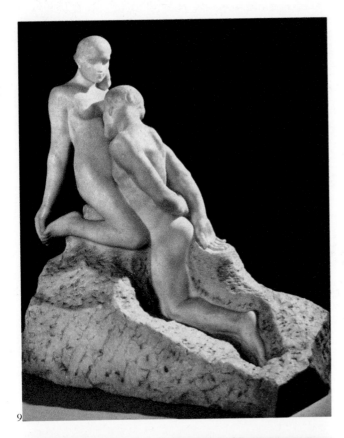

9

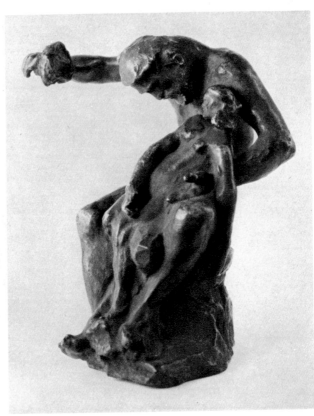

11

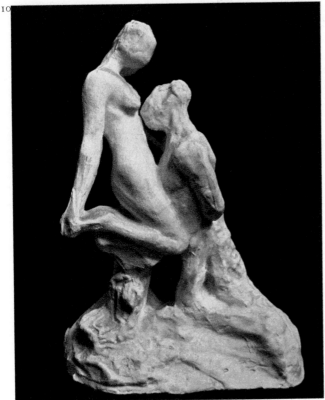

10

Plate 7
Fatigue
1887, bronze, height 6¾ inches
Musée Rodin, Paris

Plate 8
Paolo and Francesca
1887, plaster, height 14⅛ inches
Musée Rodin, Paris

Plate 9
The Eternal Idol
1889, marble, height 28¾ inches
Fogg Art Museum, Harvard University,
Cambridge, Mass. Grenville
L. Winthrop Bequest, 1943

Plate 10
The Eternal Idol
1889, plaster, height 7 1/16 inches
Fine Arts Museums of San Francisco
Spreckels' Collection

Plate 11
Vulcan Creating Pandora
c. 1889, bronze, height 7⅞ inches
Museum of Fine Arts, Boston

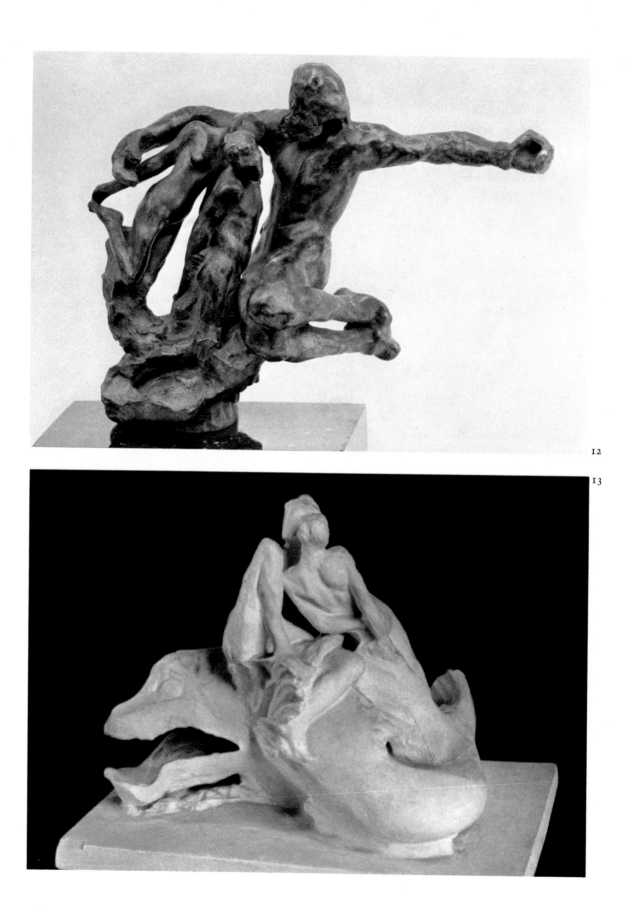

12

13

48

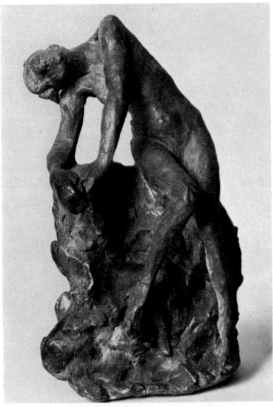

14

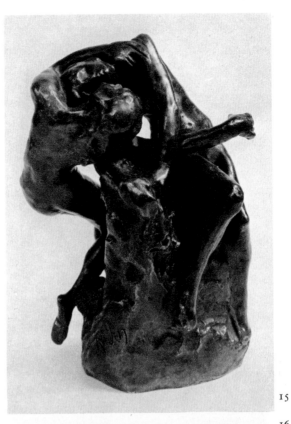

15

16

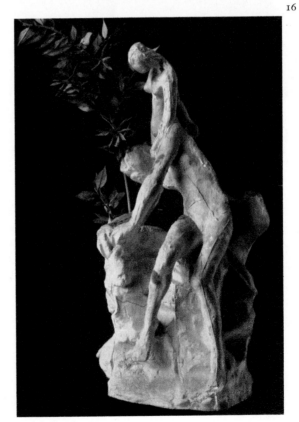

Plate 12
The Creation
c. 1889, bronze, height 7½ inches
Museum of Fine Arts, Boston

Plate 13
Triton and Nereid on a Dolphin
1900, plaster, height 8½ inches
Musée des Beaux-Arts, Lyons

Plate 14
Woman Seated on a Rock
c. 1885?, terra-cotta, height 8 inches
Musée des Beaux-Arts, Lyons

Plate 15
Two Women Embracing
c. 1885?, bronze, height 7¾ inches
St. Louis Art Museum
Gift of J. Lionberger Davis

Plate 16
Small Group with Two Figures
c. 1895?, plaster, height 10¼ inches
Musée Rodin, Paris

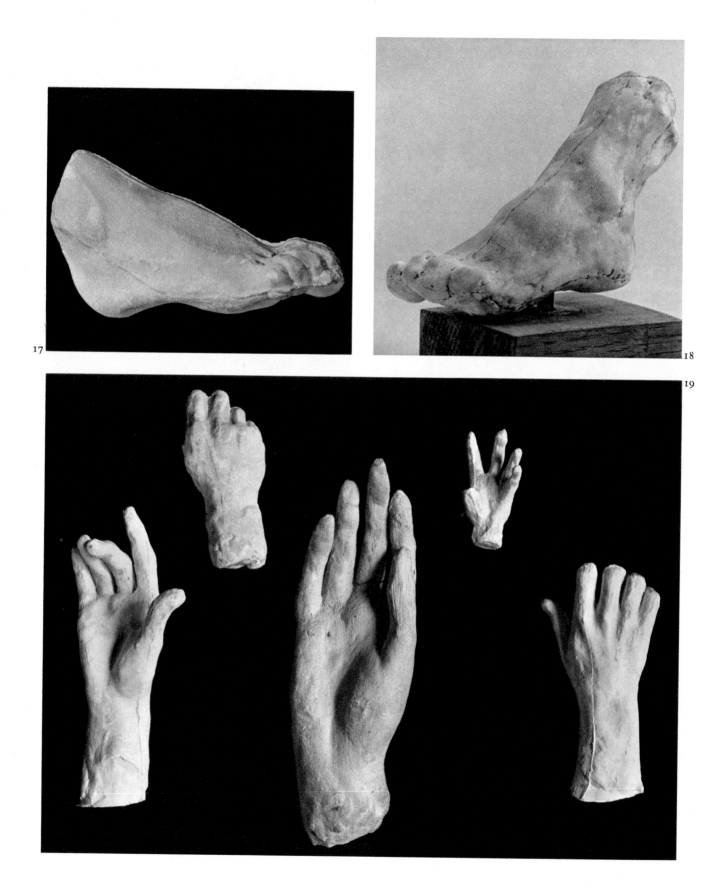

17

18

19

50

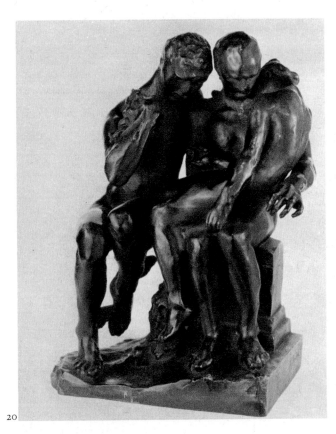

20

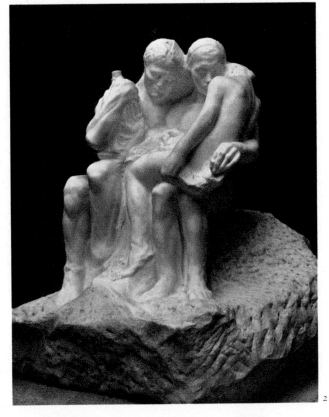

21

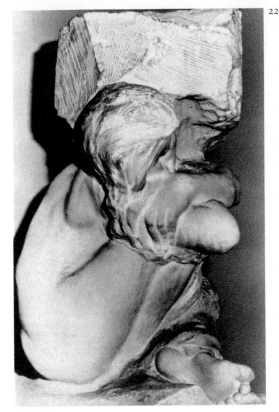

22

Plate 17 *Right Foot*
Plaster, length 2¾ inches
National Gallery of Art, Washington, D.C.
Gift of Mrs. John W. Simpson, 1942

Plate 18 *Left Foot*
Plaster, length 4¼ inches
Fine Arts Museums of San Francisco
Spreckels' Collection

Plate 19 *Studies of Hands*
Terra-cotta, greatest height 5¼ inches
National Gallery of Art, Washington, D.C.
Gift of Mrs. John W. Simpson, 1942

Plate 20 *The Death of Alcestes*
1899, bronze, height 15 inches
Museum of Fine Arts, Boston

Plate 21 *The Death of Alcestes*
1899, marble, height 33¾ inches
Thyssen-Bornemisza Collection,
Lugano-Castagnola

Plate 22 *The Fallen Caryatid Carrying Her Stone*
1881 (executed 1894), stone, height 24⅜ inches
Collection Walter R. Beardsley, Elkhart, Ind.

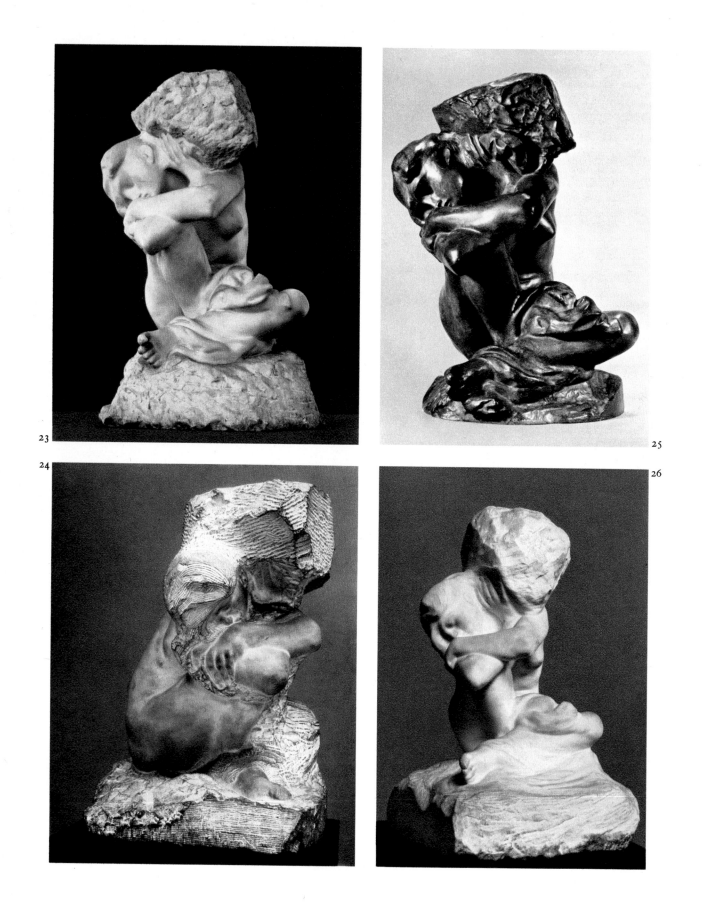

23

25

24

26

27

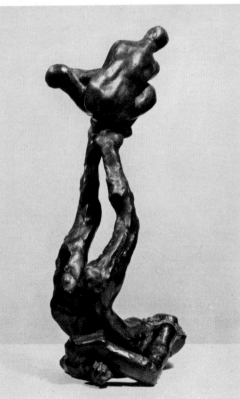

28

Plate 23
The Fallen Caryatid Carrying Her Stone
1881 (executed 1902), marble, height 20¼ inches
Private collection, New Jersey

Plate 24
The Fallen Caryatid Carrying Her Stone
1881 (executed c. 1899), stone, height 24⅜ inches
Musées Royaux des Beaux-Arts de Belgique,
Brussels

Plate 25
The Fallen Caryatid Carrying Her Stone
1881, bronze, height 17⁵/₁₆ inches
National Museum of Western Art, Tokyo

Plate 26
The Fallen Caryatid Carrying Her Stone
1881 (executed 1907), marble, height 21¾ inches
Ny Carlsberg Glyptotek, Copenhagen

Plate 27
Jean Boucher (1870–1939)
The Florentine Sculptor
Location unknown

Plate 28
The Juggler
1909, bronze, height 11⅜ inches
Peter Stuyvesant Foundation, Stellenbosch,
South Africa

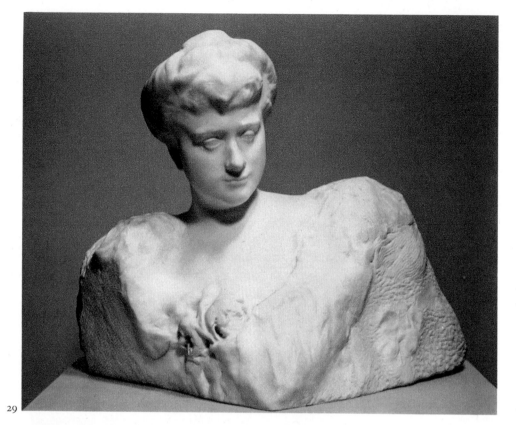

Plate 29
Mrs. John W. Simpson
1902, marble, height 21¾ inches
National Gallery of Art,
Washington, D.C. Gift of
Mrs. John W. Simpson, 1942

Plate 30
Miss Eve Fairfax
1905, marble, height 21⅜ inches
Johannesburg Art Gallery,
Johannesburg

Plate 31
Portrait of Madame X
(Comtesse Mathieu de Noailles)
1906, marble, height 19½ inches
Metropolitan Museum of Art,
New York. Gift of
Thomas F. Ryan, 1910

29

30

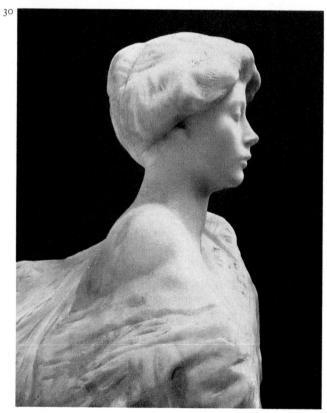

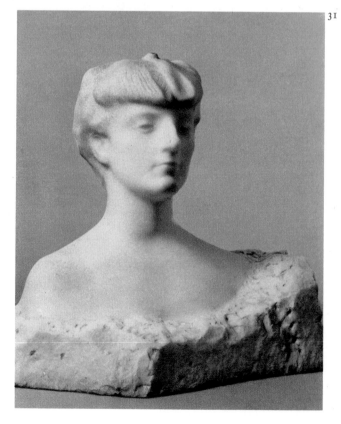

31

NOTES

1. Roger Fry, "London Sculptors and Sculptures" (1926) in *Transformations* (Garden City, N.Y.: Doubleday Anchor Books, 1956), p. 198. "But that conception is not essentially a sculptural one. Rodin's concern is with the expression of character and situation, it is essentially dramatic and illustrational."

2. Schaub-Koch [295], p. 62. "Il y a peut-être du médiocre dans cette production, mais le pis est toujours le manque de doctrine, l'indiscipline, l'absence de support monumental. Telle serait la morale de ce qu'on pourrait appeler le *cas Rodin*, car il y a un cas Rodin."

3. David Smith, tape-recorded interview with David Sylvester in New York on June 16, 1961. Reprinted in Garnett McCoy, ed., *David Smith* (New York: Praeger Publishers, 1973), pp. 173–74 (author's italics).

4. Ibid., p. 182.

5. Steinberg [310], p. 330.

6. Ibid., pp. 336, 331.

7. Frisch and Shipley [42], p. 191.

8. Gsell [57c], p. 46.

9. Dujardin-Beaumetz in Elsen [39], p. 164.

10. Ibid., p. 155.

11. Gsell [57c], p. 76.

12. Ibid., p. 77.

13. Ibid., pp. 176–77.

14. Ibid., p. 47.

15. *See* nos. 72–76, n. 62.

16. Lawton [67], p. 156.

17. Cladel [25], p. 56. "Le corps humain est un temple qui marche et, comme un temple, il a un point central autour duquel se placent et se répandent les volumes. C'est une architecture mouvante."

18. Claris [165a], p. 32.
 "J'ai tâtonné au début, puis je me suis enhardi à mesure que j'ai senti que j'étais dans la vraie tradition de vérité et de liberté.
 "C'est moi qui suis dans la tradition; l'Ecole des Beaux-Arts a rompu avec elle depuis quatre-vingt ans. Je suis dans la tradition des primitifs, des Egyptiens, des Grecs, des Romains. Je me suis simplement appliqué à copier la nature."

19. Judith Cladel, "Rodin et l'art gothique," *La Revue Hebdomadaire*, Paris, no. 45 (November 7, 1908), p. 80. "Ceux qui ont voulu expliquer leur enthousiasme devant les cathédrales ont proclamé les gothiques des idéalistes. On s'est contenté de la phrase et tout le monde l'a répétée. Ah! cette tarte à la crème de l'idéal! L'idéal est un mot inventé par les bourgeois."

20. Coquiot [31], p. 66. "A l'Institut, ils ont empaillé l'Antique."

21. Frisch and Shipley [42], p. 322. "You see.—Carpeaux was on the right track; I idolized him, I still know he is great—but that group hasn't wholly freed itself from the academic convention. The despair of that father and his wretched children is squeezed together in the middle of the piece, which makes it theatrical, almost superficial. Although it's a powerful work, it's static. There's too much striving after architectural composition; that keeps him from solving his problem."

22. *Les Maîtres Artistes* [328], p. 274. "Gustave Moreau, Puvis de Chavannes, Mallarmé, Rops et Rodin ont repris dans le répertoire de l'école des sujets mythologiques ressassés, eût-on dit, jusqu'à l'écœurement; et cependant, ils en ont fait jaillir des impressions inconnues, Moreau par l'accumulation des détails de luxe mystérieux et de symbolisme oriental, Chavannes par la sérénité simplifiée d'une nudité héroïque et pure, à peine secondée par quelques accessoires, Mallarmé par l'eurythmie des images et la savante élection des épithètes rares, Rops par la nervosité moderne. Rodin, lui, les retrouve par une esthétique personnelle de la forme, et par un sens spécial du geste, par l'étrange intensité psychologique des masques, par l'imprévu des groupements."

23. *See* nos. 67–69, n. 19.

24. *See* n. 19 above, Cladel, p. 77. "En architecture, on ignore l'art de l'opposition; on ne sait pas contrebalancer les volumes ni les noirs par les clairs; ou bien, on s'y essaye d'une façon si raide, si gauche, qui tient si peu compte de l'art des passages, des transitions d'un plan à l'autre, qu'il en est uniquement résulté la pénurie du *modern style*, tout en angles et en saccades."

25. Claris [165a], p. 37. "Allez chez les amateurs, pénétrez dans un salon de bourgeois riches, jetez un coup d'œil autour de vous; vous ne verrez que des choses tristes, mortes, laides; aucune forme intéressante, ni dans les meubles, ni dans les objets d'art, ni dans les bibelots, ni dans les vases, à moins que ce ne soit une œuvre ancienne. Partout une déformation des antiques. L'art préraphaélique qui marque cette tendance nous a envahi après avoir sévi en Angleterre."

26. Gsell [57c], p. 112.

27. Bartlett in Elsen [39], p. 91.

28. Cladel [26], p. 100. "Quand tu mouilleras ma

figure, ne la mouille pas trop pour que les jambes ne soient pas trop molles.''

29. Ibid., p. 102. Letter of October 1, 1871. "Aie soin, ma petite, des moules; tu les envelopperas à chacun, des journaux, des mouchoirs ou autres, surtout au moule de l'Alsacienne."

30. *See* Grappe [338d], nos. 9, 13, 16, 19, 24, 25, 26.

31. Ibid., nos. 29, 44, 100, 230, 231, 313.

32. Ibid., nos. 333, 348, 355, 373, 378, 386, 395, 398, 401.

33. Hoffman [222], p. 43.

34. Ibid.

35. Geffroy [199a], p. 7. "La clef grince et la porte bâille. Aucun des modèles préférés du sculpteur ne fait effort des muscles, ne dresse une statue de chair tressaillante. Rodin est seul, travaillant à assembler des groupes, cherchant des arrangements, et des harmonies."

36. Gsell [57c], p. 100.

37. Dujardin-Beaumetz in Elsen [39], p. 159.

38. Steinberg [310], p. 345, illus. 209, gives the work this title.

39. Diolé [173], p. 1. "A Meudon, chaque dimanche, venaient de nombreux visiteurs. Toutes les œuvres étaient, ce jour-là, recouvertes de housses. Un dimanche pourtant, un buste était découvert. Chaque visiteur s'arrête pour l'admirer. L'un d'entre eux, plus hardi que les autres, demande quelle est cette tête. 'C'est Jeanne d'Arc', dit Rodin. Et chacun de se récrier sur la beauté et la vérité de cette œuvre. Survient un nouvel admirateur qui lui aussi s'arrête devant la statue et demande qui elle représente. 'C'est la ville de Nantes', dit le maître. La statue changea ainsi cinq fois de personnalité en une après-midi pour la plus grande confusion de quelques thuriféraires maladroites."

40. Lami [4], p. 162. "A dater de ce moment, il changea sa technique. Jusqu'alors, il avait modelé ses statues grandeur d'exécution; dorénavant, il se contenta d'entreprendre des figures et des groupes de petite dimension, qu'il résolut de faire agrandir par un procédé mécanique: celui de la réduction, en invertissant le rôle des aiguilles. Il s'adressa donc à un réducteur, M. Henri Lebossé, qui travaillait pour le compte des sculpteurs et des éditeurs des bronzes. Ce dernier, de tous les collaborateurs ... devint le plus précieux."

Rodin's attitude before this date was summarized in the *Journal* of Edmond and Jules de Goncourt for February 26, 1888 [53], vol. 3, p. 760:

"Rodin m'avoue que les choses qu'il exécute, pour qu'elles le satisfassent complètement quand elles sont terminées, il a besoin qu'elles soient exécutées tout d'abord dans leur grandeur dernière, parce que les détails qu'il y mettait à la fin enlevaient du mouvement et que ce n'est qu'en considérant ces ébauches—et pendant de longs mois—dans leur maquette grandeur nature, qu'il se rendait compte de ce qu'elles perdaient de mouvement et que ce mouvement, il le leur rendait en leur détachant les bras, etc., etc., en y remettant enfin toute l'action, toute l'envolée, tout le détachement de terre, atténués, dissimulés par les derniers détails du travail.

"Il me disait cela à propos de la commande que vient de lui faire le gouvernement du BAISER, qui doit être exécuté en marbre dans une figure plus grande que nature et qu'il n'aurait pas le temps de préparer à sa manière."

41. From a letter of July 20, 1891, quoted in the catalogue of the Antony Roux Sale, Galerie Georges Petit, Paris, May 19–20, 1914, no. 133. "Ce modèle est unique et ne pourra jamais être reproduit en aucune matière. Je m'engage à briser le modèle en plâtre qui a servi à la fonte en bronze, aucun autre n'existant."

42. Bartlett in Elsen [39], pp. 87–88.

43. Letter of September 21, 1885, quoted in the catalogue of the Antony Roux Sale, no. 137. "Reçu de M. Antony Roux la somme de ... pour un groupe 'Iris', dont il a la propriété entière." It is further stated: "Il a été tiré plusieurs épreuves en bronze. Avec ce plâtre est transmis le droit exclusif de reproduction pour l'avenir."

44. Letter of July 22, 1891, quoted in ibid., no. 150. "Reçu de M. Antony Roux la somme de ... pour un modèle 'Glaucus' ... Je m'engage à n'en plus faire, ni en bronze, ni en marbre, l'original étant à Monsieur Roux, qui ne peut non plus en faire plusieurs ni en bronze, ni en marbre."

45. In 1927 Pittendrigh Macgillivray, Sculptor Royal of Scotland, who owned a plaster cast of the bust of Victor Hugo which was exhibited at the Glasgow International Exhibition in 1888, had two casts made by the Edinburgh founder, Henshaw.

46. Cladel [26], p. 275.

47. *L'Art et les Artistes* [330], p. 60.

"Ce bronze est destiné à l'Amerique, me dit Rodin; c'est intentionnellement que je l'expose aux intempéries de l'air. J'aime à voir l'effet que produit cette œuvre sous le rayonnement du soleil, comme sous le mystère de temps sombres. Le travail de l'atmosphère apporte à la sculpture

une collaboration précieuse. L'eau des pluies accuse les parties en relief en les lavant et en les oxydant, tandis que les poussières et les salissures, en se logeant dans les parties creuses, en accentuent la profondeur; et l'effet général y gagne.

"Il n'est pas jusqu'aux familiarités des oiseaux qui ne patinent heureusement les bronzes et les marbres laissés au grand air."

48. Letter of June 19, 1907, in the Thielska Galleriet, Stockholm.

49. Letter of March 25, 1908, in the Thielska Galleriet, Stockholm. "Le travail a été long et n'est pas encore tout à fait terminé, car la patine est longue à obtenir. Mais je la veux belle et désire que vous ayez une pièce remarquable en tous points."

50. Letter of June 3, 1908, in the Thielska Galleriet, Stockholm.

51. Letter of August 25, 1908, in the Thielska Galleriet, Stockholm.

"Je suis très heureux que mon œuvre vous ait donné toute satisfaction, et très flatté que vous lui ayez aussi assigné la plus belle place dans votre admirable collection.

"La patine, en effet, est particulierement réussie. Les méthodes varient à l'infini. Chacun a sa manière. Mais une belle patine demande, exige une longue expérience—et aussi un peu de chance."

52. Letter of July 29, 1908, in Prins Eugens Waldemarsudde, Stockholm. "'Le Penseur,' de la grandeur de celui du Panthéon, coulé en bronze patiné, commandé par le Prince Eugène, au prix de quatorze mille francs. 'Le Penseur' sera exécuté et patiné dans l'espace de six ou huit mois, peut-être un peu moins, peut-être un peu plus,—ce qui dépend de la patine."

53. Christiane de Boelpaepe, Le Séjour de Rodin en Belgique, Brussels, 1958, points out that this transaction took place in 1872 and not 1875 as stated by Grappe [338d], no. 29. Suzon exists in two sizes, heights 17⅜ inches and 9 inches. A cast of the smaller version is currently in the possession of Charles Feingarten, Los Angeles.

Much research has yet to be done on nineteenth-century foundries. In addition to those foundries referred to in the text, the following also cast works by Rodin:

Banjean—The Weeping Lion (National Gallery of Scotland, Edinburgh)

Pierre Bingen—Antonin Proust and Victor Hugo (St. Louis Art Museum). He worked for Rodin from 1884 to 1889.

Henry Bonnard Bronze Company—Joseph Pulitzer (Columbia University, School of Journalism)

Converset—Polyphemus (Musée de Belfort)

René Fulda—Iris (Sterling and Francine Clark Art Institute, Williamstown, Mass.)

Jean Honoré Gonon—Jean-Paul Laurens and Victor Hugo, exhibited at the Salons of 1883 and 1884 respectively

Griffoul et Lorge—Fugit Amor, The Spirit of War (fig. 66-2), Eternal Springtime (Musée des Beaux-Arts et d'Archéologie, Besançon). This foundry worked for Rodin from 1887 to 1895.

A. Gruet (the elder)—Bellona and Fugit Amor (Washington County Museum of Fine Arts, Hagerstown, Md.)

A. A. Hébrard—Jean-Alexandre-Joseph Falguière and The Thinker (Allen R. Hite Art Institute, University of Louisville)

Montagutelli—Albert-Ernest Carrier-Belleuse (Musée Rodin), La France, and two busts of the Duchesse de Choiseul

Léon Persinka—The Hero (no. 49), The Helmet-Maker's Wife, Mask of Crying Girl, The Good Spirit, Danaid, The Three Sirens, The Minotaur, Eve, Possession, and Jean d'Aire (reduced version)

J. Petermann—The Thinker (Musées Royaux des Beaux-Arts de Belgique) and Victor Hugo (Stanford University Art Gallery and Museum)

E. Poleszynski—Danaid (Nasjonalgalleriet, Oslo)

Thiébaut Frères—The Age of Bronze and St. John the Baptist Preaching (Bethnal Green Museum, London)

54. William Rothenstein, Men and Memories, vol. 1 (New York: Coward-McCann, 1931), p. 323.

55. Meditation (no. 19) is one of these rare exceptions.

56. Quoted in Alexandre [115], p. 4.
"C'est Desbois qui fait les trous
C'est Rodin qui fait les bosses."

57. See Rudolf Wittkower, Gian Lorenzo Bernini (London: Phaidon, 1955), p. 235.

58. See Cladel [26], p. 135.

59. Ibid., p. 100. "Je voudrais que Bernard finisse mes marbres, je lui enverrai de l'argent."

60. Bartlett in Elsen [39], p. 84.

61. Unpublished entry written in a somewhat abbreviated style in Judith Cladel's diary, Lilly Library, Indiana University, Bloomington. "Il [Pompon] a travaillé pour lui. Qd. il est entré chez lui et que Rodin a donné à interpréter en marbre une figure Pompon lui a dit: 'Je vs. demander à Escoula de me mettre au courant de la façon dt. vous aimez qu'on travaille pour vous.' 'Mais, non,' a répondu le maître, 'mes œuvres peuvent être

57

interprétés de façon différente! Vous ferez comme vous sentez, selon votre tempérament et les autres feront autrement!' C'est lui qui m'a appris qu'au lieu d'être un seul et [illegible word] une chose comme on ns l'enseignait, la sculpture varie à l'infini."

62. "The Model of 'The Kiss' Talks on Rodin," *New York Times Magazine,* July 6, 1930, pp. 17, 21, quoted in Spear [332], p. 69.

63. Hoffman [222], p. 97.

64. René Gimpel, *Diary of an Art Dealer,* trans. John Rosenberg (New York: Farrar, Straus, and Giroux, 1966), pp. 159–60.

65. Grappe [338d], no. 253.

66. Ibid., no. 321. "Cette épreuve en bronze coulée sur le plâtre démontre de façon décisive que la pratique du marbre traitant du même sujet, inscrit sous le n° 320, est inachevée. Ce marbre fut trouvé en l'état où il figure ici, dans l'atelier de Rodin, à sa mort. Ce renseignement nous paraît d'autant plus utile à donner qu'un certain nombre des marbres exposés dans les salles du Musée se trouvent dans ce cas; beaucoup de visiteurs croient que le 'flou' où baignent les personnages, est le fait d'une intention du statuaire désirant à une époque de sa vie traiter sa sculpture comme Carrière traitait la peinture, dans une sorte d'enveloppement lumineux. Mais, cette méthode ne fut pas systématique, on s'en rend compte par la comparaison de pratiques inachevées de certaines œuvres avec leurs maquettes."

67. Letter of January 24, 1894, in the possession of Walter R. Beardsley, Elkhart, Indiana.
Madame,

Conformément à votre demande, je viens de faire mettre en train la pierre de la cariathide, elle sera d'un bon tiers plus grande que mon modèle. Les soins suffisent pour protéger une pierre, si néanmoins il y avait trop de mouches dans la saison, on devrait couvrir la pierre et si elles tachaient—avaient taché on devrait immédiatement enlever la tache avec un peu de pierre ponce, les procédés que l'on vous a indiqué, le poivre, ne peuvent pas faire mal, je pense.

Laissez-moi vous dire maintenant, Madame, combien je suis honoré et touché de l'esprit avec lequel vous avez regardé mes sculptures, vous les faîtes valoir à mes propres yeux et certainement vous leur donnez l'âme que je leur avais promise.

68. Letter of June 14, 1894, in the possession of Walter R. Beardsley, Elkhart, Indiana.

Chère Madame,

J'aurais du vous écrire pour vous dire que votre cariathide était toujours au travail et que je m'étais fort trompé dans le laps de temps que j'avais demandé pour l'exécuter. Cependant j'espère vous l'envoyer d'ici six semaines. La pierre devait être bien plus vite faite, mais elle est comme toute sculpture, c'est le modelé et non la matière qui s'oppose à ce que l'on aille vite. Pardonnez-moi et croyez que je serai heureux quand terminée elle aura votre approbation. Agréez chère Madame Dumon mes respectueuses sympathies.
Rodin
La cariathide n'a pas été laissé un jour on y a toujours travaillé.

69. Letter of July 22, 1894, in the possession of Walter R. Beardsley, Elkhart, Indiana.
Chère Madame,

Voilà votre groupe pierre achevé. Le sujet sera ce que vous le baptiserez.

C'est la traduction peut-être du sonnet d'Arvers. Heureux si cette sculpture que j'ai laissé plus engagée pour l'effet de pierre, et devenue par cela plus expressive, puisse vous plaire complètement.

Je l'envoie par grande vitesse. En attendant votre appréciation je vous prie d'agréer mes sympathies respectueuses et les meilleurs souvenirs pour la visite et les paroles d'art que nous avions échangées ensemble.

A. Rodin
Eclairez le groupe par beaucoup d'ombre un peu contre jour. Le prix est de 2,500 f. convenu autrefois.

70. Bernier [134], p. 31. "Il y a une chose qu'on trouve seulement chez Rodin: il aimait laisser les marques du moule sur les figures, peut-être pour plusieurs raisons. La moule est fait de plusieurs morceaux. Si une partie du moule ne s'ajuste pas très bien, il se produit une déformation qui laisse une longue arête, une ligne épaisse—Rodin tenait à ce que les praticiens laissent ces traces du moule, parce qu'alors il pouvait voir si celui-ci n'avait pas été appliqué d'assez près ou si le moule avait joué et modifié la forme intérieure. Quoi qu'il en soit, il laissait ces marques, et le plâtre était coulé en bronze tel quel. C'est une façon de voir si la fonte est vraiment une bonne fonte. Il doit y avoir une ligne très fine le long des joues. De plus, cela donne probablement une sorte de délimitation qui souligne la forme. Pour moi, en tout cas, c'est cela. J'aime ces lignes du moule qui subsistent."

CHRONOLOGY

1840

November 12. Birth of François-
Auguste-René Rodin to Jean-
Baptiste Rodin, an employee
(later an inspector) of the
Préfecture de Police, and his
wife, the former Marie Cheffer.
(Their first child, Maria, had
been born in 1838.) The family
lives in the old twelfth district of
Paris, first at 3, rue de l'Arbalète,
and then on rue des Fossés
Saint-Jacques, rue de l'Ecole de
Médecine, and rue de la Tombe-
Issoire.

1847

The Rodin family is devout,
and Auguste is sent to a religious
school, the Ecole des Frères de
la Doctrine Chrétienne, rue du
Val-de-Grâce.

1851–53

He attends a school in Beauvais
directed by his uncle, Alexandre
Rodin, but is a poor student.

1854

He becomes a student at the
Petit Ecole (Ecole Spéciale de
Dessin et de Mathématiques),
now the Ecole Supérieure des
Arts Décoratifs, where he stays
until 1857. The school, directed
by Jean-Hilaire Belloc,
emphasizes the crafts rather than
the fine arts. Rodin is taught by
Horace Lecoq de Boisbaudran,
who trains his pupils to draw
objects from memory before
allowing them to progress to
the creation of imaginative
scenes. Rodin's fellow pupils
include Alphonse Legros and
Jean-Charles Cazin. Other pupils
of Lecoq de Boisbaudran have
included Jules Dalou, E. C. Cha-
plain, and Henri Fantin-Latour.
The students also make copies of

the French eighteenth-century
artists, Boucher, Van Loo,
Bouchardon, and Clodion.

1855
Rodin receives a bronze medal
for drawing from casts and is
admitted to the class of the
sculptor Fort, to whose teaching
he later refers with gratitude.
He is an extremely industrious
student. In the early morning he
receives instruction in painting
at the studio of Lauset. From 8
A.M. to noon he works at the
Petite Ecole. In the afternoon he
draws copies after the antique in
the Louvre or goes to the Galerie
des Estampes of the Bibliothèque
Impériale, where he studies
such books as *L'Histoire du
costume romain* and *Les Monu-
ments de la monarchie française* by
Bernard de Montfaucon, as well
as engravings after the old
masters. From 5 to 8 P.M. he
follows the drawing course given
by Lucas at the Manufacture des
Gobelins. Recognizing the
deficiencies of his education, he
begins to attend courses at the
Collège de France and to read
widely—first Victor Hugo,
Alfred de Musset, and Alphonse
de Lamartine; then Homer,
Virgil, and Dante.

Does illustrations for Alfred de
Musset's *Nuits*.

1857
He receives a first-class bronze
medal for modeling and a
second-class silver medal for
drawing from casts. Etienne-
Hippolyte Maindron, the
sculptor of the *Velléda* in the
Luxembourg Gardens, sees
Rodin's drawings and advises
him to enter the Ecole des Beaux-
Arts. However, he fails the
entrance examination three
times: his drawings are accepted,

but the eighteenth-century
manner of his sculpture fails to
meet with the approval of the
jury.

1858–62
He works to help support his
family, accepting a number of
menial jobs and working for
commercial decorators and
sculptors, among them Blanche,
Bièze, Cruchet, and Roubaud.
It is while working for Roubaud
that Rodin meets Jules Dalou.
(Perhaps Rodin first becomes
interested in the Gothic at this
period, since Bièze is occupied
with work on the restoration of
Notre-Dame under Viollet-le-
Duc.) He also works for the
plasterer Constant Simon, who
gives him advice on the science
of modeling-in-depth, which
he never forgets. Unrewarding
as this period may seem to be, it
does give Rodin a thorough
grounding in all branches of the
sculptor's craft.

Maria and Auguste Rodin, c. 1859–60

1860

He finishes a bust of his father (his
first surviving sculpture; pl. 2).
It is a highly accomplished,
austere portrait in a Neoclassical
manner.

1862
The death of his sister, Maria,
who, after an unhappy love
affair had taken vows to be a
nun, brings Rodin great sorrow,
which is only eased by his
religious faith.

Christmas. He enters the
recently founded order of the
Society of the Blessed Sacrament
as Brother Augustin.

1863

The founder of the order, Father Pierre-Julien Eymard, recognizes Rodin's true vocation and advises him to leave the order, which he does at the end of May. He returns to the house of his parents and rents a stable on the rue Lebrun, near the Gobelin factory, for a studio. He becomes a member of the Union Centrale des Arts Décoratifs, a society founded by the sculptor Jules Klagmann. The members include Delacroix, Ingres, Lecoq de Boisbaudran, Dumas *père,* and Théophile Gautier. He meets there the celebrated sculptor Jean-Baptiste Carpeaux, who greets him warmly, but later he is given a cold reception when he presents himself at Carpeaux's studio.

Rodin goes to Strasbourg and does work in the Gothic style, but soon returns to Paris.

He makes the bust of Father Eymard (no. 78).

He starts work on *Man with the Broken Nose (see* no. 79).

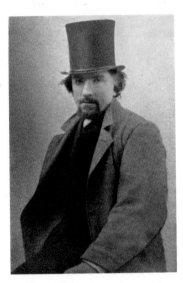

Rodin, c. 1864

1864

He follows Antoine Louis Barye's course in animal anatomy at the Musée d'Histoire Naturelle. Although not stimulated by Barye's teaching, he is impressed by his integrity and his scrupulous attention to detail. He also attends anatomy classes at the Ecole de Médecine. He continues working for decorators and commercial sculptors.

He continues working on *Man with the Broken Nose* in the freezing stable. He submits the plaster mask to the Salon, but it is rejected.

1864–65

While working for the Théâtre de Gobelins, he meets Rose Beuret (b. 1844), then working as a seamstress in the Gobelins quarter, who becomes his mistress.

Carves caryatids for the Théâtre de Gobelins.

c. 1864–70. He works on a life-size *Bacchante,* using Rose as model. This work, which he later describes as being in the style of

The Age of Bronze, is destroyed when he moves studios.

He works on the decoration of the townhouse of the Marquise de Païva.

c. 1864–71. His independent works consist mostly of busts of attractive girls, in the manner of Carrier-Belleuse and Carpeaux.

Through the photographer Charles Aubry, he meets Albert Carrier-Belleuse. He works part time in the latter's studio on rue de la Tour-d'Auvergne for the next six years, producing sketches for statues that would ultimately bear Carrier-Belleuse's name.

1866
January 18. Birth of a son, Auguste-Eugène Beuret (d. April 23, 1934). (Early in life the boy falls on his head from a window. This has a permanent effect on his mental faculties, and he becomes a great disappointment to his father because he is conspicuously lacking in artistic talent. He ends life as an alcoholic rag-and-bone man.)

1870
During the Franco-Prussian War he enlists in the 158th Regiment of the National Guard and attains the rank of corporal.

He executes the busts of M. and Mme Garnier.

1871
He is discharged from the army for nearsightedness. Since there are few opportunities for work in Paris, he joins his former employer, Carrier-Belleuse, in Brussels. This arrangement does not last long, however, since Carrier-Belleuse becomes jealous of Rodin's efforts to sell his works on his own. While he is away from Paris, his mother dies.

1871–74. Decorative work for the Palais de la Bourse, Brussels: a large bas-relief (two *putti* supporting a globe) and four caryatids representing Commerce, Industry, and the Arts for the interior; groups of *Asia* and *Africa* for the exterior.

1872

Rose joins Rodin in Brussels, where they live at 15, rue du Bourgmestre.

He models *Suzon* and *Dosia,* which the Compagnie des Bronzes purchases and casts in large numbers.

Brussels, Cercle Artistique. *Bust of M.B. . . . ,* plaster *(Man with the Broken Nose).*

1873

Carrier-Belleuse returns to Paris. Rodin remains in Brussels and on February 12 enters into partnership with a former employee of Carrier-Belleuse, Antoine Van Rasbourg. All the works issued by the *atelier* are to bear the signature of Van Rasbourg, with the exception of those intended for competition or exhibition. In addition, works destined for France are to be signed by Rodin.
Although they are still extremely poor, Rodin and Rose Beuret are very happy during their years in Brussels. They spend many afternoons in the forest of Soignes, where Rodin makes a number of oil paintings. He spends Sunday mornings in the Musée de Moulages making drawings from the plaster casts and is a frequent visitor to the Gothic Church of St.-Gudule. His friends include Constantin Meunier, Julien Dillens, the engraver Gustave Biot, and Paul de Vigne.

1874

He executes three caryatids for a house on boulevard Anspach, Brussels (called *Caryatids of St. Gilles).*
With Van Rasbourg he executes the *Allegory of the Arts and Sciences* for the Palais des Académies, rue Ducale, Brussels. These include Cupid measuring the terrestrial globe and a torso after the Apollo Belvedere. He does two bas-reliefs, representing eight of the

Caryatid of St. Gilles
1874, stone
Musée Rodin, Paris

nine provinces, for the Palais Royal.

At the invitation of Jules Pécher, Rodin and Van Rasbourg go to Antwerp to work on a monument to the burgomaster J. F. Loos. The work is finished in 1876 and, although three of the allegorical figures are executed by Rodin, it is signed by Pécher. Rodin makes copies after Rubens.

1874–76. Three figures for the Loos monument, Antwerp.

1875
Returns to Brussels.

He carves a head of Beethoven, two genii, and two caryatids in the main court of the Royal Conservatory of Music, Brussels. He works on a project for a monument to Lord Byron for London (now lost). This does not even receive a mention when the projects are judged in 1877.
June. Using as his model a Belgian soldier, Auguste Neyt, he starts work on the figure that is later known as *The Age of Bronze* (no. 64).

Paris, Salon.
3368. *Portrait of M. B. . . . ,* bust, marble *(Man with the Broken Nose).*
3369. *Portrait of M. Garnier,* bust, terra-cotta.

Winter. He departs for Italy, leaving Rose in charge of the studio in Brussels.

1876
His route takes him via Reims, Mont Cenis, Turin, Genoa, and Pisa. He crosses the Apennines on foot and visits Florence, Rome, and Naples. He makes a profound study of Michelangelo, spending a week in the Sacristy of San Lorenzo in Florence and constructing figures on Michelangelesque principles in the evenings.

Philadelphia, Centennial Exposition (listed under Belgium).
197. *The Renaissance.*
198. *Loving Thoughts.*
199. *The Rose.*
200. *Alsatian Woman.*
201. *Spring.*
202. *Autumn* (small grapes).
203. *Large Grapes.*
204. *Field Flowers.*

Returns to Brussels.

On his return he resumes work on *The Age of Bronze* and finishes it by the end of the year. Makes figure of *Adam,* which he either abandons or destroys.

66

Executes a group of *Ugolino and His Sons,* which he ultimately destroys, except for the body of the principal figure. Major undertakings like these do not prevent him from continuing to work in an eighteenth-century decorative manner.

1877

Young Girl Listening
1877, marble, height 24¾ inches
Musée de Grenoble,

January. Brussels, Cercle Artistique.
The Conquered Man, plaster
(The Age of Bronze).
The exhibition of this work gives rise to charges that the figure is cast from life.

May. Paris, Salon.
4107. *The Age of Bronze,* plaster.
The same accusation is made when the work is exhibited in Paris. He has casts and photographs made of the model, but this evidence is ignored by the Salon jury.

August 31. The partnership with Van Rasbourg is dissolved. Autumn. Rodin returns with Rose to live in Paris, after having made an extensive tour of the French cathedrals. He still has to do commercial work to support himself. He works for jewelers and *ébénistes* and for a sculptor, André Laouste.

Preliminary studies for *St. John the Baptist Preaching* (no. 65), with Pignatelli as his model. He works on a slightly over life-size figure, so as to refute the accusations made in connection with *The Age of Bronze.*

1877–78
It is while working for Laouste that he meets Jules Desbois, with whom he establishes a close rapport.

Carves decorative masks for the keystones of an arcade in the Palais du Trocadéro for the Salon exhibition of 1878.

1878

He continues working on *St. John the Baptist Preaching.*

Paris, Salon.
4558. *Portrait of M.,* bust, bronze.

Spring. He goes to Nice, where
he works for the sculptor Cordier
on the decoration of the Villa
Neptune, promenade des
Anglais.
He makes a trip to Marseilles.

He executes two caryatids and a
mask of Neptune.

Works under Fourquet on the
decoration of the Palais des
Beaux-Arts, Marseilles.

1879

The city of Paris organizes a
competition for a monument to
commemorate the defense of
Paris during the Franco-
Prussian War. Rodin's project,
The Call to Arms (no. 66), is not
even mentioned when the entries
are judged in November.
He is also unsuccessful in the
competition organized by the city
for a bust of the Republic (this
entry soon becomes known as
Bellona; see no. 107).

Paris, Salon.
5322. *St. John the Baptist
Preaching,* bust, bronzed plaster.
5323. *Portrait of Mme A.C. . . .,*
bust, terra-cotta *(Mme Cruchet).*

June. Carrier-Belleuse, now
Director of the Manufacture de
Sèvres, invites Rodin to become
a member of its temporary
staff. He works there at irregular
intervals until the end of 1882.

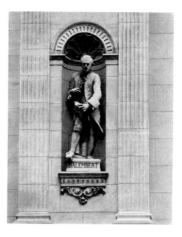

1880

Paris, Salon.
6640. *The Age of Bronze,* statue,
bronze (third-class medal).
6641. *St. John Preaching,* statue,
plaster.

May 26. *The Age of Bronze* is
bought by the state.

He is beginning to move in
more fashionable society. He
frequents the salon of Mme
Edmond Adam, which is
attended by Gambetta, Waldeck-
Rousseau, Antonin Proust,
Jules Castagnary, Sully-
Prudhomme, Pierre Loti,
Carolus-Duran, and Gounod.

He receives the commission for a
statue of d'Alembert for the
Hôtel de Ville.

In the salon of Mme de Lionville he meets the writers Guy de Maupassant, Jean Richepin, Henri Becque, Stéphane Mallarmé, Paul Bourget, and others.

July. He is given studio M in the state-owned Dépôt des Marbres, 182, rue de l'Université. Later he is given two other studios, J (where he works on *The Gates of Hell)* and H (where he works on the Victor Hugo monument). His neighbors include Eugène Guillaume, Emmanuel Frémiet, and Jean-Paul Laurens.

Through the painter Maurice Haquette he is introduced to Edmond Turquet, Undersecretary of State for Fine Arts, who secures for Rodin the commission for the decorative portals of a proposed new Museum of Decorative Arts, to be erected on the site of the former Cour des Comptes. The theme chosen is scenes from Dante's *Divine Comedy.*
August 16. First payment of 8,000 francs for "bas-reliefs representing 'The Divine Comedy.'" (For further payments, *see* no. 1, Appendix.) He works on the first architectural studies for *The Gates of Hell.* He returns to the theme of Adam, a statue of which he completes in this year (no. 4), and the related work, *The Shade* (no. 5), and models *The Thinker* (no. 3). Begins *The Helmet-Maker's Wife* (no. 7) and starts work on *The Crouching Woman* (no. 6).

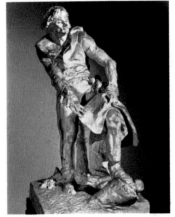

Maquette for
"Monument to Lazare Carnot"
1881, plaster, height 33 ½ inches
Musée Rodin, Paris

1881
St. John is purchased by the state after the Salon exhibition.
At the invitation of his friend Alphonse Legros, Rodin makes the first of many visits to England at the end of the year. Legros initiates him into the technique of drypoint. He meets William Ernest Henley, Director of the *Magazine of Art,* Robert Louis Stevenson, John Singer Sargent, Gustave Natorp, and Robert Browning.

He works on *Eve* (no. 8) and *The Fallen Caryatid Carrying Her Stone* (pls. 22–26). He unsuccessfully enters a competition for a monument to Lazare Carnot.
The Gates of Hell and the associated major figures occupy the greater part of his time, although he does begin work on a series of portraits of his distinguished contemporaries, including Alphonse Legros (no. 84) and Jean-Paul Laurens (no. 83).

Paris, Salon.
4262. *The Creation of Man,* decorative figure, plaster *(Adam).*
4263. *St. John Preaching,* statue, bronze.

1882

He makes the bust of Carrier-
Belleuse (no. 85).
Finishes statue of d'Alembert for
the Hôtel de Ville, Paris.

June. He is in England again,
staying with Gustave Natorp.
September and December. Works
at Manufacture de Sèvres.

During the latter part of the year
the full-scale architectural frame-
work of *The Gates of Hell* is
assembled. He begins work on a
group of *Ugolino,* using
Pignatelli as his model.

Paris, Salon.
4812. *Portrait of M. J.-P. Laurens,*
bust, bronze.
4813. *Portrait of M. Carrier-
Belleuse,* bust, terra-cotta.
His work is seen at the Triennial
Salon, Paris (*The Age of Bronze*
and *St. John the Baptist*) and in
London at the Royal Academy
(*St. John the Baptist*) and at the
Grosvenor Gallery (*Man with the
Broken Nose* and *Alphonse Legros*).

1883
He agrees to supervise the
sculpture class given by Alfred
Boucher while the latter is
away and meets Camille Claudel.

October 26. On death of his
father, he moves from 268,
rue des Fossés Saint-Jacques,
to 39, rue du Faubourg Saint-
Jacques.

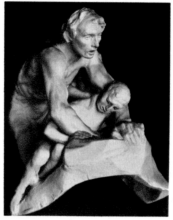

Ugolino and His Sons
1882, plaster, height 33 ½ inches
Musée Rodin, Paris

He continues with the series of
portrait busts, portraying Jules
Dalou (no. 86), Maurice
Haquette, and Henri Becque
(no. 88). He frequents the salon
of Victor Hugo and makes a bust
of the aged poet (no. 87).

Paris, Salon.
4142. *Danielli,* bust, bronze.
4143. *Portrait of M. A. Legros,*
bust, bronze.

Paris, Exposition Nationale des
Beaux-Arts.
1106. *The Age of Bronze.*
1107. *St. John the Baptist
Preaching.*

A second group of works,
including *Saint John the Baptist
Preaching* and the busts of
J. P. Laurens and Carrier-
Belleuse, is seen at the Egyptian
Hall, London.

1884
He rents a larger studio at 117,
rue de Vaugirard.

He enters a competition for a
monument to General Jean
Margueritte but is not successful.

He makes busts of Henri
Rochefort, Mme Alfred Roll,
William E. Henley, Antonin
Proust, Mme Morla Vicuña
(no. 89), and Camille Claudel.
Autumn. The Municipal Council

Paris, Salon.
3862. *Portrait of M. Victor Hugo,*
bust, bronze.
3863. *Portrait of M. Dalou,* bust,
plaster.

Shows ceramics at the Union
Centrale des Arts Décoratifs,
Paris, and *The Age of Bronze* at the
Royal Academy, London.

of Calais opens a national subscription for a monument to the Burghers of Calais. Rodin submits his first *maquette* for the monument toward the end of the year. He divides his time between *The Gates of Hell* and the project for *The Burghers of Calais,* working on the former in his studio in the Dépôt des Marbres and on the latter in his studio on rue de Vaugirard.

Rodin, c. 1885

November. *The Age of Bronze* is placed in the Luxembourg Gardens.

1885

January 28. Rodin signs a contract with the city of Calais for a monument to the Burghers of Calais (no. 67), which he assures them will be ready during the first months of 1886.

Paris, Salon.
4168. *Portrait of M. Antonin Proust,* bust, bronze.

May. He is in London, staying with Gustave Natrop.

July. He submits a second project for *The Burghers of Calais,* comprising six figures. Once this is accepted, he works individually on each of the six figures, studying them both nude and draped. These are enlarged by 1886.

1886
He moves to 71, rue de Bourgogne.

A financial crisis in Calais delays the completion of *The Burghers.* June. His project for a *Monument to Jules Bastien-Lepage* is accepted by the commissioning body. He also receives commissions for monuments to Benjamin Vicuña-Mackenna and General Patrick Lynch, both to be erected in Chile.
1886–88. He works on a series of illustrations for Baudelaire's *Les Fleurs du Mal.*

An important group of works is shown at the Fifth International Exhibition of Painting and Sculpture, Galerie Georges Petit, Paris. These include the *Eve* (small marble), *The Crouching Woman, I Am Beautiful, The Fallen Caryatid Carrying Her Stone, Andromeda,* and portraits of Dalou and Rochefort.

1887

Work continues on the Vicuña-Mackenna and Lynch monuments during 1887, but neither of them gets beyond the stage of *maquettes*.

His work is seen again at the Galerie Georges Petit, Paris (a group called *The Lovers,* probably to be identified with *The Kiss;* fragments from *The Gates of Hell;* and three *Burghers of Calais).*

December 31. He receives the Cross of the Chevalier of the Legion of Honor.

1888

January 31. The state commissions a marble replica of *The Kiss.*

Paris, Salon.
4592. *Portrait of Mme M.V...,* bust, marble *(Mme Vicuña).*

Two *Burghers of Calais* are seen at the Seventh International Exhibition of Painting and Sculpture, Galerie Georges Petit, Paris.

July 20. The bust of Mme Vicuña is purchased for 3,000 francs by the state.
He rents the Folie Neubourg on the boulevard d'Italie and spends much time there with Camille Claudel.

1889
Through Eugène Carrière, he is elected a member of the committee of the Salon des Artistes Français. He is also a member of the jury of the Exposition Universelle.

April 9. He receives the commission for a *Monument to Claude Lorrain (see* no. 70) to be erected in Nancy.

Paris, Exposition Universelle.
2123. *A Burgher of Calais.*
2124. *Portrait of M. Antonin Proust.*
2125. *Portrait of M. Dalou.*
2126. *The Age of Bronze.*
Also *St. John the Baptist* and *Bust of Victor Hugo.*

He exhibits thirty-six works in a joint exhibition with Claude Monet at the Galerie Georges Petit, Paris *(see* Paris, 1889 [347]). The complete group of *The Burghers of Calais* is seen for the first time. The Galerie Petit exhibition confirms his reputation. His defenders now include some of the outstanding critics of the

time: Camille Mauclair, Gustave Geffroy, Octave Mirbeau, and Roger Marx.

He also exhibits a group of works at the Centennial Exhibition and at the Galeries Durand-Ruel.

August. He travels to Toulouse, where he makes an intensive study of architecture. He goes on to Albi and Clermont-Ferrand.

September 16. He receives a commission from the state for a *Monument to Victor Hugo (see no. 71)* to be erected in the Panthéon. He works on this during the winter, creating not the standing figure requested by the administration but a seated figure surrounded by muses. September 29. The Bastien-Lepage monument is unveiled in the cemetery at Damvillers.

1890
He moves out of Paris to Bellevue and occupies the house that formerly belonged to the dramatist Eugène Scribe at 8, chemin Scribe.

With Dalou, Meissonier, Carrière, and Puvis de Chavannes, he becomes a founder-member of the Société Nationale des Beaux-Arts and is appointed vice-president of the sculpture section.

Paris, Société Nationale des Beaux-Arts.
1294. *Bust of Mme R...,* silver *(Mrs. Russell).*
1295. *Torso,* bronze.
1296. *Old Woman,* bronze.
1297. *Sketches,* bronze.

June 11. The inauguration of the *Monument to Castagnary,* Montmartre Cemetery.
July. His project for the Victor Hugo monument is rejected by the commissioning body, but it is decided early in 1891 that this group could be erected in the Luxembourg Gardens. (Work on this continues desultorily until 1909.)

Autumn. Travels in Touraine and Anjou; also visits Rodez and Saumur, making a fervent study of architecture.

Winter. He begins work on the first project for the second Victor Hugo monument, the "Apotheosis," to be erected in the Panthéon. Important works connected with this are the *Flying Figure* and *Iris, Messenger of the Gods.*
Begins the bust of Puvis de Chavannes (no. 90).

1891

Work on both Hugo monuments continues during 1891. The second monument commissioned is never delivered.
Receives a commission for a funerary medallion of César Franck (d. 1890).
July. He receives a commission from the Société des Gens de Lettres for a *Monument to Balzac (see* nos. 72–76), which he promises to deliver in eighteen months.

Paris, Salon de la Société Nationale.
1364. *M.P. PDEC,* bust, plaster *(Puvis de Chavannes).*

Medallion of César Franck
1891, plaster
Location unknown

August. He travels to Jersey and Guernsey with Gustave Geffroy and Eugène Carrière and visits the sites earlier frequented by Victor Hugo.
Autumn. He makes an extended stay in Tours and the Indre Valley, making sketches for the *Balzac.*

1891–92. He reads widely and makes studies of the writer's head, both from living models and portraits.

1892

February. By this time he has completed a standing draped figure of *Balzac.* He is also working on a standing nude figure with arms crossed "in the attitude of a wrestler, seeming to defy the world."

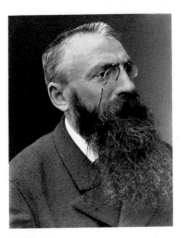

Rodin, 1893

July 19. He is appointed Officer of the Legion of Honor.

1893

He is elected president of the sculpture section of the Société Nationale des Beaux-Arts.

1894

He leaves Bellevue for Meudon, where he buys the house that is to be his principal residence until he dies.
Autumn. He travels in the south of France: the Auvergne, Dauphiné, Engadine, and also Saint Moritz.

A subscription is opened for a *Monument to Baudelaire,* for which Rodin is given the commission. The poet Charles Leconte de Lisle accepts the presidency of the commissioning body, but little progress on the monument has been made as late as 1897 since the funds raised are insufficient. Rodin completes only the head of the poet.
June 6. The Claude Lorrain monument is unveiled in Nancy. Although defended by Roger Marx and Emile Gallé, the work is strongly criticized, and against his better judgment, Rodin is obliged to modify the pedestal with Apollo and his chariot.

He is in poor health. Work on the *Balzac* slows down.

The medallion of César Franck, commissioned in 1891, is placed on his tomb in Montparnasse Cemetery.
September. The subscription for the monument to the Burghers of Calais, dormant since 1886, is renewed.

April. He goes to Calais, studies the location for the Burghers monument, and decides that it should be placed either very low "as it were, mixed with the daily life of the town" or very high, like a Breton Calvary.
He begins work on the *Monument to Labor,* a tower inspired by the famous staircase at the Château de Blois. He makes *The Benedictions* (no. 47) to crown the *Monument to Labor.*

Paris, Salon de la Société Nationale.
1572. *M.P. PDEC,* bust, marble *(Puvis de Chavannes).*

Paris, Salon de la Société Nationale.
114. *Bastien-Lepage,* medallion, plaster.

November. He visits Claude
Monet at Giverny, together
with Clemenceau, Mirbeau,
Geffroy, and Cézanne.

November 30. He receives the
commission for a *Monument to
President Domingo Faustino
Sarmiento* of Argentina (no. 77).
Work continues during 1895.
The Société des Gens de Lettres
threatens Rodin with legal action
if the statue of *Balzac* is not
delivered in twenty-four hours.
December. A new agreement is
reached, from which the trouble-
some time clause is absent. As
surety, Rodin deposits the
10,000 francs he had received
with the Société's lawyer and
agrees to make no claims for
remuneration until the statue is
actually delivered.

1895
For the most part, the press is
extremely hostile to Rodin.
Throughout 1895 he is in poor
health and depressed.
January 16. Rodin presides at a
dinner given in honor of
Pierre Puvis de Chavannes.
He attends the salon of the
composer Ernest Chausson (with
such figures as Renoir, Monet,
Degas, Redon, Albert Besnard,
Carrière, Emmanuel Chabrier,
Vincent d'Indy, Henri Duparc,
Gabriel Fauré, Erik Satie,
Henri de Régnier, André Gide,
Mallarmé, Colette, and Willy).

Paris, Salon de la Société
Nationale.
100. *Head,* marble *(Thought).*
101. *Bust of Octave Mirbeau.*

June 3. The monument to the
Burghers of Calais is unveiled
in the place Richelieu, Calais.
It is installed on a pedestal of
medium height, surrounded by a
Gothic-style iron railing,
exactly contrary to Rodin's
instructions.

76

1896

February. He feels in better health and returns to work with renewed vigor.
Rodin gives three sculptures to the Musée Rath, Geneva: *Man with the Broken Nose, The Thinker,* and *The Crouching Woman* (in fact, *The Tragic Muse* from the Victor Hugo monument), but the latter is judged indecent and relegated to the basement.

He continues working on the *Balzac,* but uses a new athletic model.

October. The figure of President Sarmiento is practically completed.

Paris, Salon de la Société Nationale.
115. *Illusion, Daughter of Icarus.*
116. *Statue (Old Age and Adolescence).*

1897

February 2. With François Vielé-Griffin and Claude Debussy, he offers dinner to Mallarmé to celebrate the publication of *Divagations.*
The first important study of one aspect of Rodin's work, *Les Dessins d'Auguste Rodin,* with a preface by Octave Mirbeau, is published by the Maison Goupil.

April. The *maquette* for the Balzac monument is finished and is in the process of being enlarged.

Paris, Salon de la Société Nationale.
125. *Victor Hugo,* plaster group. (The arm of the woman is incomplete.)
126. *The Thought of Life.*
127. *Group of Love and Psyche.* Marble belonging to M. Kahn (*Eternal Springtime*).
128. Small group of *Thought.*
129. *The Fallen Caryatid Carrying Her Stone.*

1898

The long and stormy relationship with Camille Claudel comes to an end.

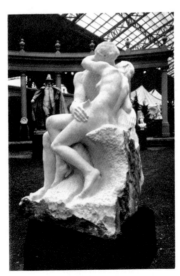

The Kiss at the Salon of 1898

May. Paris, Salon de la Société Nationale.
150. *Balzac,* plaster.
151. *The Kiss,* marble.
The Société des Gens de Lettres refuses to accept the *Balzac* on the grounds that it is not a finished work of art. There is a violent press campaign against Rodin. He receives several offers for the work—from a group of subscribers, from a committee in Belgium, and from the collector Auguste Pellerin—but he decides to keep it himself and withdraws it to his house at Meudon.
It is not cast in bronze during his lifetime.

1899

March 27. He receives a commission for a monument to Puvis de Chavannes.

Spring. He travels to Belgium and Holland with Judith Cladel, who has arranged the first important touring exhibition of his work. He is greatly moved by the return to the country where he lived so happily from 1871 to 1877. He is impressed by the works of Rubens, Van Dyck, Teniers, Snyders, and Jordaens in Antwerp and makes a copy from memory of the work of Rubens. In Holland, it is the paintings of Rembrandt that he seeks out above those of all other masters. Hoping to make a bust of Rembrandt, he looks for a man who resembles him in Amsterdam but has no success.

Paris, Salon de la Société Nationale.
119. *Eve,* bronze.
120. *Bust of Falguière.*
121. *A bust.*
122. *Group,* marble.

Traveling exhibition seen at Arti et Amicitiae, Amsterdam; Haagsche Kunstkring, The Hague; Maison d'Art, Brussels *(see* Amsterdam, 1899 [348]).

1900

May 18. In conjunction with the Exposition Universelle in Paris, his first major retrospective exhibition opens in a special pavilion in the Place de l'Alma *(see* Paris, 1900 [349]). One hundred fifty works are shown. The exhibition is financed by admirers of Rodin's art: Mme Dorizon, M. Peytel, and Gustave Kahn. Works to the value of 200,000 francs are sold. The success of this exhibition greatly contributes to Rodin's international reputation. Orders flow in from museums throughout the world and from wealthy Englishmen and Americans who want to have their portraits sculpted, despite the fact that Rodin raises his price to 40,000 francs in order to curb the demand.

In addition to the works at the Exposition Rodin, eight more are shown at L'Exposition Centennale de l'Art Français and *The Kiss* at the Decennial Exhibition.

May 25. The Sarmiento monument is unveiled in Buenos Aires to a hostile public and press.

June 11. A banquet in honor of Rodin is organized by the magazine *La Plume*. A special number of the magazine, dedicated to Rodin's art, is published *(see* [327]).
October. The pavilion from the retrospective exhibition is dismantled and sent to be reconstructed at Meudon.

1901

No major new works are undertaken this year. After the traumatic decade of the 1890s, when he worked simultaneously on the monuments to Victor Hugo, Balzac, and President Sarmiento, and the climax of the exhibition of 1900, Rodin's creativity enters a new phase. He turns away from the undertaking of new monumental sculpture, although he continues working on projects commenced before 1900 (for example, *Victor Hugo, Ugolino,* and *The Gates*). He concentrates on portrait busts, many of them of Englishmen and Americans, and on small informal sculptures, including some of dancers. He devotes much of his time to drawing and to supervising his numerous assistants in the execution of marble replicas of his sculptures, many of which are commissioned during the first decade of the century.

Paris, Salon de la Société Nationale.
122. *Victor Hugo,* marble.

His work is seen at the Venice Biennale and at the Third Berlin Secession.

1902

The photographer Edward
Steichen visits him at Meudon
and begins work on an out-
standing series of photographs
of the artist and his sculpture.
May. He goes to England on
the occasion of the donation to
the South Kensington Museum
by a body of subscribers of a
cast of *St. John the Baptist
Preaching*. After the official
banquet, students from the
Slade School of Art harness
themselves to his carriage and
pull him through the streets.
Accompanied by Alphonse
Mucha, he goes to Prague on
the occasion of the Manes
Exhibition, organized by one of
his assistants, Joseph Maratka.
Rodin and Mucha make a
triumphal tour of Czechoslovakia
and Rodin then goes on to
Vienna.

September. He meets Rainer
Maria Rilke. They correspond
until Rodin employs him in
1905. Alexis Rudier becomes his
principal founder from this date.
October–November. He stays
at Ardenza with Hélène von
Nostitz Hindenburg.
December. René Chéruy begins
working for Rodin as his
secretary.

1903

Two important books on Rodin
are published: *Auguste Rodin*
by Rainer Maria Rilke and
Auguste Rodin: Pris sur la vie
by Judith Cladel.
May 20. He becomes Commander
of the Legion of Honor.
May 25. He returns to London
at the request of students, who
organize a dinner in his honor,

Executes bust of Mrs. John
W. Simpson (pl. 29).

Rodin and Judith Cladel, c. 1903

Busts of the Honorable George
Wyndham, Eugène Guillaume
(no. 93), and Mrs. Potter
Palmer.

Paris, Salon de la Société
Nationale.
176. *The Three Shades,* plaster.
177. *Bust of Victor Hugo.*

May–July. Exhibition organized
by the Manes Society, Prague
(*see* Prague, 1902 [350]).

He is represented at the Fifth
Berlin Secession.

at which the chair is taken by
Alfred Gilbert, R.A.
June 30. His friends organize a
banquet in his honor in the
Bois de Vélizy, at which
Antoine Bourdelle speaks.
November. On the death of
Whistler he is elected president
of the International Society of
Painters, Sculptors, and
Engravers.

1904

January. He goes to London to
accept the presidency of the
International Society of Painters,
Sculptors, and Engravers. He
meets Claire Coudert, Duchesse
de Choiseul, who is to dominate
his life for the next eight years.
His infatuation with his "Muse,"
which can only be regarded as
disastrous, greatly contributes
to the cantankerousness, way-
wardness, and the unpredictabil-
ity in his personal relationships
which cloud his last years.

1905

He is awarded an honorary
degree by the University
of Jena. He gives the university
a bust of Minerva (no. 109)
as a token of his gratitude.
He purchases the ruins of the
eighteenth-century Château
d'Issy when it is on the point of
being demolished. He hopes to
reconstruct it and use it as a
museum for his collection of
antique sculpture and for his
own sculpture, but this project
has to be abandoned because of
the expense. Only the façade is
reconstructed (and later in-
corporated in Rodin's tomb).

He commences work on a *Monu-
ment to Whistler,* but produces
not the Winged Victory requested
by the commissioning body but
a Venus climbing the Mountain
of Fame. Preliminary studies and
fragments of the full-scale figure
survive.

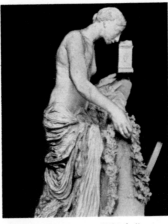

Study for "Monument to Whistler"
1903, plaster
Location unknown

He executes busts of Gustave
Geffroy, Miss Eve Fairfax
(pl. 30), and Georges Hecq.

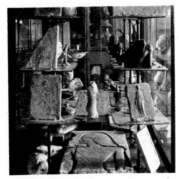

A display case in the Hôtel Biron with
Rodin's collection of antique art

Six works are seen at the
exhibition organized by the
International Society of Painters,
Sculptors, and Engravers in
London. Included are the large
plaster and the small bronze of
The Thinker.

His work is also seen at the
Seventh Berlin Secession, at the
Venice Biennale, and at the
National Arts Club in New
York.

Paris, Salon de la Société
Nationale.
2079. *The Thinker.*
2080. *Bust of Mme S. (Mrs.
John W. Simpson).*

His work is seen in Düsseldorf,
Weimar, Dresden, Leipzig,
Krefeld, and St. Louis.

February. Exhibition of prints
and of decorative work for the
Villa La Sapinière, Evian, Musée
du Luxembourg.

Paris, Salon de la Société
Nationale.
1878. *A figure,* plaster.
1879. *Bust of M. Guillaume.*

His work is also seen at the
Copley Society of Boston and at
at the Venice Biennale.

September. Rainer Maria Rilke commences work as Rodin's secretary.

1906
While Rilke is working for Rodin, George Bernard Shaw makes many trips to Meudon to pose for his bust (no.94).

He also executes busts of Mrs. and Miss Hunter, Lord Howard de Walden, Marcelin Berthelot (no.95), Comtesse Mathieu de Noailles (pl. 31), Georges Leygues, and Mme de Goloubeff. He works on the enlargement of the *Ugolino,* still using Pignatelli as his model.

Paris, Salon de la Société Nationale.
1928. *Sculpture (Marcelin Berthelot).*

His work is seen at Le Cercle Ostende Centre d'Art, Ostend, at the Eleventh Berlin Secession, and at the exhibition of the International Society of Painters, Sculptors, and Engravers, London.

With Rilke and the painter Ignacio Zuloaga he goes to Spain and visits Toledo, Madrid, Córdoba, Seville, and Pamplona.

April 21. *The Thinker* is installed in front of the Panthéon and remains there until 1922, when it is removed to the Musée Rodin.

May. He dismisses Rilke summarily, complaining that he is dealing improperly with his correspondence.
June. The Englishman Anthony Ludovici becomes his secretary.
Summer. Accompanied by Rose, he returns to Belgium for a brief visit.

His enthusiasm for the dance is renewed when King Sisowath and the Royal Ballet of Cambodia visit France. He so enjoys their performance at the Pré-Catelan Festival that he follows them to Marseilles.

He also draws in the dance school organized by Isadora Duncan in Paris.

Ignacio Zuloaga, Rodin, and Sergei I. Shchukin, Pamplona, Spain, 1906

1907
March. He stays at Menton.

He executes busts of Mme Elisseieff and Joseph Pulitzer (no.96).
He visits England to supervise the installation of the bust of W. E. Henley in the crypt of St. Paul's.

Paris, Salon de la Société Nationale.
2079. *The Walking Man,* large plaster figure.

Paris, Salon d'Automne. Busts of Georges Leygues and Comtesse Mathieu de Noailles.

June. The University of Oxford bestows an honorary degree on him. He receives this at the same time as Mark Twain, William

Booth, and Camille Saint-Saëns.
June 28. He is nominated a
corresponding member of the
Associazione degli Artisti
Italiani.
July. He stays at Fougères in
Britanny.

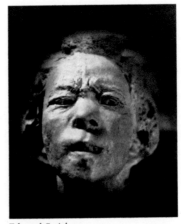

Edward Steichen
Hanako
1908, photograph

July–October. The first
important exhibition of his
drawings is held at the Galerie
Bernheim Jeune, Paris.

His work is seen in Barcelona,
Budapest, London, New York,
Venice, and Berlin.

1908
Spring. King Edward VII of
England visits him at Meudon.
Only marbles and plasters are
left in the studio on this
occasion.

June 1. Inauguration of the
Henri Becque monument, place
Prosper Goubeaux, Paris.

Paris, Salon de la Société
Nationale.
2078. *Orpheus.*
2078 bis. *Triton and Nereid,*
marble.
2078 ter. *Muse.*

September. Edward Steichen
visits Rodin at Meudon and
photographs the *Balzac* by
moonlight. Rodin begins living
in the Hôtel Biron, rue de
Varenne, at first occupying only
the ground floor. The magnif-
icent hôtel, erected by Jean
Aubert and Gabriel de Peyrenc,
had been acquired by the state
in 1904 and rented as apartments.
Among those who had lived
there before Rodin occupied
the whole building were Rilke,
Isadora Duncan, Jean Cocteau,
and Henri Matisse.

He executes portraits of the
Japanese dancer, Hanako *(see
nos. 97, 98)*, the Duchesse de
Choiseul, J. Winchester de Kay,
and Lady Warwick.

Additional exhibitions of his
drawings are held at the Galerie
Devambez in Paris, under the
auspices of the Manes Society in
Prague, and at Stieglitz's "291"
Gallery in New York.

His work is also seen in Brussels,
Leipzig, Ghent, Antwerp,
Berlin, and London.

1909

He executes portraits of Renée
Vivien, Barbey d'Aurevilly
(no. 101), Edward Harriman
(no. 100), Gustav Mahler
(no. 99), Thomas F. Ryan, the
Duc de Rohan, and Napoleon.

Paris, Salon de la Société
Nationale.
1982. *Mme Elisseieff,* bust, marble.

His work is also seen in Ghent,
Prague, and London.

September 30. A modified version of the first Victor Hugo monument is installed in the gardens of the Palais Royal.

1910

Thomas F. Ryan presents three pieces to the Metropolitan Museum of Art, New York—*Cupid and Psyche, Orpheus and Eurydice,* and *Pygmalion and Galatea*—and gives the museum a sum of money to purchase other works by Rodin. Ten marbles and bronzes are purchased, constituting the nucleus of the museum's Rodin collection (opened to the public in 1912).

June 15. Rodin is made Grand Officer of the Legion of Honor.

Rodin experimenting with the installation of the *Monument to Victor Hugo,* 1909

Paris, Salon de la Société Nationale.
1927. *Torso of a woman,* plaster.
1928. *Mme R. . . . ,* bust, bronze.
1929. *M. R. . . . ,* bust, bronze.

His work is also seen in Buenos Aires, Leipzig, and New York

1910–11. He makes a number of studies of dancing figures from a model by the name of Moreno.

1911

July. The state puts the Hôtel Biron at the disposal of the Ministry of Public Instruction and Fine Arts, and Rodin is asked to leave. Judith Cladel and Gustave Coquiot independently propose the creation of a Rodin museum. The idea rapidly gains momentum, and government commissions are appointed to examine the plan. The idea also arouses a great deal of opposition.

The British government purchases a cast of *The Burghers of Calais,* to be placed near the Houses of Parliament. Rodin travels to London to inspect the site.

February 26. The Ministry of Fine Arts commissions a marble bust of Puvis de Chavannes for the Panthéon.

He executes portraits of Professor Gabritchewski and Georges Clemenceau (no. 102).

Paris, Salon de la Société Nationale.
2002. *Portrait of the Duc de Rohan,* marble.
2003. *Eighteenth-century bust (Buste XVIIIᵉ siècle),* marble (*Gustav Mahler*).

His work is also seen in Prague, Buffalo, Düsseldorf, Venice, Rome, and Berlin.

84

A group of admirers purchase a bronze cast of the enlarged *Walking Man,* which they present to the French government for its embassy in the Palazzo Farnese, Rome.

1912
January. Rodin travels to Rome to inspect the placing of *The Walking Man* in the courtyard of the Palazzo Farnese. The work is placed where intended, but the ambassador disapproves of it, and it is removed and sent to Lyons. While in Rome he stays with John Marshall.

Paris, Salon de la Société Nationale.
2687. *Marble* (in the garden statuary section).

May 3. The Champlain monument (based on the head of Camille Claudel), commemorating the three-hundredth anniversary of the discovery of Lake Champlain, is inaugurated at Crown Point, New York.

He gives eighteen plaster casts to the Metropolitan Museum of Art, New York.

May–June. He is present at the Théâtre du Chatelet for the first performance of *L'Après-midi d'un faune,* danced by Nijinsky to the music of Debussy. He defends the dancer in the press against charges of indecency, giving rise to another scandal.

His work is seen in Venice, Lyons, Tokyo, Rome, and Chicago.

He makes a series of drawings and a sculpture of Nijinsky dancing in the nude (pl. 4). He works on a project for a monument to Eugène Carrière (*see* no. 63), but this is never constructed.

August. His relationship with the Duchesse de Choiseul comes to an end, but she does not cease in her efforts to be named a beneficiary in his will. His mental powers undergo a tragic decline in the last years of his life.

This period is marred by unseemly maneuvers on the part of professed friends to gain effective control of his work and estate. Only the alertness of such true friends as Judith Cladel

The *Monument to Barbey d'Aurevilly* is inaugurated at Saint-Sauveur-le-Vicomte.

prevents his life's work and collections from being dispersed to the personal profit of adventurers and confidence tricksters.

1913
His conversations with Henri-Charles-Etienne Dujardin-Beaumetz are published.

February. Paris, Premier Salon de la Société des Artistes Animaliers.
A Lion Roaring.
The Centauress.

Paris, Salon de la Société Nationale.
2091. *A plaster* (a running man).
2092. *A bust.*

He executes a portrait of Lady Sackville.

October. *The Burghers of Calais* is unveiled in Victoria Gardens.

His work is also seen in Munich, Algiers, Ghent, Rome, and New York (seven drawings at the Armory Show).

1914
His thoughts on the Gothic are published as *Les Cathédrales de France,* with an introduction by Charles Morice. His health and mental powers begin to deteriorate seriously. He convalesces in the Midi.
Spring. He goes to London on the occasion of the exhibition of his works at Grosvenor House, the home of the Duke of Westminster.
He returns to Paris. Immediately after the outbreak of the war in August, he travels to England again with Rose and Judith Cladel. They stay at Cheltenham.
He presents eighteen sculptures to the Victoria and Albert Museum, London, as a gesture of thanks for Britain's support of Belgium.
November. He returns to France, but leaves almost immediately for Italy, where

Rodin with Mexican visitors including Diego Rivera (left, rear), c. 1914

His work is seen in an exhibition at the Grosvenor House, London, and then at the Victoria and Albert Museum.

he stays with John and Mary Marshall. He remains in Rome until February 1915, but fails to obtain sittings from Pope Benedict XV.

1915
April 8. He returns to Rome to do the bust of the pope (no. 103), but, owing to the pope's impatience, he obtains only four sittings. He makes a short trip to Florence.

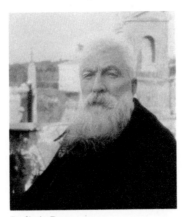
Rodin in Rome, 1915

The Thinker is seen at the Panama-Pacific International Exposition, San Francisco.

1916
March. He is extremely ill and has a fall which further debilitates him.
April 1. The first donation. He formally offers all his work to the French government for a Rodin museum to be installed in the Hôtel Biron.
July. The intrigues of Loïe Fuller and Mme Bardey and her daughter to seize for themselves considerable portions of his estate come to a climax. Fortunately his interests are guarded by several faithful friends, principally Judith Cladel and Etienne Clémentel.
July 10. He has another fall.
July 12. Makes a will in favor of Mme Bardey.
September 13. The second donation to the state.
September 15. The Chamber of Deputies votes 379 to 56 to accept the donations.
October 25. The third donation to the state.
November 9. The Senate votes by a majority of 209 to 26 to accept the three donations.
December 15. The National Assembly votes to establish a Rodin museum in the Hôtel Biron.

He executes the portrait of Etienne Clémentel (no. 104). This is his last work.

Rodin at the Hôtel Biron, 1916

December 26. Receives a commission for a monument to the defense of Verdun.

1917

January 29. He marries Rose
Beuret at Meudon, principally to
safeguard her interests in the
event of his sudden death.
February 14. Mme Rodin dies.
April 3. He puts his signature to
his will.
April 25. Provisions for legacies
for close friends and relatives
are made in his will.
October 25. Paul Cruet makes
a cast of Rodin's hand, into
which a torso is inserted (no. 127).
October 30. Léon Bonnat and
François Flameng visit him at
Meudon to offer him a place in
the Institut de France.
November 17. Rodin dies.
November 24. The funeral
service takes place at Meudon.
He is buried beside Rose in front
of the reconstructed façade of
the Château d'Issy, with *The
Thinker* as his headstone.
Speeches are made by M. Lafferre,
Minister of Public Instruction
and Fine Arts; M. Clémentel,
Minister of Commerce;
M. Bartholomê, on behalf of the
Société Nationale; Frantz
Jourdain, on behalf of the Salon
d'Automne; Albert Besnard,
Director of the French
Academy in Rome; and the
writer Séverine.
At the same time a memorial
service is held in St. Margaret's,
Westminster, in the presence of
Queen Alexandra.

1918

June 23. The status and the
financial autonomy of the Musée
Rodin are confirmed by law.

March. He exhibits six works at
the Galerie Georges Petit, Paris.

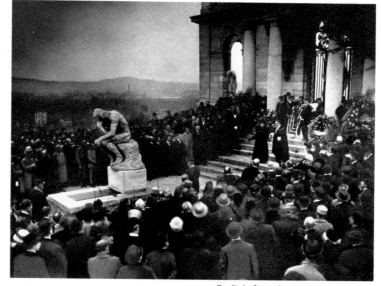

Rodin's funeral, November 24, 1917

THE GATES OF HELL
AND RELATED WORKS

1 The Gates of Hell
1880–1917

Bronze, 250¾ × 158 × 33⅜ inches
Not signed or inscribed
Foundry mark lower right side:
ALexis Rudier/Fondeur. PARIS

The Gates of Hell was commissioned at a turning point in Rodin's career. This monumental work dominated Rodin's thoughts from 1880 to 1890 and remained a source of fascination and anxiety for the remaining twenty-seven years of his life. Like Marcel Duchamp's *Large Glass,* left "definitively unfinished" in 1923, it may be regarded as the résumé of a lifetime's interests and preoccupations—the art and architecture of the Italian Renaissance, the architecture of Gothic France, the poetry of Dante and Baudelaire, and, above all, his own overwhelming response to the beauty and expressive power of the human body.

Rodin's ruminations on the tragic destiny of mankind were to a large extent conceived within the framework of *The Gates,* but the power of many of the single figures and groups led to their detachment and display as individual sculptures, a diaspora, as it were, of variously suffering figures from the realm of the damned. Many of Rodin's best-known works were originally part of *The Gates—The Thinker* (no. 3), *The Three Shades* (fig. 5–4), *The Prodigal Son* (pl. 5), *The Fallen Caryatid Carrying Her Stone* (pl. 25), *The Crouching Woman* (no. 6), and *The Martyr* (no. 18), to name but a few. As many were conceived within its aura—*The Kiss, The Helmet-Maker's Wife* (no. 7), *Adam* (no. 4), and *Eve* (no. 8). The crucial role *The Gates* was to play in Rodin's career and development as an artist could never have been anticipated, however, from the terms of the original commission.

In 1880 Rodin had already gained a considerable degree of notoriety. The realism of his nude figure *The Age of Bronze* (no. 64) had given rise to accusations that he had made liberal use of life casts in his work. Academic sculptors and critics were so unprepared for the astonishing veracity and power of this sculpture when it was first exhibited in 1877 that these charges were not easily dispelled. Three years later a committee sent to inspect the same work to determine its quality prior to purchase by the state concluded that casting from life played such a "preponderant role" in its creation that it could not really be regarded as a work of art in the strict sense of the term.[1]

By way of recompense, after a group of friends and admirers testified on his behalf, Rodin, on August 16, 1880, received the commission for a set of portals for a new Museum of Decorative Arts in Paris, to be erected on the site of the former Cour des Comptes, destroyed by fire in 1871. By the terms of the contract Rodin was to design a set of "bas-reliefs representing 'The Divine Comedy,'"[2] the choice of subject surely having been suggested by Rodin himself as he was already an avid reader of Dante and, as early as 1876, had executed a group of *Ugolino and His Sons.* It has even been plausibly suggested that some of the drawings on Dantesque themes date back as early as 1860.[3]

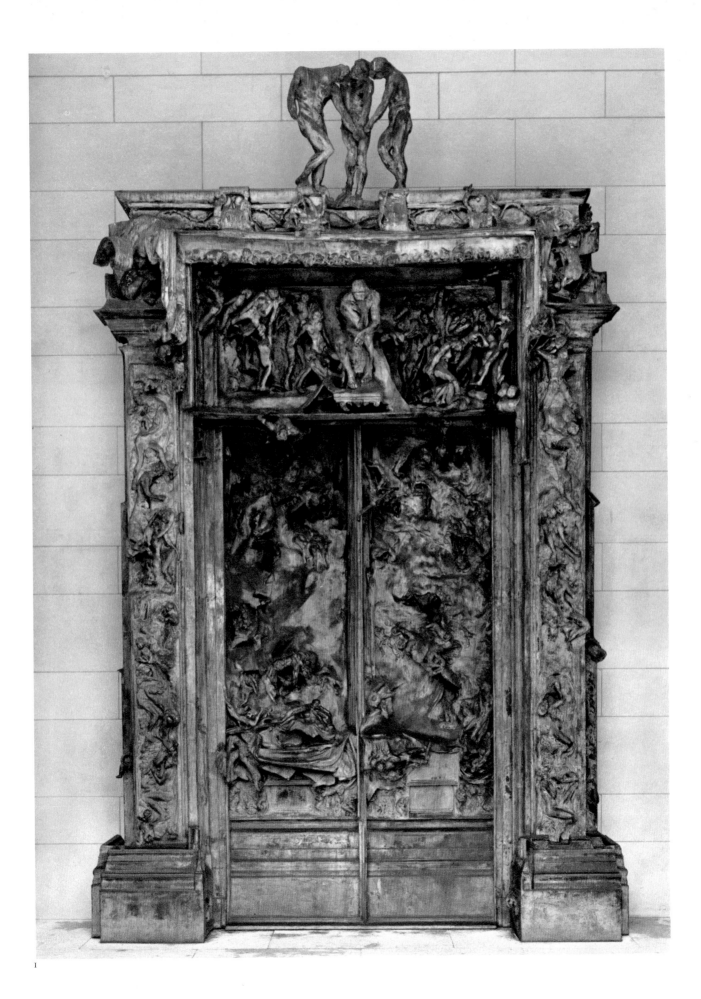

In addition to Rodin's admiration for Dante the poet,[4] in particular as creator of the *Inferno,* the choice of subject enabled him to refute the charges leveled at him in connection with *The Age of Bronze* while at the same time giving him the opportunity to represent a wider range of movement than he had previously had occasion to do. "I had no idea of interpreting Dante, though I was glad to accept the *Inferno* as a starting point, because I wished to do something in small, nude figures. I had been accused of using casts from nature in the execution of my work, and I made the 'St. John' to refute this, but it only partially succeeded. To prove completely that I could model from life as well as other sculptors, I determined, simple as I was, to make the sculpture on the door of figures smaller than life."[5]

An interest in Florentine art was not unusual in France in the third quarter of the nineteenth century. A group of sculptors, notably Paul Dubois, whose *Florentine Singer* was one of the most popular works at the Salon of 1865,[6] Antonin Mercié, and Jean-Alexandre-Joseph Falguière, derived much of their inspiration from Florence. To Rodin, however, Florence meant Michelangelo and, to a considerably lesser extent, Donatello and not the milder strains of the *quattrocento.* Michelangelo dominated his visit to Florence in the winter of 1875–76 and remained a potent influence throughout the next decade, notably in the strongly muscular, anguished figures connected with *The Gates—The Thinker, The Three Shades, Adam,* and *Eve.* But not surprisingly it was to Ghiberti that he turned in the first studies for the portal. In the four published architectural sketches of varying degrees of elaboration, the surface of the door is divided into a number of small panels. The first rough sketch shows the top half of a door divided into four panels, two of which in turn are divided into three.[7]

A second architectural sketch, also of 1880 (fig. 1–1) and more detailed than the first, represents a door divided into eight panels, with four small panels on either side, as in Ghiberti's *Gates of Paradise* in Florence. In three of the panels of the doors, there are rapid notations of crowd scenes which are related to more developed drawings like *Ugolino's Feast* in the Rodin Museum (fig. 1–3). At this point he intended to illustrate certain major incidents from Dante's poem. The third sketch (fig. 1–2) is a development of the second, with greater emphasis placed on the foliage that separates the panels and a vaguely delineated figure at the top, in the position later filled by *The Thinker.* In the fourth sketch (fig. 1–4), there is a much greater emphasis on the sculptural qualities of the door. The figures have been eliminated from the side panels; they now crouch at the corners of the inner panels like Michelangelo's *Ignudi* on the Sistine ceiling.

A more rapid development is evident in the three surviving models. The first architectural clay model (fig. 1–5) is related to the four drawings. The surface of the doors is divided into a number of panels, although there is no indication of figures. In the second model (fig. 1–6), the rigid architectural framework has been abandoned in favor of a far more pictorial approach. By this stage, Rodin was already thinking of dividing the doors into three major areas, the two leaves of the door and an area corresponding to the tympanum of the final work. In the third and final model (no. 2), there is a greater stress on the architecture of the door than in the second. The major figures indicated, *Paolo and Francesca, Ugolino,* and *The Thinker,* are now almost entirely in the round.

By the end of 1880, Rodin had already decided on the approximate size of *The Gates.* In a letter of October 20 to Edmond Turquet, the Undersecretary of State for Fine Arts, he stated that it would be "at least four and a half meters high and three and a half wide."[8] It was also his intention to flank *The Gates* with "two colossal figures" of Adam and Eve,

92

I–I

I–2

I–3

I–I
*Second Architectural Sketch for
"The Gates of Hell"*
1880, pencil
Musée Rodin, Paris

I–2
*Third Architectural Sketch for
"The Gates of Hell"*
1880, ink and pencil
Musée Rodin, Paris

I–3
Ugolino's Feast
c. 1880, pencil and ink, 6 × 7¾ inches
Rodin Museum, Philadelphia

although this proposal was not carried out by the Fine Arts Administration. The full-scale frame of *The Gates* was then erected, but unfortunately the earliest surviving documents that shed light on its appearance date only from 1883. Roger Ballu, an inspector in the Fine Arts Administration, visited Rodin in his studio to estimate how much might be paid as a second installment. Rodin showed Ballu "only isolated groups from which wet protective cloths were successively removed"[9] as they were shown to him. He stated that he was obliged to reserve his judgment on the whole, as he had not seen all the groups in place, but that he was greatly struck by what he referred to as Rodin's "really astonishing originality and power of expression."[10]

The impossibility of keeping the exceedingly complex reliefs of *The Gates* damp while he worked on them forced Rodin to work in a tentative, experimental manner that was to have an important effect on his entire *œuvre*. As each group was completed, it was cut off in sections and pieces and cast in plaster. The fine critic Gustave Geffroy described the doors and the studio as he saw them in 1889: "It is standing and it is scattered. The figures at the top, certain groups on the panels, the doorposts, the bas-reliefs are in position. But everywhere in the vast room, on the benches, on the shelves, on the sofa, on the chairs, on the ground, statuettes of all dimensions are scattered, faces raised, arms twisted, legs contracted, in absolute disorder, giving the impression of a living cemetery."[11]

Removed from its context in *The Gates,* a group might acquire an entirely new meaning that could not have been deduced from its original function. An experimental or chance juxtaposition with another group, the exchange of elements from one group to another, a different orientation (Paolo in *Fugit Amor* becoming *The Prodigal Son* when placed on his knees), were just some of the ways in which Rodin attempted to realize the diverse possibilities embodied in his sculptures. The appearance of *The Gates* thus changed incessantly throughout the 1880s, growing in an unplanned, organic manner and casting aside a stream of works that document various stages in its development.[12]

Rodin soon abandoned the idea of illustrating particular incidents from Dante's poem, although certain figures—*Ugolino and His Sons* on the left panel (no. 1, detail B), *Paolo and Francesca* also on the left (no. 1, detail A), and *The Three Shades* crowning the tympanum—were to remain. In his conversations with the American critic Truman H. Bartlett about 1887–88, Rodin avowed that his sole idea was "simply one of color and effect. There is no intention of classification, or method of subject, no scheme of illustration or intended moral purpose. I followed my imagination, my own sense of arrangement, movement and composition. It has been from the beginning, and will be to the end, simply and solely a matter of personal pleasure."[13]

Certainly the prevailing mood of *The Gates* reflects more of Rodin's own spiritual preoccupations, especially those he shared with Baudelaire, than the theological ordering of Dante. Rodin's own highly developed sense of eroticism found much to identify with in the poetry of Baudelaire, a set of illustrations for whose poetry he provided for the publisher Gallimard in 1888. The influence of Baudelaire in shaping and giving a certain edge to Rodin's understanding of human personality at the point where the sensual merges with the spiritual came, if not to rival, at least to enrich that of Dante in the latter part of the 1880s. The extraordinary group at the top of the right-hand pilaster, which represents a strongly muscled man sweeping a crouching, passive female figure off the ground in the excess of his passion (no. 1, detail C), was developed as a free-standing sculpture (no. 10) which bears on its

I-4

I-5

I-6

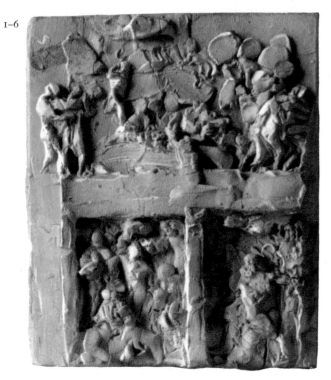

I-4
Fourth Architectural Sketch for "The Gates of Hell"
1880, pencil, ink, and wash, 21 × 15¾ inches
Musée Rodin, Paris

I-5
First Architectural Clay Model for "The Gates of Hell"
1880, terra-cotta, height 10 inches
Musée Rodin, Meudon

I-6
Second Architectural Clay Model for "The Gates of Hell"
1880, terra-cotta, 6¾ × 5½ inches
Musée Rodin, Paris

base a quotation from Baudelaire's poem "La Beauté," from *Les Fleurs du Mal*.

In July 1885 Rodin informed the Ministry of Fine Arts that the plaster model of *The Gates* would be finished in "about six months."[14] As a result, he received a grant of a further 35,000 francs for the casting in bronze.[15] However, he never lived to see this take place. He underestimated the time required to bring this immensely complicated work to a satisfactory degree of equilibrium while at the same time he accepted other commissions that required research and concentration to extraordinary degrees.

Rodin was not the kind of artist who completed one project before moving on to the next. Such a progression from one degree of completion to the next seemed to him to be the worst kind of academicism. Instead he worked simultaneously on a number of major projects, his experiences in these widely differing enterprises serving only to enrich and diversify his approach to the work that happened to be at hand. Thus in 1884, at the height of his involvement in the swirling sea of figures of *The Gates*, he accepted a commission for a monumental group on a heroic theme, *The Burghers of Calais* (no. 67). In 1889, the year of his successful exhibition with Claude Monet at the Galerie Georges Petit, he undertook to produce a monument to Victor Hugo to be erected in the Panthéon (no. 71), and two years after this he came to an agreement with the Société des Gens de Lettres whereby he promised to furnish them with a monument to Honoré de Balzac within a period of eighteen months *(see* no. 75). In all cases, while failing to keep his commitments and enduring protracted and frequently highly disagreeable negotiations with the commissioning bodies, he continued to produce an overwhelming body of independent works, monuments of a less taxing nature, for example, those to Jules Bastien-Lepage *(see* fig. 70–4), Claude Lorrain (no. 70), and President Sarmiento (no. 77); portraits of friends and celebrities, Jules Dalou (no. 86), Alphonse Legros (no. 84), Victor Hugo (no. 87), and Jean-Paul Laurens (no. 83); and, of course, fragments of and studies for his major works.

A number of individual figures and groups from *The Gates*, as well as the six separate figures of *The Burghers*, were shown at the Galerie Petit exhibition. *The Gates* as an architectural entity was far from being finished, but already certain figures connected with it, such as the marble reductions of *Eve (see* fig. 8–6), had been widely circulated, and their reputation as among the outstanding works of the century was well established.

"All those who have been able to admire in the artist's studio the finished studies and those in course of execution agree in saying that this door will be the greatest work of the century," wrote Octave Mirbeau in 1885. "One must go back to Michelangelo to form an idea of an art so noble, so beautiful, so sublime."[16] Gustave Geffroy was equally impressed by its comprehensiveness and its powerful statement of eternal themes. "The Gate of Hell," he wrote, "is the gathering, in eventful motion, of the instincts, the fatalities, the desires, the despairs, of everything that cries out and groans in man. The poem of the Ghibelline has not retained any local color but instead has lost its narrowly Florentine meaning; it has been, as it were, stripped and expressed synthetically, like an anthology of the unchanging aspects of the humanity of all countries and of all times."[17]

Such praise from critics as astute as Geffroy and Mirbeau constituted more an act of faith than a just assessment on their part of the facts, since at no point in its development

Detail A:
Paolo and Francesca (detail of the lower left panel)

Detail B:
Ugolino and His Sons (detail of the lower left panel)

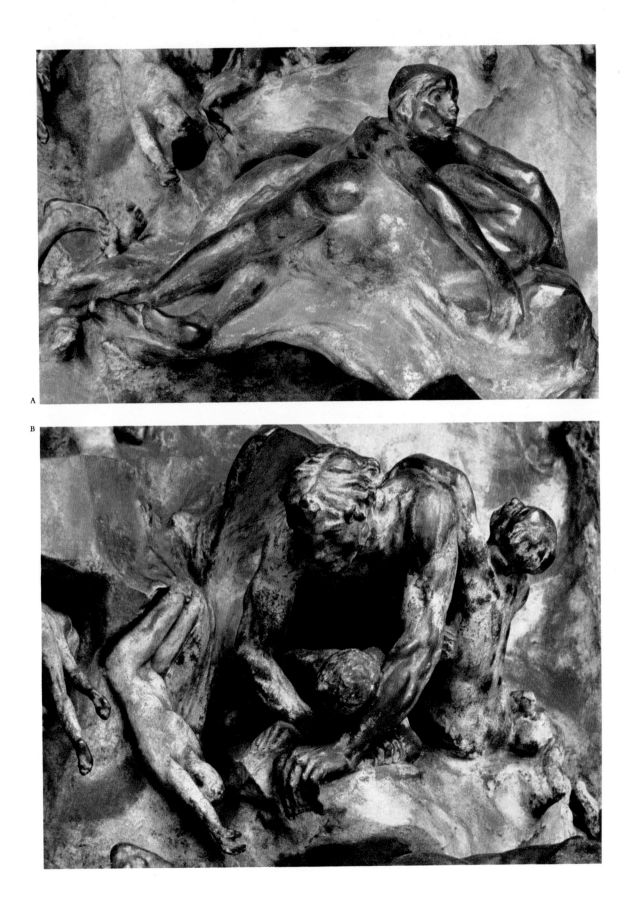

A

B

97

can *The Gates* ever have been seen in its entirety. The rare photographs of the portal that survive from the decade of the 1880s have the aspect more of the ruins of a once completed work than of one nearing completion. A photograph of the tympanum published in 1888[18] shows that many of the most prominent components, such as the flying figure above the *Kneeling Fauness (see* no. 1, detail E) and that based on the *Torso of Adèle* in the upper left-hand corner of the tympanum, are missing. The architecture is still in a rudimentary stage of development, the row of masks above the tympanum is not in place, and, with the exception of two fragmentary figures clinging to the outer brackets, the numerous small figures beneath *The Three Shades* are missing. The basis of what later became branches of thorn—plaster-covered rope—is also visible.

The fate of the two bas-reliefs in the general scheme of the work epitomizes the manner in which the doors developed. It was originally Rodin's intention to place a bas-relief in the lower section of each leaf of the door. At the center of each of these reliefs, which have since been cast separately *(see* nos. 12, 13), is the contorted head of a crying girl, while on either side are scenes of rape and violence. As time went by, however, Rodin clearly came to feel that the geometrical form and the symmetry of these reliefs belonged to an earlier period of his thinking, when Ghiberti was still at the back of his mind. Consequently they weer gradually submerged beneath the lava-like flows of form until all that could be seen was a grieving head peering through the overlay *(see* fig. 12, 13–1).

The curious manner in which these reliefs were physically incorporated into *The Gates* and not simply removed is typical of Rodin's working method. Although dealing with an architectural form, that of a monumental portal, he did not work from a plan or with any preconceived idea in mind. Once the framework of *The Gates* had been set up, it may be said to have grown organically, hence the considerable number of elements—for example, the baby balancing precariously near the bottom of the left-hand pilaster (no. 1, detail D), the figure of a dancing fauness on a small shelf at the top left-hand corner of the left-hand leaf *(see* no. 1, detail K), and the *Head of St. John the Baptist on a Platter (see* no. 21) around the corner from the top of the right-hand pilaster—that have no rational justification but nonetheless contribute immeasurably to the variety and interest of the doors.

It is no exaggeration to say that by the decade of the 1890s Rodin was one of the most knowledgeable men in France on the subject of medieval architecture, although as an artist and connoisseur rather than as an architectural historian. He traveled widely, familiarizing himself not only with the great cathedrals but also with the most obscure village churches, making endless notations that would later be incorporated into his great book, *Cathedrals of France.*[19] As is the case in the cathedrals, where exquisite carvings seem often to have been deliberately hidden, many elements in *The Gates* can be seen only with the greatest difficulty. Increasingly, however, Rodin came to distrust the proliferation of forms that encrusted the surface of the doors.

Detail C:
Man sweeping woman off her feet (detail of the right-hand pilaster)

Detail E:
Kneeling Fauness and other figures (detail of the left side of the tympanum)

Detail D:
Baby projecting over the edge and mother with children (detail of the left-hand pilaster)

Detail F:
Embracing couples (detail of the left-hand pilaster)

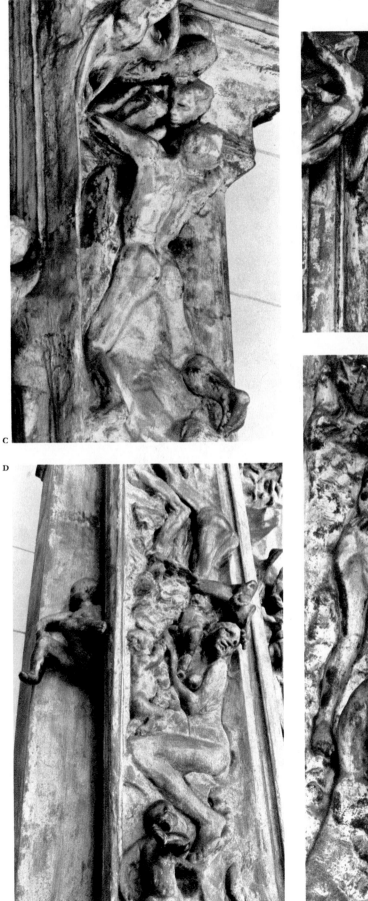

C

D

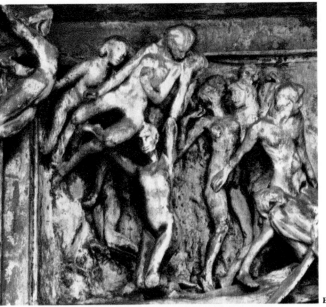

E

F

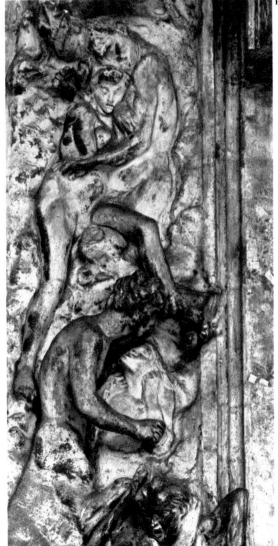

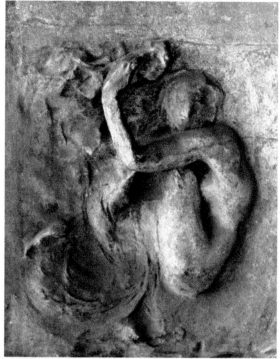

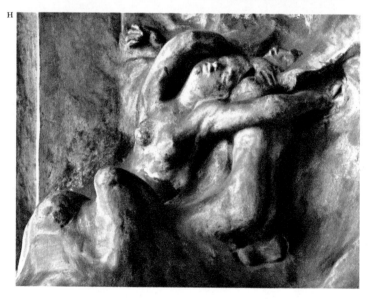

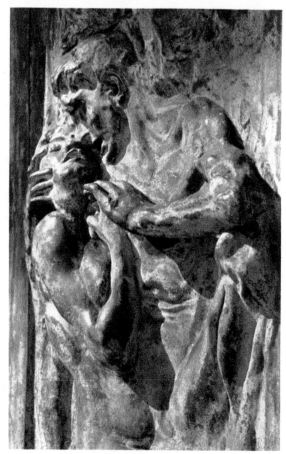

Detail G:
The Fallen Caryatid Carrying Her Stone (detail of the upper left corner)

Detail H:
Despairing female figures (detail of the right panel)

Detail I:
Siren (detail of the lower left reveal)

Detail J:
Embracing couple (detail of the bottom right-hand pilaster)

Detail K:
Tympanum

Detail L:
Damned souls (detail of the upper right-hand section of the tympanum)

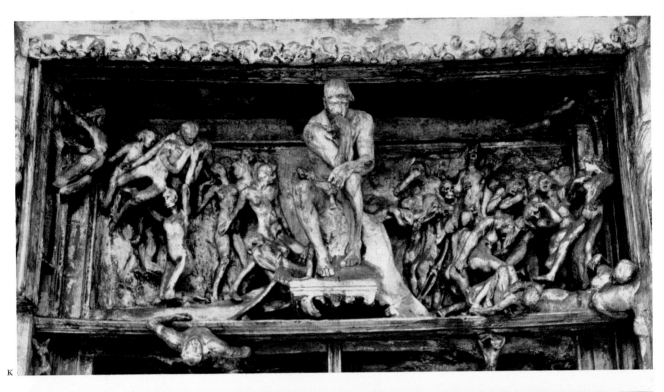

K

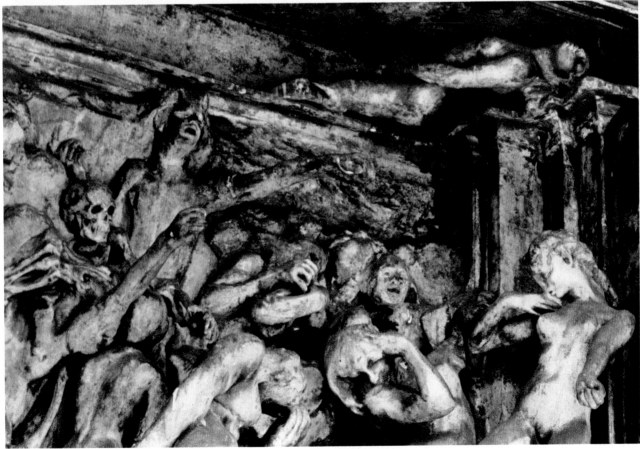

L

In 1893 the young sculptor Antoine Bourdelle began to work for Rodin. Before long a very close friendship had developed with the result that the observations of the younger man concerning the lack of architectonic qualities of *The Gates* and its ambiguous status, neither a wall nor a door, seemed to be only too well founded.[20] "The Gate is too full of holes," Rodin wrote in one of his notes,[21] and just at the point when his friends thought that the work was nearing completion, he proceeded to cut off all the projecting elements, either wholly or in part. These were then numbered, as were the corresponding parts on the door, making possible their reassembly if Rodin so desired. It was in this denuded state that *The Gates* was exhibited in Rodin's one-man exhibition in the Place de l'Alma in 1900.

Henceforth *The Gates* existed in a kind of limbo, and it is hardly surprising that in 1904, twenty-four years after the original commission, the Ministry of Fine Arts made inquiries as to the degree of completion of *The Gates* and of the other works still pending, namely the two monuments to Victor Hugo.[22] The inspector who visited Rodin reported that the work was already far advanced, but that the sculptor intended to make various modifications which in all likelihood would not be completed for another three or four years. As a result, the sum of 35,000 francs granted for the casting in bronze was withdrawn, although the Ministry still agreed in principle to pay the costs at a later date.[23]

Although no major changes in the disposition of the various groups were made at this late stage, Rodin was still struggling with the architectural framework. In 1904 when René Chéruy, Rodin's secretary at that time, asked him why he considered his *Gates of Hell* still unfinished, Rodin replied that he was not satisfied with its architecture. He wanted a molding that would be "precise enough to act as a frame to his composition, but which also would be soft enough in tone to connect it with the surrounding atmosphere, and his mind was not firmly set on the result of his last experiment."[24] The many drawings of moldings in the sketchbook in the Rodin Museum which once belonged to the critic Roger Marx reveal his extreme sensitivity to moldings, and it must be because of this that he never succeeded in finding the miraculous molding that would have achieved the unifying effect he was striving for. As it is, the Gothic molding framing the leaves of the door is cut off abruptly on the inside of the two posts.

After the debacle of the *Balzac* affair, Rodin seems to have lost interest in the creation of monumental works. Enthusiasm for *The Gates* revived, however, when Léonce Bénédite, Rodin's friend and first Director of the Musée Rodin, suggested that the work should no longer be regarded simply as a door but as a kind of iconostasis to be erected in the choir of the chapel of the St.-Sulpice Seminary, which had been handed over to the Ministry of Fine Arts in 1905 to be used as a Museum of Contemporary Art.[25] Thus between 1908 and 1910 *The Gates* was reconstructed with the aid of sketches supplied by Rodin himself.[26] The doorposts were to have been carved in marble, while the leaves of the door and *The Three Shades* were to have been cast in bronze, which might conceivably have been gilded like Ghiberti's Baptistery doors.[27] Due to the rapid decline in Rodin's health, however, and the outbreak of war, these plans were never carried out. *The Gates* was not cast in bronze during Rodin's lifetime.

Detail M:
Study for "Fugit Amor" and other figures
(detail of the right panel)

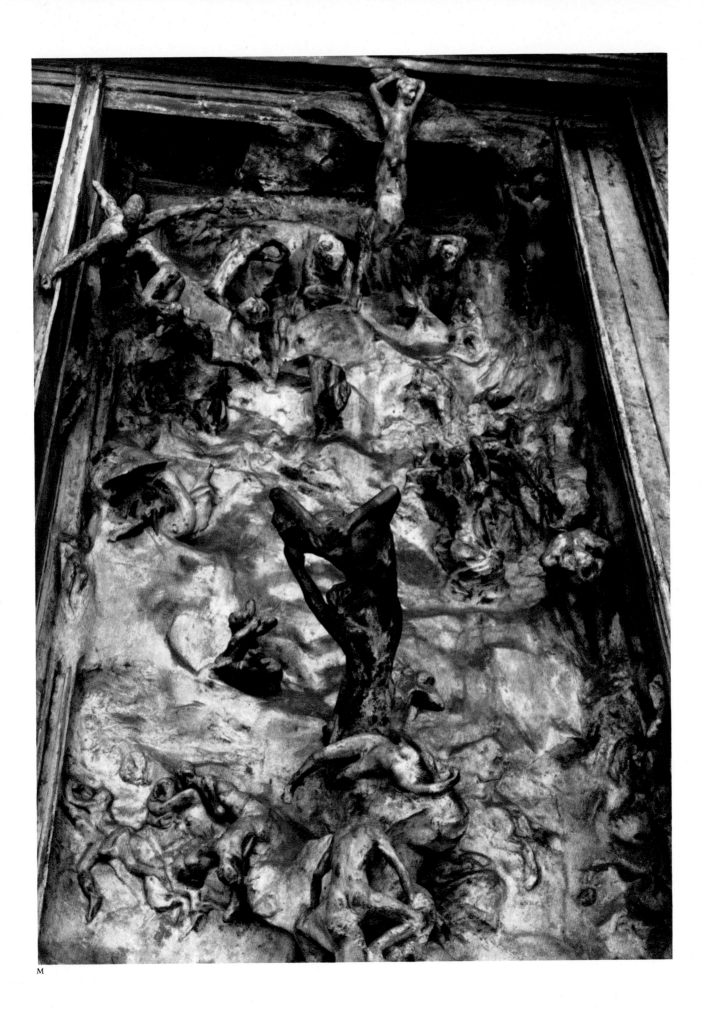

M

Seven years after his death it still had not been cast in bronze. This situation might have continued had Mr. Mastbaum not ordered two bronze casts of *The Gates,* one for his own museum and the second for the Musée Rodin in Paris. By September 1928, the casting, entrusted to the foundry of Alexis Rudier, had been completed. "You will see," said Eugène Rudier, his son, who ran the foundry after his father's death, "that I have put no patina on it. I left it in its natural state, colored simply by the burning kisses of the flames. I knew his ideas; I knew his vision; I knew he would be satisfied."[28]

APPENDIX

The payments accorded to Rodin for his work on *The Gates of Hell* are listed in two documents in the Archives Nationales in Paris: a handwritten list of acquisitions and a "note relative aux acomptes payés à Monsieur Rodin sur ses commandes en cours," dated October 26, 1903.

1880	August 16	Rodin receives the commission for "bas reliefs représentant 'La Divine Comédie' 8,000 francs."
	October 14	He receives the first payment of 2,700 francs.
1881	October 31	The credit available for the project is increased from 8,000 francs to 18,000 francs.
1883	January 27	He receives a second installment of 3,000 francs.
	November 17	He receives a third installment of 4,000 francs.
1884	August 8	The credit available for the project is increased from 18,000 francs to 25,000 francs.
	August 22	He receives a fourth installment of 2,500 francs.
1885	January 14	He receives a fifth installment of 2,500 francs.
	July 20	He receives a sixth installment of 4,000 francs.
	August 20	The Ministry of Fine Arts allots 35,000 francs for the casting in bronze.
1886	October 16	He receives a seventh installment of 3,000 francs.
1888	March 17	The credit available for the project is increased by 5,000 francs, making a total of 30,000 francs.
	March 31	He receives an eighth installment of 4,000 francs. (Of the 30,000 francs granted to Rodin during the previous eight years for his work on *The Gates of Hell,* 25,700 francs had been claimed, leaving 4,300 francs to his credit. Of the 35,000 francs granted August 20, 1885, for the casting in bronze, 35,000 francs remained.)
1904	February 24	The order of August 20, 1885, is revoked and the sum of 35,000 francs is no longer at Rodin's immediate disposal, although the Fine Arts Administration still agrees in principle to pay for the casting.
1911	July 26	The delivery of the sum of 4,300 francs still owed to Rodin is authorized by ministerial decree.

NOTES

1. Letter of February 5, 1880, in the Archives Nationales, Paris. For full account of events, *see* no. 64.
2. *See* Appendix, August 16, 1880.
3. Rostrup [292], p. 214. *See also* Frisch and Shipley [42], p. 413. Rodin told Victor Frisch that *The Gates* was first conceived in 1875 after reading Dante.
4. Bartlett in Elsen [39], p. 69. "I have always admired Dante, and have read him a great deal, but it is very difficult for me to express in words just what I think of him, or have done on the

door. I have read only one translation, that of Rivarol, the five-cent edition, and I have always carried it in my pocket." According to Bénédite, on the other hand [131], p. 211, the only edition of Dante that Rodin knew was that of Artaud de Montor.

5. Bartlett in Elsen [39], p. 69.

6. *See* Ruth Mirolli, *Nineteenth Century French Sculpture: Monuments for the Middle Class,* J.B. Speed Art Museum, Louisville, Kentucky, November 2—December 5, 1971, no. 62, repr. p. 164.

7. For a full discussion of the architectural sketches and clay models, *see* Elsen [37], pp. 64–69.

8. Letter quoted in Descharnes and Chabrun [32a], p. 73.

9. Letter of January 23, 1883, quoted in ibid., p. 82.

10. Ibid.

11. Geffroy [199a], p. 11. "Elle est debout, et elle est disséminée. Les statues du sommet, certains groupes des panneaux, les montants, les bas-reliefs, sont placés. Mais partout, dans la vaste salle, sur les selles, sur les étagères, sur le canapé, sur les chaises, sur le sol, les statuettes de toutes les dimensions sont éparses, faces levées, bras tordus, jambes crispées, pêle-mêle, au hasard, couchées ou debout, donnant l'impression d'un vivant cimetière."

12. Félicien Champsaur, "Celui qui revient de l'enfer," *Le Figaro,* Supplément, Paris, January 16, 1886, mentioned *The Three Shades* on top, *The Thinker* in the tympanum, the low reliefs on the pilasters, and the row of masks above the tympanum, but his description of the panels seems closer to the last modeled sketch than to the final door. "Chaque battant est divisé en deux panneaux séparés par un groupe. D'un côté Ugolin; de l'autre Françoise de Rimini.... En face, comme antithèse, Françoise, en qui son créateur a mis toute la sensualité gracieuse de la femme, entoure de ses bras le cou du tendrement aimé."

It seems, too, that the terrible warning above the entrance to Hell—"Lasciate ogni speranza voi ch'intrate" ("Abandon all hope, ye who enter here")—was actually written on *The Gates* at this time. Describing the summit of *The Gates,* Champsaur refers to it in the following terms: "Dominant le tout, trois personnages semblent incarner la phrase qu'ils montrent écrite sur le fronton—'Lasciate ogni speranza voi ch'intrate.'"

Writing in 1888, Bartlett (in Elsen [39], p. 75) still spoke of the *Ugolino* as being "the chief point of interest of the right-hand part of the door."

See also Mirbeau [252a], p. 16. "Les battants de la porte sont divisés en deux panneaux séparés chacun par un groupe, formant en quelque sorte marteau. Sur le battant de droite, Ugolin et ses fils; sur celui de gauche, Paolo et Françoise de Rimini."

13. Bartlett in Elsen [39], p. 69.

14. Letter quoted in Elsen [37], p. 71.

15. *See* Appendix, August 20, 1885.

16. Mirbeau [252a], p. 13. "Ceux qui ont pu admirer dans l'atelier de l'artiste les études achevées et celles en cours d'exécution s'accordent à dire que cette porte sera l'œuvre capitale de ce siècle. Il faut remonter à Michel-Ange pour avoir l'idée d'un art aussi noble, aussi beau, aussi sublime."

17. Geffroy [199a], p. 11. "La Porte de l'Enfer, c'est l'assemblage, dans une action mouvementée, des instincts, des fatalités, des désirs, des désespérances, de tout ce qui crie et gémit en l'homme. Le poème du gibelin n'a conservé aucune couleur locale, a perdu toute sa signification florentine, il a été, pour ainsi dire, dénudé et exprimé dans sa signification synthétique, comme un recueil des aspects non changeants de l'humanité de tous les pays et de tous les temps."

18. Reproduced in *L'Art Français,* Paris, February 4, 1888.

19. Rodin [92].

20. Varenne [322]. As related on p. 458, Bourdelle said to Rodin: "J'aurais peur, lui avait-il dit un jour, à propos de la *Porte de l'Enfer,* lors d'une causerie familière à l'atelier de Rodin, que si on ouvre cette porte, elle ne me crève un œil. Ce n'est ni un mur ni une porte." To make his point, Bourdelle had hung his hat from one of the projections of the sculpture.

21. Bénédite [131], p. 214. "Rodin, soudainement éclairé, écrivait dans une de ses notes: 'La Porte est trop trouée.'"

22. Letter in the Archives Nationales, Paris, from Eugène Morand to the Minister of Fine Arts, dated February 9, 1904.

Monsieur le Directeur,

Conformément à vos instructions concernant les commandes faites par l'Administration des Beaux Arts à Monsieur Rodin, je me suis rendu chez cet artiste afin d'examiner les œuvres suivantes:

1ᵉ Modèle d'une porte décorative.

"La Divine Comédie," 16 août 1880
prix total 30,000
acomptes reçus 25,700
Reste dû 4,300

Ce modèle comprend la porte proprement dite, à deux vantaux, et son encadrement composé de deux pilastres formant chambranles et d'un linteau surmonté d'un groupe de trois figures, ensemble animé par un foule innombrable d'images d'une beauté magnifique et douloureuse. L'œuvre est très avancée, mais l'intention manifestée par son auteur d'y apporter diverses modifications ne permet pas d'en prévoir l'achèvement avant une période de trois ou quatre ans. Monsieur Rodin ne demandera pas, cette année du moins, de nouvel acompte sur ce travail.

2ᵉ Fonte en bronze du modèle de porte décorative "La Divine Comédie," 20 août 1885; prix alloué, 35,000.

Aucun acompte n'a été demandé et ne sera demandé par M. Rodin sur le prix de cette commande, la question de la fonte demeurant réservée jusqu'à l'achèvement du modèle.

23. Letter of February 20, 1904, in the Archives Nationales, Paris.

Monsieur le Ministre,

Par arrêtés successifs dont le 1ᵉʳ remonte au 16 août 1880, Monsieur Auguste Rodin a été chargé d'exécuter, au prix de 30,000 fr., le modèle d'une porte décorative "La Divine Comédie."

Le 20 août 1885, l'artiste recevait la commande de la fonte en bronze à cire perdue de ce modèle, au prix de 35,000 fr.

Le modèle commandé en 1880 bien que très avancé, n'est pas encore terminé, et Monsieur Rodin qui désire y apporter des modifications, n'en prévoit pas l'achèvement avant trois ou quatre ans.

Or, les 35,000 fr. de la fonte, utilisables seulement dans 3 ou 4 ans, viennent inutilement grever, depuis 1885, le crédit des Travaux d'Art et empêcher l'emploi d'une somme correspondante, en commandes ou achats.

Le disponible existant actuellement sur le crédit des Travaux d'Art étant absolument insuffisant pour répondre aux besoins nombreux et importants auxquels doit subvenir l'Administration des Beaux Arts, j'ai l'honneur de vous proposer, Monsieur le Ministre, de rapporter l'arrêté du 20 août 1885 et de répondre un nouvel arrêté confiant en principe, à Monsieur Rodin, la commande de la fonte dont le prix serait ultérieurement fixé, ceci afin de sauvegarder les intérêts de l'artiste tout en allégeant de 35,000 fr. le total des dépenses engagées sur le crédit des travaux d'art.

The nature of this transaction has generally been misunderstood. Cladel [26], p. 142, states that in 1904 Rodin "rendait les sommes reçues et gardait La Porte." In fact, Rodin handed over no money, as the 35,000 francs granted him on August 20, 1885, for the cost of the bronze casting had not thus far been touched.

24. René Chéruy, "Rodin's 'Gate of Hell' Comes to America," *New York Herald Tribune,* Sunday Magazine Supplement, January 20, 1929, p. 18.

25. Henri Dujardin-Beaumetz commissioned a fresco from Rodin for the chapel on the theme of Paradise. *See* Bénédite [130], p. 14. "Nous revînmes souvent au séminaire, Rodin voulait beaucoup de clarté sur son œuvre. Il étudia la technique de la fresque, exécuta même une dizaine de morceaux, conservés à l'hôtel Biron, sans toutefois tracer un projet d'ensemble de cette vaste composition, qui eut pu nous donner une idée de sa conception du Paradis de Dante."

26. Ibid., p. 24. "Et l'on ne peut dire que le Maître l'avait laissée inachevée, puisque aujourd'hui elle est complète, ni qu'il l'avait définitivement condamnée, puisque de 1908 à 1910, nous avons poursuivi ensemble, avec un devis établi par lui-même, sa réalisation."

27. Bénédite [131], p. 214.

28. *See* n. 24 above, Chéruy, p. 16.

REFERENCES

Mirbeau [252]; Félicien Champsaur, "Celui qui revient de l'enfer," *Le Figaro,* Supplément, Paris, January 16, 1886; Bartlett [125], pp. 101, 199, 223–25, 249; Geffroy [199a], pp. 11–13; Henri Frantz, "The Great New Doorway by Rodin," *Magazine of Art,* London, New York, 22 (1898), pp. 274–76; Maillard [71], pp. 77–86; Anatole France, "La Porte de l'enfer," *Le Figaro,* Paris, June 7, 1900, p. 1; Mauclair [77a], pp. 8, 21–27; Lawton [67], pp. 105–16; Cladel [25], pp. 13, 55; Ciolkowska [23], pp. 35, 65–68; Coquiot [29], pp. 122–28; Cladel [25a], pp. 266–67, 269–70, 273–80, 283–84; Bénédite [131], pp. 209–19; Esther E. Baldwin, "Rodin's 'Gates of Hell,'" *International Studio,* New York, 79, no. 325 (June 1924), pp. 201–6; Léonce Bénédite, "La Porte de l'enfer d'Auguste Rodin," *Revue de l'Art Ancien et Moderne,* Paris, 46 (November 1924), pp. 306–10; Bénédite [10a], pp. 13–15, 26; Grappe [338], no. 33; René Chéruy, "Rodin's 'Gate of Hell' Comes to America," *New York Herald Tribune,* Sunday Magazine Supplement,

January 20, 1929, pp. 16–19; Watkins [342], p. 8, repr. p. 2; Grappe [338a], no. 47; Grappe [338b], no. 64; Cladel [26], pp. 138–44; Grappe [338c], no. 51; Story [103], pp. 25, 144, nos. 19–22, repr. pls. 19–22; Grappe [338d], no. 54; Waldmann [109], pp. 32–38, 74, no. 21, repr. pl. 21; Cladel [27], pp. XIX–XXI, repr. pl. 53; Cécile Goldscheider, "Rodin: L'Influence de la gravure anglaise sur le projet primitif de la 'Porte de l'Enfer,'" *Bulletin de la Société de l'Histoire de l'Art Français,* Paris, May 6, 1950, pp. 49–52; Albert E. Elsen, "The Genesis of Rodin's 'Gates of Hell,'" *Magazine of Art,* New York, 45 (March 1952), pp. 110–19; Boeck [138], pp. 161–95; Elsen [37]; Story [103a], nos. 8–10, repr. pls. 8–10; Goldscheider [49], pp. 29, 32; Caso [37; review], pp. 79–82; Elsen [38], pp. 35–48; Albert Alhadeff, "Rodin: A Self-Portrait in the *Gates of Hell,*" *Art Bulletin,* New York, 48, nos. 3–4 (September–December 1966), pp. 393–95; Spear [332], pp. 49–51; Tancock [341], no. 1, repr. pp. 25, 27; John Tancock, "The Gates of Hell," in *Sculpture of a City: Philadelphia's Treasures in Bronze and Stone,* New York: Walker and Co., 1974, pp. 158–65, repr. pp. 158, 159, 161, 162, 165.

OTHER CASTS AND VERSIONS

Bronze

FRANCE

Paris, Musée Rodin. This cast was commissioned by Jules Mastbaum in 1925 at the same time as the cast in Philadelphia. It was presented by him to the Musée Rodin.

JAPAN

Tokyo, National Museum of Western Art. Commissioned by Kojiro Matsukata about 1925 and cast at approximately the same time as the Philadelphia and Paris casts.

SWITZERLAND

Zurich, Kunsthaus Zurich. Purchased in 1949.

Plaster

FRANCE

Paris, Musée Rodin.

Plaster (stripped of projecting figures, as prepared for the Exposition Universelle of 1900)

FRANCE

Meudon, Musée Rodin.

2 Third Architectural Clay Model
for "The Gates of Hell"
1880

Terra-cotta, 39½ × 24¾ × 6¾ inches
Signed on panel at lower right: Rodin
Inscribed: A Monsieur/ Jules Mastbaum/ En hommage/ du Musée Rodin

By the time Rodin was working on the third architectural clay model for *The Gates,* he was less interested in its architecture or iconographical exactitude than in the overwhelming sculptural impact that might be achieved. Thus the doors are asymmetrical, and the architectural supports—the outer right-hand pilaster, the central pilaster above which *The Thinker* sits, and the right-hand molding on the frame of the panels—have been hacked away. Rodin was already thinking of the doors as a surface to be modeled rather than as a planar support for bas-reliefs.

The architectural forms of the doors are still basically conceived in an idiom derived from the Italian Renaissance. A Renaissance pilaster can be seen quite clearly to the left of the doors, while the three protrusions above the head of *The Thinker* may well be keystones. It is probably safe to assume that the Gothic overlay which later caused him so much dissatisfaction *(see* no. 1) was an addition made after the reawakening of his interest in architecture, which occurred about 1890.[1]

The figures on the pilasters are in high relief, unlike the low relief of the pilasters as they finally evolved. They are closely related in type to the four male figures on the terracotta vase probably made shortly after the artist's return from Italy in 1876.[2] Pronouncedly Michelangelesque in character, they point to Rodin's interest in Michelangelo's Boboli *Slaves* and his *St. Matthew.*

Only one figure in this sketch, *The Thinker* (as it was later called), occupies the position of prominence that it was to have in the final version of *The Gates (see* no. 1). The two principal groups of figures, *Paolo and Francesca* on the left leaf of the doors and *Ugolino and His Son* on the right, were to remain in the final version, although their format and relative importance were to be changed considerably. For the upright motif of *Paolo and Francesca* (developed separately into the statue known as *The Kiss*) was substituted a pair of recumbent figures, powerless in the grasp of *la bufera infernal.* The group of *Ugolino and His Son,* related to early drawings of the subject, was moved into the left panel, above the group of *Paolo and Francesca,* and an expanded grouping—that of Ugolino on all fours surrounded by his dying sons—was adopted.

The other figures on the doors are much more difficult to read, although it seems that Rodin considered dividing the area above the major figures into two panels framed by caryatids and enclosing scenes in lower relief.

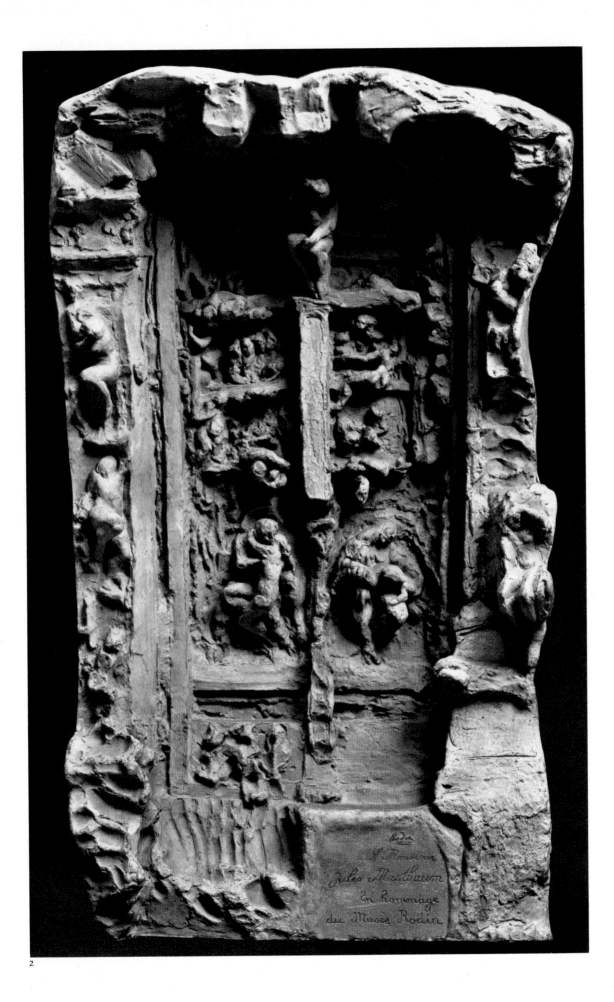

2

NOTES

1. *See* letter written to Rose Beuret from Touraine, August or September 1890, quoted in Descharnes and Chabrun [32], p. 156.

Ma chère amie,

Ne t'impatiente pas et restes chez Vivier un peu de temps je suis dans une étude de plus en plus passionnante, je me sens revivre dans les époques d'autrefois car sûrement j'ai l'atavisme de ces temps passés et la vue de cette architecture me semble réveiller du fond de mon cerveau des choses que je connaissais.

Je deviens architecte et il le faut. Car je complèterai ce qui me manque ainsi pour ma "Porte."

2. This *vasque décoratif* was exhibited as the work of Carrier-Belleuse in a Rodin exhibition in Paris in 1957 *(see* [363], no. 6). For an example of this vase in porcelain, *see* fig. 31–2. For the most recent discussion of this work, *see* Janson [225].

REFERENCES

Grappe [338], no. 32; Watkins [342], no. 123; Grappe [338a], no. 46; Grappe [338b], no. 63; Grappe [338c], no. 50; Grappe [338d], no. 53; Herriot [62], *repr.* pl. 11; Boeck [138], p. 177, *repr.* pl. 94; Elsen [37], pp. 68–69, *repr.* pl. 43; Elsen [38], *repr.* p. 39; Geissbuhler [46], *repr.* pl. 1; Tancock [341], no. 2.

OTHER CASTS

FRANCE
Paris, Musée Rodin.

JAPAN
Tokyo, National Museum of Western Art. Inscribed: a. m. Kojiro Matsukata/en hommage/ du Musée Rodin.

UNITED STATES
Washington, D.C., Hirshhorn Museum and Sculpture Garden, Smithsonian Institution. Inscribed: A.M. Edmund Davis/en hommage/ du Musée Rodin.

3 The Thinker

a 1880

Bronze, 27⅛ × 15¾ × 19¾ inches
Signed left side of base: A. Rodin
Foundry mark back of base to left:
ALEXIS RUDIER/Fondeur. PARIS

b 1880 (enlarged 1902–4)

Bronze, 79 × 51¼ × 55¼ inches
Signed right side of base: A. Rodin
Foundry mark left side of base:
ALEXIS RUDIER/Fondeur. PARIS

The early architectural studies for *The Gates of Hell (see* no. 1) show that from the very beginning Rodin felt the need for a figure, larger than the rest, to serve as a focal point. Although in the second and fourth architectural sketches (figs. 1–1, 1–4) the dominant figure is standing and seems to represent *Eve,* in the third (fig. 1–2), the vaguely delineated form seems closer to *The Thinker* as finally conceived. By the time Rodin was working on the third architectural clay model (no. 2), the identity of this figure was no longer in doubt. Seated in the tympanum with the right arm on the left knee, *The Thinker* dominates *The Gates.* (It is anticipating matters, however, to give the figure the name by which it is now universally known.)[1]

Rodin originally intended to represent Dante in this position, as he explained in a letter to the critic Marcel Adam:

> The Thinker has a story. In the days long gone by, I conceived the idea of "The Gates of Hell." Before the door, seated on a rock, Dante, thinking of the plan of his poem. Behind him, Ugolino, Francesca, Paolo, all the characters of *The Divine Comedy.* This project was not realized. Thin, ascetic, Dante separated from the whole would have been without meaning. Guided by my first inspiration I conceived another thinker, a naked man, seated upon a rock, his feet drawn under him, his fist against his teeth, he dreams. The fertile thought slowly elaborates itself within his brain. He is no longer dreamer, he is creator.[2]

Although any attributes that might have identified *The Thinker* as Dante had been removed by the time of the third architectural clay model, commentators on the progress of *The Gates* continued to identify it with the creator of *The Divine Comedy.* Writing in 1885, Octave Mirbeau described the "figure of Dante projecting a great deal and completely detached from the background, which is covered in bas-reliefs representing the arrival in Hell."[3] Rodin, however, had long ceased to identify the figure as Dante. When the figure in its original dimensions was exhibited at the Exposition Monet-Rodin at the Galerie Georges Petit in 1889, it was given the more general title, *The Thinker; The Poet, fragment of a door.*

The Thinker belongs to the group of works done in 1880–81 (nos. 4, 5, 8) in which the influence of Michelangelo is particularly strong. Its indebtedness to Michelangelo's *Il*

Penseroso has been pointed out by numerous commentators[4] and had been noted by the foundry workers. The resemblance to Michelangelo's *Jeremiah* from the Sistine ceiling has also been noted.[5] Rodin was undoubtedly impressed by the brooding power of these figures, but he was probably more directly influenced by a nineteenth-century work which was also indebted to Michelangelo, Carpeaux's *Ugolino*. In fact, he possessed a bronze cast of one of the preliminary studies for *Ugolino* (fig. 3–1).[6] The strained pose of Rodin's *Thinker,* with the right elbow on the left knee, is closer to the agitated *contrapposto* of Carpeaux than to the calm immobility of Michelangelo. It should not be forgotten, however, that the allegory of *Art* which Rodin executed in 1874 for the balustrade of the Palais des Académies in Brussels is based on the famous *Belvedere Torso* by Apollonius of Athens, now in the Musei Vaticani (fig. 3–2). There is little doubt that Rodin remembered this when he started working on *The Thinker.*

In a number of drawings, some of which are related to the Ugolino theme treated by Carpeaux,[7] the pose of *The Thinker* is adumbrated; in a terra-cotta study at Meudon a pensive gesture is roughly sketched (fig. 3–3), but the important crossed-arm motif of the final work has not yet evolved.[8] In the opinion of Albert Elsen, a wax study in Kansas City (fig. 3–4) is the final free-standing study for *The Thinker.*[9] Other scholars, however, have seen in this a study done at the time of the monument to J. F. Loos in Antwerp as part of the effort to understand the art of Michelangelo.[10]

The Thinker thus played a role of the greatest importance in *The Gates* from the time of the third architectural clay model, although Rodin gave no precise indication of its significance for him in that context. Much later, Rodin referred only to the fact that *The Thinker* thinks: "What makes my *Thinker* think is that he thinks not only with his brain, with his knitted brow, his distended nostrils and compressed lips, but with every muscle of his arms, back and legs, with his clenched fist and gripping toes."[11] Recent commentators have pointed out that *The Thinker* occupies a position in *The Gates* similar to that of holy figures in Gothic portals *(see* no. 1, detail κ); he is therefore a judge at the same time that he is a prisoner in Hell.[12] "It is a projection of Rodin the sculptor, and the artist in general, who confronts his own times and is judge of them."[13]

Such thoughts were far from the minds of the body of subscribers who presented *The Thinker* to the city of Paris in 1904. Rodin began work on the enlargement of *The Thinker* late in 1902.[14] The enlargement in plaster seems to have been exhibited in London in 1903 at the exhibition organized by the International Society of Painters, Sculptors, and Engravers. It was the exhibition of this work at the Salon de la Société Nationale in 1904 that led Gabriel Mourey, editor of the magazine *Les Arts de la Vie,* to organize a public subscription for the purpose of presenting the work to the city of Paris. Such a presentation would thereby correct the anomaly that in May 1904 Paris still had no public monument by the world's greatest living sculptor. Only in the cemeteries—Montmartre (bust of Jules Castagnary, 1890), Montparnasse (relief portrait of César Franck, 1891)—and on the façade of the Hôtel de Ville (figure of Jean Le Rond d'Alembert, 1880) could Rodin's works be seen outside of the Musée du Luxembourg and private collections.

The history of this subscription is of the greatest interest, as it reveals how Rodin's sculpture, which had a particular if not too clearly defined iconographical significance in *The Gates of Hell,* gradually became a public symbol of much wider import. The fame of *The Thinker* spread from a minority interested in aesthetic questions to a worldwide public,

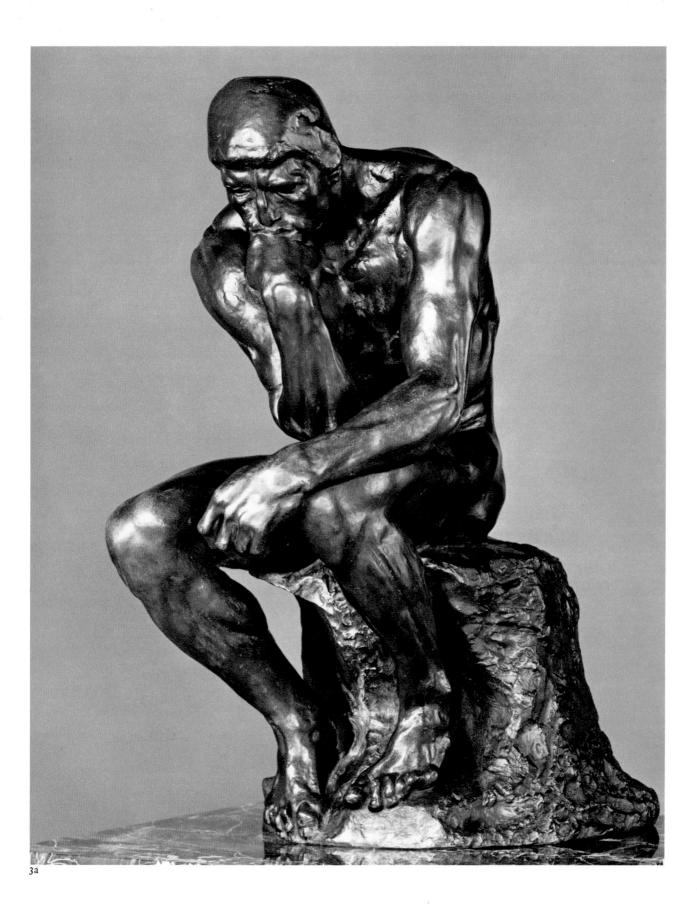

joining the ranks of those works of art, few in number, that are genuinely popular. That is to say, there are few people to whom the name of Rodin's statue will not convey something, however far removed those thoughts may be from the actual work of art.

In May 1904 Gabriel Mourey explained why *The Thinker* had been selected: "We have chosen this magnificent work from among all the others because—and this really will change us from our official glories in frock coats—it is no longer the poet suspended over the gulfs of sin and expiation, crushed by pity and terror at the inflexibility of a dogma, it is no longer the exceptional being, the hero; it is our brother in suffering, in curiosity, in thought, in joy, the bitter joy of seeing and knowing; it is no longer a superhuman being, one predestined, it is simply a man of all times."[15]

The naked figure of the poet was, as it were, demythologized and given a social significance far removed from Rodin's original intentions. It was but a short step from here to a more proletarian and socialistic interpretation of the figure, a view clearly stated by Pierre Baudin:

> His is not an illustrious name, he is not famous, he is the anonymous creator who has to confront the complex duties of social life. He is not an intellectual whose energy is sapped by heredity, who measures his weakness against the breadth of the horizons extended by scientific knowledge and who no longer has any guide but reason. He is a strong, muscular, well-balanced, calm individual who is afraid neither of his solitude nor his nothingness. He measures the value of the victory achieved by the long past of sorrows, anguish, misery, joy, and greatness, which he must make ever more far-reaching.
>
> But he also instructs the workers, in workshops, on the farms, in the mines, all those to whom no effort is worthy of more attention nor of more resourcefulness than that of thought. If his gaze is fixed on a real goal which is close at hand; if his face shows signs of the most intense concentration of spirit; if the muscles of his neck stand out in such high relief; if in their strength his back and his chest reveal such great tension; if his limbs and his feet reveal that tension infusing his whole being, it is not for one of those superhuman undertakings which the workers have to perform all the time for their wretched salaries. He breathes, summons all his resources, he knows this totality of physical and moral consciousness only for thinking. He thinks so as to make up his mind, to will and to act. Soon, almost immediately, he will relax. After thought, work.[16]

Alternatively, the thoughtfulness of *The Thinker* is seen not as preparation for effective work but as a profitable activity after physical labor. "The sculptor wants to personify the human being who, after a hard day's work, plunges completely into reverie and interior contemplation."[17]

In *Les Arts de la Vie* of May 1904, the opening of the public subscription was announced. The honorary presidents of the committee were Eugène Carrière and Albert Besnard; the treasurer was Gustave Geffroy, and the secretary general, Gabriel Mourey. By June 1904, 5,833 francs had been collected;[18] by July, 8,685 francs;[19] by August, 9,316 francs;[20] by September, 9,528 francs;[21] by October, 9,618 francs;[22] by November, 10,688 francs (including 1,000 francs from the Ministry of Public Instruction and Fine Arts).[23]

In December 1904 it was announced that the subscription was complete and that Rodin had chosen a site in front of the Panthéon for the statue. The gifts ranged from contributions of 1 and 2 francs (Charles Despiau gave 2 francs) to the sums of 2,000 francs given at the end by Maurice Fenaille and Baron Vitta, the distinguished *amateurs*. In *Les Arts de la Vie* of February 1905, it was announced that a final gift of 2 francs had been received from M. and

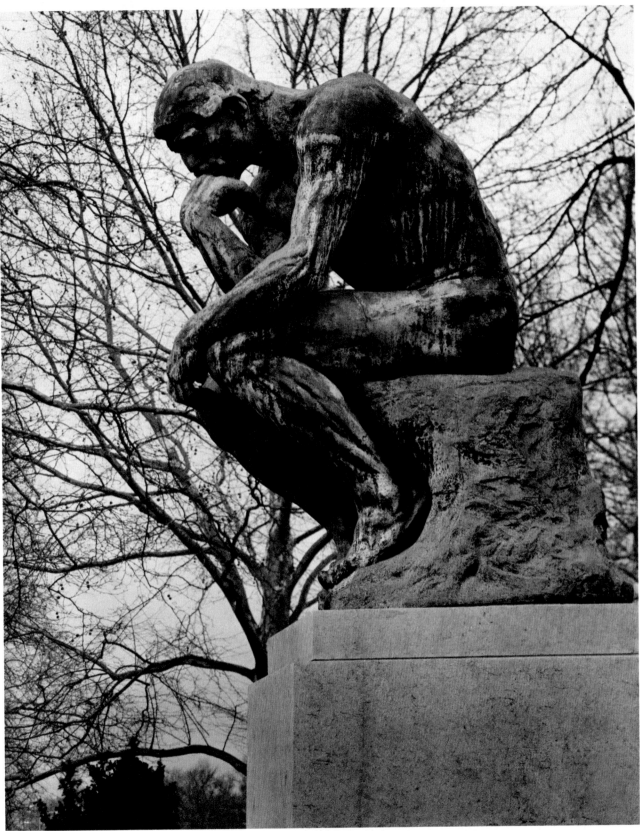

Mme Aubert "instituteur à Pantin," bringing the total to 15,245 francs. On December 6, 1904, a letter was sent to the Ministry of Public Instruction and Fine Arts announcing the proposed gift, which was accepted immediately. The statue was unveiled in front of the Panthéon on April 21, 1906.[24]

What is remarkable about this particular subscription is the wide variety of opinions included in the Committee of Patronage and the list of subscribers, a fact already pointed out in *La Liberté* in June 1904:

> Until recently Rodin was a major topic of discussion. One belonged either to the group which saw Rodin as a second Michelangelo or to the party which thought that Rodin sculpted like a concierge. There was no middle course. Today Rodin is an excellent worker for national reconciliation. The committee which has just been formed to purchase Rodin's *The Thinker* is composed of the greatest enemies in the world. For example, one finds: Ranc and Jules Lemaître, Quentin-Bauchart and Denys Cochin, Henri Letellier and Jean Dupuy. And, a great surprise, here are Joseph Reinach and Henri Rochefort fraternizing in the bosom of this happy committee.[25]

The predominantly left-wing and pro-Dreyfus character of the list of subscribers for the monument to Balzac had led Rodin in 1899 to reject their offer of financial help, although he accepted their sympathy *(see no. 75)*. But by 1904, when the political situation had changed and Rodin's one-man exhibition of 1900 had established once and for all his dominance as an artist, support for him was no longer necessarily linked to political persuasions, nor thought to be so. Rodin himself recognized the nonpartisan character of the committee and wrote the following note to Gabriel Mourey, which at the same time reveals the true reasons for the apparent baseness of his decision with regard to the monument to Balzac: "You have composed a Committee without any particular political leaning and this gives to my sculpture its true value; and thanks to the friends of the last moment [that is, Baron Vitta and Maurice Fenaille] the subscription has closed at a very suitable figure."[26] Rodin was anxious that his sculpture should make its own way in the world rather than in the wake of a shift in political opinion.

To diehards, *The Thinker* still seemed the fatalistic image that it was when first positioned in *The Gates*. One writer even referred it back to one of its probable sources: "Rodin's *Thinker* is Carpeaux's *Ugolino* devouring his last son and digesting him painfully."[27] But the movement inaugurated by *Les Arts de la Vie* and crowned when Dujardin-Beaumetz, Undersecretary of State for Fine Arts, unveiled *The Thinker* in front of the Panthéon, soon prevailed, and the work began its public career. *The Thinker,* once it was detached from *The Gates of Hell,* where it had been seen as a figure despairing at man's powerlessness, now became the universal symbol of hope and belief in man's resourcefulness that it still is today.

3–1
Jean-Baptiste Carpeaux
Study for "Ugolino"
1857, bronze, height 21⅝ inches
Musée Rodin, Paris

3–2
Apollonius of Athens
The Belvedere Torso
150 B.C., marble, height 62⅝ inches
Musei Vaticani, Vatican City

3–3
Study for "The Thinker"
1880, terra-cotta, height 10¼ inches
Musée Rodin, Meudon

3–4
Study of a Seated Man
c. 1874–76?, wax, height 14½ inches
William Rockhill Nelson Gallery of
Art-Atkins Museum of Fine Arts,
Kansas City, Mo. Nelson Fund

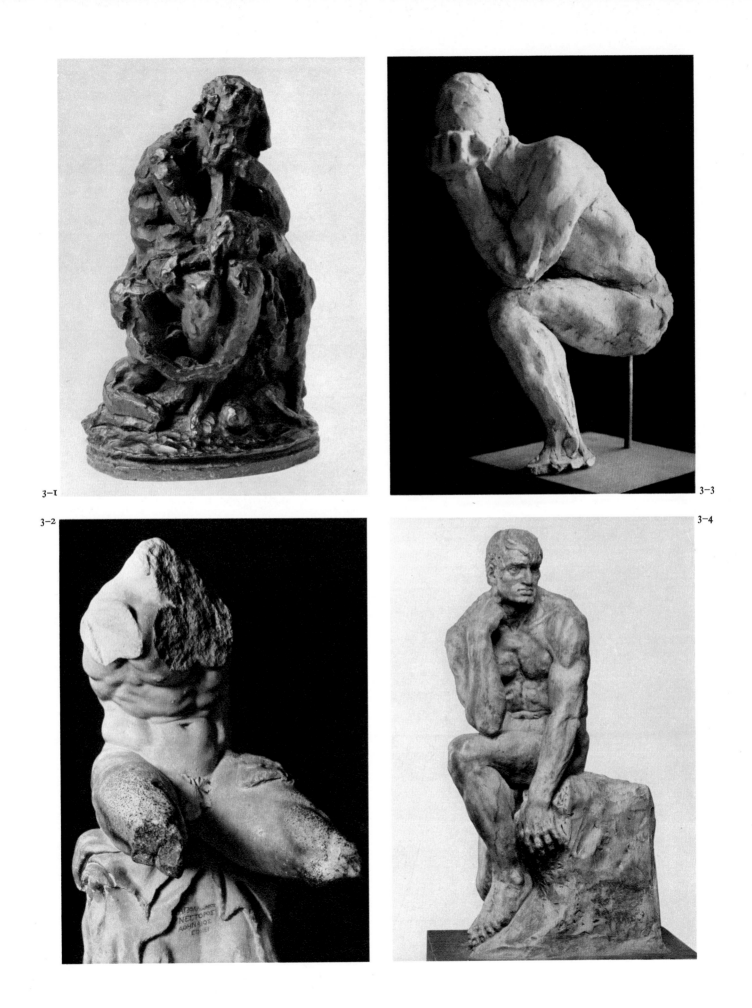

3-1

3-3

3-2

3-4

S'avançaient plus câlins que les anges du mal,
Pour troubler le repos où mon âme était mise,
Et pour la déranger du rocher de cristal,
Où calme et solitaire elle s'était assise.

Je croyais voir unis par un nouveau dessin
Les hanches de l'Antiope au buste d'un imberbe,
Tant sa taille faisait ressortir son bassin.
Sur ce teint fauve et brun le fard était superbe!

— Et la lampe s'étant résignée à mourir,
Comme le foyer seul illuminait la chambre,
Chaque fois qu'il poussait un flamboyant soupir,
Il inondait de sang cette peau couleur d'ambre!

3–5
The Thinker, illustration for Charles Baudelaire's
"Les Bijoux," from *Les Fleurs du Mal*
1886–88

1. Judith Cladel says that the foundry workers identified this figure with *Il Penseroso* of Michelangelo, thereby giving rise to its popular name.

2. This letter was published in the newspaper *Gil Blas,* Paris, July 7, 1904, and is quoted in Elsen [37], p.96.

3. Mirbeau [252a], p.15. "Dans un panneau légèrement creusé en voûte, figure le Dante très en saillie et se détachant complètement sur le fond, revêtu de bas-reliefs qui représentent l'arrivée aux enfers." *See also* Félicien Champsaur, "Celui qui revient de l'enfer," *Le Figaro,* Supplément, Paris, January 16, 1886.

4. *See* Elsen [37], p.77; Gantner [43], p.27.

5. Ibid.

6. This was pointed out by Charles Seymour, "Ideas on Sculpture," *Baltimore Museum of Art News,* Baltimore, 17, no.4 (April 1954), p.12.

7. *See* Elsen [37], pl.58.

8. Ibid., pl.59.

9. Ibid., pp.77–78.

10. *See* Alhadeff [116], p.366. *See also* Mirolli [81], p.150, n.1, who agrees with Alhadeff. She believes that the detailed treatment of the facial features and the hair, in addition to the lack of tension in the Kansas City sketch, makes an earlier date more acceptable.

11. *Saturday Night,* Toronto, December 1, 1917, quoted in Elsen [38], p.52.

12. *See* Elsen [37], pp.96, 129–30.

13. Ibid., p.129.

14. According to Lami [4], p.173, the enlargement was made in 1904 by Henri Lebossé for the sum of 7,500 francs. René Chéruy, "Rodin's 'Gate of Hell' Comes to America," *New York Herald Tribune,* Sunday Magazine Supplement, January 20, 1929, p.17, relates that he started working for Rodin in December 1902 and that the first letter he wrote began: "My dear Lebossé, I shall see you tomorrow about 'Le Penseur.'" Thus the enlargement seems at least to have been begun in 1902.

15. Gabriel Mourey, "Le Penseur de Rodin offert par souscription publique au peuple de Paris," *Les Arts de la Vie,* Paris, no. 5 (May 1904). "Nous avons choisi cette œuvre magnifique entre toutes les œuvres parce que—et vraiment cela nous changera de nos gloires officielles en redingote—ce n'est plus le poète suspendu sur les gouffres du péché et de l'expiation, écrasé de pitié et d'épouvante par l'inflexibilité d'un dogme, ce n'est plus

l'être exceptionnel, le héros; c'est notre frère de souffrance, de curiosité, de réflexion, de joie, l'âpre joie de chercher et de connaître, ce n'est plus un surhumain, un prédestiné, c'est simplement un homme de tous les temps."

16. Pierre Baudin, "Le Penseur," *Le Journal,* Paris, May 20, 1904.

"Il n'illustre aucun nom, il n'assure aucune renommée, il est l'anonyme créateur qui doit affronter les complexes devoirs de la vie sociale. Il n'est point l'intellectuel appauvri par d'épuisantes hérédités qui mesure sa faiblesse devant l'étendue affranchie des horizons par la connaissance scientifique, et qui n'a plus de guide autre que la raison. C'est l'être fort, musclé, équilibré et calme, qui ne s'effraye ni de sa solitude ni de son néant. Il mesure la valeur de la victoire remportée par tout le long passé de peines, d'angoisses, de misères, de joies et de grandeurs dont il doit élargir la conquête.

"Mais il enseigne aussi aux travailleurs, à ceux de l'atelier, de la terre, de la mine, à tous, que nul effort n'est digne de plus d'attention ni de plus de ressources que celui de la pensée. Si ses regards fixent un but réel, proche même; si sa face témoigne de la plus grande concentration d'âme; si son cou fait saillir ses muscles en reliefs si puissant; si son dos et son thorax révèlent une tension de leurs ressorts à un si haut degré; si ses membres et ses pieds accusent une telle crispation de toute sa volonté, ce n'est pas pour une de ses entreprises presque surhumaines dont à tout instant ceux-là doivent s'acquitter pour leur maigre salaire. Il ne respire, il n'appelle tout son souffle, il ne connaît cette totalité de conscience physique et morale que pour penser. Il pense pour se résoudre, pour vouloir, pour agir. Tout à l'heure, presque tout de suite, il se lèvera dans une brusque détente. Après la pensée, le travail."

17. Auguste Reiser, *Le Journal d'Asnières,* Asnières, June 5, 1904. "Le sculpteur a voulu personnifier l'être humain, qui, après une lourde journée de labeur, se plonge entièrement dans le rêve et la contemplation intérieure."
18. *Les Arts de la Vie,* Paris, no. 6 (June 1904).
19. Ibid., no. 7 (July 1904).
20. Ibid., no. 8 (August 1904), p. 128.
21. Ibid., no. 9 (September 1904), p. 190.
22. Ibid., no. 10 (October 1904), p. 264.
23. Ibid., no. 11 (November 1904), p. 326.
24. It was moved to the Musée Rodin in 1922.
25. "Notes parisiennes," *La Liberté,* June 1, 1904.

"Naguère encore, Rodin était un redoutable sujet de discussion. On était du clan qui voit en Rodin un autre Michel-Ange ou de la bande qui trouve que Rodin sculpte comme un concierge. Pas de milieu.

"Aujourd'hui Rodin est un excellent artisan de réconciliation nationale. Le comité qui vient de se former pour acheter le 'Penseur' de Rodin est composé des meilleurs ennemis du monde. On y voit, par exemple: Ranc et Jules Lemaître, Quentin-Bauchart et Denys Cochin, Henri Letellier et Jean Dupuy. Et voici, ô surprise! que dans le sein de cet heureux comité fraternisent Joseph Reinach et Henri Rochefort."

26. *Les Arts de la Vie,* Paris, no. 12 (December 1904), p. 333.
27. "Le Salon d'Automne," *Le Musée,* Paris, October 1907. *See also* Furetières, "Au jour le jour. Un art qui s'en va," *Le Soleil,* Paris, February 28, 1905. "Il est vrai que l'on vient d'y donner asile à la statue en bronze du prétendu Penseur de Rodin. Le désespéré, qui dévore ses mains, ce raté de la vie, assiégé par les remords, accablé par l'inanité de l'existence, est en contradiction avec ce temple élevé à la mémoire des illustres."

REFERENCES

L'Art Français, Paris, July 6, 1889, repr.; Bartlett [125], p. 224; Geffroy [199a], p. 12; Arsène Alexandre, "Les Salons de 1904," *Le Figaro,* Paris, April 16, 1904, pp. 3–4; Paul Hervier, "Pour le peuple 'Le Penseur de Rodin,'" *La Presse,* Paris, May 15, 1904; "Le Penseur," *Le Journal,* Paris, May 20, 1904; Gabriel Mourey, "Le Penseur de Rodin offert par souscription publique au peuple de Paris," *Les Arts de la Vie,* Paris, no. 5 (May 1904); Pierre Baudin, "Le Penseur et la statuaire de la rue," *Les Arts de la Vie,* Paris, no. 6 (June 1904); Achille Ségard, "La Souscription Rodin," *Echo du Nord,* Paris, July 1, 1904; "La Vie artistique, la souscription du 'Penseur,'" *L'Humanité,* Paris, July 7, 1904; Edmond Picard, "Auguste Rodin, la statue du Penseur," *Le Peuple,* Paris, July 17, 1904; Gustave Geffroy, "La Statue du Penseur," *La Dépêche,* Toulouse, July 15, 1904; Gustave Geffroy, "Le 'Penseur' de Rodin au Panthéon," *La Revue Bleue,* Paris, 2, ser. 5 (1904), pp. 774–77; Gino d'Amerini, "Il Pensatore di Rodin davanti il Pantheon francese," *Campo,* Turin, January 15, 1905; Mauclair [77a], p. 23, repr. p. 26; L. Roger-Milès, "Inauguration du 'Penseur' de Rodin," *Le Figaro,* Paris, April 22, 1906, p. 3; Lawton

[67], pp.107–8, repr. opp. p.239; Dr. Marie, "Erostratisme et folie," *Le Siècle,* Paris, November 6, 1907; *L'Art et les Artistes* [330], p.61, repr. p.65; Lami [4], p.173; Grappe [338], nos.143, 144; Watkins [342], p.6 and no.15, repr. p.3; Grappe [338a], nos.167–69; Grappe [338b], nos.65–67; Grappe [338c], nos.52, 52 bis; Story [103], pp.25, 144, nos.15–18, repr. pls.15–18 and frontispiece; Grappe [338d], nos.55, 56; Waldmann [109], pp.46–47, 76, nos.42–45, repr. pls.42–45; Elsen [37], pp.77–78, 96, 129–30; Story [103a], nos.14–16, repr. pls.14–16; Elsen [38], pp.52–57, repr. p.54; Mirolli [81], pp.218–23; Spear [332], pp.51–52, 55, no.x, repr. p.53; Tancock [341], no.3; John L.Tancock, "The Thinker," *Facet, Journal of the Northampton Arts Association,* Northampton, Mass., no.44 (1968), pp.15–17; Jacques de Caso and Patricia B.Sanders, *Rodin's Thinker: Significant Aspects,* San Francisco: California Palace of the Legion of Honor, 1973; Carolyn Pitts, "The Thinker," in *Sculpture of a City: Philadelphia's Treasures in Bronze and Stone,* New York: Walker and Co., 1974, pp.166–67.

OTHER CASTS AND VERSIONS

a

AUSTRALIA
Melbourne, National Gallery of Victoria (ex. Collection Ionides).

BELGIUM
Brussels, Musées Royaux des Beaux-Arts de Belgique. Signed: Rodin. Founder: J.Petermann.

CANADA
Montreal, Montreal Museum of Fine Arts. Purchased from Rodin at Exposition d'Art Français, 1909. Signed: A.Rodin. Founder: Alexis Rudier.

DENMARK
Copenhagen, Ny Carlsberg Glyptotek. Cast in 1901 and purchased by Carl Jacobsen in same year. Signed: A.Rodin.
— Ordrupgaardsamlingen. Signed. Founder: Alexis Rudier.

FINLAND
Helsinki, Kunstmuseum Athenaeum. Cast in 1964 and purchased by the state in 1965 Founder: Georges Rudier.

FRANCE
Montauban, Musée Ingres.

Paris, Musée Rodin. Signed: A.Rodin. Founder: Alexis Rudier.

GERMANY (EAST)
Berlin, Nationalgalerie. Gift of Oskar Huldschinsky, Berlin, 1905.

GREAT BRITAIN
Glasgow, Glasgow Art Gallery and Museum. Burrell Collection. Purchased in 1922. Signed: A.Rodin. Founder: Alexis Rudier.

JAPAN
Tokyo, National Museum of Western Art. Signed: A.Rodin. Founder: Alexis Rudier.

THE NETHERLANDS
Laren, Singer Museum.

NORWAY
Oslo, Nasjonalgalleriet. Purchased at French exhibition, Blomqvist Art Gallery, Oslo 1898. Signed: Rodin.

SWITZERLAND
Geneva, Musée d'Art et d'Histoire (ex.Musée Rath—gift of Rodin, 1896). Signed: Rodin.

UNITED STATES
Beverly Hills, Collection Leona Cantor. Founder: Georges Rudier.
Beverly Hills and New York City, B.G.Cantor Collections. Founder: Alexis Rudier.
Cambridge, Fogg Art Museum, Harvard University. Grenville L.Winthrop Bequest, 1943.
Greenwich, Collection Herbert Mayer. Founder: Georges Rudier. Cast no.5/12.
Madison, N.J., Estate of Geraldine R.Dodge. Founder: Alexis Rudier.
Manhasset, N.Y., Collection William S.Paley (2 casts). One bears the following inscription: Le Penseur, exécuté en 1906 dans mes ateliers et sous ma surveillance pour Ralph Pulitzer—Rodin.
New Haven, Yale University Art Gallery. Bequest of Susan Vanderpoel Clark, 1967.
New York City, Metropolitan Museum of Art. Gift of Thomas F.Ryan, 1910. Purchased from Rodin.
— Paul Rosenberg and Company.
Toledo, Toledo Museum of Art. Acquired in 1926. Signed: A.Rodin. Founder: Alexis Rudier.
Washington, D.C., National Gallery of Art. Gift of Mrs.John W.Simpson, 1942. Signed: A.Rodin.

VATICAN CITY
Musei Vaticani. Gift of the Musée Rodin. Founder: Georges Rudier. Cast in 1956.

b

Bronze

ARGENTINA
Buenos Aires, Plaza del Congresso. Property of the city of Buenos Aires.

DENMARK
Copenhagen, Ny Carlsberg Glyptotek. Purchased by Carl Jacobsen in 1906. Signed: A. Rodin.

FRANCE
Meudon, Musée Rodin. Placed over Rodin's tomb.
Paris, Musée Rodin. Erected in front of Panthéon in 1906. Transferred to Musée Rodin in 1922.

GERMANY (WEST)
Bielefeld, Kunsthalle Richard Kaselowsky-Haus. Purchased in 1968. Signed: A. Rodin. Founder: Georges Rudier.

JAPAN
Kyoto, Kyoto National Museum.
Tokyo, National Museum of Western Art (ex. Collection Matsukata). Signed: A. Rodin.

SWEDEN
Stockholm, Prins Eugens Waldemarsudde. Purchased in 1909. Signed: A. Rodin.

UNITED STATES
Baltimore, Baltimore Museum of Art. Jacob Epstein Collection. Signed: A. Rodin. Founder: Alexis Rudier.
Beverly Hills, Cantor, Fitzgerald Art Foundation. Cast no. 10/12.
Cleveland, Cleveland Museum of Art. Gift of Ralph King, 1917. Signed: A. Rodin. Founder: Alexis Rudier.
Denver, Columbia Savings and Loan Association, Cherry Creek Office. Purchased in 1966. Founder: Georges Rudier. Cast no. 8/12.
Detroit, Detroit Institute of Arts. Gift of Horace H. Rackham, 1922 (ex. Collection Dr. and Mrs. Linde, Lübeck). Founder: Alexis Rudier.
Kansas City, Mo., William Rockhill Nelson Gallery of Art—Atkins Museum of Fine Arts. Property of Kansas City Park Department.
Los Angeles, Norton Simon, Inc. Museum of Art. Founder: Georges Rudier. Cast no. 11/12.
Louisville, Allen R. Hite Art Institute, University of Louisville. On loan from the city of Louisville. Founder: A. A. Hébrard.
New York City, Columbia University. Signed: A. Rodin. Founder: Alexis Rudier.

San Francisco, California Palace of the Legion of Honor. Given to the city and county of San Francisco, April 1916. Founder: Alexis Rudier.

U.S.S.R.
Moscow, State Pushkin Museum of Fine Arts.

Plaster

FRANCE
Béziers, city of Béziers.
Meudon, Musée Rodin.

GERMANY (EAST)
Dresden, Staatliche Kunstsammlungen. Purchased at Grosse Kunstausstellung, 1904.

ITALY
Venice, Galleria Internazionale d'Arte Moderna. Gift of Principe Giovanelli. Acquired at the Biennale, 1895.

POLAND
Poznań, Museum Narodowe w Poznaniu. Acquired in 1910.

UNITED STATES
New York City, Metropolitan Museum of Art. Shown at Louisiana Purchase Exhibition in 1904 and presented by the commissioners of the French government. Cast from a bronze.

Bronze, height 15¼ inches

GREAT BRITAIN
Oxford, Ashmolean Museum. Bequest of Rev. J. W. R. Brocklebank, 1927.

JAPAN
Tokyo, Bridgestone Museum of Art.

UNION OF SOUTH AFRICA
Stellenbosch, Peter Stuyvesant Foundation.

UNITED STATES
Beverly Hills, Collection Mrs. Jefferson Dickson. Signed: A. Rodin. Founder: Alexis Rudier.
Beverly Hills and New York City, B. G. Cantor Collections. Founder: Alexis Rudier.
New York City, Collection Mrs. David Bortin. Founder: Alexis Rudier.
St. Louis, City Art Museum. Signed: Rodin. Founder: Alexis Rudier.

Plaster, height 16 inches

UNITED STATES
Maryhill, Wash., Maryhill Museum of Fine Arts.

4 Adam

1880

Bronze, 75½ × 29½ × 29½ inches
Signed right side of base: RODIN
Foundry mark back of base to left:
ALEXIS RUDIER/Fondeur PARIS

Shortly after Rodin's return from Italy in 1876, he made a figure of *Adam* as part of an effort to understand the art of Michelangelo. This he either abandoned, returning to it later,[1] or destroyed altogether.[2] Writing in 1952, Judith Cladel referred to it as being "so close to Michelangelo that it could almost be described as a caricature."[3] Certainly in the three major works of 1880–81—*Adam, Eve* (no. 8), and *The Shade* (no. 5)—the influence of Michelangelo is particularly evident. Writing to Rose Beuret from Italy in 1875, Rodin had said:

> None of the photographs or plasters I have seen gives any idea of the Sacristy of San Lorenzo. The tombs must be seen in profile, in a three-quarter view. I have spent five days in Florence, but I have only seen the Sacristy today; for five days I have been cold. Here are the three most lasting impressions I have received: Reims, the ramparts of the Alps, and the Sacristy. One cannot analyze something on first seeing it, but you will not be astonished when I tell you that I have been studying Michelangelo since my first hour in Florence and I think that the great magician is revealing some of his secrets to me. However, none of his students or his masters is like him; I do not understand that, as I have been looking at his immediate students, but only he has the secret. I have made sketches at home in the evening, not after his works but after all the scaffoldings, the methods I have invented to understand him; I think I have succeeded in giving to them some of that nameless quality that only he knows how to give.[4]

How did the visit to Italy and, in particular, the knowledge gained of Michelangelo affect Rodin's style? In an interview given some thirty years later, Rodin said that before he went to Italy he had thought that movement was the secret of Michelangelo's art, and he had given Michelangelesque poses to his figures. Upon returning, however, and observing the movements of his models when left to themselves, he noticed that they adopted such poses spontaneously. "I had gone to Rome to look for what is everywhere: the latent heroism of really natural movement."[5] He gave the following summary of the ideas suggested to him by Michelangelo: "The essential principle is modeling, the plane, which alone renders the intensity, the supple variety of movement and of character."[6]

Henceforth, Rodin paid much closer attention to the contours of his model—and of his sculpture—than, with certain exceptions, he had been able to do in the past. The effects of this attention can first be seen in *The Age of Bronze* (no. 64) and *St. John the Baptist Preaching* (no. 65). These earlier works, however, are less pronouncedly Michelangelesque than those of 1880–81, which are characterized by an exaggerated musculature and constricted, angular poses. It seems as though he had tried to give to these later figures, when seen from every

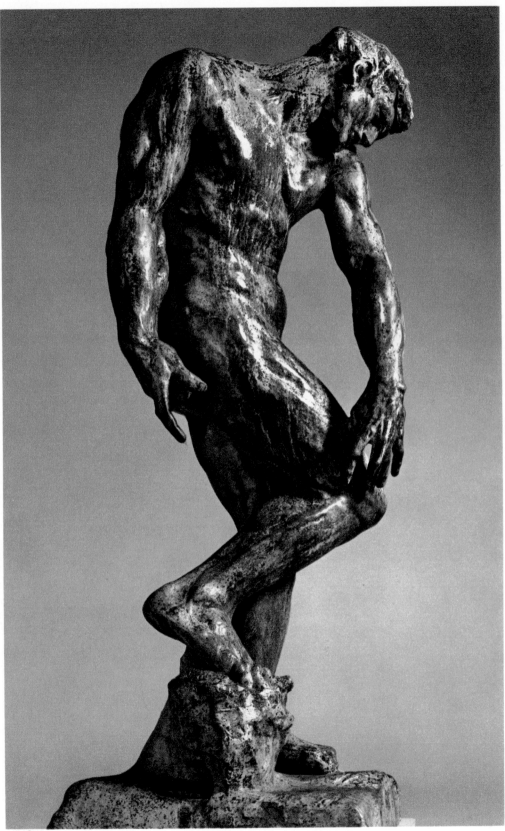

4 Left

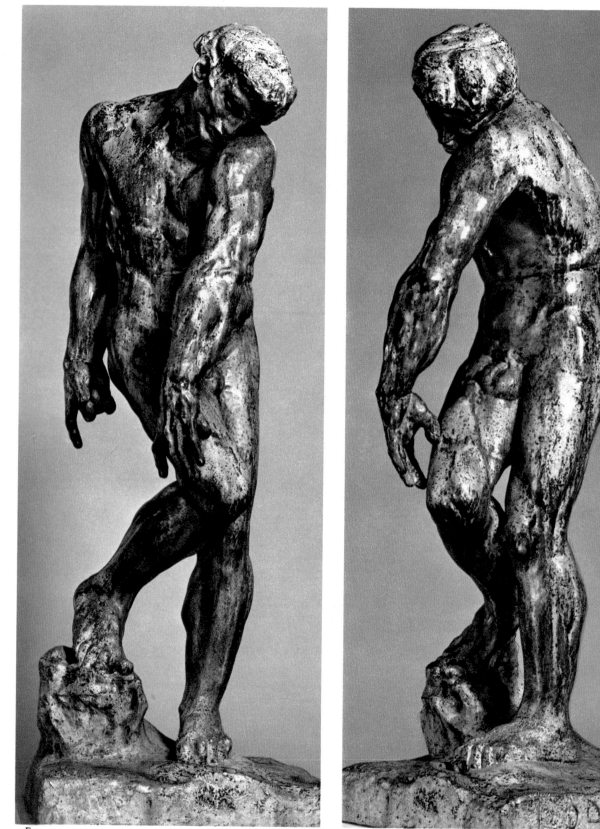

4 Front

angle, the swelling contours he had admired in Michelangelo's Sacristy figures when seen in profile or in three-quarter view.

This belated emergence of a more direct reference to Michelangelo is to be explained by the fact that in the earlier works the circumstances surrounding the conception and execution determined the type of physique represented and, to a certain extent, the pose adopted by the figure. In the later group, the nature of the theme, the agonized awakening of *Adam* and the guilt of *Eve,* and the choice of appropriate models, made almost inevitable the reappearance of what Rodin referred to as Michelangelo's "console" organization of the figure. By "console," Rodin understood the organization of the figure favored by Michelangelo, in which the thrusting forward of the legs and the hollowing of the torso create an effect of strain in contrast to the typical Phidian figure, in which the succession of four basic planes creates a gentler undulation, making a more harmonious impression on the spectator.[7]

Writing to Rose from the Midi in 1878, Rodin remarked that at Marseilles, "which continues to be completely without interest for an artist," he had seen "a *Satyr* by Puget, almost in the position of my big figure"[8] (fig. 4–1). There is, in fact, a small figure of a youth by Rodin which is closely related to Puget's *Satyr,* although in reverse.[9] This study was used as the model for the marble sculpture of the *Niobid* now in the Toledo Museum of Art (fig. 4–3). The original idea for this work, which represents one of the twelve sons and daughters of Niobe slain by Apollo, must date from the late 1870s, although the handling of the marble and, in particular, the features of the head, which resemble those of the Slav woman who posed for a number of Rodin's works in the early 1900s, suggest that the actual execution did not take place until the early years of this century. Another figure (fig. 4–2), which is related in pose to the above-mentioned works but is closer to the final version of *Adam* and which also seems to date from the late 1870s, was incorporated, together with a sketch for *Eve,* into the fireplace which Rodin designed for the South American millionaire, Matias Errazuriz, in 1912–13 (fig. 8–9).[10]

In comparison with the figure as finally conceived, the forms of the study are delicate and elongated, and the attitude is altogether more languorous. It is conceivable that this figure is one of those done from memory in order to understand Michelangelo more profoundly. When Rodin started working from the model—a man by the name of Caillou, who was a professional fairground strongman known as "the man with the iron jaw"[11]—the forms became stockier and more muscular, just as the graceful pose of the study was replaced by a more agonized flection and torsion of the limbs, resignation in the former becoming desperate urgency in the latter. The change of emphasis is most apparent in the arms, which have increased enormously in scale and in proportion to the rest of the figure. There is no mistaking now, in the figure's right arm, the reference to the left hand of Michelangelo's *Adam* in the Sistine ceiling through which life has just been received and, in the left arm, to the leaden limb of the Duomo *Pietà.*[12]

It soon became apparent to Rodin that the addition of the figures of *Adam* and *Eve,* the tragic predecessors of suffering mankind, would greatly enrich the iconography of *The Gates.* A rapid sketch shows how he proposed incorporating them into his scheme, with one on either side of the Ghibertian doors.[13] Since neither of these figures had been included in the initial project, Rodin had to approach the Ministry for more money. He wrote first to his friend Maurice Haquette, asking him to recommend the two figures, "which flank the Gate and which have not been officially commissioned nor accepted," to his brother-in-law,

Edmond Turquet.[14] Finally, on October 20, 1880, he wrote to the Undersecretary himself, asking for a further sum of 10,000 francs, 5,000 for each figure. Rodin's plea evidently met with a favorable response, as the fund of 8,000 francs placed to his credit was increased to 18,000 francs as of October 31, 1881 *(see no. 1, Appendix)*.

The plaster figure was exhibited as *The Creation of Man* at the Salon of 1881. It was called *The Slave* by the molders because of its resemblance to Michelangelo[15] and has on occasion been known as *The First Man*.[16]

During Rodin's lifetime, bronze casts of *Adam* and *The Shade* were placed in the empty niches of the façade of the Château d'Issy, which he had purchased in 1905 and which was partially reconstructed at Meudon. These remained in position when Rodin was buried in front of the château façade in 1917, a bronze cast of *The Thinker* surmounting his tomb. It is through a replica of this Rodin memorial that the visitor enters the Rodin Museum in Philadelphia, although the figures of *Adam* and *The Shade* are no longer in the niches.

NOTES

1. Cladel [26], pp. 135–36. "Il l'a produite peu après son retour de Rome, et durant ses âpres recherches entreprises pour découvrir 'le secret de Michel-Ange.' Mécontent de son œuvre, il l'abandonna, mais la reprit ensuite."

2. Grappe [338d], no. 47. "Après le voyage de Rome, en 1875, dans l'enthousiasme qu'avait suscité en lui l'art de Michel-Ange, Rodin se prit à exécuter une figure d'Adam. Mais la trouvant mauvaise, il la détruisit. Il la reprit un peu plus tard."

3. Cladel [28], p. xv. "Si près du style de Michel-Ange qu'on en dirait presque la caricature."

4. Quoted in Cladel [26], pp. 112–13. "Tout ce que j'ai vu de photographies, de plâtres, ne donne aucune idée de la Sacristie de Saint-Laurent. Il faut voir ces tombeaux de profil, de trois quarts. J'ai passé cinq jours à Florence, ce n'est qu'aujourd'hui que j'ai vu la Sacristie; eh! bien, pendant cinq jours, j'ai été froid. Voilà trois impressions durables que j'ai reçues: Reims, les Murailles des Alpes et la Sacristie. Devant, on n'analyse pas la première fois que l'on voit. Te dire que je fais depuis la première heure que je suis à Florence une étude de Michel-Ange ne t'étonnera pas et je crois que ce grand magicien me laisse un peu de ses secrets. Cependant, aucun de ses élèves ni de ses maîtres ne font comme lui, ce que je ne comprends pas, car je cherche dans ses élèves directs, mais ce n'est que dans lui, lui seul, où est le secret. J'ai fait des croquis, le soir, chez moi, non pas d'après ses œuvres, mais d'après tous les échafaudages, les systèmes que je fabrique dans mon imagination pour le comprendre; eh! bien, je réussis selon moi à leur donner l'allure, ce quelque chose sans nom que lui seul sait donner."

Mirolli [81], p. 155, makes the important point that Rodin's attitude toward learning from the art of his predecessors differed fundamentally from that of his contemporaries. Whereas Carpeaux and Chapu returned from Italy with notebooks filled with direct copies of famous works of the antique world and of the Renaissance, Rodin tried to understand the principles that underlay such works. In Rodin's drawings, references to particular works are always extremely rare.

5. Mauclair [248], p. 208. "Je croyais auparavant que le mouvement tel que je le rêvais était un secret de cet art [of Michelangelo] et, pour y atteindre, je donnais à mes modèles des poses michelangelesques. Mais, en observant, au retour, les allures de mes modèles laissés libres, je remarquai qu'ils avaient naturellement ces attitudes que Michel-Ange avait, non pas préconçues, mais transcrites d'après la nécessité individuelle des mouvements: la pensée créait l'attitude mieux que le sculpteur ne l'eût commandée. J'avais été chercher à Rome ce qui est partout: l'héroïsme latent de tout mouvement vraiment naturel. En sorte que j'atteignais au réalisme: et pourtant, c'est à ce moment-là que j'ai perçu les éléments de ce qu'on appelle mon symbolisme. Je n'entends rien aux théories. Mais je suis symboliste si cela doit désigner les idées que m'a suggérées Michel-

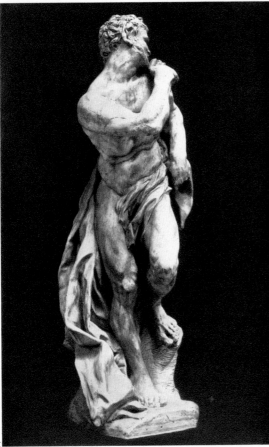

4-1

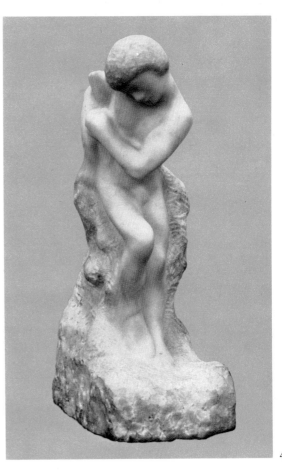

4-3

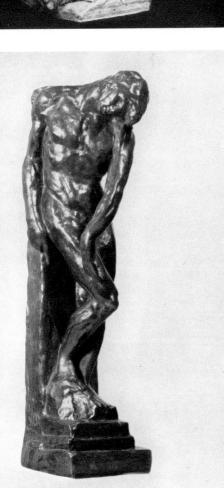

4-2

4-1
Pierre Puget (1620–1694)
Satyr
Musée des Beaux-Arts, Marseilles

4-2
Study for "Adam"
1878–80, bronze, height 10¼ inches
Location unknown

4-3
Niobid
c. 1900, marble, height 19½ inches
Toledo Museum of Art. Gift of
Edward Drummond
Libbey, 1935

127

Ange. C'est-à-dire que le principe essentiel est le modelé, le plan, qui seul rend l'intensité, la souple variété du mouvement et du caractère. Si nous pouvons imaginer la pensée de Dieu tandis qu'il créait le monde, pour moi, je dirais qu'il a pensé au modelé, principe de la nature, des êtres, et peut-être des planètes."

6. Ibid.

7. *See* the chapter "Phidias and Michel Angelo," in Gsell [57c], pp. 201–16.

8. Quoted in Cladel [26], p. 135. He refers to the museum in Marseilles "où j'ai vu un *Satyre* de Puget, presque dans la pose de mon grand bonhomme."

9. A plaster version of this figure, height 11 inches, was listed by Grappe as *Jeunesse* [338d], no. 303. He dated it 1899 and described it as the figure of a bather. However, in recent years this work has been recognized as a study for *Adam* and was exhibited as such in London in 1970 (see [389], no. 9, illus.; bronze, height 10¼ inches).

10. Don Matias Errazuriz commissioned a fireplace for his hall from Rodin in 1912. The correspondence between the artist and the millionaire, dated May 15 and May 18, 1912, and April 22 and May 26, 1913, is preserved in the archives of the Museo Nacional de Arte Decorativo, Buenos Aires. A bronze cast of the project, $18\frac{1}{8} \times 23\frac{5}{8}$ inches, cast by Alexis Rudier, is in the collection of the Buenos Aires museum.

 Two projects may also be seen in the Musée Rodin, Meudon. In the less developed of the two, figures of *Adam* and *Eve* flank the fireplace, which is crowned with a classical pediment *(see* fig. 8–9). In the second, voluminous drapery descends from Adam's left shoulder. Together with *Eve,* he supports the relief of *The Death of the Poet* (fig. 24–2), which dates from 1888. Several other versions are reproduced *(see* Coquiot [31], opp. p. 112). The figures of *Adam* and *Eve* have since been cast in bronze.

11. Tirel [106a], p. 23.

12. This was pointed out by Elsen [38], p. 49.

13. Reproduced in Elsen [37], pl. 42.

14. Letter quoted in Cladel [26], p. 140. "Rendez-moi le service de lui parler, si vous pouvez (soit ce soir ou demain) de ces deux figures qui sont autour de ma Porte et qui ne sont pas officiellement commandées, ni signées. Vous voyez que c'est sérieux pour moi et qu'il n'y a que vous pour faire aboutir."

15. Ibid., p. 143.

16. Coquiot [30], pl. 12.

REFERENCES

Bartlett [125], p. 113; Lawton [67], pp. 60–61, 108–9, repr. p. 61; Lami [4], p. 165; Bénédite [10a], pp. 19, 26, repr. pl. XIV; Grappe [338], no. 27; Watkins [342], p. 7, repr. p. 6; Grappe [338a], no. 39; Grappe [338b], no. 53; Cladel [26], pp. 135–36, 140; Grappe [338c], no. 44; Grappe [338d], no. 27; Grappe [54], p. 140, repr. p. 38; Elsen [37], p. 10, repr. pl. 8; Elsen [38], p. 49, repr. p. 51; Mirolli [81], pp. 207–9, 211–12; Tancock [341], no. 4.

OTHER CASTS

CANADA
Toronto, Art Gallery of Ontario. Purchased in 1929. Signed: Rodin. Founder: Alexis Rudier.

FRANCE
Paris, Musée Rodin.

ISRAEL
Jerusalem, Israel Museum. Billy Rose Collection.

JAPAN
Kyoto, Kyoto Municipal Museum of Art.
Tokyo, National Museum of Western Art (ex. Collection Matsukata). Signed.

UNITED STATES
Chicago, Art Institute of Chicago. Robert Allerton Collection. Acquired in 1924. Signed: Rodin.
Kansas City, Mo., William Rockhill Nelson Gallery of Art—Atkins Museum of Fine Arts (ex. Collection Alexis Rudier).
Montclair, N.J., Kasser Foundation.
New York City, Metropolitan Museum of Art. Gift of Thomas F. Ryan, 1910. Purchased from Rodin.

5 The Shade

1880 (enlarged c. 1898)[1]

Bronze, 75½ × 44⅛ × 19¾ inches
Signed on center front of base: A. Rodin
Foundry mark center rear of base:
ALEXIS RUDIER/Fondeur. PARIS[2]

The history of *The Shade* is closely linked with that of *Adam* (no. 4). Dissatisfied with his first figure of *Adam,* or *The Creation of Man,* because of its proximity to the style of Michelangelo, Rodin destroyed it, whether wholly or in part, and made a second version, which was exhibited at the Salon of 1881. According to Judith Cladel,[3] *The Shade* is a development of this first study for *Adam,* a variant of which was used in a design for a fireplace in 1912–13 (fig. 8–9). In comparison with *Adam,* the attitude of *The Shade* is less contorted. There is not so much tension in the raised right leg, and the left arm is thrust forward and does not hang down across the body as in *Adam.* In brief, the movement seems more coordinated.

There is no indication in the surviving preliminary drawings, or in the architectural clay models, that by 1881 Rodin had thought of incorporating the figure of *The Shade* in *The Gates* as he finally did. In the third architectural clay model (no. 2), however, the brooding figure of *The Thinker* is situated under the remains of three massive keystones, or brackets, which provide an emphatic architectural climax and direct the gaze of the spectator down through *The Gates.*

Sometime between 1881 and 1886 Rodin decided to group at the summit of *The Gates* three casts of *The Shade,* each lacking the right hand. They represented the souls of departed countrymen whom Dante speaks to on his voyage. On January 16, 1886, they were seen *in situ* and described by Félicien Champsaur: "Dominating everything, three figures seem to embody the phrase which they point to written on the pediment, 'Lasciate ogni speranza voi ch'intrate.'"[4] With the downward pull of their gestures, they performed admirably the function of the keystones in the third architectural clay model, that of forcing the viewer's gaze to remain within the confines of *The Gates.* By 1889, however, the inscription had evidently been removed, for Gustave Geffroy described them at that time as "an animated equivalent of the Dantesque inscription, *Lasciate ogni speranza.*"[5]

No more striking example of the unique advantages of profile modeling, adumbrated in the *Man with the Broken Nose (see* no. 79) and consciously elaborated after the Italian trip of 1875–76, could be found. In this grouping of three identical casts, seen respectively from the left, from head on, and from the right, there is no repetition of contours. The interest is sustained evenly all around the figure and not confined to one or two major vantage points. One can only speculate as to the meaning Rodin attached to the missing extremity. It seems that in depriving them of the right hand, the modeling hand, with its ability to create, he may well have wanted to symbolize the powerlessness of *The Shades* before fate and the resulting ineffectualness of all their efforts.

About 1898, according to Cécile Goldscheider,[6] the figure of *The Shade* was enlarged from the original size of 38 ⅝ inches (fig. 5–1) to 75 ½ inches (the dimensions of the Philadelphia cast), although the purpose of the enlargement, with the right arm completed, is not known. In 1902 an enlarged plaster version of *The Three Shades* was exhibited at the Société Nationale (fig. 5–3), although the figures were placed farther apart, giving the impression of a round dance. At some later date[7] this enlarged version was cast in bronze, with the right arms completed and grouped as they were originally at the top of *The Gates* (fig. 5–4).

The Shade, with its expansive gesture, was more readily usable by the sculptor in diverse groupings and assemblages than the *Adam.* The head alone, looking up and touched by a left hand, was used in an assemblage known as *The Shade: The Head and the Left Hand.*[8] In 1913, according to Gustave Coquiot,[9] the enlarged plaster of *The Shade,* minus the right hand, was placed beside the mutilated figure of *Meditation* from the fourth project for the first monument to Victor Hugo *(see* no. 71) and entitled *Adam and Eve* (fig. 5–5).

Like the *Adam, The Shade* has also been known as *The Slave* and on occasion has been referred to as *The Titan.*[10] For *The Three Shades* the titles of *Three Despairing Men* and *The Vanquished* have also been used.[11] Like the *Adam, The Shade* was used in the Rodin memorial at Meudon.

NOTES

1. Grappe makes many adjustments in his dating of the various versions of *The Shade.* In the 1927 edition [338], he lists only the enlarged plaster version of *The Shade,* no. 248, which he dates 1902. In the 1929 edition [338a], he lists the small version of *The Three Shades* as no. 50, dating the bronze 1881. The enlarged version of *The Three Shades* is listed as no. 51, although he does not date this. He lists the enlarged *Shade* as no. 282 and dates the bronze 1902. By 1931 [338b], he had changed the date of the enlarged *Shade* in bronze, no. 68, to 1880, although no reason was given for the change. He also revised the dating of the small version of *The Three Shades* in bronze, no. 69, to 1880 and listed the enlarged version of *The Three Shades,* no. 70, in gilded bronze without assigning a date to it.

 In the 1938 edition [338c], he retained the dating of 1880 for the enlarged bronze of *The Shade,* no. 53. He gave no date, however, to the small bronze group of *The Three Shades,* no. 54, and listed only a plaster of the enlarged version of *The Three Shades,* no. 54 bis, which he dated 1880.

 In the catalogue issued by Jianou and Goldscheider [65], p. 89, the small and the large versions of *The Shade* are listed as being in the collection of the Musée Rodin. No reference is made to the enlarged version of *The Three Shades,* no. 70, mentioned in the 1931 edition of Grappe, nor of the plaster version, no. 54 bis, mentioned in the 1938 edition of his catalogue. In the face of such inconsistency, it seems more sensible to rely on one's own eyes and common sense when trying to assign a date to the various versions. The present author's dating will be seen in the main body of the text.

 The Shade should not be confused with the work known as *Small Shade (No. 1)* and *Small Shade (No. 2)* (Grappe [338d], nos. 123, 124). This figure, equally Michelangelesque in its inspiration, may be seen in the upper left-hand section of the left panel of *The Gates.* Bronze casts of *Small Shade (No. 1)* are in the collections of the Musée Rodin; the Yale University Art Gallery (fig. 5–2); Lord Clark of Saltwood, Kent; Baroness Cécile de Rothschild, Paris; and Benedict Nicholson, London.

2. According to information provided by the Musée Rodin at the time of purchase, this is the third cast.

3. Cladel [28], p. xvi. "De l'étude première de la *Création* est née la *Grande Ombre* devenue le modèle des *Trois Ombres* qui surmontent de leur groupe émouvant le fronton de la *Porte de l'Enfer.*"

4. Félicien Champsaur, "Celui qui revient de l'enfer," *Le Figaro,* Supplément, Paris, January 16, 1886. "Dominant le tout, trois personnages sem-

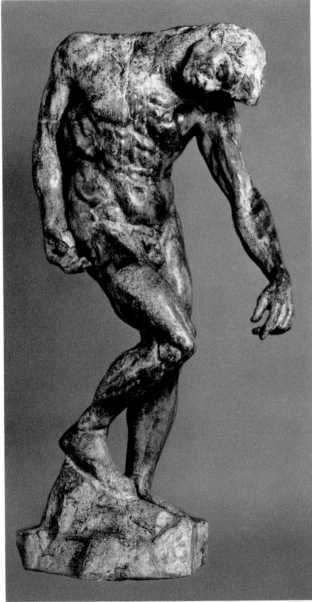
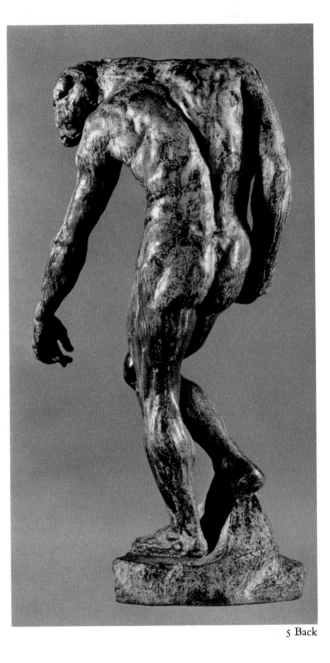

5 Front

5 Back

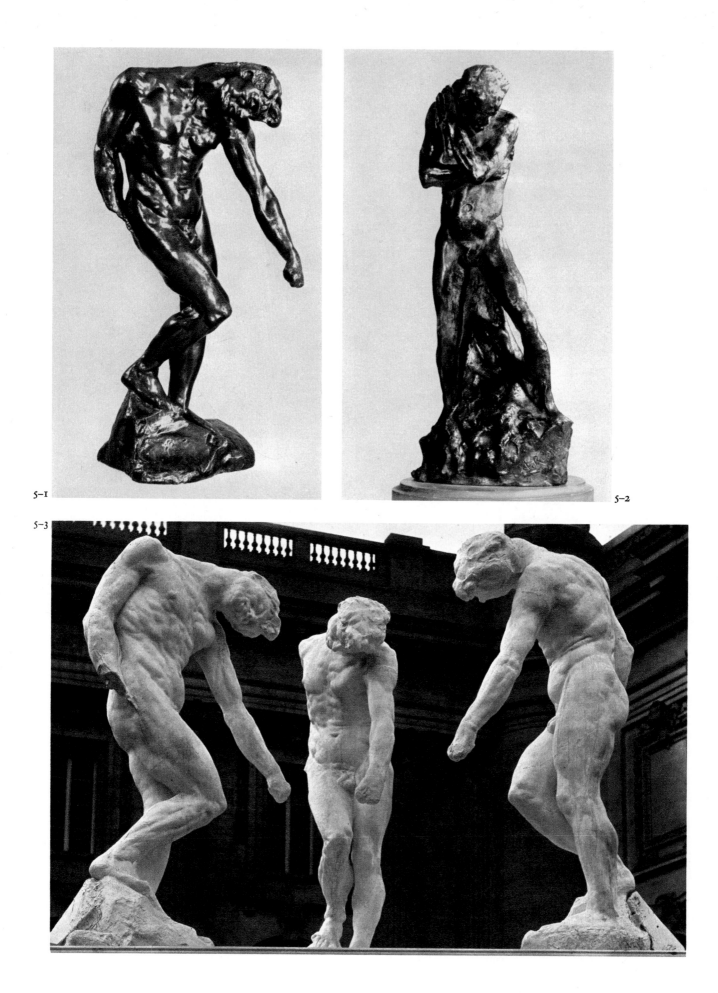

5-1

5-2

5-3

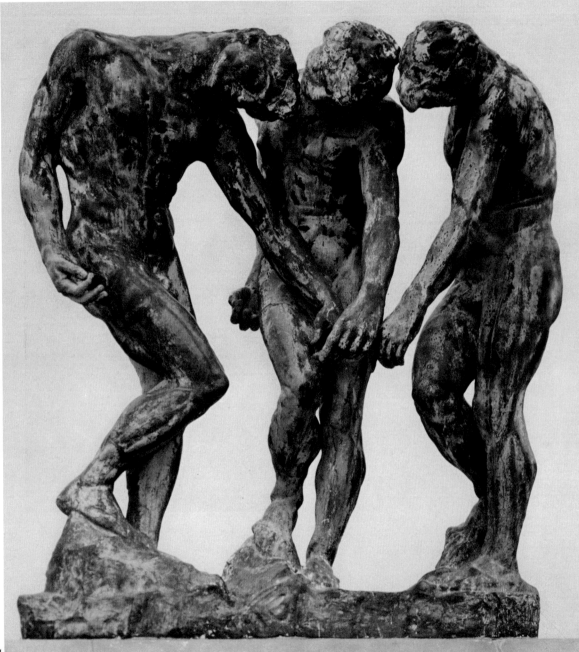

5-4

5-1 *The Shade*
 1880, bronze, height 38⅝ inches
 Dallas Museum of Fine Arts. The Eugene
 and Margaret McDermott Fund

5-2 *Small Shade (No.1) (Figure of Standing Man)*
 1885, bronze, height 12½ inches
 Yale University Art Gallery, New Haven.
 Gift of Elisabeth Achelis

5-3 *The Three Shades*
 1902, plaster, height 75½ inches
 As exhibited at the Société Nationale, 1902

5-4 *The Three Shades*
 By 1886 (enlarged c. 1898), bronze, height 75½ inches
 Property of the city and county of San Francisco.
 Situated at the entrance to the California Palace of
 the Legion of Honor.

blent incarner la phrase qu'ils montrent écrite sur le fronton—'Lasciate ogni speranza voi ch'intrate.'"

5. Geffroy [199a], p.12. "Tout en haut, au-dessus du fronton, trois hommes dressent au sommet de l'œuvre un équivalent animé de l'inscription dantesque: *Lasciate ogni speranza*. Ils s'appuient l'un sur l'autre, se penchent dans des attitudes de désolation, leurs bras tendus et rassemblés vers le même point, leurs doigts indicateurs rapprochés, exprimant le certain et l'irréparable."

6. New York, 1963 [369], no.23.

7. Grappe [338d], no.59, does not give the date of this final version.

8. This cast, whose subject is not included in any of the catalogues of the Musée Rodin, was sold at Parke Bernet, New York, March 16, 1960, no.42. According to the sale catalogue, this was the first of four casts by Alexis Rudier.

9. Coquiot [30], p.79.

10. Grappe [338d], no.57.

11. Ibid., no.59. Grappe states incorrectly that *The Three Shades* were exhibited as *The Vanquished* at the Rodin retrospective of 1900. Only one of *The Shades* was exhibited as no.61, *Figure Standing (One of the Shades)*.

REFERENCES

Bénédite [10a], p.26, repr. pl. xv; Grappe [338], no.248; Watkins [342], p.7; Grappe [338a], nos.50, 51, 282; Grappe [338b], nos.68–70; Grappe [338c], nos.53, 54, 54 bis; Story [103], p.144, no.11, repr. pl.11; Grappe [338d], nos.57–59; Cladel [28], p.xvi; Story [103a], no.12, repr.pl.12; Tancock [341], no.5

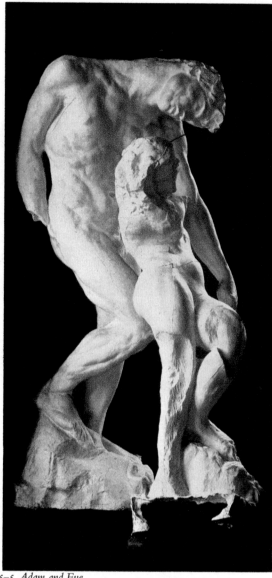

5-5 *Adam and Eve*
c. 1913, plaster, heights 76⅜ inches, 63¾ inches
Ny Carlsberg Glyptotek, Copenhagen

OTHER CASTS AND VERSIONS

Bronze

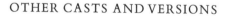

DENMARK
Copenhagen, Ny Carlsberg Glyptotek. Gift of Ny Carlsbergfondet, 1953 (ex. Collections Alphonse Kann; Kleinmann, Paris). Cast in 1902.

FRANCE
Lyons, Musée des Beaux-Arts. Purchased from Rodin in 1905.
Paris, Musée Rodin.

SWITZERLAND
Basel, Kunstmuseum Basel. Purchased in 1938.

UNITED STATES
Atlanta, High Museum of Art. Presented by the French government in 1968 in memory of 120 Atlantans who died at Orly in 1962. Founder: Georges Rudier.
Beverly Hills and New York City, B.G.Cantor Collections. Founder: Georges Rudier. Cast no.9/12.

Los Angeles, Los Angeles County Museum of Art. Gift of B. G. Cantor Art Foundation. Founder: Susse. Cast no. 6.

St. Louis, Washington University. Gift of Morton D. May, 1968. Signed: A. Rodin. Founder: Alexis Rudier.

Bronze, height 38⅝ inches

FINLAND
Helsinki, Kunstmuseum Athenaeum. Signed. Founder: Georges Rudier. Cast in 1964.

FRANCE
Orléans, Musée des Beaux-Arts. Purchased in 1955.
Paris, Musée Rodin.

GREAT BRITAIN
Sussex, Gravetye Manor Hotel, Collection Robin Howard. Founder: Georges Rudier.

UNITED STATES
Dallas, Dallas Museum of Fine Arts. The Eugene and Margaret McDermott Fund. Inscribed no. 1/2. Founder: Alexis Rudier (fig. 5–1).

Greenwich, Collection Herbert Mayer. Founder: Georges Rudier. Cast 12/12.

Larchmont, N.Y., private collection. Founder: Georges Rudier.

St. Louis, Collection Joseph Pulitzer, Jr. Founder: Alexis Rudier.

The Three Shades

Bronze, height 35⅜ inches

FRANCE
Paris, Musée Rodin. Founder: Alexis Rudier.

Bronze, height 75½ inches

UNITED STATES
Beverly Hills and New York City, B. G. Cantor Collections. Founder: Georges Rudier. Cast no. 4/12.

San Francisco, Property of the city and county of San Francisco. Situated at the entrance to the California Palace of the Legion of Honor. Founder: Alexis Rudier (fig. 5–4).

Plaster

FRANCE
Paris, Musée Rodin.

Adam and Eve (casts of "The Shade" and "Meditation")

Plaster, heights 76⅜ inches, 63¾ inches

DENMARK
Copenhagen, Ny Carlsberg Glyptotek. Casts purchased by Carl Jacobsen in 1903 and 1904 (fig. 5–5).

FRANCE
Meudon, Musée Rodin.

The Shade: The Head and the Left Hand

Bronze, height 8 inches

According to the Parke Bernet sale catalogue, March 16, 1960, no. 42, there are four casts of this work.

6 The Crouching Woman
1880–82

Bronze, 33 × 21 × 18 inches
Signed top of base by figure's left foot: A. Rodin
Foundry mark rear of base to right:
ALEXIS. RUDIER./FONDEUR. PARIS.

One of Rodin's most daring and expressive figures, *The Crouching Woman* is remarkable for the complexity and compactness of the pose. Created at the same time as those works—*Adam* (no. 4), *Eve* (no. 8), and *The Shade* (no. 5)—in which the influence of Michelangelo is most pronounced, it seems probable that in this work Rodin tried to emulate yet another aspect of Michelangelo's style, best exemplified by the Leningrad *Crouching Youth*.[1] Although Rodin modeled his figure rather than carved it, as Michelangelo had done, Rodin may have tried to create a figure so much of a piece that it would fulfill Michelangelo's requirement for a sculpture, namely, that it could be rolled down a hill without suffering any damage.

According to Frisch and Shipley,[2] the model for *The Crouching Woman* was Adèle, who posed for Rodin over a period of four years, notably for the *Torso of Adèle* (fig. 32-1). Grappe assigned a date of 1882 to the large bronze.[3] However, a date of 1880 for the terra-cotta study (fig. 6-2), as suggested by Cécile Goldscheider, would be in keeping with the Michelangelesque character of the work.[4]

Comparison of the terra-cotta with the large bronze suggests that the latter is an enlargement of the former. Wonderfully sensitive and eventful as it is, the forms of the bronze are somewhat more generalized than those of the study, in which the decisions of the modeler are left intact. A comparison of certain areas, notably the back and the head, reveals this with particular clarity. There are two slightly different versions of the large bronze. The chief difference between them is the base, one of which is considerably higher than the other (fig. 6-1).

The head of this work was detached and exhibited as an independent sculpture known as *Head of Lust* (figs. 6-3a, b). This detachment was no simple operation since the head rests on the figure's right knee. Consequently drastic surgery was required, and there is a pronounced contrast between the undulating surfaces of the front of the face and the angular faceting of the right-hand side, where the surfaces of the head met those of the knee. Nowhere else is Rodin's disdain for conventional finish exhibited so dramatically.

Bronzes also exist of the small-scale version of *The Crouching Woman* (fig. 6-4). With the addition of a roughly modeled right arm, which now hangs limply and does not clasp the left foot, *The Crouching Woman* in these dimensions was used in the group *I Am Beautiful* (no. 10), which exists both as a free-standing work and in high relief at the top of the right-hand decorative pilaster of *The Gates (see* no. 1, detail c).[5]

Grappe states that at a later date Rodin converted *The Crouching Woman* into a caryatid and considered using it as part of a fountain.[6] It is presumably the marble in Boston (fig. 6-5) to which Grappe referred. Léonce Bénédite mentioned a small marble version in the collection of Octave Mirbeau, but no other reference to it has been found.[7]

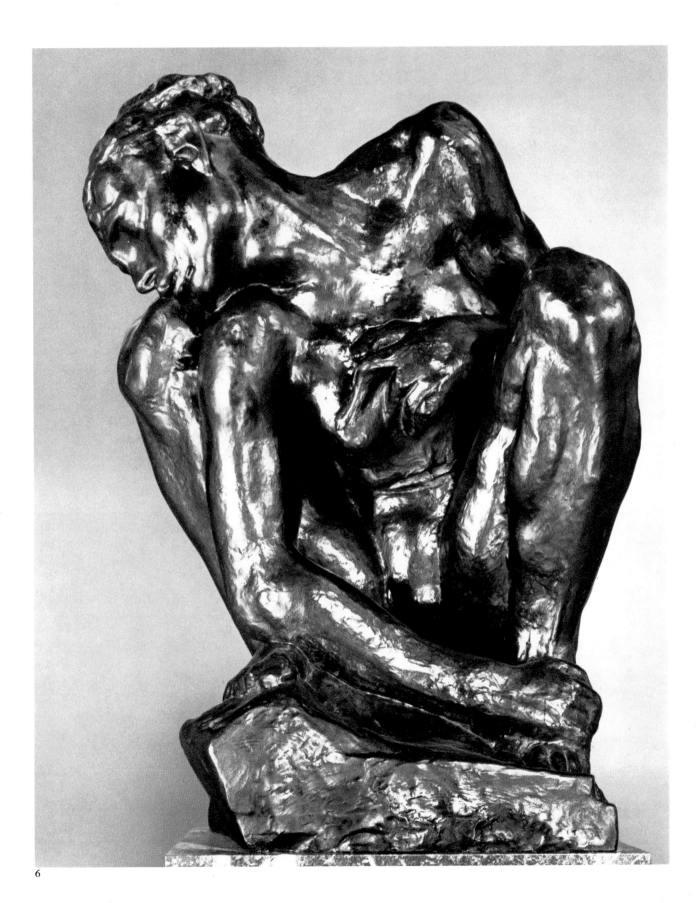

6

137

NOTES

1. Elsen [38], p.57, suggests that Rodin may have seen a photograph or print of this work.
2. Frisch and Shipley [42], p.416.
3. Grappe [338d], no.83.
4. New York, 1963 [369], no.77.
5. *The Crouching Woman,* in modified form, thus makes two appearances in *The Gates of Hell*—crouching to the left of *The Thinker (see* no.1, detail κ) and cradled in the arms of *The Falling Man* at the top of the right-hand pilaster.
6. Grappe [338d], no.83. "Plus tard, durant ses loisirs moins mesurés, Rodin, cherchant à adapter ses œuvres anciennes à des projets nouveaux, songea à transformer cette figure en cariatide, un bloc sur son épaule, ou à l'utiliser pour une fontaine."
7. Bénédite [10a], p.27.

REFERENCES

Lami [4], p.169; Bénédite [10a], p.27, repr. pl.xx; Grappe [338], no.54; Watkins [342], no.70; Grappe [338a], no.71; Grappe [338b], no.96; Grappe [338c], no.73; Frisch and Shipley [42], p.416; Story [103], p.145, nos.30, 32, 33, repr. pls.30, 32, 33; Grappe [338d], no.83; Grappe [54], p.141, repr. p.51; Waldmann [109], p.75, nos.33, 34, repr. pls.33, 34; Boeck [138], p.180, repr. pl.98; Story [103a], nos.26, 27, repr. pls. 26, 27; Elsen [38], pp.57–59, repr. pp.58, 59; Tancock [341], no.9, repr. p.34.

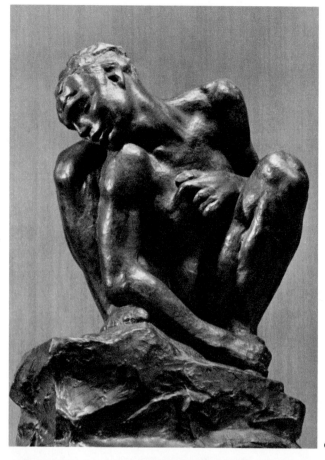

6-1

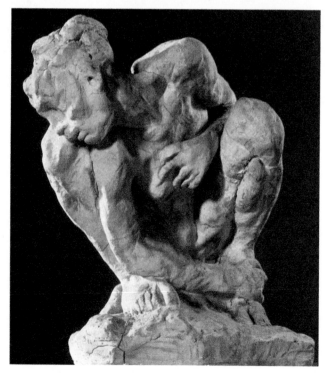

6-2

6-1 *The Crouching Woman*
 1880–82, bronze, height 37½ inches
 National Museum of Western Art,
 Tokyo

6-2 *The Crouching Woman*
 1880, terra-cotta, height 11¾ inches
 Musée Rodin, Paris

6-3 a, b *Head of Lust*
 1882, bronze, height 15 inches
 Collection Mrs. Emil L. Froelicher, New York

6-4 *The Crouching Woman*
 1880–82, bronze, height 12⅝ inches
 Location unknown

6-5 *Caryatid*
 c. 1900?, marble, height 17¾ inches
 Museum of Fine Arts, Boston. Gift of the Estate
 of Samuel Isham, 1917

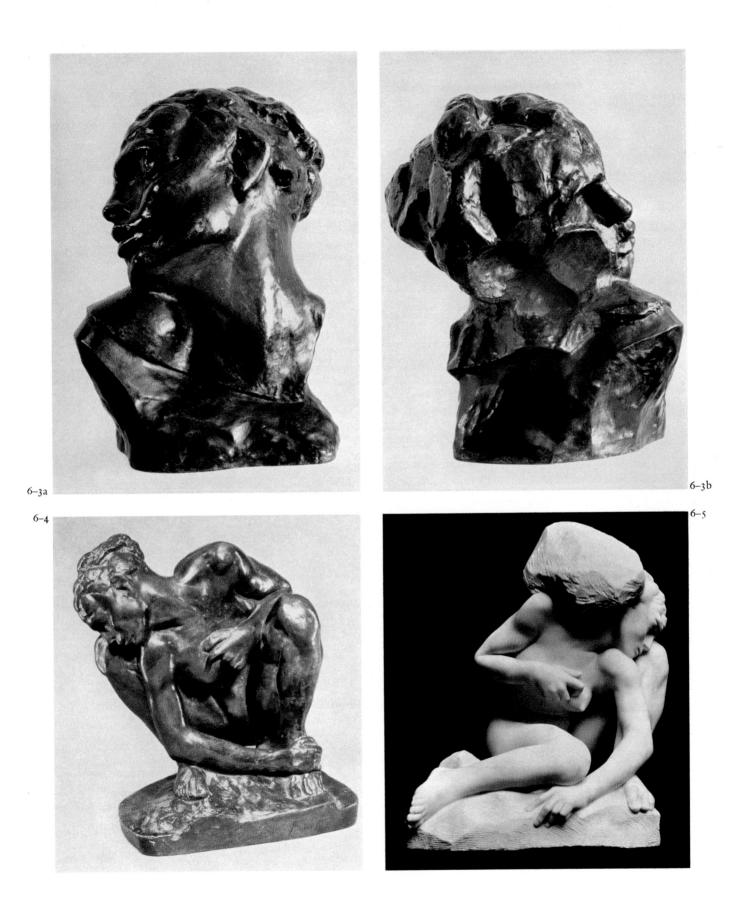

6–3a

6–3b

6–4

6–5

139

OTHER CASTS AND VERSIONS

Bronze

FRANCE

Paris, Musée Rodin. Signed: A. Rodin. Founder: Alexis Rudier.

GERMANY (WEST)

Essen, Museum Folkwang. Commissioned by Karl-Ernst Osthaus, Hagen, in 1912. Signed: A. Rodin.
Munich, Neue Pinakothek. Founder: Alexis Rudier.

SWITZERLAND

Lausanne, Collection Samuel Josefowitz. Founder: Georges Rudier.

UNITED STATES

Washington, D.C., Hirshhorn Museum and Sculpture Garden, Smithsonian Institution. Signed: A. Rodin. Founder: Georges Rudier. Cast no. 3/12.

Bronze, height 12⅝ inches
Location unknown (fig. 6–4).

AUSTRALIA

Brisbane, Queensland Art Gallery. Purchased in 1955. Signed. Founder: Georges Rudier.

FRANCE

Paris, Musée Rodin.

GREAT BRITAIN

Four casts in private collections.

UNITED STATES

New York City, Collection Mr. and Mrs. Richard Davis. Founder: Alexis Rudier.
Washington, D.C., Hirshhorn Museum and Sculpture Garden, Smithsonian Institution. Founder: Alexis Rudier.

Bronze, height 37½ inches (the figure is seated on a higher, rocky base)

JAPAN

Tokyo, National Museum of Western Art. Founder: Alexis Rudier (fig. 6–1).

THE NETHERLANDS

Otterlo, Rijksmuseum Kröller-Müller. Acquired from the Musée Rodin in 1950. Signed. Founder: Alexis Rudier.

SWITZERLAND

Zurich, Kunsthaus Zurich. Gift of Nelly Bär in 1968. Purchased in 1959 from the Musée Rodin by Werner and Nelly Bär. Signed: A. Rodin.

UNITED STATES

Houston, Houston Museum of Fine Arts. Gift of B. G. Cantor Art Foundation. Founder: Georges Rudier. Cast no. 5/12.
Los Angeles, Los Angeles County Museum of Art. Gift of B. G. Cantor Art Foundation. Founder: Susse. Cast no. 4.

Terra-cotta, height 11¾ inches

FRANCE

Paris, Musée Rodin (fig. 6–2).

Plaster, height 12 inches

FRANCE

Paris, Musée Rodin.

UNITED STATES

Beverly Hills, Collection Mrs. Jefferson Dickson (ex. Collection Jules Mastbaum).

RELATED WORKS

Caryatid

Marble, height 17¾ inches

UNITED STATES

Boston, Museum of Fine Arts. Gift of the Estate of Samuel Isham, 1917 (fig. 6–5).

Head of Lust

Plaster, height 15 inches

FRANCE

Paris, Musée Rodin.

Bronze

ALGERIA

Algiers, Musée National des Beaux-Arts. Purchased by the state in 1934.

UNITED STATES

New York City, Collection Mrs. Emil L. Froelicher. Purchased from Otto Gerson in 1961. Founder: Alexis Rudier (figs. 6–3a, b).

7 The Helmet-Maker's Wife
1880–83

Bronze, 19½ × 9¼ × 10½ inches
Signed right side of base under figure's left hand: A. Rodin.
Foundry mark center rear of base:
ALEXIS. RUDIER./fondeur. PARIS.

Although *The Helmet-Maker's Wife* was dated 1890 by Grappe in the first two editions of the catalogue of the Musée Rodin,[1] the dating was revised to before 1885 in later editions. The revision was made after it was discovered that the work had been exhibited at Angers in 1889.[2] There is reason to believe, however, that the origins of this work may go back to a period well before that assigned to it by Grappe. While working at the Manufacture de Sèvres in 1880, Rodin, together with Jules Desbois, made the vase *Limbo and the Sirens,* on which appears in relief the image of an old woman seated in profile, before whom kneels a younger woman.[3] Certain details, notably the way in which the hair is arranged with a center part and a small chignon, make it seem probable that the same model was used for the figure on the vase and for *The Helmet-Maker's Wife.*

There are two slightly different accounts of the way in which Rodin became acquainted with the model. According to one version, she was "an old Italian widow, very old, very poverty-stricken, and very thin, who had come to Paris to seek for a son whom she had not heard of for a long time. Reduced to straits, she was told to knock at Rodin's door, probably directed by some one of her fellow country people who had posed as a model."[4]

At a later date, Jules Desbois gave a somewhat different account to Paul Gsell of the circumstances surrounding this meeting. His account, although less romantic, is probably closer to the truth. He told Gsell that he asked Rodin to come to see his statue of *Misery,* which he had just finished (compare fig. 7–1). Rodin asked for the address of the model, whose name was Caïra and who belonged to an Italian family of professional models. She then posed for *The Helmet-Maker's Wife.*[5]

It seems probable that she posed for Rodin over a considerable period of time. Although executed on a comparatively small scale, the work leaves no doubt that Rodin scrutinized the model as intensely as he did when engaged in working from the model on a life-size figure. Moreover, the existence of a small torso of the same old woman by Camille Claudel (fig. 7–2), which most probably dates from 1883, the year she first met Rodin, or shortly after, suggests that he was still working from Caïra at that date. For these reasons a dating of 1880–83 is suggested for this work.

The accidental discovery of this model led Rodin into unfamiliar territory, forcing him to reconsider his attitude toward beauty and ugliness. Following his Italian visit of 1875–76, the influence of Donatello had been subsidiary to that of Michelangelo, but in *The Helmet-Maker's Wife,* Donatello, the creator of the *Mary Magdalen* in the Baptistery in Florence,

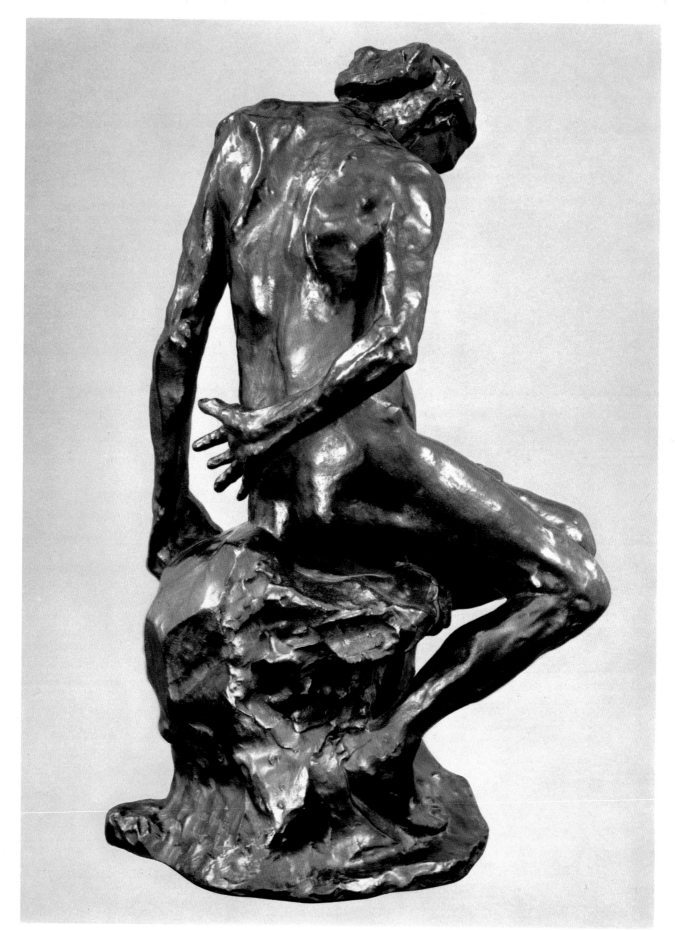

7 Back

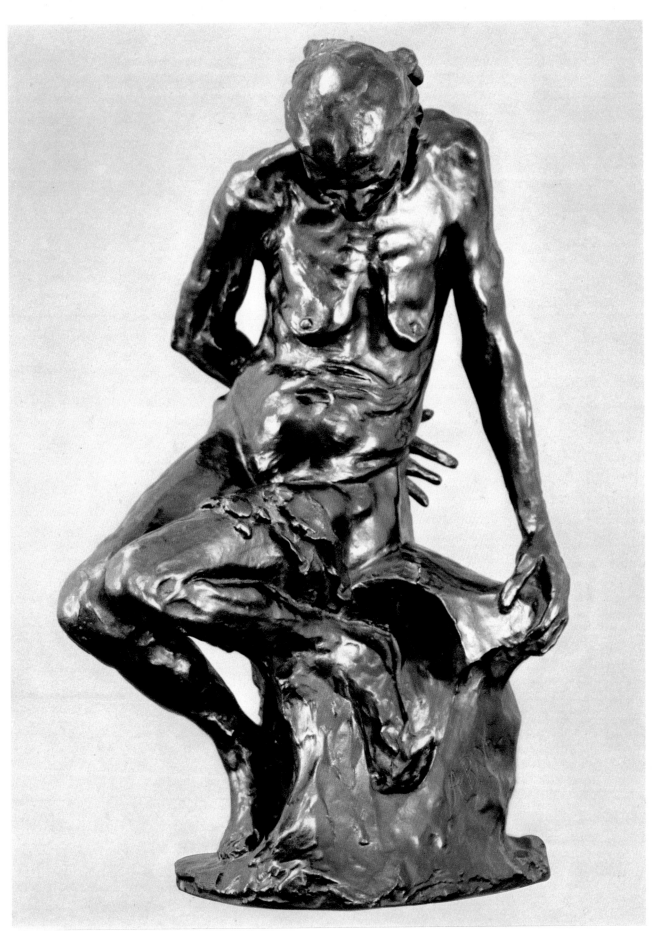

7 Front

took precedence. Caïra's weary body had to be approached in a different way from that of Caillou, the circus strongman who posed for *Adam* (no. 4), and Mme Abruzzezzi, the "panther" who posed for *Eve* (no. 8). There is a much greater naturalism and fidelity to the particularities of the human anatomy, however unfelicitous they might be, in *The Helmet-Maker's Wife* than in any of Rodin's Michelangelesque figures.

With the solitary exception of the *Man with the Broken Nose (see* no. 79), the relationship between ugliness and beauty had really not concerned Rodin before this date. The major figures—*The Age of Bronze* (no. 64), *St. John the Baptist Preaching* (no. 65), *Adam, Eve,* and *The Shade* (no. 5)—although not conventionally handsome or beautiful, are strong and full of character. But with *The Helmet-Maker's Wife,* Rodin came fully to the realization that:

> "What is commonly called *ugliness* in nature can in art become full of great beauty.
>
> "In the domain of fact we call *ugly* whatever is deformed, whatever is unhealthy, whatever suggests the idea of disease, of debility, or of suffering, whatever is contrary to regularity, which is the sign and condition of health and strength: a hunchback is *ugly,* one who is bandy-legged is *ugly,* poverty in rags is *ugly.*
>
> "*Ugly* also are the soul and the conduct of the immoral man, of the vicious and criminal man, of the abnormal man who is harmful to society; *ugly* the soul of the parricide, of the traitor, of the unscrupulously ambitious.
>
> "And it is right that beings and objects from which we can expect only evil should be called by such an odious epithet. But let a great artist or a great writer make use of one or the other of these *uglinesses,* instantly it is transfigured: with a touch of his fairy wand he has turned it into beauty; it is alchemy; it is enchantment!"[6]

As examples of physical ugliness and moral turpitude transformed by the artist, he cites the painted figures of Velázquez and Millet, the characters of Baudelaire, Shakespeare's Iago and Richard III, and the Nero and Narcissus of Racine. In the field of sculpture he might have mentioned the antecedents of his own work, Germain Pilon's *Tomb of Valentine Balbiani,* completed before 1583 and now in the Louvre, or a sixteenth-century Italian bronze of a naked old woman in the Bibliothèque Nationale.[7]

The title of Rodin's work, derived from François Villon's ballad by the same name, in which an old courtesan laments the loss of her beauty,[8] has often given rise to misunderstanding. At the time when Rodin was criticized for being a "literary" sculptor, it was assumed that the title came first and that the work was designed to illustrate it. However, there is no reason to suppose that this work received its title in a way that differed fundamentally from his normal practice of relying on the created work to suggest its own title.

7–1 Jules Desbois
 Misery
 c. 1896, wood, height 50 inches
 Musée des Beaux-Arts, Nancy
 Gift of the state, 1897

7–2 Camille Claudel
 Torso of an Old Woman
 1883
 Location unknown

7–3 *Drawing after "The Helmet-Maker's Wife"*
 Location unknown

7–4 *Dried-Up Springs*
 1889, plaster, height 26 inches
 Musée Rodin, Meudon

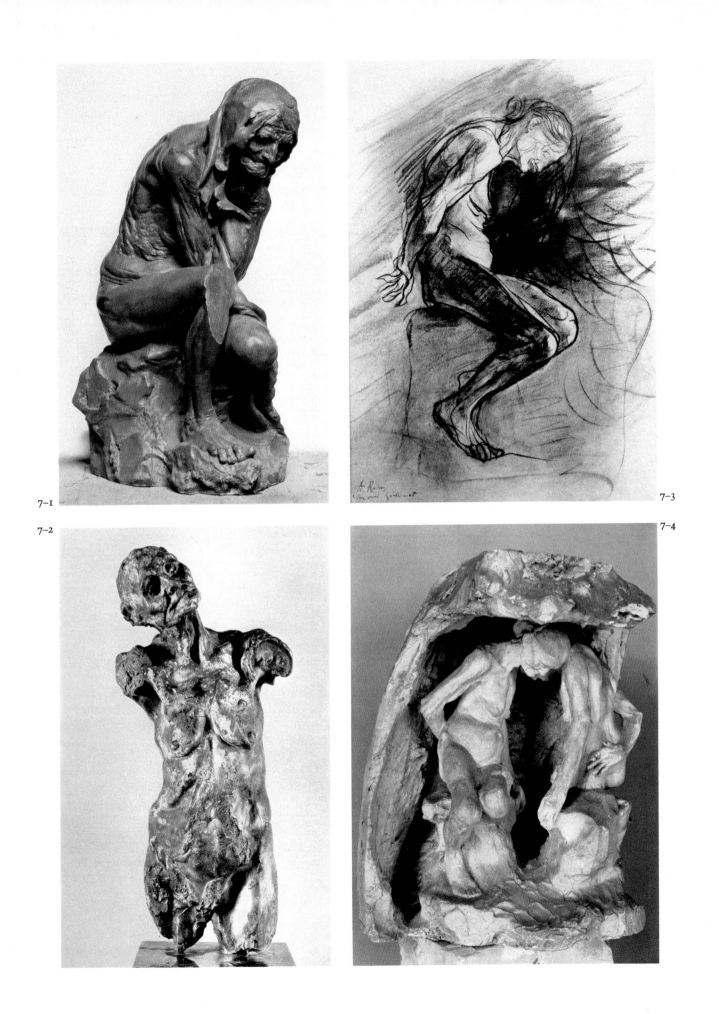

7-1

7-3

7-2

7-4

About 1890, Rodin sometimes referred to the work as *Old Woman,* under which title it was exhibited at the Société Nationale in 1890, and as *Winter,* and it has frequently been called *The Old Courtesan.* In 1892, when Gustave Geffroy discussed the work's literary parallels, he did not mention the name of Villon. He described the sculpture as "an old woman who is the very image of the decline and the regrets of old age. Looking at it, one thinks of the poetry of Ronsard and of Baudelaire. A life that has been spent appears with its hopes annihilated and its irremediable decrepitude."[9]

A drawing which Rodin made from the sculpture for his friend Maurice Guillemot, which was to have appeared in a book the latter was preparing on "misérabilisme" (never published),[10] bears no title (fig. 7–3). When two casts of the figure, placed opposite each other in a grotto, were exhibited at the Exposition Monet-Rodin at the Galerie Georges Petit in 1889, the work was entitled *Dried-Up Springs* (fig. 7–4).[11]

Léonce Bénédite refers to a half life-size marble of *The Helmet-Maker's Wife,* of which Victor Peter made a cast, but the present location of this work is not known.[12] The appearance of the work in marble may be judged, however, from the version of this figure used in *Youth Triumphant,* which is clearly cast from a marble *(see no. 26).*

NOTES

1. Grappe [338], no. 165; [338a], no. 190.
2. Grappe [338d], no. 122.
3. *See* Marx [75], pl. XVII.
4. Lawton [67], p. 121.
5. Paul Gsell, "Un Maître: Le grand sculpteur Jules Desbois est mort hier," *Comoedia,* Milan, October 4, 1935.

 "Desbois venait de modeler dans l'argile, pour son propre compte, la statue de *La Misère* qui est maintenant l'orgueil du Musée de Nancy.

 "Il appelle Rodin pour le lui faire voir. Rodin regarde cela un long moment et dit:

 —'C'est très beau! très beau.'

 Un moment après, il demande à Desbois:

 —'Donne-moi le nom et l'adresse de ton modèle.'

 Desbois les lui écrit sur un morceau de papier.

 "Celle qui avait posé pour *La Misère* était une véritable Parque édentée qui s'appelait Caïra, presque le mot de Kère, qui, en grec, désigne les sœurs filandières. Elle appartenait à une tribu italienne dont tous les membres étaient modèles de père en fils et de mère en fille.

 "Rodin courut à l'adresse indiquée. Il emmène sur-le-champ la vieille Caïra à son atelier et, sans

désemparer, il commence à pétrir un chef-d'œuvre immortel: *La Vieille Heaulmière,* en reprenant presque l'attitude trouvée par Desbois, mais en donnant un sens nouveau à ce fantôme féminin.

 "De la figure dédiée par Desbois à la compassion, Rodin avait fait une hautaine et brutale leçon philosophique où il affirmait l'antagonisme de la chair qui se corrompt et de l'âme aux aspirations illimitées."
6. Gsell [57b], pp. 42–43.
7. *See* Dr. Henry Meige, "La Vieille Femme nue de la Bibliothèque Nationale," *Aesculape,* Paris, July 1, 1927, pp. 178–81. In this article the author draws a comparison between the sixteenth-century bronze statuette of an old woman in the Cabinet des Médailles de la Bibliothèque Nationale and a figure of an old woman suffering from Parkinson's disease made by Dr. Paul Richer in 1895.
8. François Villon, "The Lament of the Belle Hëaulmiere," from *The Complete Works of François Villon,* trans. Anthony Bonner (New York: Bantam Books, 1960), pp. 47, 49.

 Ah! You treacherous, fierce Old Age,
 why have I been beaten down so soon?

Who will care if I strike myself
and with that blow give up my life?

.

Oh, when I think of those good days,
what I was then—what I've since become!
When I look at my naked body
and see myself so changed,
poor, skinny, dried out and shrivelled,
I almost lose my mind.

Where's the smooth forehead,
the blond hair, the arched eyebrows,

.

Those lovely little shoulders,
the long arms and pretty hands,
the small breasts, the full hips,
high, smooth, and so well made
to enter tournaments of love;

.

So this is human beauty's end!
The arms short, the fingers stiff,
the shoulders completely humped.
The breasts, you ask? All shrivelled—
hips and paps alike.
. . . The thighs
no longer thighs but skin and bone
mottled like some sausage.

9. Geffroy [200], p.226. "Une Vieille femme qui est la statue même des décadences et des regrets de la vieillesse. On songe, en la regardant, aux vers de Ronsard, aux vers de Baudelaire. La vie vécue apparaît avec ses espoirs anéantis et sa décrépitude irrémédiable."

10. In 1967 this drawing belonged to M. Claude Cueto, Paris. It had been in the collection of Mlle Guillemot, daughter of Maurice Guillemot, until that date.

11. Spear [332], p.78, n.11, believes that this work cannot be the same as that exhibited as no.6, *Bas-relief. Deux vieilles femmes. L'une d'elles est à modifier,* in the 1889 exhibition, although it is difficult to see what other work it could be.

12. Bénédite [10a], p.29. "He also made a marble version of this figure in half life-size, of which Victor Peter made a cast, which was bought by a foreign collector and then presented to one of the Viennese galleries. The marble was acquired by the State for the Musée du Luxembourg for the sum of 2,000 francs." *See also* the catalogue of the Rodin exhibition, Basel, 1918 [351], no.31. "Rodin en a exécuté anciennement une figure grandie à la demi-nature, en marbre."

REFERENCES

Maillard [71], pp.131–32; repr. opp. p.126; Mauclair [77a], p.29, repr.opp.p.29; Lawton [67], pp.121–22, repr.opp.p.121; Gsell [57b], pp.35–40, repr.pl.7; Lami [4], p.168; Bénédite [10a], p.29, repr. pl. XXXVII; Grappe [338], no.165; Watkins [342], no.26, repr.p.13; Grappe [338a], no.190; Grappe [338b], no.148; Grappe [338c], no.109; Story [103], pp.19, 145, nos.40, 41, repr. pls.40, 41; Grappe [338d], no.122; Grappe [54], p.141, repr.p.58; Elsen [37], p.133, repr.pl.93; Story [103a], nos.30, 31, repr. pls.30, 31; Elsen [38], pp.62–66, repr.pp.64–65; Tancock [341], no.6, repr.p.30.

OTHER CASTS

FRANCE
Paris, Musée Rodin. Signed: A.Rodin.

GREAT BRITAIN
Glasgow, Glasgow Art Gallery and Museum. Burrell Collection.

JAPAN
Tokyo, National Museum of Western Art. Signed. Founder: Alexis Rudier.

SWITZERLAND
Lausanne, Collection Samuel Josefowitz. Founder: Persinka.

UNITED STATES
Beverly Hills and New York City, B.G.Cantor Collections. Founder: Georges Rudier. Cast no. 5/12.
New York City, Metropolitan Museum of Art. Gift of Thomas F.Ryan, 1910. Purchased from Rodin.
Stanford, Stanford University Art Gallery and Museum. Gift of B. G. Cantor Art Foundation. Founder: Georges Rudier.
Washington, D.C., Hirshhorn Museum and Sculpture Garden, Smithsonian Institution. Founder: Alexis Rudier.

RELATED WORK

Dried-Up Springs

Plaster, height 26 inches

FRANCE
Meudon, Musée Rodin (fig. 7–4).

8 Eve

1881

Bronze, 67 × 18½ × 23¼ inches
Signed by figure's left foot: A. Rodin
Foundry mark back of base to right:
ALEXIS RUDIER./Fondeur Paris.

On October 20, 1880, Rodin wrote to Edmond Turquet, Undersecretary of state for Fine Arts, that he proposed to flank *The Gates of Hell* on which he was working with "two colossal figures" which would cost 5,000 francs each *(see no. 4)*. One of these figures was *Adam.* The other was *Eve,* the first life-size female figure since the accidentally destroyed *Bacchante* of about 1864–70. It is hardly surprising that, in his endeavor to understand Michelangelo, Rodin first concentrated on the male figure. The prehistory of the *Adam,* as part of Rodin's preoccupation with Michelangelo, can be pieced together from references in letters and from other sources before completion of the work in 1880. For the *Eve,* however, this is not the case. It seems more probable that Rodin first thought of making a figure of *Eve* when work on the *Adam* was nearly complete, rather than that the two were initially conceived of as a pair. This idea probably occurred when he considered flanking *The Gates* with colossal figures of the tragic couple.

Eve was an extremely popular subject with academic sculptors in the late nineteenth century. Eugène Delaplanche (1836–1891) exhibited an *Eve after the Fall* (fig. 8–1) at the Salon of 1870 as did Alfred Boucher (1850–1934) at the Salon of 1875 (fig. 8–2). Gaston Guitton's *Eve* was exhibited at the Salon of 1876[1] while Laurent-Honoré Marqueste's was shown in 1888 (fig. 8–3). Rodin, whose iconography is much closer to that of the Salon artists of his time than is generally recognized, may well have worked on his *Eve* as a Salon entry.

The study for *Eve,* used in the same design for a fireplace in 1912–13 as the *Adam* (figs. 8–4, 8–9), bears the same relationship to the finished sculpture as does the study for the latter work. The forms are elongated and elegant, with a pronounced *contrapposto,* but they lack the intensity of emotion and the power of the larger figure.[2] As is the case with *Adam,* Rodin then studied the same figure from life, using the well-known model Mme Abruzzezzi, who also posed for *Cybele* of 1889 (fig. 25–3) and *Ariadne,* before 1889.[3] He was particularly impressed by her, describing her in the following words to Dujardin-Beaumetz:

> The dark one had sunburned skin, warm, with the bronze reflections of the women of sunny lands; her movements were quick and feline, with the lissomeness and grace of a panther; all the strength and splendor of muscular beauty, and that perfect equilibrium, that simplicity of bearing which makes great gesture. At that time I was working on my statue "Eve."
>
> Without knowing why, I saw my model changing. I modified my contours, naïvely following the successive transformations of ever-amplifying forms. One day, I learned that she was pregnant;

148

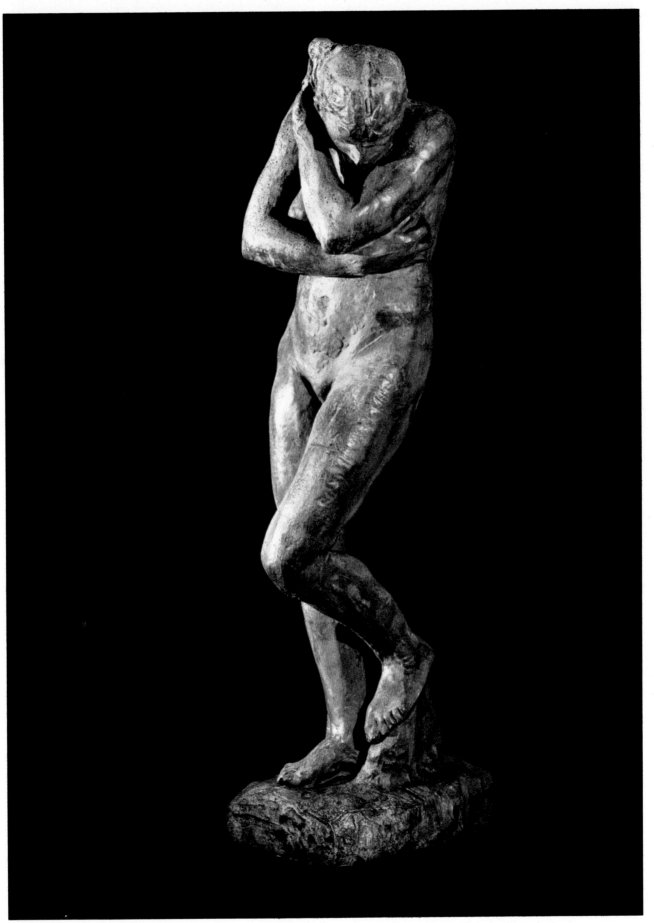

8 Front

then I understood. The contours of the belly had hardly changed; but you can see with what sincerity I copied nature in looking at the muscles of the loins and sides.

It certainly hadn't occurred to me to take a pregnant woman as my model for Eve; an accident—happy for me—gave her to me, and it aided the character of the figure singularly. But soon, becoming more sensitive, my model found the studio too cold; she came less frequently, then not at all. That is why my "Eve" is unfinished.[4]

Thus Rodin stopped work abruptly on this first life-size figure of *Eve*. The surfaces of certain areas—notably on the stomach and head—are left very rough in comparison with Rodin's major figures before that date (although not with those completed afterward), and the forms are much more generalized than those of the *Adam*. The metal supporting strap over the figure's right foot was left uncovered and was retained when the work was finally cast in bronze. Ruth Mirolli has observed that in the process of reworking the figure the nature of the gesture has changed altogether. With one arm held across the body under the breasts and the other held against the head, the reference now is to the *Adam* of *The Expulsion* on the Sistine ceiling.[5]

The life-size *Eve* was not exhibited at the Salon until 1899. Rodin's decision not to employ a pedestal but to place the figure on the ground excited more comment than the sculpture itself. "M. Rodin is an unyielding revolutionary," declared one journalist. "He has simply placed his statue on ground level. This suppression of the pedestal will count as a most dangerous innovation for some, as a most daring one for others; and at the next salon I expect to see the sculptors divided into two parties who will perhaps come to blows over it."[6]

The work itself, however, had long been popular, although it had been seen only in reduced size (fig. 8–5). In 1883 a half life-size version was exhibited at the Egyptian Hall in London, together with six other works.[7] (By 1886 a marble reduction was in the collection of Auguste Vacquerie and by 1887 another marble was in the possession of Mme Savinel.[8]) Unfortunately, in the process of reduction the suggestive *non-finito* of the full-scale figure was abandoned in favor of smoother surfaces and greater detail, especially in the treatment of the head, and the forms became more compact. The left foot of the figure rests on a small support, as it does in the life-size version. The forms have become smoother in the marbles (*see* fig. 8–6) and, through compression, the figure of *Eve* seems to have become considerably younger.

As often occurs in Rodin's marbles, the legs are supported by a rough-hewn, rocky outcrop. This led Georges Grappe to christen the life-size marble *Eve on the Rock* so as to distinguish it from the first *Eve*.[9] Bronzes were then cast from the marble reduction (fig. 8–7).

It has not been possible to determine when the marble enlargement that is now in the Musée Rodin was made. Others can be dated with some accuracy, however. Working from the original plaster in 1906–7, Antoine Bourdelle carved the stone version of *Eve on the Rock* (fig. 8–8) which is now in Copenhagen. Rodin authorized him to employ a new model for the head and the feet, which had been left unfinished in the plaster.[10] A further life-size marble was commissioned by Samuel P. Colt in 1906. A comparison of the various reductions and enlargements with the life-size bronze of *Eve* reveals, as is often the case, a great decline in expressive power and sensitivity.

At the Musée Rodin in Meudon there is an assemblage, 37 by 20⅞ by 13½ inches, which consists of three figures, *Eve, Meditation,* and *The Crouching Woman.*[11]

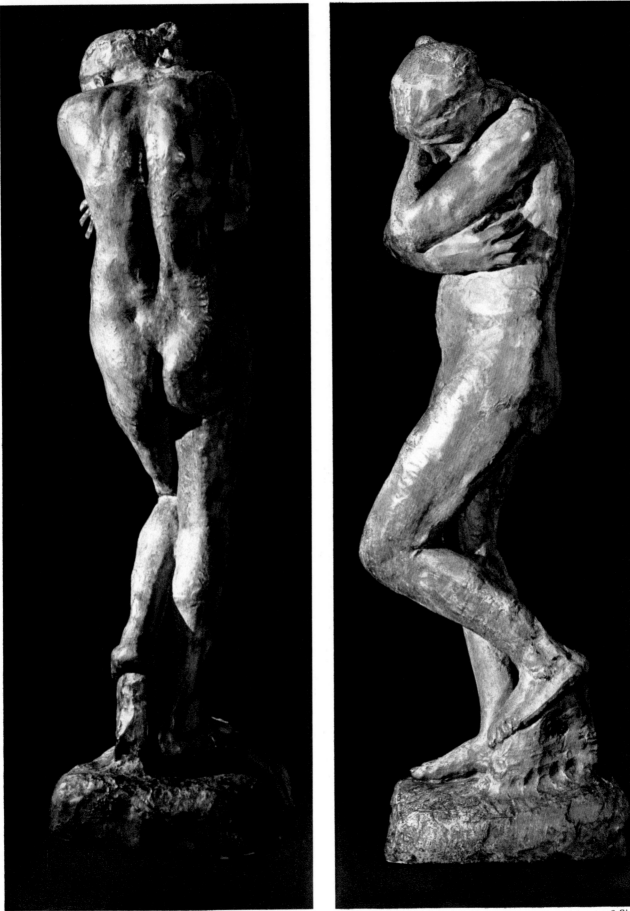

8 Back

8 Side

1. Mirolli [81], repr.pl.142.

2. Ibid., pp.209–10. Mirolli has observed that the forms of the figure are close to those of the French Mannerists. She compares a Carpeaux drawing after a figure from the *Fontaine des Innocents* with Rodin's sketch for *Eve*. A drawing such as no.72 in the Musée Rodin of a reclining female figure holding an urn gives further indication of Rodin's interest in the School of Fontainebleau.

3. Grappe [338d], nos.224 and 238 respectively. This information was conveyed to Judith Cladel on May 13, 1930, by Auguste Beuret. The interview is preserved in the Cladel archives in the Lilly Library, Indiana University, Bloomington.

4. Dujardin-Beaumetz in Elsen [39], p.164. *See also* an account of the same incident in Ludovici [70], p.123. Maillard [71], p.119, was also struck by the happy coincidence that Rodin's model had become pregnant while posing for him: "La créature est dans l'extase palpitante d'une attente mystérieuse; quelque chose d'inoui et de définitif va se révéler à elle, et en elle:

'Et, pâle, Eve sentit son flanc qui remuait.'

"L'évocation statuaire dit magnifiquement l'exquise caresse du vers de la *Légende des Siècles*. Rodin, comme Hugo, a résumé l'inconnu de la création en une formule de frisson."

5. Mirolli [81], p.211.

6. *See* "La Sculpture," *La Revue de l'Art,* Paris, 1899, p.474. "On ne savait trop que dire, en effet, de cette figure en bronze, austère, triste, évidemment qu'on n'aimait pas, mais sur laquelle on ne pouvait pas développer de longues théories d'esthétique mondaine. Heureusement, il y avait le socle! ou du moins il n'y en avait pas. Car, voilà, Monsieur Rodin est un révolutionnaire irréductible: il a simplement mis sa statue à ras du sol. Cette suppression du piédestal comptera comme une innovation des plus dangereuses pour les uns, des plus hardies pour les autres, et je m'attends pour le salon prochain à voir les statuaires se partager en deux camps qui peut-être en viendront aux mains."

The writer of "Le Salon de 1899" in *La Vigie,* Paris, May 9, 1899, was also struck by the figure's absence of a base: "Dépourvue de socle et comme plantée en terre, notre mère commune cache son front dans ses bras."

7. Bartlett in Elsen [39], p.54. The other works exhibited included *St.John the Baptist* (plaster), the *Man with the Broken Nose,* busts of *Laurens, Legros,* and *The Little Alsatian Girl,* and *The Children's Kiss.*

8. *See* Grappe [338d], no.65. *See also* Félicien Champsaur, "De Cinq à Six," *L'Evénement,* Paris, February 5, 1887. The marble in the Staatliche Kunstsammlungen, Dresden, was purchased in 1901, while that in the possession of Mr. and Mrs. Dan Erskine Edgerton was commissioned by Mrs. Julia Richardson in 1899. Another marble was also in the collection of Henri Vever in 1901.

9. Grappe [338d], no.66. Grappe's notion of the relationship between the various versions was somewhat vague. He lists three, a life-size bronze, height 67 inches, no.65; a life-size marble, height 69 inches, no.66; and another life-size bronze, height 69 inches, no.67, of which he says mysteriously: "Le plâtre n'est qu'une réplique agrandie de l'œuvre précédente."

10. Information conveyed by M. Michel Dufet, Conservateur du Musée Bourdelle, Paris.

11. It seems most unlikely that in 1881 Rodin assembled this group, which also incorporates a bough, as suggested by Jianou and Goldscheider [65], p.89.

8–1
Eugène Delaplanche
Eve after the Fall
c. 1870, marble
Location unknown

8–2
Alfred Boucher
Eve after the Fall
c. 1875, marble
Location unknown

8–3
Laurent-Honoré Marqueste
Eve
c. 1888, marble
Location unknown

8–4
Study for "Eve"
1878–80?, bronze
Location unknown

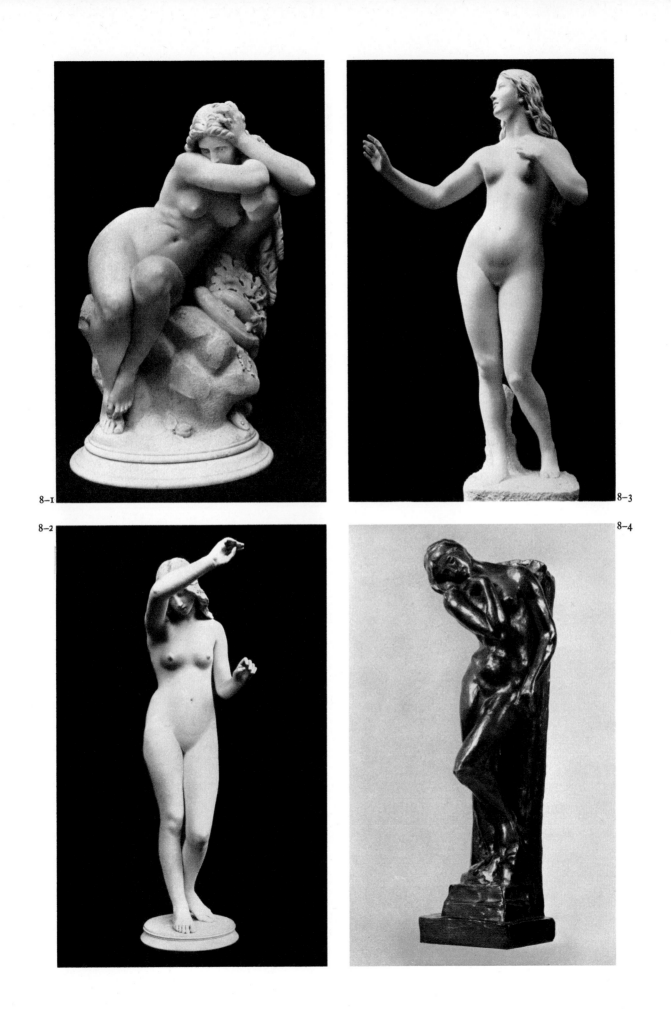

8–1

8–2

8–3

8–4

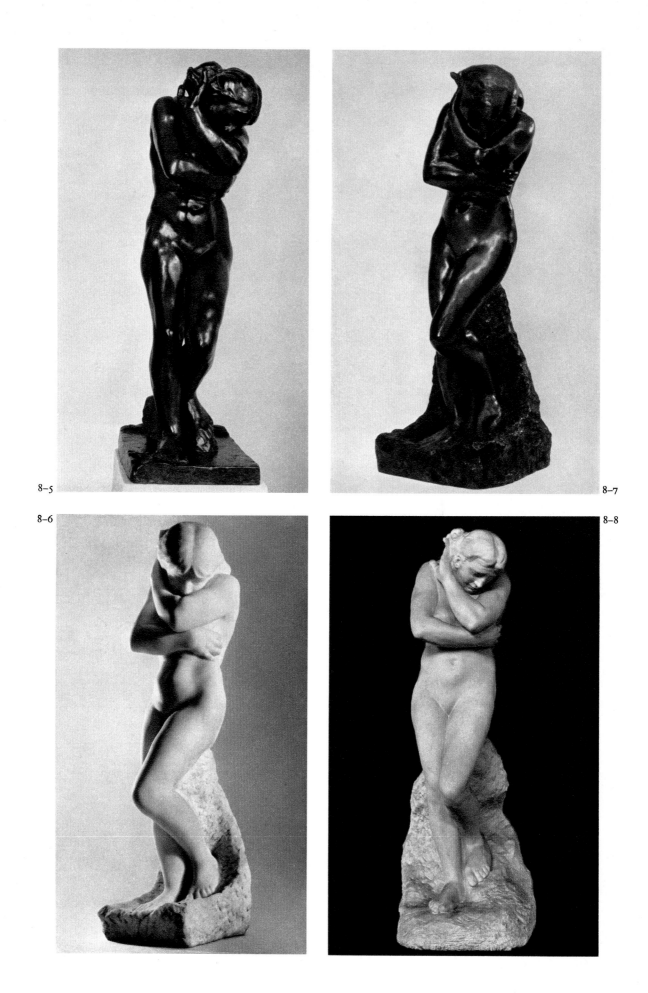

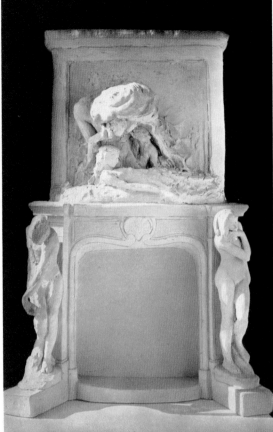

8-9

8-5
Eve (reduction "B")
By 1883, bronze, height 29½ inches
Hessisches Landesmuseum, Darmstadt

8-6
Eve (reduction "A")
By 1883, marble, height 30½ inches
Location unknown

8-7
Eve (reduction "A")
By 1883, bronze, height 27⅝ inches
Walker Art Gallery, Liverpool

8-8
Eve on the Rock
1906-7, limestone, height 68½ inches
Ny Carlsberg Glyptotek, Copenhagen
Gift of Ny Carlsbergfondet, 1907

8-9
Fireplace showing figures of
Adam and *Eve* (first project)
1912-13, plaster, height 29⅞ inches
Musée Rodin, Meudon

REFERENCES

Bartlett [125], p. 113; Geffroy [199a], p. 16; Maillard [71], p. 119; Mauclair [77a], p. 14, repr. opp. p. 12; Lawton [67], pp. 108-9, repr. opp. p. 109; Rilke [87], p. 30, repr. pls. 21-22; Dujardin-Beaumetz [35], p. 64; Lami [4], p. 171; Bénédite [10a], pp. 19, 26-27, repr. pl. XVI; Ludovici [70], p. 123; Grappe [338], nos. 39-41; Watkins [342], p. 7, repr. p. 6; Grappe [338a], nos. 55-58; Grappe [338b], nos. 75-77; Cladel [26], p. 143; Grappe [338c], nos. 59, 59 bis, 59 ter; Story [103], p. 144, nos. 27, 28, repr. pls. 27, 28; Grappe [338d], nos. 65-67; Waldmann [109], pp. 39, 75, nos. 26, 27, repr. pls. 26, 27; P. L. Grigaut, "Rodin's Eve," *Detroit Institute Bulletin,* Detroit, 33, no. 1 (1953-54), p. 14; Elsen [37], pp. 66, 89; Story [103a], no. 22, repr. pl. 22; Elsen [38], p. 49, repr. p. 51; Mirolli [81], pp. 208-11; Tancock [341], no. 7, repr. p. 33.

OTHER CASTS AND VERSIONS

Bronze

AUSTRIA
Vienna, Kunsthistorisches Museum. Purchased in 1928 from the Musée Rodin. Signed: A. Rodin. Founder: Alexis Rudier.

FRANCE
Lyons, Musée des Beaux-Arts. Purchased from Rodin in 1906.
Paris, Collection Valentin Abdy.
— Musée Rodin. Signed: A. Rodin. Founder: Alexis Rudier.

GERMANY (WEST)
Essen, Museum Folkwang (ex. Collection Karl-Ernst Osthaus, Hagen). Signed: A. Rodin.
Frankfurt, Städelsches Kunstinstitut. Purchased in 1953 from a private collection. Signed. Founder: Alexis Rudier.
Hannover, Städtische Galerie (ex. Collections Boghos Pascha Nubar; Zareh Nubar, Paris). Signed: A. Rodin. Founder: Alexis Rudier.
Mannheim, Städtische Kunsthalle. Signed: A. Rodin. Founder: Alexis Rudier.

GREAT BRITAIN
Cardiff, National Museum of Wales. Purchased in 1916 by Miss G. Davies. Bequeathed to museum in 1952. Signed: A. Rodin. Founder: Alexis Rudier.

Harlow (Essex), Harlow Urban District Council. Situated in garden adjoining the Town Hall. Acquired from the Musée Rodin in 1960.

Manchester, City Art Gallery. Commissioned from Rodin by the gallery and cast between October 1911 and September 1912. Signed: A. Rodin. Founder: Alexis Rudier.

UNITED STATES

Buffalo, Albright-Knox Art Gallery. Purchased in 1926 by Fellows for Life Fund. Signed: A. Rodin. Founder: Alexis Rudier. Cast in 1913.

Detroit, Detroit Institute of Arts. Gift of the Founders Society (ex. Collection Alexis Rudier). Signed. Founder: Alexis Rudier.

Los Angeles, Los Angeles County Museum of Art. Gift of B. G. Cantor Art Foundation. Founder: Susse. Cast no. 9.

New York City, Metropolitan Museum of Art. Gift of Thomas F. Ryan, 1910. Purchased from Rodin.

Toledo, Toledo Museum of Art. Gift of Edward Drummond Libbey. Signed: A. Rodin. Founder: Alexis Rudier. Cast in 1910.

Plaster

BELGIUM

Brussels, Musée d'Ixelles (height 68⅞ inches).

FRANCE

Paris, Musée Rodin. Presented by the heirs of Alexis Rudier in 1950 (height 63¾ inches).

THE NETHERLANDS

Rotterdam, Museum Boymans-van Beuningen. Commissioned from Rodin in 1899 by J. Hudig. Given to the museum in 1901 (height 69¼ inches).

UNITED STATES

Maryhill, Wash., Maryhill Museum of Fine Arts (height 68 inches).

Bronze, height about 29½ inches (cast from the reduced marble, the figure is free-standing)

FRANCE

Paris, Collection M. B. Lorenceau. Founder: Alexis Rudier.

GERMANY (WEST)

Darmstadt, Hessisches Landesmuseum. Signed: A. Rodin. Founder: Alexis Rudier (fig. 8–5).

NEW ZEALAND

Wellington, National Art Gallery. Signed: A. Rodin. Founder: Georges Rudier. Cast in 1959.

SWITZERLAND

Lausanne, Collection Samuel Josefowitz. Founder: Alexis Rudier.

UNION OF SOUTH AFRICA

Johannesburg, Johannesburg Art Gallery. Signed.

UNITED STATES

Baltimore, Baltimore Museum of Art. Jacob Epstein Collection. Signed: A. Rodin. Founder: Alexis Rudier.

Beverly Hills, Collection Mrs. Jefferson Dickson (ex. Collection Jules Mastbaum). Founder: Alexis Rudier.

New York City, Collection Mrs. David Bortin. Founder: Alexis Rudier.

Pittsburgh, Museum of Art, Carnegie Institute. Purchased in 1920 from the Musée Rodin. Founder: Alexis Rudier.

Shreveport, R. W. Norton Art Gallery. Signed. Founder: Alexis Rudier.

Bronze, height 27⅝ inches (cast from the reduced marble, the figure emerges from a rough-hewn base)

ARGENTINA

Buenos Aires, Museo Nacional de Bellas Artes. Gift of Ines Llobet de Gowland. Founder: Persinka.

AUSTRALIA

Collection G. V. Parmentier.

FRANCE

Paris, Musée Rodin. Founder: Georges Rudier.

GREAT BRITAIN

Glasgow, Glasgow Art Gallery and Museum. Burrell Collection. Signed: A. Rodin. Founder: Alexis Rudier.

Liverpool, Walker Art Gallery (fig. 8–7).

UNITED STATES

Beverly Hills and New York City, B. G. Cantor Collections. Founder: Georges Rudier. Cast no. 12/12.

Terra-cotta

GERMANY (WEST)

Munich, Bayerische Staatsgemäldesammlungen.

Plaster

FRANCE

Paris, Musée Rodin.

ROMANIA

Bucharest, Muzeul de Artă.

UNITED STATES

San Francisco, California Palace of the Legion of Honor. Spreckels Collection. Inscribed: Modèle pour le bronze Eve [illegible word] par Rodin.

Marble

Location unknown (height 30½ inches) (fig. 8–6).

CANADA

Toronto, Art Gallery of Ontario. Gift of Mr. and Mrs. Frank P. Wood, 1928. Not signed or dated (height 30 inches).

GERMANY (EAST)

Dresden, Staatliche Kunstsammlungen. Purchased from Rodin in 1901. Signed: A. Rodin (height 31 inches).

GERMANY (WEST)

Krefeld, Kaiser Wilhelm Museum. Signed: A. Rodin (height 31½ inches).

SWITZERLAND

Lausanne, Collection Samuel Josefowitz (height 30 inches).

UNITED STATES

Buffalo, Albright-Knox Art Gallery. Gift of Colonel Charles Clifton, 1924 (ex. Collections Hector Brame, Paris; Knoedler, 1922). Signed: A. Rodin (height 30 inches).

Chicago, Art Institute of Chicago. Mr. and Mrs. Martin A. Ryerson Collection. Made by Rodin as a gift for Dr. Vivier, who had brought Mme Rodin through a severe illness. Signed: A. Rodin (height 30 inches).

New York City, Estate of Geraldine R. Dodge (height 31 inches).

Portland, Me., Collection Mr. and Mrs. Dan Erskine Edgerton. Commissioned by Mrs. Julia Richardson in 1899 and delivered the same year (height 30¾ inches).

Washington, D. C., Corcoran Gallery of Art. Acquired from Rodin by Mr. W. A. Clarck (height 30 inches).

U.S.S.R.

Moscow, State Pushkin Museum of Fine Arts.

Eve on the Rock

Limestone, height 68½ inches

DENMARK

Copenhagen, Ny Carlsberg Glyptotek. Gift of Ny Carlsbergfondet, 1907. Purchased by Carl Jacob-

sen in 1907. Carved by Antoine Bourdelle. Signed: A. Rodin 1907 (fig. 8–8).

Marble, height 63 inches

FRANCE

Paris, Musée Rodin

UNITED STATES

Dallas, Elizabeth Meadows Sculpture Garden, Southern Methodist University.

Bronze (cast from the marble)

JAPAN

Tokyo, National Museum of Western Art (ex. Collection Matsukata). Signed: A. Rodin. Founder: Alexis Rudier.

9 Head of Sorrow (Joan of Arc)
by 1882 (enlarged 1907?)

Bronze, 17 × 19½ × 21¼ inches
Signed front of rocky base to right: A. Rodin
Foundry mark back of base to left:
Alexis Rudier/Fondeur PARIS

Rodin had worked on a group of *Ugolino and His Sons* while still in Brussels in 1876, but he was apparently dissatisfied with the work and destroyed it, with the exception of the body of the principal figure.[1] A second version of this theme dates from 1882 (*see* Chronology). In this group, for the figure of the son pulling himself up onto his father's back, Rodin used a head that was to appear on many occasions in his later work. When cast separately in bronze in various dimensions it was to be called *Head of Sorrow*. The dimensions of this head as used in the group correspond with the detached 2½-inch version.

This head is used four times in *The Gates of Hell*—in the group of *Ugolino and His Sons* already mentioned (no. 1, detail B), as the head of Paolo in the group of *Paolo and Francesca* low down in the middle of the left-hand leaf of *The Gates* (no. 1, detail A), and in the male figure in the group that became known as *Fugitive Love (Fugit Amor)* at the bottom right-hand corner of the right leaf.[2] A somewhat modified version, in which the line of the brow is much more marked, is used in the male figure in the group from the center of the right-hand leaf (*see* no. 1, detail M), which Grappe referred to as *Study for "Fugitive Love."*[3]

Detached from the group of *Fugitive Love* and in an upright, beseeching position, the male figure became known as *The Prodigal Son*. This was subsequently enlarged to 55 inches in height and carved in marble. From this a number of bronze casts were made (*see* pl. 5).[4] Thus, this head, which was used at a number of focal points in *The Gates*, gained an ever wider currency when these groups and figures were detached and exhibited as independent works.[5]

In the first two editions of the catalogue of the Musée Rodin,[6] Grappe assigned a date of 1892 to the life-size head. It had, however, undergone enlargement by at least 1889, having been used in the figure of *The Prodigal Son*, and in subsequent editions of his catalogue Grappe revised the dating to 1882, the year of its initial conception. The first of the marble versions seems to date from 1904. In that year a marble in which the head rests on the shell of a tortoise was presented to the Kunstmuseum in Düsseldorf by Frau Dr. Louise Haniel (fig. 9–1). According to Grappe[7] it was about to be called *Head of Medusa* before the title *Head of Orpheus* was chosen as being more appropriate. It is now known as *The Last Sigh*.

Rodin returned to the head in 1905. On the occasion of a visit from the great Italian tragedian Eleanora Duse, who delighted him by her readings from Dante, he took an enlarged version of the head and gave it his own title of *Anxiety* (fig. 9–3).

The same head was again used in 1913 when it was proposed to raise a monument to Joan of Arc in the United States. In this project the head emerged from a much larger base,

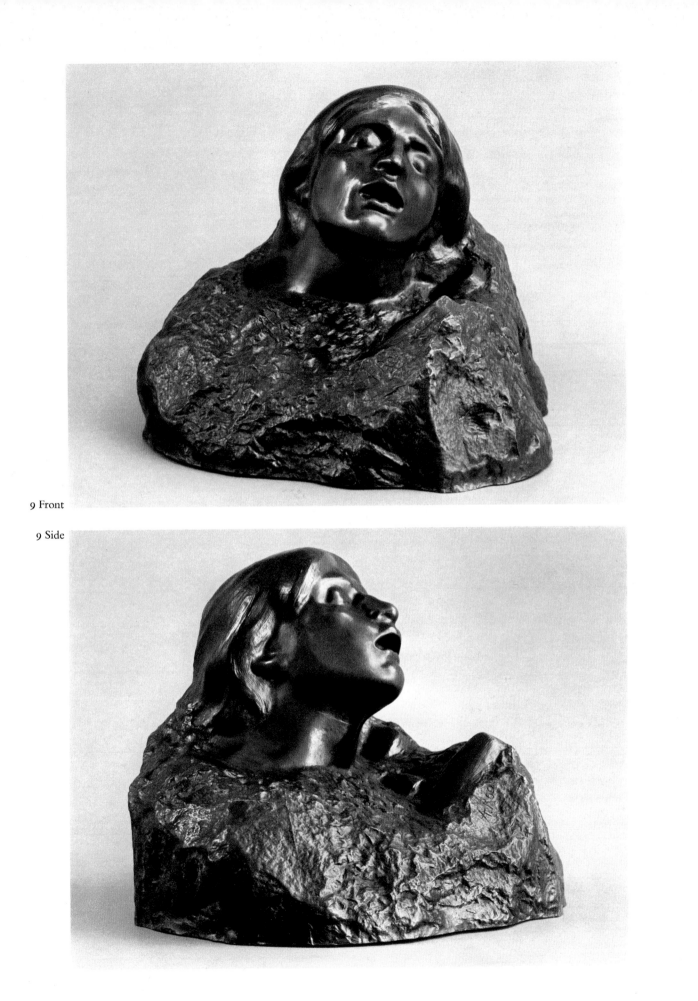

9 Front

9 Side

and through the surface there appeared the ends of the faggots used in the bonfire on which Joan of Arc suffered martyrdom. It is clearly from this version that the Philadelphia bronze was cast, as is evinced by the comparison between the chisel marks in the marble (fig. 9–5) and the indentations on the surface of the bronze cast.

The dating of this work poses a number of problems. Grappe's description of the ends of the faggots appearing through the surface of the marble leaves little room for doubt that the Philadelphia bronze corresponds with that version. The marble in the Ny Carlsberg Glyptotek, however, which appears to correspond exactly with the bronze under discussion, was commissioned by Carl Jacobsen in 1907. A number of other marbles were commissioned at the same time, that is to say, six years before the unrealized Joan of Arc project. It seems, then, that in 1913 Rodin merely returned to a project that had been fully elaborated six years before. The marble from which the Philadelphia bronze was cast thus probably dates from 1907, although the actual casting did not take place until the mid 1920s, when it was commissioned by Jules Mastbaum.

There is a striking resemblance between the sightless eyes and wide-open mouth of Rodin's head and certain heads by Bernini, notably that of St. Theresa on the Altar of St. Theresa in the Cornaro Chapel (fig. 9–2), and that of the Blessed Lodovica Albertoni in the Altieri Chapel in San Francesco a Ripa in Rome. Of all the major sculptors of the European West, Bernini seems to have meant least to Rodin. His pomp, the rhetorical nature of his gestures, the extravagance of his draperies, and his capabilities as an organizer of space, both architectural and sculptural, had little appeal for Rodin in the earlier years, although he came to appreciate him later on.[8] The emotional extremes of the figures represented in *The Gates of Hell,* however, did on occasion result in resemblances between Rodin's figures, or fragments of them, and the emotionally elated figures of Bernini. It is intensity of grief that links Rodin's head with Bernini's *St. Theresa,* represented at the supreme moment of her visions, her "transverberation" (the piercing of her heart by the arrow of Divine Love), and with his *Blessed Lodovica Albertoni,* depicted at the moment of her death.

NOTES

1. *See* Bartlett in Elsen [39], p. 33.
2. *See* Tacha [308], pp. 23–39. A plaster cast of *Fugitive Love* was first exhibited at the Sixth International Exhibition of Painting and Sculpture at the Galerie Georges Petit, Paris, 1887. Athena C. Tacha, p. 27, believes that "the *Fugit Amor* was probably conceived between 1881 and 1885, when the major part of the Gates was executed. The absence of direct Michelangelesque influence, the spatial freedom of the posture and its passionate character (which might be due to the beginning of Rodin's relation with Camille Claudel in 1883) possibly could limit the dating to 1883–85." This work was then enlarged and carved in marble.
3. Grappe [338d], no. 173.
4. Tacha [308], p. 23, believes that there are eleven casts of this work. Grappe [338d], no. 210, as-

signed to it a date of by 1889.
5. Tacha [308], p. 37, also observes that reworked versions of both the head and the torso of *The Prodigal Son* are used in *The Centauress* (no. 20) and in *Orpheus* (fig. 20–3), the latter dated 1892 by Grappe [338d], no. 261.
6. Grappe [338], no. 178; [338a], no. 206.
7. Grappe [338d], no. 67.
8. *See* no. 103.

REFERENCES

Bénédite [10a], p. 27, repr. pl. XVII (A); Grappe [338], no. 178; Watkins [342], no. 49; Grappe [338a], no. 206; Grappe [338b], no. 88; Grappe [338c], no. 67; Story [103], p. 144, no. 24, repr. pl. 24; Grappe [338d], no. 76; Grappe [54], p. 141, repr. p. 49; Story [103a], no. 19, repr. pl. 19; Tacha [308], p. 34, repr. pl. 8; Tancock [341], no. 8.

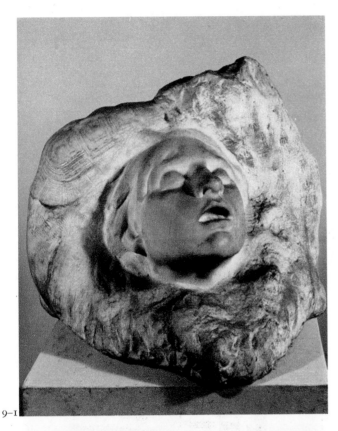

9–1

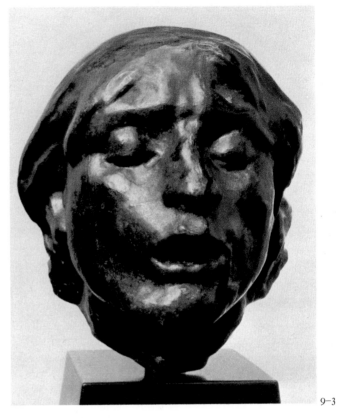

9–3

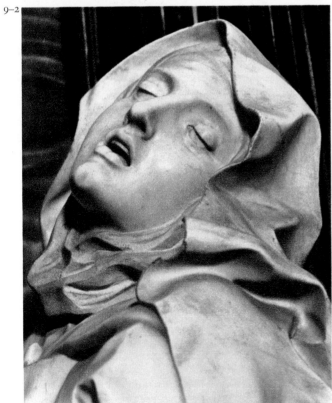

9–2

9–1
Head of Sorrow (The Last Sigh)
1904, marble, height 16⅛ inches
Kunstmuseum, Düsseldorf

9–2
Giovanni Lorenzo Bernini
The Ecstasy of St. Theresa (detail)
1645–52, marble
Cornaro Chapel, Santa Maria della
Vittoria, Rome

9–3
Head of Sorrow (Anxiety)
By 1882, bronze, height 8⅝ inches
Museum of Art, Carnegie Institute,
Pittsburgh. Gift of
G. David Thompson, 1955

OTHER CASTS AND VERSIONS

Marble

DENMARK

Copenhagen, Ny Carlsberg Glyptotek. Commissioned by Carl Jacobsen in 1907. Signed: A. Rodin (fig. 9–5).

Bronze, height 2½ inches

GREAT BRITAIN

London, Collection Elizabeth Davison. Founder: Georges Rudier.

UNITED STATES

Washington, D.C., Hirshhorn Museum and Sculpture Garden, Smithsonian Institution. Founder: Alexis Rudier.

Bronze, height 8⅝ inches

ARGENTINA

Buenos Aires, Collection Mercedes Santamarina.

FRANCE

Paris, Musée Rodin. Signed: A. Rodin.

ISRAEL

Tel Aviv, Tel Aviv Museum.

UNITED STATES

Chicago, Art Institute of Chicago. Robert Allerton Collection. Given in 1924.

Greenwich, Collection Herbert Mayer. Founder: Alexis Rudier.

New Haven, Yale University Art Gallery. Gift of Mrs. Patrick Dinehart (ex. Collection Jules Mastbaum). Founder: Alexis Rudier.

Pittsburgh, Museum of Art, Carnegie Institute. Gift of G. David Thompson, 1955. Signed: A. Rodin. Founder: Alexis Rudier (fig. 9–3).

Stanford, Stanford University Art Gallery and Museum. Gift of B. G. Cantor Art Foundation. Founder: Georges Rudier.

Washington, D.C., Hirshhorn Museum and Sculpture Garden, Smithsonian Institution. Signed: A. Rodin. Founder: Georges Rudier.

Worcester, Worcester Art Museum. Given in 1923. Signed: A. Rodin. Founder: Alexis Rudier.

Plaster, height 9 inches

CZECHOSLOVAKIA

Prague, Národní Galerie.

Marble

GERMANY (WEST)

Bielefeld, Kunsthalle Richard Kaselowsky-Haus. Signed: A. Rodin (height 19⅝ inches).

Düsseldorf, Kunstmuseum. Presented by Frau Dr. Louise Haniel in 1904 as *Der Letzte Seufzer*. Signed: A. Rodin (height 16⅛ inches) (fig. 9–1).

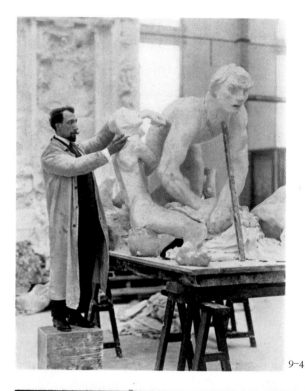

9–4

9–5

9–4
Henri Lebossé attaching the *Head of Sorrow* to the enlargement of *Ugolino* in 1906

9–5
Head of Sorrow (Joan of Arc) 1907?, marble, height 17 inches Ny Carlsberg Glyptotek, Copenhagen

10 I Am Beautiful
1882

Bronze, 27¾ × 12 × 12½ inches
Signed on rock between man's legs, toward the left: A. Rodin
Inscribed front of base:
Je suis belle, ô Mortels, Comme un rêve de pierre
Et mon sein, où Chacun s'est meurtri tour à tour
Est fait pour inspirer au poète un Amour
Etant alors muet ainsi que la matière
Foundry mark center rear of base: ALEXIS RUDIER/Fondeur. PARIS.

According to Georges Grappe,[1] the plaster version of *I Am Beautiful* dates from 1882 and was originally called *The Rape,* as it still was by Léon Maillard in 1899,[2] and in 1900 when it was exhibited under that title at the Exposition Rodin.[3] It was also known as *The Kiss,* but this name was abandoned when it became inseparably associated with the more famous marble. It has also been called *Carnal Love* and *The Cat,* but the definitive title comes from the first line of the verse by Baudelaire inscribed on the base; in Arthur Symons's translation it reads:

I am beautiful as a dream of stone, but not maternal;
And my breast, where men are slain, none for his learning,
Is made to inspire in the Poet passions that, burning,
Are mute and carnal as matter and as eternal.[4]

The same lines were later carved into the marble of *The Kiss.*

In this extraordinary group Rodin has brought together two figures conceived separately and used in *The Gates of Hell*—*The Falling Man* (placed underneath the lintel at the top of the left-hand leaf of the doors; *see* no. 1, detail κ) and *The Crouching Woman* (seen in the tympanum to the left of *The Thinker; see* no. 1, detail κ). In bringing these two works together, Rodin had to give fresh thought to certain parts of each figure. The male figure in *I Am Beautiful* has both feet on the ground, while the right leg of *The Falling Man* is bent back at the knee (fig. 10–4). He also had to revise the position of the arms. In the final work they are much less highly finished than the rest of the body, indicating that they were conceived separately and added afterward. He was also obliged to change the position of the right arm of *The Crouching Woman,* which hangs limply and does not clasp the foot. This same group was then utilized in *The Gates of Hell.* It can be seen in low relief at the top of the right-hand decorative pilaster (no. 1, detail c).

The complete figure of *The Crouching Woman* was enlarged and given a separate existence of its own (no. 6), while *The Falling Man* was used in a number of other compositions. In 1885 the collector and connoisseur Antony Roux asked Rodin to substitute a snake for the woman. "It is agreed," Rodin wrote, "only I am not making any modifications for myself.

163

It is for you that I am making changes, and it is to enter into the subject of a man struggling with a serpent that I will change the arms."[5] *The Man with a Serpent* (fig. 10–1) was thus made at the personal request of a friend.

At the Exposition of 1900 the body of *The Falling Man,* as modified for *I Am Beautiful* and *The Man with a Serpent,* was confronted with another armless figure and exhibited as *Two Struggling Figures* (fig. 10–3).[6] The splendid muscular torso, evidently the part of the figure that interested Rodin most, was also given a separate existence, in its original dimensions (fig. 10–2) and in a greatly enlarged version (height 43 ¼ inches).[7] It was the latter, sometimes referred to as *Marsyas,* that was exhibited at Düsseldorf in 1904 and entitled *Torso Louis XIV.*

NOTES

1. Grappe [338d], no. 85.
2. Maillard [71], p. 130.
3. Paris, 1900 [349], no. 123.
4. Charles Baudelaire, "Beauty" from *Flowers of Evil,* in *Baudelaire, Rimbaud, Verlaine,* ed. Joseph M. Bernstein, trans. Arthur Symons (New York: The Citadel Press, 1947), p. 24.
5. From an undated letter quoted in the catalogue of the Antony Roux Sale, Galerie Georges Petit, Paris, May 19–20, 1914, no. 145. "C'est convenu, seulement mon étude reste sans modifications pour moi. C'est pour vous que je fais des modifications et c'est pour entrer dans le sujet, d'homme luttant avec un serpent, que je changerai les bras."
6. Paris, 1900 [349], no. 118.
7. Grappe [338d], no. 82.

REFERENCES

Bartlett [125], p. 200, repr. p. 223; Geffroy [199a], p. 15; *L'Art Français,* Paris, July 6, 1889, repr.; Maillard [71], pp. 129–30, repr. opp. p. 138; Bénédite [10a], p. 31, repr. pl. LV(A); Grappe [338], no. 56; Watkins [342], no. 6; Grappe [338a], no. 73; Grappe [338b], no. 98; Grappe [338c], no. 75; Grappe [338d], no. 85; Grappe [54], p. 141, repr. p. 50; Elsen [38], pp. 61–62, repr. p. 60; Tancock [341], no. 10.

OTHER CASTS AND VERSIONS

Bronze

FINLAND
Helsinki, Kunstmuseum Athenaeum. Antell Collection. Bought in 1893.

FRANCE
Paris, Musée Rodin. Signed. Founder: Alexis Rudier.

JAPAN
Tokyo, National Museum of Western Art (ex. Collection Matsukata). Founder: Alexis Rudier.

UNITED STATES
Beverly Hills and New York City, B. G. Cantor Collections. Founder: Georges Rudier. Cast no. 5.
Philadelphia, Collection Mrs. Charles J. Solomon. Signed. No foundry mark.

Terra-cotta

UNITED STATES
Maryhill, Wash., Maryhill Museum of Fine Arts.

Plaster

FRANCE
Paris, Musée Rodin (ex. Collection Antony Roux).

RELATED WORKS

The Man with a Serpent

Plaster, height 27½ inches

UNITED STATES
Williamstown, Mass., Sterling and Francine Clark Art Institute (ex. Collection Antony Roux) (fig. 10–1).

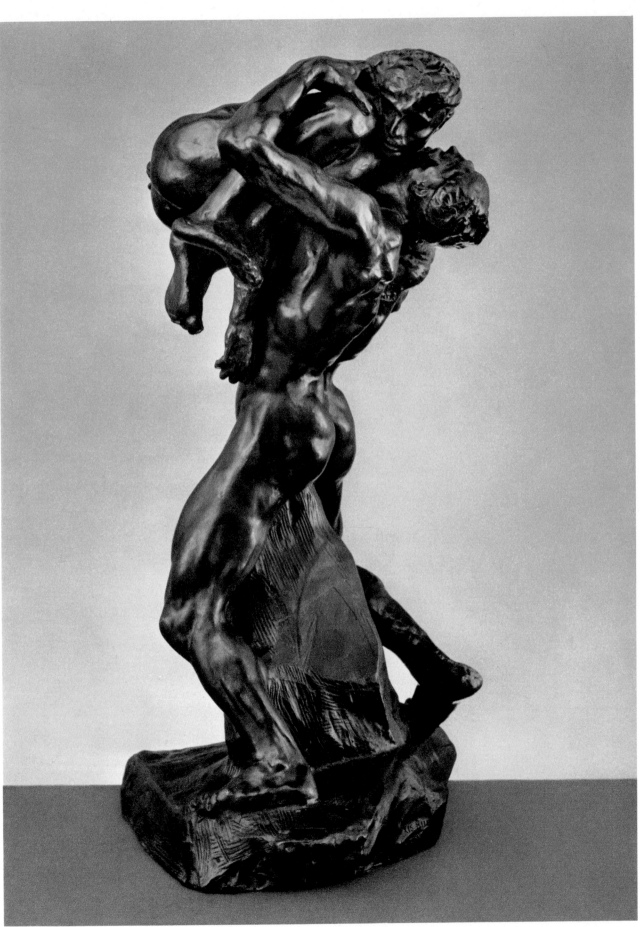

10

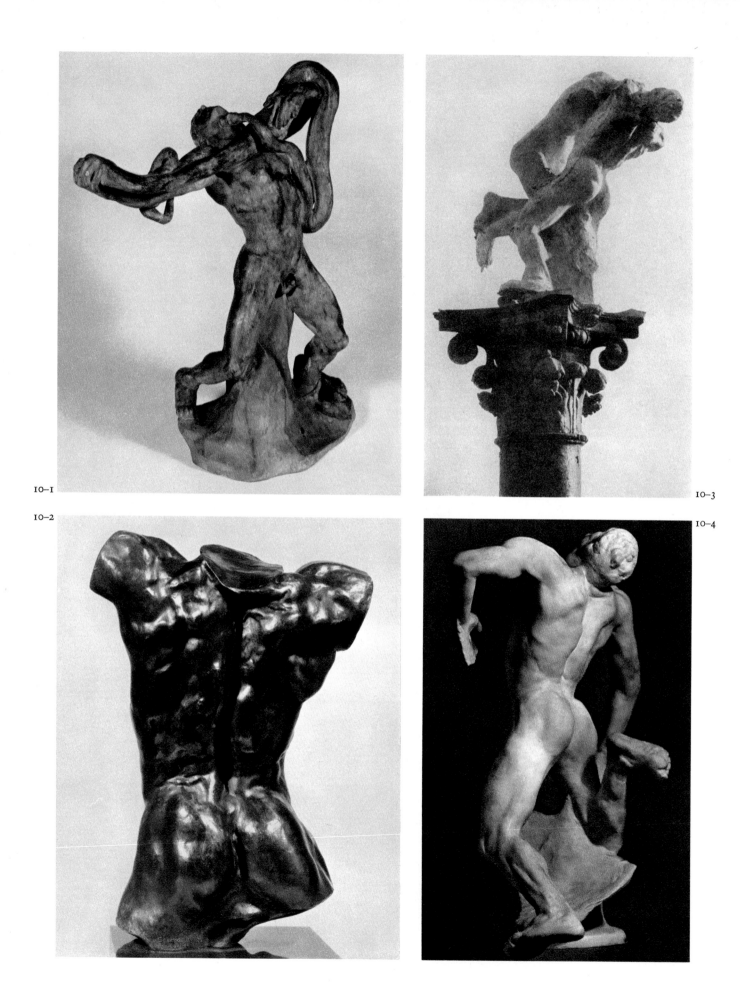

10–1

10–2

10–3

10–4

Bronze

FRANCE

Paris, Collection Mrs. Jacques Ray (ex. Collections Sterling and Francine Clark; Antony Roux). Signed.

The Falling Man

Plaster, height 23⅝ inches

FRANCE

Paris, Musée Rodin (fig. 10–4).

Torso of "The Falling Man"

Bronze, height 12¼ inches

Location unknown (fig. 10–2).

UNION OF SOUTH AFRICA

Stellenbosch, Peter Stuyvesant Foundation. Founder: Georges Rudier. Cast no. 9/12.

UNITED STATES

Beverly Hills, Collection Leona Cantor. Founder: Georges Rudier. Cast no. 4/12.

Chicago, Collection A. James Speyer. Founder: Georges Rudier.

Stanford, Stanford University Art Gallery and Museum. Founder: Georges Rudier. Cast no. 7/12.

Bronze, height 13½ inches (with slightly different treatment of base)

UNITED STATES

Montclair, N. J., Kasser Foundation. Signed: A. Rodin. Founder: Alexis Rudier. Cast no. 1/12.

Marsyas (enlarged version of the "Torso of 'The Falling Man'")

Plaster, height 43¼ inches

FRANCE

Paris, Musée Rodin.

Bronze

SWITZERLAND

Lausanne, Collection Samuel Josefowitz. Founder: Georges Rudier.

UNITED STATES

Los Angeles, Los Angeles County Museum of Art. Gift of B.G. Cantor Art Foundation. Founder: Georges Rudier. Cast no. 2.

10–1
The Man with a Serpent
1885, plaster, height 27½ inches
Sterling and Francine Clark
Art Institute, Williamstown,
Mass.

10–2
Torso of "The Falling Man"
1882, bronze, height 12¼ inches
Location unknown

10–3
Two Struggling Figures
Mid 1880s?, plaster
Location unknown

10–4
The Falling Man
1882, plaster, height 23⅝ inches
Musée Rodin, Paris

11 Kneeling Fauness
c. 1884

Bronze, 21 × 8 (base) × 10½ inches
Signed top of base by figure's left leg: A. Rodin.
Inscribed front of base: Faunesse
and on right side of base, toward front: 2^{ème} Epreuve.
Foundry mark right side of base: F. RUDIER./ FONDEUR.PARIS.

This figure, of particularly demonic aspect, can be seen kneeling at the far left of the tympanum of *The Gates of Hell (see* no. 1, detail E).[1] It was dated 1886 in the first two editions of the Musée Rodin catalogue,[2] but in subsequent editions Grappe revised the dating to 1884 after finding a plaster belonging to a collector by the name of Stenesco, entitled *Condemned Fauness,* which was dated 1884. He suggests plausibly that it may date from an even earlier period in the evolution of *The Gates,* that is to say, 1882–83.[3] A *Kneeling Fauness* was exhibited at the Exposition Monet-Rodin in 1889 and is probably to be identified with this figure.[4] Noteworthy is the extreme contrast between the svelte curves of the body and the battered treatment of the facial features. It is related to a number of other figures in the tympanum, notably to the two kneeling figures seen from behind to the right of *The Thinker (see* no. 1, detail K).

Another related bronze (fig. 11–1), which must date from the same period, replaces the head of the fauness with one that is inclined more to the right. In addition, the figure's left leg is merged with the rough-hewn base, which climbs as far as the navel. It is this figure, rather than the fauness from the tympanum, that Rodin used in 1888 to illustrate Baudelaire's "Le Guignon" ("Bad Luck"), from *Les Fleurs du Mal* (fig. 11–2). *La Toilette de Vénus* (fig. 11–4), before 1886,[5] also belongs to this group of kneeling female figures, but the pose is more relaxed, the hair longer, and the mood less baleful.

At approximately the same time, the figure of the fauness was removed from *The Gates,* together with the group of figures hovering over it, and retitled *Orpheus and the Maenads* (fig. 11–3). The work, enlarged in marble, was assigned a date of before 1889 by Grappe.[6]

It is interesting to note that Rodin was not alone in using the figure of the *Kneeling Fauness* as the subject of a work in another medium. Some fourteen years after he used it to illustrate Baudelaire's poem, Edvard Munch turned to it in his print *Veranda* (fig. 11–5), which forms part of a suite of sixteen etchings and lithographs entitled "The House of Max Linde." To the right there is a group of palms and flowers while to the left the *Kneeling Fauness* can be seen on a pedestal. Munch's highly ambivalent attitude toward women and the female principle makes it seem almost inevitable that he should have been attracted to Rodin's sensual but glowering creature. As desirable as it is threatening, it seems to be the physical embodiment of certain of Munch's voracious females.

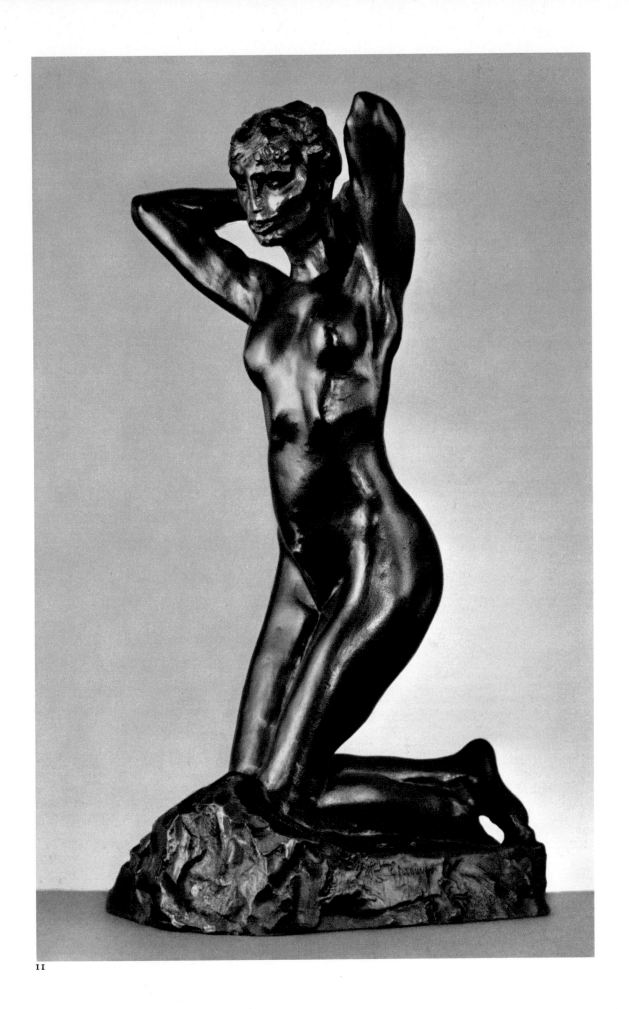

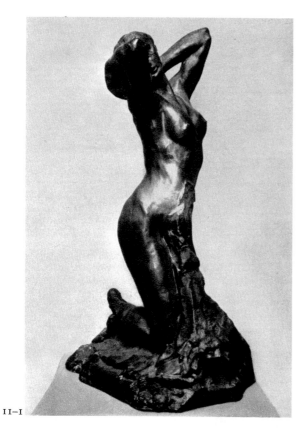

11-1

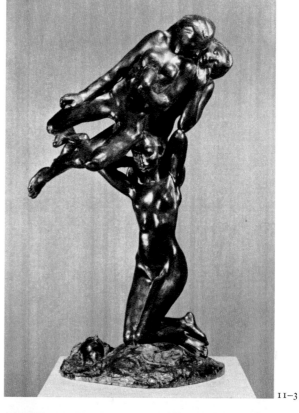

11-3

11-2

11-4

XI

LE GUIGNON

Pour soulever un poids si lourd,
Sisyphe, il faudrait ton courage!
Bien qu'on ait du cœur à l'ouvrage,
L'Art est long et le Temps est court.

Loin des sépultures célèbres,
Vers un cimetière isolé,
Mon cœur, comme un tambour voilé,
Va battant des marches funèbres.

— Maint joyau dort enseveli
Dans les ténèbres et l'oubli,
Bien loin des pioches et des sondes;

Mainte fleur épanche à regret
Son parfum doux comme un secret
Dans les solitudes profondes.

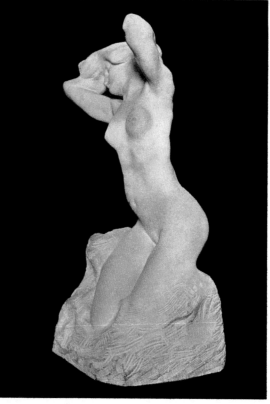

170

11–5

NOTES

1. Bartlett in Elsen [39], p. 74, described this figure in the following words: "The central figure of this part of the panel is a kneeling female satyr clasping her hands behind her head. She personifies sensual passion, and expresses in her position the consciousness of her condition and readiness to accept the coming punishment."
2. Grappe [338], no. 95; [338a], no. 117.
3. Grappe [338d], no. 109. "Il est vraisemblable que l'œuvre, dans cette effervescence qui se produisit chez Rodin lors de la commande de *la Porte* vit le jour, dès l'élaboration des premiers projets, à une date qu'on peut ainsi estimer antérieure même à 1884." Grappe seems to be mistaken when he says that the figure was enlarged when detached from *The Gates of Hell*.
4. *See* Paris, 1889 [347], no. 7.
5. Grappe [338d], no. 159.
6. Ibid., no. 216.

11–1
Kneeling Fauness (No. 2)
c. 1884, bronze
Musée Rodin, Paris

11–2
Kneeling Fauness, illustration for Charles Baudelaire's "Le Guignon," from *Les Fleurs du Mal*
1886–88

11–3
Orpheus and the Maenads
Before 1889, bronze, height 31⅞ inches
National Museum of Western Art, Tokyo

11–4
La Toilette de Vénus (Awakening)
Before 1886, limestone, height 19½ inches
John G. Johnson Collection, Philadelphia

11–5
Edvard Munch
Veranda, from the series "The House of Max Linde"
1902, etching, 7¾ × 10⅞ inches
Art Institute of Chicago. Clarence Buckingham Collection

REFERENCES

Bartlett [125], p.225, repr.p.249; Grappe [338], no.95; Watkins [342], no.35; Grappe [338a], no.117; Grappe [338b], no.131; Grappe [338c], no.96; Story [103], p.145, no.38, repr.pl.38; Grappe [338d], no. 109; Story [103a], no.32, repr.pl.32; Tancock [341], no.12.

OTHER CASTS AND VERSIONS

Bronze

AUSTRALIA
Perth, Western Australia Art Gallery.

CANADA
Don Mills, Ontario, Collection Mr. and Mrs. W.B. Herman.
Montreal, private collection. Founder: Georges Rudier. Cast no.7/12.

GREAT BRITAIN
Private collection.

SWITZERLAND
Lausanne, Collection Samuel Josefowitz.

UNITED STATES
Bradford, Pa., Collection Mrs. T. Edward Hanley.
Los Angeles, Los Angeles County Museum of Art. Gift of B. G. Cantor Art Foundation.

Plaster

FRANCE
Paris, Musée Rodin.

UNION OF SOUTH AFRICA
Stellenbosch, Collection Dr. Anton Rupert. Inscribed: Au maître Puvis de Chavannes.

Kneeling Fauness (No. 2)

Bronze

FRANCE
Paris, Musée Rodin (fig. 11–1).

RELATED WORKS

La Toilette de Vénus

Bronze, height 18⅛ inches

FRANCE
Paris, Musée Rodin.
— Collection Jean de Ruaz.

JAPAN
Tokyo, National Museum of Western Art (ex. Collection Matsukata).

UNITED STATES
Beverly Hills and New York City, B.G. Cantor Collections. Founder: Georges Rudier. Cast no.4/12.
Greenwich, Collection Herbert Mayer. Founder: Georges Rudier. Cast no.3/12.

Marble, height 23¾ inches

UNITED STATES
Washington, D.C., National Gallery of Art (as Morning). Gift of Mrs. John W. Simpson, 1942 (ex. Collection M. Masson). Signed: A.Rodin, 1906.

Limestone, height 19½ inches

UNITED STATES
Philadelphia, John G.Johnson Collection (fig. 11–4).

Orpheus and the Maenads

Bronze, height 31⅞ inches

JAPAN
Tokyo, National Museum of Western Art (ex. Collection Matsukata). Founder: Alexis Rudier (fig. 11–3).

Marble, height 38⅝ inches

FRANCE
Paris, Musée Rodin.

12 Bas-relief for "The Gates of Hell" (left side) by 1885

Bronze, 12½ × 43½ × 5¾ inches
Not signed or inscribed; no foundry mark

13 Bas-relief for "The Gates of Hell" (right side) by 1885

Bronze, 12½ × 43½ × 6¼ inches
Not signed or inscribed; no foundry mark

Although by 1883 Rodin had given up the idea of dividing the surface of *The Gates of Hell* into separate panels, for a long time he experimented with the composition of a pair of bas-reliefs which he proposed placing at the bottom of each leaf. They were described by Octave Mirbeau in 1885: "Below the groups are bas-reliefs from which masks of grief project. Centaurs gallop along the rivers of mud carrying the bodies of women who struggle, tumble, and writhe on the rearing creatures; other centaurs point arrows at the unfortunate creatures who want to escape, and one sees women, prostitutes, carried away in rapid flight, throwing themselves and falling, their heads in the flaming mud."[1] An early photograph shows one of the falling figures, which were suppressed in the final composition.

Bartlett saw and described them in 1888, referring to the masks of "those who have died in misery." "The spaces on each side," he continues, "are filled with an illustration of the festival of Thetis and Peleus when invaded by Centaurs. Thoughtless pleasure is personified by a youth borne on the back of a siren, who is about to dive into the sea carrying her joyful and unconscious victim with her."[2]

Bartlett seems to have confused the story of Thetis and Peleus with the wedding festival of Pirithoüs and Hippodame, which took place in Thessaly, the home of the lapithae. The centaurs, sons of Ixion and of Juno in the form of a cloud, were invited to the banquet. Ovid gives the following account of the event: "We congratulated Pirithoüs upon his bride, an act which all but undid the good omen of the wedding. For your heart, Eurytus, wildest of the wild centaurs, was inflamed as well by the sight of the maiden as with wine, and it was swayed by drunken passion redoubled by lust. Straightway the tables were overturned and the banquet in an uproar, and the bride was caught by her hair and dragged violently away. Eurytus caught up Hippodame, and others, each took one for himself according as he fancied or as he could, and the scene looked like the sacking of a town. The whole house resounded with the women's shrieks."[3]

Thus these bas-reliefs, which represent the victory of passion over reason and, in the two grieving heads, the resulting despair, formed, as it were, a résumé of *The Gates* as a whole. They were described by Gustave Geffroy in 1889[4] and were evidently in place when Maillard wrote his book on Rodin in the late 1890s.[5]

When the stripped version of *The Gates* was exhibited at the Exposition Rodin in 1900, however, the bas-reliefs had suffered the fate of so many other figures. A photograph of the

studio taken about 1906, in which the stripped plaster version of *The Gates* appears, shows that the relief panels have been partially buried inside *The Gates* (fig. 12, 13–1). A crying head can be seen peering through the flat panel that became the tombstone in the final version, but the group on the right-hand side has been completely buried under a swirl of drapery. There is little doubt that Rodin decided to remove them because their rectangular format and symmetry contrasted too sharply with the much freer flow of the panels themselves. Although Rodin continued until as late as 1900 to make minor adjustments to these reliefs, it seems that their basic form was established by the time Octave Mirbeau saw them in 1885, therefore suggesting the date of by 1885.

12, 13–1
Rodin sitting in front of the partly dismantled plaster version of *The Gates of Hell* with his cousin, Mlle H. Coltat, about 1905. The *Bas-reliefs* can be seen partly buried in the lower part of the leaves of *The Gates*.

NOTES

1. Mirbeau [252a], p. 17. "Au-dessous des groupes, des bas-reliefs encore, sur lesquels saillent des masques de la douleur. Le long du fleuve de boue, des centaures galopent, emportant des corps de femmes qui se débattent, se roulent et se tordent sur les croupes cabrées; d'autres centaures tirent des flèches sur les malheureux qui veulent s'échapper, et l'on voit des femmes, des prostituées, emportées dans des chutes rapides, se précipiter et tomber, la tête dans la fange enflammée."
2. Bartlett in Elsen [39], p. 75.
3. Ovid, *Metamorphoses,* trans. Frank Justus Miller (Cambridge, Mass.: Harvard University Press, 1946), 12.217–27.
4. Geffroy [199a], pp. 11–12.
5. Maillard [71], p. 82.

REFERENCES

Bartlett [125], p. 225; Mirbeau [252a], p. 17; Geffroy [199a], pp. 11–12; Watkins [342], p. 21; Elsen [37], p. 86, repr. pl. 70; Tancock [341], nos. 13, 14.

OTHER VERSIONS

Plaster, length of each 44⅛ inches

FRANCE
Paris, Musée Rodin.

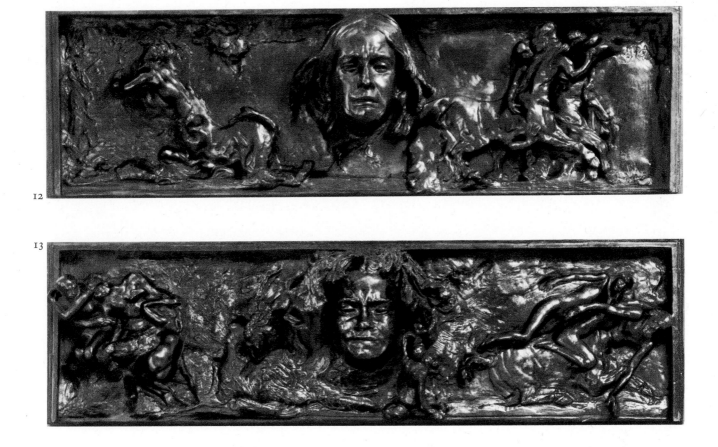

12

13

14 Crying Girl
by 1885

Bronze, 8 × 5 ¼ × 5 ¼ inches
Signed front of support to right
and on stamp inside: A. Rodin
Foundry mark rear of base to left:
.Alexis. RUDIER./.Fondeur. Paris.

15 Mask of Crying Girl
by 1885

Bronze, 12 ¼ × 6 ¾ × 4 ½ inches
Signed lower left of base
and on stamp inside: A. Rodin
Foundry mark lower right side of supporting
member: ALEXIS RUDIER./
FONDEUR. PARIS

16 Crying Woman
c. 1889

Bronze, 7 ¾ × 5 × 5 ⅛ inches
Signed right side of supporting
member: A. Rodin
Foundry mark back of supporting
member: Alexis RUDIER/Fondeur.
PARIS.

For a long time Rodin considered placing a bas-relief at the foot of each leaf of *The Gates of Hell (see* nos. 12, 13). At the center of each of these was the head of a crying girl, masks of "those who have died in misery" in the words of Bartlett, who saw the bas-reliefs *in situ* in 1888.[1] It must have seemed as if all the anguish of the inhabitants of Hell were concentrated in these grieving masks.

Crying Girl (no. 14) is close to the head on the bas-relief intended for the left leaf of the doors (no. 12), while *Mask of Crying Girl* (no. 15), to which a rough bas has been added, is closer to the head at the center of the right-hand relief (no. 13). A version of *Mask of Crying Girl* was exhibited at the Exposition Rodin in 1900.[2] There exist several marble versions of these crying heads which are closer in type to number 15 than to number 14. In an example in the Musée Rodin, the head rests on a marble block, while in the marble in the National Museum of Western Art in Tokyo (fig. 14–16–2), the head emerges from a roughly hewn background. In a third marble, the present location of which is not known (fig. 14–16–1), the head is surrounded by a garland of leaves.

There is also a third crying head, *Crying Woman* (no. 16), not used in either of the bas-reliefs for *The Gates of Hell,* in which the features are apparently those of an older woman.

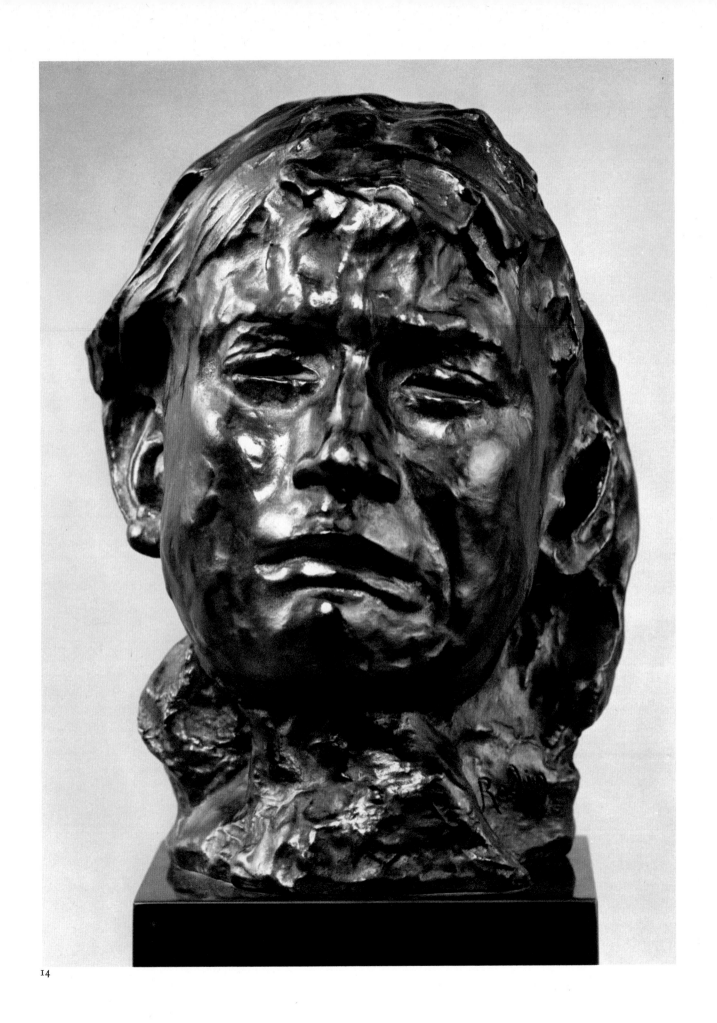

Victor Frisch related that when he started working for Rodin, an old Russian woman by the name of Bosnouskaya was still posing for him. When Frisch remarked that she always seemed to be on the point of breaking into tears, Rodin made him a gift of a small bust for which she had posed. It may be that this head, the features of which are decidedly Slavic, is based on the features of old Bosnouskaya.[3] It was with this model, according to Frisch, that the series of weeping figures dating from the late 1880s was inaugurated[4]—*Crying Nymph, Woman Crying,* and *Danaid Overcome.*[5]

 Crying Girl (no. 14) and *Mask of Crying Girl* (no. 15) are thus datable to before 1885, the year when Octave Mirbeau saw the reliefs from which they are taken.[6] *Crying Woman* (no. 16), on the other hand, is datable about 1889, the date attributed to the various crying figures by Georges Grappe.

NOTES

1. Bartlett in Elsen [39], p.75.
2. Paris, 1900 [349], no.25. "Visage violemment contracté par la douleur et pleurant 'à chaudes larmes' les cheveux épars. En marbre, cette tête est soit encastrée dans un bloc, en guise de haut-relief, soit posée sur un socle, au ras du menton."
3. Frisch and Shipley [42], p.422.
4. Ibid.
5. Grappe [338d], nos.219, 220, and 221 respectively.
6. Mirbeau [252a], p.17.

REFERENCES

Crying Girl
Bartlett [125], p.225; Mirbeau [252a], p.17; Geffroy [199a], pp.11–12; Watkins [342], no.3; Tancock [341], no.15.

Mask of Crying Girl
Bartlett [125], p.225; Mirbeau [252a], p.17; Geffroy [199a], pp.11–12; Watkins [342], no.37; Tancock [341], no.16.

Crying Woman
Watkins [342], no.33.

OTHER CASTS AND VERSIONS (No. 14)

Bronze, height 7¼ inches

UNITED STATES
New York City, Collection Mrs. Patrick Dinehart (ex. Collection Jules Mastbaum). Founder: Alexis Rudier.
Philadelphia, Collection Mrs. Charles J. Solomon (ex. Collection Jules Mastbaum). Not signed. No foundry mark.

Plaster head in marble basin, height 8½ inches

UNITED STATES
San Francisco, California Palace of the Legion of Honor. Gift of Alma de Bretteville Spreckels.

Plaster mask, height 5⁷/₁₆ inches

UNITED STATES
San Francisco, California Palace of the Legion of Honor. Gift of A. B. Spreckels, Jr.

Bronze mask, height 6 inches

UNITED STATES
San Francisco, California Palace of the Legion of Honor. Gift of Alma de Bretteville Spreckels. Signed: A.Rodin. No.1.

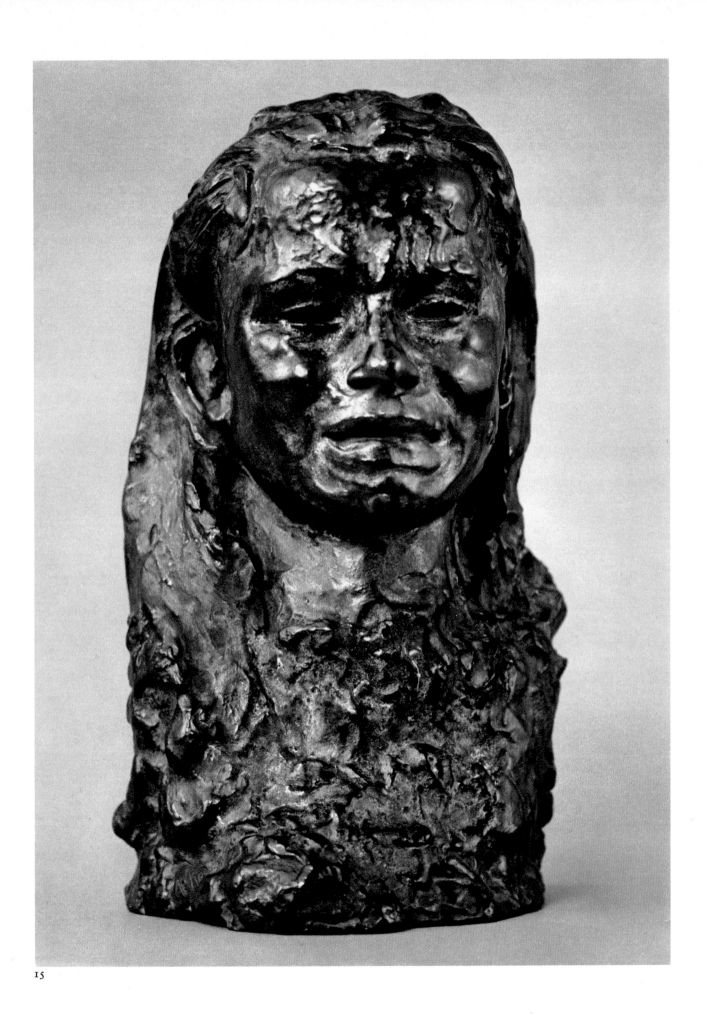

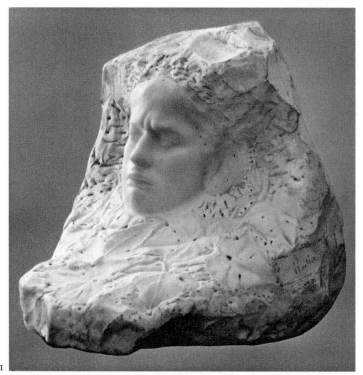

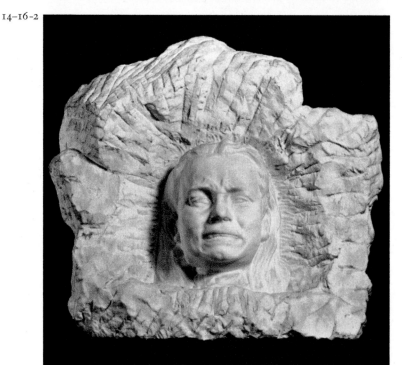

14-16-1

14-16-2

Bronze, height 11¾ inches

FRANCE
Paris, Musée Rodin.

SWITZERLAND
Lausanne, Collection Samuel Josefowitz.

UNITED STATES
Beverly Hills, Cantor, Fitzgerald Art Foundation.
— Collection Mr. and Mrs. Henry Mancini. No
foundry mark.
Dallas, Collection Paul M. Raigorodsky.
Washington, D.C., Collection Mr. and Mrs. Oscar
Cox. Founder: Persinka.

Bronze, height 8¼ inches (head only, without extension of neck)

FRANCE
Dijon, Musée de Dijon. Gift of Baron Alphonse de
Rothschild, 1891.

*Glazed ceramic (by Edmond Lachenal),
height 12½ inches*

UNITED STATES
Beverly Hills, Cantor, Fitzgerald Art Foundation.

*White marble, height 19¾ inches (the head emerges
from a rough-hewn background)*

JAPAN
Tokyo, National Museum of Western Art. Matsukata
Collection (fig. 14–16–2).

Gray marble, height 13¾ inches

FRANCE
Paris, Musée Rodin.

*Marble (the head, surrounded by leaves, emerges from
a rough-hewn background)*

Location unknown. Signed: Rodin (fig. 14–16–1).

OTHER CASTS (No. 16)

UNITED STATES
New York City, Collection Mrs. Patrick Dinehart
(ex. Collection Jules Mastbaum). Founder: Alexis
Rudier.
Philadelphia, Collection Mrs. Charles J. Solomon (ex.
Collection Jules Mastbaum). Signed: A. Rodin.
Founder: Alexis Rudier.

14–16–1
Mask of Crying Girl
By 1885, marble
Location unknown

14–16–2
Mask of Crying Girl
By 1885, marble, height 19¾ inches
National Museum of Western Art,
Tokyo. Matsukata Collection

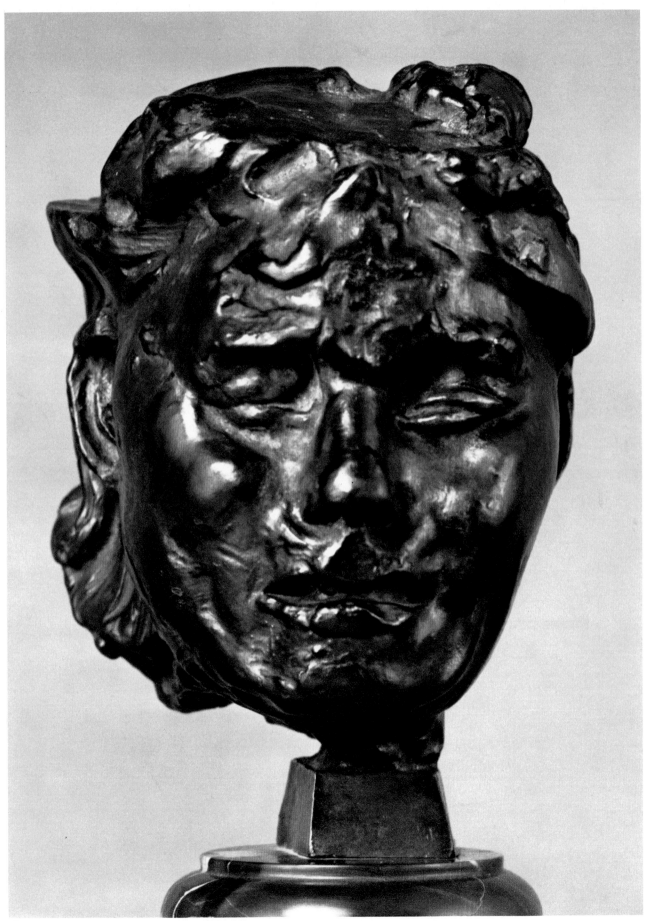

16

17 Young Mother in the Grotto
1885

Plaster, 14 × 10 × 7 inches
Not signed or inscribed

Maternal love plays a much less important role in Rodin's work than does the love between man and woman. In his early work there is little difference between a group such as *Maternal Tenderness*[1] and another known by the title of *Venus and Cupid.*[2] In both cases it is a rather superficial charm that predominates. Certain drawings preserved in the Musée Rodin[3] suggest that Rodin may have done drawings of Rose Beuret and their son, Auguste Beuret, either from life or from memory, but in the drawings of women and children done between 1879 and 1882, while Rodin was working at Sèvres, mythological titles would again seem more appropriate.[4]

The lowest group on the left-hand pilaster of *The Gates of Hell,* completed by 1885 (*see* no. 1, detail D), is related to the work done at Sèvres. This in turn is related to the more developed groups of 1885, *Young Mother, Fleeting Love,* and *Young Mother in the Grotto.* The figures in each of these groups were originally conceived separately. In *Young Mother* (fig. 17–1), entitled *Woman and Love* when Rodin offered a cast of it to the *tombola* organized by the committee of the Claude Lorrain monument in 1885, the child sits on the woman's left knee. In a closely related marble version in the National Gallery of Scotland (fig. 17–3), the mother's hair flows over her shoulders while the child sits in an upright position on the mother's knee, in contrast to the more precarious position of the child in the former work. In *Fleeting Love,* which exists both in bronze and in marble (fig. 17–2) versions, the child glides past the seated figure of the mother, the relationship between the two being obviously symbolic. In *Young Mother in the Grotto,* modified versions of the figures in *Young Mother* are seen against the background of a hollow cavern. The child is partly supported by the walls of the cavern and touches the roof with his left hand. A marble version of this work is located in the Kasser Foundation (fig. 17–4).

NOTES

1. Grappe [338d], no. 24.
2. Ibid., no. 25.
3. *See,* for example, no. 353 (according to their system of notation), which consists of three studies of a mother and child that are very Leonardesque in style.
4. *See* Marx [75], pl. VI (*Femme et enfant*).

REFERENCES

L'Art Français, Paris, February 4, 1888, repr.; Maillard [71], p. 146; Mauclair [77a], p. 31; Lawton [67], p. 229; Maclagen [335a], pp. 20–21, repr. pl. XVII; Watkins [342], no. 102, repr. p. 23; Grappe [338c], no. 116; Grappe [338d], no. 132; Tancock [341], no. 17.

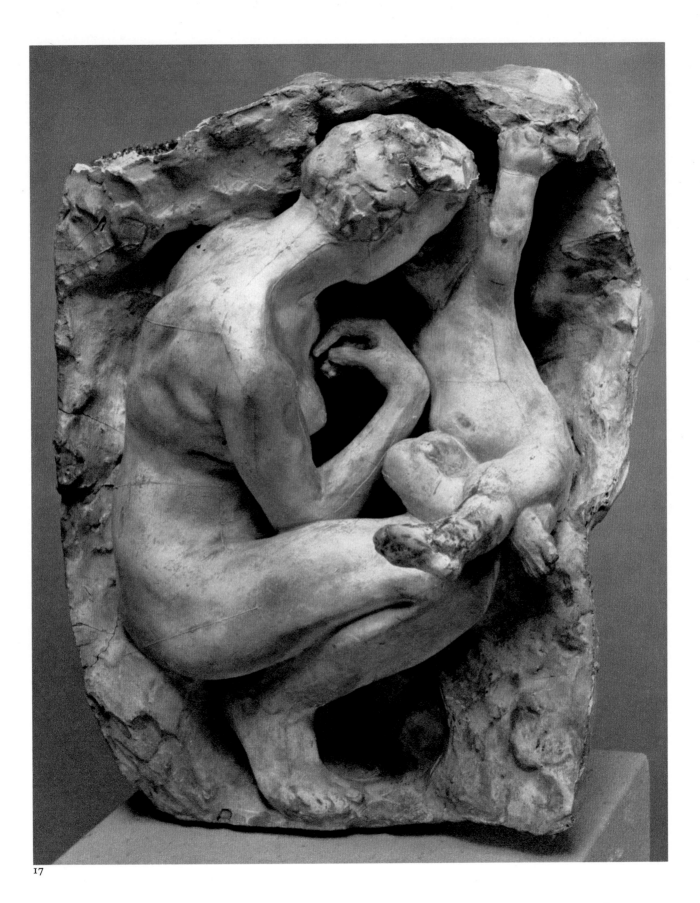

17

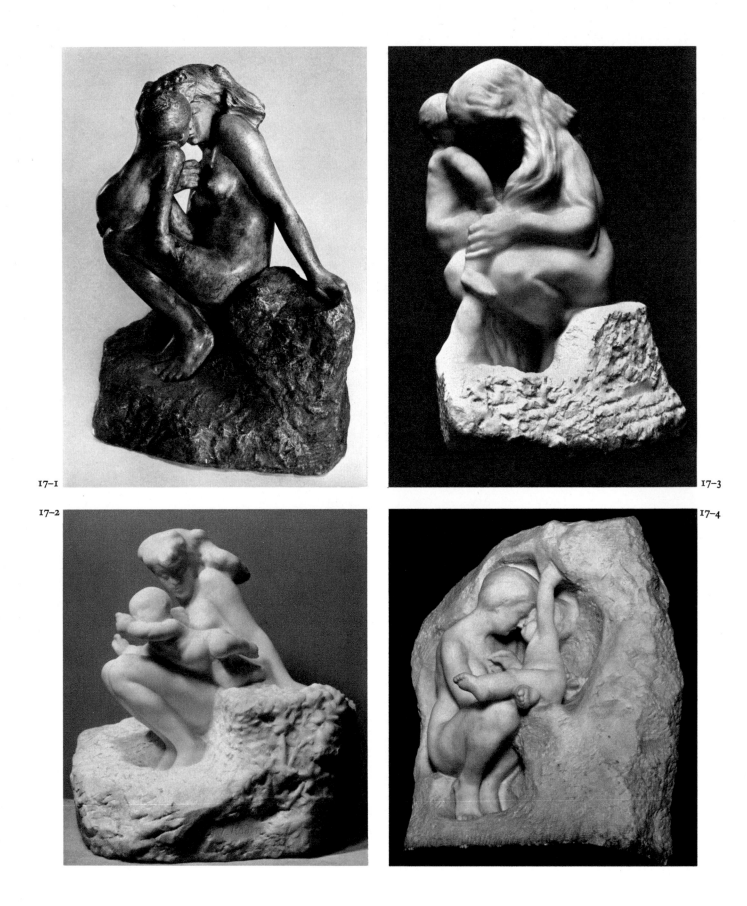

17-1

17-3

17-2

17-4

184

OTHER CASTS AND VERSIONS

Plaster

FRANCE
Paris, Musée Rodin.

GREAT BRITAIN
London, Bethnal Green Museum. Bequest of Sir Claude Phillips to the Victoria and Albert Museum, 1924. Formerly inscribed: A mon ami C. Phillips. A. Rodin. No inscription now visible.

Bronze

ARGENTINA
Buenos Aires, Collection Mercedes Santamarina.

GREAT BRITAIN
Glasgow, Glasgow Art Gallery and Museum. Burrell Collection.

UNITED STATES
New York City, Estate of Geraldine R. Dodge.
Stanford, Stanford University Art Gallery and Museum. Gift of B. G. Cantor Art Foundation.

Marble, height 24¼ inches

UNITED STATES
Canton, O., Canton Art Institute. Acquired by John Hemming Fry in 1924.
Montclair, N. J., Kasser Foundation (fig. 17–4).

17–1
Young Mother (Mother and Child)
1885, plaster, height 15⅜ inches
Fine Arts Museums of San Francisco
Spreckels' Collection

17–2
Fleeting Love (Woman and Child)
1885, marble, height 17 inches
National Gallery of Art, Washington, D. C.
Gift of Mrs. John W. Simpson, 1942

17–3
Young Mother (No. 2)
1885, marble, height 23½ inches
National Gallery of Scotland, Edinburgh
Bequest of Sir Alexander Maitland, 1965

17–4
Young Mother in the Grotto
1885, marble, height 24¼ inches
Kasser Foundation, Montclair, N. J.

RELATED WORKS

Young Mother

Bronze, height 15⅜ inches

CANADA
Montreal, private collection. Founder: Georges Rudier. Cast no. 10/12.

FRANCE
Paris, Musée Rodin.
Riom, Musées de Riom. Deposited by the state in 1946.

UNITED STATES
Ann Arbor, University of Michigan, Museum of Art. Margaret Watson Parker Bequest, 1955. Signed: A. Rodin.
New York City, Collection Margret Suzanne Zander Loewy. Founder: Georges Rudier. Cast no. 2/12.

Plaster variant

UNITED STATES
San Francisco, California Palace of the Legion of Honor. Gift of Alma de Bretteville Spreckels (fig. 17–1).

Marble, height 23½ inches

GREAT BRITAIN
Edinburgh, National Gallery of Scotland. Bequest of Sir Alexander Maitland, 1965. Bought from Rodin's studio before 1906 by Mrs. Craig Sellar. Signed: A. Rodin (fig. 17–3).

Fleeting Love

Plaster, height 15⅜ inches

FRANCE
Paris, Musée Rodin.

Bronze, height 15 inches

GREAT BRITAIN
Glasgow, Glasgow Art Gallery and Museum. Burrell Collection (as *L'Amour*).

Marble, height 17 inches

UNITED STATES
Washington, D. C., National Gallery of Art. Gift of Mrs. John W. Simpson, 1942. Signed: A. Rodin (fig. 17–2).

18 The Martyr
1885

Bronze, 18 × 59 × 38 inches
Signed on base by back of head: A. Rodin
Foundry mark on edge of work by figure's left shoulder:
Alexis Rudier/Fondeur Paris

Grappe dated this figure 1887 in the first two editions of the catalogue of the Musée Rodin,[1] but the dating was revised to 1885 in subsequent editions on the strength of a reference found in Rodin's correspondence.[2] The curious incompleteness of this figure, fully conceived in the round apart from a slice cut off the back, shows very clearly that this figure was first executed for *The Gates of Hell*. It was not originally thought of in terms of its relationship to a solid base, lying on the ground, or its substitute, the pedestal, but floating and attached to a background in the imaginary space of *The Gates*.

When given a separate existence, whether in its original dimensions of approximately 27½ inches in length or in the enlarged version, the figure was turned upside down, the area of attachment to *The Gates* serving as the base of the sculpture. The deathlike rigidity of *The Martyr,* who seems to have fallen from a great height, is in part the result of this removal from a particular context and of being turned upside down. Limbs which are hanging when seen from one angle are thrust stiffly upward when seen from another.

The complete figure, with eyes concealed and with the addition of wings, holding a wheel in the right hand, is seen at the bottom of the left-hand panel of *The Gates* (fig. 18–1). Albert Elsen has suggested that this figure "may symbolize those subject to Fortune,"[3] Rodin having substituted a wheel for Dante's sphere. The same head and shoulders can be seen partially concealed beneath the figure, while the head alone appears many times throughout *The Gates*. It is used on the figure at the lower left of the right panel (above the falling couple). It appears several times in the tympanum *(see no. 1, detail* κ*)*, on the figure with raised arms to the right of the *Kneeling Fauness (see no. 11)* and on the two figures hovering over it as well as on the woman lying over the frame at the top right, and by itself at the back of the tympanum toward the right. It also appears several times in the row of small heads above the tympanum. The head and shoulders have since been issued as an independent sculpture (fig. 18–7).

When detached from *The Gates,* this figure is known as *The Martyr,* and sometimes, inappropriately, as *The Christian Martyr*. In choosing to represent the decapitated head of St. John *(see no. 21)*, Rodin associated himself with a late-nineteenth-century trend that appreciated scenes of martyrdom more for their elements of perversity than for moral or religious reasons. It may be presumed that Rodin had little appreciation of or insight into the motives of religious martyrs.

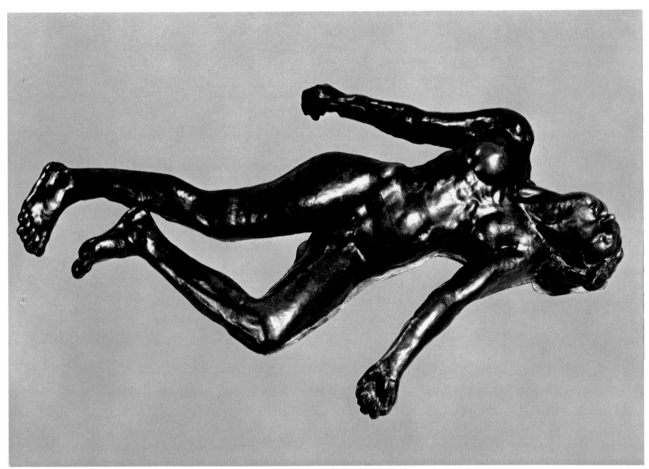

18

187

On the other hand, with his tendency to identify love and suffering, he would have comprehended martyrdom for love. Speaking of Dante's Francesca, he said: "Sensual joy is too great in our time, it calls forth pain. It is indeed true, as Francesca da Rimini, the saint of Love, teaches us, that suffering together with the beloved object, brings us joy."[4] One of Baudelaire's poems from *Les Fleurs du Mal* that Rodin chose to illustrate was "Une Martyre," a lurid description of the ravaged body of a brutally murdered woman. Rodin's illustration represents a recumbent, headless female figure. The element of perversity is lacking in Rodin's bronze of *The Martyr,* but in his interpretation it is in the arena of sensual passion rather than religious devotion that her death occurred.

Rodin must have found this particular torsion of the limbs especially expressive, as he returned to it on a number of occasions. A figure based on *The Martyr* was used to represent the muse hovering over Orpheus's right shoulder in the plaster *Orpheus* of 1892.[5] About 1895 the figure, with the addition of wings and falling sideways, was used in the *Fall of Icarus,*[6] a version of which was in the collection of Albert Kahn (fig. 18-2).

The same figure was also used in the decorative work that Rodin executed for Baron J. Vitta. About 1897[7] Rodin designed two ornamental pediments, *Spring and Autumn* and *Winter and Summer* (nearly 12 feet in length), and two jardinieres, *The Harvest* and *The Grape Harvest,* for the Villa La Sapinière at Evian, which belonged to Mme Foa, Baron Vitta's sister. Among the other artists employed on the decoration of this house, described by Léonce Bénédite as "the most typical example of the modern collector's residence,"[8] were Alexandre Falguière, Félix Bracquemond, Albert Besnard, Jules Chéret, and Alexandre Charpentier.[9] At no other time did Rodin become involved in a joint project like this, which was so typical of the desire of *fin-de-siècle* artists to create unified environments to which all the arts contributed. Although he was not averse to working in their company, he was not, however, prepared to modify his style significantly, and the reliefs and jardinieres look back to Michelangelo and the ancient world as well as to his own work. A figure related to *The Martyr,* with the left arm in a different position, was used in one of the large reliefs, *Spring and Autumn.*[10] Another pediment entitled *Autumn* (fig. 18-3), approximately twelve feet in length, originally intended for the ensemble at Evian but later utilized for the gallery of Baron Vitta's house in Paris, contains a figure much more closely related to *The Martyr.*

In 1911 the same figure, placed vertically and enlarged in marble, was used in the Sourisseau tomb in the St.-Acheul Cemetery near Amiens. This was commissioned by Marius Sourisseau shortly before his death in 1907. In this new guise the figure was retitled *The Broken Lily* (fig. 18-6).[11] A phrase from Alfred de Musset—"Dieu passe, il m'appelle"— and the date 1911 are inscribed in the marble.

With slight adjustments in the position of the limbs, the figure of *The Martyr* was used in the group of *Orpheus and Eurydice,* which exists in marble in the Metropolitan Museum of Art (fig. 18-5). Finally, about 1910, the enlarged torso of *The Martyr,* with the head falling forward and not back, was exhibited as *Torso of a Woman* (fig. 18-4).

18–1

18–1
The Martyr (detail of the left panel
of *The Gates of Hell,* no. 1)

18–2
Fall of Icarus
c. 1895, plaster, height 17¾ inches
Musée Rodin, Paris

18–2

18–3

18–3
Autumn, project for a pediment at
the Villa La Sapinière, Evian
c. 1897, plaster, length 133⅞ inches
Musée des Beaux-Arts, Lyons
Gift of Baron Vitta, 1913

NOTES

1. Grappe [338], no. 104; [338a], no. 126.
2. Grappe [338d], no. 146.
3. Elsen [37], p. 93.
4. Nostitz [83b], p. 21.
5. When cast in bronze, the figure of the muse was omitted (*see* fig. 20-3). The appearance of the complete work in plaster, however, may be judged from a photograph of Rodin's studio taken sometime between 1893 and 1899 (repr. in Descharnes and Chabrun [32], p. 153).
6. This work should not be confused with that known by the names of *Illusion, Daughter of Icarus,* or *Fall of Icarus,* which consists of the falling female taken from *The Kiss of the Angel, Sleep,* or *The Dream* (Grappe [338d], no. 237).
7. The decorative work for the Villa La Sapinière is dated 1897 by Descharnes and Chabrun [32], p. 209. Jianou and Goldscheider [65], p. 108, assign a date of 1901 for the Villa La Sapinière ornaments without giving any reasons.
8. Bénédite [127], p. 48. "Cette maison d'Evian restera, en effet, comme le vrai type de la demeure de l'amateur moderne."
9. *See* ibid., pp. 48–51. For this important project, Alexandre Falguière contributed a series of terracotta reliefs for the exterior of the house, the titles being *The Hunt, Shepherdess and Satyr, Amphitrite, Acis and Galatea Surprised by Polyphemus, Music, Sculpture, Faun and Bacchante Playing, Hylas Enticed by the Nymphs,* and a suite of decorative cartouches. Albert Besnard's contribution consisted of a suite of frescoes with the following titles: *Day, Fruits,* and *Flowers* (repr. in Gabriel Mourey, *Albert Besnard* [Paris: Henri Davoust, n.d.], pp. 106, 108, 109 respectively). Alexandre Charpentier designed a wide variety of objects, ranging from bronze fixtures for the billiard room to a bas-relief for the piano in the gallery. Félix Bracquemond designed electric light fixtures, vases, a fireplace, and numerous utilitarian items, including an enamel, gold, and ivory mirror for which Rodin designed a relief of Venus Astarte. Jules Chéret's principal contribution consisted of a suite of frescoes for the billiard room.
10. Descharnes and Chabrun [32], p. 209, state that these reliefs were carved by Alfred Halou, who was doing a lot of work for Rodin at this time.
11. Grappe [338d], no. 146, states that the monument was installed in 1909, while Descharnes and Chabrun [32], p. 79, and Pierre Rappo, "Dans l'ancien cimetière de Saint-Acheul plus de mystère autour d'une sculpture d'Auguste Rodin," *Le Courrier Picard,* Amiens, August 4, 1965, point out that this did not occur until 1911.

REFERENCES

Grappe [338], no. 104; Watkins [342], no. 8; Grappe [338a], no. 126; Grappe [338b], no. 168; Cladel [26], p. 243; Grappe [338c], no. 130; Grappe [338d], no. 146; Grappe [54], p. 141, repr. p. 65; Elsen [38], p. 151, repr. p. 153; Pierre Rappo, "Dans l'ancien cimetière de Saint-Acheul plus de mystère autour d'une sculpture d'Auguste Rodin," *Le Courrier Picard,* Amiens, August 4, 1965; Descharnes and Chabrun [32], pp. 78, 79, repr. pp. 78, 79; Spear [332], pp. 55–56; Tancock [341], no. 18.

OTHER CASTS AND VERSIONS

Bronze

CZECHOSLOVAKIA
Prague, Národní Galerie. Cast in 1925 from plaster in museum.

FRANCE
Paris, Musée Rodin. Signed: A. Rodin. Founder: Alexis Rudier.

SWITZERLAND
Zurich, Kunsthaus Zurich.

UNITED STATES
New York City, Metropolitan Museum of Art. Gift of Watson B. Dickerman, 1913. Signed: A. Rodin.

Plaster

CZECHOSLOVAKIA
Prague, Národní Galerie. Acquired in 1923.

Bronze, length 27½ inches

FRANCE
Paris, Musée Rodin.

SWITZERLAND
Lausanne, Collection Samuel Josefowitz. Founder: Georges Rudier.

UNITED STATES
Indianapolis, Indianapolis Museum of Art. Gift of B. G. Cantor Art Foundation. Founder: Georges Rudier. Cast no. 5.

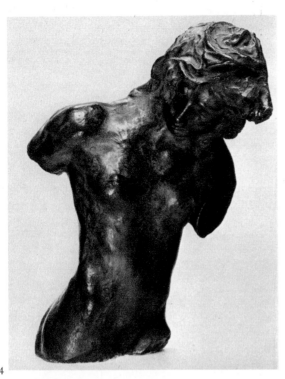

18–4
Torso of a Woman
1909, bronze, height 29¼ inches
Fine Arts Museums of San Francisco
Spreckels' Collection

18–5
Orpheus and Eurydice
1893, marble, height 50 inches
Metropolitan Museum of Art, New York
Gift of Thomas F. Ryan, 1910

18–6
The Broken Lily (Tomb of Marius Sourisseau)
1911, marble
St.-Acheul Cemetery, Amiens

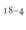
18–4

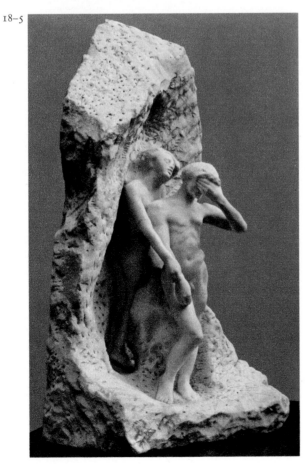
18–5

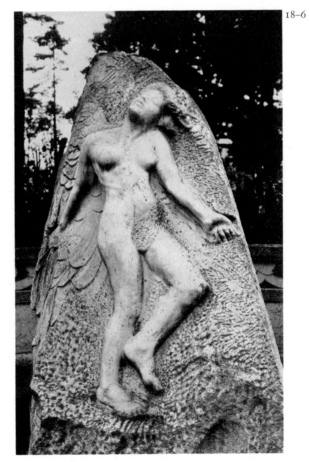
18–6

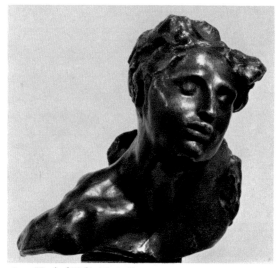

18–7 *Head of "The Martyr"*
1885, bronze, height 7½ inches
Location unknown

Plaster

FRANCE
Paris, Musée Rodin.

Head of "The Martyr"

Bronze, height 7½ inches

Location unknown (fig. 18–7).

FRANCE
Paris, Musée Rodin.

SWITZERLAND
Lausanne, Collection Samuel Josefowitz. Founder:
 Alexis Rudier.

UNITED STATES
Beverly Hills, Collection Leona Cantor. Founder:
 Alexis Rudier.
Cleveland, Cleveland Museum of Art (ex. Collection
 Salmon Portland Halle, purchased before Rodin's
 death). Signed: A. Rodin. Founder: Alexis
 Rudier.
San Francisco, California Palace of the Legion of
 Honor. Spreckels Collection. Signed: Rodin.

Plaster

FRANCE
Paris, Musée Rodin.

Terra-cottas (cut differently)

FRANCE
Meudon, Musée Rodin.

RELATED WORKS

Fall of Icarus

Plaster, height 17¾ inches

FRANCE
Paris, Musée Rodin (ex. Collection Albert Kahn)
 (fig. 18–2).

Marble

Location unknown.

The Broken Lily

Marble

FRANCE
Amiens, St.-Acheul Cemetery, Tomb of Marius
 Sourisseau (fig. 18–6).

Orpheus and Eurydice

Marble, height 50 inches

UNITED STATES
New York City, Metropolitan Museum of Art. Gift
 of Thomas F. Ryan, 1910 (ex. Collection Charles
 T. Yerkes). Signed and dated 1893 (fig. 18–5).

Autumn

Plaster, length 133⅞ inches

FRANCE
Lyons, Musée des Beaux-Arts. Gift of Baron Vitta,
 1913 (fig. 18–3).

Stone, length 91¾ inches

FRANCE
Paris, Musée Rodin.

Torso of a Woman (half-length)

Bronze, height 29¼ inches

FRANCE
Paris, Musée Rodin.

UNITED STATES
Richmond, Virginia Museum of Fine Arts. Gift of
 B. G. Cantor Art Foundation. Founder: Georges
 Rudier. Cast no. 4/12.
San Francisco, California Palace of the Legion of
 Honor. Gift of Alma de Bretteville Spreckels
 (fig. 18–4).
Stanford, Stanford University Art Gallery and Mu-
 seum. Gift of B. G. Cantor Art Foundation. Foun-
 der: Georges Rudier. Cast no. 5/12.

19 Meditation

1885

Bronze, 29 × 11 × 11 inches
Signed top of base by figure's right foot: A. Rodin
Foundry mark rear center of base:
ALEXIS. RUDIER./FONDEUR. PARIS. 2/12

The figure now generally known as *Meditation* was first used in the tympanum of *The Gates of Hell*. It can be seen on the far right-hand side, among the crowd of those who have just been judged (fig. 19–3).[1] The lower part of the figure is closely related to the first study for the *Eve* (fig. 8–4),[2] although the upper part of the body differs considerably, as it does from the small bronze of *Meditation* when conceived separately. The left arm is raised but does not touch the breast; the right arm is held across the body and pushes back the hair above the eyes.

Somewhat enlarged and modified, *Meditation* was detached from *The Gates* in 1885[3] and assumed a life of its own. The raised left arm now touches the breast; the drooping head rests on the projecting right arm. In the process of enlargement the forms and the gesture have become more impressive, creating an astonishing variety of profiles.[4]

On September 16, 1889, Rodin received the commission for a monument to Victor Hugo to be erected in the Panthéon *(see* no. 71). On an enlarged scale, the figure of *Meditation,* rechristened *The Inner Voice* (after *Les Voix Intérieures* of Victor Hugo, a collection of lyrical poems), was introduced into the third project for the monument. Thereafter it was to undergo a variety of transformations. Most significant in this first appearance is the change in the position of the arms—the right arm, still bent at the elbow, is held close to the body, while the left, which touches it, is raised above the head *(see* fig. 71–5).

In the fourth project, of which there are two slightly different versions, *The Inner Voice* stands farther away from and parallel to the reclining figure of Victor Hugo. In the first of the two (fig. 71–6), the knee and part of the upper leg have been covered with drapery. The right arm, which touches the right breast, is held down close to the body, while the left arm helps support a load on the shoulders. In the second of the two (fig. 71–7), the left knee is covered with more rudimentary drapery, but there has been a significant change in the position of the arms. They are both raised above the head and meet in a more dancelike movement. It is from this version, with a slight modification of the massive left arm, that the bronze enlargement was made (fig. 19–1), giving to it a date of 1896–97 rather than the 1885 date assigned to it by Grappe.

In the final version of the first project for the Hugo monument, exhibited at the Salon of 1897 *(see* fig. 71–8), the knee of *Meditation* is still covered with rudimentary drapery, but both arms have been amputated. This version was also given a separate existence by Rodin. With the knees severed at the point of contact with the drapery and with the arms left as

they were, a plaster cast of this work was presented by Rodin to the Musée des Beaux-Arts in Marseilles in 1898 (fig. 19–2).

When asked why he had left the figure incomplete, Rodin rationalized his decision and replied: "My figure represents *Meditation*. That's why it has neither arms to act nor legs to walk. Haven't you noticed that reflection, when persisted in, suggests so many plausible arguments for opposite decisions that it ends in inertia?"[5] This version of *Meditation*, or *The Inner Voice*, is to be dated 1896–97 rather than 1885.[6]

A comparison of Rodin's mutilated yet dynamically organized figure, with its pronounced *contrapposto*, with a typical nineteenth-century version of this theme by Jean-Marie-Bienaimé Bonnassieux (1810–1892; fig. 19–6) reveals how far Rodin had departed by this time from academic ideals and procedures, despite the identity of title. The subject of Meditation automatically suggested to the academic sculptor, with his classical training, a standing matronly figure draped in classical garb. To Rodin, however, such personifications of abstract notions seemed meaningless. He allowed the form he created to suggest its own title, choosing what seemed to be the most appropriate nomenclature for the work through an intuitive understanding of the forces at play within the figure.

The same figure which proved to be so adaptable in the *Monument to Victor Hugo* was also incorporated by Rodin into a number of other works. Carved in stone and with a fishtail instead of legs, the first version of *Meditation* became *The Siren* (fig. 19–7). With another nude figure gliding against it, it entered the work known as *Constellation*, although the position of the arms has been changed again (fig. 19–4). Seen from behind, the same figure was used in the group known as *Christ and the Magdalen* (fig. 19–5).[7] Finally, about 1913, the mutilated figure of *Meditation* from the fourth project for the first monument to Victor Hugo was placed beside the enlarged plaster of *The Shade,* minus the right hand, and entitled *Adam and Eve (see* no. 5).

NOTES

1. To the left of *The Thinker,* Rodin represented the Arrival in Hell; to the right, the Judgment of the Damned Souls.

2. In the first three editions of his catalogue, Grappe described the mutilated plaster of *Meditation,* also called *The Inner Voice,* as being "la première étude que fit Rodin de son Eve" *(see* [338], no. 86; [338a], no. 105; [338b], no. 154). This is clearly not the case for reasons cited in the text, but there certainly is a relationship between the tympanum figure and the first study later employed in the design for a fireplace *(see* fig. 8–9).

3. In the first two editions of the catalogue, Grappe dated the small version of *Meditation* 1886 *(see* [338], no. 85 and [338a], no. 104). In subsequent editions he changed the dating to 1885. Jianou and Goldscheider [65], p. 90, retain the dating of 1885 for all versions of this figure.

4. Steinberg in New York, 1963 [369], p. 21, states: "The gesture is neither taken from life nor wholly invented. It is a pathos-formula out of 15th Century art: cf. a drawing in the Wallace Collection, London, attributed to Pollaiuolo, or Jacopo della Quercia's *Expulsion* on the portal of S. Petronio, Bologna."

Another case of the use of time-honored poses and gestures by Rodin, who was extremely well versed in the history of art, is to be seen in the group of *Ugolino (see* no. 1, detail B). The pose of the distraught father is illustrated in Andrea Alciati's book of emblems, where it symbolizes extreme melancholy. William Blake's *Nebuchadnezzar* derives from the same source.

5. Gsell [57b], p. 162.

6. Alley [334], p. 214, arrived at a similar conclusion.

7. Coquiot [30], p. 36, asked Rodin why he had modeled only one religious group, *Christ and the Magdalen.* "Ma foi, à vrai dire, ce serait plutôt ce

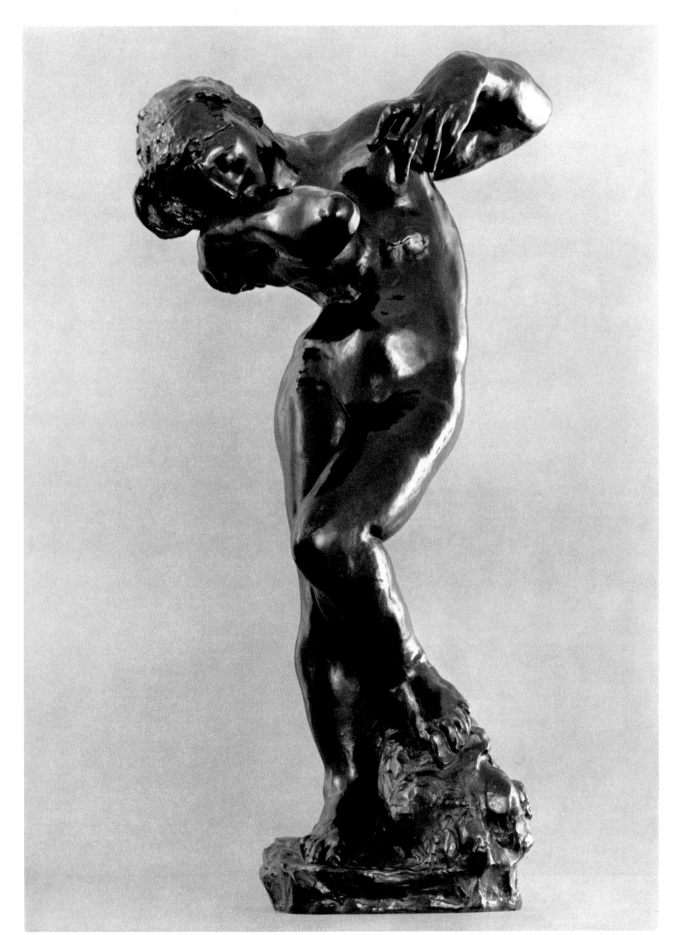

19

groupe auquel vous faites allusion, *Prométhée et une Océanide*. De la sculpture religieuse, sans doute, cela me tentait, mais on ne peut l'exécuter sans beaucoup de draperies, et j'en avais tant fait chez Carrier-Belleuse que le nu s'imposa tout de suite à moi, et pour toujours presque irrésistiblement."

REFERENCES

Lawton [67], pp.131–32, 184, 259–62, repr.opp. p.132; Gsell [57b], pp.161–63; Cladel [25a], pp. 308–11; Bénédite [10a], p.29, repr.pl. XXXVII(B); Grappe [338], nos.85, 86; Watkins [342], no.21; Grappe [338a], nos.104–6; Grappe [338b], nos. 153–55; Cladel [26], pp.174–80; Grappe [338c], nos.113, 113 bis; Grappe [338d], nos.127, 128; Grappe [54], p.141, repr. p. 59; Waldmann [109], pp.43, 76, no.35, repr.pl.35; Boeck [138], pp.168–69, repr.pls.174, 175; Alley [334], pp.213–14, no.6049, repr.pl.47a; Tancock [341], no.19.

OTHER CASTS AND VERSIONS

ALGERIA
Algiers, Musée National des Beaux-Arts. Purchased by the state in 1929.

BRAZIL
São Paulo, Museu de Arte de São Paulo. Gift of Geremia Lunardelli. Purchased from Galerie Charpentier, Paris.

FRANCE
Paris, Musée Rodin. Signed: A.Rodin. Founder: Alexis Rudier.

GREAT BRITAIN
London, Collection Stavros S. Niarchos (ex. Collection Bénézit). Signed. Founder: Alexis Rudier. Cast no.11/12.

UNITED STATES
New York City, Collection Hilda Folkman-Bell. Signed. Founder: Alexis Rudier.

Philadelphia, Collection Mrs. Charles J. Solomon. Signed: A.Rodin. Inscribed: 7ᵉᵐᵉ épreuve. Founder: Alexis Rudier.

The Inner Voice (figure with both arms raised and clasped over head)
Bronze, height 62¼ inches

CZECHOSLOVAKIA
Prague, Národní Galerie. Cast in 1925 from plaster in museum (fig. 19–1).

FRANCE
Paris, Musée Rodin.

JAPAN
Tokyo, National Museum of Western Art (ex. Collection Matsukata). Signed: A.Rodin.

Plaster

CZECHOSLOVAKIA
Prague, Národní Galerie. Acquired in 1923.

Bronze, height 57½ inches (mutilated version)

GREAT BRITAIN
London, Bethnal Green Museum (as *The Muse*). Gift of Rodin to the Victoria and Albert Museum, 1914. Signed: A.Rodin. Founder: Alexis Rudier.

Plaster, height 60 inches

FRANCE
Marseilles, Musée des Beaux-Arts. Gift of Rodin, 1898 (fig. 19–2).
Paris, Musée Rodin.

GERMANY (EAST)
Dresden, Staatliche Kunstsammlungen. Purchased in 1897 from the Internationale Kunstausstellung, Dresden.

19–1
The Inner Voice
1896–97, bronze, height 62¼ inches
Národní Galerie, Prague

19–2
The Inner Voice
1896–97, plaster, height 60 inches
Musée des Beaux-Arts, Marseilles

19–3
Meditation (detail of the tympanum of *The Gates of Hell*, no.1)

196

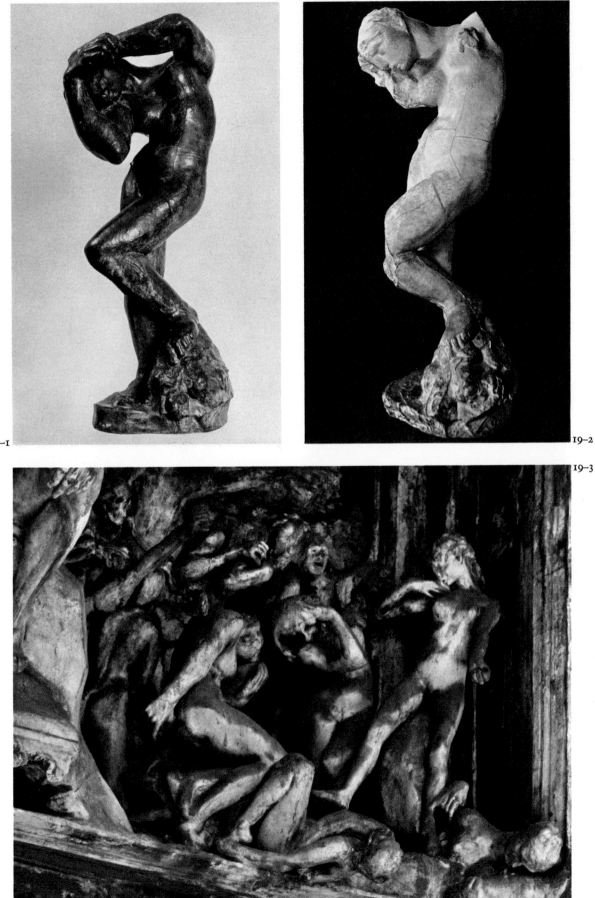

19-1

19-2

19-3

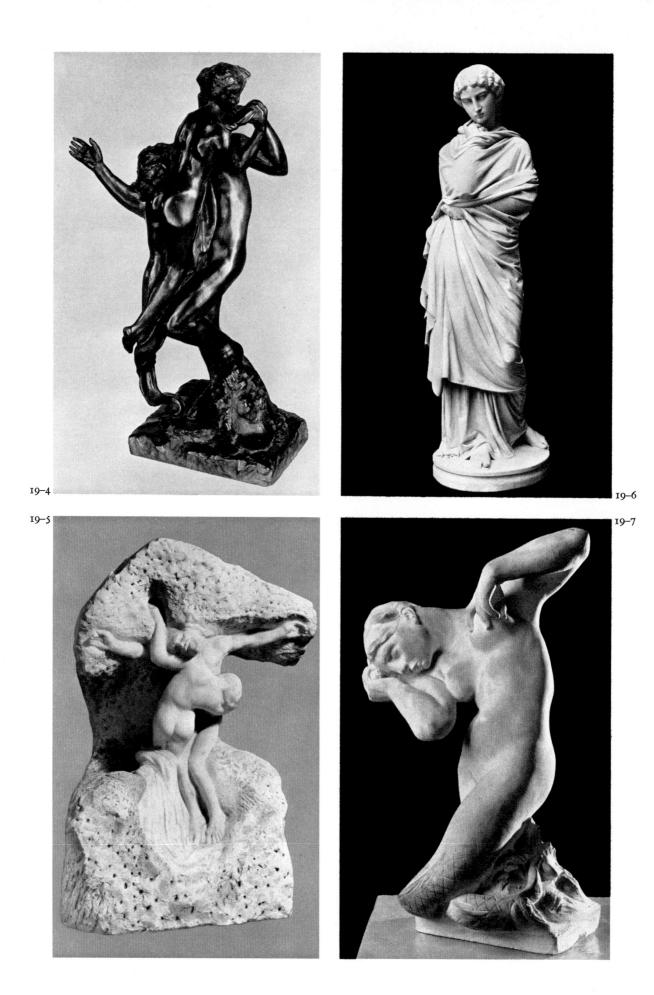

19–4

19–6

19–5

19–7

Bronze, height 23⅝ inches

FRANCE
Paris, Musée Rodin.

Adam and Eve

See *The Shade* (no. 5), Other Casts and Versions.

RELATED WORKS

The Siren

Stone

FRANCE
Paris, Musée Rodin (fig. 19–7).

Christ and the Magdalen

Plaster, height 40¼ inches

FRANCE
Paris, Musée Rodin.

UNITED STATES
Maryhill, Wash., Maryhill Museum of Fine Arts.
San Francisco, California Palace of the Legion of
 Honor. Spreckels Collection.

Marble, height 44½ inches

Private collection (fig. 19–5).

SWITZERLAND
Lugano-Castagnola, Thyssen-Bornemisza Collection.
 Purchased from Rodin.

Study for "Christ and the Magdalen"

Plaster, height 54⅝ inches

FRANCE
Paris, Musée Rodin.

Constellation

Bronze, height 28¾ inches

FRANCE
Paris, Musée Rodin (fig. 19–4).

JAPAN
Tokyo, National Museum of Western Art (ex. Col-
 lection Matsukata). Founder: Alexis Rudier.

Marble, height 31½ inches

FRANCE
Paris, Musée Rodin.

19–4
Constellation
1902, bronze, height 28¾ inches
Musée Rodin, Paris

19–5
Christ and the Magdalen
1894, marble, height 44½ inches
Private collection

19–6
Jean-Marie-Bienaimé Bonnassieux
Meditation
1855, marble
Location unknown

19–7
The Siren
Stone
Musée Rodin, Paris

20 The Centauress
by 1887

Bronze, 18⅛ × 17 × 5⅞ inches
Signed top of base to right, near horse's left hoof: A. Rodin
Foundry mark back of base to left: Alexis Rudier/Fondeur Paris

Among the inhabitants of the mythological world that meant so much to Rodin, the centaur held a special place. There are many representations of this figure in the early "black" drawings *(see* fig. 20–2), and, according to Grappe,[1] in one of the first versions of *The Gates of Hell* a troop of centaurs formed a decorative frieze framing the central panels. On the two bas-reliefs which Rodin intended to place low down on the doors (nos. 12, 13) the crying heads in the center were flanked by representations of centaurs carrying off the struggling bodies of women. In the final version of *The Gates* a centaur can be seen three-quarters of the way up the left-hand decorative pilaster *(see* no. 1, detail F), among the inhabitants of Limbo.

According to Comte Robert de Montesquiou, one of Rodin's earliest admirers, *The Centauress* was entitled *Soul and Body* by Rodin. Montesquiou described this work in the following words: "A male torso stretches out from a horse's body, as if in a vain effort to separate humanity from bestiality, thought from animal life."[2] Thus the centaur seems to have had a particularly tragic significance for Rodin.[3]

Like so many other figures in Rodin's *œuvre, The Centauress* is a composite figure. The horse's body is taken from the 1886 project for a monument to the Chilean general, Patrick Lynch (fig. 20–1).[4] To this Rodin then added a female torso, a pair of very roughly made arms, and a head which is that of the male figure from the group of *Fugitive Love (Fugit Amor)* in the center of the right-hand leaf of *The Gates of Hell (see* no. 1, detail M). This head differs slightly from that used in the group of *Paolo and Francesca* and the definitive group of *Fugitive Love* (fig. 20–4) in that the forms are more angular and the line of the brow much more strongly developed. In 1892 the figure of *Orpheus* was constructed in a similar way from closely related parts (fig. 20–3). As Grappe does not give any reasons for dating *The Centauress* 1889, and as the component parts—the horse from the General Lynch project and the head from the *Fugitive Love* group on *The Gates*—were already in existence by 1887,[5] a date of by 1887 is here suggested for this figure.[6]

Discussing *The Centauress* with Rodin, Comte de Montesquiou remarked that such a work and also the *Orpheus* would make admirable motifs for a mausoleum.[7] It may be that in enlarging it and having it carved in marble Rodin had some such idea in mind (fig. 20–5). However, the bronze version is superior, as in the marble the extended arms require a support, thereby eliminating the feeling of strain, which is such an important feature of the work.

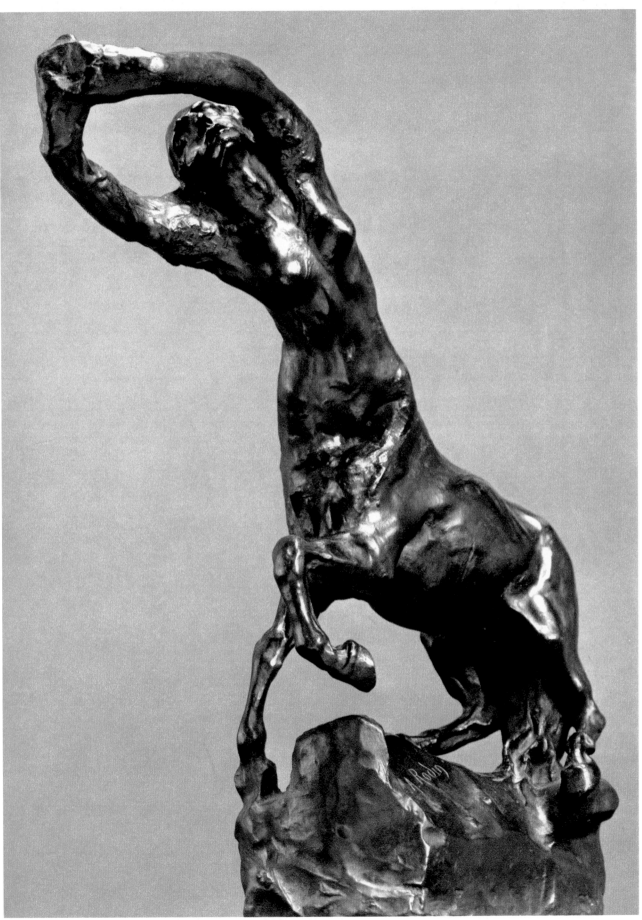

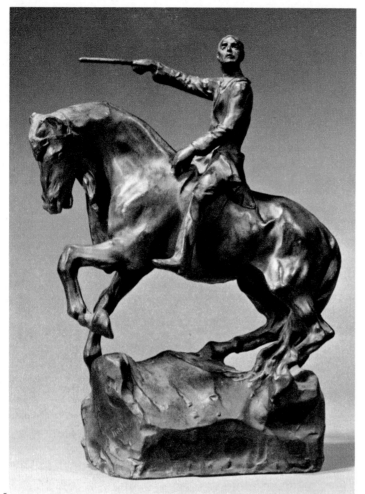

20-1

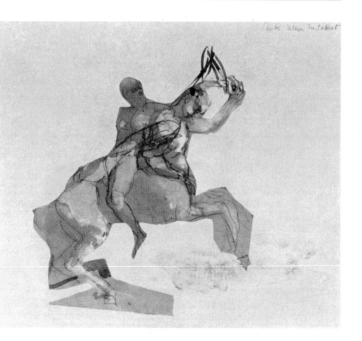

20-2

NOTES

1. Grappe [338d], no. 239. "Dans une des premières versions de la *Porte,* leur [the centaur's] troupe formait la frise décorative encadrant les vantaux."
2. Montesquiou [258], p. 122. "Enfin Rodin intitule *l'Ame et le Corps* cet être hybride qui ressemble à un Centaure étiré; un torse d'homme qui se prolonge hors d'un corps de cheval, comme dans un vain effort de séparer l'humanité de la bestialité, la pensée de la vie animale."
3. Grappe [209], p. 206, suggested that this work may be yet another example of the influence of Ovid on Rodin. He proposed that the centauress represented is Hylonome, whose story can be found in *Metamorphoses.* Hylonome, the most beautiful of the centauresses, was in love with Cyllarus. When he was killed by an arrow from an unknown hand, and she saw that he was dead, "she threw herself upon the spear which had pierced Cyllarus and fell in a dying embrace upon her lover" (Ovid, *Metamorphoses,* trans. Frank Justus Miller [Cambridge, Mass.: Harvard University Press, 1946], 12. 427–28). The rather unusual choice of a centauress on Rodin's part makes this supposition seem distinctly possible.

20-1
Study for the "Monument to General Lynch"
1886, bronze, height 16⅛ inches
National Museum of Western Art, Tokyo

20-2
Centaur
Watercolor and gouache, 7½ × 9 inches
Rodin Museum, Philadelphia

20-3
Orpheus
1892, bronze, height 59 inches
National Museum of Western Art, Tokyo

20-4
Fugitive Love (Fugit Amor)
By 1887, bronze, height 14⅛ inches
National Museum of Western Art, Tokyo

20-5
The Centauress
By 1887, marble, height 28 inches
Musée Rodin, Paris

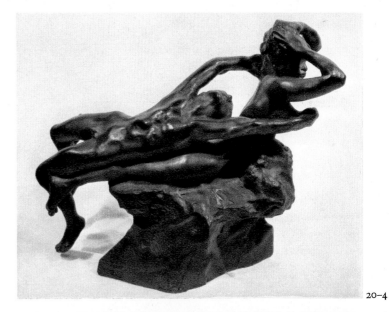

20-4

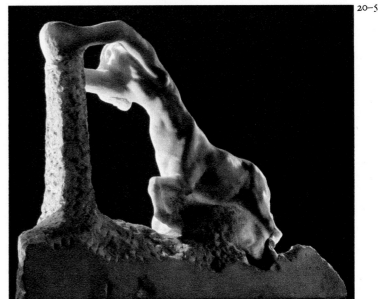

20-5

20-3

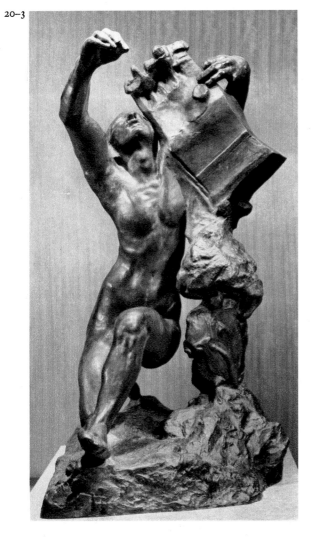

203

4. Steinberg in New York, 1963 [369], p.21, states: "*The Centauress* unites the androgynous torso of *Orpheus*—himself an uneasy graft—with the mount of the equestrian *General Lynch*." The addition of a pair of rough arms and a head related to, although not the same as, that of *The Centauress* does create an hallucinating resemblance to the earlier work.
5. Grappe [338d], nos.163 and 173 respectively.
6. In the first two editions of the catalogue of the Musée Rodin, Grappe dated *The Centauress* about 1900 (*see* [338], no.238 and [338a], no.272). In subsequent editions he revised the dating to 1889, although he does say, "Elle semble contemporaine des premiers projets relatifs à la *Porte,* mais Rodin faisait souvent le silence sur ses recherches et ne les divulguait que longtemps après leur élaboration complète."
7. Montesquiou [258], p.122.

REFERENCES

Lawton [67], p.269, repr.opp.p.266; Montesquiou [258], p.122; *L'Art et les Artistes* [330], p.62; Bénédite [10a], p.31, repr.pl. LI(A) (marble); Grappe [338], no.238; Watkins [342], no.30; Grappe [338a], no.272; Grappe [338b], no.267; Grappe [338c], no.209; Grappe [338d], no.239; Grappe [54], p.143, repr. p.94; Elsen [38], p.53, repr.p.55 (marble); Tancock [341], no.20.

OTHER CASTS AND VERSIONS

When Jules Mastbaum made his purchase from the Musée Rodin, he was offered a choice of this work in two dimensions, heights 18⅛ inches or 36¼ inches. No trace of the larger work is now known.

Bronze

SWITZERLAND
Lausanne, Collection Samuel Josefowitz.

UNITED STATES
Los Angeles, Los Angeles County Museum of Art. Mr. and Mrs. George Gard de Sylva Collection. Signed: A.Rodin. Inscribed: 3^eme épreuve. Founder: Alexis Rudier.

New York City, Collection Mrs. David Bortin. Founder: Alexis Rudier.
Stanford, Stanford University Art Gallery and Museum. Gift of B.G. Cantor Art Foundation. Founder: Godard. Cast no.3.

Marble, height 28 inches

FRANCE
Paris, Musée Rodin (fig.20–5).

Torso of "The Centauress"

Bronze, height 8 inches

UNITED STATES
Beverly Hills, Collection Mrs. Jefferson Dickson (ex. Collection Jules Mastbaum).

RELATED WORKS

Study for the "Monument to General Lynch"

Plaster, height 17¾ inches

FRANCE
Paris, Musée Rodin.

Bronze, height 16⅛ inches

JAPAN
Tokyo, National Museum of Western Art (ex. Collection Matsukata). Signed (fig.20–1).

UNITED STATES
Beverly Hills, Cantor, Fitzgerald Art Foundation. Founder: Georges Rudier. Cast no.3.

Orpheus

Bronze, height 59 inches

FRANCE
Paris, Musée Rodin.

JAPAN
Tokyo, National Museum of Western Art (ex. Collection Matsukata). Signed: A.Rodin (fig.20–3).

SWITZERLAND
Zurich, Kunsthaus Zurich.

UNITED STATES
Los Angeles, Los Angeles County Museum of Art. Gift of B.G. Cantor Art Foundation. Founder: Susse.

21 Head of St. John the Baptist on a Platter
1887

Bronze, 7½ × 14½ × 10½ inches
Signed back of hair to right: A. Rodin
Foundry mark back of platter to left: Alexis. Rudier./Fondeur. Paris.

Rodin's interest in the character of St. John the Baptist led him, some years after the life-size figure of *St. John the Baptist Preaching* (no. 65), to treat a later episode in the story, the moment immediately after the beheading of John at the request of Salome. As in so many other cases—and very often in the most surprising places—Rodin's choice of subject found ample precedent in the Salon sculpture of his time.

At the Salon of 1879, for example, Markus Antokolski (1843–1902) had exhibited a *Head of St. John the Baptist on a Platter,* and the critic Eugène Véron had complained that "the confusion of sculpture and painting is invading us so much that here is a sculptor, M. Antokolski, who sets about simply copying the painting of M. Henner, *Head of St. John the Baptist on a Platter.*"[1]

The sculptor Jean Carriès (1855–1894) made something of a specialty of severed heads. Among his works are *The Frightened Man* (or *The Despairing Clown*), which represents a head on a cushion, and *Head of Charles I,* represented after the execution (fig. 21–1). But Rodin, with his considerable knowledge of medieval and Renaissance sculpture, may be expected to have been familiar with earlier versions of this subject. During the fourteenth and fifteenth centuries chargers with the heads of St. John the Baptist were utilized as devotional images *(Andachtsbild)* and were particularly popular in the northern countries and in northern Italy.[2] Typical is the *Head of St. John the Baptist—in disco* (on a platter)—from South Germany, dating from the beginning of the sixteenth century and bearing the inscription "Inter Natos no surrexit maior Johanne Baptista," now in the Musée de Cluny in Paris.

In 1887, at any rate, Rodin made two versions of this subject which adhere very closely to previous representations of it. In the first version the severed head rests on its side on a large tray with irregular edges. In the second version the head, with open mouth and tightly closed eyes, rests on its back (fig. 21–4). It is this latter version which, on a reduced scale, can be seen near the top of *The Gates of Hell,* around the right corner.[3] Both versions were also carved in marble (figs. 21–2, 21–3), an example of the former entering the collection of the Swedish painter Fritz Thaulow. A marble was exhibited at the Exposition Monet-Rodin in 1889, while the Thaulow version was exhibited at the Exposition Rodin in 1900.[4] At a later date the second version was reduced to approximately 1⅜ inches in height. This was cast in silver and mounted as a pendant for Judith Cladel and probably about 1910 was used in an assemblage with three detached hands (fig. 21–5). This same head was also incorporated in *The Poet and Love* (no. 50).

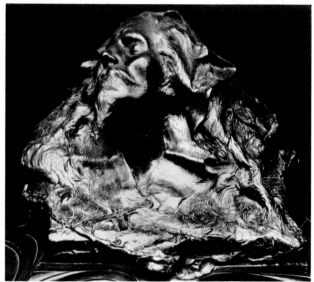

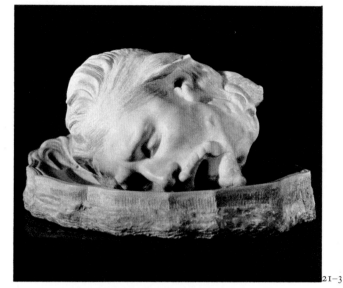

21–1

21–3

21–2

21–4

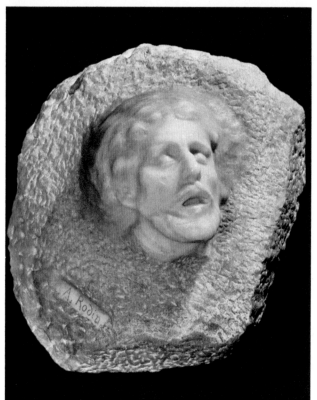

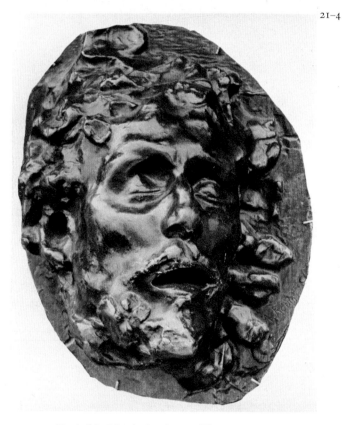

21–1 Jean Carriès (1855–1894)
 Head of Charles I
 Bronze
 Location unknown

21–2 *Head of St. John the Baptist on a Platter (No. 2)*
 1887, marble, height 7⅞ inches
 National Museum of Western Art, Tokyo

21–3 *Head of St. John the Baptist on a Platter*
 1887, marble, height 7⅞ inches
 Location unknown

21–4 *Head of St. John the Baptist on a Platter (No. 2)*
 1887, bronze, height 5⅜ inches
 Hirshhorn Museum and Sculpture Garden,
 Smithsonian Institution, Washington, D.C.

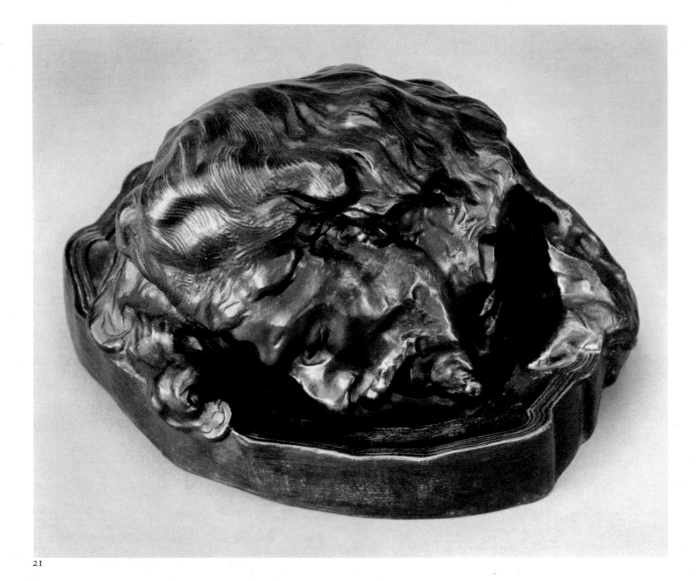

21

NOTES

1. Eugène Véron, "La Sculpture au Salon de Paris, 1879," *L'Art,* Paris, 2 (1879), p. 294. "La confusion de la sculpture et de la peinture nous envahit tellement que voici un sculpteur, M. Antokolski, qui se met à copier simplement la toile de M. Henner, la *Tête de saint Jean* sur un plat." In light of Rodin's preoccupation with *The Gates of Hell* from 1880 onward, it is worth further quoting of Eugène Véron's strictures on the confusion between painting and sculpture. He goes on to mention "M. Hugues qui traduit en plâtre celle [painting] de Ary Scheffer, *Paolo et Francesca.* Quel sujet pour un sculpteur! La peinture, avec toutes ses ressources, a déjà bien de la peine à distinguer des ombres de corps réels. Comment s'imaginer des ombres en marbre ou en bronze?" Rodin showed how this could be done the following year!

2. *See* Erwin Panofsky, *Studies in Iconology: Humanistic Themes in the Art of the Renaissance* (New York: Oxford University Press, 1939), p. 13 and pl. II, no. 4, in which a *Head of St. John,* a Netherlandish wood carving dated about 1500 in the Museum für Kunst und Gewerbe, Hamburg, is reproduced. Compare also the fresco on this theme, *S. Giovanni Decollato,* circle of Cigoli, in S. Maria della Croce al Tempio, Florence (repr. in Eugenio Battisti, *L'Antirinascimento* [Florence: Feltrinelli, 1962], pl. 6).

3. This was incorrectly called *Head of Christ* at an exhibition in 1918. *See* Grappe [338d], no. 178.

4. *See* Paris, 1889 [347], no. 17, and Paris, 1900 [349], no. 98.

REFERENCES

L'Art Français, Paris, July 6, 1889, repr.; Geffroy [199a], repr. opp. p. 8; Maillard [71], p. 154; Lami [4], p. 169; Grappe [338], no. 101; Watkins [342], no. 64; Grappe [338a], no. 123; Grappe [338b], no. 207; Grappe [338c], no. 157; Grappe [338d], no. 177; Descharnes and Chabrun [32], repr. p. 85; Tancock [341], no. 21.

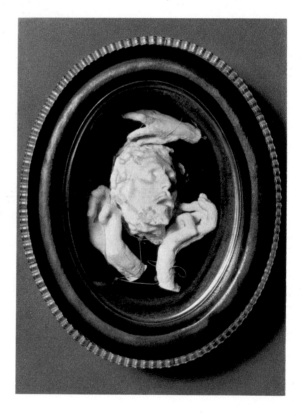

21–5
Assemblage of Three Hands and the "Head of St. John the Baptist"
c. 1910, plaster
Musée Rodin, Paris

OTHER CASTS AND VERSIONS

Bronze

FRANCE
Paris, Musée Rodin.

Marble, height 7⅞ inches
Location unknown (fig. 21–3).

UNITED STATES
Montclair, N.J., Kasser Foundation.
San Francisco, Collection Mr. and Mrs. H. Mitchell.

Head of St. John the Baptist on a Platter (No. 2)

Bronze, height 5⅜ inches
FRANCE
Paris, Musée Rodin.

UNITED STATES
Des Moines, Des Moines Art Center. Given to Jean-Paul Laurens by Rodin. Acquired by the Des Moines Association of Fine Arts from Paul Foinet in 1931.
Madison, N.J., Estate of Geraldine R. Dodge. Signed: A. Rodin.
Princeton, Princeton University, Art Museum. Gift of J. Lionberger Davis, 1953. Founder: Alexis Rudier.
Washington, D.C., Collection David Sellin. Presented by Rodin to Cosmo Monkhouse following the publication of his book *The Christ on the Hill*, 1895. Cast from a plaster in the same collection. Inscribed: A Monsieur Monkhouse. No foundry mark.
— Hirshhorn Museum and Sculpture Garden, Smithsonian Institution. Signed: A. Rodin. Founder: Alexis Rudier (fig. 21–4).

Plaster

UNITED STATES
San Francisco, California Palace of the Legion of Honor. Gift of A.B. Spreckels, Jr. Signed: Auguste Rodin/1916.
Washington, D.C., Collection David Sellin.

Marble, height 9⅞ inches

JAPAN
Tokyo, National Museum of Western Art (ex. Collection Matsukata). Signed: A. Rodin (fig. 21–2).

Bronze, height 1⅜ inches

FRANCE
Paris, Musée Rodin.

Silver (mounted as pendant for Judith Cladel)

FRANCE
Paris, Musée Rodin.

Detached head

Plaster, height 2⅝ inches

UNITED STATES
Washington, D.C., National Gallery of Art. Inscribed: en souvenir de Paris/l'an 1907/ a monsieur J.W./ Simpson de/New York en grande sym/pathie/A Rodin.

Assemblage of Three Hands and the "Head of St. John the Baptist"

Plaster

FRANCE
Paris, Musée Rodin (fig. 21–5).

22 Polyphemus, Acis, and Galatea
1888

Plaster, $11\frac{5}{8} \times 6\frac{3}{4} \times 8\frac{3}{4}$ inches
Not signed or inscribed

According to Grappe,[1] this group, which was originally intended for *The Gates of Hell*, dates from 1888. He remarks that Rodin probably had in mind the well-known Medici Fountain[2] by Auguste-Louis-Marie Ottin (1811–1890), which he often must have seen on his walks through the Luxembourg Gardens. This incorporated a group representing Polyphemus about to crush Acis and Galatea.

Like so many of Rodin's mythological works, the literary source for *Polyphemus, Acis, and Galatea* came from Ovid's *Metamorphoses*. In Book 13 there is an account of the love of the cyclops Polyphemus for the nymph Galatea, who in turn is loved by Acis. Polyphemus goes out to the end of a rocky promontory to court Galatea. In her account she says: "All the mountains felt the sound of his rustic pipings; the waves felt it too. I, hiding beneath a rock and resting in my Acis' arms, at a great distance heard the words he sang and well remember them."[3] When Polyphemus saw them together, he hurled a rock at them which crushed Acis, while Galatea escaped by jumping into the sea.

Although the small figures of Acis and Galatea are closely related to *The Eternal Idol* of 1889 *(see* Introduction), few other works of Rodin adhere so closely to a literary source, making the substitution of any other title difficult to conceive. Perhaps because the group seemed too complicated and too particular in its iconography,[4] it was never inserted in *The Gates*. However, the figure of Polyphemus does appear there, above the center of the right panel *(see* no.23).

NOTES

1. Grappe [338d], no.200.
2. Ibid. The project for the *Polyphemus* by Ottin was exhibited at the Salon of 1852, no.1504, and at the Exposition Universelle, 1855, no.4521. The model for the fountain was commissioned by the state on September 25, 1862, and cast by Thiébaut in July 1863.
3. Ovid, *Metamorphoses*, trans. Frank Justus Miller (Cambridge, Mass.: Harvard University Press, 1946), 13.785–88.
4. This seems to be a more likely reason than that suggested by Grappe [338d], no.200, namely, that the figures were suppressed at the time when Rodin began to feel there were too many holes and projections in the doors. The figure of Polyphemus himself protrudes far more than either of the suppressed figures.

REFERENCES

Watkins [342], no.93; Grappe [338a], no.139 bis; Grappe [338b], no.224; Grappe [338c], no.173; Story [103], repr.pl.72; Grappe [338d], no.200; Grappe [54], p.142, repr.p.82; Boeck [138], pp.167, 170, repr.pl.87; Tancock [341], no.23.

OTHER VERSIONS

Bronze

FRANCE
Paris, Musée Rodin. Signed: A. Rodin. Founder: Alexis Rudier.

UNITED STATES
San Francisco, California Palace of the Legion of Honor. Signed: A.Rodin/no.2. Founder: Alexis Rudier.

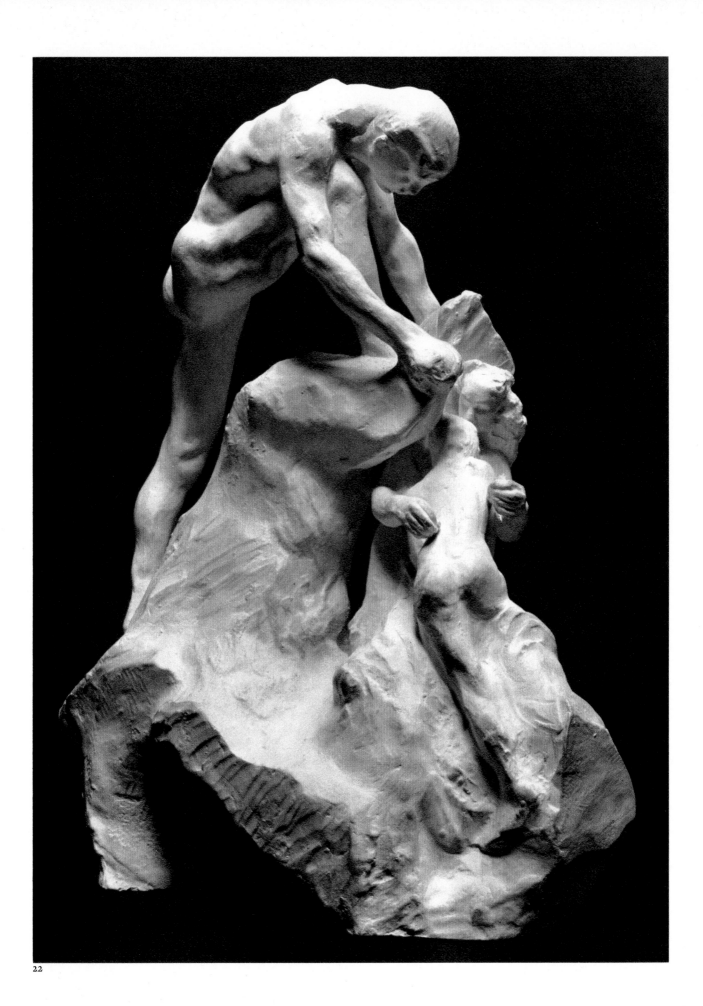

23 Polyphemus
1888

Plaster, 9¾ × 6 × 5¾ inches
Inscribed on rock: A Mʳ/L Hugo/ Rodin.[1]

Once the group of Acis and Galatea was removed *(see* no. 22), it was possible to think of other equally appropriate identities for the figure of *Polyphemus*,[2] which is to be seen above the center of the right panel of *The Gates of Hell.* On the base of one of the plasters in the Musée Rodin the following alternative titles are written in pencil: *Narcisse* and *Milon de Croton.* Thus the work suggested to Rodin either the figure of Narcissus admiring his own reflection in the water or Milon of Croton, the son of Diotimus, famous for his bodily strength as a wrestler, held in the grasp of a tree. As an old man, Milon saw the trunk of a tree which had been partially split open by woodcutters. When he attempted to split the tree further, the wood closed upon his hands and held him fast until he was devoured by wolves.

This is a very good example of the relationship between the work of art and the title by which it is known in Rodin's *œuvre*. Almost always *(Polyphemus, Acis, and Galatea* is perhaps a rare exception) the title was given after the completion of the work, very often at the suggestion of one of Rodin's literary friends. Thus it often happens that several titles are equally appropriate, the choice of one from among them emphasizing certain features at the expense of the others.

A figure closely related to *Polyphemus* was used in the unfinished marble *Day and Night* (fig. 23–1), on which work had ceased by 1907.[3] The relationship between Day and Night is conceived of as an equal contest between two wrestlers. Like *Sorrow (No. 2)* (no. 42), the plaster figure of *Polyphemus* is dedicated to the sculptor Léopold-Armand Hugo and not to any relative of Victor Hugo.

NOTES

1. Purchased from F. and J. Tempelaere, Paris.
2. Grappe [338d], nos. 201 and 202, lists two other figures of Polyphemus: *Polyphemus (No. 1),* plaster, 9⅞ × 5½ × 6¼ inches (identical with no. 200) and *Polyphemus (No. 2),* plaster, 5⅛ × 11¾ × 2¾ inches, which he takes to be a study for a figure of *Polyphemus,* although the two works appear to be very different.
3. Ibid., no. 367. This date is derived from a letter written in 1907.

REFERENCES

Lami [4], p. 171; Grappe [338], nos. 118, 119; Watkins [342], no. 97; Grappe [338a], nos. 140, 141; Grappe [338b], nos. 225, 226; Grappe [338c], nos. 173 bis, 173 ter; Story [103], pp. 146–47, no. 72, repr. pl. 72; Grappe [338d], nos. 201, 202; Boeck [138], pp. 167, 171, repr. pl. 88; Story [103a], no. 51, repr. pl. 51; Tancock [341], no. 24.

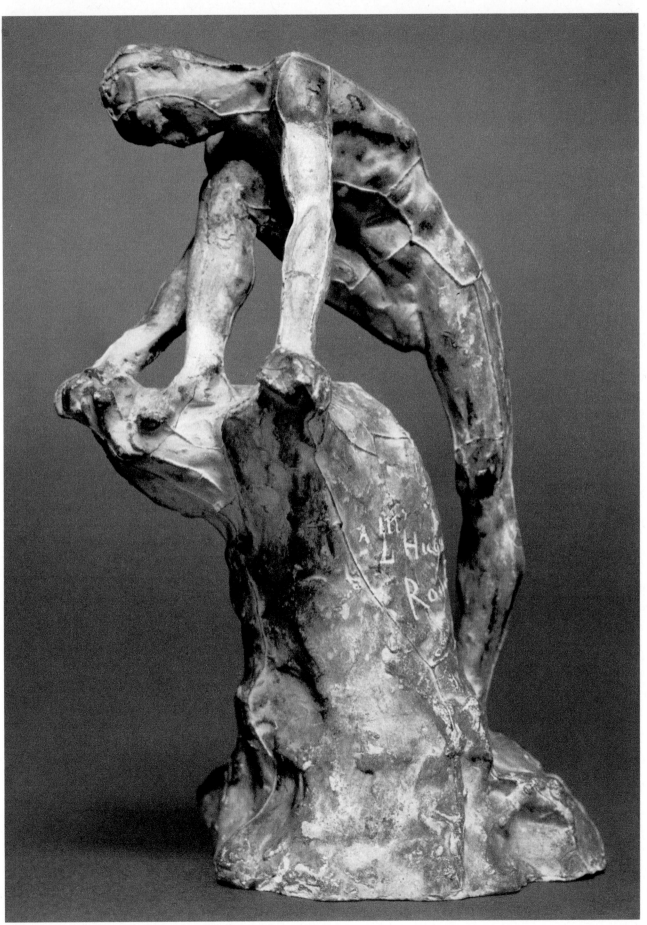

OTHER CASTS AND VERSIONS

Plaster

FRANCE
Paris, Musée Rodin.

UNITED STATES
Maryhill, Wash., Maryhill Museum of Fine Arts.

Bronze

BELGIUM
Antwerp, Koninklijk Museum voor Schone Kunsten. Purchased in 1951. Signed: Rodin.

CANADA
Toronto, Collection Mr. and Mrs. R. W. Finlayson.

FRANCE
Belfort, Musée de Belfort. Signed and inscribed: A mon cher ami Lefèvre Rodin. Founder: Converset.
Paris, Musée Rodin.

GREAT BRITAIN
Kent, Saltwood Castle, Collection Lord Clark.

UNITED STATES
Beverly Hills, Collection Leona Cantor, Founder: Georges Rudier. Cast no. 9/12.
New Orleans, Collection Mrs. Hunt Henderson.
New York City, Collection Mrs. Patrick Dinehart (ex. Collection Jules Mastbaum). Founder: Alexis Rudier.

23–1
Day and Night (in course of execution)
By 1907, marble, height 29½ inches
Musée Rodin, Paris

214

24 The Sirens

a c. 1888

Plaster, painted with brown varnish,
19½ × 17 × 10 inches
Not signed or inscribed

b c. 1888

Bronze, 17¾ × 17¼ × 10½ inches
Signed to left of base by kneeling figure's
right foot: A. Rodin
Foundry mark back of base to right:
Alexis RUDIER/Fondeur Paris

This group, also known as *The Nereids* and *The Song of the Sirens,* can be seen halfway up on the left side of the left panel of *The Gates of Hell* (fig. 24-4). Dated 1889 in the first two editions of Grappe's catalogue,[1] the dating was revised to before 1888 in subsequent editions. As pointed out by Athena Spear, however, the group does not appear in a photograph of the left panel of *The Gates* published by Bartlett in 1889.[2] When enlarged, the group was called *Niobe,* but this name was not used for long. In the catalogue of the Exposition Rodin of 1900, where the group was exhibited, comparison was drawn with Wagner's Rhinemaidens.[3]

Rodin returned to this group on a number of other occasions. Mounted at a different angle, they hover over the dying poet in the work known as *The Death of the Poet* (fig. 24-2), dated 1888 by Grappe.[4] This was placed in the tympanum of the fireplace designed in 1912, which also incorporated figures of Adam and Eve *(see* no. 4). Rodin also proposed using them in the definitive project for the second monument to Victor Hugo *(see* no. 71). Considerably enlarged to a height of a little over four feet and seen from behind, they represent the voices of the sea to which the poet is listening.

As originally utilized in *The Gates* the group of closely entwined figures was about nine inches high *(see* fig. 24-1). In pose the siren kneeling to the left is related to the insatiable *Succubus* (fig. 24-5), certain slight adjustments in the positioning and the rigidity of the limbs, however, in addition to the treatment of the hair, creating a widely different effect. The group was then enlarged to a height of 17¾ inches, the sinuous intertwining of the bodies and the rhythms of breasts and buttocks resulting in a work of great sensuality. From the enlarged version at least four marble replicas were made *(see* Other Casts and Versions and fig. 24-3).

NOTES

1. Grappe [338], nos. 150, 151; [338a], nos. 175, 176.
2. Bartlett [125], repr. between pp. 282-83.
3. Paris, 1900 [349], no. 35. "Ces 'Trois Sirènes,' aux lignes si jeunes et si suaves, aux chants enlacés comme leurs bras, évoquent invinciblement le trio des *Filles du Rhin* dans l'œuvre de Wagner."
4. Grappe [338d], no. 198.

REFERENCES

Geffroy [199a], p. 15; Grappe [338], nos. 150, 151; Watkins [342], nos. 9, 121; Grappe [338a], nos. 175, 176; Grappe [338b], nos. 211, 212; Grappe [338c], nos. 164, 164 bis; Grappe [338d], nos. 186, 187; Grappe [54], p. 142, repr. p. 78; Spear [332], pp. 61, 99, repr. pp. 60, 61, no. XIII; Tancock [341], no. 22.

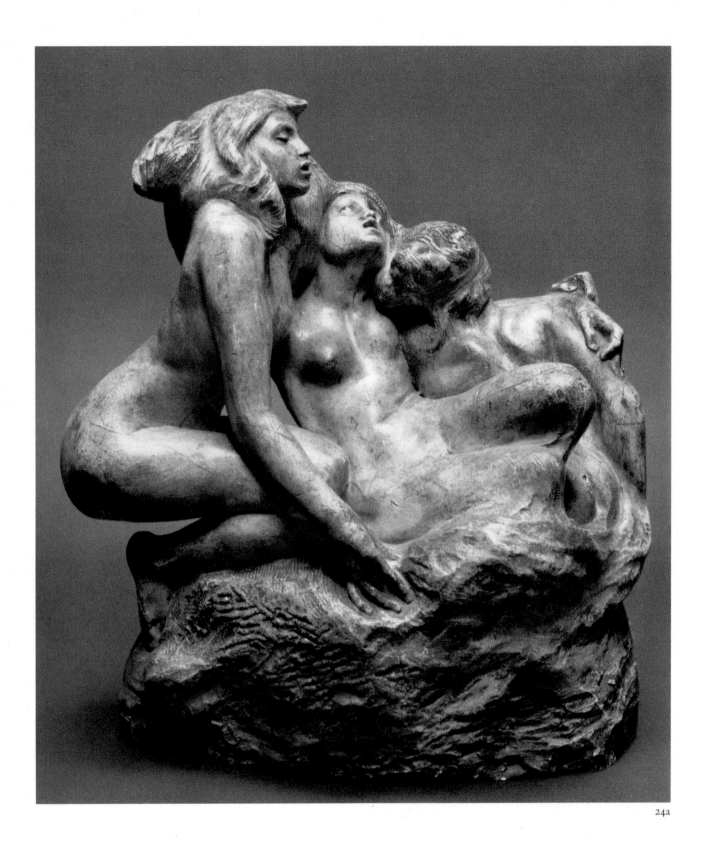

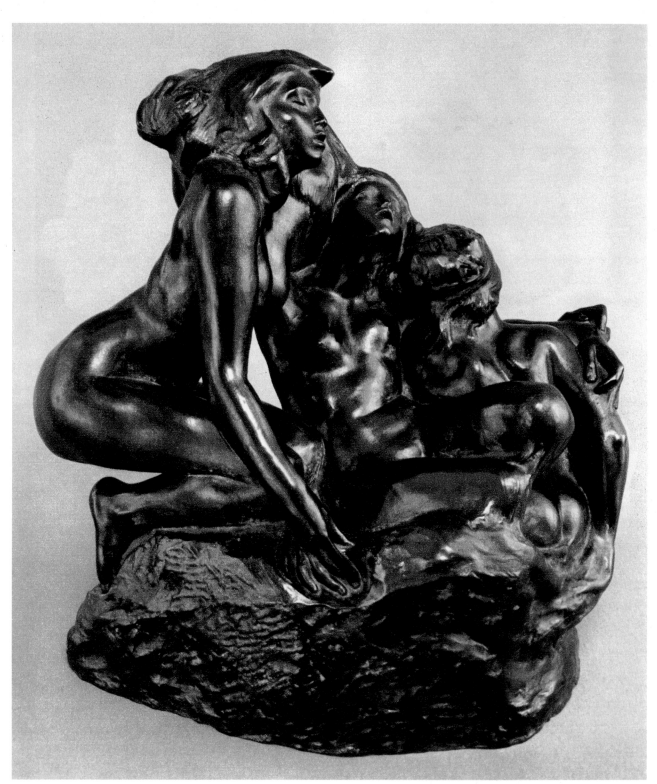

24b

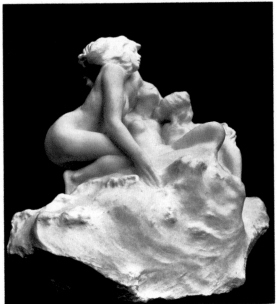

24-3

24-1

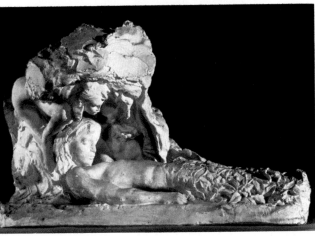

24-2

24-4

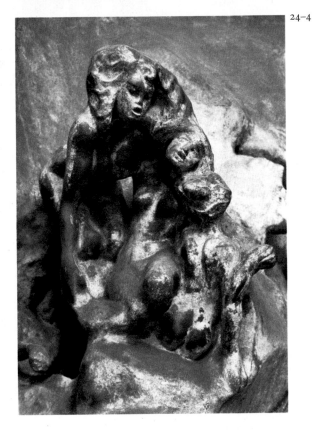

24-1 *The Sirens*
 c. 1888, bronze, height 9 inches
 Wadsworth Atheneum, Hartford

24-2 *The Death of the Poet*
 c. 1888, plaster, height 10⅝ inches
 Musée Rodin, Paris

24-3 *The Sirens*
 c. 1888, marble, height 30 inches
 Ny Carlsberg Glyptotek, Copenhagen
 Gift of Ny Carlsbergfondet, 1927

24-4 *The Sirens* (detail of the left panel
 of *The Gates of Hell*, no. 1)

OTHER CASTS AND VERSIONS

Plaster

FRANCE
Paris, Musée Rodin.

Bronze

FRANCE
Paris, Musée Rodin. Signed: A. Rodin. Founder: Alexis Rudier.

GERMANY (EAST)
Dresden, private collection. On loan to the Staatliche Kunstsammlungen. Signed: A. Rodin.

HUNGARY
Budapest, Szépmüvészeti Múzeum. Purchased from Rodin in 1900. Signed: A. Rodin.

JAPAN
Tokyo, National Museum of Western Art (ex. Collection Matsukata). Signed: A. Rodin.

SWITZERLAND
Lausanne, Collection Samuel Josefowitz. Founder: Persinka.

UNITED STATES
Beverly Hills and New York City, B. G. Cantor Collections. Founder: Georges Rudier. Cast no. 5/12.
Cleveland, Cleveland Museum of Art (ex. Collection Ralph King). Purchased at the Carnegie International Exhibition, Pittsburgh, 1920. Signed: A. Rodin. Founder: Alexis Rudier.

Bronze, height 10¼ inches (small version used in "The Gates of Hell")

FRANCE
Paris, Musée Rodin. Founder: Alexis Rudier.

Bronze, height 9 inches

UNITED STATES
Beverly Hills, Collection Leona Cantor. Founder: Georges Rudier. Cast no. 11/12.
Hartford, Wadsworth Atheneum (ex. Collection Mme Rudier). Purchased in 1959 (fig. 24-1).

Plaster

FRANCE
Paris, Musée Rodin.

UNITED STATES
Beverly Hills, Collection Mrs. Jefferson Dickson (ex. Collection Jules Mastbaum).

Marble

CANADA
Montreal, Montreal Museum of Fine Arts (as *The Wave*) (ex. Collection Drummond). Signed: A. Rodin (height 17½ inches).

DENMARK
Copenhagen, Ny Carlsberg Glyptotek. Gift of Ny Carlsbergfondet, 1927 (ex. Collection Dr. Linde, Lübeck). Signed: A. Rodin (height 30 inches) (fig. 24-3).

SWEDEN
Stockholm, Thielska Galleriet (height 20½ inches).

UNITED STATES
Toledo, Toledo Museum of Art. Gift of Edward Drummond Libbey. Signed: A. Rodin (height 19½ inches).

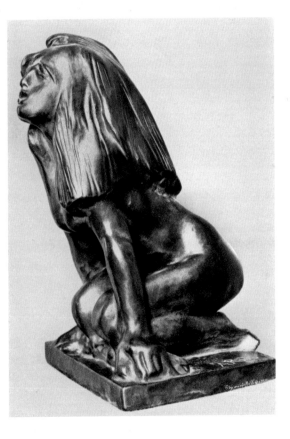

24-5
The Succubus
1889, bronze, height 5¼ inches
Musée Rodin, Paris

25 Shame (Absolution)

c. 1889–90

Bronze, 25¾ × 15 × 12½ inches
Signed front of base, lower right: A. Rodin
Inscribed beneath left foot of seated figure: la/pudeur
and on top of base, right-hand side: absolution
Foundry mark center rear of base: Alexis Rudier/Fondeur Paris

No other casts of this work are known, nor are there any references to it in the extensive literature on Rodin. It is an assemblage of parts used in or intended for use in *The Gates of Hell*. The body of the seated girl is a smaller version of the *Study of a Seated Woman (Cybele)* (fig. 25–3). It is known that the popular model Mme Abruzzezzi posed for this study, as she did for the reclining figure of *Ariadne*.[1] According to Grappe, the *Study of a Seated Woman* was executed in 1889.

To this body, which is headless in the *Study of a Seated Woman,* has been added a head used in *The Gates of Hell,* most prominently in the row of masks above the tympanum, directly above the figure of *The Thinker*. This is closely related to the head which Grappe refers to as *Closed Eyes,*[2] dated 1885.

Finally, the figure balanced on the knees of the seated girl is a slightly modified version of *Andromeda* (no. 35), to which Grappe also assigned a date of 1885. The legs of this figure are held closer to the body than they are in the detached figure.

The use of parts conceived in the period 1885–89 makes a date of about 1889–90 seem inescapable. Moreover, the organization of this group is very close to that of the two figures in *Brother and Sister* (fig. 25–2), the bronze version of which dates from 1890. The pose of the young girl in the latter work is almost identical with that of the *Study of a Seated Woman,* although it is in reverse. However, the mood of the two works differs considerably. The youthful charm of *Brother and Sister* looks back to the work produced by Rodin when he was employed by Carrier-Belleuse, although the gaucherie of the movements leaves no doubt that a period of twenty years has intervened.

Shame is much more anguished, due to the fact that the parts used in the assemblage were originally conceived for *The Gates of Hell,* and far more enigmatic. The two adolescent girls are almost of the same age. Are they sisters or lesbians? The titles that Rodin inscribed on the base—"la pudeur" and "absolution"—are not so much descriptive as evocative. They do not narrow the possible range of meanings contained in the work, as is very often the case with titles. Rather the words "la pudeur" and "absolution" ("shame" and "absolution"), with their moral and religious overtones, greatly extend the range of shades of meaning embodied in the conjunction of these two figures.

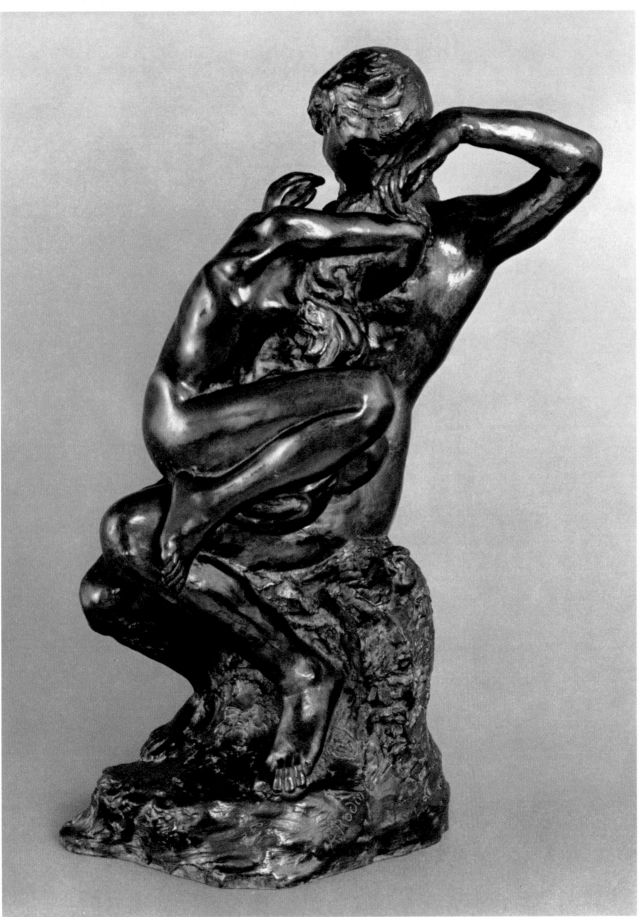

It is in works like these that Rodin is most closely related to the Symbolists, for whom the element of mystery was all important. The pronouncedly enigmatic quality of *Shame* is, however, not the result of deliberate mystification on Rodin's part, as is often the case with the Symbolists, so much as the inevitable result of his creative process, in this case that of assemblage. The juxtaposition of parts originally conceived separately and the choice of a title encouraging speculation rather than settling doubts were bound to result in the creation of works that are elusive although not incoherent.

NOTES

1. Grappe [338d], no. 238.
2. Ibid., no. 143.

REFERENCES

Watkins [342], no. 16; Tancock [341], no. 25.

RELATED WORKS

Study of a Seated Woman (Cybele)

Bronze, height 20⅛ inches

FRANCE
Paris, Musée Rodin.

UNITED STATES
Greenwich, Collection Mr. and Mrs. Walter Bareiss. Cast no. 6.
Memphis, Collection Mr. and Mrs. William W. Goodman. Founder: Alexis Rudier. Cast no. 2.

Bronze, height 63½ inches

GREAT BRITAIN
London, Bethnal Green Museum. Gift of Rodin to the Victoria and Albert Museum, 1914. Signed: A. Rodin. Founder: Alexis Rudier.

Plaster

FRANCE
Bordeaux, Musée des Beaux-Arts. Bought by the city at the Exposition de la Société des Amis des Arts de Bordeaux, 1906 (fig. 25-3).
Paris, Musée Rodin.

Brother and Sister

Bronze, height 15⅜ inches

ARGENTINA
Buenos Aires, Collection Francisco Llobet.

AUSTRALIA
Collection Mrs. Alan Murray.

CANADA
Montreal, Collection Jack L. Cummings. Founder: Georges Rudier. Cast no. 5.

DENMARK
Copenhagen, Ordrupgaardsamlingen.

FRANCE
Paris, Musée Rodin.

25-1
Brother and Sister
1890, marble, height 17 inches
Location unknown

25-2
Brother and Sister
1890, bronze, height 15⅜ inches
Metropolitan Museum of Art,
New York. Rogers Fund, 1908

25-3
Study of a Seated Woman (Cybele)
1889, plaster, height 63½ inches
Musée des Beaux-Arts, Bordeaux

25-4
Galatea
Mid 1890s, marble, height 23⅝ inches
Musée Rodin, Paris

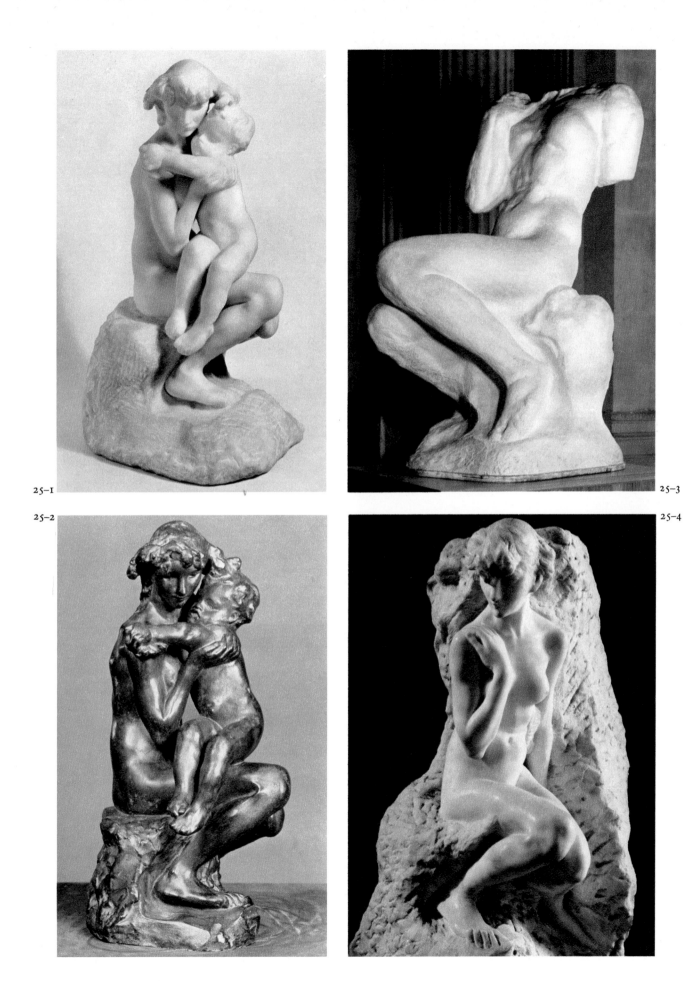

25-1

25-2

25-3

25-4

GREAT BRITAIN

Cambridge, Fitzwilliam Museum. Given to the donor, G. J. F. Knowles, by Rodin and believed to be the first cast. Signed: A. Rodin. No foundry mark.

Glasgow, Glasgow Art Gallery and Museum. Burrell Collection. No foundry mark.

IRELAND

Dublin, Municipal Gallery of Modern Art. On loan from the National Gallery of Ireland. Signed: A. Rodin.

JAPAN

Tokyo, National Museum of Western Art (ex. Collection Matsukata). Signed: A. Rodin.

PORTUGAL

Lisbon, Calouste Gulbenkian Foundation (ex. Collection Mme de Béarn).

UNION OF SOUTH AFRICA

Cape Town, South African National Gallery. Gift of A. A. de Pass, 1926.

UNITED STATES

Beverly Hills, Collection Leona Cantor. No foundry mark.

— Collection Mr. and Mrs. Nathan Smooke.

Boston, Museum of Fine Arts. Bequest of Henry Lee Higginson, 1921.

Chicago, Art Institute of Chicago. Gift of the Arts Club of Chicago, 1923.

Indianapolis, Indianapolis Museum of Art.

Madison, N. J., Estate of Geraldine R. Dodge. Signed: A. Rodin. Inscribed: 2eme épreuve.

New York City, Collection Dr. and Mrs. Harry Bakwin. Signed: A. Rodin. Founder: Alexis Rudier.

— Metropolitan Museum of Art. Rogers Fund, 1908 (fig. 25-2).

Philadelphia, Philadelphia Museum of Art. Louis E. Stern Collection. Signed: A. Rodin. Founder: Alexis Rudier.

Portland, Ore., Portland Art Museum (ex. Collection Jacques Zoubaloff, who purchased it directly from Rodin). Signed. Founder: Alexis Rudier.

South Orange, N. J., Collection Milton J. Wigder. Founder: Georges Rudier. Cast no. 11/12.

Marble

UNITED STATES

Burlington, Vt., Robert Hull Fleming Museum, University of Vermont. Gift of Jean Simpson, 1942. Signed: A. Rodin 1906. Inscribed: Monsieur et Madame J. W. Simpson, a leur fille Jean.

Plaster

UNITED STATES

San Francisco, California Palace of the Legion of Honor. Spreckels Collection. Inscribed: Hommage de vive sympathie/A. Rodin.

Marble, height 17 inches

Location unknown (fig. 25-1).

Galatea (consists of the seated figure only from "Brother and Sister")

Marble, height 23⅝ inches

FRANCE

Paris, Musée Rodin (ex. Collection Dr. Faure) (fig. 25-4).

26 Youth Triumphant
1894

Bronze, 20½ × 16½ × 12 inches
Signed front of base to right: A Rodin
Foundry mark (small seal of Fumière et Gavignot)
removed from left-hand side of base

Youth Triumphant is a combination of two figures originally conceived separately. The seated female figure is that of *The Helmet-Maker's Wife* (no. 7), here dated 1880–83, while the figure of the young girl, probably, as Athena Spear suggests,[1] a reject from *The Gates of Hell,* is used in a number of other compositions. In the work known as *Aesculapius* (fig. 70–5), the young girl is held in the arms of a male figure while, together with another nude and enlarged, she is used in the work known as *The Earth and the Moon.*[2]

An alternate title for this work was *The Grandmother's Kiss.* At the Salon of 1893 Jean Dampt (1853–1946) exhibited a work by this same name, which represents an old lady kissing a baby (fig. 26–1). There is no doubt that in Dampt's work the relationship between the two figures is that of grandmother to grandchild.

There is no such certainty in Rodin's group, however, as indicated by the abundance of titles for it, including *Fate and the Convalescent.* In the apt description of Parker Tyler: "The juxtaposition of the two figures, especially when conceived as originally apart, has a shocking quality—not moral, but psychological. Terrible things may be involved; not only the kiss of the girl imprinted on the mouth of her malign and future fate, but the aggressiveness of the child implied in the title *Youth Triumphant,* as though she were drawing life from the old woman's mouth in a kind of death-and-resurrection; then again, as implied in the title *The Old Courtesan,* this headlong contact may picture the corruption of virgins for one of the most ancient trades."[3]

For all its macabre quality, this was one of the first works Rodin had edited commercially on a large scale.[4] On October 24, 1898, he signed a contract with the foundry of Fumière et Gavignot, giving them the right, for the next ten years, to edit the work known as *Youth Triumphant.*[5] At the end of this period Fumière et Gavignot reserved the right to extend the period for a further ten years.

The founders were authorized to make reductions in all the sizes they thought fit, Rodin reserving for himself the right to have reproductions made in marble or in stone in the original dimensions. After the sale of the fifth reduced cast, Rodin was to receive a commission of 20 per cent of the selling price on all future sales, while for the sale of casts in the original dimensions a commission was received from the sale of the first cast.

Given the commercial nature of the agreement, it is hardly surprising that the casts of *Youth Triumphant* are completely lacking in the eventfulness and sensitivity of surface that characterize Rodin's best bronzes. In fact, the bronze must have been cast from a marble (which has since disappeared), as indicated by the dull, generalized modeling and by the way in which certain forms, notably the feet of the old woman, emerge from an uncut matrix.

NOTES

1. Spear [332], p. 73.
2. Grappe [338d], no. 294.
3. Tyler [321], p. 64.
4. For further discussion of this topic, *see* Introduction.
5. *See* copy of this contract in the Judith Cladel archives, Lilly Library, Indiana University, Bloomington.

REFERENCES

Maillard [71], p. 141; Lami [4], p. 170; Watkins [342], no. 23; Grappe [338b], no. 301; Grappe [338c], no. 235; Grappe [338d], no. 270; Tyler [321], p. 64; Tancock [341], no. 26.

OTHER CASTS AND VERSION

Bronze

FRANCE
Paris, Musée Rodin.

GREAT BRITAIN
Walthamstow, William Morris Gallery. Gift of Frank Brangwyn in 1940, who obtained it from Rodin.

UNION OF SOUTH AFRICA
Durban, Durban Museum and Art Gallery.

UNITED STATES
Cleveland, Cleveland Museum of Art. Signed: A. Rodin. Inscribed: 24me épreuve.
Lafayette, La., Collection Dr. William E. McCray. Inscribed: 28me épreuve.
Maryhill, Wash., Maryhill Museum of Fine Arts.
New York City, Collection Mrs. David Bortin.
— Collection Mr. and Mrs. Borden Stevenson.
Reading, Pa., Reading Public Museum and Art Gallery. Inscribed: 59eme épreuve.
San Francisco, California Palace of the Legion of Honor. Spreckels Collection.
Stanford, Stanford University Art Gallery and Museum. Gift of B. G. Cantor Art Foundation.

Plaster

Location unknown (fig. 26–2).

26–1
Jean Dampt
The Grandmother's Kiss
1893, marble
Location unknown

26–2
Youth Triumphant
1894, plaster
Location unknown

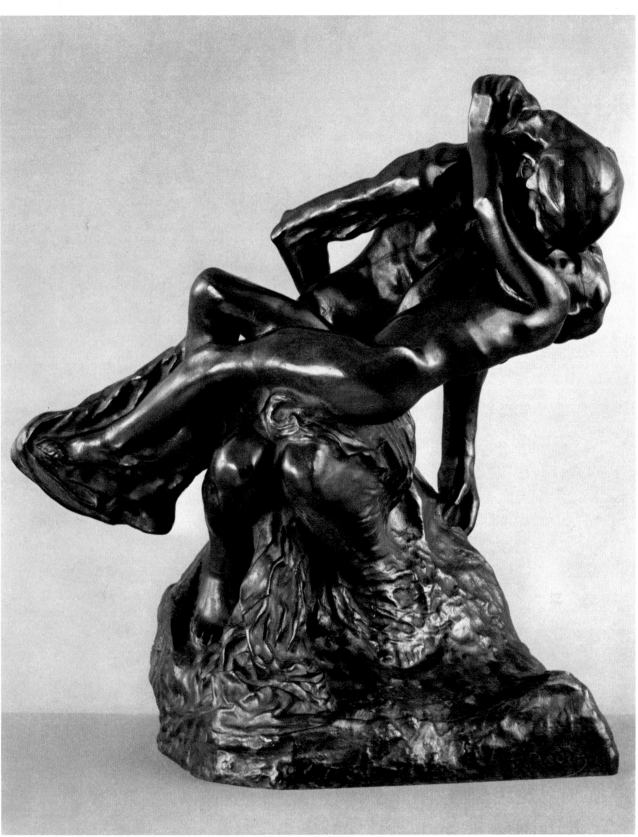

227

27 Decorative Pilaster from "The Gates of Hell" *(bottom section)*

c. 1900

28 Decorative Pilaster from "The Gates of Hell" *(top section)*

c. 1900

Bronze, 10⅞ × 2⅝ × ⅞ inches
Signed bottom right-hand corner: A. Rodin
Foundry mark on left side:
A. RUDIER/FONDEUR./PARIS.

Bronze, 4¾ × 2⅛ × ¾ inches
Signed bottom right-hand corner: A. Rodin
No foundry mark[1]

By February 1885, the decorative pilasters of *The Gates of Hell* were already in existence. Octave Mirbeau described the left-hand pilaster as representing "Limbo, where one sees, through a sort of mysterious mist, falling children among horrible figures of old women."[2] To a considerable extent the designs on the pilasters recall those Rodin made for the Manufacture de Sèvres, where he worked from the middle of 1879 to the end of 1882.[3]

Sometime after stripping *The Gates* of all the most projecting figures, that is to say, probably about 1900, Rodin made reductions of three sections of the left-hand pilaster—(nos. 27 and 28) and the small medal called *Protection*[4]—and one *Embracing Couple*[5] from the bottom of the right-hand pilaster. That these small reliefs are reductions of the full-scale versions and not preparatory studies is verified by the fact that they reproduce the pilasters on the stripped version of *The Gates,* as exhibited in 1900, and not the intact pilasters.

Number 27 is the reduction of the bottom half of the full-scale version of the left-hand pilaster. The major projecting parts, namely, from the bottom upward, the baby's left arm, the projecting feet of the woman seen from behind, the projecting rocky forms at the level of the old woman's head, the lower half of the baby's legs and his left arm, and the left leg of the climbing baby are all omitted.

Number 28 is the continuation of number 27. The forms are greatly simplified, in keeping with the reduction in scale. The leg of the standing male figure, with his arm across his body, is in low relief and does not project as in *The Gates,* nor does his left arm hang over the edge of the door. The right arm of the female figure is cut off at the elbow.

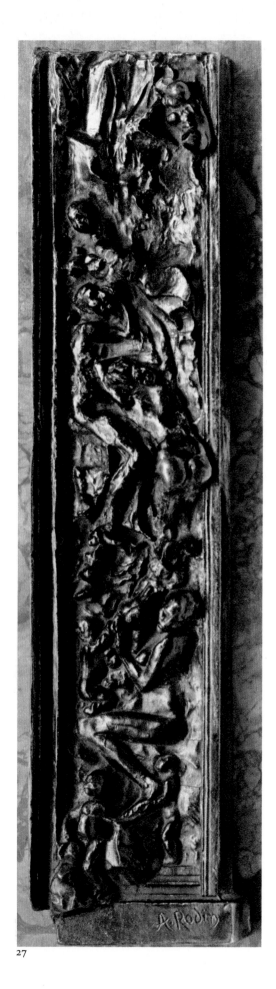

27

28

229

NOTES

1. According to information provided by the Musée Rodin at the time of purchase, these were the first bronze casts of the pilasters.
2. Mirbeau [252a], p. 17. "Les montants sont formés aussi de bas-reliefs admirables; celui de droite exprime les amours maudites qui s'enlacent toujours et ne s'assouvissent jamais; celui de gauche, les limbes où l'on voit, dans une sorte de vapeur mystérieuse, des dégringolades d'enfants, mêlées à d'horribles figures de vieilles femmes."
3. *See* Marx [75], p. 11.
4. *Protection*, $3\frac{3}{4} \times 1^9/_{16} \times {}^5/_{16}$ inches, silver casts of which exist in the Musée Rodin and in the Cleveland Museum of Art, was made by Rodin in 1916 for the French Actors Fund. It is a reduction of the embracing couple called *Vain Tenderness* (Grappe [338d], no. 213), which is the continuation of the section of which our no. 28 is the reduction. *See* Spear [332], p. 63, repr. pl. 82, no. xv.
5. A cast of this is in the Cleveland Museum of Art. There is also a plaster in the National Gallery of Art, Washington, D.C. *See* Spear [332], pp. 62, 63, repr. pl. 80, no. xiv. She is of the opinion that the Cleveland plaster "must be a reduction of and not the model for the larger (H. 35 in.) relief of this subject on the *Gates*.... The proof that the small plaster casts were copied from the stripped door, probably after 1900, is that the lower right post with the relief of the *Embracing Couple* intact is reproduced in the *Gazette des Beaux-Arts* of May 1898, p. 421."

REFERENCES

René Chéruy, "Rodin's 'Gate of Hell' Comes to America," *New York Herald Tribune,* Sunday Magazine Supplement, January 20, 1929, repr. p. 17 (no. 1); Watkins [342], nos. 79–81; Elsen [37], p. 69; Tancock [341], nos. 27, 28.

OTHER VERSION (No. 27)

Plaster

UNITED STATES

San Francisco, California Palace of the Legion of Honor. Inscribed on right-hand side: Modèle en réduction éxecuté par Monsieur Henri Lebossé. H. Lebossé. Inscribed on left-hand side: [Original] Modèle d'après la réduction Guioché mouleur. Inscribed at bottom: Loie. Rodin.

SMALL GROUPS AND FIGURES

29 Medea

1865–70

Plaster, 23 ½ × 12 ½ × 9 ½ inches
Not signed or inscribed

In the earlier catalogue of the Rodin Museum, this plaster was described as a Madonna.[1] If this were the case, it would be, with the exception of *St. John the Baptist Preaching* (no. 65), *Head of St. John the Baptist on a Platter* (no. 21), and *Christ and the Magdalen* (fig. 19–5), one of the very few religious subjects in Rodin's *œuvre*. However, the fact that the left knee and arms of the female figure are uncovered and the headless figure of a struggling child can be seen slipping off her knee leaves no doubt that this plaster is a study for *Medea Killing Her Children* and not for the *Madonna Succoring the Infant Christ*. It is not surprising that Rodin, who had been fascinated with the theme of Ugolino and his children since at least the middle of the 1870s[2] and probably much earlier, should have been tempted to represent Ugolino's classical counterpart.

One of the characteristics of Rodin's early "black" drawings is that the sex of the figures evoked is not always immediately apparent. Léonce Bénédite pointed out that one of the early Michelangelesque drawings of Ugolino could have been, with slight adjustments, made into a Medea, and that a manuscript note in Rodin's own hand revealed that he himself was aware of this possibility.[3] Thus the study for *Medea* is strongly reminiscent of those studies for *Ugolino,* including that on the *Third Architectural Clay Model for "The Gates of Hell"* (no. 2), in which the seated adult figure holds a struggling figure or figures on its knee.

Throughout his life Rodin professed such a profound admiration for the art of Delacroix that he "thus knew by heart his famous letter on competitions."[4] In 1863 he became a member of the Union Centrale des Arts Décoratifs, a society founded by Jules Klagmann which included Delacroix among its members. However, the shy young apprentice sculptor can have had little to do with the distinguished and autocratic painter.

Between 1838 and 1862 Delacroix painted four versions of *Medea,* the first of which was exhibited at the Exposition Universelle in 1855 (fig. 29–2).[5] It seems almost certain that Rodin, as a young and enthusiastic student of Horace Lecoq de Boisbaudran at the Petite Ecole, would have gone to the Exposition Universelle, and distinctly probable that when he commenced work on his own version of *Medea* he remembered Delacroix's powerful painting.

The rather exaggerated *contrapposto* and the abundance of drapery associate this plaster study with such works as *Young Woman and Child* (fig. 29–1), to which Grappe assigned a date of 1865–70. It seems probable that the *Medea,* in spite of the darkness of its theme, which is in distinct contrast to the rest of Rodin's work of this period, dates from the same time.

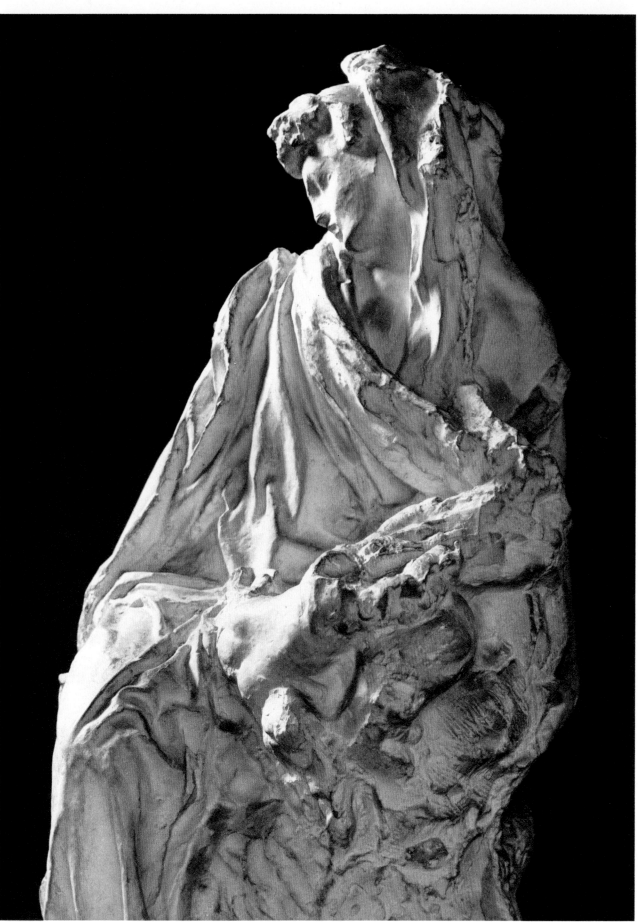

29

NOTES

1. Watkins [342], no. 100.
2. *See* no. 1.
3. Bénédite [131], pp. 209–19. On p. 216, Bénédite mistakenly identified the group opposite *The Kiss* on the *Third Architectural Clay Model for "The Gates of Hell"* as a Mother and Child. On p. 217, he wrote: "On remarque, cependant, dans certains albums de jeunesse, quelques croquis, déjà très influencés par Michel-Ange, où il s'essaye à un *Ugolin* qui, suivant sa méthode, pourrait bien être appelé à devenir une Médée; une petite note manuscrite fait foi de ces hésitations."
4. Coquiot [31], p. 107. "Moi, qui ai pour Delacroix une admiration si profonde et qui connaissais par conséquent par cœur sa fameuse lettre sur les concours."
5. A second version, now in the Nationalgalerie in East Berlin, was painted with Pierre Andrieu in 1859. A third version was painted for E. Péreire in 1862 and is now in the Musée du Louvre; a fourth version, now in the collection of the Vicomtesse de Noailles, was also painted in 1862.

REFERENCES

Watkins [342], no. 100; Tancock [341], no. 29, repr. p. 43; Tancock [315], p. 47, repr. p. 46.

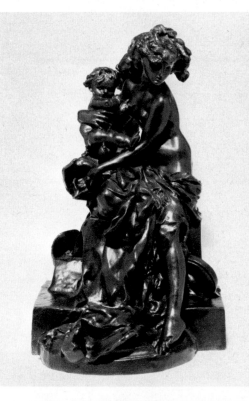

29–1

29–2

29–1
Young Woman and Child
1865–70, bronze, height 22½ inches
Location unknown

29–2
Eugène Delacroix
Médée Furieuse
1838, oil on canvas, 102 × 65 inches
Musée des Beaux-Arts, Lille

30 Scene from the French Revolution
c. 1880

Black wax, 8 × 15 × 1½ inches
Not signed or inscribed[1]

During the reign of Napoleon III, the period which coincided with Rodin's halting emergence as an independent sculptor, the appearance of Paris was transformed. Georges Haussmann, the Prefect of the Seine, imposed his master plan on the capital, and as a result a vast amount of public sculpture was commissioned to decorate the new civic buildings, churches, and public spaces that were created in the process. Sculpture was needed for the Hôtel de Ville and the Palais de Justice, for the Palais de l'Institut and the Palais Bourbon, for the new *mairies,* and for the museum at Versailles. In addition, the Opéra and the Louvre provided unparalleled opportunities for numerous painters and sculptors.

Rodin's attempts to extricate himself from the obscure world of the decorative sculptor in his capacity as assistant to such figures as Albert Carrier-Belleuse *(see* no. 85) and Antoine Van Rasbourg *(see* Chronology) were met by many more failures than successes in these early years. In 1875 he worked on a project for a monument to Lord Byron to be erected in London, only to have his work rejected in favor of that of the obscure English sculptor Richard Belt in 1877. In 1879 he was unsuccessful in two competitions organized by the city of Paris, one for a monument to commemorate the defense of Paris during the Franco-Prussian War and another for a bust of the Republic *(see* nos. 66 and 107). In 1880 he did receive a commission for a statue of Jean Le Rond d'Alembert intended for the Hôtel de Ville, but in view of the fact that the decoration on this building included 254 statues in three dimensions and 141 bas-reliefs, it would perhaps have been surprising if he had been rejected.[2] To his list of failures, however, should be added his attempts to secure commissions for a monument to Lazare Carnot for the town of Nolay in 1881 and another to General Jean Margueritte in 1884.

It appears that Rodin did not enter the competition for the monument to the Republic for the place du Château d'Eau that was announced in 1879,[3] but the wax relief under discussion indicates that he might well have given the subject some consideration. Jules Dalou was one of the competitors, but the prize finally went to the sculptor Léopold Morice (1846–1920). On the base of Morice's monument are twelve reliefs depicting certain incidents in the history of the revolution and climactic moments in more recent history,[4] two of which appear to coincide with the subjects of Rodin's reliefs.

At Rodin's one-man exhibition in 1900, "two bas-reliefs" were shown and described in the following terms: "These two wax sketches, formerly intended for a competition, represent two scenes from the Revolution: the enrollment and an assembly discussing."[5] The Philadelphia wax appears to represent the enrollment of the volunteers and recalls in theme François Rude's great relief of *The Departure of the Volunteers in 1792* on the Arc de

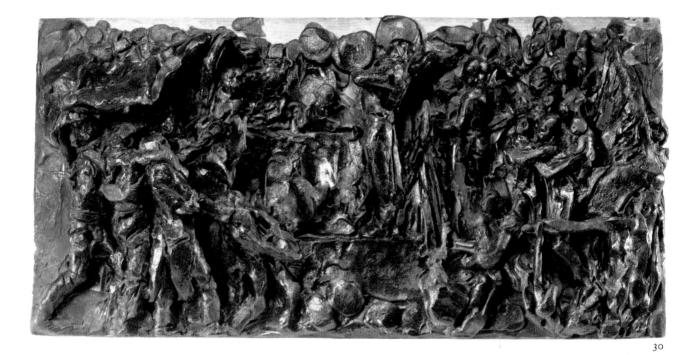

30

Triomphe. The tightly packed vertical organization of the carefully orchestrated figures and the billowing flags of Rodin's work are strongly reminiscent of Rude, allowing for the difference beetwen a sketch in wax and an over life-size stone monument. That Rude was in the forefront of Rodin's mind during this period when he entered various competitions that dealt with patriotic subjects and military heroes is amply demonstrated by *The Call to Arms* (no. 66) and the project for the monument to General Margueritte *(see* Chronology). Within Rodin's own *œuvre* the closest stylistic affinity is with the *Second Architectural Clay Model for "The Gates of Hell"* (fig. 1–6), which dates from the period when Rodin might have been considering entering the competition for the monument to the Republic.

It is instructive to compare Rodin's relief with Jules Dalou's *Mirabeau Replying to Dreux-Brézé at the Session of June 23, 1789* (fig. 30–1), which was part of a decoration for a monument at Versailles. The model for Dalou's relief was exhibited at the Salon of 1883. For the same monument Jean-Paul Aubé (1837–1916 or 1920) executed a relief entitled *The Opening of the States General.*[6] Dalou's carefully delineated figures are situated in a clearly organized Renaissance space, and all attention is focused on the dramatic encounter. It is a highly competent work but perhaps rather dry. Rodin's agitated study would surely have been

236

more exciting if it had been enlarged and fully executed, but it is doubtful that he would have been capable of undertaking such a task at this stage in his career. To Dalou, with his academic training, the organization of large crowds of people on a flat surface presented no problems. To Rodin it did, since the surface of *The Gates of Hell* was just at the point of moving from a series of tightly controlled tableaux to the representation of the boundless space that is its most remarkable characteristic.

NOTES

1. The provenance of this work is as follows: Dorothea Landau, gift of the artist; Mrs. da Fano, London (daughter of Mrs. Landau); Dr. da Fano, London (son of Mrs. da Fano). It was purchased for the Rodin Museum in 1970.
2. *See* "Chronique française," *L'Art,* Paris, 1 (1879), pp. 302–3.
3. *See* no. 66, n. 2.
4. The subjects of these reliefs include: Oath in the Jeu de Paume; Capture of the Bastille; Renunciation of Privileges; Festival of the Federation; Abolition of the Monarchy and Proclamation of the Republic; Battle of Valmy; Volunteers Enrolling; Combat of the Avenger; Resumption of the Tricolor in 1830; Provisional Government of 1848; Proclamation of the Third Republic, September 4, 1870; and National Holiday, July 14, 1880.
5. Paris, 1900 [349], no. 34. "Deux Bas-reliefs. Ces deux ébauches en cire, destinées jadis à un concours, représentent deux scènes de la Révolution:

les Enrôlements et une Assemblée discutant."

It seems probable that Guillemot [218] referred to one of these reliefs in the following description of Rodin's studio. "Les quelques tableaux restés dans le grand salon-atelier du bas sont voilés d'un rideau, et la pièce où l'artiste alors peut s'isoler lui appartient complètement; sur un socle, au milieu, le buste de Victor Hugo, non pas celui de l'Hôtel de Ville, mais un fragment énorme de l'apothéotique statue destinée au Jardin du Luxembourg; dans un bahut fermé, des livres peu nombreux, exemplaires de choix aux dédicaces précieuses; sur une table, un vase de Sèvres dont la frise est de l'ancien collaborateur de Carrier-Belleuse, du Rodin déjà, puis la maquette d'un bas-relief sur la Révolution Française, grouillement d'humanité grandiloquente, qui évoque la *Séance de Boissy d'Anglas* de Delacroix."

6. For a full description of this monument, *see* Maurice Dreyfous, *Dalou: Sa vie et son œuvre* (Paris: Librairie Renouard, 1903), pp. 170–71.

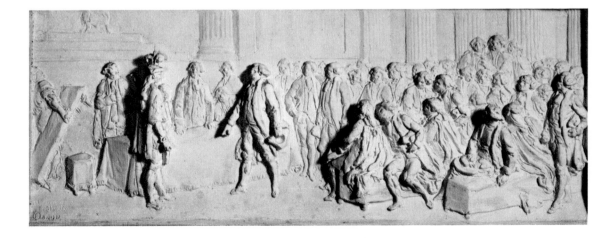

30–1 Jules Dalou (1838–1902)
*Mirabeau Replying to Dreux-Brézé
at the Session of June 23, 1789*
Plaster?, Location unknown

31 Despairing Man
1880–85

Plaster, 12½ × 21½ × 15½ inches
Not signed or inscribed

Little is known about this handsome figure, entitled *Woman Resting on Rock* in the earlier catalogue of the Rodin Museum,[1] although the figure is clearly male. It must surely belong, however, to the group of despairing figures done in the mid 1880s at the time when Rodin was working most intensively on *The Gates of Hell*. The figure, a highly finished marble version of which is to be found in the St. Louis Art Museum (fig. 31–1), is related in mood and format to the *Danaid* of 1885 (fig. 35–2), of which it forms the male counterpart. The contrast between the lithe, flowing forms of the *Danaid* and the highly developed musculature of the male figure, with its contorted posture, contracted toes, and tightly clenched hands, points to a date in the earlier part of the decade for the *Despairing Man,* when Rodin's approach to the male figure was still strongly influenced by his study of Michelangelo.

In fact the closest resemblance is to be found with a work that Rodin executed while still employed by Carrier-Belleuse, the problematic *Vase des Titans*. This vase was first shown in the exhibition "Rodin: Ses collaborateurs et ses amis," held at the Musée Rodin in 1957.[2] Since that date a number of separate studies of the individual figures in terra-cotta, bronze, and marble, as well as four other examples of the complete vase *(see* Other Casts and Versions), have come to light. Although the terra-cotta examples in the Musée Rodin and in the Maryhill Museum of Fine Arts and the porcelain in the Bethnal Green Museum (fig. 31–2) all bear the signature "A. Carrier-Belleuse," it is clear on stylistic grounds that the four figures are the work of the employee and not the employer. Carrier-Belleuse's propensity was toward the refined, feminine style of the eighteenth century and could not have encompassed the Michelangelesque asperities of these figures. The undiluted nature of their indebtedness to the Florentine master places these figures firmly in the years immediately following Rodin's return from Italy in 1876.

In pose and physique, then, the *Despairing Man* is closely related to the four figures on the *Vase des Titans* although, in keeping with its greater dimensions, its anatomy is more detailed. Since it seems improbable that Rodin would have embarked on this work during the latter part of the 1870s, when major undertakings like *The Age of Bronze* (no. 64), *The Call to Arms* (no. 66), and *St. John the Baptist Preaching* (no. 65) must have occupied almost all his time and consumed most of his available capital, a date immediately following this period of trial and tribulation, that is to say, in the first half of the 1880s, is here proposed for this figure.

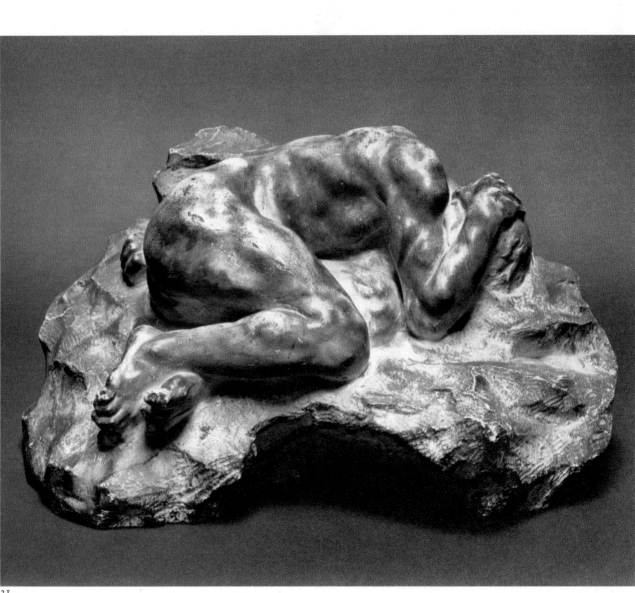

31

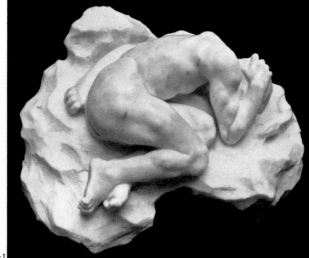

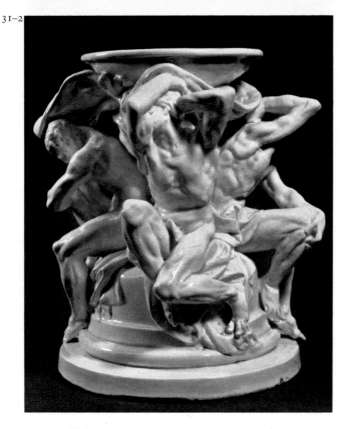

NOTES

1. Watkins [342], no. 120.
2. Paris, 1957 [363], no. 6. For the initial discussion of this vase, *see* Alhadeff [116], pp. 366–67. For further discussion, *see also* Janson [225], pp. 278–80.

REFERENCES

Watkins [342], no. 120; Adams [5], repr. p. 17; Tancock [341], no. 30.

OTHER VERSIONS

Marble, height 13¾ inches

UNITED STATES
St. Louis, City Art Museum (ex. Collection Arthur Upham Pope). Signed: A. Rodin (fig. 31–1).

Bronze

FRANCE
Paris, Collection Mme de Cusset. Inscribed: A Fidi.

RELATED WORKS

Vase des Titans

Terra-cotta, height 15⁹/₁₆ inches

FRANCE
Paris, Musée Rodin. Signed: A. Carrier-Belleuse.

UNITED STATES
Maryhill, Wash., Maryhill Museum of Fine Arts. Acquired between 1915 and 1923 by Samuel Hill from either Rodin or Loïe Fuller. Signed: A. Carrier-Belleuse.

Porcelain

GREAT BRITAIN
London, Bethnal Green Museum. Signed: A. Carrier-Belleuse (fig. 31–2).

Plaster and sand mixture, height 14⁹/₁₆ inches

GREAT BRITAIN
London, David Barclay Ltd. (2 casts). Unsigned.

Terra-cotta (original maquettes for the four figures)

UNITED STATES
Maryhill, Wash., Maryhill Museum of Fine Arts. Acquired between 1915 and 1923 by Samuel Hill from either Rodin or Loïe Fuller.

31–1
Despairing Man
1880–85, marble, height 13¾ inches
St. Louis Art Museum

31–2
Vase des Titans
c. 1876, porcelain, height 15⁹/₁₆ inches
Bethnal Green Museum, London

32 Eternal Springtime



a 1884

Plaster, painted white,
26 × 27⅝ × 16⅝ inches
Inscribed on plaque, front center:
A R.L.Stevenson/au sympathique/
Artiste au grand/et cher poète/A Rodin[1]

b 1884

Bronze, 25½ × 31½ (base) × 15½ inches
Signed to right behind support of arm:
Rodin
Foundry mark left side of base:
F. BARBEDIENNE, FONDEUR



With the commissioning of *The Gates of Hell,* there came about a pronounced change in the totality of Rodin's work, not only in that narrowly connected with *The Gates* themselves. Broadly speaking, it could be said that the intensity of emotion found in Rodin's major works of the 1870s—*The Age of Bronze* (no.64), *St. John the Baptist Preaching* (no.65), and *The Call to Arms* (no.66)—intimately related to his experiencing of Michelangelo in Florence, was extended to works on a much smaller scale. Until this time the subject matter of smaller works had for the most part been frivolous and lighthearted—works incorporating *putti* had been predominant—but now his immersion in the poetry of Dante, Baudelaire, and Ovid imparted a much greater emotional urgency to these smaller groups, many of which did, in fact, end up in *The Gates.*

From dealing with love in an allegorical way, Rodin began treating it in more human terms. There is a marked increase in the erotic content of his art and a corresponding growth in the daring of the poses adopted by his figures. In part this is a reflection of his studio practice, of his growing preference for allowing his models to move freely and adopt their own poses.[2] More importantly, perhaps, it is the inevitable outcome of the fact that the landscape of *The Gates of Hell* is one of the imagination, without solid ground, without distance. Not confined by the physical conditions of the terrestrial world, the inhabitants of *The Gates* maintain their equilibrium through the unbridled physical expression of extreme emotional states.

Toward 1882, working from a beautiful model by the name of Adèle, Rodin created the sensuous torso that bears her name, *Torso of Adèle* (fig. 32–1). Conceived not in relation to a definite plane, neither beneath nor behind, but as though totally surrounded by space, this torso was later used in a variety of ways and positions.

In *The Gates* a figure based on this torso, with the legs tucked up behind, can be seen descending through the air from the top left-hand corner of the tympanum (*see* no. 1, detail κ). With the lower part of the legs in a different position, this same torso was used about 1884 in the work now universally known as *Eternal Springtime,* although it was first called *Zephyr and the Earth, Youth,* or *Ideal.* When exhibited at the Salon for the first time in 1898, it was entitled *Cupid and Psyche.* Resting on its back, together with a figure closely related to *The Fallen Caryatid Carrying Her Stone,* the torso was later used in the work known as *Illusions Received by the Earth* (fig. 32–2).

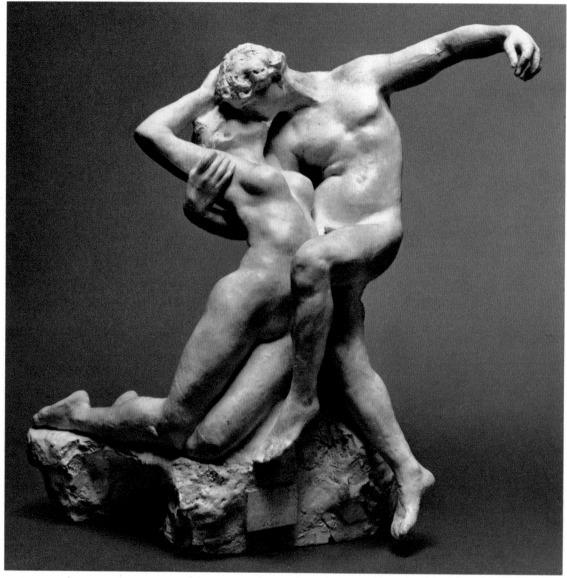

32a

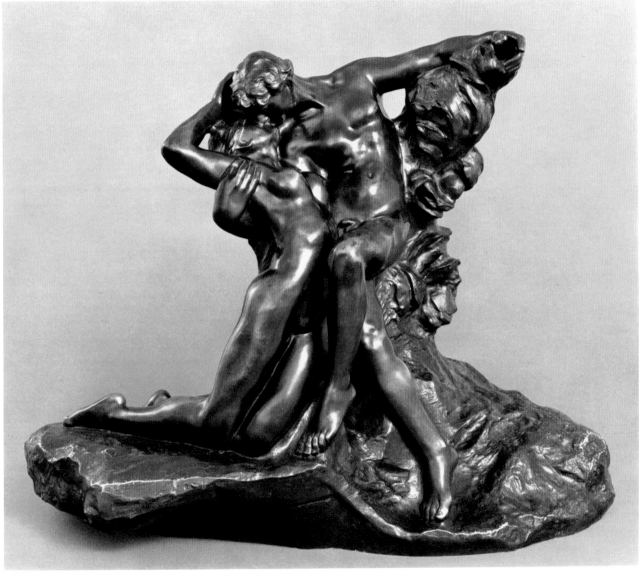

32b

Like many of Rodin's works, *Eternal Springtime* is the result of the grouping of figures, at least one of which was already in existence. In what must be the first version of this work (fig. 32–4), the outstretched arm and the overhanging leg of the male figure and the apparent instability of the encounter between the two figures recall Rodin's contemporary experiments with *The Gates of Hell*. It was a plaster of this version, now in the Rodin Museum (no. 32a), that Rodin gave to Robert Louis Stevenson in 1885.[3]

The demand for this work soon became very great and a number of marble replicas were made *(see* Other Casts and Versions). In the marbles the projecting limbs were of necessity suppressed (fig. 32–3), and the base was extended so that the right foot of the male figure might rest on the ground. Additional support for the left arm was provided in the form of a rocky outcrop, covered with a floral design. In 1898, when the foundry of Barbédienne acquired the rights for editing the bronze, it was this second solution, as being less difficult to cast, that was adopted.

As in all Barbédienne casts *(see* Introduction), the surfaces of the second version are slick and mechanical. The youthful impetuosity, sensuality, and lyricism of the first version have been replaced by a cloying sweetness. In purely sculptural terms the first version is superior to the second, since the freely floating arm and leg give to it an *élan* that the second bronze version does not have.

NOTES

1. Donated to the Rodin Museum by Paul Rosenberg in 1953.
2. Rodin probably first drew from the perambulating model in the classes organized by Horace Lecoq de Boisbaudran at the Petite Ecole. Lecoq used to take groups of students into the countryside around Paris, where they would draw from naked models who wandered freely in natural surroundings. Delacroix had also arrived at a similar method. From a friend's house Monet and Bazille watched Delacroix working in his garden and saw the models moving freely while he sketched them. *See* Gaston Poulain, *Bazille et ses amis* (Paris: La Renaissance du Livre, 1932), pp. 47–48. "En novembre, Frédéric abandonne son atelier de la rue de Vaugirard, pour aller habiter avec Monet 6, rue Furstenberg, où ils demeureront du 15 janvier 1865 au 4 février 1866. Deux ans auparavant, de cet atelier où logeait alors un camarade, ils ont vu Delacroix à son chevalet. Par la fenêtre, m'a conté Monet, ils le regardaient. Sa main et son bras, toujours, rarement plus, leur apparaissaient. Les deux jeunes gens étaient frappés de ce que le modèle remuait sans cesse et ne posait pas, à l'encontre de l'habituelle coutume. Pendant les repos, le modèle s'asseyait; Delacroix ne le dessinait qu'en mouvement."
3. Rodin was introduced to Stevenson by Alphonse Legros. A close friendship ensued, Stevenson defending Rodin against the accusation that he was the "Zola of sculpture" in a letter to the London *Times* of September 6, 1886 *(see* Lawton [67], pp. 246–47).

In the same year Rodin gave this plaster of *Eternal Springtime* to Stevenson, although the inscription was added somewhat later. Stevenson wrote to Rodin: "The 'Printemps' duly arrived, but with a broken arm; so we left it, as we fled, in the care of a statue-doctor. I am expecting every day to get it, and my cottage will soon be resplendent with it. I much regret about the dedication; perhaps it won't be too late to add it, when you come to see us; at least I hope so. The statue is for everybody; the dedication is for me. The statue is a present, too beautiful a one even; it is the friend's word which gives it me for good. I am so stupid that I have got mixed up and don't know where I am; but you will understand me, I think" (p. 245).

REFERENCES

Mauclair [77a], p. 33, repr. as frontispiece (marble); Lawton [67], pp. 111, 245, repr. opp. p. 111; Bénédite [10a], p. 31, repr. pl. LIII (A); Grappe [338], nos. 69, 70; Watkins [342], no. 18; Grappe [338a], nos. 87, 88; Grappe [338b], nos. 135, 136; Grappe [338c], no. 100; Grappe [338d], no. 113; Waldmann [109], pp. 45, 76, no. 41, repr. pls. 41, 42; Tancock [341], no. 31.

OTHER CASTS AND VERSIONS

a

Bronze

ALGERIA

Algiers, Musée National des Beaux-Arts. Purchased by the state in 1929.

FRANCE

Besançon, Musée des Beaux-Arts et d'Archéologie. Founder: Griffoul et Lorge.

Paris, Musée Rodin.

JAPAN

Tokyo, National Museum of Western Art (ex. Collection Matsukata). Signed: A. Rodin.

PORTUGAL

Lisbon, Calouste Gulbenkian Foundation (ex. Collection Chéramy). Founder: Alexis Rudier.

UNITED STATES

Beverly Hills, Cantor, Fitzgerald Art Foundation. Founder: Georges Rudier. Cast no. 6/12. (Right-hand side of base is cut off straight.)

Cambridge, Fogg Art Museum, Harvard University. Grenville L. Winthrop Bequest, 1943 (ex. Collection Alfred Roll). Given to Roll by Rodin in exchange for a painting. (Right-hand side of base has a rough-hewn appearance) (fig. 32–4).

Greenwich, Collection Herbert Mayer. Founder: Georges Rudier. Cast no. 4/12.

Minneapolis, Collection Mr. and Mrs. Charles B. Sweatt.

New York City, Antique Porcelain Company of New York, Inc. Purchased in 1922 from the Musée Rodin by General Menocal, late President of Cuba. Inscribed: A ma chère Cousine, Henriette Coltat, affectueux souvenir, A. Rodin. Founder: Alexis Rudier. (A small head emerges from the rear of the piece. The head and the inscription were added when Rodin gave the sculpture to his cousin.)

— Collection Harold B. Weinstein (ex. Collection Jules Mastbaum). Inscribed: Hommage à M.E. Spuller. Founder: Alexis Rudier. (Rodin gave the plaster to Eugène Spuller when the latter was Minister of Public Instruction and Fine Arts. At his request it was then cast in bronze by Alexis Rudier.)

Philadelphia, Collection Mrs. Charles J. Solomon (ex. Collection Jules Mastbaum). Signed: A. Rodin. Founder: Alexis Rudier. (A small head emerges from the support for the left arm of the male figure as in the cast in the Antique Porcelain Company of New York.)

U.S.S.R.

Moscow, State Pushkin Museum of Fine Arts.

Bronze, height 20½ inches

FRANCE

Paris, Musée Rodin.

UNITED STATES

Los Angeles, Los Angeles County Museum of Art. Mr. and Mrs. Allan C. Balch Collection.

Marble

Location unknown. Reproduced in *Studio*, May 1915, p. 242 (the left arm of the male figure rests on a narrow, free-standing stone support).

ARGENTINA

Buenos Aires, Museo Nacional de Arte Decorativo (ex. Collection Maurice Masson). Purchased by D. Matias Errazuriz in Paris, February 27, 1911 (height 27½ inches).

DENMARK

Copenhagen, Ny Carlsberg Glyptotek. Gift of Ny Carlsbergfondet. Commissioned in 1910 (height 28⅜ inches).

HUNGARY

Budapest, Szépmüvészeti Múzeum. Purchased from Rodin in 1901. Signed: A. Rodin (height 28¾ inches) (fig. 32–3).

UNITED STATES

New York City, Metropolitan Museum of Art. Bequest of Isaac D. Fletcher, 1917 (height 28 inches).

U.S.S.R.

Leningrad, State Hermitage Museum (ex. Collection Barbara Eliseev). Entered the Hermitage in 1923. Signed: A. Rodin (height 30⅜ inches).

b

Between 1898 and 1918 the firm of Barbédienne edited 69 casts, height 9⅛ inches; 80 casts, height 15¾ inches; 32 casts, height 20¾ inches; and 50 casts, height 25¼ inches. No attempt has been made to list all the Barbédienne casts.

Bronze, height 9⅛ inches

FRANCE

Paris, Musée Rodin.

UNITED STATES

Boston, Museum of Fine Arts.

Montclair, N.J., Kasser Foundation.

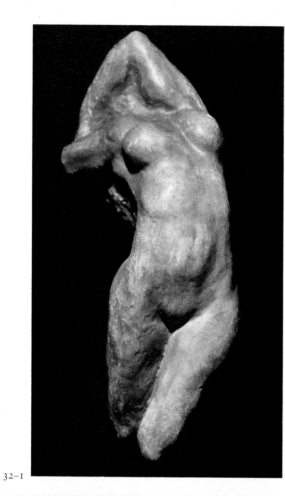

32-1

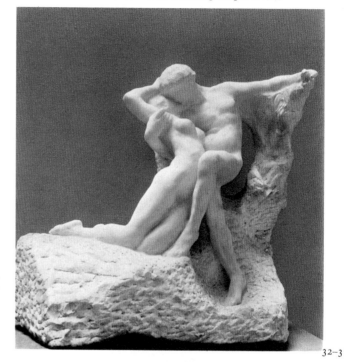

32-3 *Eternal Springtime*
1884, marble, height 28¾ inches
Szépmüvészeti Múzeum, Budapest

32-4 *Eternal Springtime*
1884, bronze, height 26 inches
Fogg Art Museum, Harvard University, Cambridge,
Mass. Grenville L. Winthrop Bequest, 1943

32-2

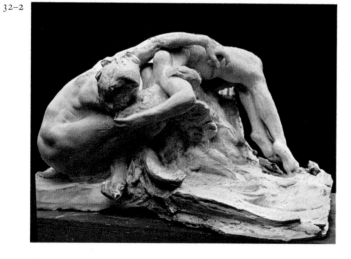

32-4

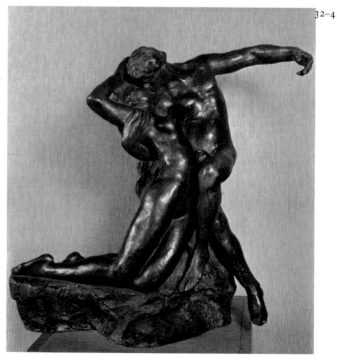

32-1 *Torso of Adèle*
1882, plaster, height 5⅞ inches
Musée Rodin, Paris

32-2 *Illusions Received by the Earth*
1895, plaster, height 21⅝ inches
Musée Rodin, Paris

246

Philadelphia, Collection C. Elbert Hoffmann.
Stanford, Stanford University Art Gallery and
 Museum. Gift of B. G. Cantor Art Foundation.

Bronze, height 15¾ inches

GREAT BRITAIN
Cardiff, National Museum of Wales (ex. Collections
 Leicester Galleries; Miss G. Davies). Acquired by
 bequest, 1952.

UNITED STATES
Baltimore, Baltimore Museum of Art. Gift of Wilton
 C. Dinges.
Madison, N. J., Estate of Geraldine R. Dodge.
San Francisco, California Palace of the Legion of
 Honor. On loan from Mr. and Mrs. Boris Kitchin.

Bronze, height 20¾ inches

ARGENTINA
Buenos Aires, Jockey Club.

UNITED STATES
Los Angeles, Los Angeles County Museum of Art.
 Mr. and Mrs. Allan C. Balch Collection.
Poughkeepsie, on loan to the Vassar College Art
 Gallery.

Bronze, height 25¼ inches

BRAZIL
São Paulo, Museu de Arte de São Paulo. Gift of
 Francisco Pignatari.

ROMANIA
Bucharest, Muzeul de Artă (ex. Collection Anastase
 Simu).

UNITED STATES
New York City, private collection. Signed. Foun-
 der: Georges Rudier.
Pittsburgh, Collection Mrs. Alexander Crail Speyer.

Plaster

FRANCE
Paris, Musée Rodin (fig. 32–1).

RELATED WORK

Torso of Adèle

Bronze, height 5⅞ inches

FRANCE
Paris, Musée Rodin.

GREAT BRITAIN
Collection William Shand Kydd.

SWITZERLAND
Lausanne, Collection Samuel Josefowitz. Founder:
 Alexis Rudier.

33 Fording the Stream
before 1885

Plaster, 12 × 7 × 4 inches
Not signed or inscribed

Grappe related this little work, dated before 1885 in all five editions of his Musée Rodin catalogue, to *The Gates of Hell*. Although not actually incorporated in *The Gates,* the work, with its theme of a muscular male figure carrying off a female, has many parallels both on the decorative pilasters *(see* no. 1, detail c) and in the panels of *The Gates* themselves. To support his claim, Grappe points out that this group was originally entitled *Demon Carrying Off a Woman.*[1] The work seems never to have been cast in bronze.

NOTES

1. Grappe [338d], no. 135.

REFERENCES

Rod [286], p.427; Grappe [338], no.74; Watkins [342], no. 118; Grappe [338a], no.93; Grappe [338b], no.158; Grappe [338c], no. 119; Frisch and Shipley [42], p.418; Grappe [338d], no. 135; Tancock [341], no.32.

OTHER CAST

FRANCE
Paris, Musée Rodin.

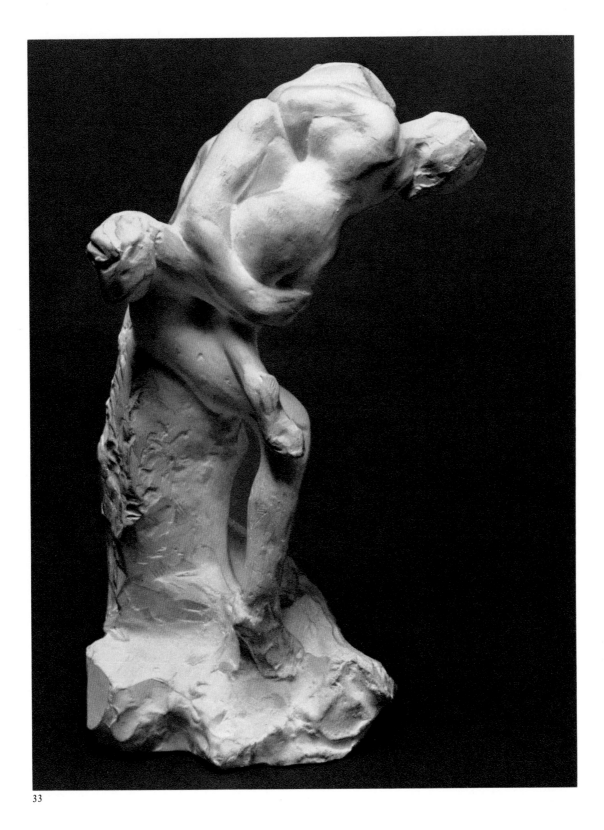

34 The Zoubaloff Fauness
1885

Bronze, 7⅛ × 4 × 6½ inches
Signed top of base, near left buttock: Rodin
No foundry mark[1]

This little-known but intriguing figure is among the most provocative of all the inhabitants of Rodin's mythological world. Chewing her long hair, she rocks back on her haunches, crossing both arms and legs for greater protection. Examination of the sculpture reveals that the upper and lower parts were conceived separately. The human part of *The Fauness,* with its crossed arms, is close in movement to the group of small bathing figures which date from approximately the same period (figs. 34–2, 34–3). It appears that the legs of one of these bathing figures were then amputated at the knees and that a pair of furry lower limbs, terminating in large cloven hooves, was inserted in the space between the stumps of the legs and the hands. Surface incisions on the upper legs show how Rodin tried to create a unified figure from the disparate parts.

An analogous transformation from human (or divine) to mythological by the addition of a pair of cloven hooves may be seen in the curious work in the Städelsches Kunstinstitut in Frankfurt, known in that collection simply as *Faun* (fig. 34–1). At the top left of the right-hand panel of *The Gates of Hell* may be seen a nude male figure, with arms outstretched, falling backward into the abyss (*see* no. 1, detail M). Standing upright, this figure was called *Mercury Standing* by Grappe[2] and dated 1888. At about the same time Rodin replaced the portion of the legs below the knees with a pair of cloven hooves, rather large in scale in comparison with the body, and confronted this composite figure with the little *Dancing Fauness* who stands on a shelf at the top left-hand corner of the left-hand panel of *The Gates* (*see* no. 1, detail K). The *Faun* thus consists of a juxtaposition of modified figures from *The Gates.*

In order to distinguish the fauness under discussion from the many other faunesses in Rodin's *œuvre,* this work is generally referred to as *The Zoubaloff Fauness.* Jacques Zoubaloff, who made an important donation of paintings, drawings, and sculpture to the Musée du Louvre, especially strong in the work of Antoine Barye, purchased the original plaster at the Antony Roux Sale in 1914.[3] This was acquired by the Musée Rodin at the Zoubaloff Sale in 1927.[4]

NOTES

1. Purchased from F. and J. Tempelaere, Paris.
2. Grappe [338d], no. 204.
3. Antony Roux Sale, Galerie Georges Petit, Paris, May 19–20, 1914, no. 139.
4. Jacques Zoubaloff Sale, Galerie Georges Petit, Paris, June 16, 17, 1927, no. 244.

REFERENCES

Watkins [342], no. 24; Grappe [338b], no. 159; Grappe [338c], no. 120; Grappe [338d], no. 136; Grappe [54], p. 141, repr. p. 64; Tancock [341], no. 33.

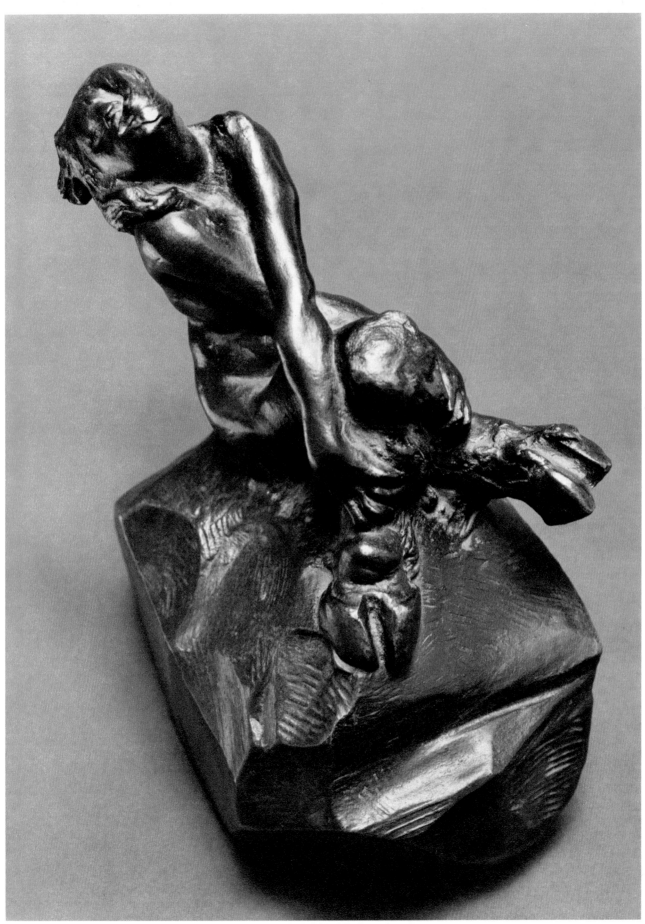

OTHER CAST AND VERSION

Bronze

FRANCE
Paris, Musée Rodin.

Plaster

FRANCE
Paris, Musée Rodin.

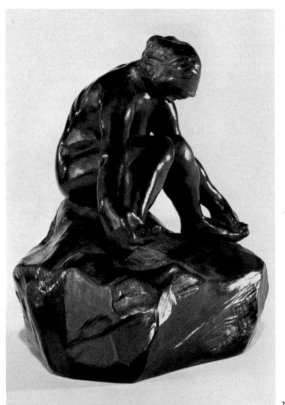

34–2

34–3

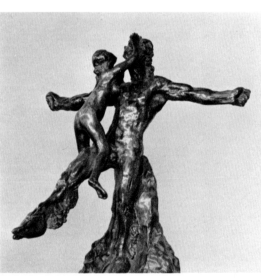

34–1

34–1
Faun
c. 1885?, bronze, height 15⅜ inches
Städelsches Kunstinstitut, Frankfurt

34–2
Woman with a Crab
c. 1886, bronze, height 8½ inches
Collection Mrs. Samuel J. Zacks,
Toronto

34–3
Large Crouching Bather
c. 1886, bronze, height 7½ inches
Peter Stuyvesant Foundation,
Stellenbosch, South Africa

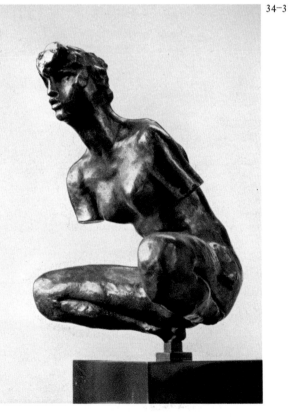

35 Andromeda
1885

Marble, $11\frac{3}{4} \times 11\frac{1}{2} \times 9$ inches
Inscribed front of base:
A Mon AMI / R MArX / Rodin

Andromeda was the daughter of the Ethiopian king, Cepheus, and of Cassiopeia. When the nereids learned of Cassiopeia's boast that her daughter surpassed them in beauty, they persuaded Poseidon to visit the country. A sea monster was sent to the land, and the oracle of Ammon proclaimed that the people would be delivered of it if Andromeda were sacrificed to the monster. King Cepheus then chained his daughter to a rock so that the monster might find her, but she was saved by Perseus.

Rodin chose to represent Andromeda just after she has been chained to the rock rather than at the most commonly depicted moment of her delivery. In the 1929 edition of the catalogue of the Musée Rodin, Grappe gave a date of 1892 to this work in bronze, as the first reference he had then discovered was in the catalogue of the Chicago exhibition of 1893.[1] However, he justly observed that it is closely related to the marble *Danaid* (fig. 35–2), which dates from 1885 (*see also Study for the "Danaid,"* 1884 or 1885; fig. 35–1).

In the 1931 catalogue, Grappe revised the dating of the bronze to 1890 on the basis of a reference that had been discovered in an exhibition catalogue dating from that year.[2] By 1938 he had arrived at the definitive date of 1885 for the bronze. He identified it with a figure described as "pliée en deux" ("bent in half"), seen at the Fifth International Exhibition of Painting and Sculpture at the Galerie Georges Petit in 1886.[3]

According to Grappe, this figure can be seen in *The Gates of Hell,* although I have not been able to locate it. It should be pointed out, however, that the indirect cause of Andromeda's despair, the nereids (*see* no. 24), were included in the final version of *The Gates,* halfway up on the far left of the left-hand leaf.

NOTES

1. Grappe [338a], no. 209. "Cette statuette a été exposée en 1893 sous ce titre à l'exposition de Chicago et, jusqu'ici, c'est la première mention qui ait été relevée de ce nom et de cette œuvre; mais il ne paraît pas douteux qu'il s'agit là d'une étude à rapprocher de la *Danaïde,* dont elle constitue une variante habile qu'on retrouve dans la *Porte de l'Enfer.*"
2. Grappe [338b], no. 274.
3. Grappe [338c], no. 125. "En 1886, à l'Exposition internationale de peinture et de sculpture, Rodin montrait plusieurs figures ou groupes. Cette pièce n'avait pas été désignée clairement, mais la description la montrant 'pliée en deux,' simplement, la fit longtemps tenir pour une œuvre inconnue; nous la pensions bien contemporaine de la Danaïde et le hasard d'une lecture a permis l'identification certaine."

REFERENCES

Watkins [342], no. 82; Grappe [338a], no. 209; Grappe [338b], no. 274; Grappe [338c], no. 125; Grappe [338d], no. 141; Boeck [138], pp. 182–83, pls. 99, 100 (bronze); Tancock [341], no. 34.

Marble, height 10¼ inches (the marble base is shaped differently; Andromeda sits on one block and leans on another)

Location unknown. Sold at Zoubaloff Sale, June 16–17, 1927, no.252, as *Femme penchée sur un rocher*.

Bronze

FRANCE
Paris, Musée Rodin.

SPAIN
Madrid, Collection Carlos Morla Lynch.

RELATED WORKS

Study for the "Danaid"

Bronze, height 5 inches

UNITED STATES
Jacksonville, Cummer Gallery of Art. De Ette Holden Cummer Museum Foundation. Signed: A.Rodin (fig.35–1).

Danaid

Terra-cotta, height 7¼ inches

SWEDEN
Stockholm, Nationalmuseum (ex. Collections Heijne, Stockholm; Ab. H.Bukowski). Acquired in 1964.

Bronze, height 6½ inches

UNITED STATES
Baltimore, Baltimore Museum of Art. Gift of Wilton C.Dinges. Signed: A.Rodin.

Bronze, height 9⅛ inches

ARGENTINA
Buenos Aires, Collection Antonio Santamarina. Signed: A.Rodin. Founder: Alexis Rudier.

CANADA
Montreal, Collection Mr. and Mrs. Bernard Lande. Founder: Georges Rudier. Cast no.5/12.

UNITED STATES
Madison, N.J., Estate of Geraldine R.Dodge.
Maryhill, Wash., Maryhill Museum of Fine Arts.

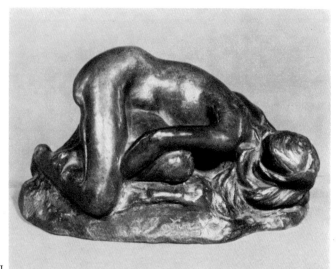

35–1

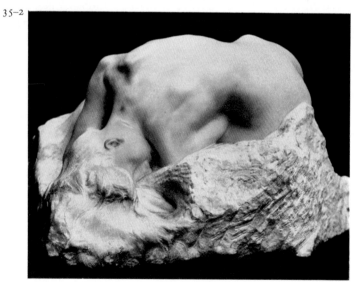

35–1
Study for the "Danaid"
1884 or 1885, bronze, height 5 inches
Cummer Gallery of Art. De Ette Holden Cummer
Museum Foundation, Jacksonville, Fla.

35–2
Danaid
1885, marble, height 13¾ inches
Kunstmuseum Athenaeum, Helsinki
Antell Collection

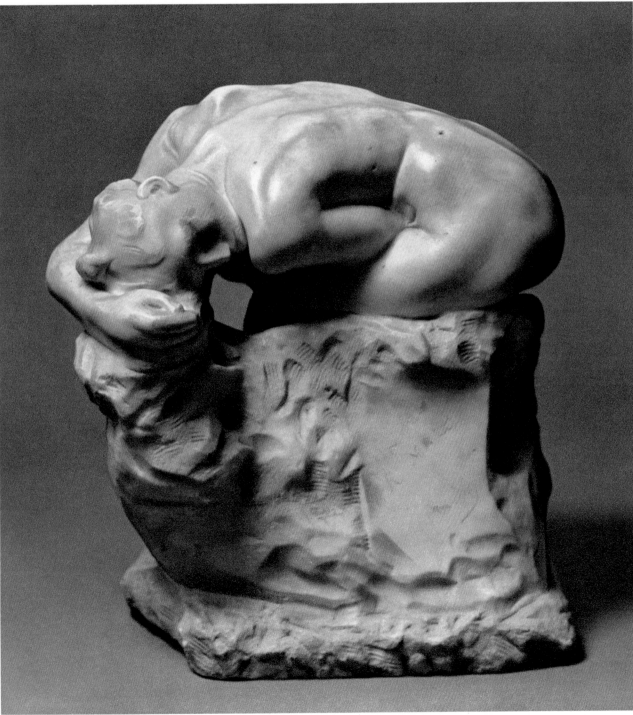

Philadelphia, Collection Mrs. Charles J. Solomon (ex. Collection Jules Mastbaum). Founder: Alexis Rudier.

Stanford, Stanford University Art Gallery and Museum. Gift of B.G.Cantor Art Foundation. Founder: Georges Rudier. Cast no.9/12.

Bronze, height 12¾ inches

FRANCE
St.-Etienne, Musée d'Art et d'Industrie. Deposited by the Musée du Louvre. Founder: Alexis Rudier.

NORWAY
Oslo, Nasjonalgalleriet. Plaster purchased at French exhibition, Blomqvist Art Gallery, Oslo, 1898. Signed: A.Rodin. Founder: E.Poleszynski. Cast in 1911.

SWITZERLAND
Lausanne, Collection Samuel Josefowitz. Founder: Alexis Rudier.

UNITED STATES
Beverly Hills and New York City, B.G.Cantor Collections. Founder: Georges Rudier. Cast no.5/12.

Los Angeles, Los Angeles County Museum of Art. Gift of B.G.Cantor Art Foundation. Founder: Georges Rudier. Cast no.4/12.

New York City, Collection Harold B. Weinstein. Founder: Alexis Rudier.

Plaster, height 13⅜ inches

FRANCE
Bagnols-sur-Cèze (Gard), Musée de Bagnols-sur-Cèze. Gift of Georges Grappe.

Marble, height 9⅛ inches

UNITED STATES
Princeton, Princeton University, Art Museum (ex. Collections Sam Lewisohn; Adolph Lewisohn). Signed: Rodin.

Marble, height 13¾ inches

DENMARK
Copenhagen, Ny Carlsberg Glyptotek. Gift of Ny Carlsbergfondet, 1927. Executed in 1901 for Dr.Linde, Lübeck.

FINLAND
Helsinki, Kunstmuseum Athenaeum. Antell Collection. Purchased in 1893. Signed: A.Rodin (fig. 35-2).

FRANCE
Paris, Musée Rodin.

UNITED STATES
Brooklyn, Brooklyn Museum. Executed for the exhibition of the International Society of Artists in 1904 and purchased in 1922. Signed: A.Rodin.

Philadelphia, Pennsylvania Academy of the Fine Arts. Gift of Alexander Harrison, 1902.

Stone, height 11⅜ inches

PORTUGAL
Lisbon, Museu Nacional de Arte Antiga. Presented by C.S.Gulbenkian, who acquired it at the Galerie Georges Petit in 1922.

36 Damned Women

1885 (executed after 1911)

Plaster, 8⅛ × 11¼ × 5 inches
Signed and inscribed on front of base: à Mucha/—Rodin

Among the many themes that were opened up to the artists of the nineteenth century by the Romantic movement was that of sexual perversion. Lesbianism, in particular, proved to be of special interest to such painters as Courbet, Degas, and Toulouse-Lautrec, whose approach to the contemporary world took in not only its appearance but also the psychological reaction of its inhabitants to their environment.

Rodin's feeling for female beauty was so intense that he took pleasure in observing the behavior of women who would have been repelled by his own advances. The models for this group, to which Grappe assigned a date of 1885,[1] were in fact two lesbian dancers from the Opéra who had been recommended to Rodin by Degas. They were evidently fully prepared to demonstrate their affection for one another in public, as their entwined bodies became the basis for a number of works on erotic themes dating from the middle of the 1880s. According to Victor Frisch and Joseph Shipley,[2] the same models were used in *The Metamorphoses of Ovid* (fig. 36-1), *Cupid and Psyche* (fig. 36-2), and *Daphnis and Lycenion* (fig. 36-5), all of which were completed by 1886.

As described elsewhere, Rodin paid little attention to the apparent sex of the figures in his group compositions when the time came to give them a title *(see* no. 37). He enjoyed the surprise inherent in giving the names of members of the opposite sex in classical antiquity to couplings of members of the same sex in his own sculpture. *Damned Women,* on the other hand, has never been given a title from classical antiquity because the reference is so clearly to the poetry of Baudelaire, which rapidly came to equal that of Dante in importance for Rodin as he worked on *The Gates of Hell.* Among the poems of Baudelaire's *Les Fleurs du Mal* for which Rodin provided illustrations in 1888 is, in fact, "Femmes Damnées" ("Damned Women"; fig. 36-4).[3] In the absence of other evidence, Grappe's date of 1885 must be accepted for this work.

This particular plaster is dedicated to Alphonse Mucha, who became a close friend of Rodin about 1898, when he developed an interest in sculpture. In spite of Rodin's adverse opinions of Art Nouveau *(see* Introduction), he seems for a time to have associated himself with artists and thinkers whose sympathies were with that style. Like Mucha, Rodin belonged to Jean Lahor's Société Internationale de l'Art Populaire, members of which included René Lalique, Emile Gallé *(see* no. 70), Eugène Grasset, and Victor Horta.[4]

Lahor outlined a plan for an International Exhibition of Art and Popular Hygiene in which designs for dwellings and public buildings, furniture, and "mobile decoration" (cheap prints, lithographs, etc.) were to be displayed side by side. However, this project was never realized. Rodin was also a member, together with Jules Chéret, Hector Guimard, and

Alphonse Willette, of Frantz Jourdain's Société du Nouveau Paris, which agitated for the demolition of the slums.[5] Jourdain, the architect who built the Samaritaine, would have been responsible for the design of the pedestal and architectural setting of the *Balzac,* had this monument been accepted by the Société des Gens de Lettres *(see* nos. 72–76).

In 1902 Mucha accompanied Rodin on his triumphant journey to Prague and the surrounding countryside, and he continued to visit him regularly on returning to France. In October 1909 Rodin dedicated two drawings to Mucha and in December 1911 gave him a bronze cast of the *Damned Women,* with the dedication, "à Mucha—Rodin."[6] First conceived as early as 1885, the Philadelphia plaster must nevertheless have been executed from the original clay after 1911, when the inscription was added.

NOTES

1. Grappe [338d], no. 144.
2. Frisch and Shipley [42], pp. 419–20.
3. Other names by which the work under discussion has been known are *Vampire* (in Romania) and *Fighting Women,* according to Grappe [338d], no. 144.
4. Also associated were Anatole France, Reynaldo Hahn, Alexandre Charpentier, František Kupka, Edmond Rostand, Ginisty, Henri Rochefort, Paul Adam, Haraucourt, Edouard Schuré, Charles Normand, and Jules Claretie. *See* Jiří Mucha, *Alphonse Mucha: His Life and Art* (London: William Heinemann, 1966), pp. 213–15.
5. Ibid., pp. 217–18.
6. *See* Jiří Mucha, *Alphonse Mucha: The Master of Art Nouveau* (Prague: Knihtisk Artia, 1966), p. 258.

REFERENCES

Lami [4], p. 168; Grappe [338], no. 82; Grappe [338a], no. 101; Watkins [342], no. 113; Grappe [338b], no. 166; Grappe [338c], no. 128; Frisch and Shipley [42], p. 419; Grappe [338d], no. 144; Boeck [138], pp. 191–92, repr. pl. 108; Tancock [341], no. 36.

OTHER CASTS AND VERSIONS

Plaster

FRANCE
Meudon, Musée Rodin. Inscribed: à Mucha.
Paris, Musée Rodin. Gift of B. G. Cantor Art Foundation (ex. Collection Antony Roux).

UNITED STATES
San Francisco, California Palace of the Legion of Honor. Spreckels Collection.

Bronze

Location unknown. Given to Alphonse Mucha by Rodin in 1911. Inscribed: à Mucha–Rodin.

FRANCE
Paris, Musée Rodin.

UNITED STATES
Beverly Hills and New York City, B. G. Cantor Collections. Founder: Coubertin.

RELATED WORKS

The Metamorphoses of Ovid

Plaster, height 7⅞ inches

FRANCE
Paris, Musée Rodin.

Bronze, height 13 inches

FRANCE
Paris, Musée Rodin.

Plaster, height 13¼ inches

GREAT BRITAIN
London, Bethnal Green Museum. Bequest of Charles Shannon to the Victoria and Albert Museum, 1937. Inscribed: Au poète W. E. Henley/son vieil ami/A. Rodin.

Marble, height 13¾ inches

DENMARK
Copenhagen, Ny Carlsberg Glyptotek. Commissioned by Carl Jacobsen in 1907 (fig. 36–1).

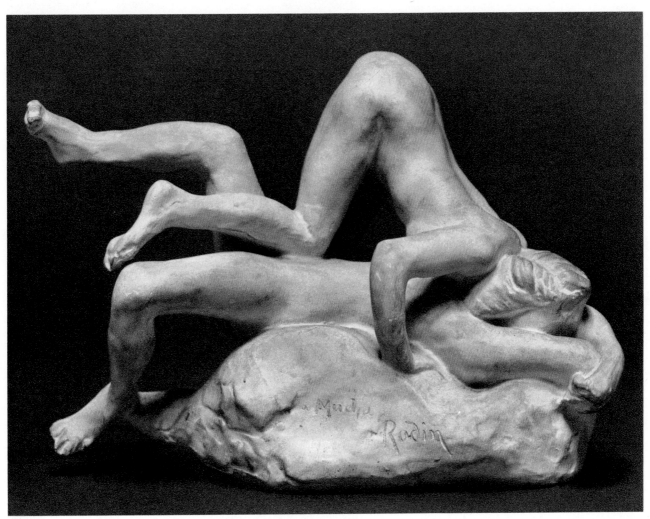

FINLAND

Helsinki, Kunstmuseum Athenaeum. Antell Collection (as *Volupté*). Purchased in 1893.

Daphnis and Lycenion

Bronze, height 11½ inches

FRANCE

Paris, Musée Rodin.

UNITED STATES

Elkhart, Ind., Collection Walter R. Beardsley (fig. 36–5).

Cupid and Psyche

Plaster, height 9 inches

FRANCE

Paris, Musée Rodin (fig. 36–2).

Marble, height 9⅞ inches

FRANCE

Paris, Musée du Petit Palais. Bequest of Mme Thoks, 1930.

UNITED STATES

New York City, Metropolitan Museum of Art. Gift of Thomas F. Ryan, 1910 (ex. Collection Charles T. Yerkes).

Damned Lovers

Stone, height 17¾ inches

FRANCE

Lyons, Musée des Beaux-Arts. Tripier Bequest, 1917 (fig. 36–6).

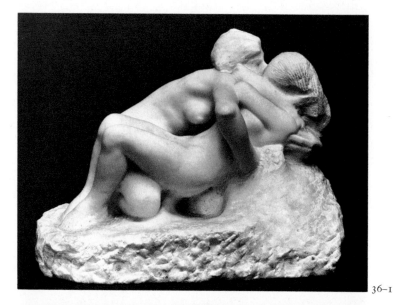

36–1

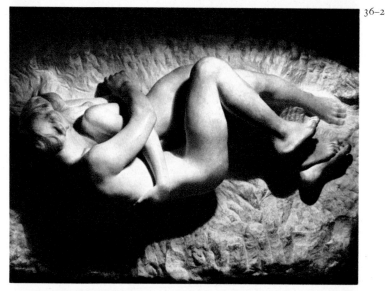

36–2

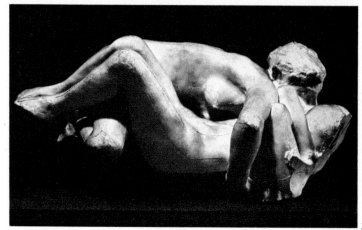

36–3

36–1
The Metamorphoses of Ovid
Before 1886, marble, height 13¾ inches
Ny Carlsberg Glyptotek, Copenhagen

36–2
Cupid and Psyche
Before 1886, plaster, height 9 inches
Musée Rodin, Paris

36–3
Daphnis and Chloe
Before 1886, plaster, height 9⅛ inches
Musée Rodin, Paris

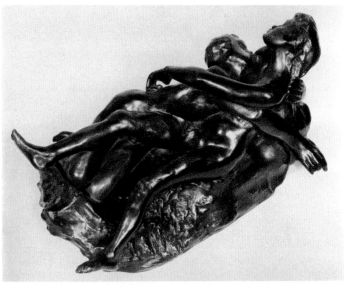

36–5

36–4

36–6

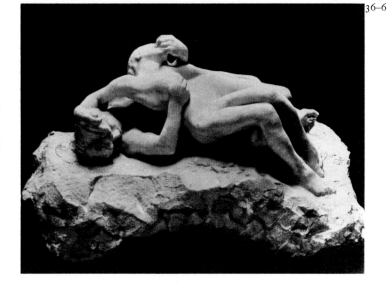

CLVI

FEMMES DAMNÉES

A la pâle clarté des lampes languissantes,
Sur de profonds coussins tout imprégnés d'odeur,
Hippolyte rêvait aux caresses puissantes
Qui levaient le rideau de sa jeune candeur.

Elle cherchait d'un œil troublé par la tempête
De sa naïveté le ciel déjà lointain,
Ainsi qu'un voyageur qui retourne la tête
Vers les horizons bleus dépassés le matin.

De ses yeux amortis les paresseuses larmes,
L'air brisé, la stupeur, la morne volupté,
Ses bras vaincus, jetés comme de vaines armes,
Tout servait, tout parait sa fragile beauté.

Étendue à ses pieds, calme et pleine de joie,
Delphine la couvait avec des yeux ardents,
Comme un animal fort qui surveille une proie,
Après l'avoir d'abord marquée avec les dents.

Beauté forte à genoux devant la beauté frêle,
Superbe, elle humait voluptueusement
Le vin de son triomphe, et s'allongeait vers elle
Comme pour recueillir un doux remerciment.

267

36–4
Damned Women, illustration for Charles Baudelaire's
"Femmes Damnées," from *Les Fleurs du Mal,* 1886–88

36–5
Daphnis and Lycenion
1886, bronze, height 11½ inches
Collection Walter R. Beardsley, Elkhart, Ind.

36–6
Damned Lovers
c. 1885?, stone, height 17¾ inches
Musée des Beaux-Arts, Lyons. Tripier Bequest, 1917

37 Eve and the Serpent
c. 1885

Plaster, 10⅝ × 5½ × 5 inches
Not signed or inscribed

This small plaster, in which the forms are inextricably confused, is generally known as *Eve and the Serpent* and has also been titled *Eve by the Apple Tree*. It was executed in the mid 1880s and, according to Grappe,[1] cast in bronze by Bingen. It is not surprising that Rodin should have been drawn to this subject at the time when he was most deeply involved with *The Gates of Hell*. A thematically related terra-cotta in the National Gallery of Art in Washington, D.C. (fig. 37–1), represents the culminating moment of Eve's temptation when, swayed by the devil's words, she furtively sinks her teeth into the apple. The suffering of the inhabitants of Hell could be traced back, in Rodin's view, to Eve's original transgression. But Grappe made the plausible suggestion that Rodin was equally impressed by the scene in Flaubert's *Salammbô* in which the heroine encounters the genius of the family before she leaves the palace of Hamilcar.

> The heavy tapestry trembled, and the python's head appeared above the cord that supported it. The serpent descended slowly like a drop of water flowing along a wall, crawled among the scattered stuffs, and then, gluing its tail to the ground, rose perfectly erect; and his eyes, more brilliant than carbuncles, darted upon Salammbô.
>
> A horror of cold, or perhaps a feeling of shame, at first made her hesitate. But she recalled Schahabarim's orders and advanced; the python turned downwards, and resting the centre of its body upon the nape of her neck, allowed its head and tail to hang like a broken necklace with both ends trailing to the ground. Salammbô rolled it around her sides, under her arms and between her knees; then taking it by the jaw she brought the little triangular mouth to the edge of her teeth, and half shutting her eyes, threw herself back beneath the rays of the moon. The white light seemed to envelop her in a silver mist, the prints of her humid steps shone upon the flagstones, stars quivered in the depth of the water; it tightened upon her its black rings that were spotted with scales of gold. Salammbô panted beneath the excessive weight, her loins yielded, she felt herself dying, and with the tip of its tail the serpent gently beat her thigh; then the music becoming still it fell off again.[2]

Great reader of Baudelaire that he was, Rodin had an attitude toward subject matter that may be paralleled in the *correspondances* Baudelaire experienced between the various senses. Thus one and the same work could be called *Christ and the Magdalen* or *Prometheus and an Oceanid*.[3] Alternative names for *Polyphemus* were *Narcissus* and *Milon of Croton* (see no. 23). In Rodin's view, a work that adhered too closely to the representation of a given subject or incident risked being "fixed," or "static," and was as lacking in the fluidity of life as the photograph of a subject in movement. Rodin eliminates this static quality by fusing a sequence of movements into the same image, which of necessity led to the rejection of any exact equivalence between the work of art and its title. Instead Rodin liked to give his works

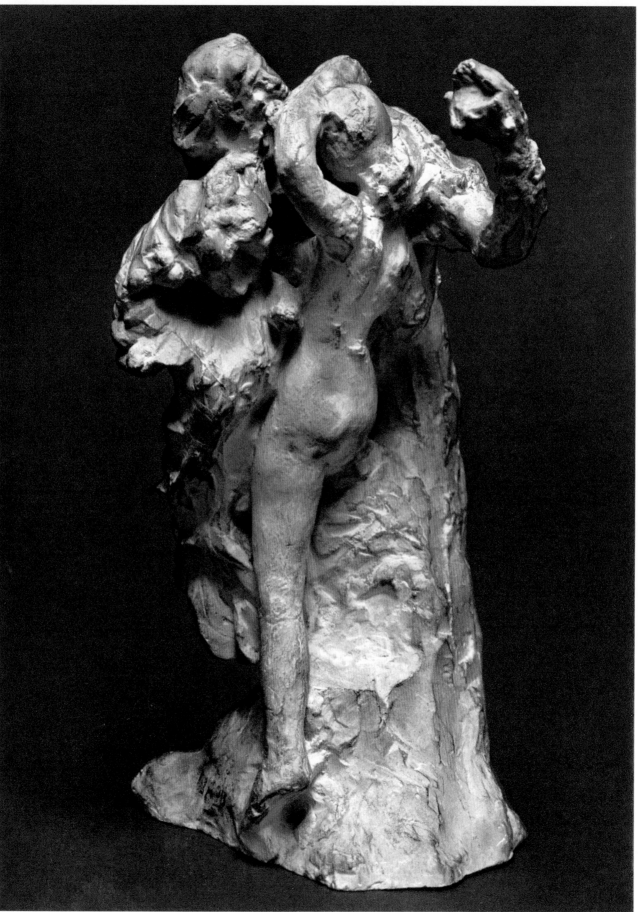

37

any number of titles, inspired by the forms he created rather than inspiring the finished work, enjoying the *correspondances* thus discovered between episodes or figures of very different natures. *Eve and the Serpent,* or *Salammbô,* as the work with equal appropriateness can be entitled, is a particularly good example of this peculiar characteristic of Rodin's style.

Thus for Rodin it was a natural development to see even more far-reaching equivalences, between the sexes (for example, *St. George* becoming *St. Joan of Arc; see* no. 110, and the use of two female figures in *The Death of Adonis; see* no. 43) and between human nature and the elements: "When a woman combs her hair, the movement of the stars can be traced in her gestures, and when, with flowing hair, she stands before the sea, one does not know which is more beautiful, for she herself is the sea."[4] And also, "If you really study it, you can see the setting of the sun in a flower. It can move you as the sight of the sea, only the sea is greater and produces a stronger emotion."[5]

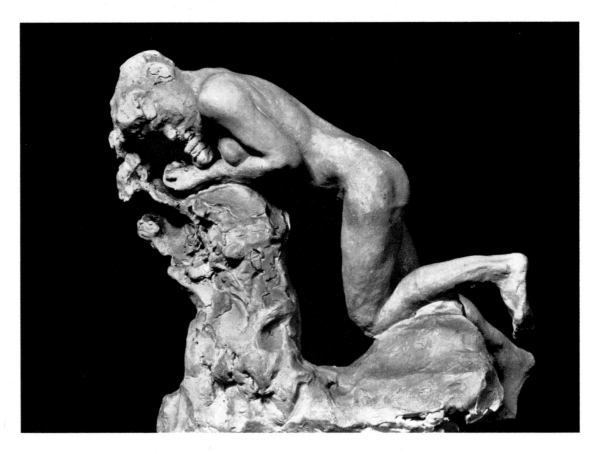

37–1
Eve Eating the Apple
c. 1885?, terra-cotta, height 10¾ inches
National Gallery of Art, Washington, D.C.
Gift of Mrs. John W. Simpson, 1942

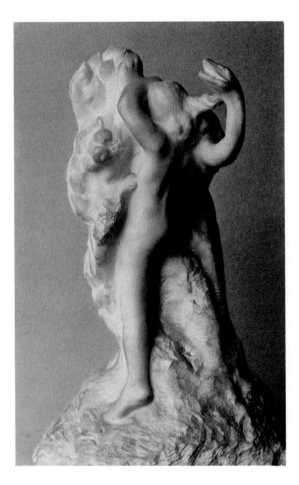

37–2
Eve and the Serpent
c. 1885, marble, height 19¾ inches
Musée Rodin, Paris

NOTES

1. Grappe [338d], no. 121.
2. Gustave Flaubert, *Salammbô,* trans. J.C.Chartres (New York: E.P.Dutton, 1956), p.164. Geffroy [199a], p.83, wrote, "Qu'il suffise de dire que la lecture, très libre, avec de tenaces préférences pour Dante, pour Baudelaire, pour Flaubert, et pour quelques vivants, n'a pas fait du sculpteur original un illustrateur."
3. *See* no. 19, n.7.
4. Rodin, quoted in Nostitz [83b], p.21.
5. Ibid., p.32.

REFERENCES

Lami [4], p.170; Grappe [338], no.236; Watkins [342], no.103; Grappe [338a], no.270; Grappe [338b], no.145; Grappe [338c], no.108; Grappe [338d], no.121; Tancock [341], no.35.

OTHER VERSION

Marble, height 19¾ inches

FRANCE
Paris, Musée Rodin (fig.37–2).

RELATED WORK

Eve Eating the Apple

Terra-cotta, height 10¾ inches

UNITED STATES
Washington, D.C., National Gallery of Art. Gift of Mrs. John W.Simpson, 1942 (fig.37–1).

Plaster

UNITED STATES
Maryhill, Wash., Maryhill Museum of Fine Arts.

38 Headless Woman Bending Over

a mid 1880s?

Plaster, 9 × 6½ × 5 inches
Inscribed on front of base:
A. Dolent. Rodin

b mid 1880s?

Bronze, 9½ × 5⅛ × 4¾ inches
Signed on base of pillar to right: A. Rodin
Foundry mark back of base to left:
Alexis Rudier/Fondeur PARIS[1]

39 Torso of a Man
mid 1880s?

Plaster, painted with yellowish brown
varnish, 5½ × 3⅛ × 2¼ inches
Not signed or inscribed

40 Torso of a Man
mid 1880s?

Plaster, 10½ × 7⅛ × 3¼ inches
Not signed or inscribed

In 1910 Rodin asked the writer Muriel Ciolkowska why he was blamed for isolating limbs or the torso of a figure. "Why," he went on, "is it allowed to isolate the head and not portions of the body? Every part of the human body is expressive. And is not an artist always isolating, since in nature nothing is isolated? When my works do not consist of the complete body, with four limbs, ten fingers, ten toes, people call it unfinished. What do they mean? Michelangelo's finest works are precisely those which are called 'unfinished.' Works which are called 'finished' are works which are clear, that is all."[2]

Discussing this same topic in the special issue of the magazine *La Plume* of 1900 devoted to the work of Rodin, the writer Yvanhoé Rambosson quoted Puvis de Chavannes to the effect that "'there is something still more beautiful than a beautiful thing and that is the ruins of a beautiful thing!' A beautiful thing, complete and new, moves from an aesthetic point of view, but a beautiful thing that has been used and broken, how much more human it is and closer to our heart for having suffered, and to how great an extent is there added an indefinable sensation of melancholy pity to the impression of pure beauty, a sad and human side which amplifies our emotion."[3]

Rodin's attitude toward the partial or incomplete figure had crystallized as early as 1864, when he preserved the head of the *Man with the Broken Nose* after the cold had caused the back of the head to fall off *(see no. 79)*. In the late 1870s he became dissatisfied with his group of *Ugolino and His Sons* and preserved only the torso.[4] In 1889 it seems probable that he exhibited the extremely Michelangelesque *Torso* (fig. 65-3),[5] a preparatory study for *St. John the Baptist Preaching,* and *The Walking Man* (fig. 65-1) at the exhibition which

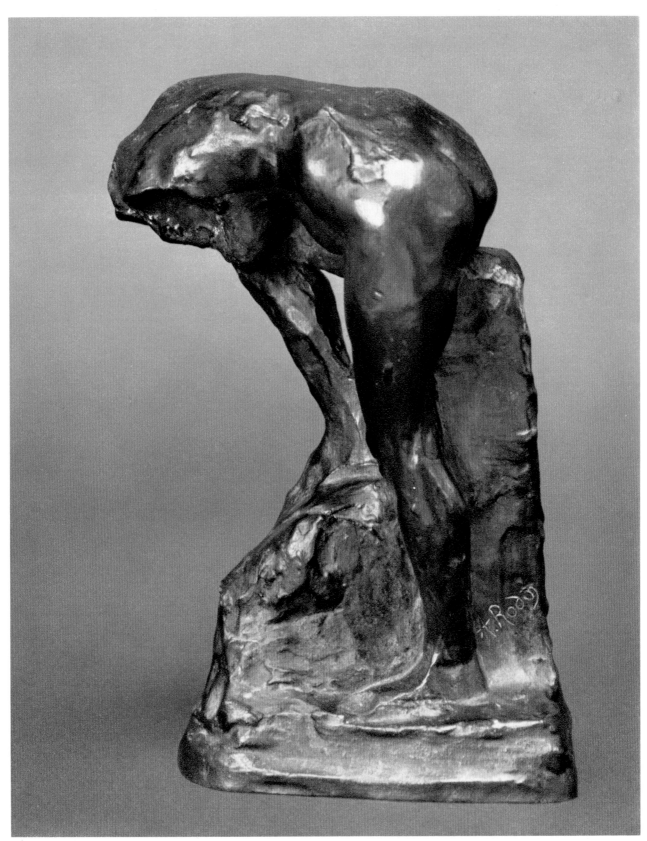

38b

he shared with Claude Monet at the Galerie Georges Petit. When a figure was modeled as Rodin required, that is to say, when all the contours were truthfully recorded, each part, however small and apparently insignificant, was in itself beautiful insofar as it was the embodiment of truthful observations of nature. In Rodin's *œuvre* minute fragments—for example, the foot and the central portion of a leg in the collection of the Cleveland Museum of Art[6]—are complete sculptural statements. But the suppression of parts of the figure had yet another effect. In the sculpture of the antique and medieval worlds which Rodin so loved and of which he became a passionate collector after 1900,[7] survival is generally marked by damage, weathering, or patination. For Rodin this evidence of a previous history, although diminishing the purely formal coherence of the work of art, greatly increased its pathetic appeal. In much of his own sculpture Rodin deliberately set out to create this effect.

Among the fragmentary studies in the Rodin Museum there are two male torsos (nos. 39, 40) which presumably date from the first years of Rodin's work on *The Gates of Hell*. Compact and yet full of life, these small torsos are strongly evocative of fragments from the antique world, a number of which Rodin was later to acquire.[8]

The two versions of the *Headless Woman Bending Over* (nos. 38a, 38b), in plaster and bronze, probably also date from the decade of the 1880s, by far the most productive period in Rodin's entire career. The plaster is dedicated to the connoisseur, collector, and writer, Jean Dolent (1835–1909).

NOTES

1. According to information provided by the Musée Rodin at the time of purchase, this is the second cast.
2. Ciolkowska [154], pp. 266–67.
3. *La Plume* [327], pp. 72–73. "Pourquoi brise-t-il certaines de ses œuvres et n'en montre-t-il que des fragments? Qu'est-ce que cela ajoute à leur signification? disent certains. Ceux-là n'ont certainement pas médité le mot de Puvis de Chavannes: 'Il y a quelque chose de plus beau encore qu'une belle chose, ce sont les ruines d'une belle chose!' Une belle chose, complète et neuve, nous émeut au point de vue esthétique, mais une belle chose usée, cassée, comme elle est plus humaine et plus près de notre cœur, pour avoir participé à la souffrance, et comme à l'impression de beauté pure s'ajoute une indéfinissable sensation de pitié mélancolique, un côté douloureux et d'humanité qui amplifie notre émotion!"
4. Bartlett in Elsen [39], p. 33.
5. *See* Paris, 1889 [347]. A torso was exhibited as no. 28, *Torso. Bronze;* another was exhibited as no. 34, *Torso.*
6. Spear [332], nos. XXI, XXII.
7. *See* catalogue of the exhibition "Rodin collectionneur," Paris, 1967–68 [384].
8. Ibid., nos. 142, 156, 159, and 160.

REFERENCES

Headless Woman Bending Over
Watkins [342], nos. 22, 96; Tancock [341], no. 112, repr. p. 91.

Torso of a Man (no. 39)
Watkins [342], no. 86; Tancock [341], no. 110.

Torso of a Man (no. 40)
Watkins [342], no. 91; Los Angeles, 1967–68 [383], no. 16, repr. p. 39; Tancock [341], no. 111.

OTHER CASTS (No. 40)

JAPAN
Tokyo, National Museum of Western Art (ex. Collection Matsukata). Founder: Alexis Rudier.

UNITED STATES
Cincinnati, Cincinnati Art Museum. Gift of Mr. and Mrs. Lucien Wulsin, 1956.

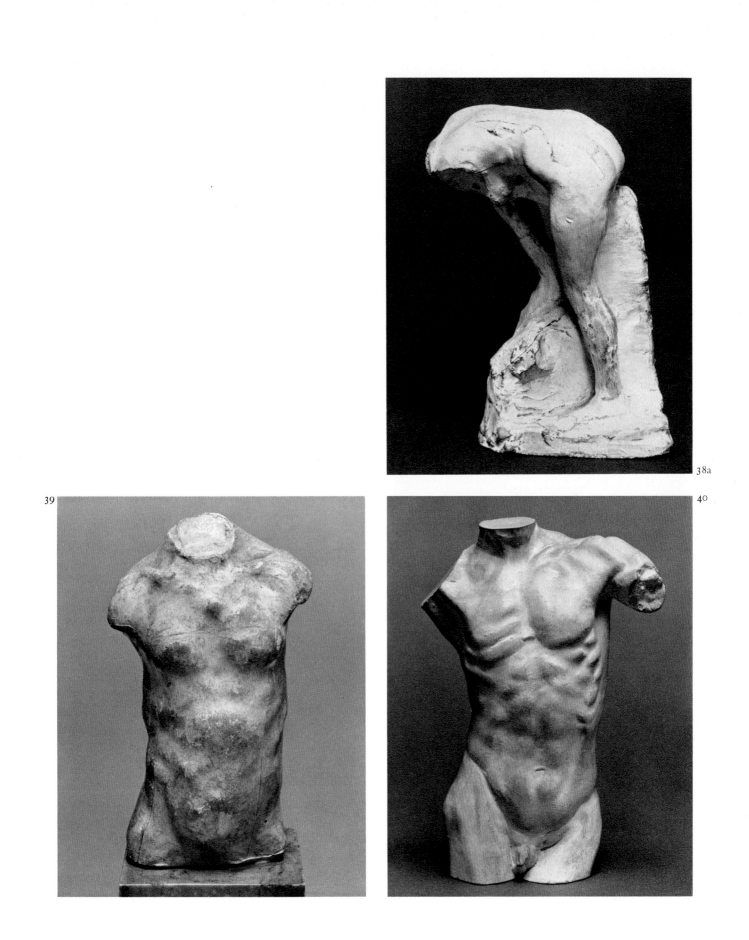

38a

39

40

41 The Minotaur

c. 1886

Plaster, painted with yellowish brown varnish,
13 ½ × 9 ½ × 8 inches
Inscribed on base near faun's left foot:
à Maître/Md Goncourt./A Rodin.

The Minotaur has also been known under the titles *Faun and Nymph, Faun and Woman,* and, most commonly, *Jupiter Taurus.*[1] It is one of the many works produced by Rodin during the 1880s which draws heavily on the world of Ovid for inspiration. Entitled *Jupiter Taurus,* the group would represent the preliminary scenes of the incident when Jupiter, "the father and ruler of the gods, who wields in his right hand the three-forked lightning, whose nod shakes the world, laid aside his royal majesty along with his sceptre, and took upon him the form of a bull."[2] He sees Europa and abducts her, the eventual offspring of the match being Minos, King of Crete.

Rodin, however, greatly preferred that the work retain its title of *The Minotaur.* Minos married Pasiphaë, and from her union with a bull, the minotaur was born. Each year seven maidens and seven youths were exacted from the Athenians as tribute for him to devour until he was finally slain by Theseus.[3] Rodin's group thus represents the minotaur with one of his unwilling victims.

In his conversations with Rodin, Paul Gsell relates that when Rodin asked him if he would like to see the first sketch for *Pygmalion and Galatea* (fig. 45–3) he showed him *The Minotaur,* although only the head of Pygmalion, the first artist, which is close to that of the faun, resembles anything in the earlier work. Rodin's concluding comment was that "you must not attribute too much importance to the themes that you interpret. Without doubt, they have their value and help to charm the public; but the principal care of the artist should be to form living muscles."[4]

There is, however, a little-known work that is much more closely related to *The Minotaur,* namely the group of *Triton and Nereid,* a terra-cotta version of which is in the collection of the Metropolitan Museum of Art in New York. In this fragmentary study (fig. 41–2) the grappling figures are intertwined even more amorously than they are in *The Minotaur,* the triton evidently succeeding in his intention of implanting a kiss on the nereid's back. The deprivation of all but the essential limbs in this group gives a particular intensity to the expression of sensual desire. Since it is so closely related to *The Minotaur,* a date of about 1886 is here assigned to it.

Stylistically *The Minotaur* points to Rodin's continued enthusiasm for the art of the eighteenth century. The education he received at the Petite Ecole was still deeply imbued with eighteenth-century approaches, while the periods he spent with Carrier-Belleuse, "the Clodion of the Second Empire" and one of the major protagonists of the revival of eighteenth-

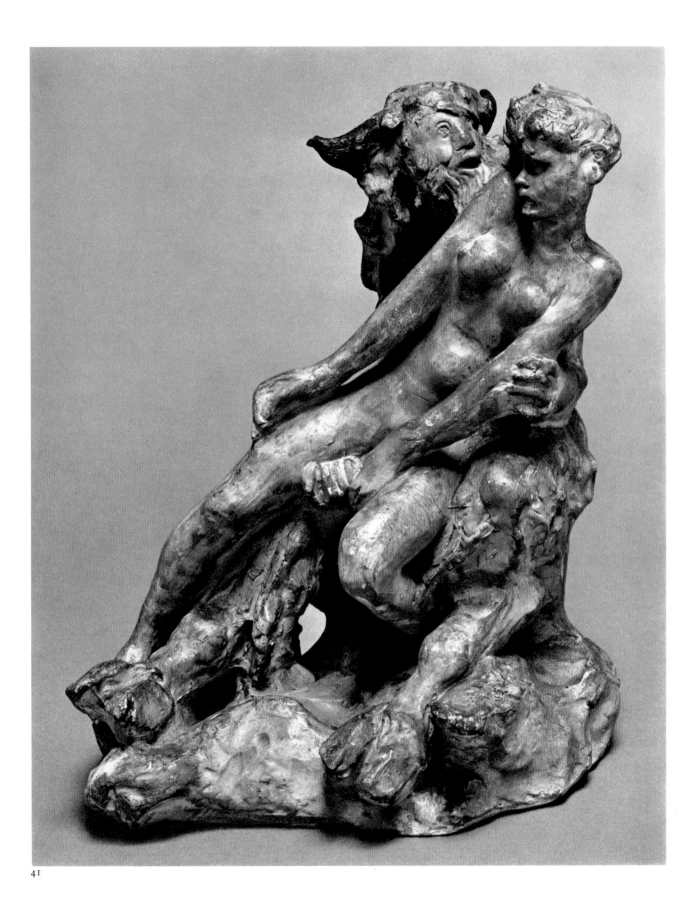

century art, in Paris, Brussels, and later at Sèvres, further strengthened this inclination. It may be for this reason that it was one of the works most widely admired by early connoisseurs. The first cast was owned by Edmond de Goncourt (to whom this plaster is dedicated), whom Rodin first met in 1879 through the engraver Félix Bracquemond[5] and who later became a frequent visitor to Rodin's studio. One of the few contemporary works admitted into his house at Auteuil, it was undoubtedly the pronounced eighteenth-century character of the piece that so impressed him.

At the de Goncourt Sale the work passed into the hands of another discerning connoisseur, Comte Robert de Montesquiou (one of the principal inspirations for Marcel Proust's Baron de Charlus). It also seems probable that a plaster cast of this work was in the possession of Mallarmé, whose salon Rodin frequented in the late 1880s and 1890s.[6] The original plaster, height 13 ½ inches, was later enlarged. In Grappe's catalogues of 1929 and 1931[7] a plaster 22 ½ inches in height is listed, although this is omitted from later editions. In the catalogue of the 1918 Rodin exhibition in Basel, there is a reference to a marble version of this work. Presumably it is the one that is now in the collection of the Museum Folkwang in Essen (fig. 41–1).

NOTES

1. Grappe [338d], no. 160.

2. Ovid, *Metamorphoses,* trans. Frank Justus Miller (Cambridge, Mass.: Harvard University Press, 1946), 2.847.

3. Ibid., 8.169–72.

4. Gsell [57b], pp. 163–64.

5. Lawton [67], pp. 52, 53.

6. *See* Henri Mondor, *Vie de Mallarmé* (Paris: Gallimard, 1946), p. 643.

"Ils viennent, chaque mardi, s'émerveiller, s'orienter, se mieux connaître. Pour la gloire de leur maître, leur ferveur et leur fidélité seront décisives.

"La salle à manger, où se disent les plus belles paroles que la Poésie ait inspirées, ne change guère. Les murs s'enrichissent lentement de quelques toiles ou gravures: aux deux Manet s'ajoutent maintenant, une marine de Berthe Morisot, une nymphe de Whistler, un pastel de fleurs de Redon, un plâtre de Rodin groupant un faune plus agressif, moins joueur de flûte que celui du poète et une nymphe sans étonnement; enfin ce bois orangé de Gauguin où le profil d'un Maori permet à Mallarmé de taquiner Mauclair sur une ressemblance approximative."

7. Grappe [338a], no. 237; [338b], no. 175.

REFERENCES

Geffroy [199a], p. 15; Maillard [71], repr. p. 33; Lawton [67], p. 134; Rilke [87], repr. pl. 29 (bronze); Lami [4], p. 170; Bénédite [10a], p. 31, repr. pl. LVII (A); Grappe [338], nos. 206, 207; Watkins [342], no. 99; Grappe [338a], nos. 237, 238; Grappe [338b], nos. 175, 176; Grappe [338c], no. 142; Story [103], p. 146, no. 49, repr. pl. 49 (plaster); Grappe [338d], no. 160; Waldmann [109], pp. 40, 41, 75, no. 32, repr. pl. 32 (bronze); Cladel [27], repr. pl. 32; Charbonneau [22], repr. pl. 61 (bronze); Herriot [62], repr. pl. 48 (plaster); Story [103a], no. 50, repr. pl. 50; Goldscheider [49], repr. p. 77 (bronze); Sutton [104], p. 24, repr. fig. 7 (bronze); Tancock [341], no. 37.

OTHER CASTS AND VERSIONS

Plaster

ARGENTINA
Buenos Aires, Collection Mercedes Santamarina. Dedicated to Catulle Mendès.

FRANCE
Belfort, Musée de Belfort. Gift of Rodin to Camille Lefèvre. Not signed.
Paris, Musée Rodin. Inscribed: A mon ami Michelet. Rodin.
— Collection Claude Roger-Marx.

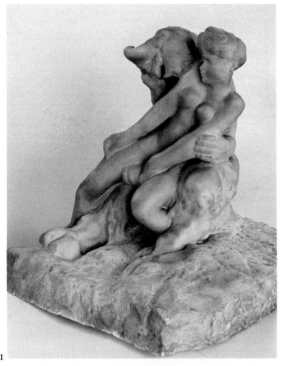

41-1

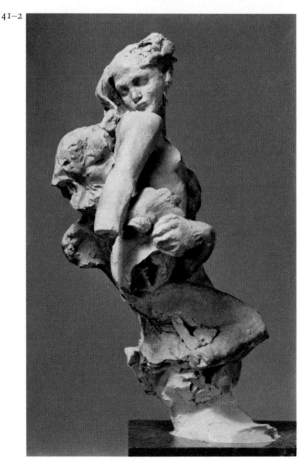

41-2

Bronze

FRANCE
Paris, Musée Rodin.

UNITED STATES
Maryhill, Wash., Maryhill Museum of Fine Arts.
San Francisco, California Palace of the Legion of Honor. Spreckels Collection. Founder: Alexis Rudier.

Marble, height 22⅝ inches

GERMANY (WEST)
Essen, Museum Folkwang (ex. Collection Karl-Ernst Osthaus, Hagen). Purchased in 1921 (fig. 41–1).

RELATED WORK

Triton and Nereid

Terra-cotta, height 16 inches

UNITED STATES
New York City, Metropolitan Museum of Art. Rogers Fund, 1910 (fig. 41–2).

Bronze, approximate height 14½ inches

GERMANY (EAST)
Dresden, Staatliche Kunstsammlungen (as *Entführung*). Purchased in 1966 from a Berlin private collection. Signed: A. Rodin. Also monogrammed: A.R.
Leipzig, Museum der Bildenden Künste (as *Entführungsszene*). Signed: A.Rodin.

UNITED STATES
Wellesley, Wellesley College, Jewett Arts Center. On permanent loan. Cast from the Metropolitan Museum terra-cotta. Signed: A.Rodin. Also monogrammed: A.R.

41–1
The Minotaur
c. 1886, marble, height 22⅝ inches
Museum Folkwang, Essen

41–2
Triton and Nereid
c. 1886, terra-cotta, height 16 inches
Metropolitan Museum of Art, New York
Rogers Fund, 1910

273

42 Sorrow (No. 2)

c. 1887

Plaster, $7\frac{1}{4} \times 7\frac{7}{8} \times 3\frac{1}{4}$ inches
Inscribed front of rocky base: A. Mr/L. Hugo/ Rodin.[1]

In *The Gates of Hell* there is a vast repertoire of forms expressing grief, despair, and hopeless-
ness. A group of works dating from the mid 1880s,[2] created at the same time as the more
joyful Ovidian works, share these same concerns, although they do not actually appear in
The Gates. Sorrow (No. 2)[3] belongs to this group. In the 1929 catalogue of the Musée Rodin,
Grappe dated this work 1892 on the basis of photographs taken in Rodin's studio that
showed it beside *The Death of Adonis* (no. 43), a work which he then dated 1893.[4] In the 1931
catalogue, however, he revised his dating to 1887, as apparently he learned of the existence
of a dated example, although he did not state its location.[5] Certainly *Sorrow (No. 2)* is closely
related in feeling to the *Andromeda* of 1885 (no. 35), both figures being so overcome with
grief that they fling themselves forward and fold their arms around their heads in an attempt
to shut out the external world.

 This plaster is dedicated to the sculptor Léopold-Armand Hugo, a pupil of Horace
Vernet and an exhibitor at the Salon from 1874.

NOTES

1. Purchased from F. and J. Tempelaere, Paris.
2. Compare *Danaid* (fig. 35–2), *Andromeda* (no. 35),
 and *Despairing Man* (no. 31).
3. *Sorrow (No. 1)*, in plaster and dated about 1889
 (Grappe [338d], no. 223), represents a nude female
 figure, her hands covering her eyes, seen from
 behind and facing a rock. Neither *Sorrow (No. 1)*
 nor *Sorrow (No. 2)* should be confused with *Head
 of Sorrow* (no. 9).
4. Grappe [338a], no. 208. "D'anciennes photo-
 graphies, prises dans les ateliers de Rodin, la
 représentent au milieu d'autres statuettes disposées
 sur une table; on la voit notamment à côté de la
 Mort d'Adonis, ce qui, en l'absence de renseigne-
 ments antérieurs, permet de les juger 'contempo-
 raines,' au moins, l'une de l'autre."
5. Grappe [338b], no. 209. Although he dates the
 bronze 1887, he states that it was cast in 1929.

REFERENCES

Watkins [342], no. 106; Grappe [338a], no. 208;
Grappe [338b], no. 209; Grappe [338c], no. 161;
Grappe [338d], no. 182; Tancock [341], no. 38.

OTHER CASTS AND VERSIONS

Bronze

FRANCE
Paris, Musée Rodin.

UNITED STATES
New York City, Collection Margret Suzanne Zan-
 der Loewy. Founder: Georges Rudier. Cast no.
 2/12.

Marble

GERMANY (WEST)
Bielefeld, Kunsthalle Richard Kaselowsky-Haus.

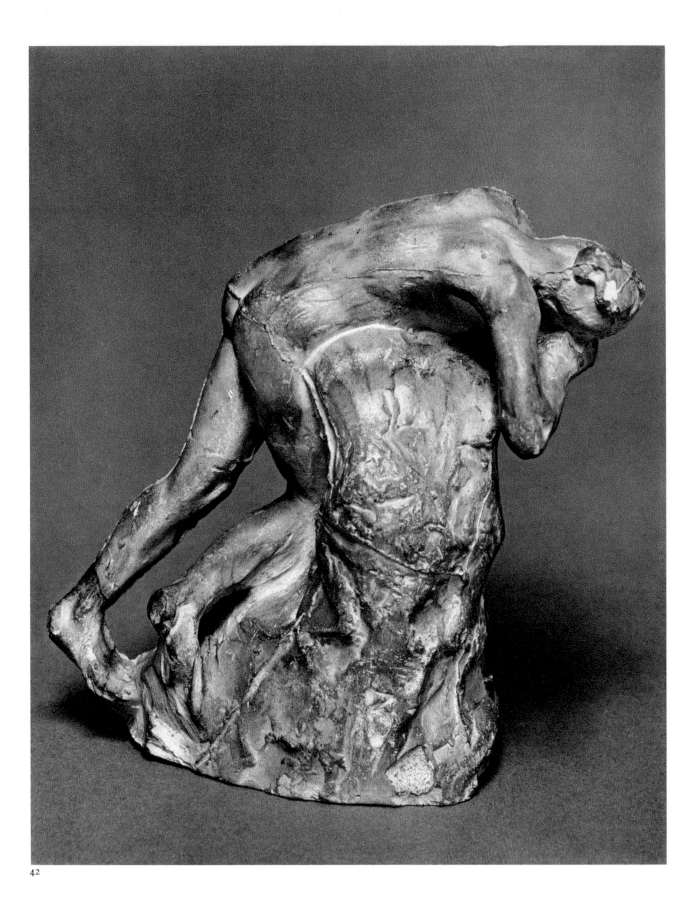

43 The Death of Adonis
by 1888

Plaster, 5⅞ × 10⅝ × 5¾ inches
Not signed or inscribed

The Death of Adonis, which has also been known as *Venus Kissing Adonis,*[1] is one of Rodin's many works with associations from the Ovidian world. Adonis, son of Myrrha by her father, Cinyras, and born after his mother was turned into a tree, was beloved of Venus because of his great beauty. Although warned by her not to hunt any ferocious beasts, he hunted a wild boar and was mortally wounded. From his blood there sprang the anemone.[2] Here Venus is shown mourning over the lifeless body of Adonis.

This is a composite work formed from two female figures not identical with, but closely related to, many figures in *The Gates of Hell.* The recumbent figure is especially close to the figure at the top center of the right-hand leaf of *The Gates (see* no. 1, detail M). The contrast between the high degree of finish of the bodies and the sketchy heads indicates that they were once conceived separately. Grappe observed correctly that the female figure bending over the recumbent figure recalls the *Danaid* (fig. 35–2). He also pointed out the relationship between the figure of Adonis and *The Kneeling Man* (fig. 43–4), although the form of Adonis has taken on female characteristics.

According to an unnamed *praticien* (reported by Grappe), work was finished on the marble group in 1891.[3] However, the plaster study must date from 1888 at the latest, as a detailed drawing of it decorates the poem "Le Poison" ("The Poison") in the edition of Baudelaire's *Les Fleurs du Mal* that Rodin illustrated for Gallimard in 1888. With the addition of lavish draperies, the group illustrates the theme of Baudelaire's poem, a fatalistic love beside which wine and opium have little power, a love which may well be lesbian. The naming of the work after the sculptural confrontation of the component parts, as was very frequently Rodin's practice, gives it a strange new ambiguity. It is not so much an illustration of an incident from Ovid as a lesbian reenactment of it, and its use for the illustration of Baudelaire's poem supports this interpretation.

In the original plaster version, here dated not later than 1888, and in the bronzes made from it, two female figures are used. But in the marble enlargement (fig. 43–1), finished by 1891, the form of Adonis is more definitely masculine (masculine genitalia have been added), as it is in the bronze enlargement (fig. 43–2). The form of the base in the bronze enlargement, which represents uncut rock, indicates that this was made from a marble.

The grouping of the figures in this work evidently appealed to Rodin, as in 1906 he used a very close paraphrase of it in the work known as *Aurora and Tithonus* (fig. 43–3). In Greek legend Eos (Dawn, or Aurora in Roman mythology) fell in love with Tithonus because of his great beauty. She obtained the gift of immortality for her lover from Zeus but forgot to ask for eternal youth. Consequently Tithonus turned into a hideous old man,

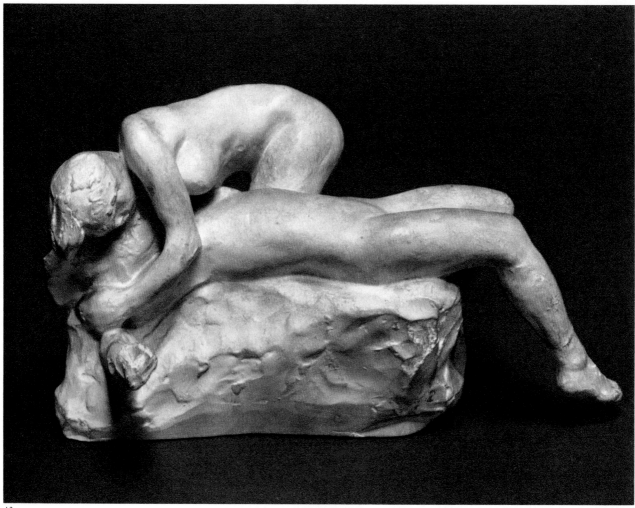

43

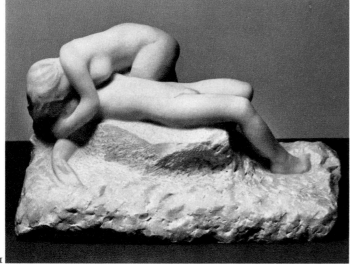

43–1

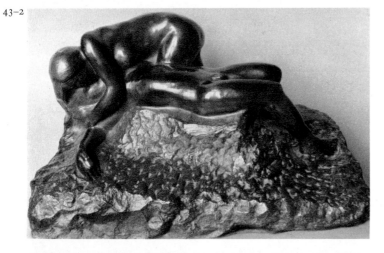

43–2

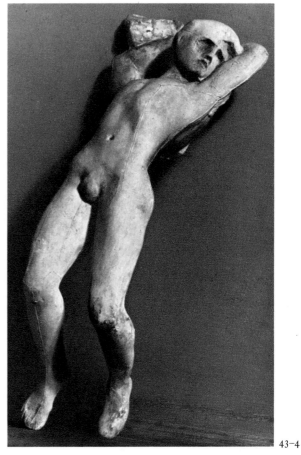

43–4

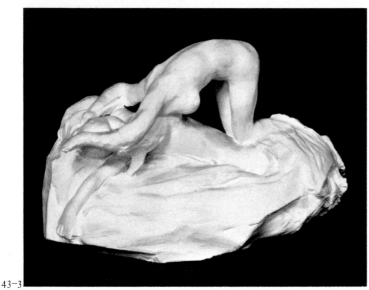

43–3

43–1
The Death of Adonis
By 1891, marble, height 14½ inches
Walters Art Gallery, Baltimore

43–2
The Death of Adonis
By 1891, bronze, height 14⅛ inches
Musée Rodin, Paris

43–3
Aurora and Tithonus
Before 1906, plaster, length 10½ inches
National Gallery of Art, Washington, D.C.
Gift of Mrs. John W. Simpson, 1942

43–4
The Kneeling Man
Mid 1880s, plaster, height 4 inches
Musée Rodin, Paris

his limbs having ceased to function. Rodin represented Aurora leaning over his lifeless body and lamenting his fate, the relationship between the two figures being strongly reminiscent of that between Venus and Adonis.

Thematically related to *The Death of Adonis* is the work entitled *The Resurrection of Adonis,* which Grappe dates 1889.[4] He observes that in this work Adonis stands for Spring, the rebirth of life.

NOTES

1. Grappe [338d], no. 226.
2. Ovid, *Metamorphoses,* trans. Frank Justus Miller (Cambridge, Mass.: Harvard University Press, 1946), 10.712–24. "Straightway the fierce boar with his curved snout rooted out the spear wet with his blood, and pursued the youth, now full of fear and running for his life; deep in the groin he sank his long tusks, and stretched the dying boy upon the yellow sand. Borne through the middle air by flying swans on her light car, Cytherea [Venus] had not yet come to Cyprus, when she heard afar the groans of the dying youth and turned her white swans to go to him. And when from the high air she saw him lying lifeless and weltering in his blood, she leaped down, tore both her garments and her hair and beat her breasts with cruel hands."
3. Grappe [338d], no. 226.
4. Ibid., no. 227.

REFERENCES

Lami [4], p. 169; Grappe [338], no. 182; Watkins [342], no. 112; Grappe [338a], no. 212; Grappe [338b], no. 252; Grappe [338c], no. 196; Frisch and Shipley [42], p. 425; Grappe [338d], no. 226; Grappe [54], p. 143, repr. p. 90; Adams [5], repr. p. 17; Waldmann [109], pp. 45, 76, no. 40, repr. pl. 40 (bronze); Cladel [27], repr. pl. 58 (bronze); Tancock [341], no. 39.

OTHER CASTS AND VERSIONS

Plaster (first version)

DENMARK
Copenhagen, Ny Carlsberg Glyptotek. Gift of Ny Carlsbergfondet, 1946 (ex. Collections Léveillé; Charles Madvig, Paris).

Bronze, height 6¼ inches

FRANCE
Paris, Collection Darthea Speyer. Founder: Georges Rudier. Cast no. 12/12.
— Musée Rodin. Signed: A. Rodin. Founder: Alexis Rudier.

UNITED STATES
San Francisco, Collection Mr. and Mrs. Tevis Jacobs. Founder: Georges Rudier. Cast no. 7/12.

Marble, height 14½ inches

UNITED STATES
Baltimore, Walters Art Gallery (fig. 43–1).

Bronze, height 14⅛ inches

FRANCE
Paris, Musée Rodin (fig. 43–2).

RELATED WORKS

The Resurrection of Adonis

Plaster, height 17⅜ inches

FRANCE
Paris, Musée Rodin.

Marble

ISRAEL
Private collection.

Aurora and Tithonus

Marble, height 22⅞ inches

FRANCE
Paris, Musée Rodin.

Plaster, length 10½ inches

UNITED STATES
Washington, D.C., National Gallery of Art. Gift of Mrs. John W. Simpson, 1942. Inscribed: L'Aurore se leve de la/couche du beau Typhon [sic]/Metamorphose d'Ovide/hommage à Mme Kate Simpson/A Rodin/1907 (fig. 43–3).

44 Possession

c. 1888

Plaster, 9¼ × 4¾ × 4½ inches
Not signed or inscribed

In the first two editions of the Musée Rodin catalogue,[1] Georges Grappe assigned a date of before 1900 to *Possession* and several works related to it. At the Exposition Rodin of 1900 *Possession* and *The Sin* were exhibited, the former work being described in the following words: "Small group of two figures, standing and entwined; the woman dominates the upper part of the body almost entirely and encloses in a ferocious grasp the man on whom she has pounced, as if he were her prey; he no longer offers any resistance."[2]

In subsequent editions of Grappe's catalogue, however, the dating was revised to about 1888, apparently because of the similarity in mood between this group of works and *The Gates of Hell*. Grappe lists five works altogether—*Possession* (marble, height 24⅜ inches); *Possession* (plaster, height 9¼ inches); *Possession (No. 2)* (plaster, height 7¹/₁₆ inches); *The Sin* (plaster, height 21¼ inches); and finally *The Sin (No. 2)* (plaster, height 7¹/₁₆ inches).[3]

The Philadelphia plaster corresponds in size with the second work and seems to be almost identical with the third. In this version of the battle between the sexes, the woman (whose diminutive tail suggests that she might well be a satyress) assumes the dominant role. In so many of Rodin's work the woman resists her partner's passionate advances *(see,* for example, *The Minotaur* [no. 41] or *Avarice and Lust;* fig. 46–4) or even manages to escape from his grasp. In *Possession,* however, the situation is reversed, all the aggression deriving from the strongly muscled female.

NOTES

1. Grappe [338], nos. 227–29; [338a], nos. 258–62.
2. Paris, 1900 [349], nos. 1 and 2. "No. 1. L'Emprise. Petit groupe de deux figures debout et enlacées; la femme domine de presque tout le buste, et étreint férocement, l'homme sur qui elle a fondu comme sur une proie, et qui ne résiste plus."
3. Grappe [338d], nos. 189–93.

REFERENCES

Grappe [338], no. 228; Watkins [341], no. 90; Grappe [338a], no. 259; Grappe [338b], no. 215; Grappe [338c], no. 166 bis; Grappe [338d], no. 190; Boeck [138], repr. pl. 104; Tancock [341], no. 40.

OTHER CASTS AND VERSIONS

Plaster

FRANCE
Paris, Musée Rodin.

Marble, height 24⅜ inches

FRANCE
Paris, Musée Rodin.

Possession (No. 2)

Plaster, height 7¹/₁₆ inches

FRANCE
Paris, Musée Rodin.

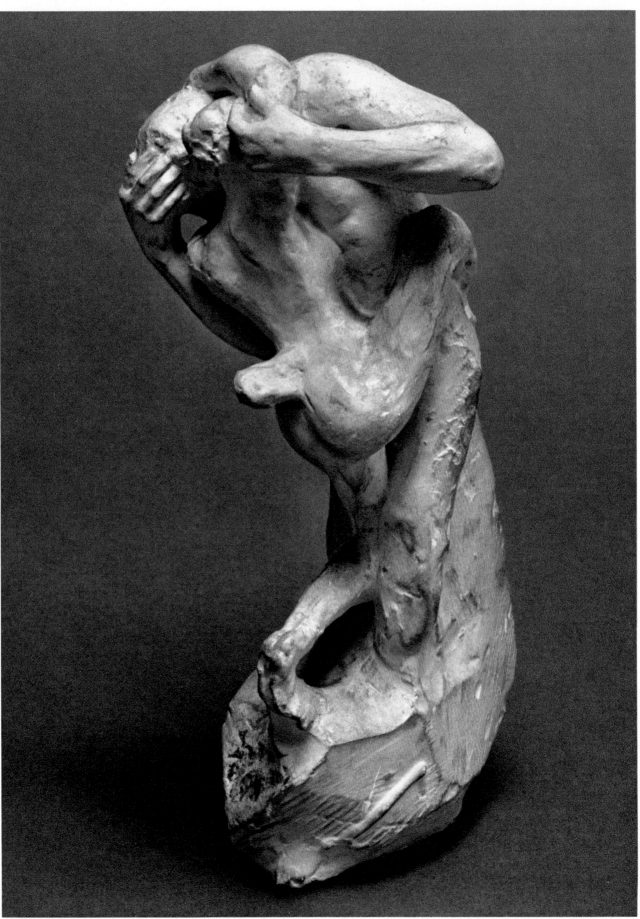

45 Nude Woman (Galatea)
1889

Bronze, 14½ × 9 (arms) × 6 inches
Signed by figure's left foot: A. Rodin.
Inscribed rear of base to right: 1ère Epreuve
Foundry mark rear of base: ALEXIS RUDIER/Fondeur Paris

This figure is related to the female figure in the group *Pygmalion and Galatea,* dated 1889 by Grappe.[1] Pygmalion, the first artist, was so enamored of his creation that it came to life under his hands. The myth undoubtedly had a very personal significance for Rodin, who later, in *The Hand of God* (no. 121), identified the sculptor's creation of forms with God's creation of the world. When Rodin asked Paul Gsell if he would like to see the first sketch for *Pygmalion,* Rodin, somewhat to Gsell's surprise, produced *The Minotaur* (no. 41), although only the head of Pygmalion bears any resemblance to a specific feature of the earlier work.[2] Georges Grappe gave the best explanation of this unexpected kinship. Rodin, he said, "gave his Pygmalion a face like those of the fauns and satyrs, as if to show even more clearly the appearance of those ages when man liberated himself with difficulty from the original clay."[3]

In the various editions of Grappe's catalogue of the Musée Rodin, only a plaster cast of *Pygmalion and Galatea* is listed. There are, however, at least two marbles and possibly three in existence, although the present location of the third is not known. The first marble is in the Metropolitan Museum of Art in New York and was given by Thomas F. Ryan in 1910 (fig. 45–3), while the second, now in the collection of the Ny Carlsberg Glyptotek in Copenhagen, was purchased by Carl Jacobsen in the same year. A third marble may have been carved for Judith Cladel; however, her testimony is somewhat confusing.[4]

The bronze figure under discussion is clearly a preliminary study for the marble group, which was probably assembled from preexisting figures in Rodin's customary manner. A date of 1889 must thus be assigned to the original idea for *Galatea,* although the fact that it was cast by Alexis Rudier shows that it did not actually exist until after 1902.[5] A related study of a headless figure, lacking both left arm and leg and in reverse, was included in the 1927, 1929, and 1931 catalogues of the Musée Rodin and dated 1889. Omitted from the 1938 catalogue it was reinserted in the 1944 edition with the date changed to 1909. Grappe suggested plausibly that this might be a study for a new version of the group in reverse. Another plaster, with head although still without left arm and leg, was included in the group of eighteen plaster casts that Rodin gave to the Metropolitan Museum of Art in 1912 (fig. 45–2).

His beautiful vision of a sculpture that has just come to life is curiously reminiscent of Renoir's *Venus Triumphant,* which dates from 1913 (fig. 45–1). However, a closer analysis reveals the profound difference in the aesthetic of the two artists. Rodin's figure, still attached to a marble outcrop, steps hesitantly into life and seems plagued with self-doubt beside the

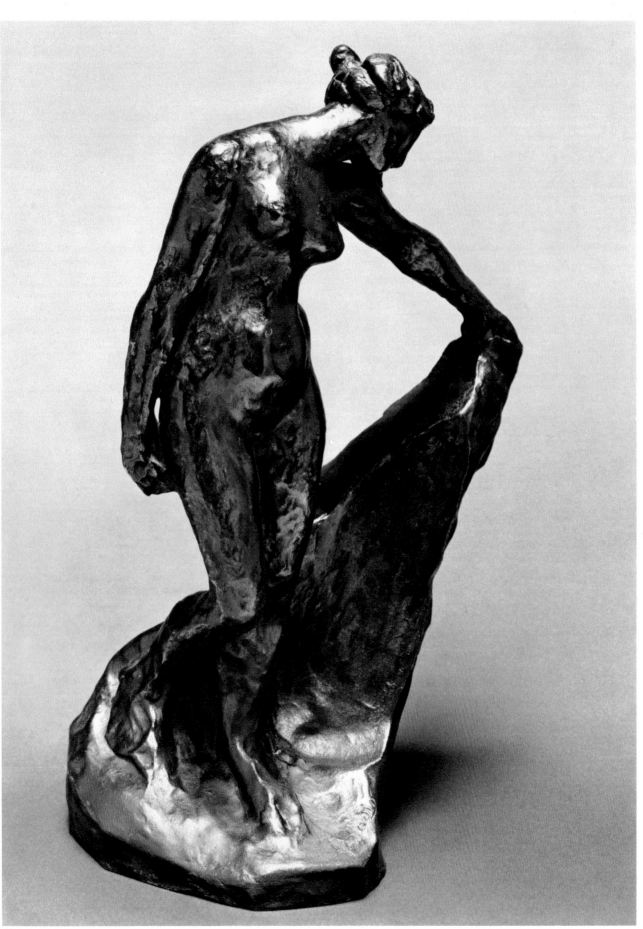

45

sturdy figure of Renoir's *Venus,* confident of her beauty and totally lacking the Christian attribute of shame. Movement has ceased in Renoir's sculpture whereas in Rodin's it continues.[6]

Rodin was not alone in his enthusiasm for this mythological subject. Gérôme's painting of *Pygmalion and Galatea* had recently been a noted success at the Salon,[7] although Rodin was probably more in sympathy with Falconet's version of the subject[8] than with Gérôme's more pedestrian work. A reduced version of Falconet's group in *biscuit de Sèvres* (fig. 45-4) had been made at the Sèvres factory some time after 1762, and it seems more than probable that Rodin would have seen it during the three-year period (1879–82) when he worked there. Whereas Falconet's sculptor expresses naïve admiration at the results of his labors, Rodin's looks lecherously at the glowing flesh.

NOTES

1. Grappe [338d], no. 233.
2. Gsell [57b], pp. 163–64.
3. Grappe [338d], no. 233. "Il a donné à son Pygmalion une physionomie qui l'apparente aux faunes et aux satyres, comme pour mieux marquer l'aspect de ces âges où l'homme se dégageait avec peine du limon originel."
4. Cladel [26], pp. 303–4.

"De là, dans une lettre d'esprit très détendu, il m'annonça que le groupe de *Pygmalion et Galathée* qu'il me destinait depuis des années était terminé; mais ce marbre, d'un poids considérable, nécessitait une selle spéciale pour le recevoir. A moi de m'en occuper.

"Pour la première fois, Rodin me faisait un don de cette importance. Le petit marbre qu'il destinait à ma cheminée, une première épreuve de *Pygmalion et Galathée,* une fois exécuté, se trouva de dimensions telles que, seul, un vaste rez-de-chaussée pouvait le recevoir. Un peu confus,—et si bon, alors,—il demanda si je lui permettais de le vendre en Amérique, et le groupe charmant partit pour le Musée Métropolitain de New-York. Il en fit exécuter un second exemplaire, de moindres dimensions; c'est celui-là qu'il m'offrait. Un expert reconnut que le plancher de l'appartement que j'occupe dans la vieille maison où Eugène Delacroix vécut ses dernières années et mourut, ne supporterait pas le poids de l'œuvre munificente. De plus, envoyée par le médecin à la campagne, je ne pus en faire effectuer le transport avant mon départ."

Mlle Cladel places these events in 1914, but the marble now in the Metropolitan Museum was given in 1910, and the marble in the Ny Carlsberg Glyptotek was purchased in that same year. Rodin's rather cavalier attitude toward the dating of his letters may have caused this confusion. It may be, as she implies, that Rodin made a smaller marble version for Mlle Cladel, although the work dedicated to her in the Musée Rodin is the bronze study for *Pygmalion and Galatea* (see Paris, 1962–63 [367], no. 137).

45-1
Pierre-Auguste Renoir
Venus Triumphant
1913, bronze, height 23¾ inches
Hirshhorn Museum and Sculpture Garden,
Smithsonian Institution, Washington, D.C.

45-2
Study for "Galatea"
1909, plaster, height 12½ inches
Metropolitan Museum of Art, New York
Gift of Rodin, 1912

45-3
Pygmalion and Galatea
1889 (executed c. 1908–9), marble, height 30¾ inches
Metropolitan Museum of Art, New York
Gift of Thomas F. Ryan, 1910

45-4
Etienne-Maurice Falconet
Pygmalion and Galatea
After 1762, *biscuit de Sèvres,* height 15¾ inches
Musée National de Céramique, Paris

45-1

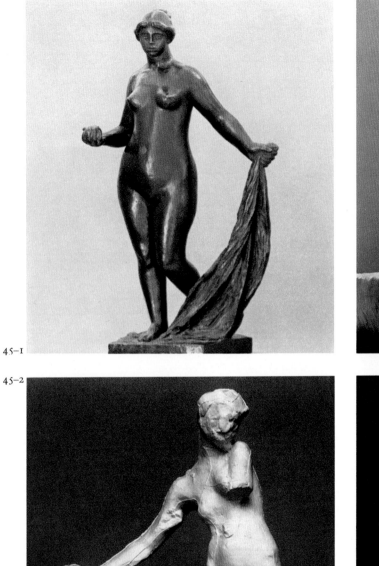

45-2

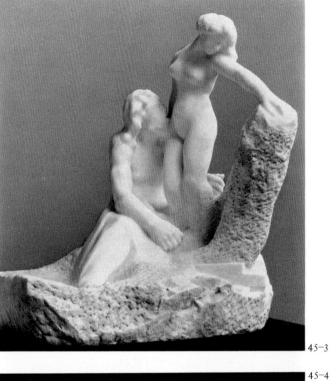

45-3

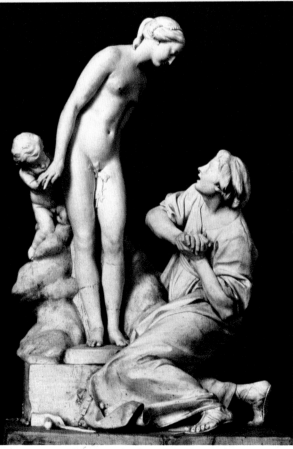

45-4

285

5. In her own copy of the 1931 edition of Grappe's catalogue of the Musée Rodin, Mlle Cladel changed the dating of *Pygmalion and Galatea* and the small plaster study for the figure of *Galatea* to 1902 or 1903. It may be that her conversations with Rodin led her to change the date, but since she gives no reason for her redating, Grappe's date must be accepted.

6. Worth noting in this context is the drawing *Nude with Drapery*, pencil and watercolor, 17½ × 12½ inches, in the Art Institute of Chicago, reproduced in Elsen [38], opp. p. 155. The smooth-flowing, downward movement of the dancer contrasts with the more angular and hesitant movements of Galatea.

7. *See* Charles Sterling and Margaretta M. Salinger, *French Paintings: A Catalogue of the Collection of the Metropolitan Museum of Art,* vol. 2 (New York: Metropolitan Museum of Art, 1966), pp. 172–73. Gérôme evidently made a sculptured group of this subject "sometime after 1881," which leads the authors to conclude that the museum's painting dates from that time.

8. Etienne-Maurice Falconet, *Pygmalion and Galatea,* marble, 1761, exhibited at the Salon of 1763.

REFERENCES

L'Art et le Beau [329], repr. p. 106 *(Pygmalion and Galatea);* Grappe [338], nos. 147, 148 *(Pygmalion and Galatea);* Watkins [342], no. 58; Grappe [338a], nos. 172, 173; Grappe [338b], nos. 259, 260; Grappe [338c], no. 203; Grappe [338d], no. 233; Grappe [54], p. 143, repr. p. 92; Tancock [341], no. 53.

OTHER CASTS

FRANCE
Paris, Musée Rodin. Dedicated to Judith Cladel.

UNITED STATES
Washington, D.C., Hirshhorn Museum and Sculpture Garden, Smithsonian Institution. Signed: A. Rodin. Founder: Georges Rudier. Cast no. 7/12.

Study for "Galatea"

Plaster (without head), height 11⅜ inches

FRANCE
Paris, Musée Rodin.

Plaster (with head), height 12½ inches

UNITED STATES
New York City, Metropolitan Museum of Art. Gift of Rodin, 1912 (fig. 45–2).

RELATED WORKS

Pygmalion and Galatea

Marble, height 30¾ inches

DENMARK
Copenhagen, Ny Carlsberg Glyptotek. Gift of Ny Carlsbergfondet, 1910. Bought from Rodin in 1910 by Carl Jacobsen. Signed: A. Rodin. Inscribed: Pygmalion.

UNITED STATES
New York City, Metropolitan Museum of Art. Gift of Thomas F. Ryan, 1910. Inscribed: Pygmalion— A. Rodin (fig. 45–3).

Plaster

FRANCE
Paris, Musée Rodin.

46 Seated Figure
early 1890s?

Plaster, painted with brown varnish,
7½ × 9¾ × 7½ inches
Not signed or inscribed[1]

The limitless space and the lack of gravitational pull in the reliefs of *The Gates of Hell* enabled Rodin to experiment with poses of unprecedented freedom and movements of unparalleled violence. The tormented figures obey no laws of decorum, the last freedom left to them being that of expressing their agony and desolation in total abandon. Noticing this, Gustave Geffroy commented that Rodin's greatness lay in having discovered an infinite variety of new positions:

> New positions! It is through these, in limiting oneself to the technique of a craft and the materiality of art, that Rodin's unheard-of boldness and profound originality can be demonstrated. It has to be said—and this can easily be verified at the annual exhibitions—that in this period the practice of the Ecole and the routine of commissioned works, the habit so easily gained and kept of contenting oneself with conventional patterns, results in a situation where sculpture consists of a few permitted poses which could easily be enumerated. An upright body, one leg bent, one arm raised; a body stretched out, leaning on an elbow; hands crossed behind the head to make the bust project; a head leaning to one side, one hand holding an elbow, the other at the chin—these are the principal arrangements of lines, barely augmented by several insignificant variants, which make the multitude of comparable statues so monotonous. Rodin, venturing to compare existing forms with reproduced forms, was dumbfounded when confronted with the innumerable positions that were possible. For him, the positions of the human body could not be reduced to a few types. Rather they seemed to be infinite, all giving rise to new ones through the decomposition and recomposition of movements, multiplying in fleeting aspects each time the body shifts.[2]

In addition to vastly increasing the repertory of positions that were now at his disposal, Rodin's method of working on the complex reliefs gave new impetus to his predilection for fragmentary forms. The parts into which the human body could be broken down and reassembled in innumerable combinations could also be a source of fascination in their own right. His decision to exhibit two *Torsos* as well as finished groups in the exhibition he shared with Claude Monet in 1889 shows that he was already sufficiently confident of his position to demonstrate his conviction before the general public. A further contributing factor in the growth of his satisfaction with the fragment was undoubtedly his work on the monument to Victor Hugo (*see* no. 71), the most complex of all his monuments iconographically and the one in which the compositional methods developed in *The Gates of Hell,* specifically his habit of assembling figures and works from previously unrelated fragments, were worked out on a large scale.

The group of works associated with *Iris, Messenger of the Gods* (fig. 46–2) of 1890–91, to which the Philadelphia *Seated Figure* can be related, are the direct result of the freedom gained while working on *The Gates*—in the abandon of their poses, the frankness of their sexuality, and the severely abridged forms. They also surely reflect his newly awakened interest in styles of modern dance, particularly in their more athletic manifestations. It has been pointed out that Rodin cut out and kept in his files an article on the *chahut* dancer Grille d'Egout which appeared in *Gil Blas* in May 1891. Only professional dancers could have adopted the extreme—and sexually revealing—positions that characterize this group of works.[3]

The extraordinary leaping figure of *Iris, Messenger of the Gods,* headless and lacking the left arm, is generally thought to have been conceived in connection with the second project for the Victor Hugo monument. According to Georges Grappe[4] this figure was intended to be the personification of Glory, descending from above and hovering over Victor Hugo. It exists in two versions, the headless one just described and another smaller one, with the addition of a head. Related to this, although even more truncated, is the work known as *Flying Figure* (fig. 46–1), an enlargement and modification of part of the female figure in *Avarice and Lust* of about 1889 (fig. 46–4). In *Avarice and Lust,* which was incorporated in *The Gates of Hell* toward the bottom of the right-hand leaf, the woman is lying on her back, her limbs stiff and her body unyielding. In isolating the torso and balancing it on the stump of her left leg as he did in *Flying Figure,* Rodin was able to concentrate on the play of forces and stresses within the human body.

In two other works—the Philadelphia plaster, also used upside down in *Ecclesiastes* (no. 54), and the *Crouching Woman* in the Bethnal Green Museum (fig. 46–5)—Rodin turned to a model who was unusually fleshy. In the Philadelphia work she leans forward and clasps her feet with both hands while in the London bronze the model is on the point of doing the splits while holding her right foot in her right hand. An early photograph of a plaster of the *Crouching Woman* shows the work in the course of execution (fig. 46–6). To the portions of the body that needed expansion—the foot and the thighs above all—Rodin has added dabs of clay. A roughly modeled clay neck attaches the head to the body, no attempt having been made to conceal the grafting. Rodin was clearly intrigued by the fleshy forms of this head, as he later enlarged it to a colossal scale. This work, now known as *Large Head of Iris* (fig. 46–3), was first exhibited in 1909 and 1910 under the title *Head of Demeter*. Monumental and impassive, this is certainly one of the most curious works in Rodin's *œuvre,* recalling in scale, although not in impact, a colossal fragment of Hellenistic sculpture.

Two other works can be associated with this group, the *Torso of a Woman Clasping Her Left Leg* (fig. 46–7), pivoted excitingly on the stump of the right leg and probably made from the heavy model favored by Rodin at this time, and the small *Crouching Dancer,* related in pose to the above-mentioned works but customarily dated with the group of dancers of 1910.

Thus the Philadelphia plaster is the only complete figure in a group of works in which Rodin began to explore with method the progressive dismantling of the human figure, depriving it of an arm in the *Crouching Woman;* the head and one arm in *Iris, Messenger of the Gods;* the head and the lower limbs in *Torso of a Woman Clasping Her Left Leg;* and the head, lower left arm, and legs in *Flying Figure.* It may indeed be because of its completeness that the *Seated Figure* was never enlarged.

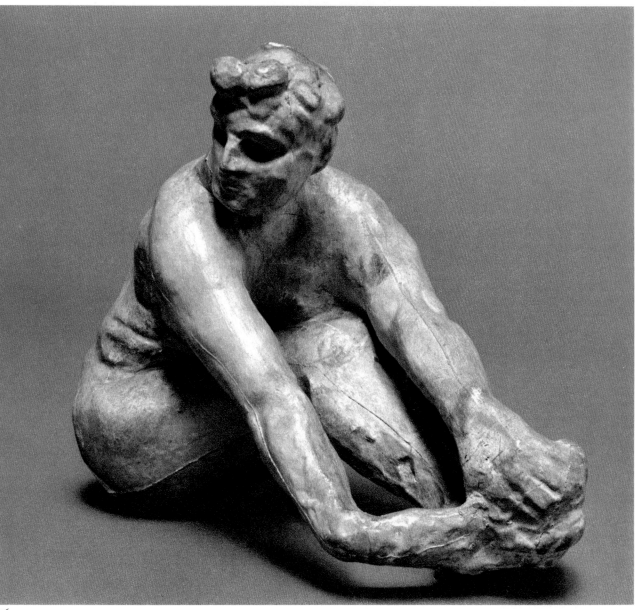

46

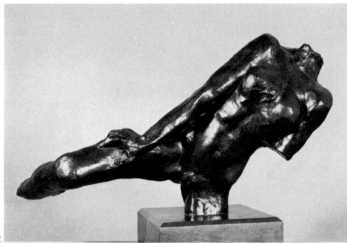

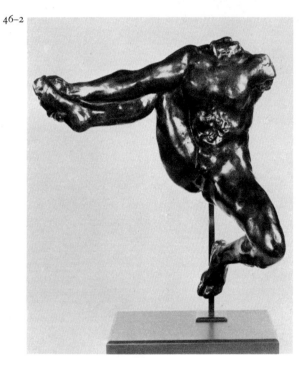

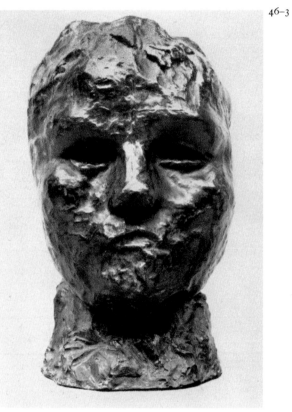

46–1
Flying Figure
1890–91, bronze, height 17 inches
Kasser Foundation, Montclair, N.J.

46–2
Iris, Messenger of the Gods
1890–91, bronze, height 18⅛ inches
Collection Sam Weisbord, Los Angeles

46–3
Large Head of Iris
1890–91, bronze, height 23⅝ inches
Bethnal Green Museum, London

NOTES

1. A small section of the head of this figure has been cut out and carefully replaced. No explanation has been found for this detachable element.
2. Geffroy [199a], pp. 13–14.

"Les attitudes nouvelles! c'est par elles, pour s'en tenir à la technique d'un métier et à la matérialité d'un art, que peut se démontrer la hardiesse inconnue, l'originalité profonde de Rodin. Dans ce temps-ci, la remarque doit en être faite, et elle peut être facilement vérifiée aux expositions annuelles, les pratiques de l'Ecole, la routine des commandes, l'habitude si facilement prise et gardée de se contenter des moules conventionnels, font que la sculpture réside en quelques poses admises qui pourraient être facilement énumérées. Un corps droit, une jambe infléchie, un bras levé,—un corps étendu, accoudé,—les mains croisées derrière la tête pour faire se projeter le buste en avant,—une tête inclinée, une main tenant un coude, et l'autre main au menton,—tels sont les principaux arrangements de lignes, à peine augmentés de quelques variantes insignifiantes, qui rendent si monotone la foule semblable des statues.

"Rodin, s'avisant de comparer les formes existantes avec les formes reproduites, est resté stupéfait devant les innombrables positions possibles. Non seulement, pour lui, les attitudes ne peuvent être réduites à quelques types, mais encore elles lui apparaissent infinies, s'engendrant les unes les autres par les décompositions et les recompositions de mouvements, se multipliant en fugitifs aspects à chaque fois que le corps bouge."

3. For a full account of Rodin's interest in the dance, see Goldscheider [204], pp. 321–35.
4. Grappe [338d], no. 248.

REFERENCES

Watkins [342], no. 105; Tancock [341], no. 41.

RELATED WORKS

Iris, Messenger of the Gods (without head)

Bronze, height 7⅞ inches

FRANCE
Paris, Musée Rodin.

Bronze, height 18⅛ inches

FRANCE
Paris, Musée Rodin.

SWITZERLAND
Lausanne, Collection Samuel Josefowitz. Founder: Alexis Rudier.

UNITED STATES
Bloomington, Ind., Collection Rudolf B. Gottfried. Founder: Georges Rudier.
Los Angeles, Collection Sam Weisbord (fig. 46–2).
New York City, Collection David Daniels. Founder: Alexis Rudier.
— Estate of Alexander Dobkin. Founder: Georges Rudier.
— Collection Helen Frankenthaler. Founder: Georges Rudier.
— Collection Margret Suzanne Zander Loewy. Founder: Georges Rudier. Cast no. 7/12.

Bronze, height 20⅞ inches

FRANCE
Paris, Musée Rodin.

Bronze, height 37½ inches

CZECHOSLOVAKIA
Prague, Národní Galerie. Cast in 1925 from plaster in museum.

FRANCE
Paris, Musée Rodin.

SWITZERLAND
Lausanne, Collection Samuel Josefowitz. Founder: Georges Rudier.
Zurich, Kunsthaus Zurich.

UNITED STATES
Los Angeles, Los Angeles County Museum of Art. Gift of B. G. Cantor Art Foundation. Founder: Georges Rudier. Cast no. 9/12.
Washington, D.C., Hirshhorn Museum and Sculpture Garden, Smithsonian Institution. Founder: Alexis Rudier.

Plaster

CZECHOSLOVAKIA
Prague, Národní Galerie. Acquired in 1923.

Iris, Messenger of the Gods (with head)

Bronze, height 18 inches

FRANCE
Paris, Musée Rodin.

UNITED STATES
Stanford, Stanford University Art Gallery and Museum. Gift of B. G. Cantor Art Foundation. Founder: Susse. Cast no. 1/12.

Head of Iris
Bronze, height 4 inches

Location unknown.

FRANCE
Paris, Musée Rodin.

UNITED STATES
Shawnee Mission, Kan., Collection Mrs. Louis Sosland. Founder: Georges Rudier. Cast no. 2/12.

Bronze, height 7½ inches

UNITED STATES
Stanford, Stanford University Art Gallery and Museum. Gift of B. G. Cantor Art Foundation. Founder: Susse. Cast no. 1/12.

Large Head of Iris
Bronze, height 23⅝ inches

GREAT BRITAIN
London, Bethnal Green Museum. Gift of Rodin to the Victoria and Albert Museum, 1914. Founder: Alexis Rudier (fig. 46–3).

UNITED STATES
Stanford, Stanford University Art Gallery and Museum. Gift of B. G. Cantor Art Foundation. Founder: Georges Rudier. Cast no. 7/12.

Terra-cotta, height 10⅝ inches

FRANCE
Paris, Musée Rodin.

Flying Figure
Bronze, height 8⅜ inches

FRANCE
Paris, Musée Rodin.

SWEDEN
Kungälv, Collection Bo Boustedt. Founder: Georges Rudier. Cast no. 10/12.

SWITZERLAND
Lausanne, Collection Samuel Josefowitz. Founder: Alexis Rudier.

UNITED STATES
Portland, Ore., Collection Peter F. Opton. Founder: Georges Rudier. Cast no. 8/12.

Bronze, height 17 inches

FRANCE
Paris, Musée Rodin.

UNITED STATES
Los Angeles, Los Angeles County Museum of Art. Gift of B. G. Cantor Art Foundation. Founder: Georges Rudier. Cast no. 5/12.
Montclair, N. J., Kasser Foundation (fig. 46–1).

Avarice and Lust
Plaster, height 8¾ inches

Location unknown (fig. 46–4).

Plaster, height 9⅞ inches

FRANCE
Paris, Musée Rodin.

Bronze

SWITZERLAND
Lausanne, Collection Samuel Josefowitz. Signed. No foundry mark.

U. S. S. R.
Moscow, State Pushkin Museum of Fine Arts.

Crouching Woman
Bronze, height 20⅞ inches

GREAT BRITAIN
London, Bethnal Green Museum. Gift of Rodin to the Victoria and Albert Museum, 1914. Founder: Alexis Rudier (fig. 46–5).

Torso of a Woman Clasping Her Left Leg
Plaster, height 5¼ inches

UNITED STATES
San Francisco, California Palace of the Legion of Honor. Gift of A. B. Spreckels, Jr. (fig. 46–7).

Bronze, height 13½ inches

SWITZERLAND
Lausanne, Collection Samuel Josefowitz. Founder: Alexis Rudier.

UNITED STATES
Beverly Hills and New York City, B. G. Cantor Collections. Founder: Georges Rudier. Cast no. 11/12.
New York City, Collection Marjorie F. Iseman. Founder: Georges Rudier. Cast no. 6/12.

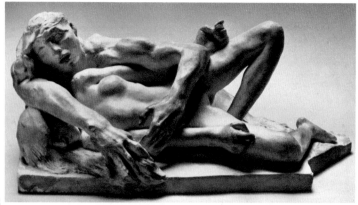

46-4

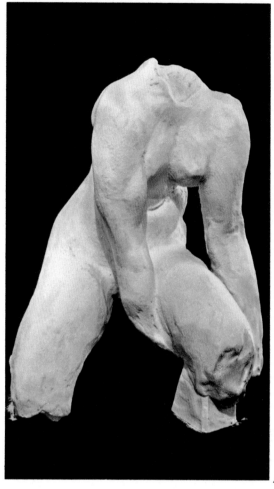

46-7

46-5

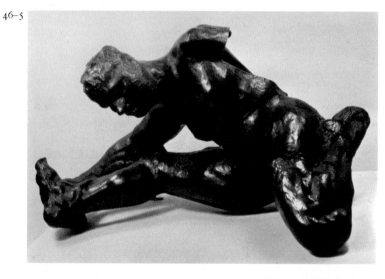

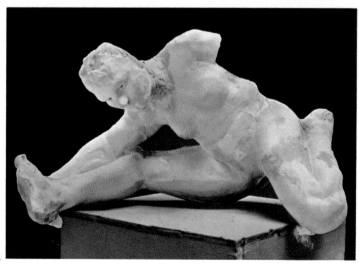

46-6

46-4
Avarice and Lust
c. 1889, plaster, height 8¾ inches
Location unknown

46-5
Crouching Woman
1890-91, bronze, height 20⅞ inches
Bethnal Green Museum, London

46-6
Crouching Woman (in course of execution)

46-7
Torso of a Woman Clasping Her Left Leg
1890-91, plaster, height 5¼ inches
Fine Arts Museums of San Francisco
Spreckels' Collection

293

47 The Benedictions
1894

Bronze, 31 ½ × 23 ¼ × 25 inches
Signed front of base to right: A. Rodin
Foundry mark back of base to right:
ALEXIS RUDIER.FONDEUR.PARIS.[1]

Rodin was by no means a socialist, but he did believe in the value of work. In 1894 Armand Dayot, an inspector general of fine arts, proposed to Jules Desbois that he design a monument to Labor. Desbois, however, felt that Rodin was better qualified than he was to execute the monument and passed the project on to him.[2] Rodin, who in 1890 had begun to make an even more intensive study of architecture than he had in previous years, accepted with alacrity and designed a monument (fig. 47-1) which was based on the famous staircase of the Château de Blois. He gave the following description of his aims:

> The plan of the monument, in which the artist has combined architecture and sculpture, for the glorification of work, is composed of a substructure forming a crypt and of a tall column, covered with bas-reliefs.
> The bas-reliefs covering the friezes of the crypt represent the underground labors of miners and divers. On the platform which tops the crypt rise on either side of the column the statues of Day and Night, symbols of the Eternity of work. The ascension begins: around the column, a stairway accompanying the succession of bas-reliefs, is entwined,—an endless propeller, like progress. Loggias allow air and light to penetrate amply and permit the sculpture to be seen. The bas-reliefs which unwind around the column represent the workers at their occupations, in costumes of the period, masons, blacksmiths, carpenters, reaching [finally] up to the artists, the poets, the philosophers. A sheaf forms the pinnacle of the column, on which are alighting the Benedictions, two winged genuises who descend from heaven, like a beneficent rain, to bless the work of men.[3]

It even seems that at one time Rodin considered being buried in *The Tower of Labor:* "In the crypt below the ground will repose my remains when I am no more—the remains of one who was a great worker."[4]

Finishing the project by 1899, Rodin hoped that the monument might be built in 1900, but the plan—fortunately perhaps—was never to be realized. Had it been constructed, the tower would have been about 100 feet high and 24 feet wide. In 1908 an international committee was formed, and it was hoped that the tower might be executed by an international group of artists, but the idea proved to be impracticable. Loïe Fuller's attempts to have the monument erected in the United States proved no more successful.

The group entitled *The Benedictions* was intended to crown the monument. It is related more or less closely to winged figures on *The Gates of Hell,* although there are no exact counterparts. A work entitled *Spirit Blessing,*[5] to which Grappe assigned a date of 1894 and which can be seen three-quarters of the way up the left-hand leaf of *The Gates,* is most closely related in mood and general movement to *The Benedictions.*

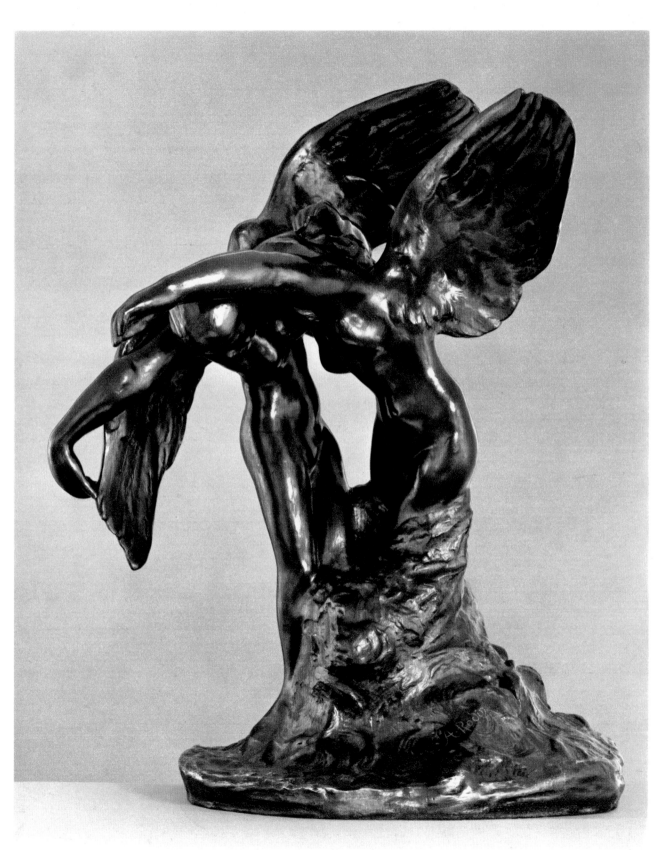

It seems probable that the two winged figures were originally just under one foot high. For the project now at Meudon they were enlarged to about three times that size, probably in 1894, according to Grappe, as a *praticien* signed a receipt relative to the attachment of the wings in that year.[6] The group was then carved in marble (fig. 47-3). In the process the forms became much smoother, and the projecting limbs of the first project, which made it seem as if *The Benedictions* had just alighted on top of the monument, were swathed in drapery and incorporated into the mass of the marble. The bronze enlargement which is under discussion here was evidently cast from a marble.

The group has been given various names. In the collection of Octave Mirbeau it was entitled *Taking Wing*. At the exhibition in Geneva in 1896 the work was called *Glories* and was also frequently referred to as *The Victories*.[7]

NOTES

1. According to information provided by the Musée Rodin at the time of purchase, this is the second cast.
2. Coquiot [29], p. 113.
3. This description, in Rodin's own words and handwriting, is among the Rodin memorabilia formerly in the collection of René Chéruy and now in the Princeton University Library. It is reprinted, reproduced, and translated in Rice [283], p. 41.
4. Tirel [106a], pp. 113-14.
5. Grappe [338d], no. 271.
6. Ibid., no. 272.
7. Ibid.

REFERENCES

Bénédite [10a], p. 31, repr. pl. LIII (B); Grappe [338], no. 214; Watkins [342], no. 11, repr. p. 11; Grappe [338a], no. 245; Grappe [338b], no. 229; Grappe [338c], no. 237; Grappe [338d], no. 272; Waldmann [109], pp. 51, 77, no. 56, repr. pl. 56; Rice [283], p. 41; Descharnes and Chabrun [32], pp. 146, 149, 152; Tancock [341], no. 42.

OTHER CASTS AND VERSIONS

Bronze, height 11 inches

Location unknown.

FRANCE
Paris, Musée Rodin.

UNITED STATES
Greenwich, Collection Herbert Mayer. Founder: Alexis Rudier.

Bronze, height 25⅝ inches

FRANCE
Paris, Musée Rodin.

Bronze, height 33 inches

FRANCE
Paris, Musée Rodin.

UNITED STATES
Baltimore, Baltimore Museum of Art. Jacob Epstein Collection. Signed: A. Rodin. Founder: Alexis Rudier.

Greenwich, Collection Herbert Mayer. Founder: Georges Rudier. Cast no. 3/12.

Bronze, height 35½ inches

FRANCE
Paris, Musée Rodin. Signed: A. Rodin. Founder: Alexis Rudier.

UNITED STATES
Madison, N. J., Estate of Geraldine R. Dodge. Founder: Alexis Rudier.

Plaster, height 7 inches

UNITED STATES
San Francisco, California Palace of the Legion of Honor. Gift of Alma de Bretteville Spreckels (fig. 47-2).

Marble, height 36¼ inches

DENMARK
Copenhagen, Ny Carlsberg Glyptotek. Commissioned by Carl Jacobsen in 1907. Signed: A. Rodin 1912 (fig. 47-3).

PORTUGAL
Lisbon, Calouste Gulbenkian Foundation. Probably executed for Lord Howard de Walden in 1901.

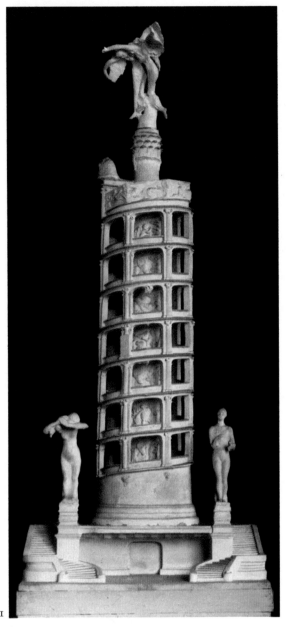

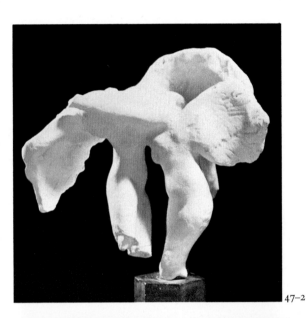

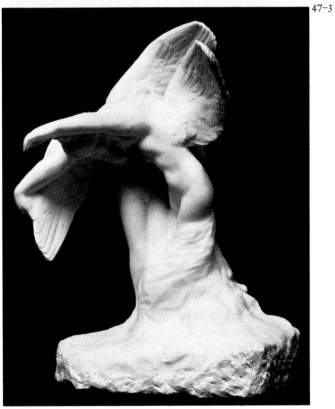

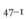

47–1 *The Tower of Labor*
1894–99, plaster
Musée Rodin, Paris

47–2 *The Benedictions*
1894, plaster, height 7 inches
Fine Arts Museums of San Francisco
Spreckels' Collection

47–3 *The Benedictions*
1894, marble, height 36¼ inches
Ny Carlsberg Glyptotek, Copenhagen

297

48 The Sorceress
1895

Bronze, 11⅞ × 11¾ × 6 inches
Signed front of base to left: A Rodin
Foundry mark back of base to right:
Alexis Rudier/Fondeur PARIS

Grappe observes that this work is not connected with any known project. To him it seemed as if this rather malevolent-looking creature were participating in a Witches' Sabbath.[1] He refers to a number of drawings derived from the same source of inspiration.

The Sorceress is very close in movement to the drawing of a flying female figure with hair flowing behind her that Rodin provided for Baudelaire's poem "Le Vin des Amants" ("The Wine of Lovers"; fig. 48–1). The sculpted figure, like those in Baudelaire's poem, seems to be "balanced on the wing of the intelligent whirlwind," although her grim expression leaves no doubt that her journey is toward a far more sinister goal than the blissful euphoria of which Baudelaire's lovers dream.

NOTES

1. Grappe [338d], no. 275. "La figure est emportée comme dans le tourbillon magique du Sabbat."

REFERENCES

Watkins [342], no. 60; Grappe [338b], no. 303; Grappe [338c], no. 240; Grappe [338d], no. 275; Tancock [341], no. 43.

OTHER VERSION

Plaster, height 12¼ inches

FRANCE
Paris, Musée Rodin.

48–1
Flying Figure, illustration for
Charles Baudelaire's "Le Vin des Amants,"
from *Les Fleurs du Mal,* 1886–88

CXXXII

LE VIN DES AMANTS

Aujourd'hui l'espace est splendide!
Sans mors, sans éperons, sans bride,
Partons à cheval sur le vin
Pour un ciel féerique et divin!

Comme deux anges que torture
Une implacable calenture,
Dans le bleu cristal du matin
Suivons le mirage lointain!

Mollement balancés sur l'aile
Du tourbillon intelligent,
Dans un délire parallèle,

Ma sœur, côte à côte nageant,
Nous fuirons sans repos ni trêves
Vers le paradis de mes rêves!

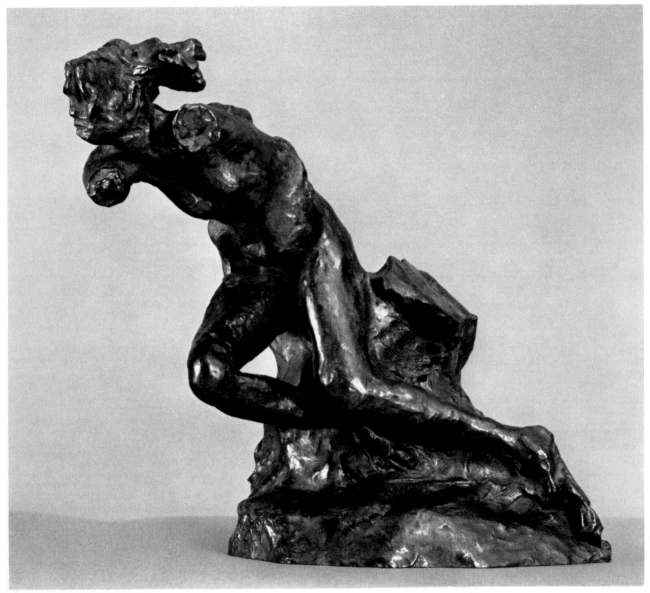

48

49 The Hero

c. 1896

Bronze, 16 × 7 × 6½ inches
Signed right side of base: Rodin
Foundry mark back of base to left:
Persinka./fondeur. Versailles

50 The Poet and Love

c. 1896

Plaster, 16¾ × 11 × 6 inches
Not signed or inscribed

51 Group of Three Figures

mid 1890s

Plaster, 11⅝ × 9¾ × 7½ inches
Not signed or inscribed

In the 1927 and 1929 editions of the Musée Rodin catalogue,[1] Georges Grappe assigned a date of about 1908 to the work entitled *The Poet and Love* (no. 50), although in subsequent editions the dating was revised to about 1896. He identified this work with one referred to about 1896 as *The Garden of Olives of the Genius,* or *Christ in the Garden of Olives,* and also with a work entitled *The Hero,* exhibited at the Exposition Rodin of 1900. In the catalogue of that exhibition the work was described in the following terms: "The young, vigorous hero, leaning on a rock, tries to hold back a Victory, a small, winged figure of a capricious woman, ready to fly away."[2]

The male figure in the group of *The Poet and Love* is, however, anything but "young and vigorous." His attitude, with the outstretched arm and drooping head, which is based on the severed head of St. John *(see no. 21),* is in fact one of deepest despair. It must be concluded, therefore, that the work exhibited in 1900 was not *The Poet and Love* as we know it today.

In 1912 Rodin was commissioned to make a monument to Eugène Carrière which was never realized *(see no. 63).* The youthful male figure which, with the exception of the head, was clearly modeled in one piece and not constructed from already existing fragments, is basically the same as the figure of the poet in *The Poet and Love.* There is, however, another closely related group (no. 49) in which the same figure, slightly modified, is used. In this the head of the male figure is very broadly treated, while the winged female, although minus head and arms, seems just on the point of moving away. Since the inscription of the name of Carrière on the front of the plaster project (no. 63) provides a very firm basis for assigning a date of 1912 to this work, it must have been the bronze (no. 49) that was exhibited in 1900. Further confirmation of this is provided by the fact that the Philadelphia bronze was cast by the foundry of Persinka, which worked for Rodin between 1896 and 1901.

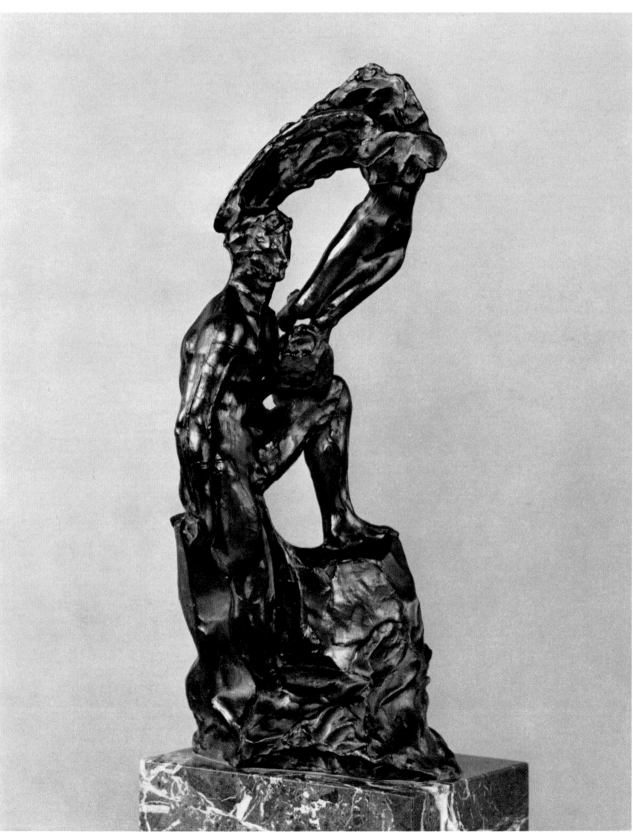

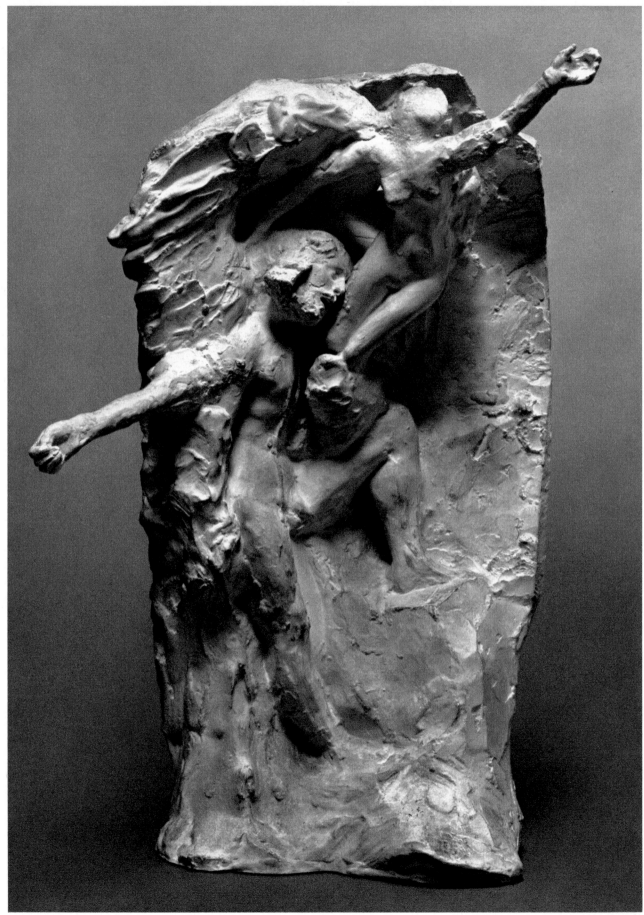

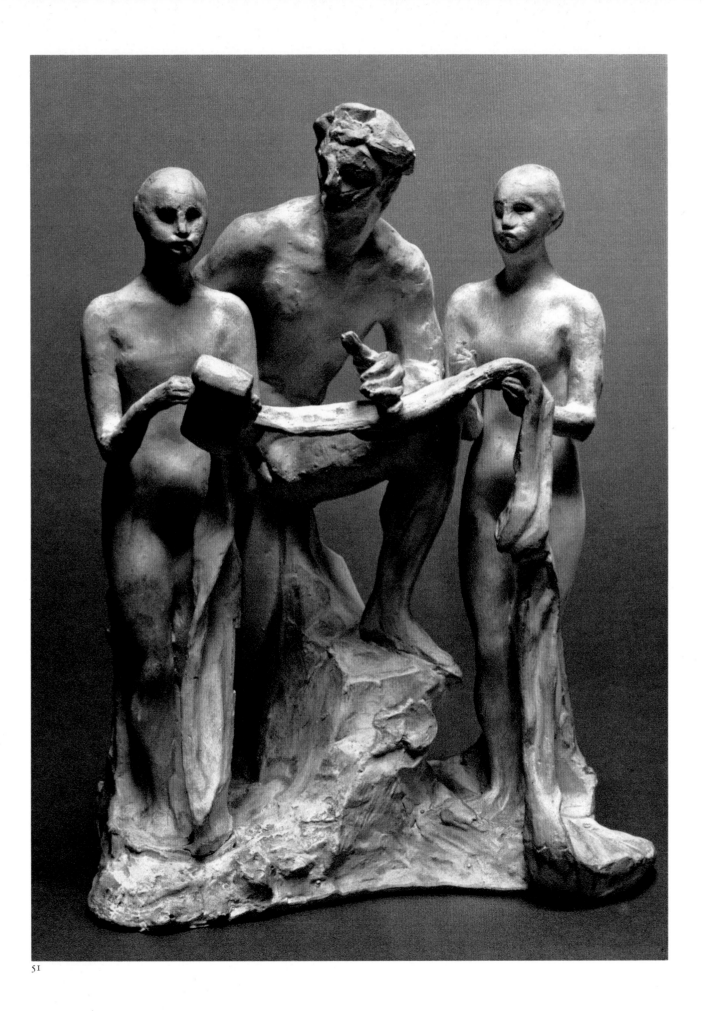

Finally, there is another assemblage (no. 51) incorporating a version of the male nude with left leg raised.[3] He is flanked by a pair of identical female nudes, one of whom holds a scroll in her left hand. The history of this female figure can be traced back to the work known as *Small Standing Torso* (fig. 49–51–1), to which Grappe assigned a date of 1882. Notable for its rigid pose and well-rounded proportions, the figure served Rodin on a number of occasions when a statuesque form was required. In an unpublished work at Meudon, evidently on the theme of the creativity of the sculptor, the figure stands on a plinth in front of the seated sculptor from *The Sculptor and His Muse*. With the addition of a head and arms that rest on the shoulders of two partially draped female figures, it dominates the group known as *The Three Virtues*.[4] In a little-known variation of this theme (fig. 49–51–3) more movement has been imparted by placing the flanking figures in front of and at an angle to a modified version of the *Small Standing Torso*. The figures lock arms and look intently at one another. Although this variation is not specifically mentioned by Grappe, it seems appropriate to refer to it as *The Secret*, a title once given to *The Three Virtues*. It even seems that Rodin considered enlarging the figure to monumental proportions, as a version of it was used in the model for *The Tower of Labor* (fig. 47–1), standing to the right of the entrance and representing Day.

In all four works—*The Poet and Love*, the work here identified as *The Hero*, exhibited in 1900, the *Group of Three Figures*, and the *Project for the "Monument to Eugène Carrière"*—an identical male figure was used, although the adjustments made by Rodin give to it a different character in each case. In *The Hero* the head of the male figure is treated in a very generalized fashion, and the winged female, minus head and arms and at some distance from the hero, attempts to escape. In *The Poet and Love* both figures are conceived in high relief, and the winged figure attempts with even greater urgency to escape from the poet's grasp. Crudely modeled outstretched arms have been roughly attached to both figures, and the poet's head is similar to the severed head of St. John the Baptist.

In the plaster enlargement of this work (fig. 49–51–2), which seems to have been cast from a marble, the dramatically projecting limbs of the plaster sketch are fused with the rocky background. In the *Group of Three Figures* the additional figures and accoutrements impart an air of ruminative authority to the male nude, which is quite distinct in character from any of its previous manifestations. Finally, in the *Project for the "Monument to Eugène Carrière,"* the right arm of the male figure has been restored to the position that it occupied in *The Hero*, but the head has been replaced by that of a charming young man, familiar from its use in other figures in Rodin's œuvre. The winged female, who now has a head and arms and holds a laurel wreath in her left hand, hovers protectively over him.

The mid 1890s were years of particular difficulty for Rodin, both professionally (the *Balzac* affair) and in his emotional life (the steady deterioration of his relationship with Camille Claudel). The variations on a theme that have been discussed above, which date from that period, are comparable to a number of other works in his œuvre in which a female figure escapes from the grasp of a male, for example, *Fugitive Love* or the illustration for Baudelaire's poem "De Profundis Clamavi," which commences, "J'implore ta pitié, Toi, l'unique que j'aime."[5] It is suggested here that, working with fragments from his own œuvre, Rodin gave symbolic expression not only to his thoughts on the creativity of the artist but also to the emotional upheavals which then beset him.[6] Entitling his work *The Poet and Love*, and substituting the head of the decapitated martyr for that of the young hero,

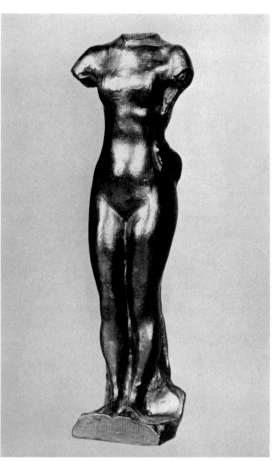

49–51–1

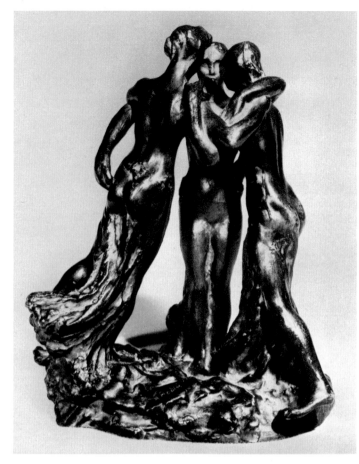

49–51–3

49–51–2

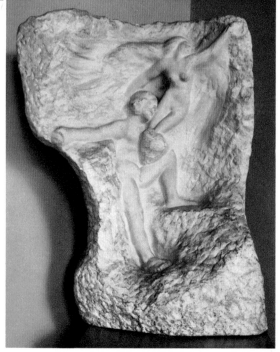

49–51–1
Small Standing Torso
1882, bronze, height 9 inches
Musée Rodin, Paris

49–51–2
The Poet and Love
1896, plaster, height 32 ¼ inches
Musée Rodin, Paris

49–51–3
The Secret
c. 1882, bronze, height 8 ½ inches
Private collection, Beverly Hills,
Calif.

Rodin seems to have given expression to his own feelings of defeat on an emotional level. Retitled *The Garden of Olives of the Genius*,[7] on the other hand, the work undoubtedly refers to his interminable battle with the Société des Gens de Lettres concerning the *Balzac* (*see* nos. 72–76).

NOTES

1. Grappe [338], no. 301; [338a], no. 338.
2. Paris, 1900 [349], no. 105. "Le vigoureux et jeune héros, appuyé à un roc, cherche à retenir une Victoire, une petite figure de femme ailée, capricieuse, prête à prendre son essor."
3. This male nude was used in yet another group preserved in the Musée Rodin in Meudon. To the left of the male figure there stands another male nude with arms folded; behind, there is a falling figure. The following titles are written in pencil on the work: *Le Bon Conseil (Good Advice)* and *Charon et Achille (Charon and Achilles)*.
4. Grappe [338d], no. 89.
5. Charles Baudelaire, *Les Fleurs du Mal*, reprinted with 27 drawings by Rodin (London: Limited Editions Club, 1940), reproduced between pp. 44 and 45.
6. A number of works in Rodin's *œuvre* give symbolic expression to his thoughts about the role of the artist in general and the sculptor in particular, for example, *The Sculptor and His Muse*.
7. For a comparable example of self-identification with the sufferings of Christ, compare Gauguin's *Christ in the Garden of Olives*, Norton Gallery and School of Fine Arts, West Palm Beach, Florida (Georges Wildenstein, *Gauguin* [Paris: Editions Les Beaux-Arts, 1964], no. 326). Gauguin is reported to have said of this work: "C'est mon portrait que j'ai fait là" (Jules Huret in *Echo de Paris*, Paris, February 23, 1891). Compare also Gauguin's *Self-Portrait, near Golgotha*, Museu de Arte, São Paulo (Wildenstein, no. 534).

REFERENCES

The Hero
Watkins [342], no. 31; Tancock [341], no. 44.

The Poet and Love
Grappe [338], no. 301; Watkins [342], no. 115; Grappe [338a], no. 338; Grappe [338b], no. 307; Grappe [338c], no. 246; Frisch and Shipley [42], p. 430; Grappe [338d], no. 281; Tancock [341], no. 45.

Group of Three Figures
Watkins [342], no. 110; Tancock [341], no. 115; Tancock [315], p. 48, repr. p. 49.

OTHER CASTS AND VERSION (No. 49)

Bronze

GERMANY (WEST)
Berlin, Nationalgalerie (wrongly listed as *Der Mensch und sein Genius*). Purchased in 1961.

UNITED STATES
San Francisco, California Palace of the Legion of Honor. Gift of Alma de Bretteville Spreckels. Signed: A. Rodin/no. 2. Founder: Alexis Rudier.

Plaster

UNITED STATES
San Francisco, California Palace of the Legion of Honor. Gift of Alma de Bretteville Spreckels. Signed.

OTHER CAST AND VERSION (No. 50)

Plaster, height 32¼ inches

FRANCE
Paris, Musée Rodin (fig. 49–51–2).

Marble, height 23⅝ inches

FRANCE
Paris, Musée Rodin.

52 Seated Man
mid 1890s?

Plaster, painted with yellowish brown
varnish, 7¾ × 4 × 5¼ inches
Signed on base of feet: A Rodin

53 Study for a Monument
mid 1890s?

Plaster, 20½ × 12 × 11 inches
Not signed or inscribed

Rodin's prodigal working methods left him with an abundance of complete figures, many of which were created with no definite aim in mind, although they were later utilized when the need arose. One such figure is the *Seated Man* (no. 52), which in pose is reminiscent of the four male nudes on the *Vase des Titans* of about 1876 *(see* fig. 31–2); the forms, however, are much less Michelangelesque. The very generalized treatment of the features, comparable to the head of the male figure in *The Hero* (no. 49), makes a date in the mid 1890s seem most probable.

This figure, in a modified form, was then used in the *Study for a Monument* (no. 53), which cannot be connected with any known project. In this work a kneeling female nude holds the *Seated Man* in her arms, with a change in the position of his lower legs and his right arm. The difference in scale between the two figures makes the male figure look very small. Over the entire group there hovers a winged female which is based on the angels from *The Benedictions* (no. 47), while behind there is a luxurious growth of foliage and a lyre. The use of an angel from *The Benedictions* reinforces a dating of the mid 1890s for both the *Study* and the *Seated Man*. The presence of the lyre suggests that this project was destined to be a funerary monument for a poet, although so far nothing is known of the circumstances of its creation. At one time the phrase "La terre donne généreusement" ("The earth gives generously") was inscribed on the left-hand side of the square base, but by the time Jules Mastbaum purchased it this had been erased.

Finally, with what appears to be a slightly modified version of the small torso that was inserted into the cast of Rodin's hand *(see* no. 127), the same figure was used, head downward, in a work in the Glasgow Art Gallery and Museum. This arresting group bears the name *Fallen Angels* and presumably dates from the same period as the works already discussed.

REFERENCES

Seated Man
Watkins [342], no. 101; Tancock [341], no. 113.

Study for a Monument
Watkins [342], no. 114; Tancock [341], no. 114; Tancock [315], pp. 48, 50, repr. p. 50.

RELATED WORK

Fallen Angels

Bronze, height 4⅜ *inches*

GREAT BRITAIN
Glasgow, Glasgow Art Gallery and Museum. Burrell Collection.

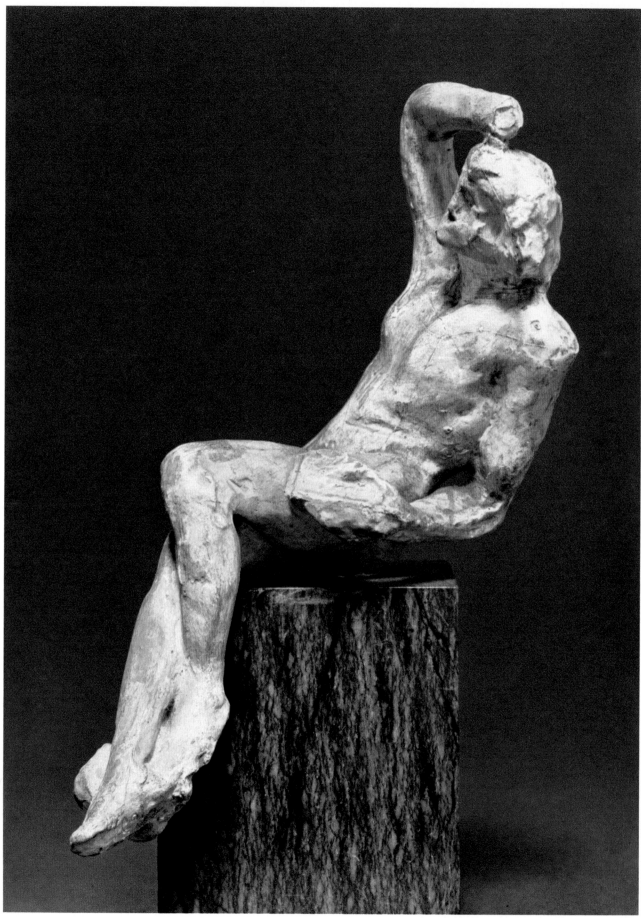

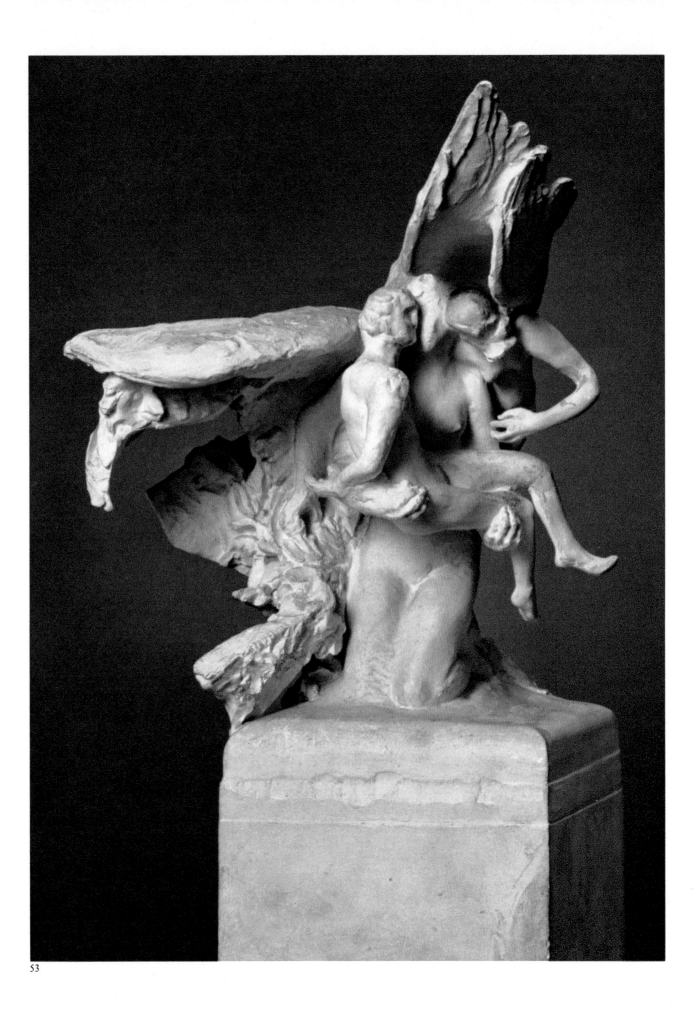

54 Ecclesiastes
before 1898

Plaster, 10 × 11 × 10 inches
Not signed or inscribed

Reference has already been made to Rodin's habit of deriving new sculptural ideas from unexpected assemblages of fragments of his own sculpture or from the confrontation between his own work and totally unconnected objects *(see* nos. 34, 49–51, 52, 53). *Ecclesiastes* is one of the most surprising of these assemblages, consisting, as it does, of the work known as *Seated Figure* (no. 46), here dated in the early 1890s, placed on its back on a plaster cast of a real book. At the Exposition Rodin in 1900 it was called simply *Figure on the Book,* but it soon became known as *Ecclesiastes,* perhaps, as suggested by Grappe, to recall the famous dictum *Vanitas vanitatum.*[1]

This assemblage was then used as the basis for a carved version, a fine marble being in the collection of Patrick de Laszlo in London (fig. 54-1). In transposing the work from the fragility of plaster to the permanence of marble, Rodin decided to eliminate the form of the open book, substituting the kind of formless rocky base that is so characteristic of his marbles.[2] The plaster in the Musée Rodin is clearly cast from a marble, although its dimensions do not correspond with those in the de Laszlo Collection.

NOTES

1. Grappe [338d], no. 292.
2. Grappe states that Rodin's effrontery in attaching a Biblical title to this rather risqué work greatly offended the Brussels public when it was exhibited in that city in 1899. In suppressing the Bible in the carved version, however, it seems that Rodin was moved more by purely sculptural reasons than by fear of offending the public. Certainly the task of carving an open Bible would have been profoundly distasteful to him at this stage in his career.

REFERENCES

Grappe [338], no. 233; Watkins [342], no. 117; Grappe [338a], no. 267; Grappe [338b], no. 322; Grappe [338c], no. 258; Grappe [338d], no. 292; Cladel [27], repr. pl. 80; Descharnes and Chabrun [32], repr. p. 140; Tancock [341], no. 46.

OTHER CASTS AND VERSION

Plaster, height 12⅝ inches

FRANCE
Paris, Musée Rodin.

Plaster, height 15¾ inches (figure rests on a rocky base)

FRANCE
Paris, Musée Rodin.

Marble, height 18 inches

GREAT BRITAIN
London, Collection Patrick de Laszlo (fig. 54-1).

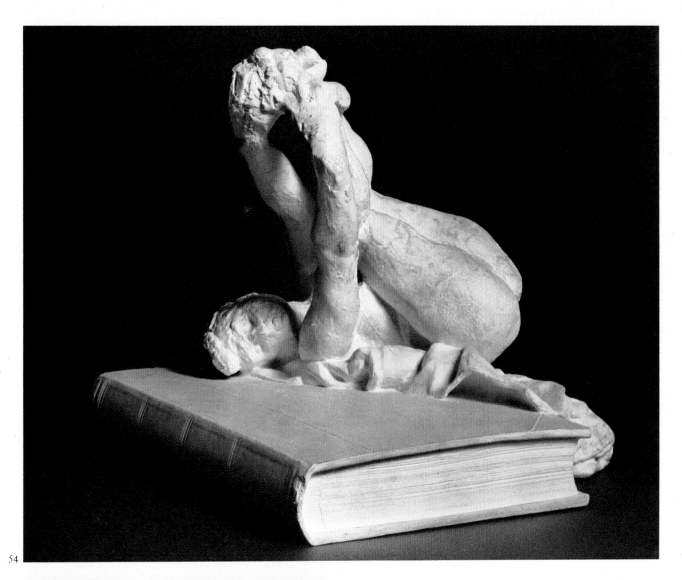

54

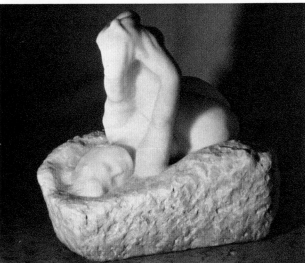

54-1

54-1
Ecclesiastes
Before 1898, marble, height 18 inches
Collection Patrick de Laszlo, London

55 Evil Spirits
1899

Bronze, $12\frac{3}{4} \times 7\frac{7}{8} \times 9$ inches
Signed below foot of descending female nude figure: A. Rodin
Foundry mark rear of base to left:
Alexis Rudier/Fondeur PARIS

Evil Spirits, also known as *Woman Combing Her Hair,* belongs to the large group of works which are composed of figures originally conceived separately. Two young female forms, one nude and the other draped, hover in the air and whisper into the ear of a young girl who is combing her hair.

This latter figure was conceived at the same time as the group of bathers *(see* no. 60) and was exhibited separately as *Woman Combing Her Hair* at the Exposition Rodin in 1900.[1] The flying figures, on the other hand, seem first to have been conceived for *The Gates of Hell,* although only one of them was actually used. The one whispering into the young woman's left ear can be seen from behind and embedded in the surface of the left-hand leaf of *The Gates* three-quarters of the way up on the right-hand side.

Subsequently the group was enlarged and two marbles were carved, one of which was purchased by Mrs. John W. Simpson and is now in the National Gallery of Art in Washington, D.C (fig. 55–1). As is often the case in the marble enlargements, the sex of the constituent figures is more firmly delineated than in the preliminary studies.[2] In the Philadelphia bronze the spirit at the right is of indeterminate sex, for while the treatment of the lower part of the figure is clearly female, breasts are barely indicated. In the Washington marble, however, this same figure has masculine sexual organs.

It is instructive to compare Rodin's mysterious and animated work with an academic treatment of a somewhat similar theme. In Paul-Eugène Breton's *Confidence* (fig. 55–2), a satyr whispers into the ear of a smiling, ornamentally posed nymph, who evidently welcomes his attention. The frontal and decorative approach of the sculptor resulted in a work that is not without charm but is certainly lacking in drama and mystery when compared to the complex intertwining of forms and the chiaroscuro of Rodin's work.

NOTES

1. Paris, 1900 [349], no. 21. "Femme qui se peigne. Figure assise, nue, penchée en avant, à grands cheveux retombants."
2. Compare *The Death of Adonis* (no. 43).

REFERENCES

Grappe [338], nos. 222, 223; Watkins [342], no. 28; Grappe [338a], nos. 253, 254; Grappe [338b], nos. 331, 332; Grappe [338c], nos. 273, 273 bis; Frisch and Shipley [42], p. 426; Grappe [338d], nos. 305, 306; Grappe [54], p. 144, repr. p. 119; Waldmann [109], pp. 50, 77, no. 54, repr. pl. 54; Tancock [341], no. 47.

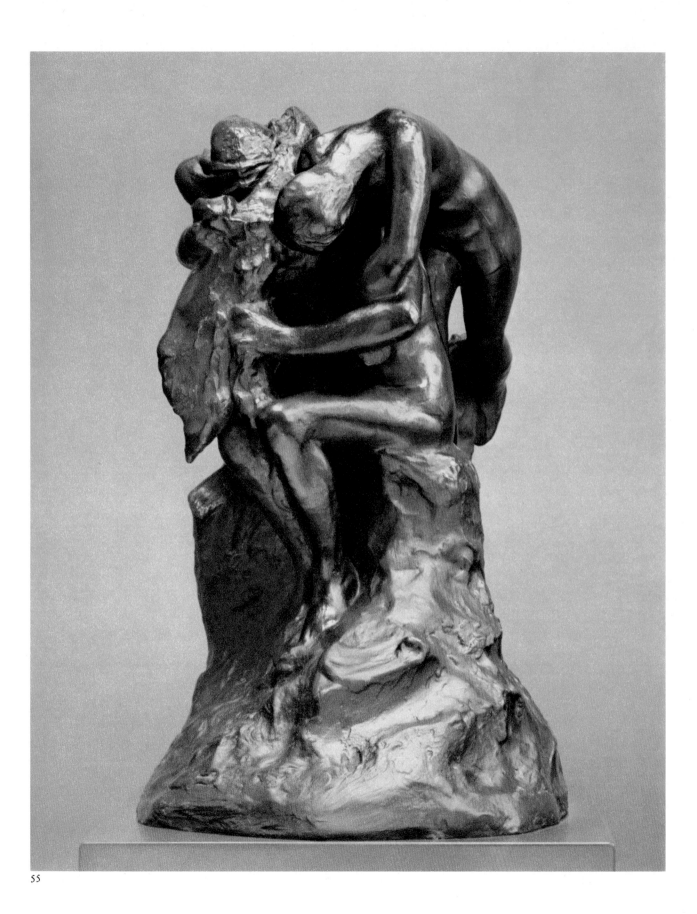

OTHER CASTS AND VERSIONS

Bronze

FRANCE
Paris, Musée Rodin. Signed: A. Rodin. Founder:
Alexis Rudier.

UNITED STATES
Cincinnati, Cincinnati Art Museum. Signed: A. Ro-
din—86.

Plaster

FRANCE
Paris, Musée Rodin.

Bronze, height 21⅝ inches

FRANCE
Paris, Musée Rodin. Founder: Alexis Rudier.

Marble, height 23⅝ inches

FRANCE
Paris, private collection.

Marble, height 28 inches

UNITED STATES
Washington, D.C., National Gallery of Art. Gift of
Mrs. John W. Simpson, 1942. Signed: A. Rodin
(fig. 55–1).

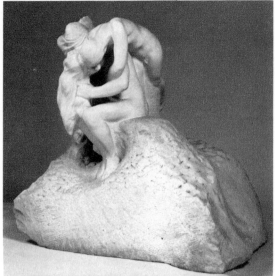

55–1

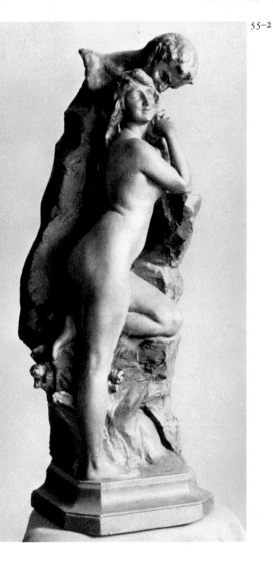

55–2

55–1
Evil Spirits
1899, marble, height 28 inches
National Gallery of Art, Washington, D.C.
Gift of Mrs. John W. Simpson, 1942

55–2
Paul-Eugène Breton (1868–1933)
Confidence
Location unknown

314

56 The Good Spirit

c. 1900

Plaster, 9½ × 5¼ × 5 inches
Not signed or inscribed

Like so many other groups, *The Good Spirit,* as this work is now generally known, is composed of two figures that were originally conceived separately. It has been pointed out by Athena Spear[1] that, in order to adapt the height of the kneeling figure to that of the young girl, Rodin had to increase the size of the upper part of its body. In doing so, he simply placed the upper torso of another female figure (or possibly another plaster cast of the upper torso of the same figure) on top of the torso of the kneeling woman, with the result that this figure has two pairs of breasts. It was evidently for this reason that one of the alternative titles for *The Good Spirit* was *Young Girl Confiding Her Secret to Ceres* (or to *Isis* or to a *Shade*).[2] It has also been known as *Embrace.*

Under the former title, it is interesting to compare Rodin's work with the *Young Girl Confiding Her First Secret to Venus* by François Jouffroy (1806–1882; fig. 56–1). Sharing the same type of theme, no two works could be more different from one another. The academic sculptor started working with a specific subject and sculptural idea in mind and did not diverge from that during the course of execution. The concern for archaeological detail shows that he was anxious to evoke a particular epoch of the past. The finished work thus becomes an illustration of the title.

Rodin's approach seems to have been exactly the reverse. Stirred first of all by the sculptural relationship between the two figures, the play of solid and void, he then proceeded to search for the title that most fully expressed the meaning of the work, whether independently or with the help of literary friends.

Dwelling so much in the realms of history, mythology, and literature, Rodin frequently saw analogies with given situations in the past in these chance encounters of figures, dictated by purely sculptural necessity. Thus it was not the desire to create a work on a specific theme (as in the case of Jouffroy), but the chance result that the kneeling figure had two sets of breasts that led to its being called *Young Girl Confiding Her Secret to Ceres* (or *Isis*). Soon, however, this descriptive title was abandoned in favor of the more general one of *The Good Spirit.*

In 1907 a marble enlargement of this group was made. In this version there is no space between the two figures, and they are seated on a much larger rocky base. From this version a bronze cast was subsequently made.

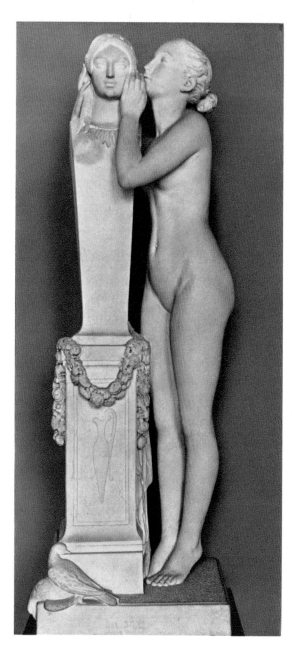

56-1
François Jouffroy
*Young Girl Confiding Her First
Secret to Venus*
1839, height 56 inches
Musée du Louvre, Paris

NOTES

1. Spear [332], p.77. Mrs. Spear believes that although this group was exhibited at the Exposition Rodin of 1900, the individual figures were conceived much earlier.
2. Rodin himself used this title. In a letter to Sir John Lavery of December 30, 1907 (now in the Tate Gallery, London), he wrote: "Votre groupe en bronze 'Jeune fille confiant son secret à Isis ou à la Nature' est prêt." It is not known where this cast is now located.

REFERENCES

Grappe [338], no.226; Watkins [342], no.94; Grappe [338a], no.257; Grappe [338b], no.341; Grappe [338c], no.276; Grappe [338d], no.310; Waldmann [109], pp.49, 77, no.52, repr. pl.52; Spear [332], p.77, no.XIX, repr. pls.94, 95; Tancock [341], no.48.

OTHER CASTS AND VERSIONS

Bronze

FRANCE
Paris, Musée Rodin.

UNITED STATES
Cleveland, Cleveland Museum of Art (ex. Collection Albert Pontremoli). Signed: Rodin. Founder: Persinka.

Marble

DENMARK
Copenhagen, Ny Carlsberg Glyptotek. Gift of Ny Carlsbergfondet, 1907. Purchased by Carl Jacobsen in 1907. Signed: A.Rodin (height 29⅛ inches).

SWITZERLAND
Lugano-Castagnola, Thyssen-Bornemisza Collection (as *La Bonne Nouvelle)*. Purchased from Rodin by Baron Heinrich Thyssen-Bornemisza (height 28¾ inches).

Plaster, height 28⅜ inches (after a marble)

FRANCE
Paris, Musée Rodin.

Bronze (after a marble)

FRANCE
Paris, Musée Rodin.

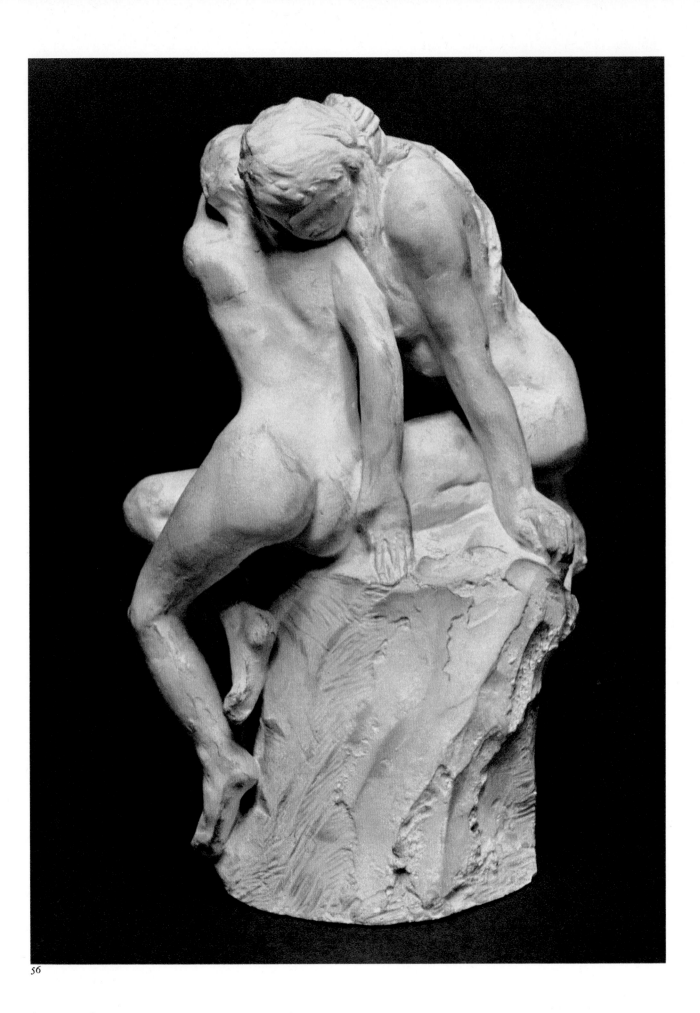

57 The Athlete

1901-4

Bronze, 16⅞ × 12½ × 11¼ inches
Signed top of base to right: A. Rodin
Foundry mark rear left of base:
.Alexis RUDIER./.Fondeur. PARIS.

The model for the work generally known as *The Athlete* was Samuel Stockton White, 3rd, of Germantown, Pennsylvania (fig. 57–1). His first physical training was done as a youth at the Germantown Academy, and at Princeton he was a prominent member of the gymnastics team. He then went to Cambridge University and became the protégé of the strongman Eugene Sandow, winning the Sandow Medal in 1899 for the best physical development in the United Kingdom.

Mr. White gave the following account of his meeting with Rodin:

I posed for him in 1901 and 1904 for the statuette which he called, "The Athlete.". . .

How I came to pose for him is rather interesting; while I was attending Cambridge University in England, I joined Sandow's Academy in London as I was very interested in physical development, hand balancing, etc. and won the Sandow Gold Medal for Development. During this period, I was spending some time in Paris and a friend of mine suggested that I offer myself as model to Rodin; the idea interested me and I paid a visit to Rodin who complimented me on my development and accepted me as a model.

After trying me in several standing poses, he suggested that I take a pose of my own which I did,—seated—the pose being somewhat similar to "The Thinker."[1]

An account of the first posing sessions was published in the *Philadelphia Sunday Press* on March 16, 1902. Mr. White recalled, "When I first posed for him, he complimented me most highly and said that my chest, arms, shoulders and back were beautiful, and that, from him, means so much."[2] A further account of these sessions was published in 1926 when Mr. White saw the bronze cast of this work that had just been purchased by Jules Mastbaum:

Well do I remember the care with which the master worked. He used little pellets of clay, with a most minute attention to every detail.

It was a long time before he was satisfied with the pose. He had me walk around his studio and studied me from all angles. Finally, he asked me to assume a natural pose. I remember sitting on a bench, with my arm resting on my leg as Rodin worked and worked with his infinite sense of detail. . . .

He was very moody and very temperamental. Some days he would hardly speak at all. I doubt whether he paid much attention to the people around him. The workingmen who used to carve his marbles would rarely work more than one hour in the day, but Rodin never noticed their absence.[3]

Rodin, who greatly preferred working from unprofessional models, must have been exceptionally impressed by Mr. White's physique as, according to Grappe, the young American

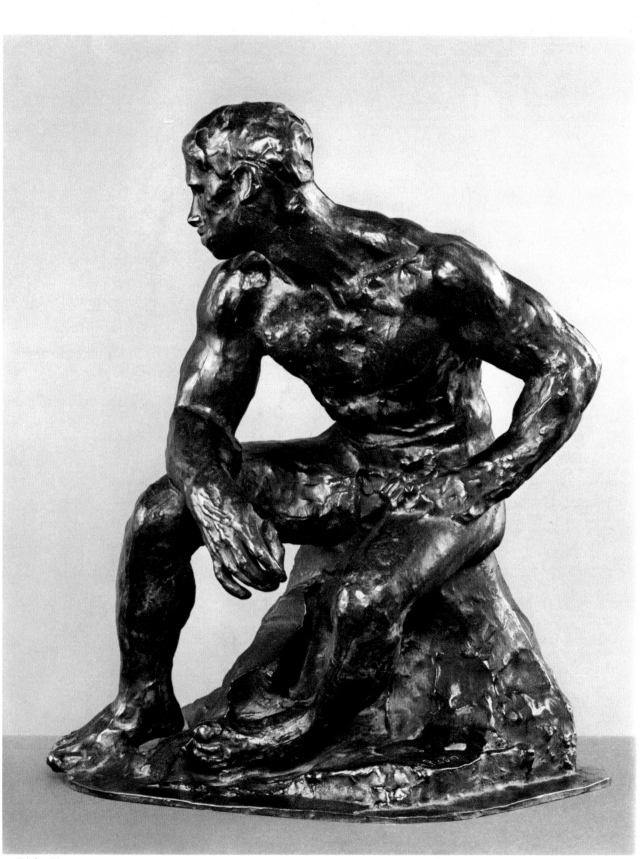

57 Right side

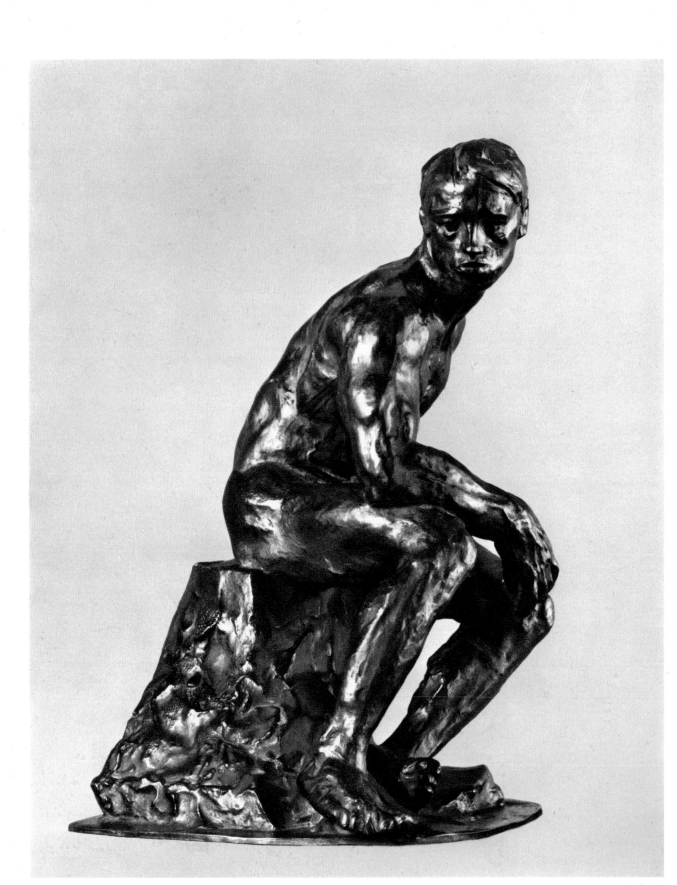

57 Left side

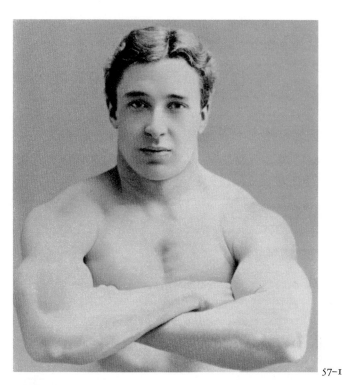

57–1

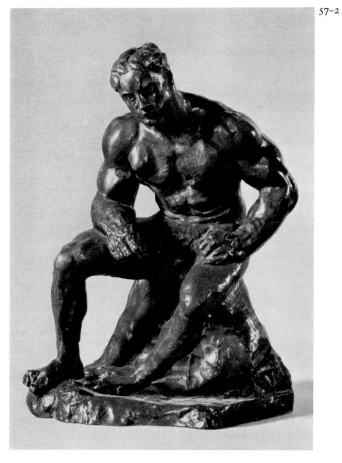

57–2

57–1
Samuel Stockton White, 3rd
c. 1900
Photograph

57–2
The Athlete (first version)
1901–4, bronze, height 15¾ inches
Philadelphia Museum of Art
Samuel S. White, 3rd,
and Vera White Collection

crossed the Atlantic specifically to allow Rodin to continue his studies.[4] A comparison of *The Athlete* with *The Thinker* (no. 3), which was the work Mr. White had in mind when he posed, reveals how profound a change had occurred in Rodin's aesthetic by the early years of this century. The taut, constricted pose of the earlier work has been replaced by a much more relaxed position. Unlike *The Thinker,* the athlete is not brooding on questions of vital importance but is simply in repose between feats of athletic prowess. It was not until after 1900 that the uneasy relationship between the physical and the spiritual which characterizes so much of Rodin's art was transformed into one of equilibrium.

This work exists in two versions, one with the head looking straight forward (fig. 57–2) and the other with the head turned to the left (no. 57).[5] It was the first cast of the former that Rodin gave to Mr. White to repay him for his services.[6]

NOTES

1. Letter from Samuel Stockton White to Mrs. Margery Mason, May 25, 1949 (typescript in the archives of the Philadelphia Museum of Art).
2. *Philadelphia Sunday Press,* March 16, 1902, p. 5.
3. *Evening Bulletin,* Philadelphia, February 17, 1926.
4. Grappe [338d], no. 328.
5. In a variant of no. 57 belonging to Mrs. Hoffman Nickerson of Oyster Bay, New York, the figure of *The Athlete* is seated not on the modeling stool of the other two versions but on a small mound, the sides of which are cut off as in the cast of *The Prodigal Son* in the California Palace of the Legion of Honor.
6. *See* n. 1 above.

REFERENCES

Lawton [67], p. 269; Grappe [338], no. 252; Watkins [342], no. 4; Grappe [338a], no. 287; Grappe [338b], no. 354; Grappe [338c], no. 292; Grappe [338d], no. 328; Adams [5], repr. p. 35; Cladel [27], repr. pl. 86 (first version); Herriot [62], repr. pl. 83 (first version); Descharnes and Chabrun [32], repr. p. 205 (first version); Tancock [341], no. 49.

OTHER CASTS AND VERSIONS

Bronze

UNION OF SOUTH AFRICA
Stellenbosch, Peter Stuyvesant Foundation.

UNITED STATES
New York City, Collection Mr. and Mrs. Harold B. Weinstein. Founder: Alexis Rudier.
Santa Barbara, Collection Wright Ludington. Signed: A. Rodin. Founder: Georges Rudier.
Washington, D.C., Collection Mr. and Mrs. David Lloyd Kreeger. Cast no. 4/12. Founder: Alexis Rudier.

Plaster

UNITED STATES
San Francisco, California Palace of the Legion of Honor. Spreckels Collection.

Bronze, height 15¾ inches (first version)

FRANCE
Paris, Musée Rodin.
— Private collection (with Gallery Gertrude Stein, New York City).

UNITED STATES
Beverly Hills, Collection Mr. and Mrs. John Pennish.
Philadelphia, Philadelphia Museum of Art. Samuel S. White, 3rd, and Vera White Collection (fig. 57–2).
Stanford, Stanford University Art Gallery and Museum. Gift of B. G. Cantor Art Foundation.

Bronze, height 18 inches (figure is seated on a mound)

UNITED STATES
Oyster Bay, N.Y., Collection Mrs. Hoffman Nickerson. Purchased from Rodin in 1913 by Mr. Nickerson.

58 Exhortation

1903

Plaster, 15¾ × 12½ × 14¾ inches
Not signed or inscribed

This group, known for a long time as *Group B,* is closest in feeling and movement to *The Benedictions* (no. 47). The similarity between the two works led Georges Grappe to surmise that this group, like *The Benedictions,* might have been intended to crown a monument.[1] Like other works of this type, it is an assemblage of preexisting parts. The pose of the standing figure, with the left leg slightly in advance of the right leg, is identical with that of one of the bathers which Rodin executed to decorate the swimming pool of Maurice Fenaille.[2] Great changes have been made, however, in the upper part of the figure. The left breast is missing, the arms stretch forward instead of holding the cloak in which the bather is draped, and the smiling head has been replaced by another, the delicate features of which recall those of the three sirens at the feet of Victor Hugo in the first project for the second monument *(see* no. 71).

Assembled in this manner, the relationship between the two figures is as mysterious as any in Rodin's work. Timeless and without attributes, they exist in a realm where gesture is the most vital means of communication. Like a choreographer, Rodin controls the movements of his figures to reveal them as fully as possible and to create arresting sculptural arrangements. Like the dance itself, the sculpture communicates, but on a non-verbal, intuitive level.

NOTES

1. Grappe [338d], no. 329.
2. Reproduced in Descharnes and Chabrun [32], p. 208.

REFERENCES

Watkins [342], no. 107; Grappe [338a], no. 288; Grappe [338b], no. 355; Grappe [338c], no. 293; Grappe [338d], no. 329; Grappe [54], p. 144, repr. p. 123; Tancock [341], no. 50.

OTHER VERSIONS

Bronze

FRANCE
Paris, Musée Rodin.

JAPAN
Tokyo, National Museum of Western Art (wrongly identified as *Aesculapius)* (ex. Collection Matsukata). Signed: A. Rodin.

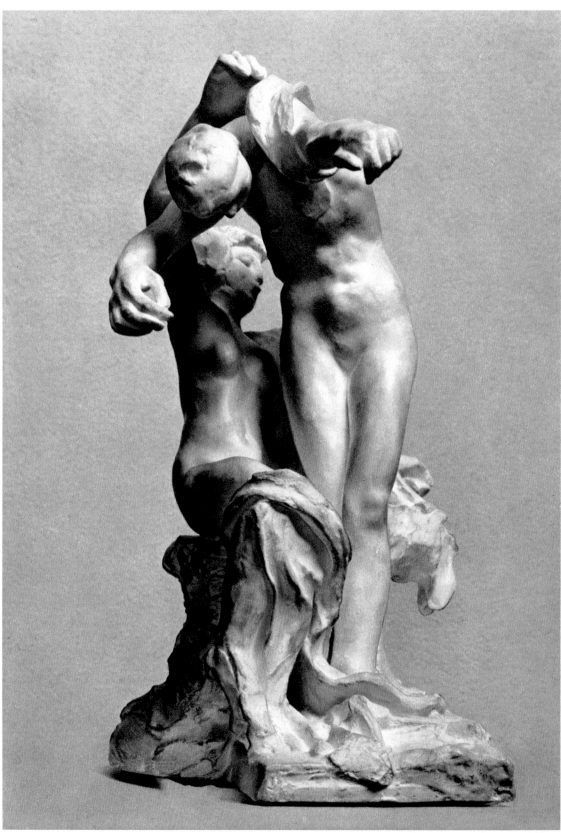

58 Front

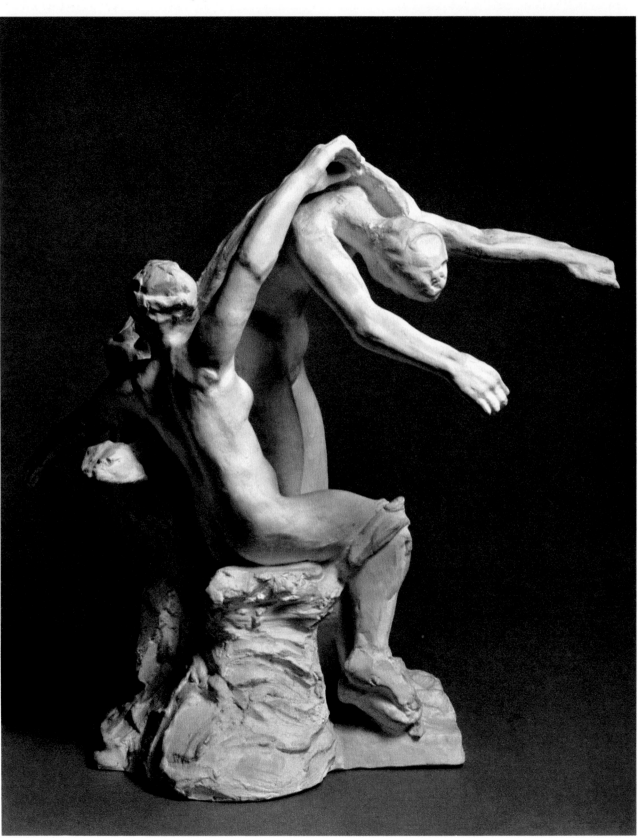

58 Side

59 The Fish Woman

c. 1906

Plaster, 13 × 17 × 10 inches
Not signed or inscribed

Rodin's precarious financial position as a young man forced him to produce a large amount of sculpture that was frankly decorative in intent. Much of this work he later rejected as his *péchés de jeunesse*. After 1900, however, with the change in his sculptural aesthetic and the intensification of his interest in the sculpture and decorative arts of the ancient world, Rodin returned with new enthusiasm to the challenge of decorative sculpture. It is impossible to imagine Rodin designing the back of a mirror[1] while he was working on *The Burghers of Calais* (no.67) or the *Balzac* (no.75), but such enterprises were not uncommon after 1900.

Among the most important of his undertakings were the stone pediments and jardinieres designed for the Villa La Sapinière, the property of Mme Foa at Evian *(see* no.18), and the pediment and four bathers to decorate a swimming pool[2] that were ordered by Maurice Fenaille for his villa in Paris.

The Fish Woman was clearly intended to form part of a fountain, although so far as is known it was not commissioned by Maurice Fenaille for his property. The head, which seems as if it is just coming up for air, is taken from a terra-cotta study at the Musée Rodin in Meudon of an open-mouthed, armless and legless female figure bent forward at the waist. This was not the only occasion on which Rodin converted a female figure into an aquatic creature. Another example of such a transformation is provided by the substitution of a fishtail for the legs of *Meditation* (no.19) in the work known as *The Siren* (fig.19–7). This clearly was also intended to perform a decorative function, although the circumstances of its commissioning are not yet known.

NOTES

1. *Venus Astarte*, plaster relief, 5 × 3 inches, Collection Claude Roger-Marx, Paris. Rodin executed this for the back of a mirror in translucent enamel, gold, and ivory designed by Félix Bracquemond. This formed part of the decorative ensemble commissioned by Baron Vitta *(see* no.18).
2. Four terra-cotta studies of *Bathers,* about 1900, are now in the collection of the Comtesse de Billy, Paris (repr. in Descharnes and Chabrun [32], p.208).

REFERENCES

Lami [4], p.169; Grappe [338], no.274; Watkins [342], no.119; Grappe [338a], no.310; Grappe [338b], no.376; Grappe [338c], no.315; Grappe [338d], no.359; Cladel [27], repr. pl.92; *Rodin inconnu* [93], repr. pls.33, 41 (study); Paris, 1962–63 [367], no.73; Tancock [341], no.51.

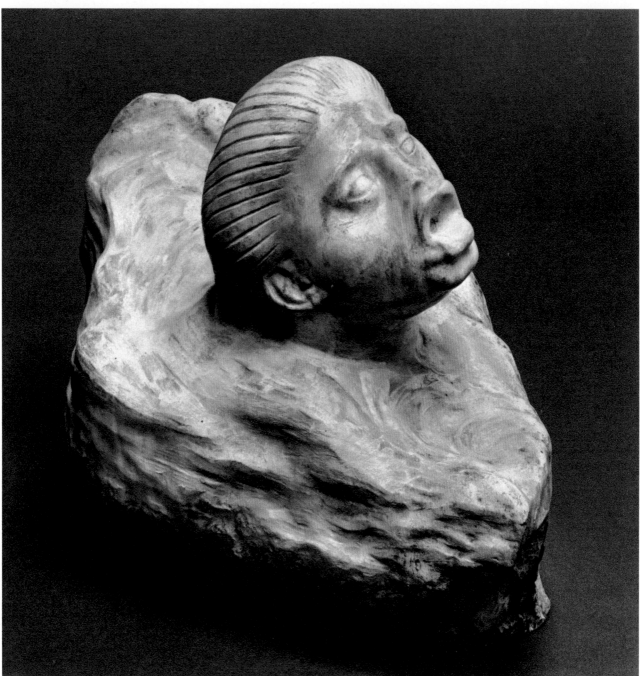

59

OTHER VERSIONS

Marble

FRANCE
Paris, Musée Rodin.

Terra-cotta

FRANCE
Meudon, Musée Rodin.

Marble, height 10¹³/₁₆ inches

UNITED STATES
San Francisco, California Palace of the Legion of
 Honor. Gift of Alma de Bretteville Spreckels.
 Signed: A. Rodin.

60 Beside the Sea

c. 1907

Bronze, 22⅝ × 33 × 22½ inches
Signed top of base to right: A. Rodin
Foundry mark back of base to left:
Alexis RUDIER./Fondeur. PARIS[1]

Some time before 1906, Rodin carved the portrait bust of a young Slav woman.[2] Her features were used in the charming work known as *Beside the Sea,* to which Georges Grappe assigned a date of before 1907.[3] About 1900 Rodin also modeled four standing figures of *Bathers*[4] for his patron and defender Maurice Fenaille.

Several studies of seated nude female figures which date from the mid 1880s are, however, more closely related to *Beside the Sea*. In one small study, *Small Crouching Bather* (fig. 60–1), the pose of the seated bather is adumbrated, although the legs are spread more widely apart, the feet are clasped in both hands, and the figure is headless. With the addition of a head, and seated on a small mound, this figure is known as *Woman with a Crab* (fig. 34–2). In another slightly larger study (fig. 60–3), the figure is seated in an identical pose, but the forms of the body are less rounded.[5] The base of this study is square and shallow, unlike the sizable rock on which the bather sits.

It thus seems that the source of *Beside the Sea* lies in a much earlier and to some extent more fertile period of Rodin's career. To the body of a seated figure he simply added the small head of the Slav woman, making no attempt to conceal the evidence of his grafting. The full-scale work was first carved in marble (fig. 60–2), and the Philadelphia bronze was then cast from the marble, probably at the request of Jules Mastbaum.

In later years Rodin came to feel that his work, especially that connected with *The Gates of Hell,* was too agitated, both emotionally and sculpturally. In the years after 1900 he was particularly active as a collector,[6] and it is no coincidence that works of Egyptian, Greek, and Roman origin prevail. In compositions like *Beside the Sea* he tried to recapture some of the serenity that he admired so much in ancient art. "It is toward serenity that we ought to tend," he said. "I am trying ceaselessly to render my vision of nature calmer. There will always be enough Christian anxiety in us in the presence of mystery."[7] He referred to "Greek sculpture, ever-increasingly my Muse."[8]

Although there is an apparent resemblance between Rodin's work and that of Maillol, the younger sculptor took exception to Rodin's decision to allow his figure to be seated on a rocky shelf. While looking through a series of photographs of works of art with Henri Frère, Maillol came across a photograph of *Beside the Sea*. "What bad taste," he said, "that enormous lump of useless marble. It should be cut there and there. Rodin did not see that. He aimed for the fragment and could not see the decorative side of things. It is astonishing for such a man not to have seen that."[9]

328

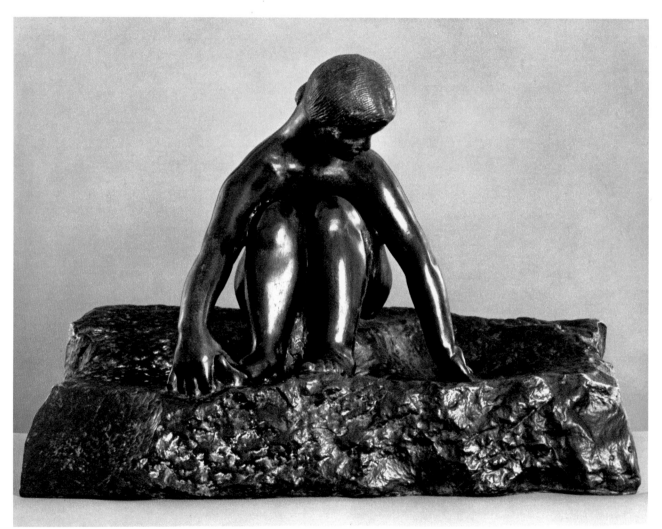

60

329

To Maillol and his contemporaries among the younger generation of sculptors—Matisse, Bourdelle, Brancusi, and Duchamp-Villon in particular—Rodin seemed to lack any feeling for the formal qualities of a work of art. They could admire his prodigious powers as an observer and modeler of the human body while believing that he should have moved beyond this to more carefully considered formal statements. To varying degrees they reacted against his powerful influence, seeking to redress the balance which they felt had been impaired by his practice. New stress was placed on the craft of sculpture and on the sculptor's direct contact with the material to be fashioned. Synthesis of observations and organization of space seemed once again to be the primary sculptural qualities. Formed in direct opposition to Rodin's example, the sculptural aesthetic of the twentieth century nonetheless owed a great deal to his innovations, as is becoming increasingly apparent.

NOTES

1. No other bronze casts of this work are known.
2. Grappe [338d], no.364.
3. Grappe maintained the same date in all five editions of the Musée Rodin catalogue.
4. Reproduced in Descharnes and Chabrun [32], p.208.
5. This bronze was exhibited at the Curt Valentin Gallery, New York, 1954 [361], no.28, and dated 1895.
6. *See* "Rodin collectionneur," Paris, 1967–68 [384].
7. Coquiot [30], p.27. "C'est vers la sérénité que nous devons tendre. J'essaie de rendre sans cesse plus calme ma vision de la nature. Il restera toujours en nous assez de l'anxiété chrétienne devant le mystère."
8. Cladel [25a], p.174.
9. *See* Henri Frère, *Conversations de Maillol* (Geneva: Pierre Cailler, 1956), p.173.
 "Quelques photos d'œuvres de Rodin venaient ensuite. D'abord un petit marbre: *Devant la mer.*
 "—Ce n'est pas bien rigolo, dit Maillol. Quel mauvais goût, cet énorme morceau de marbre inutile! Il faudrait le tailler là, et là. Rodin ne le voyait pas. Il s'acharnait au morceau, et il ne voyait pas le côté décoratif. C'est étonnant, d'un pareil homme, qu'il n'ait pas vu ces choses-là."

p.144, repr. p.131; Story [103a], no.82, repr. pl.82; Elsen [38], p.134, repr. p.137; Descharnes and Chabrun [32], p.202; Tancock [341], no.52, repr. p.50.

OTHER VERSIONS

Marble

UNITED STATES
New York City, Metropolitan Museum of Art. Gift of Thomas F. Ryan, 1910 (fig.60–2).

Plaster

FRANCE
Paris, Musée Rodin.

Study for "Beside the Sea"

Bronze, height 6⅝ inches

Location unknown (fig.60–3).

REFERENCES

Bénédite [10a], p.31, repr. pl. LVIII (A); Grappe [338], no.293; Watkins [342], no.68; Grappe [338a], no.330; Grappe [338b], no.390; Grappe [338c], no.320 bis; Story [103], p.149, nos.100, 102, repr. pls. 100, 102; Grappe [338d], no.365; Grappe [54],

60–1
Small Crouching Bather
c. 1886, bronze, height 5 inches
Location unknown

60–2
Beside the Sea
c. 1907, marble, height 22⅝ inches
Metropolitan Museum of Art, New York
Gift of Thomas F. Ryan, 1910

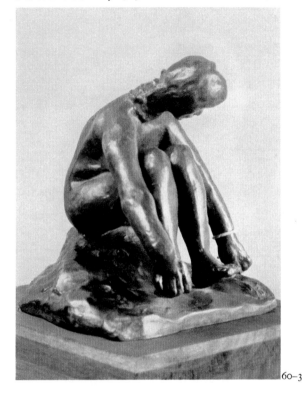

60–3

60–1

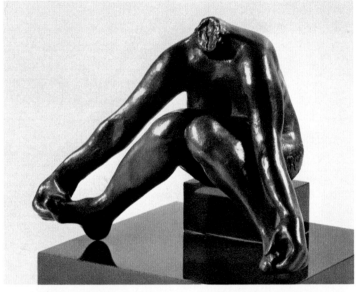

60–2

60–3
Study for "Beside the Sea"
c. 1907, bronze, height 6⅝ inches
Location unknown

331

61 Oceanids
before 1910

Bronze, 20½ × 29½ × 18 inches
Signed front of base to right: A. Rodin
Foundry mark front of base, far right:
ALEXIS RUDIER/FONDEUR. PARIS

Toward 1910, Rodin's interest in pagan themes became increasingly pronounced. *Oceanids* belongs to a group of works which includes *Ecstasy, Entwined Women, Bacchantes, Nymphs Playing, Nymphs Embracing,* and *Entwined Bacchantes.*[1]

Like so many other works by Rodin, *Oceanids* has its origins in an assemblage of preexisting parts. The pair of crouching figures is based in fact on the *Entwined Bacchantes* (fig. 61–2), the original marble version of which was dedicated to Paul Escudier and dated before 1910 by Georges Grappe (fig. 61–3).[2] In keeping with the change from a terrene to a marine location, however, the cloven hooves of the female figure with her back to the spectator have been suppressed. Above the crouching forms hovers a female figure related to many in *The Gates of Hell*. The three figures were carved in marble and emerge only partially from the body of the stone on which the forms of leaves are incised.

It is from the marble that the Philadelphia bronze was cast, thereby accounting for the smoothness of the forms and the velleities of the transitions. For a time the marble was known as *The Springtime of Life*.

Sirens and oceanids were particularly popular as subject matter among *fin-de-siècle* painters and sculptors. Their intertwined bodies and flowing locks provided the perfect excuse for the sinuous, linear aspirations of Art Nouveau artists. The painter Adolphe La Lyre made a specialty of paintings of sirens, his *Sirens in Repose* gaining wide publicity at the Salon of 1890 (fig. 61–1). Comparison of La Lyre's swooning and far from streamlined maidens, festooned with seaweed on a distinctly inhospitable looking coastline, with Rodin's *Oceanids* shows how much the latter work benefits from the suppression of anatomical details and accessories, leaving everything to the imagination.

NOTES

1. Grappe [338d], nos. 403–8.
2. Paul Escudier gave the Musée Rodin permission to reproduce this work in bronze, and it was installed in 1927. *See* Grappe [338d], no. 408.

REFERENCES

Watkins [342], no. 13; Tancock [341], no. 54.

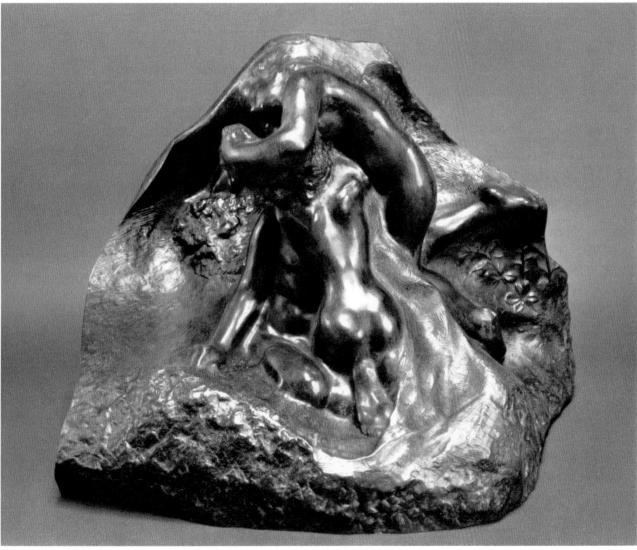

61

OTHER CASTS AND VERSION

Bronze

FRANCE
Paris, Musée Rodin. Signed: A. Rodin. Founder:
Alexis Rudier.

JAPAN
Tokyo, National Museum of Western Art (ex. Col-
lection Matsukata). Signed: A. Rodin.

Marble, height 22⅛ inches

FRANCE
Paris, Musée Rodin.

RELATED WORKS

Entwined Bacchantes

Marble, height 15¾ inches

UNITED STATES
Beverly Hills, Collection Leona Cantor (ex. Collec-
tions Paul Escudier; Aage Fersing, Paris). Signed:
Rodin. Inscribed: A. P. Escudier (fig. 61-3).

Bronze

FRANCE
Paris, Musée Rodin. Acquired in 1927. Cast from
marble formerly in the collection of Paul Escudier.

Plaster

FRANCE
Paris, Collection Aage Fersing. Cast from marble
formerly in the collection of Paul Escudier.

Bronze, height 7 inches

FRANCE
Paris, Collection Aage Fersing.

JAPAN
Tokyo, National Museum of Western Art (ex. Col-
lection Matsukata). Signed: A. Rodin (fig. 61-2).

Plaster

FRANCE
Paris, Collection Aage Fersing. Signed: Rodin. In-
scribed: A. P. Escudier.

Bronze, height 6⅛ inches

GREAT BRITAIN
Cambridge, Fitzwilliam Museum (as *La Nature*) (ex.
Collection G. J. F. Knowles). Signed.

Entwined Women

Marble, height 23¼ inches

FRANCE
Paris, Musée Rodin.

Bacchantes

Marble, height 17¾ inches

FRANCE
Paris, Musée Rodin.

Nymphs Playing

Marble, height 21¼ inches

FRANCE
Paris, Musée Rodin.

Ecstasy

Marble, height 33 inches

FRANCE
Paris, Musée Rodin.

Nymphs Embracing

Marble, height 30¼ inches

FRANCE
Paris, Musée Rodin.

61-1

61-2

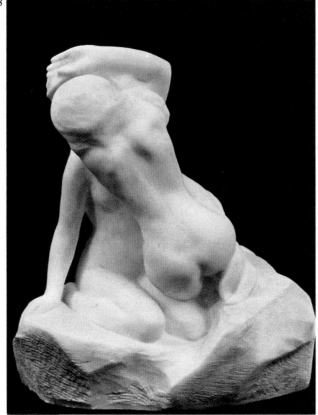

61-3

61-1
Engraving after Adolphe La Lyre
Sirens in Repose, 1889?

61-2
Entwined Bacchantes
Before 1910, bronze, height 7 inches
National Museum of Western Art, Tokyo

61-3
Entwined Bacchantes
Before 1910, marble, height 15¾ inches
Collection Leona Cantor, Beverly Hills,
Calif.

335

62 Bacchus in the Vat

1912

Bronze, 23 7/8 × 16 1/2 × 17 inches
Signed top of base to right: A. Rodin
Foundry mark back of base to left:
Alexis. Rudier/Fondeur. Paris[1]

Reference has been made elsewhere to Rodin's habit of assembling figures from the vast stock of component parts he had at his disposal in his various studios *(see* nos. 49–51, 52, 53, 55). Not infrequently, however, he juxtaposed one of his sculptures or a fragment of one with objects, for example, a book (no. 54), or a vase, that had no connection with his sculpture at all. Examples of these are the curious plaster studies in Meudon for *The Little Water Fairy, Woman Crouching in a Bowl, Woman Standing in an Antique Vase, Woman Swimming,* and *Woman Sitting in a Marble Vase.*[2] Some of these assemblages were used as the basis of works carved in marble or cast in bronze.

 Bacchus in the Vat, in which the jolly god falls laughingly backward into a vat of wine, belongs in this category of assembled works. So far as is known, the original assemblage, if it still exists, has never been exhibited. Nothing is known about the circumstances that led to the creation of this work, although Grappe is probably correct in assuming that it was originally intended for use as a garden ornament.[3] For a long time this work was also known as *Goat-Foot.*

NOTES

1. No other bronze casts of this work are known.
2. These works, varying in height from 5 3/4 inches to 10 1/8 inches, were shown in the exhibition "Rodin inconnu," Paris, 1962–63 [367], nos. 163–67.
3. Grappe [338d], no. 427.

REFERENCES

Grappe [338], no. 351; Watkins [342], no. 46; Grappe [338a], no. 392; Grappe [338b], no. 445; Grappe [338c], no. 365; Grappe [338d], no. 427; Cladel [27], repr. pl. 106; Herriot [62], repr. pl. 84; Tancock [341], no. 55.

OTHER VERSION

Marble

FRANCE
Paris, Musée Rodin.

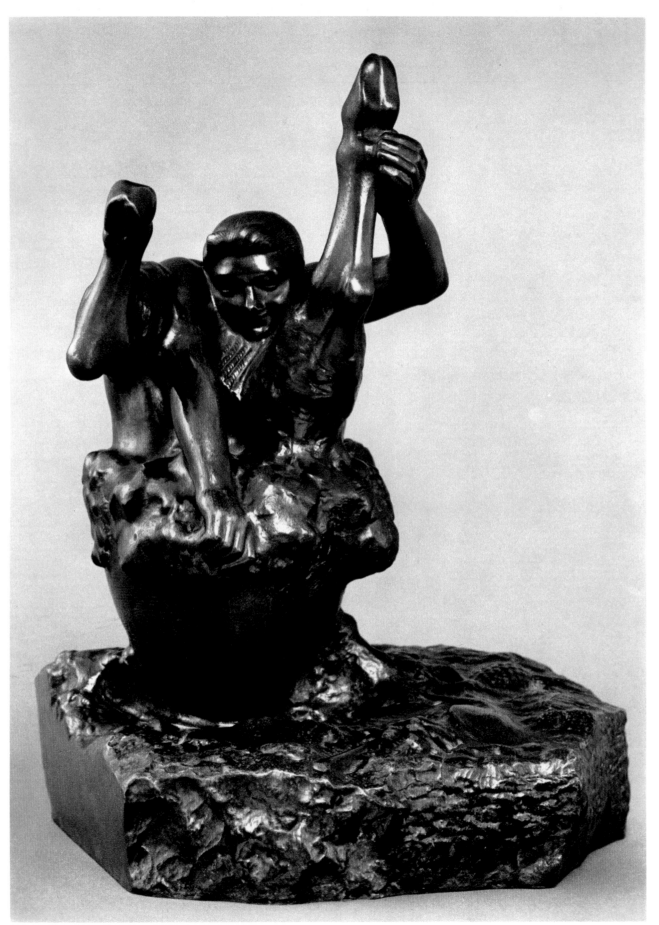

62

63 Project for the "Monument to Eugène Carrière"
1912

Plaster, 16 × 7 × 7¾ inches
Inscribed center front of rocky base: Carrière

In 1912 a committee asked Rodin to make a monument to the painter Eugène Carrière, who had died in 1906. Carrière, born in 1849 at Gournay (Seine-et-Marne), entered the Ecole des Beaux-Arts in 1870. During the war with Germany he was interned at Dresden, but from 1872 to 1873 he studied in the *atelier* of Jules Chéret and from 1873 to 1876 in that of Alexandre Cabanel. After failing to win the Prix de Rome in 1876, he left school, married the following year, and spent six months in London, where the painting of Turner exerted considerable influence on him.

It was not until 1879 that he exhibited his first *Maternity* at the Salon (now in the Musée Calvet in Avignon). In spite of his academic background, Carrière was one of the earliest admirers of Rodin. Together with Albert Besnard and Alfred Roll, Carrière was drawn to Rodin by the disputes over *The Age of Bronze* (no. 64) and *St. John the Baptist Preaching* (no. 65). It was through Carrière that Rodin was elected a member of the jury of the Salon des Artistes Français in 1889, although he was not to retain this position for long. In 1890, together with Carrière and Puvis de Chavannes (*see* no. 90), he became a founder-member of the Société Nationale des Beaux-Arts (*see* Chronology).

In 1900 Carrière was one of four artists asked to contribute a preface to the catalogue of the Exposition Rodin, the others being Claude Monet, Albert Besnard, and Jean-Paul Laurens (*see* no. 83), while in 1904 Rodin presided over a banquet to celebrate the twenty-fifth anniversary of the showing of Carrière's first *Maternity*. He expressed his admiration for the artist in the following words:

> My very dear and very great Eugène Carrière, who left us so soon, showed genius in painting his wife and his children. It was enough for him to celebrate maternal love to be sublime. The masters are those who see with their own eyes what the whole world has seen and who know how to see the beauty of what is too familiar to strike other minds.
>
> The great thing is to be moved, to love, to hope, to tremble, to live. To be a man before being an artist! Real eloquence mocks eloquence, Pascal said. Real art mocks art. I return again to the example of Eugène Carrière. In exhibitions most pictures are only painting; in the midst of works by others, his own seem to be windows open onto life.[1]

Rodin owned a number of important works by Carrière, including a *Maternity,* painted in 1891,[2] and in many of his own more wistful works, for example, *Sleep* of 1889[3] and *Mother and Her Dying Daughter* of 1908,[4] the influence of Carrière is strongly felt. This is especially true of the marbles, as the way in which distinct forms emerge from the uncut matrix recalls the way in which Carrière's figures are bathed in mist. For Rodin this served to heighten the

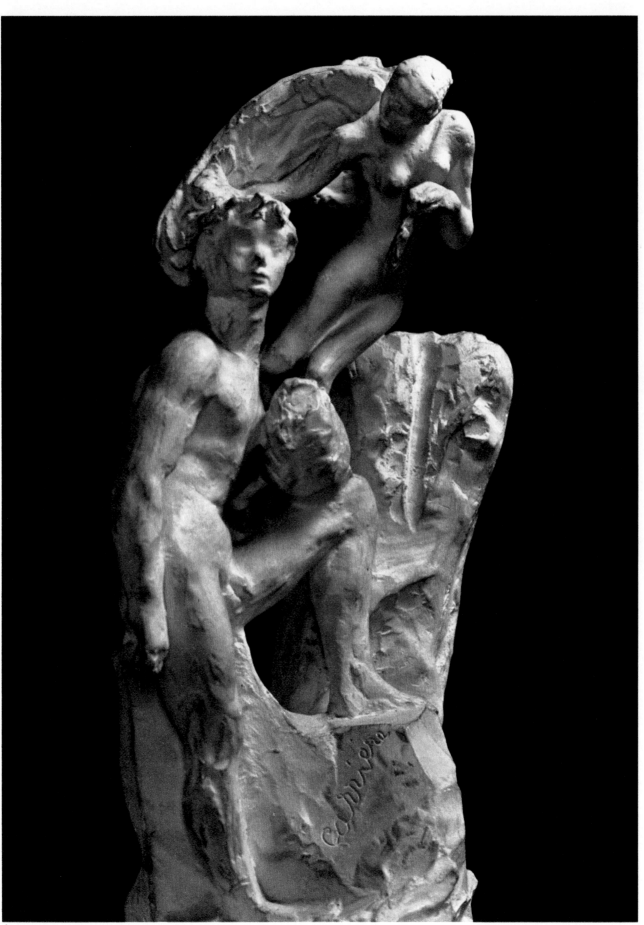

mystery and poignance of Carrière's painting. Frisch and Shipley recall that to a young man who complained once that he could not feel anything because everything was bathed in a mist, Rodin replied: "Can't you feel a punch in a mist?"[5]

Rodin was present at Carrière's deathbed, he acted as one of his executors, and he pronounced the funeral oration at his grave. When it was proposed to erect a monument in 1912, Rodin had long been out of the habit of thinking in monumental terms. From 1898 onward, when he refused to sell the *Balzac* (no.75), he had concentrated on portraits, on small-scale work, and on marble recapitulations of earlier works. It is therefore hardly surprising that he decided to utilize a group that seems to have been in existence since at least 1900 (when the group known as *The Hero* was exhibited at the Exposition Rodin) and probably since the mid 1890s (*see* nos.49–51). As was the case with other proposals for monuments after 1900, Rodin did not develop the Carrière monument beyond the initial project.

Comparison of the bronze of *The Hero* (no.49) and the plaster project for the monument shows that Rodin merely made slight adjustments to a group that had been in existence for over fifteen years. The youthful head of the male figure gives a feeling of much greater self-confidence to the work, while the winged female, now in possession of her head and arms and holding a laurel wreath in her left hand, hovers protectively over the youth rather than struggling to get away. The addition of the rocky outcrop to the right of the group gave a somewhat more monumental feeling to the ensemble. Such changes were in keeping with the mood of a monument dedicated to a friend and a painter whom Rodin admired greatly.

NOTES

1. Elder [175], p.19.

"Mon très cher et très grand Eugène Carrière, qui nous quitta si vite, montra du génie à peindre sa femme et ses enfants. Il lui suffisait de célébrer l'amour maternel pour être sublime. Les maîtres sont ceux qui regardent avec leurs propres yeux ce que tout le monde a vu et qui savent apercevoir la beauté de ce qui est trop habituel pour frapper les autres esprits.

"Le grand point est d'être ému, d'aimer, d'espérer, de frémir, de vivre. Etre homme avant d'être artiste! La vraie éloquence se moque de l'éloquence, disait Pascal. Le vrai art se moque de l'art. Je reprends ici l'exemple d'Eugène Carrière. Dans les expositions, la plupart des tableaux ne sont que de la peinture: les siens semblaient, au milieu des autres, des fenêtres ouvertes sur la vie."

2. Reproduced in Descharnes and Chabrun [32], p.218.
3. Grappe [338d], no.235.
4. Ibid., no.376.
5. Frisch and Shipley [42], p.299.

REFERENCES

Watkins [342], no.116; Descharnes and Chabrun [32], repr. p.219; Jianou and Goldscheider [65], p.113; Tancock [341], no.69, repr. p.65.

OTHER CAST

FRANCE
Paris, Musée Rodin.

MAJOR WORKS

64 The Age of Bronze
1875–76

Bronze, 67 × 23⅝ × 23⅝ inches
Signed top of base to right: Rodin
Foundry mark back of base to left:
Alexis RUDIER./Fondeur. PARIS.

The Age of Bronze was not Rodin's first life-size sculpture, but it is the first that has survived. By the time he was twenty-six years old Rodin had been working for about two years on a *Bacchante,* but this was destroyed while he was moving studios.[1] It was not for another decade that he was able to devote himself to a comparably intense study of the full-scale human figure. In the middle of 1875, immediately after his return to Brussels from Antwerp,[2] he began work on the figure now known as *The Age of Bronze.* According to Judith Cladel, he worked on this figure for eighteen months altogether, from June 1875 to December 1876,[3] and it does seem from his own statements that he had already done a considerable amount of work on it when he left for Italy late in 1875.

Rodin wrote: "While engaged on my 'Age d'Airain,' I paid a visit to Italy, and I saw there an Apollo, with a leg in exactly the same pose as that of my figure on which I had spent months of labour. I studied it; and remarked that, whereas in surface everything seemed summary, in reality all the muscles were properly constructed, and the details could be distinguished individually."[4] However, the greater part of the work on the figure was done after his return from Italy and after the end of his association with the sculptor Antoine Van Rasbourg.[5]

The model was a young Belgian soldier by the name of Auguste Neyt, who received permission to pose for Rodin from the captain of his regiment. Neyt himself has left an account of the exacting demands made on him by Rodin,[6] who was at last able to study the contours of his model with all the diligence that his previous commercial obligations had largely prevented him from exercising. "When I was working on 'The Age of Brass,'" Rodin said, "I procured one of those ladders painters use for their big canvases; I climbed up and did what I could to make my model and my clay agree in foreshortening, and I looked at the contours from above."[7] Elsewhere he said: "I was in the deepest despair with that figure and I worked so intensely on it, trying to get what I wanted, that there are at least four figures in it."[8]

The despair was due not only to Rodin's desire for absolute fidelity to the contours of his model but also to his hesitation about the iconographic significance of his figure. He seems to have hesitated between two opposing views. On the one hand, his reading of Jean-Jacques Rousseau and his long country walks in the forest of Soignes, just outside Brussels, led him to think of representing "one of the first inhabitants of our world, physically perfect, but in the infancy of comprehension, and beginning to awake to the world's meaning."[9] On

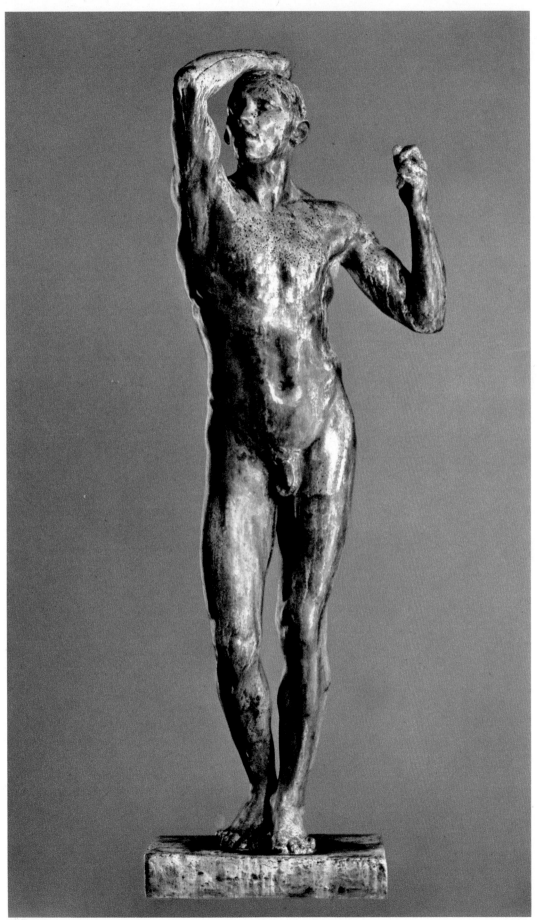

64 Front

the other hand, the figure originally wore a fillet and carried a spear in the left hand *(see fig. 64–1)*,[10] and in fact, the furrow left by the fillet can still be seen. The figure was exhibited as *The Conquered Man* at the Cercle Artistique in Brussels in January 1877, although the spear and the fillet had already been removed.

This lack of an identifiable subject matter was extremely puzzling to contemporary critics, who expected the sculptor to provide the spectator with clues, in the form of attributes or an explicit title, so as to facilitate immediate identification. The critic of the *Echo du Parlement,* a Belgian newspaper, thought very highly of Rodin's work, saying that it was closer to the metopes of the Parthenon and to the *Ilissus* of Alcamenes than to the servile realism of much contemporary sculpture, but he thought that Rodin had "forgotten only one thing and that is to explain his subject."[11] Far more damaging was the accusation that Rodin had used casts taken directly from the model in the creation of his work.

In disclaiming any obligation to examine what part life casting had played in *The Age of Bronze*—"Quelle part la surmoulure a dans ce plâtre, nous n'avons pas à l'examiner ici"[12]—the critic of *L'Etoile Belge* made public rumors that were to plague Rodin for the next three years. Rodin replied to these charges on February 2, 1877: "If any connoisseur will do me the favor of assuring himself of it, I will put him in the presence of my model, and he will be able to ascertain for himself how far an artistic interpretation is from a servile copy."[13] This offer was not taken up then nor was it several months later in Paris when the same accusations were made about the work, exhibited at the Salon under the new title *The Age of Bronze.*

On April 25, 1877, Félix Bouré wrote to Rodin expressing his dismay at the turn the controversy had taken:

> There is nothing really astonishing in the fact that a few Brussels artists accused your statue of being a cast from life—those worthy individuals have no idea what a life cast is.
>
> But that French sculptors, and what is more, members of the jury, should say the same thing, that is just not possible.
>
> In any case I declare and affirm that I saw you model that statue from the beginning to the end with your fingers and the roughing chisel.[14]

Rodin asked his friend, the engraver Gustave Biot, for a statement to the same effect and the latter wrote on April 26, 1877: "I declare on oath that your figure, *The Conquered Man,* currently on exhibition in Paris, was entirely modeled after the living model and that I saw you begin it and finish it."[15] Such expressions of confidence must have been some consolation to Rodin, but it was still necessary to prove himself in the eyes of the public. On May 22, 1877, he wrote to the Marquis de Chennevières, Director of the Ministry of Fine Arts, requesting the purchase by the state of his plaster statue, but on June 23, 1877, he received notification that the state was not interested in his work.[16]

The Age of Bronze was again exhibited at the Salon of 1880. On January 13 of that year, Rodin wrote to Edmond Turquet, Undersecretary of State for Fine Arts, asking for an inquiry to be held and giving a résumé of the whole affair:

> Following the interview that you were so kind as to grant me on January 11, at the end of which you asked me for a summary report on the events which occurred and of which I had knowledge at the time of the Salon of [1877], it is my honor to inform you that I sent to the Salon of 1877 a statue which I entitled *The Age of Bronze—The Conquered Man,* which was accepted and classified as no. 4107.

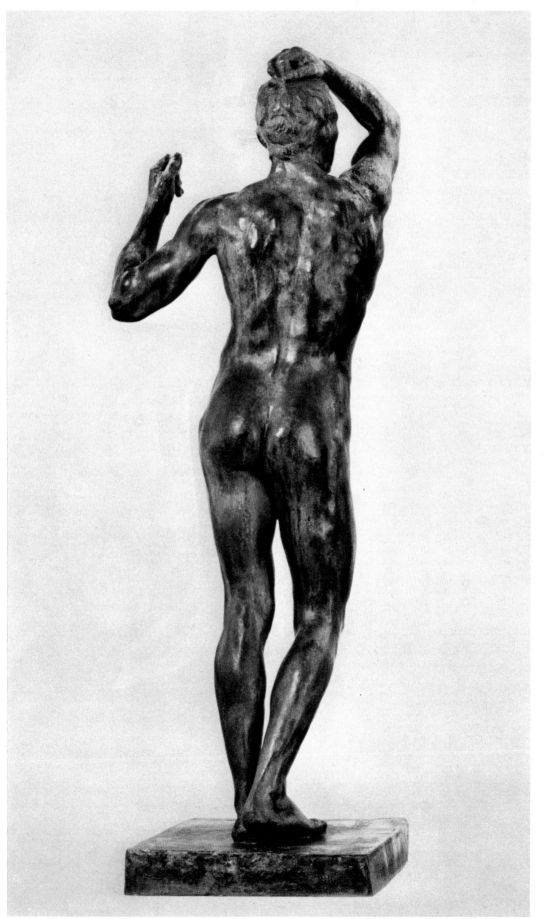

64 Back

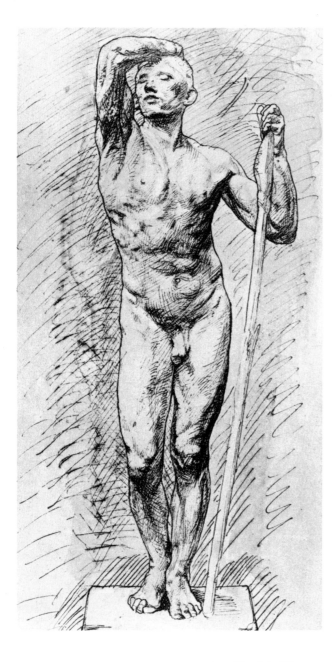

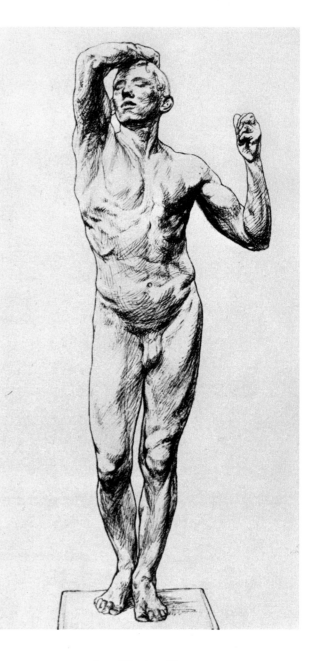

64–1 *The Age of Bronze*
1877?, pen and ink?
Location unknown

64–2 *The Age of Bronze*
1880?, pen and ink, 12⅜ × 9³/₁₆ inches
Cabinet des Dessins, Musée du Louvre,
Paris. Cosson Bequest, 1926

346

From the opening of the Salon, and even some time before, in spite of the admission of my statue, I was aware of the rumor circulating that I had used casts taken directly from the model. Distinguished artists, members of the jury, believed that this figure was cast from life!

As soon as I became aware of these rumors, I went to find M. Guillaume, President of the Sculpture Jury, and informed him of the extreme annoyance I felt at such [suspicions]; I suggested that the man who had [posed] for me should be sent for; he advised me to have casts taken from [life]. In addition, I had photographs taken both of my model and of my statue in order to make the comparison more [conclusive?]. I lost no time in doing this; I wrote to [Brussels], where financial questions had forced me to go and where, not forgetting the fact that I was a French artist, I worked for two years on my statue *The Age of Bronze*. Some artists, very important figures in the arts, decorated by their countries, M. Biot, winner of a first-class medal in Paris for engraving, M. Bouré, also recipient of a medal in Paris, wrote to me; I enclose in this letter certified copies of their attestations, which are conclusive. I also enclose an article from the *Echo du Parlement* signed by M. Jean Rousseau, Secretary General of the Commission of Monuments and Director of Fine Arts.

As soon as I had the photographs, I sent a complete set to M. Falguière, a member of the jury. I sent my life casts, my photographs, and my letters to the Palais des Champs-Elysées.

I waited anxiously, hoping once and for all to put an end to the suspicion which weighed on me, hoping at the same time that I would be rewarded so as to encourage me for the future and make amends for the enormous expenses which the execution of this figure had required of me.

All this was to remain without result. The jury was probably not sufficiently well-informed, for when I went to find out the result of its examination, they gave me back my photographs,[17] and I established, with despair, I confess, that everything I had done had been of no use; the seals of the envelope in which all this was enclosed had not even been broken. Discouraged, depressed, I saw myself refused the redress to which I firmly believed I had the right.

The following year I submitted a bust to which objections were made which prevented me yet again from being supported by the jury.

In 1879 I exhibited another bust, St. John. I was lucky enough to obtain an honorable mention.

Encouraged by you, M. le Ministre, whose good advice and kind words have, so to speak, given me new strength, I come to you to ask you to do me justice, and I ask you to hold another inquiry which will vindicate me in the eyes of artists and reinstate me after the blows I received in 1877.

I finish this too long letter by thanking you from the bottom of my heart for the friendly welcome I received from you; I always hoped that one day a liberal minister would come to office and do me justice. Entirely devoted to my work, I did not know that what I hoped for was so close.

Encouraged and fortified by you, if ever I am so fortunate as to obtain satisfaction, I shall be largely rewarded in thinking that it is to you I owe it.[18]

On January 19, 1880, Maurice Haquette wrote to Edmond Turquet, asking him to arrange for a committee to go to Rodin's studio as soon as possible "in order to judge if this work is worthy of this mark of distinction,"[19] that is, of being cast in bronze at the government's expense. The committee assembled on February 5 and decided in the negative:

Following your instructions we went to M. Rodin's, the sculptor, and we examined, with the greatest attention, the work called *The Age of Bronze*, which was shown at the exhibition of 1877.

This examination has convinced us that if this statue is not a life cast in the absolute sense of the word, casting from life clearly plays so preponderant a part in it that it cannot really be regarded as a work of art.

We do not think that there is any justification for having this work cast in bronze; the comparison with the terra-cotta model of a St. John the Baptist which we saw in the artist's studio confirms us in this opinion, that M. Rodin, without the assistance of the literal translation that direct casting from life permits, is not yet capable of modeling correctly the ensemble and the details of a figure.[20]

At this point things took a turn for the better, as apparently the sculptor Alfred Boucher saw Rodin modeling a group of children holding a cartouche. He took the sculptor Paul Dubois to see Rodin, and Dubois was so impressed by what he saw that a letter was dispatched to the Fine Arts Department, also signed by Henri Chapu, Alexandre Falguière, Albert Carrier-Belleuse, Eugène Delaplanche, E. C. Chaplain, and G. J. Thomas, all attesting to the "elevated tendencies" of Rodin's talent.[21]

This letter evidently had the desired effect, as on May 26, 1880, the plaster of *The Age of Bronze* was purchased by the state for 2,000 francs. It was cast in bronze by the foundry of Thiébaut Frères and placed in the Luxembourg Gardens in 1884,[22] close to the *Velléda* of Etienne-Hippolyte Maindron and near the boulevard St. Michel. It finally entered the Musée du Luxembourg in 1890.[23]

Rodin later reacted against this work on which he had lavished such attention. He found fault with the Thiébaut cast, writing in 1900 to Roger Marx of his desire to have a new one made,[24] but above all he was critical of his own style. He was even unwilling to include it in the exhibition Judith Cladel organized in Brussels in 1899 because he believed his modeling had become much stronger in the meantime.

It was Rodin's belief that he could only have arrived at his later style through the careful analysis and observation of the human body that characterized his work on *The Age of Bronze,* "in which the reproduction was very exact, quite rigorous,"[25] but that art had ceased to satisfy him—"my statue is a bit cold."[26] In later years he came to think that the art of sculpture demanded "more grandeur, a sort of exaggeration."[27] "Sculpture is the art of the hole and the projection; it is not the precision of smooth, unmodeled figures."[28] Nevertheless, *The Age of Bronze* was crucial to Rodin's development as a sculptor as, in fact, he later admitted to Judith Cladel.[29]

There is no doubt that Rodin regarded *The Age of Bronze* as his "masterwork," in the medieval sense of the word. "To those who asked him why he did not resolve to begin a work in which he could give everything that was expected of him, Auguste Rodin replied that one should not hurry, and that there was always time to begin the moment one was certain of doing something. 'It is enough for an artist to make one statue to establish his reputation,' he added, addressing himself to the pupils in Van Rasbourg's studio, who loved to talk with him."[30]

The Age of Bronze was the work intended to "establish his reputation," hence the bitterness over the false accusations and the doggedness of his attempts to prove himself. The first major work done after Rodin's return from Italy, it was also the first to show the strong influence of Michelangelo (especially the Louvre *Dying Slave),* the artist through whom Rodin claimed to have freed himself from academicism.[31] There is a greater seriousness and emotional depth in *The Age of Bronze* than in any of Rodin's earlier works (with the exception of the best of the portraits), which reflects his deeper understanding of the Florentine master.

At the same time there is a great advancement in fidelity to the particularity of the model, the result of the patient even fanatical observation of all the profiles. It was while working on *The Age of Bronze* that Rodin discovered what is perhaps the most important secret of his art—that expressiveness is not something that can be sought. It comes as a gift, as a reward for the sculptor's submission to Nature, the abnegation of his own personality in the desire merely to record what he has seen while circling the model and registering the complexity of the human form through delineation of its contours.

Rodin first entitled his figure *The Conquered Man,* but this title was soon changed to *The Age of Bronze,* "that is to say, one who is passing from the unconsciousness of primitive man into the age of understanding and of love."[32] At other times it has been known as *Man Awakening to Nature, The Wounded Soldier, The Iron Age, The Bronze Age, The Stone Age,*[33] *Primitive Man,*[34] and *The Golden Age.* In 1907 a pacifist group called Le Groupe Interparlementaire de l'Arbitrage International presented Léon Bourgeois, the first French delegate to the Hague Peace Conference, with a cast of the reduced version, retitled for the occasion *The Awakening of Humanity.*

The Age of Bronze was modeled life-size and reduced much later when it had become very popular (probably toward the end of the 1890s). It exists in three dimensions; no preliminary studies are known. There is a cast lacking head and arms in Munich, but this was damaged in the Great Fire of 1931 in the Glaspalast. A cast in papier-mâché in Budapest was apparently approved of by the artist as it was purchased from him during his lifetime.

According to Judith Cladel,[35] Rodin "had several copies cast in bronze and cut in stone," although no traces of the latter have been found. However, it is known that Rodin was anxious to see the work in marble, as he told Sir William Rothenstein on October 31, 1900, that it would be "doubly expressive in that material."[36]

The first bronze cast was made by Thiébaut Frères. According to the catalogue of the exhibition "Mostra di Auguste Rodin," held at the Villa Medici in Rome in 1967, nineteen casts were made before Rodin's death and eight have been cast posthumously.[37] It is clear, however, that this greatly underestimates the number of casts made by Thiébaut Frères, Alexis Rudier, and more recently by Georges Rudier. According to Emil Waldmann,[38] the work was cast 150 times by Alexis Rudier alone, and this seems to be a much more likely figure.

NOTES

1. Dujardin-Beaumetz in Elsen [39], pp. 148–50.
2. Bartlett in Elsen [39], p. 31. "Rodin, again the object of brutal treatment, returned to his old studio in Brussels, at 111 Rue Sans-Souci, and began, with the little money he had saved by the greatest economy, 'The Age of Brass.'"
3. Cladel [26], p. 115. "Il travaille sa figure pendant plus de dix-huit mois, jusqu'en décembre 1876."
4. "La Leçon de l'antique," *Le Musée,* Paris, no. 1 (1904), quoted in Lawton [67], p. 193. *See also* Brownell [144], p. 217. Rodin told Brownell that he had spent three months on the leg of his statue, "'which is equivalent to saying that I had at last absolutely mastered it.' One day in the Museo Nazionale [Naples] he noticed in an antique the result of all his study and research."
5. Autobiographical sketch prepared by Rodin on June 3, 1906, in response to a request from the Academy of Berlin, which was about to elect him a member. This is quoted in Rice [283], p. 37.

"My associate [Van Rasbourg] having no more work for me, I returned to Paris, but with a figure of The Age of Bronze which I did during the year we had no other work."

6. Article by Auguste Neyt published in *Gand Artistique,* Ghent, no. 4 (April 1922), quoted in Descharnes and Chabrun [32], p. 49. "I was a soldier from 1874 to 1877 in the telegraph corps, and it was in about 1876 that Rodin asked the commanding captain Malevé for nine of the best-built men in his company; of these nine I was the one Rodin chose. I was at once introduced to his studio at the rue Sans-Souci in Ixelles, where I had to go through all kinds of poses every day in order to get the muscles right. Rodin did not want any exaggerated muscle, he wanted naturalness. I worked two, three, and even four hours a day and sometimes for an hour at a stretch. Rodin was very pleased and would encourage me by saying; just a little longer. When I happened to pose in the morning, Rodin would take me home with him for the midday meal.

He was then living in a small apartment on the rue d'Hulst. Ever calm and simple, he had taken a liking to me, would tell me about his ideas, asking my opinion when he had designed some subject or other, for he was always making sketches and always had some clay that he carried with him."

7. Dujardin-Beaumetz in Elsen [39], p. 156.

8. Bartlett in Elsen [39], p. 32.

9. Lawton [67], p. 45. *Also* letter from Rodin to the Director of the Kunsthalle, Bremen, on Jan. 29, 1906, quoted in Waldmann [109], p. 73. "Es ist das Erwachen, das langsame Heimkehren aus einem tiefen schweren Traum, ausgedrückt in der träumerischen Haltung und Gebärde."

10. *See* Henri Lechat, "Sculptures de Rodin," *Bibliothèque des Musées de Lyons,* Lyons, 1919, p. 8. "Primitivement je lui avais mis une lance; mais cela empêchait de voir les profils." According to the reference on p. 8, n. 3, this is a quotation from a letter addressed to M. Treu, Director of the Staatliche Kunstsammlungen, Dresden, who quoted the passage in an article in *Jahrbuch der Bildenden Kunst,* Berlin, 1903, p. 82.

11. Jean Rousseau, "Revue des Arts," *Echo du Parlement,* Brussels, April 11, 1877, p. 1.

 "Uniquement soucieux des questions de style et d'exécution, comme tout artiste vraiment épris de son art, l'auteur n'avait oublié qu'une chose: c'était de baptiser son plâtre et d'en révéler le sujet. De là force questions et même force critiques: à quoi rimaient ces yeux mi-clos et cette main levée? Etait-ce la statue d'un somnambule?

 "Qu'on se rassure; tout s'explique clairement et logiquement par le titre seul de la figure, *Le Vaincu,* et il nous suffira d'ajouter que la main levée doit tenir deux javelots.

 "Ce réalisme-là n'est pas seulement d'une frappante vérité, il est en même temps d'un grand choix et d'un grand style. Si Monsieur Rodin a eu des modèles, ce ne sont certainement pas les sculpteurs réalistes de nos jours, qui s'en tiennent si souvent à de serviles surmoulages. Il s'est plutôt inspiré de ces puissantes métopes du Parthénon, dont Phidias avait remis l'exécution aux sculpteurs réalistes des écoles doriennes, et de ce souple et robuste Ilyssus, d'Alcamène, qui en décore le fronton occidental."

12. *L'Etoile Belge,* Brussels, January 29, 1877, quoted in Cladel [26], pp. 115–16.

 "M. Rodin, un de nos sculpteurs de talent, qui ne s'était fait remarquer jusqu'ici au Salon que par ses bustes, a exposé au Cercle Artistique une statue destinée à figurer à la prochaine Exposition de Paris.

 "Elle n'y passera certes pas inaperçue, car si elle attire l'attention par son étrangeté, elle la retient par une qualité aussi précieuse que rare: la vie.

 "Quelle part la surmoulure [*sic*] a dans ce plâtre, nous n'avons pas à l'examiner ici. Nous avons voulu simplement signaler cette figure dont l'affaissement physique et moral est traduit si expressivement que sans avoir d'autres indications que l'œuvre elle-même, il nous paraît que l'artiste a voulu représenter un homme sur le point de se suicider."

13. Ibid., p. 116.

 "M. Rodin proteste contre la supposition que sa figure exposée au Cercle Artistique ait été moulée sur nature. Il nous écrit: 'Si quelque connaisseur veut me faire le plaisir de s'en assurer, je le mettrai en présence de mon modèle et il pourra constater à quel point une interprétation artistique doit s'éloigner d'une copie servile.'

 "Pour nous, notre conviction est faite; mais nous tenons à faire observer à M. Rodin que nous n'avons pas songé un instant à qualifier sa statue de copie servile et qu'il est au moins étrange de le voir profiter de notre compte rendu tout bienveillant pour répondre aux doutes qui ont pris naissance au Cercle."

14. Letter in the Archives Nationales, Paris.

 Bruxelles, le 25 avril 1877

 Mon cher Rodin

 Je viens d'apprendre avec le plus grand étonnement ce qui vous arrive à l'Exposition de Paris à propos de votre statue (le vaincu).

 C'est à ne pas y croire!

 Que quelques artistes de Bruxelles aient reproché à votre statue d'être un moulage sur nature, il n'y avait là rien de bien étonnant, ces braves gens ne savent rien pas à ce que c'est qu'un moulage.

 Mais que des sculpteurs français, et surtout de Membres de Jury, viennent confirmer cette chose, cela n'est pas possible.

 Dans tous les cas, je déclare et j'affirme que je vous ai vu modeler cette statue depuis le commencement jusqu'à la fin avec le doigt et l'ébauchoir.

 Ne vous laissez pas abattre par ce fâcheux contretemps, prenez courage. Votre statue a un caractère peu ordinaire, et c'est à cela sans doute que vous devez d'être traité de la sorte.

 Votre tout devoué, Félix Bouré

15. Letter in the Archives Nationales, Paris.

Ixelles, 26 avril 1877
M. Biot, 280, Chaussée d'Ixelles à Bruxelles
Cher Rodin

Je trouve étrange qu'à Paris une attestation pareille à celle que vous me demandez soit nécessaire; néanmoins je me fais un plaisir et un devoir de vous la donner—donc.

Je déclare sur l'honneur que votre figure *Le Vaincu*, en ce moment à l'Exposition de Paris, a *été entièrement modelée d'après le modèle vivant que je vous l'ai vu commencer et finir.*

Faites mon cher ce que bon vous semblera de la présente et permettez-moi de vous féliciter de nouveau à propos de ce savant travail.

Recevez, cher Rodin, l'assurance de ma sincère amitié.

Gustave Biot, Graveur
Chevalier de l'Ordre de Léopold,
première médaille à Paris

16. These letters, now in the Archives Nationales, Paris, always followed the same form.

3, rue Bretonvilliers
A Monsieur le Marquis de Chennevières, Directeur des Beaux Arts

J'ai l'honneur Monsieur le Marquis de vous adresser une demande pour l'achat de la figure en plâtre que j'ai exposée au Salon, sous le numéro 4107 ayant pour titre L'Age d'Airain.

Je serai heureux Monsieur le Ministre que vous la jugez digne de cette faveur.

Agréez l'expression de mes hommages respectueux.

Aug. Rodin.
22 mai 1877

23 juin 1877
Le Directeur à Monsieur Rodin
Monsieur,

Vous avez exprimé le désir d'obtenir l'acquisition de la statue plâtre que vous avez exposée au Salon de cette année.

Je regrette d'avoir à vous annoncer que l'état des crédits n'a pas permis de donner une suite favorable à votre demande.

Agréez, Monsieur, l'assurance de ma considération distinguée.

Le Directeur des Beaux Arts.

17. These photographs existed as late as 1918, as seems apparent from the following statement by Léonce Bénédite [129], pp. 17–18. "Et, cependant, si l'on compare l'original avec le modèle, dont je possède une photographie qui m'avait été donnée par Falguière, on est surpris de leur dissemblance, et—le cher et vénéré maître ne m'entendant plus—si je puis proférer à mon aise un blasphème, je dirais qu'ici la Nature a été vaincue par l'Art." However, according to Mme Goldscheider, former Conservateur of the Musée Rodin in Paris, these photographs have since disappeared.

18. This letter, damaged along the right-hand side of the page, is in the Archives Nationales, Paris. The probable replacements of the missing words are enclosed in brackets.

36, rue des Fourneaux.
Paris, le 13 janvier 1880.
Monsieur le Sous-Secrétaire d'Etat,

Pour faire suite à l'audience que vous avez bien voulu m'accorder le 11 janvier, à l'issue de laquelle vous me demandiez un rapport sommaire sur les faits qui se sont produits et dont j'ai eu connaissance lors du Salon de [1877], j'ai l'honneur de vous faire savoir que j'envoyai au Salon de 1877 une statue, que j'intitulai *L'Age d'Airain—Le Vaincu* qui fut reçue et classée sous le n° 4107.

Dès l'ouverture du Salon et quelque temps avant même, (aussitôt) de la réception de ma statue, j'eu connaissance des bruits de moulage qui circulait sur mon compte; des artistes de valeur, membres du Jury, supposèrent que cette figure était moulée sur nature!

Dès que j'eu connaissance de ces bruits, j'allai trouver M. Guillaume, Président du Jury de Sculpture et lui fait part de la vive contrariété que j'éprouvais vis-à-vis de pareilles [suppositions]; je lui proposais de faire venir l'homme qui m'avait [servi] comme modèle; il me conseille de faire des moulages sur [nature], je fis faire en plus des photographies et de mon modèle et de ma statue, pour que la comparaison fut plus [persuasive]. C'est ce que je m'empressai de faire; j'écrivais à [Bruxelles] où des motifs pécuniers m'avaient forcé à aller et en l'entretemps, n'oubliant pas que j'étais Artiste Français, je travaillai depuis deux ans à ma statue *L'Age d'Airain*. Des artistes, de véritables notabilités des Arts, décorés de leurs pays, M. Biot, 1e médaille à Paris dans la gravure, M. Bouré, médaille aussi à Paris, m'écrivirent; je joins à cette lettre les copies certifiés de leurs attestations, qui sont concluantes. Je joins également un article de *L'Echo du Parlement* signé de M. Jean Rousseau,

Secrétaire Général de la Commission des Monuments et Directeur des Beaux Arts.

Dès que j'eu les photographies, j'en remis une collection complète à M. Falguière, Membre du Jury. Je remis au Palais des Champs-Elysées mes moulages sur nature, mes photographies et mes lettres, photographies et lettres sous pli cacheté.

J'attendis anxieux, espérant faire disparaître et anéantir le soupçon qui pesait sur moi en même temps qu'une récompense viendrait m'encourager pour l'avenir et me dédommager des frais énormes que m'avait demandé l'exécution de cette figure.

Tout cela devait rester sans résultat, le Jury ne fut probablement pas suffisamment informé, car lorsque j'allais connaître le résultat de son examen, l'on me remit mes photographies, et je constatai avec désespoir je l'avoue que tout ce que j'avais fait n'avait servi à rien; les cachets qui fermaient l'enveloppe dans laquelle ce tout était renfermé, n'avaient même pas été brisés. Découragé, abattu, je me vis refuser [sic] une réparation à laquelle je croyais fermement avoir droit.

L'année suivante, j'envoyai un buste sur lequel s'élevèrent des objections, qui m'empêchaient encore une fois d'être encouragé par le Jury.

En 1879, j'exposai un autre buste St. Jean, je fus assez heureux pour obtenir une mention honorable.

Encouragé par vous, Monsieur le Ministre, dont les bons conseils et les bonnes paroles m'ont pour aussi dire donné de nouvelles forces, je viens aujourd'hui vous demander de me rendre justice, en vous priant de faire une nouvelle enquête, qui me réhabilitera aux yeux des artistes, et me relèvera des coups que j'ai reçus en 1877.

Je termine cette trop longue lettre en vous remerciant au fond du cœur du bienvieillant accueil que j'ai reçu de vous; j'attendais toujours qu'un Ministre Libéral vint un jour aux affaires et me rendre justice; je ne savais pas tout entier à mon travail, que ce que j'espérai était si près.

Aujourd'hui, encouragé, fortifié par vous, si un jour je suis assez heureux pour obtenir une réparation, je serai largement récompensé en songeant que c'est à vous que je le dois.

Veuillez agréer, Monsieur le Ministre, l'assurance de ma haute considération et de mon entier dévouement.

Auguste Rodin

19. Letter in the Archives Nationales, Paris.

20. Letter in the Archives Nationales, Paris.

5 février 1880

Monsieur le Sous-Secrétaire d'Etat,

Nous nous sommes rendus, conformément à vos instructions, chez Rodin, artiste sculpteur, et nous y avons examiné, avec la plus grande attention, la statue intitulée L'Age d'Airain qui a figuré à l'Exposition de 1877.

Cet examen nous a convaincus que si cette statue n'est pas un surmoulage dans le sens absolu du mot, le surmoulage y tient une place nettement prépondérante, qu'elle ne peut véritablement passer pour une œuvre d'art.

Nous ne pensons donc pas qu'il y ait lieu de couler cette statue en bronze. La comparaison avec le modèle en terre d'un Saint Jean-Baptiste que nous avons vu dans l'atelier de l'artiste nous a confirmés dans cette opinion, que M. Rodin, sans l'aide de la traduction littérale que prête le moulage direct, n'est point encore capable de modeler avec correction l'ensemble et les détails d'une figure.

Nous avons l'honneur d'être, Monsieur le Sous-Secrétaire d'Etat, avec respect vos très dévoués serviteurs.

D'Escamps. A. Kaempfen.
Paul de Saint Victor. G. Lafenestre.
A. de Gruyer. Roger Ballu.

21. Cladel [26], p. 120. *See also* letter in the Archives Nationales, Paris.

Paris, le 23 février 1880

Monsieur le Sous-Secrétaire d'Etat,

Permettez-nous de solliciter votre bienveillant appui en faveur de M. Auguste Rodin, sculpteur. Après une visite à son atelier et une étude approfondie de ses travaux, nous sommes heureux, dans l'intérêt de l'art, de vous signaler les tendances élevées de son talent; ainsi, les figures groupées ou seules, des fragments ébauchés ou finis, tels que "le St. Jean" "la Création de l'homme" "le Buste de la République" et surtout sa statue de *"L'Age d'Airain"* sont des témoignages d'une énergie et d'une puissance de modelé très rares et de plus d'un très grand caractère.

Nos appréciations unanimes et sincères ont pour but de mettre à néant les accusations de surmoulages qui sont absolument erronées.

Nous serions heureux, Monsieur le Sous-Secrétaire d'Etat, si, prenant nos vœux en considération, vous voulussiez bien encourager cet artiste, qui nous paraît appelé à tenir une grande

place parmi les sculpteurs de notre temps.

Veuillez agréer, Monsieur le Sous-Secrétaire d'Etat, l'assurance de notre haute considération.

P. Dubois. E. C. Chaplain.
A. Falguière. G. J. Thomas.
A. Carrier-Belleuse. E. Delaplanche.
H. Chapu.

22. Lami [4], p. 165.
23. Bénédite [10a], p. 12.
24. Letter to Roger Marx in the Judith Cladel archives, Lilly Library, Indiana University, Bloomington.
25. Cladel [25], pp. 39–40.

"Je suis plutôt un réaliste, comme les Anciens; au lieu d'essayer de corriger, je me suis appliqué à rendre l'admirable architecture du corps de l'homme. Cela m'a d'abord donné mon *Homme de l'Age d'Airain* d'une reproduction très exacte, tout à fait rigoureuse. Pourtant, à moi, cet art-là ne me suffisait pas, ma statue garde un peu de froideur....

"Le *Buste de Rochefort,* le *Victor Hugo* lui sont supérieurs, d'un modelé plus large; pourtant, je n'ai pu atteindre à cette seconde manière que par la première qui représente l'étude stricte: c'est elle qui fait gagner la connaissance anatomique, d'après le corps vivant; car nous travaillons à faux l'anatomie; nous l'étudions toujours sur le cadavre et non pas sur la nature en action, ce qui est bien différent.... Après, j'ai compris que l'art demandait un peu plus de grandeur, une sorte d'exagération; je vous l'indiquais l'autre jour, je vais vous l'expliquer aujourd'hui. Je crois que c'est Flaubert qui a dit: 'Il n'y a que les exagérés qui soient vraiment grands'; c'est une vérité bien dite. En sculpture, il faut accentuer la saillie des faisceaux musculaires, forcer les raccourcis, creuser les trous: ça donne de la vigueur et de l'ampleur. La sculpture, c'est l'art du trou et de la bosse; ce n'est pas la netteté des figures lisses et sans modelé."

26. Ibid., p. 39.
27. Ibid.
28. Ibid., p. 40.
29. Cladel [25a], p. 86. When Rodin refused to allow Judith Cladel to include *The Age of Bronze* in the exhibition she was organizing for Brussels, she took him to the Musée du Luxembourg.

"Finally he admitted quietly that he had been mistaken, that the statue seemed to him really beautiful, well constructed, and carefully sculptured. In order to comprehend it he had had to forget it, to see it again suddenly, and to judge it as if it had been the work of another hand.

"After this readoption, his affection for it was restored; he had several copies cast in bronze and cut in stone."

30. Pierron [277], pp. 161–62. "A ceux qui lui demandaient pourquoi il ne voulait pas se résoudre à commencer une œuvre où il pourrait donner tout ce qu'on attendait de lui, Auguste Rodin répondait qu'il ne fallait pas se hâter et qu'il était toujours temps de commencer, du moment qu'on avait la certitude de faire quelque chose. 'Il suffit qu'un artiste fasse une seule statue pour établir sa réputation,' ajoutait-il, en s'adressant aux élèves de l'atelier Van Rasbourg, qui aimaient à s'entretenir avec lui."

31. "Ma libération de l'académisme a été par Michel-Ange." Letter to Emile Bourdelle, written about 1906 and published in Cladel [26], p. 113.
32. Cladel [25a], p. 69.
33. *L'Art et les Artistes* [330], p. 61.
34. Maillard [71], p. 7.
35. Cladel [25a], p. 86.
36. William Rothenstein, *Men and Memories,* vol. 1 (New York: Coward-McCann, 1931), p. 371. In 1900 it was proposed that a bronze should be acquired for the Victoria and Albert Museum in London. John Singer Sargent was in favor of getting *The Age of Bronze,* and on October 31, 1900, Rodin wrote to Sir William Rothenstein concerning the matter:

"Pour le marbre le prix est le double peut-être plus, avec l'achat du marbre *l'âge d'airain* et *l'homme qui s'éveille* serait pour la 7e fois en marbre et je le vois dans cette matière doubler d'expression; car il y a dans cette douleur des nuances fines qui ne seraient rendues que par le marbre et, si je pouvais, du marbre grec.

"Aussi bien cette figure debout, le bras sur la tête, qui a été acheté en bronze par Copenhague, serait si bien en marbre que je fais des vœux pour cela."

Rodin's grammar was extremely erratic, and it seems that the phrase "avec l'achat du marbre *l'age d'airain* et *l'homme qui s'éveille* serait pour la 7e fois en marbre" means that six bronze casts were already in existence and that the carving of the marble would bring the number of examples of the work to seven. If there are seven marble versions of *The Age of Bronze,* no trace of them has been found so far.

37. *See* Rome, 1967 [381], no. 6.
38. Waldmann [109], p. 73.

L'Etoile Belge, Brussels, January 29, 1877; Jean Rousseau, "Revue des Arts," *Echo du Parlement,* Brussels, April 11, 1877, p.1; Charles Tardieu, "Le Salon de Paris–1877–La Sculpture," *L'Art,* Paris, 3, pts. 3 and 4 (1877), p.108; Geffroy [199a], pp.9–10; Bartlett [125], pp. 27, 65, 99, 100, 249–50, 263; Maillard [71], pp. 7–9, 55–56 (drawing of fig. repr. opp. p. 6); Mauclair [77a], pp. 7, 10–11, repr. opp. pp. 6, 8; Lawton [67], pp. 44–49, 193, repr. opp. pp. 32, 45; Cladel [25], pp. 39, 83–86, repr. opp. pp. 86, 88; Gsell [57], pp. 79–80, repr.p.79; Ciolkowska [23], pp.29–33, repr.opp.p.28; Dujardin-Beaumetz [35], pp.12, 82; Rilke [87], pp.28–29, repr. pls.4, 5; Coquiot [29], pp.74–75, repr.opp.p.14; *L'Art et les Artistes* [330], p.62; Cladel [25a], pp.67–86, repr.p.71; Coquiot [31], pp.100–101; Lami [4], p.165; Bénédite [10a], pp.11–12, 25, repr.pls.III–V; Grappe [338], nos.11, 12; Watkins [342], p.7, repr. p.7; Grappe [338a], nos.18, 19; Grappe [338b], nos.38, 39; Grappe [338c], no.34; Frisch and Shipley [42], pp.97–104; Story [103], p.143, nos.4–6, repr. pls.4–6; Grappe [338d], no.36; Grappe [54], p.140, repr.p.35; Waldmann [109], pp.22, 73, nos.3, 4, repr.pls.3, 4; Cladel [27], pp.XII–XV, repr.pl.5; Cladel [26a], pp.114–21; Alley [334], pp.210–11, repr.pl.46f; Elsen [37], p.8, repr.pl.2; Story [103a], nos.4, 5, repr. pls.4, 5; Goldscheider [49], pp.22, 26, repr. pls. 54, 55; Elsen [38], pp.21–26; repr.p.20; Mirolli [81], pp.160–69, repr.pl.115; Descharnes and Chabrun [32], pp.49, 52–54; Tancock [341], no.56.

Bronze

ALGERIA

Algiers, Musée National des Beaux-Arts. Purchased by the state in 1929.

BELGIUM

Antwerp, Koninklijk Museum voor Schone Kunsten. On loan to the Openluchtmuseum voor Beeldhouwkunst, Middleheim. Purchased in 1924. Signed: Rodin. Founder: Alexis Rudier.

CANADA

Ottawa, National Gallery of Canada. Acquired in 1956.

CZECHOSLOVAKIA

Prague, Galerie Hlavního Města Prahy. On loan to the Národní Galerie. Purchased from Rodin before his death.

DENMARK

Copenhagen, Ny Carlsberg Glyptotek. Purchased by Carl Jacobsen in 1901. Signed: Rodin. Cast in 1901.

FRANCE

Dijon, Musée de Dijon. Purchased in 1950. Founder: Alexis Rudier.

Lyons, Musée des Beaux-Arts. Purchased from Rodin in 1910.

Paris, Lycée Rodin. Installed in 1962. Founder: Georges Rudier. Cast no. 12/12.

– Musée Rodin. Signed: A.Rodin. Founder: Alexis Rudier.

– place Rodin.

GERMANY (EAST)

Altenburg, Staatliches Lindenau-Museum.

Berlin, Nationalgalerie. Gift of Dr. K.V.Wesedonck, 1903.

Weimar, Schlossmuseum. On exhibition from 1904. Entered museum collection in 1906.

GERMANY (WEST)

Bremen, Kunsthalle. Gift of the Vereinigung von Freunden der Kunsthalle, 1905. Signed: Rodin.

Cologne, Wallraf-Richartz Museum. Purchased in 1954. Signed: A.Rodin. Founder: Alexis Rudier.

Düsseldorf, Kunstmuseum. Purchased in 1904 through the Galerieverein. Signed: A.Rodin.

Essen, Museum Folkwang (ex. Collection Karl-Ernst Osthaus, Hagen). Signed: Rodin.

GREAT BRITAIN

Birmingham, Barber Institute of Fine Arts (ex. Collection Sir Edmund Davis). Founder: Alexis Rudier.

Glasgow, Glasgow Art Gallery and Museum. Burrell Collection.

London, Bethnal Green Museum. Gift of Rodin to the Victoria and Albert Museum, 1914. Signed: Rodin. Founder: Alexis Rudier.

Manchester, City Art Gallery. Commissioned by the gallery from Rodin and cast between October 1911 and September 1912. Signed: Rodin. Founder: Alexis Rudier.

IRELAND

Dublin, Municipal Gallery of Modern Art. Hugh P. Lane Bequest. Signed: Rodin. Founder: Alexis Rudier.

ITALY

Rome, Galleria Nazionale d'Arte Moderna. Signed: Rodin. Founder: Alexis Rudier.

JAPAN

Tokyo, National Museum of Western Art (ex. Collection Matsukata). Signed: Rodin. Founder: Alexis Rudier.

THE NETHERLANDS

The Hague, Haags Gemeentemuseum. Signed: A. Rodin. Founder: Alexis Rudier.

PORTUGAL

Lisbon, Museu Nacional de Arte Contemporânea. Purchased by the state in 1934.

ROMANIA

Bucharest, Muzeul de Artă (ex. Collection Anastase Simu). Signed: Rodin. Founder: Alexis Rudier.

SPAIN

Barcelona, Museo de Arte Moderno. Purchased at the Exposition of 1907.

SWEDEN

Stockholm, Nationalmuseum. Acquired in 1913 by Mr. Piltz through Carl Milles. Acquired by the museum in 1914. Signed: Rodin.

SWITZERLAND

Lausanne, Collection Samuel Josefowitz. Founder: Alexis Rudier.

Zurich, Kunsthaus Zurich. Signed: A. Rodin. Founder: Alexis Rudier.

UNITED STATES

Buffalo, Albright-Knox Art Gallery. Purchased in 1925. Signed: Rodin. Founder: Alexis Rudier. Cast in 1911.

Cleveland, Cleveland Museum of Art. Gift of Mr. and Mrs. Ralph King, 1918. Signed: Rodin. Founder: Alexis Rudier.

Minneapolis, Minneapolis Institute of Arts (ex. Collection Eugène Rudier). Signed: Rodin.

New Orleans, Isaac Delgado Museum of Art. Signed: Rodin. Founder: Alexis Rudier.

New York City, Metropolitan Museum of Art. Gift of Mrs. John W. Simpson, 1907. Signed: Rodin. Founder: Alexis Rudier.

— Collection Charles Zadok (ex. Collections Reynaud Icare; Wildenstein). Signed: Rodin. Founder: Alexis Rudier.

San Francisco, California Palace of the Legion of Honor. Gift of Alma de Bretteville Spreckels. Signed: Rodin. Founder: Alexis Rudier.

Plaster

FRANCE

Cognac, Musée de Cognac.

Paris, Musée Rodin.

GERMANY (EAST)

Dresden, Staatliche Kunstsammlungen. Purchased in 1894 from Rodin. Signed: Rodin.

GREAT BRITAIN

London, Lycée Français.

UNITED STATES

Philadelphia, Pennsylvania Academy of the Fine Arts.

U.S.S.R.

Leningrad, State Hermitage Museum. Presented by Rodin to the Academy of Arts. Transferred to the Hermitage in 1911. Signed: Rodin.

Bronze, height 41 inches

ARGENTINA

Buenos Aires, Collection Alejandro Shaw.

AUSTRALIA

Brisbane, Queensland Art Gallery. Signed: Rodin. Founder: Georges Rudier.

FRANCE

Paris, Musée Rodin.

SWITZERLAND

Lausanne, Collection Samuel Josefowitz. Founder: Alexis Rudier.

UNITED STATES

Brooklyn, Brooklyn Museum. Gift of B. G. Cantor Art Foundation. Founder: Georges Rudier. Cast no. 10/12.

New York City, Collection Mr. and Mrs. Harold
L. Renfield. Signed: Rodin. Founder: Georges
Rudier.
Princeton, Princeton University, Art Museum.
Signed: Rodin. Founder: Alexis Rudier.
Stanford, Stanford University Art Gallery and Mu-
seum. Gift of B. G. Cantor Art Foundation.
Founder: Georges Rudier. Cast no. 11/12.
Washington, D.C., National Gallery of Art. Gift of
Mrs. John W. Simpson, 1942. Signed: Rodin.

Bronze, height 26 inches

ARGENTINA
Buenos Aires, Collection Antonio Santamarina.
Founder: Alexis Rudier.

FRANCE
Paris, Musée Rodin.

GREAT BRITAIN
Oxford, Ashmolean Museum. Bequest of Rev.
J. W. R. Brocklebank, 1927. Signed: Rodin.

JAPAN
Tokyo, Bridgestone Museum of Art.

UNITED STATES
Beverly Hills, Collection Mrs. Jefferson Dickson (ex.
Collection Jules Mastbaum).
Cambridge, Fogg Art Museum, Harvard University.
Grenville L. Winthrop Bequest, 1943.
Honolulu, Honolulu Academy of Arts. Acquired
in 1970.
Maryhill, Wash., Maryhill Museum of Fine Arts.
New York City, Collection Dr. and Mrs. Harry
Bakwin. Signed: Rodin. Founder: Alexis Rudier.
St. Louis, Collection Mr. and Mrs. Joseph Pulitzer, Jr.
Founder: Alexis Rudier.
Santa Barbara, Collection Wright Ludington. Foun-
der: Alexis Rudier.

Bronze (without head and arms), height 58¼ inches

GERMANY (WEST)
Munich, Bayerische Staatsgemäldesammlungen.
Damaged in a fire in the Glaspalast in 1931.

Papier-mâché

HUNGARY
Budapest, Szépmüvéstzeti Múzeum. Purchased from
Rodin in 1901. Signed: Rodin.

DRAWINGS

Location unknown. Pen and ink? Reproduced in
Maillard [71], p. 6 (fig. 64–1).

FRANCE
Paris, Musée du Louvre, Cabinet des Dessins. Cos-
son Bequest, 1926. Pen and ink, 12⅜ × 9³/₁₆ inches.
Inscribed in pen: L'age d'airain Rodin. Inscribed
in pencil: dessin de l'auteur d'après son plâtre
(fig. 64–2).

65 St. John the Baptist Preaching
1878

Bronze, 79 × 21 ¾ × 38 ½ inches
Signed top of base between feet: A Rodin
Foundry mark rear of base to left:
Alexis Rudier/Fondeur Paris

The accusations leveled at Rodin in connection with *The Age of Bronze* (no. 64) made him decide to make his next major figure, *St. John the Baptist Preaching*, somewhat larger than life-size,[1] although Bartlett pointed out that "he began a sketch half the size of what he intended the statue to be."[2] The figure of St. John was a popular subject with Salon sculptors, although they mostly chose to execute a youthful representation.[3] Rodin's decision to undertake this subject, however, was due not so much to a desire to emulate his contemporaries as to the excitement caused by the sudden appearance in his studio, late in 1877 or early in 1878, of a model who had never posed before.

> One morning, someone knocked at the studio door. In came an Italian, with one of his compatriots who had already posed for me. He was a peasant from Abruzzi, arrived the night before from his birthplace, and he had come to me to offer himself as a model. Seeing him, I was seized with admiration: that rough, hairy man, expressing in his bearing and physical strength all the violence, but also all the mystical character of his race.
>
> I thought immediately of a St. John the Baptist; that is, a man of nature, a visionary, a believer, a forerunner come to announce one greater than himself.
>
> The peasant undressed, mounted the model stand as if he had never posed; he planted himself, head up, torso straight, at the same time supported on his two legs, opened like a compass. The movement was so right, so determined, and so true that I cried: "But it's a walking man!" I immediately resolved to make what I had seen.[4]

Unfortunately the history of this piece is much less simple than is suggested by this account, which was given some thirty or more years after the event. It has generally been thought that *The Walking Man* (fig. 65–1) is a study for *St. John the Baptist Preaching* and that it dates from 1877–78.[5] A more thorough study of the scanty sources reveals, however, that the relationship between the two works is much more complex. Rodin's own accounts of his difficulties are confirmed by those of other witnesses.

In Rodin's own words:

> It was customary then, when looking over a model, to tell him to walk, that is, to make him carry the balance of the upright body onto a single leg; it was believed that thus one found movements that were more harmonious, more elegant, "well turned out." The very thought of balancing a figure on both legs seemed like a lack of taste, an outrage to tradition, almost a heresy. I was already

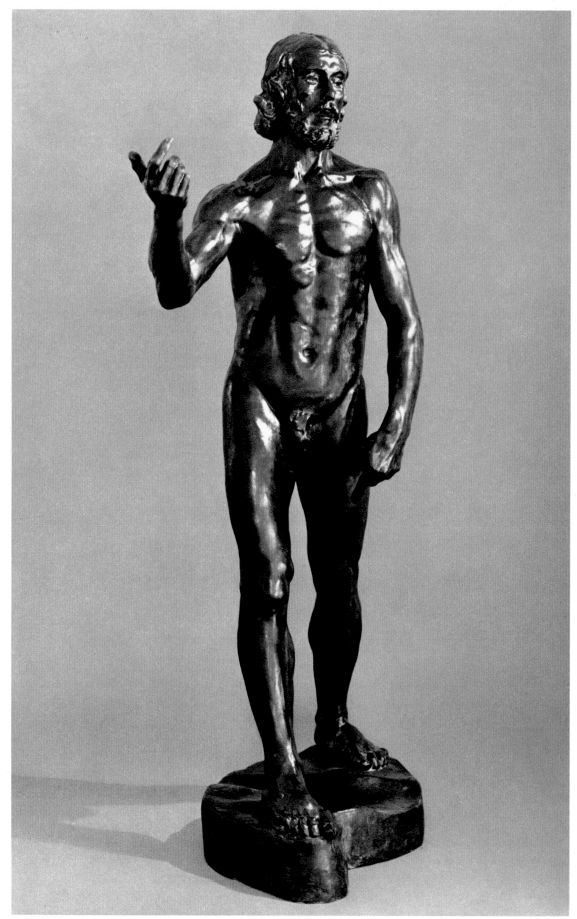

65 Front

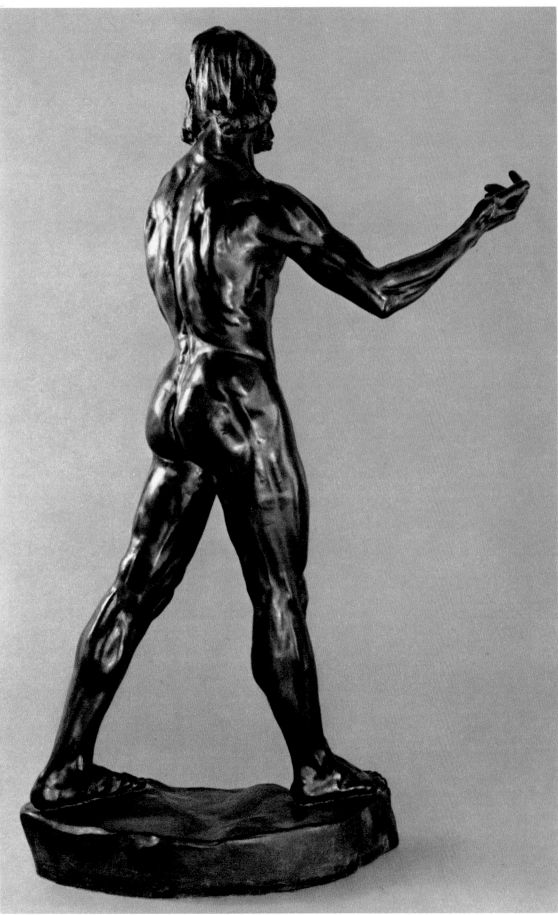

65 Left side

willful, stubborn. I thought only that it was absolutely necessary to make something good, for if I didn't transmit my impression exactly as I had received it, my statue would be ridiculous and everyone would make fun of me. I promised myself. I promised myself then to model it with all my might, and to come close to nature, which is to say, to truth.[6]

Considerably later Henri Matisse stated that he "could not understand how Rodin could work on his St. John by cutting off the hand and holding it on a peg; he worked on the details holding it in his left hand, it seems, anyhow keeping it detached from the whole, then replacing it on the end of the arm; then he tried to find its direction in accord with his general movement."[7]

These statements convey the desperate urgency with which Rodin tried to "realize his idea,"[8] experimenting ceaselessly with the positioning of the legs and the angle of the hands. It is a measure of the unique rightness of his final solutions that no trace of the difficulties encountered in the course of execution is preserved in the finished figure of *St. John*. In *The Walking Man,* on the other hand, no attempt was made to conceal what those difficulties might have been. These two works might thus be regarded as the obverse and the reverse of the same sculptural idea.

In her discussion of the origins of *St. John the Baptist Preaching,*[9] Judith Cladel suggested that Rodin might have had his first ideas for the figure in Brussels (that is, before the spring of 1877), using the torso of a badly damaged statue of *Joshua* for the torso of *The Walking Man,* which she regarded as a preliminary study for the more finished sculpture. In a later account,[10] Mlle Cladel revised her assessment of the relationship between *The Walking Man* and *St. John.* Referring to *The Walking Man* as a preliminary study for the *St. John,* which Rodin had developed to "the limit of his inexorable will,"[11] she stated that he kept this study in two parts, that is, torso and limbs, so as to facilitate his work. "He proposed to join them some time in the future. It was not until about twenty years later, after 1900, that he was able to do this.... Unfortunately the impressive model of 1878 was no longer available and he had no end of trouble in joining the parts."[12]

Referring to this account as confirmation of his own observations, Albert Elsen, in collaboration with Henry Moore, has suggested that the Michelangelesque torso (fig. 65–3) used in *The Walking Man* was deliberately created by Rodin "in the manner of antiquarian sculpture that goes back through the Baroque and Renaissance to the Romans."[13] He is thus of the opinion that Rodin did not refer to the live model in the creation of the *Torso.* Believing this and accepting Grappe's statement that it was Danielli and not Pignatelli who had posed for the head of *St. John the Baptist,*[14] Professor Elsen suggests that Pignatelli served Rodin as model only for the legs and possibly the back of his sculpture. Nonetheless, it is difficult to reconcile this dismemberment of the figure with Rodin's statement that he was "seized with admiration" when he first saw Pignatelli. Professor Elsen points to the difference in degree of finish between the front and the back of the torso as confirmation of his belief that the torso was derived from "art" rather than "life," since it was Rodin's practice to work from all around the figure. Yet Rodin's determination "to make something good" could equally well account for the battered appearance of the torso. Moreover, Truman Bartlett stated quite clearly that it was Pignatelli (and not Danielli) who posed for the head of the figure,[15] and Grappe himself admitted that there was no physical resemblance between the head of *St. John the Baptist* and the features of Danielli, of whom Rodin made a bust in 1878.[16]

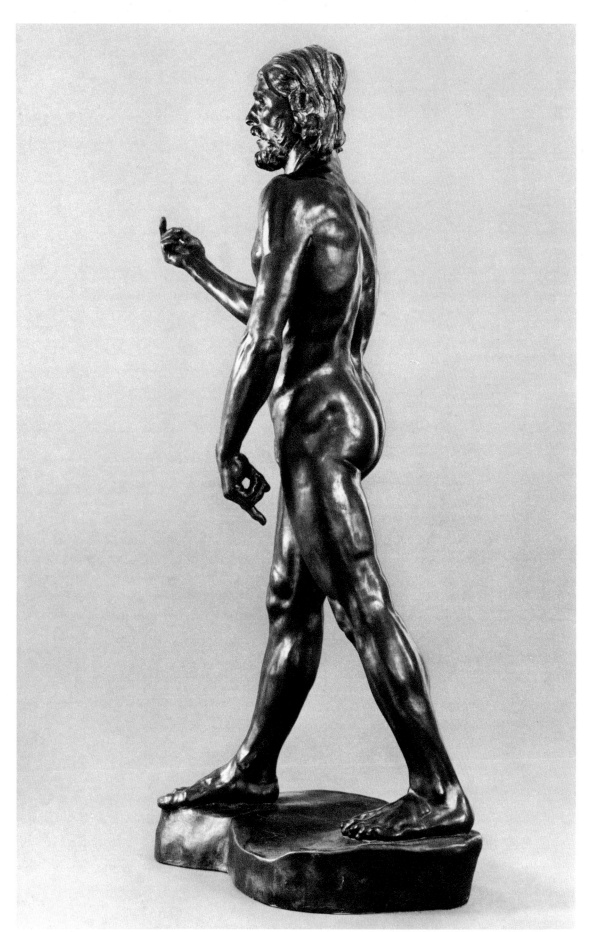

65 Right side

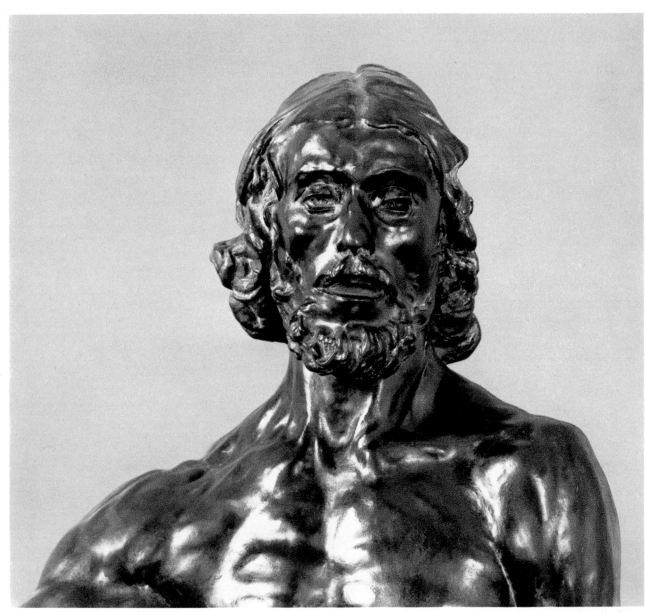

65 Detail of head

It is proposed, then, that Pignatelli, who posed for a number of figures in the early 1880s, including *The Thinker* (no.3) and *Ugolino (see* Chronology), and who was still working for Rodin in 1906,[17] was indeed the main source of inspiration for the figure of *St. John the Baptist.* The torso (fig.65–3) which may have been exhibited in 1889 at the Monet-Rodin exhibition, battered and Michelangelesque as it is, is most probably a record of Pignatelli's physique and is the victim of Rodin's perfectionism, his desire to transmit his impression exactly as he received it, as much as it is the result of his desire to emulate Michelangelo. The limbs and extremities, also modeled after Pignatelli, were kept detached from the torso, enabling Rodin to find the most telling pose by completely changing their position and to experiment with unconventional ways of representing movement. It was not until about 1900 that the original torso and the legs of the work now known as *The Walking Man* were assembled. Referring to the *Balzac* (no.75), Rodin stated that he wished to do something other than "photography in sculpture."[18] By this date the high degree of finish of *St. John the Baptist* had ceased to have any meaning for Rodin, with the result that in *The Walking Man* no attempt was made to conceal the attachment of the legs to the torso or to adjust the proportions of the two parts one to the other.

In 1879 Rodin felt ready to exhibit a bust of *St. John the Baptist* in galvanized plaster at the Salon. Photographs preserved in the Cabinet des Estampes of the Bibliothèque Nationale show a study for this work and for the head of the over life-size figure (fig.65–2). It was not until 1880, however, that *St. John the Baptist* was exhibited in plaster at the Salon. The bronze was exhibited at the Salon of 1881, when it was purchased by the state for 6,000 francs.[19]

While displaying a number of innovative tendencies that point to the future development of Rodin's art, *St. John the Baptist Preaching* nonetheless represents a conscious effort on his part to create a convincingly realistic image of an historical figure. Although initially inspired by the spontaneously adopted pose of his model, there are very pronounced similarities with the *St. John the Baptist* of Giovanni Francesco Rustici on the Baptistery of Florence, with which Rodin was almost certainly familiar.[20] To further his understanding he may also have investigated literary characterizations of the precursor of Christ. Certainly by 1889 Octave Mirbeau had pointed out the relationship between Rodin's saint and the "wild hermit" of Gustave Flaubert.[21] At first Rodin provided his figure with an identifying attribute, a cross supported against the left shoulder. This can still be seen in one of the early drawings made after the statue *(see* fig.65–4), but by the time it was first exhibited at the Salon of 1880 the cross had been removed (fig.65–5), as had been the case with the spear in *The Age of Bronze (see* no.64), in part because it interfered with the lines of the statue but principally because the power of the figure made such details unnecessary and distracting.

It was while working on the figure of the saint, however, that Rodin evolved the attitude toward movement that henceforth was to characterize his art, for this is the first major work in which the pose of the figure is derived from the spontaneous movements of the model. He indicated the results of this radical departure from normal studio practice in one of his conversations with Paul Gsell:

> …my Saint John is represented with both feet on the ground, it is probable that an instantaneous photograph from a model making the same movement would show the back foot already raised and carried toward the other. Or else, on the contrary, the front foot would not yet be on the ground if the back leg occupied in the photograph the same position as in my statue.

Now it is exactly for that reason that this model photographed would present the odd appearance of a man suddenly stricken with paralysis and petrified in his pose, as it happened in the pretty fairy story to the servants of the Sleeping Beauty, who were all suddenly struck motionless in the midst of their occupations....

...it is the artist who is truthful and it is photography which lies, for in reality time does not stop, and if the artist succeeds in producing the impression of a movement which takes several moments for accomplishment, his work is certainly much less conventional than the scientific image, where time is abruptly suspended.[22]

In allowing the model to dictate the pose, Rodin reversed normal academic practice. Pignatelli was allowed to adopt a stance that came naturally to him and was not asked to conform to any of the accepted canons of suitable poses. Clumsy according to conventional standards, Pignatelli's forked stance enabled Rodin to see how a simple movement, from beginning to end, might be represented in the one figure. Shortly afterward Rodin's models would no longer be asked to hold fixed poses at all, nothing annoying him more than the overfamiliar, static poses of the trained model. They would move freely about the studio, while Rodin followed their every movement. As his modeling became bolder, he was able to suggest in one figure not merely a change in position from one point to another but a much more complex sequence of changes in place and time. *St. John the Baptist,* moving indomitably forward, might be regarded as the first step on the path that led to the frenzied gyrations of *Nijinsky* (pl. 4) in 1912.

NOTES

1. Bartlett in Elsen [39], p. 69. "I had no idea of interpreting Dante, though I was glad to accept the *Inferno* as a starting point, because I wished to do something in small, nude figures. I had been accused of using casts from nature in the execution of my work, and I made the 'St. John' to refute this, but it only partially succeeded."

2. Ibid., p. 40.

3. *See The Infant St. John* by Paul Dubois (1861); *The Infant St. John the Baptist* by Alfred-Charles Lenoir. Other figures of St. John the Baptist were made by Marius-Jean-Antonin Mercié and Eugène Delaplanche.

4. Dujardin-Beaumetz in Elsen [39], pp. 165–66.

5. *See* Grappe [338d], no. 38. "L'Homme qui marche figura en 1900 seulement à l'exposition particulière de Rodin, place de l'Alma, sous le nom de *Saint Jean,* et, en 1907, au Salon avec le titre de *L'Homme qui marche;* mais, en réalité, c'était une étude pour le *Saint Jean-Baptiste prêchant;* de sorte que l'œuvre remonte à la fin de l'année 1877 au plus tard."

6. Dujardin-Beaumetz in Elsen [39], p. 166.

7. Quoted in Raymond Escholier, *Matisse: A Portrait of the Artist and the Man* (New York: Praeger Publishers, 1960), p. 138.

8. It seems appropriate to borrow Cézanne's phrase to describe Rodin's equally fanatical endeavors to recreate three-dimensional forms in all their complexity.

9. Cladel [26], pp. 132–33.

10. Cladel [27], pp. XVI–XIX, quoted in Mirolli [81], p. 193. "Parmi les Etudes préparatoires du *Saint Jean,* il en est une que Rodin avait 'poussée' jusqu'à la limite de son inexorable vouloir.... La plupart du temps, ne pouvant poursuivre ses créations personnelles que le soir, il s'éclairait d'une lampe ou d'une chandelle et fut amené, pour plus de facilité, à traiter son Etude en deux parties, le torse d'une part, les jambes de l'autre. Il se proposait de les raccorder un jour à venir. Ce ne fut que vingt ans après, aux environs de 1900, qu'il réalisa ce projet. Il organisait alors l'exposition d'ensemble de son œuvre au pavillon construit dans ce but place de l'Alma et tenait à y faire figurer ce splendide Essai. Malheureusement, il ne disposait plus de l'impressionnant modèle de 1878 et il eut une peine infinie à mener à bien le raccord. Se livrant à d'incessantes retouches, il faisait prendre chaque fois un estampage du

65–1
The Walking Man
1877–78, bronze, height 33⅛ inches
Metropolitan Museum of Art, New York
Gift of G. Louise Robinson, 1940

65–2
Study for the Head of "St. John the Baptist
Preaching," 1878, terra–cotta
Location unknown

65–3
Torso (Study for "The Walking Man")
1877, bronze, height 20⅞ inches
Musée du Petit Palais, Paris. Gift of Sir
Joseph Duveen, 1923

65–2

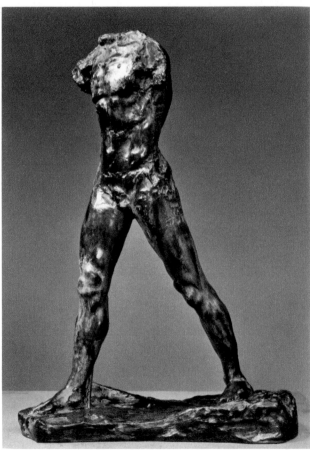

65–1

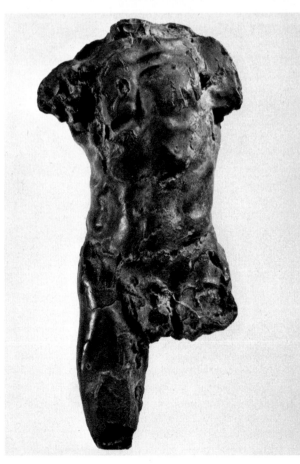

65–3

nouvel état de sa figure et n'en était jamais content."

Mrs. Mirolli asks: "What did Rodin's secretary mean when she said that he no longer had the 1878 model at his disposition?" (p. 193). She suggests that Mlle Cladel was referring to "an assembled sketch in walking position" (p. 194) when surely what is meant is the model himself, that is, Pignatelli. Rodin's difficulties in assembling the two parts arose from the fact that the original model for both of them was temporarily unavailable.

11. Ibid., p. 193.
12. Ibid.
13. Elsen and Moore [183], p. 27.
14. Grappe [338d], no. 40. "Au Salon de 1879, Rodin avait exposé le buste seul [of *St. John the Baptist*] pour lequel avait, dit-on, posé Danielli."
15. Bartlett in Elsen [39], p. 42. "While Rodin was perfecting his sketch of 'St. John,' he made a bust of the same subject and from the same model, an Italian, about forty-two years of age, who was named Pagnitelli [*sic*]." According to Cladel [26], p. 132, Danielli worked on the bust, although he did not sit for it: "Le buste en plâtre, galvanisé par Danielli."
16. Grappe [338d], no. 39. "Or, il n'y a aucune ressemblance entre ce portrait et la tête bien caractéristique du Précurseur, on le notera."
17. *See* René Chéruy, "Rodin's 'Gate of Hell' Comes to America," *New York Herald Tribune,* Sunday Magazine Supplement, January 20, 1929, p. 19.

"We were at luncheon one day in the spring of 1906 when the bell at the gate was heard. The maid, an old peasant woman who had retained the roughness and cautiousness of her remote native village, came back looking perturbed.

"'There's a man at the gate who says he is St. John the Baptist,' she announced.

"With a hazy expression in his gray eyes Rodin said: 'A poor beggar out of his mind. Give him some food.'

"But we were interrupted again by the maid.

"'He refused my bread and he is as lean as a shotten herring,' she announced excitedly. 'He swears he is St. John the Baptist and he has a beard longer than yours.'

"Rodin laughed heartily.

"'Of course he is St. John the Baptist,' he said, 'I shall show him in myself.'

"And as he rose he told us amusedly, '*C'est Pignatelli!*'

"The mystery was solved. It was Pignatelli,

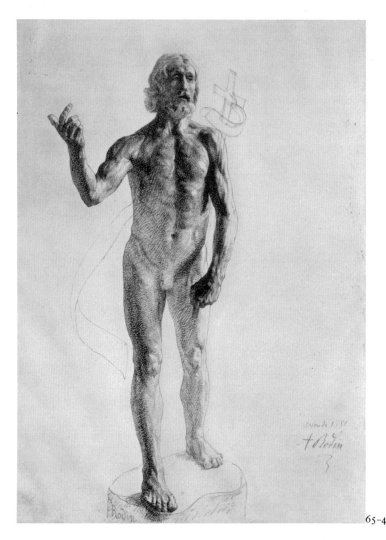

65-4

65-4
St. John the Baptist Preaching
1880, pen and ink, 12¾ × 8¾ inches
Fogg Art Museum, Harvard University,
Cambridge, Mass. Grenville L. Winthrop
Bequest, 1943

65-5
St. John the Baptist (in profile)
from *Catalogue illustré du Salon,* 1880

366

the best male model Rodin ever had, who had posed as St. John the Baptist twenty years before, as well as for the first group of 'Ugolino.' Rodin, who at the time was busy enlarging this group, had engaged old Pignatelli again, but for the moment he had forgotten the appointment."

Pignatelli was much sought after by younger artists after posing for Rodin. In 1900, under the name of Bevilaqua, he posed for Matisse's *Le Serf*. See Albert E. Elsen, *The Sculpture of Henri Matisse* (New York: Harry N. Abrams, 1972), pp. 28–29.

18. *See* nos. 72–76, n. 62.

19. List of acquisitions by the state in the Archives Nationales, Paris.

20. This was pointed out by Elsen [38], p. 27.

21. Mirbeau [254], p. 76. "Son Saint Jean est tel que l'avait conçu Gustave Flaubert: une sorte d'anachorète farouche, à la puissante ossature, décharnée par les fatigues et les jeûnes. Les flancs se creusent, les reins s'évident, le torse de lutteur amaigri montre la carcasse tourmentée et douloureuse. Il marche à grandes enjambées, très droit sur des jambes nerveuses et des pieds secs que les cailloux et les brûlants sables de la route ont durcis et cuirassés de corne. Et, prêchant comme on bataille, il fait un geste violent qui distribue l'anathème. Sa face est tout entière allumée de lueurs mystiques, sa bouche vomit les imprécations."

22. Gsell [57b], pp. 74–76.

65-5

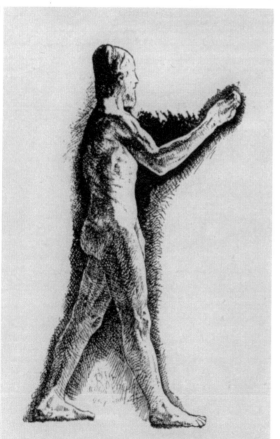

RODIN (A.). Ex. *Saint Jean prêchant.*
St. John preaching.

REFERENCES

Geffroy [199a], p. 10; Bartlett [125], pp. 99, 101, 113, 262–63; Maillard [71], pp. 9–10, 56, repr. p. 57; D. S. MacColl, "'St. John the Baptist Preaching' by Rodin," *Art Journal,* London, 53 (1901), pp. 59–60; Mauclair [77a], pp. 7–8, repr. opp. p. 10; Lawton [67], pp. 50–52, repr. opp. p. 51; Ciolkowska [23], pp. 32, 33–34, repr. opp. p. 32; Gsell [57b], pp. 72–76, repr. opp. pp. 72, 74; Dujardin-Beaumetz [35], pp. 65–66; Rilke [87], pp. 29–30, repr. pl. 6; Cladel [25a], pp. 258–60, 263–64; Lami [4], p. 166; Bénédite [10a], pp. 13, 25, repr. pls. VI–IX; Grappe [338], nos. 20, 21; Watkins [342], no. 48, repr. p. 16; Grappe [338a], nos. 31, 32; Grappe [338b], nos. 44, 45; William Rothenstein, *Men and Memories,* vol. 1, New York: Coward-McCann, 1931, pp. 371–72; *John Tweed Sculptor: A Memoir,* London: Lovat Dickson, 1936, p. 100; Cladel [26], pp. 132–34; Grappe [338c], no. 38; Story [103], pp. 18–19, 143–44, nos. 8–10, repr. pls. 8–10; Grappe [338d], no. 40; Grappe [54], p. 140, repr. p. 37; Waldmann [109], pp. 26–27, 74, nos. 6–9, repr. pls. 6–9; Cladel [27], pp. XVI–XIX, repr. pls. 7, 8; Alley [334], pp. 209–19, no. 6045, repr. pl. 46e; Story [103a], nos. 6, 7, repr. pls. 6, 7; Goldscheider [49], p. 26; Elsen [38], pp. 27–33, repr. opp. pp. 22, 29; Mirolli [81], pp. 183–95; Descharnes and Chabrun [32], pp. 56, 57, repr. pp. 56–57; Elsen and Moore [183], pp. 26–31; Tancock [341], no. 57, repr. p. 55.

Bronze

CZECHOSLOVAKIA
Prague, Národní Galerie. Acquired in 1925. Signed: Rodin.

DENMARK
Copenhagen, Ny Carlsberg Glyptotek. Commissioned by Carl Jacobsen in 1901. Signed: Rodin. Founder: Alexis Rudier. Cast in 1902.

FRANCE
Paris, Musée Rodin. Signed: Rodin. Founder: Alexis Rudier.

GERMANY (EAST)
Leipzig, Museum der Bildenden Künste. Signed.

GERMANY (WEST)
Bremen, Kunsthalle. Gift of Konsul Carl Theodor Melchers, 1911. Founder: Alexis Rudier.

GREAT BRITAIN
Cardiff, National Museum of Wales. Purchased by Miss G.Davies in 1913 and presented to the museum in 1940. Founder: Alexis Rudier.
London, Bethnal Green Museum. Gift of a committee of subscribers to the Victoria and Albert Museum, 1902. Signed: Rodin. Founder: Thiébaut Frères.
Scotland, private collection.

JAPAN
Tokyo, National Museum of Western Art (ex. Collection Matsukata). Signed: A.Rodin.

UNITED STATES
Los Angeles, Norton Simon, Inc. Museum of Art. Founder: Georges Rudier. Cast no.7/12.
New York City, Museum of Modern Art. Mrs. Simon Guggenheim Fund, 1955. Founder: Alexis Rudier.
St.Louis, City Art Museum. Acquired in 1946. Said to be one of five casts executed under Rodin's supervision. Signed: A.Rodin. Founder: Alexis Rudier.
San Francisco, California Palace of the Legion of Honor. Gift of Alma de Bretteville Spreckels. Signed: A.Rodin. Founder: Alexis Rudier.

Plaster

FRANCE
Cambrai, Musée de Cambrai. Purchased in 1929.

GERMANY (EAST)
Dresden, Staatliche Kunstsammlungen. Purchased in 1902 from the Internationale Kunstausstellung, Dresden, 1901. Signed: A.Rodin.

Bronze, height 31⅛ inches

FRANCE
Paris, Musée Rodin.

UNITED STATES
Collection Mr. and Mrs. Meyer P. Potamkin (ex. Collection Jules Mastbaum). Signed: A. Rodin. Founder: Alexis Rudier.
Cambridge, Fogg Art Museum, Harvard University. Grenville L.Winthrop Bequest, 1943.
Hagerstown, Md., Washington County Museum of Fine Arts. Signed: A.Rodin. Founder: Alexis Rudier.
Los Angeles, Los Angeles County Museum of Art. Gift of B.G.Cantor Art Foundation. Founder: Georges Rudier. Cast no.6/12.
— Collection Mrs. Charles J. Solomon. Signed: A.Rodin. Founder: Alexis Rudier.
Pittsburgh, Museum of Art, Carnegie Institute. Purchased in 1920 from the Musée Rodin. Signed: A.Rodin. Founder: Alexis Rudier.

Bronze, height 7½ inches

UNITED STATES
San Francisco, California Palace of the Legion of Honor. Gift of Alma de Bretteville Spreckels.

Bust of St.John the Baptist

Bronze, height 19⅝ inches

CANADA
Montreal, private collection. Founder: Georges Rudier. Cast no.3/12.

FRANCE
Paris, Musée Rodin.

SWITZERLAND
Lausanne, Collection Samuel Josefowitz. Founder: Alexis Rudier.

UNITED STATES
Beverly Hills, Collection Leona Cantor. Founder: Georges Rudier. Cast no.7/12.

Bronze, height 21⅝ inches

FRANCE
Paris, Musée Rodin.

UNITED STATES
New York City, Metropolitan Museum of Art. Gift of George A.Lucas, 1893.

Richmond, Virginia Museum of Fine Arts. Purchased in 1971.

Stanford, Stanford University Art Gallery and Museum. Gift of B.G. Cantor Art Foundation. Founder: Georges Rudier. Cast no. 3.

RELATED WORKS

The Walking Man

Bronze, height 33⅛ inches

FINLAND

Helsinki, Kunstmuseum Athenaeum. Signed: A. Rodin. Founder: Georges Rudier.

FRANCE

Paris, Musée Rodin.

GERMANY (WEST)

Wuppertal, Von der Heydt-Museum. Gift of Dr. Robert Wichelhaus, 1910.

GREAT BRITAIN

Aberdeen, Art Gallery and Museum. Purchased in 1953. Signed: A. Rodin. Founder: Alexis Rudier.

Much Hadham, Collection Henry Moore. Founder: Alexis Rudier.

UNITED STATES

Chicago, Collection A. James Speyer.

Glen Head, N.Y., Collection Mary Steichen Calderone (ex. Collection Edward Steichen).

Minneapolis, Collection Mr. and Mrs. Richard P. Gale.

New York City, Metropolitan Museum of Art. Gift of G. Louise Robinson, 1940 (fig. 65-1).

— Collection Mr. and Mrs. Rafael Recanati. Founder: Georges Rudier. Cast no. 7/12.

Washington, D.C., National Gallery of Art. Gift of Mrs. John W. Simpson, 1942. Signed: A. Rodin.

Plaster

UNITED STATES

Cambridge, Fogg Art Museum, Harvard University. Grenville L. Winthrop Bequest, 1943. Inscribed: a J. Sargent affecteux admirateur Rodin.

Bronze, height 87⅞ inches

FRANCE

Barentin (Seine Maritime), Musée de Sculpture en Plein Air.

Lyons, Musée des Beaux-Arts. Deposited by the state in 1923.

Paris, Musée Rodin.

THE NETHERLANDS

Rotterdam, municipality of Rotterdam.

UNITED STATES

Beverly Hills and New York City, B.G. Cantor Collections. Founder: Georges Rudier.

Carbondale, Ill., Southern Illinois University. Located in Lovejoy Library, Edwardsville campus. Purchased in 1965. Founder: Georges Rudier. Cast no. 8/12.

Houston, Museum of Fine Arts. Founder: Georges Rudier. Cast no. 6/12.

Los Angeles, Norton Simon, Inc. Museum of Art. Founder: Georges Rudier. Cast no. 7/12.

— University of California. Presented by the Norton Simon Foundation. Founder: Georges Rudier. Cast no. 11/12.

Northampton, Smith College Museum of Art. Founder: Georges Rudier. Cast no. 9/12.

Washington, D.C., Hirshhorn Museum and Sculpture Garden, Smithsonian Institution. Founder: Georges Rudier. Cast no. 5/12.

Wellesley, Wellesley College. Presented by the Norton Simon Foundation. Founder: Georges Rudier. Cast no. 12/12.

Plaster

SWITZERLAND

Basel, Kunstmuseum Basel. Purchased in 1920.

Torso (Study for "The Walking Man")

Bronze, height 20⅞ inches

FRANCE

Paris, Musée du Petit Palais. Gift of Sir Joseph Duveen, 1923 (fig. 65-3).

DRAWINGS

Location unknown. Pen and ink? Reproduced in the *Catalogue Illustré du Salon*, 1880, p. 538. Signed (fig. 65-5).

FRANCE

Paris, Musée du Louvre, Cabinet des Dessins. Pen and ink, 13⅛ × 8³⁄₁₆ inches. Signed and inscribed: A Monsieur Arago/Hommage reconnaissant. A. Rodin.

UNITED STATES

Cambridge, Fogg Art Museum, Harvard University. Grenville L. Winthrop Bequest, 1943. Pen and ink, 12¾ × 8¾ inches. Signed: Rodin. Inscribed: salon de 1880/ A. Rodin (fig. 65-4).

66 The Call to Arms
1879

Bronze, 43 ½ × 22 ½ × 15 inches
Signed by male figure's left foot: A. Rodin
Foundry mark rear center: ALEXIS RUDIER/Fondeur. PARIS.

In the middle of 1879 a competition was organized by the Préfecture de la Seine to select a project for a proposed monument to the defense of Paris in the Franco-Prussian War of 1870, to be erected at the rond-point de Courbevoie (now rond-point de la Défense).[1] At the same time the city organized a competition for a monument to the Republic, projects for which had to be handed in by October 6, 1879.[2]

It is significant that Rodin decided to enter the competition for the monument to the defense of Paris rather than for the monument to the Republic. Writing about the latter, Eugène Véron declared: "But the figure of the Republic is altogether more difficult to find [than the *Marseillaise,* an image already perfected by François Rude]. It is not a question here of a simple and strong idea, like that of love of the threatened mother country. Nothing is more complex than the idea of the Republic; consequently, nothing lends itself with more difficulty to plastic expression."[3] There is no doubt that Rodin felt the same way about the respective merits of the subjects. A monument to the war of 1870 could be expressed in terms of dramatic human content, while a monument to the Republic would of necessity be more abstract in concept.

Although still involved in the scandal provoked by *The Age of Bronze* (no. 64), Rodin submitted to the competition the group now generally known as *The Call to Arms.* His project shows a wounded warrior sinking to the ground, supporting himself by the sword held in his left hand and looking up at the impassioned figure of the Genius of War, who rises behind him. In this use of a symbolic figure, Rodin respected the major convention of the public sculpture of his period, although endowing it with an unprecedented vitality, and there is no doubt that he must have studied some of the more recently erected Parisian monuments. For example, a similar relationship between the two constituent figures can be seen in Alexandre Falguière's *Switzerland Succoring the French Army,* shown at the Salon of 1875.[4]

Another possible influence on the grouping of the two figures is Antonin Mercié's *Gloria Victis,* seen at the Salon of 1874, in which a dead warrior is supported by a figure of

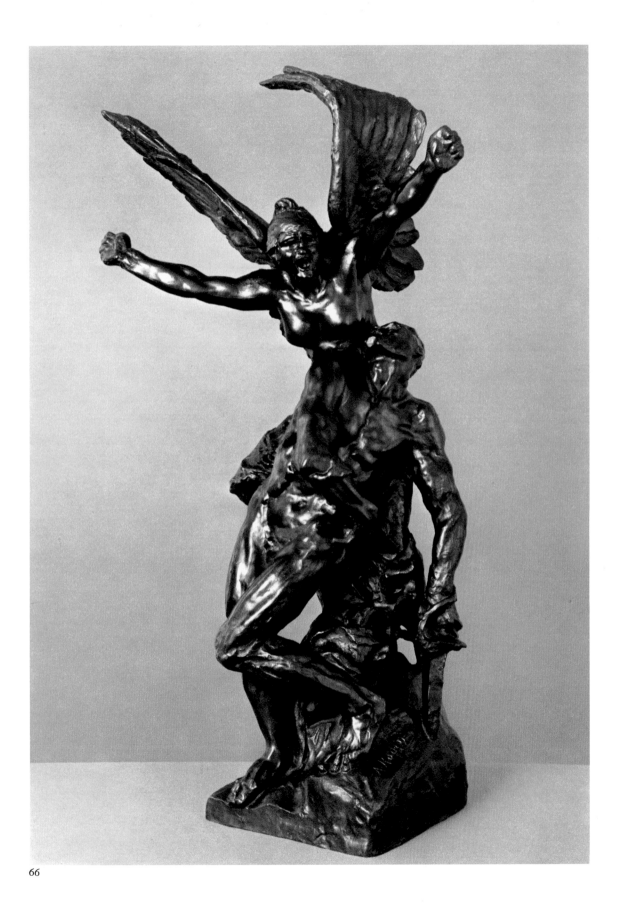

Victory.[5] Stylistically the influence of Michelangelo is predominant—the warrior is closely related to Michelangelo's *St. Matthew* in the Accademia in Florence, while his left arm resembles that of Christ in the Duomo *Pietà*. The figure of the Genius of War, on the other hand, for which Rose Beuret posed, is closely related to Rude's *Marseillaise*, a work for which Rodin had the deepest respect.[6]

The competition was won by Louis-Ernest Barrias, Rodin's project failing to receive even an honorable mention. The jury probably disapproved of it on both moral and aesthetic grounds. The collapsing figure of the warrior must have seemed insufficiently heroic, a charge later leveled against *The Burghers of Calais* (no. 67), while the spiraling rhythms and agitated profiles of the work must have appeared to be lacking in the decorum that was required of public statuary. It was certainly very far from what Véron referred to as "la forme vulgaire" of the monument—"a statue, a pedestal, a base, the whole more or less well linked and combined."[7]

In spite of this setback, Rodin did not lose interest in the group. In 1883 he returned to the figure of the Genius alone in the work known as *The Spirit of War* (fig. 66–2), a cast of which entered the well-known Pontremoli Collection.[8] In this work a swirl of drapery links the figure to the lower half of the sculpture, a function once performed by the warrior himself. The lava-like flow of free form is reminiscent of Rodin's contemporary experiments with the formless background to the figures in *The Gates of Hell (see* no. 1).

Twenty-nine years later Rodin's thoughts were again centered on this project for a monument to the defense of Paris. Although there was still no question of its being erected in a public place, he undertook to have it enlarged by Henri Lebossé. It has been suggested with some plausibility that the enlargement was undertaken so that the work might assume its rightful place within Rodin's monumental *œuvre,* once the idea had been proposed for a Rodin Museum.[9] It was thus enlarged in height from 43½ inches to 92¾ inches. Rodin's involvement with the enlargement, sometimes thought to be a purely mechanical process, is clearly demonstrated in the letters he wrote to Lebossé while the work was in process. On April 17, 1912, he wrote: "My dear Lebossé, would you be so kind as to use more material in the Defense on which you are working at the moment and make it thicker, as I find it rather thin."[10]

In 1916 the question arose of making yet a further enlargement. A group of Dutchmen wished to offer a work in homage to France and Lorraine, and Rodin proposed the project for *The Call to Arms,* executed in 1879. It was commissioned on December 26, 1916, by M. J. B. de La Faille, President of the Verdun Committee.

According to the account given by L. de Bevervoorde, Secretary General of the Dutch Committee for Verdun, "Rodin authorized the enlargement to twice the size of the work, which was still in the course of execution [that is to say, Lebossé's enlargement, begun in 1912, height 92¾ inches]. Rodin, happy to associate himself with this homage rendered to his country, refused to accept a fee."[11]

The enlargement (fig. 66–1) was once again undertaken by Lebossé *père et fils.* It was cast by Eugène Rudier and inaugurated on August 1, 1920. On the plinth were engraved (incorrectly) the three dates of its execution—1880–1916–1920—and the following inscription: "A LA GLOIRE—DE LA FRANCE ÉTERNELLE;—A VERDUN, L'HÉROÏQUE CITÉ LORRAINE;—LES AMIS DE HOLLANDE—QUI N'ONT JAMAIS DOUTÉ DU TRIOMPHE—DU DROIT ET DE LA JUSTICE.—DÉCEMBRE 1916–JUILLET 1920."[12]

NOTES

1. *See L'Art,* Paris, 2 (1879), pp. 263–64. "La préfecture de la Seine vient de faire annoncer par des affiches le concours ouvert entre les sculpteurs pour l'érection, au rond-point de Courbevoie, d'un monument allégorique du siège de Paris. On devra utiliser le piédestal existant actuellement sur cet emplacement. Le groupe à exécuter devra comprendre deux figures. Les concurrents devront produire des esquisses et les déposer au palais du Luxembourg le 5 novembre, avant quatre heures du soir. L'œuvre classée la première sera coulée en bronze aux frais de l'administration, et l'auteur recevra pour l'exécuter une somme de 15,000 francs. Les deux œuvres classées ensuite recevront, la deuxième, 3,000 francs, la troisième, 2,500 francs."

See also announcement in *L'Art,* 4 (1879), p. 96; the date arranged for depositing the models at the Ecole des Beaux-Arts was postponed from November 5, 1879, to November 24, 1879. This was not the first competition for a public monument that Rodin had entered. In 1877 he submitted a project in competition for a monument to Lord Byron, to be erected in London, but he was unsuccessful and no trace of it survives.

2. *See L'Art,* Paris, 2 (1879), p. 46. "Conformément aux conclusions du rapport de M. Viollet-le-Duc,

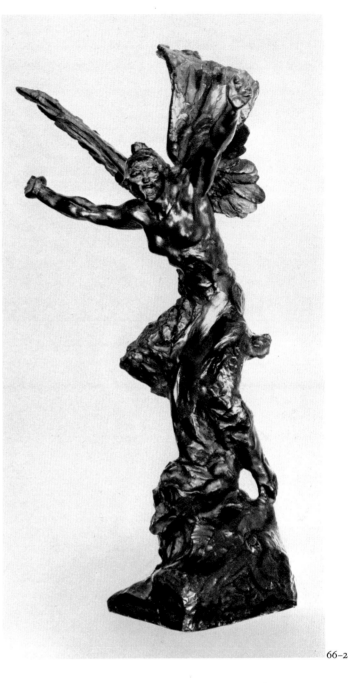

66–2

66–1

66–1
The Defense of Verdun
1916–20, bronze, height 185 ½ inches
In front of Porte St.-Paul, Verdun

66–2
The Spirit of War
1883, bronze, height 44 ½ inches
Collection Mrs. Henry A. Markus, Chicago

la statue de la République sera représentée suivant la forme traditionnelle, debout et avec le bonnet phrygien. Elle aura 7 mètres de hauteur, non compris la plinthe; le piédestal pourra être accompagné de figures allégoriques ou symboliques."

3. Eugène Véron, "Concours pour le monument de la place de la République," *L'Art,* Paris, 4 (1879), p.131. "Mais la figure de la République est autrement difficile à trouver. Il ne s'agit pas ici d'une idée simple et forte, comme celle de l'amour de la patrie menacée. Rien n'est plus complexe que l'idée de République; rien par conséquent ne se prête plus difficilement à l'expression plastique."

4. This was pointed out by Alhadeff [7], p.47.

5. *See* ibid., and Mirolli [81], p.196.

6. *See* Mirolli [81], p.200.

7. *See* n.3 above, Véron, p.132. "La forme vulgaire: une statue, un piédestal, un soubassement, le tout plus ou moins bien relié et combiné."

8. The date of this work is given by Maillard [71], p.153, and Riotor [89], p.205.

9. L. de Bevervoorde, "Un Hommage de la Hollande à la France: 'La Défense' de Rodin," *La Revue de l'Art Ancien et Moderne,* Paris, 38 (July-August 1920), p.120. "Le maître avait une prédilection marquée pour cette œuvre. Il avait toujours eu le regret de ne l'avoir point vu réalisé. Aussi, lorsqu'il conçut l'idée de son musée, voulut-il lui donner une place dans son œuvre monumentale et, dès le mois de mars 1912,—plusieurs lettres en témoignent,—il en commanda l'aggrandissement à M. Lebossé."

10. Extract from a letter dated April 17, 1912, a photograph of which is in the archives of H. Roger-Viollet, Paris; the location of the original letter is unknown. "Mon cher Lebossé, Voudriez-vous avoir l'obligeance de mettre beaucoup de matière et plus d'épaisseur dans la Défense que vous travaillez et que je trouve un peu maigre."

11. *See* n.9 above. "Rodin donna l'autorisation de reproduction pour l'agrandissement au double du groupe qui était alors en voie d'exécution, et refusa tout droit d'auteur, heureux d'associer son nom à cet hommage rendu à son pays en des heures si graves. Une souscription publique couvrit les frais, et le travail commença."

12. The inscription on the plinth now reads: "A LA FRANCE IMMORTELLE/A LA GLORIEUSE VILLE/DE VERDUN/LA HOLLANDE AMIE." Jianou and Goldscheider [65], p.87, assign a date of 1878 to the project for *The Call to Arms,* 1879 for the first enlargement, and 1912 for the second enlargement. None of these dates is correct.

REFERENCES

Bartlett [125], pp.100–101; Maillard [71], pp.68–70, repr. p.72 and opp. p.70 *(Le Génie de la Guerre);* Riotor [89], p.205; Mauclair [77a], p.14, repr. opp. p.14; Lawton [67], pp.54–55, repr. opp. p.55; Ciolkowska [23], p.36, repr. opp. p.36; L. de Bevervoorde, "Un Hommage de la Hollande à la France: 'La Défense' de Rodin," *La Revue de l'Art Ancien et Moderne,* Paris, 38 (July-August 1920), p.120; Lami [4], p.166; Bénédite [10a], p.27, repr. pl. XVIII; Grappe [338], nos.18, 19; Watkins [342], no.17; Grappe [338a], nos.28, 29; Grappe [338b], nos. 48, 48 bis; Cladel [26], p.129; Grappe [338c], nos.40, 374; Frisch and Shipley [42], pp.114–15, 412; Grappe [338d], nos. 42, 437; Grappe [54], p.140, repr. p.36; Elsen [38], pp.67–70, repr. p.68; Mirolli [81], pp.195–201; Tancock [341], no.58.

OTHER CASTS AND VERSIONS

Bronze

ARGENTINA
Buenos Aires, Museo Nacional de Bellas Artes. Founder: Alexis Rudier.

CANADA
Montreal, Montreal Museum of Fine Arts. This is a very early cast, the arms and wings having been cast separately. Signed: A. Rodin. No foundry mark.

CZECHOSLOVAKIA
Prague, Národní Galerie. Cast in 1934 from a plaster in the museum.

FRANCE
Paris, Musée Rodin. Founder: Alexis Rudier.

GREAT BRITAIN
Edinburgh, National Gallery of Scotland. Gift of J. J. Cowan, 1930. Purchased from Rodin in 1897. No foundry mark.
Glasgow, Glasgow Art Gallery and Museum. Burrell Collection.

UNITED STATES
Cambridge, Fogg Art Museum, Harvard University. Grenville L. Winthrop Bequest, 1943.

Chapel Hill, William Hayes Ackland Memorial Art Center, University of North Carolina.
New York City, Paul Rosenberg and Company.
San Francisco, California Palace of the Legion of Honor. Gift of Alma de Bretteville Spreckels. Founder: Alexis Rudier.

Plaster, height 44⅛ inches

CZECHOSLOVAKIA
Prague, Národní Galerie. Obtained in 1923.

Bronze, height 92¾ inches

FRANCE
Paris, Musée Rodin.

JAPAN
Tokyo, National Museum of Western Art (ex. Collection Matsukata). Signed: A.Rodin.

The Defense of Verdun

Bronze, height 185½ inches

FRANCE
Verdun, in front of Porte St.-Paul. Monument erected in 1920 (fig.66–1).

Plaster

FRANCE
Paris, Musée Rodin.

RELATED WORKS

The Spirit of War

Bronze, height 44½ inches

UNITED STATES
Chicago, Collection Mrs. Henry A. Markus. Founder: Griffoul et Lorge (fig.66–2).

Head of "The Spirit of War"

Bronze, height 6¼ inches

FRANCE
Paris, Musée Rodin.

UNITED STATES
Stanford, Stanford University Art Gallery and Museum. Gift of B.G. Cantor Art Foundation. Founder: Georges Rudier. Cast no.6/12.

67 The Burghers of Calais
1884–95

Bronze, 82½ × 94 × 75 inches
Signed top of base between feet of
Jean de Fiennes and Jacques de Wiessant:
A. Rodin
Foundry mark rear of base to right:
ALEXIS. RUDIER./FONDEUR.
PARIS.

68 Small Head of
Pierre de Wiessant
1886

Bronze, 4¼ × 3 × 3¼ inches
Signed on neck to right: A. Rodin
Foundry mark back of neck to left:
ALEXIS. RUDIER/Fondeur. Paris.

69 Assemblage of Heads of
"The Burghers of Calais"
late 1880s?

Plaster, 9½ × 11 × 9¼ inches
Not signed or inscribed

In 1884 Rodin was approached by the city of Calais to make a monument to the celebrated burghers of that city who in 1347 offered themselves as hostages to England's King Edward III after Calais had been besieged for more than eleven months. The English king had agreed to lift the siege if six hostages, wearing sackcloth and halters and carrying the keys of the city, would present themselves at his camp. This they did, although their liberty was later restored to them at the request of Edward III's wife, Queen Philippa.

It is not often realized how controversial a figure one of the hostages, Eustache de Saint-Pierre, was in the eighteenth and nineteenth centuries. In 1764 M. de Bréquigny, a member of the Académie des Inscriptions, was sent to London by the French government.[1] Documents he discovered revealed that on August 24, 1347, a life concession of the houses formerly belonging to Jean d'Aire, another of the hostages, was made to Queen Philippa of England, while on October 8 of the same year some of the houses formerly belonging to Eustache de Saint-Pierre were returned to him, and he was granted a pension of 40 marks sterling.

"How," Bréquigny asked, "could Eustache de Saint-Pierre, who is represented as sacrificing himself with so much generosity to the duties of a subject and a citizen, how could

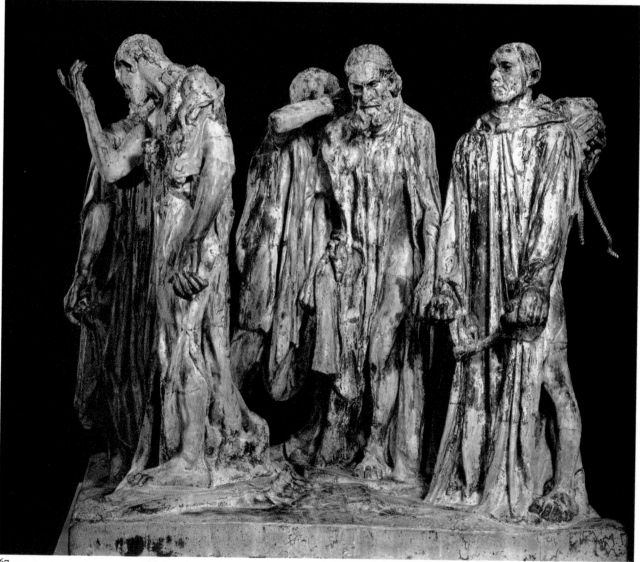

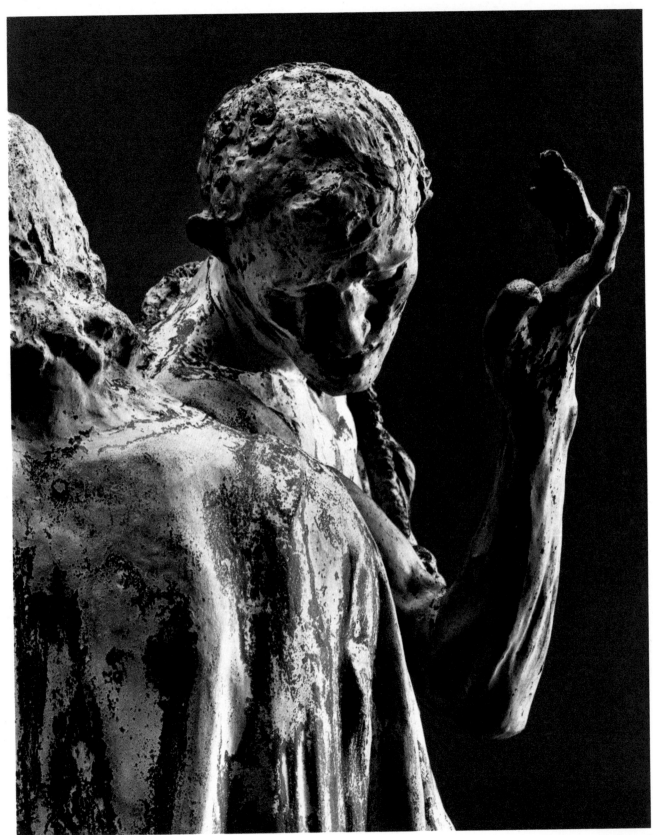

67 *The Burghers of Calais* (detail of Pierre de Wiessant)

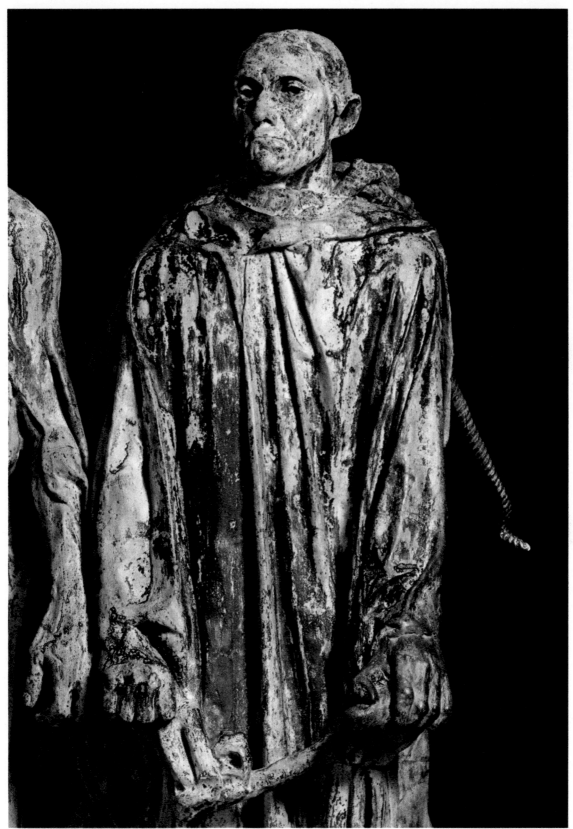

67 *The Burghers of Calais* (detail of Jean d'Aire)

he consent to recognize the enemy of his country as sovereign and solemnly undertake to maintain for him the very place that he had defended for such a long time against him; and, finally how could he bind himself to him by the strongest tie of all, the acceptance of favors? It is this that seems to me to conflict with the elevated ideas formed so far of his patriotic heroism."[2] In his *Essai sur les mœurs,* Voltaire had even been led to conclude that the most famous episode was the least remarkable of the entire siege, that Edward III never had any intention of beheading the burghers, and that it was ridiculous to see in it a tragic incident.[3]

About 1767–68, when the citizens of Calais first considered raising a monument to Eustache de Saint-Pierre, they approached M. de Bréquigny directly. The latter replied to M. Pignault de Lépinoy, Mayor of Calais: "It was not until October 1347 that Eustache de Saint-Pierre attached himself to the King of England; the truce which suspended hostilities between the two nations was so prolonged that, as long as he lived, he saw no more war between England and France. However, one cannot help regretting, for his greater glory, that he did not imitate his companions Wiessant and d'Aire, who let their goods be confiscated without reclaiming them; but the beautiful deed done to save his fellow citizens is no less deserving of the monument that you propose to erect to him."[4] Bréquigny promised to speak to Jean-Jacques Caffieri about a monument, but nothing came of this first attempt, although a plaque was attached to the house on the site of Eustache de Saint-Pierre's birthplace.

In 1835 the Société des Antiquaires de Morinie de Saint-Omer organized a competition for a dissertation on the theme of "the devotion of Eustache de Saint-Pierre and his companions at the siege of Calais in 1347, an historic fact that several authors seem to have doubted."[5] To the indignation of the citizens of Calais the prize was awarded to M. Auguste Clovis Bolard, who concluded on a note of doubt: "Let nobody think that we have repudiated his devotion as senseless. We would have liked to proclaim him vanquisher of the country—but we have said that we have doubts."[6]

In 1838 the Société d'Agriculture, du Commerce, Sciences et Arts de Calais organized another competition, the theme being "the devotion of Eustache de Saint-Pierre and his companions in 1347." The rules of the competition stated: "This dissertation, at the same time as it contains the panegyric of the heroic action of the great citizens of Calais, should have as its principal aim the refutation of the historical doubts entertained with regard to these events by M. de Bréquigny, member of the Académie des Inscriptions, and by one of the most recent laureates of the Société des Antiquaires de Morinie."[7] At the session of August 24, 1839, the gold medal was given to M. Auguste Lebeau, who concluded that the devotion of Eustache de Saint-Pierre was undeniable.[8]

Attempts to commemorate the heroic events in sculptural form had begun as early as 1819. In that year the sculptor Eugène Cortot received the commission for a bust of Eustache de Saint-Pierre. This was inaugurated in 1820 and remained in the Hôtel de Ville in Calais until World War II. In 1845 the Société d'Agriculture asked David d'Angers to submit a project for a monument to Eustache de Saint-Pierre, but he died before it could be submitted. Two of his pupils then undertook to complete the work, but this idea had to be abandoned because public funds proved to be insufficient. In 1868 further attempts were made. The sculptor Jean-Baptiste Clésinger was entrusted with the task, but the outbreak of the Franco-Prussian War caused this project to be abandoned as well. In the autumn of 1884 the Municipal Council of Calais took up the idea again. It was decided to open a national subscription, at the

68

69

head of which the city subscribed 5,000 francs. An inhabitant of Calais, M. Alphonse Isaac, informed Rodin of the competition and arranged for M. Omer Dewavrin, Mayor of Calais, to visit Rodin in his studio. Two other sculptors, Laurent-Honoré Marqueste and Emile-François Chatrousse, were also asked to submit projects.[9]

There is little doubt that Rodin must have consulted the already considerable iconography of this subject in his preparation for the undertaking.[10] His prime source of inspiration, however, were the fourteenth-century *Chronicles* of Jean Froissart, in which the most detailed account of the events is given.

> Soon afterwards, the richest burgher in the town, Sir Eustace de Saint-Pierre, got up and said: "Gentlemen, it would be a great shame to allow so many people to starve to death, if there were any way of preventing it. And it would be highly pleasing to Our Lord if anyone could save them such a fate. I have such faith and trust in gaining pardon and grace from Our Lord if I die in the attempt, that I will put myself forward as the first. I will willingly go out in my shirt, bareheaded and barefoot, with a halter round my neck and put myself at the mercy of the King of England."
> ...Another very rich and much respected citizen, called Jean d'Aire, ...rose up and said he would keep him company. The third to volunteer was Sir Jacques de Wissant, who was very rich both by inheritance and by his own transactions; he offered to accompany his two cousins, and so did Sir Pierre his brother. Two others completed the number, and set off dressed only in their shirts and breeches, and with halters round their necks, as they had been told.[11]

In the autumn of 1884 Rodin worked on his first *maquette* (fig. 67–69–1). "The idea," he wrote to M. Dewavrin on November 20, 1884, "seems to me to be completely original from the point of view of architecture and sculpture. Moreover, the subject itself is original and imposes an heroic conception; this group of six self-sacrificing figures has a communicative expression and emotion. The pedestal is triumphal and has the rudiments of a triumphal arch, in order to carry, not a quadriga, but human patriotism, abnegation, and virtue.... Rarely have I succeeded in giving a sketch such élan and sobriety. Eustache de Saint-Pierre, alone, his arm slightly raised, leads his relatives and his friends by the dignity of his determined movement."[12]

In this letter Rodin estimated the cost at 25,000 francs, plus the sculptor's fees. In a letter of November 25, 1884,[13] the estimated cost of the monument had been raised to 34,000 francs, the founder having confirmed that the casting would cost 15,000 francs and the architecture, in hard stone, about 4,000 francs. By the middle of January 1885, the committee had decided unanimously in favor of Rodin's group, although it was agreed that before submitting the finished monument the artist should complete a *maquette* one third the final size.[14] On January 28, 1885, the contract between the two parties was signed, Rodin receiving a first payment of 15,000 francs, the rest to be paid in installments.[15] On February 12 Rodin announced that the work, but not the casting, would be finished in the first months of 1886.[16]

Rodin now worked on the development of the individual figures, choosing as models men of strong character rather than of physical perfection. It is generally said that Auguste Beuret, Rodin's son, and the painter Jean-Charles Cazin posed for certain parts of the figures. It has also been suggested that the popular model Pignatelli *(see no. 65)* may have posed for the tall, thin nude study of Eustache de Saint-Pierre. According to Rodin's practice, the individual burghers were modeled in the nude before being clothed *(see figs. 67–69–2 through 6)*. The importance he attached to this procedure can be seen from the letter he wrote to M. Dewavrin on July 14, 1885, in which he said that the *maquette* was on the point of being sent.

It [the *maquette*] is made to be executed on a large scale, so there are negligences of details that should not be the cause of astonishment, since in general all the draperies will be reworked on a large scale; the modeling of the folds varies, as the mannequin on which one experiments with the drapery does not give the same result twice running.

The nudes, that is to say the part underneath, are complete, and I am going to have them executed definitively so as not to waste any time. You see it is the part one does not see, which is nonetheless the most important, that is finished.[17]

In view of what has so far been said about the susceptibilities of the citizens of Calais with regard to their beloved burghers, it is hardly surprising that they found fault with Rodin's moving group. However, their objections were couched as much in terms of the doctrines of academic art as in those of wounded pride. The committee declared:

This is not the way we envisaged our glorious citizens going to the camp of the King of England. Their defeated postures offend our religion.... The silhouette of the group leaves much to be desired from the point of view of elegance. The artist could give more movement to the ground which supports his figures and could even break the monotony and dryness of the silhouette by varying the heights of the six subjects.... We notice that Eustache de Saint-Pierre is dressed in a material which is much too heavy to represent the light costume which history accords him.... We feel it our duty to insist that M. Rodin modify the attitudes of his figures and the silhouette of his group.[18]

These criticisms occasioned from Rodin one of the most explicit statements of his aesthetic principles. In an undated letter to M. Dewavrin, which must have been written early in August 1885, Rodin wrote:

I have just reread a note in the *Patriote de Calais* which almost repeats the criticisms which have already been heard, but which would mutilate my work: *the heads should form a pyramid* (the Louis David method); *instead of a cube, the straight line.* It is quite simply the Academy which is giving me rules. *I am directly opposed to this principle,* which has prevailed in our period from the beginning of the century, and is directly opposed to the preceding periods of great art, and results in frigidity, lack of movement, and conventionalism in works conceived in this spirit.

Second. Eustache de Saint-Pierre seems to the critic to be in front of the king; what are the others doing who are behind, then? No, he is leaving the town and descending toward the camp; it is this that gives to the group the appearance of walking, of movement. Eustache is the first to descend and for my lines he needs to be like this.

Third. The monument must be in a garden or in an architectural framework. *It must be in the middle of a square.*

Only the one who is in despair and is lurching forward can be modified; if you can get away with this, my group will be saved. These gentlemen do not realize that it is a question of a model one third the final size and not a consultation for doing a completely new work.

In Paris I am the opponent of that theatrical art of the Academy. This is an attempt to make me follow people whose conventional art I despise.

...The cube gives expression; the cone is the hobbyhorse of pupils competing for the Prix de Rome.[19]

In spite of these setbacks Rodin was authorized to proceed with his work. On June 17, 1886, he received the sum of 2,000 francs, probably to pay for the enlargement of the figures seen in the studio in 1886 by Edmond de Goncourt. In his *Journal* de Goncourt referred to the "life-size clay studies for the six hostages of Calais, modeled with a powerful, realistic accentuation and having the beautiful hollows in the human flesh that Barye put in the flanks of his animals."[20]

67-69-1

In 1886 a financial crisis in Calais caused the subscription to be suspended, although Rodin did not cease working on the group for this reason. Three of the over life-size figures were seen at the Galerie Georges Petit in 1887,[21] and two more at the same gallery in 1888, while in the spring of 1889 the whole group was seen in plaster at the Exposition Monet-Rodin. The firm of Thiébaut Frères was prepared to cast the group for 18,000 francs, but the money for the subscription was still not forthcoming. On October 18, 1890, Rodin wrote to M. Dewavrin: "I have begun to hope again, although I will tell you that I have never despaired. Even the best things always need time, and they are better for that reason; and I often look at my group and reflect on little things to make it better."[22]

The completion of the individual figures did not by any means signify the end of Rodin's work on this monument. The composition of the group posed particular problems. Rodin later said:

> I did not want a pedestal for these figures. I wanted them to be placed on, even affixed to, the paving stones of the square in front of the Hôtel de Ville in Calais so that it looked as if they were leaving in order to go to the enemy camp. In this way they would have been, as it were, mixed with the daily life of the town: passersby would have elbowed them, and they would have felt through this contact the emotion of the living past in their midst; they would have said to themselves: "Our ancestors are our neighbors and our models, and the day when it will be granted to us to imitate their example, we would show that we have not degenerated from it." ... But the commissioning body understood nothing of the desires I expressed. They thought I was mad ... Statues without a pedestal! Where had that ever been seen before? There must be a pedestal; there was no way of getting around it.[23]

Alternatively Rodin considered placing them on a very high pedestal, like a Breton Calvary. In the end, however, he was forced to resign himself to a pedestal of medium height. The most pressing problem he had to face was how to insure that the group of figures did not remain static. He wanted to arrange the six figures so that, as in the single figure of *St. John the Baptist Preaching* (no. 65), the movement of the group was represented in all its stages, from beginning to end. Seen from the front, the group seems more or less static, the attitudes of the visible figures ranging from the immobility of Jean d'Aire to the incipient movement of Eustache de Saint-Pierre. However, as the spectator is directed in a clockwise direction around the group by the expansive gesture of Pierre de Wiessant, the movement quickens until, when seen from behind, the limbs are aligned as if the burghers are just setting off. The skill with which Rodin solved the compositional problem posed by this group is in general not sufficiently realized.

Another problem that faced Rodin was the achievement of the necessary monumental unity while retaining the individuality of the figures. Anxious as he was to make individuals of the six burghers, there was a risk that this group of six very different characters might fall into incoherence. One of the main ways in which this was avoided was the thematic repetition of parts throughout the whole, a device used extensively in *The Gates of Hell (see no. 1)*. For example, the right hand of Pierre de Wiessant is also used for the right hand of Jacques de Wiessant. Variations on the same head with grimly clenched lips and a prominent brow are

67–69–1 *First Maquette for "The Burghers of Calais"*
 1884, plaster, height 23 ½ inches
 Musée Rodin, Paris

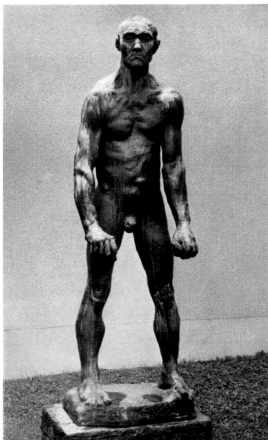

67-69-2

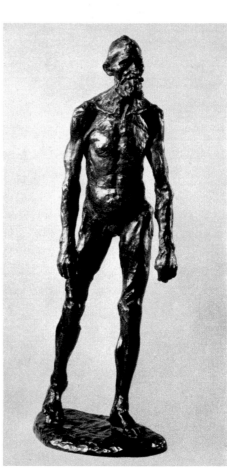

67-69-4

67-69-3

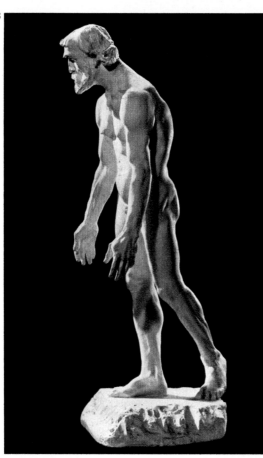

67-69-5

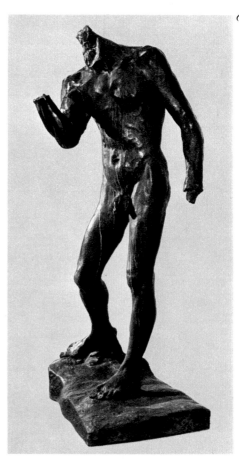

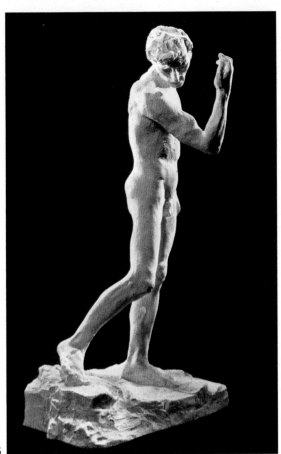

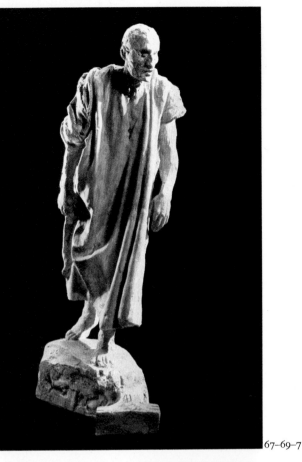

67–69–6

67–69–7

67–69–8

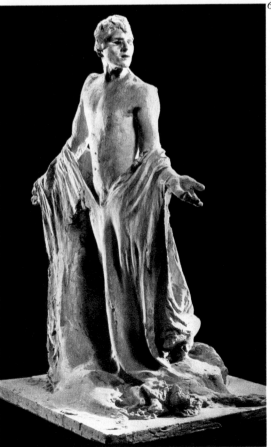

67–69–2
Study for Nude Figure of Jean d'Aire
By 1886, bronze, height 80¾ inches
Kunsthaus Zurich

67–69–3
Study for Nude Figure of Eustache de Saint-Pierre
1885, plaster, height 26¼ inches
Musée Rodin, Paris

67–69–4
Study for Nude Figure of Eustache de Saint-Pierre
1885, bronze, height 38½ inches
Location unknown

67–69–5
Study for Nude Figure of Pierre de Wiessant
By 1886, bronze, height 75 inches
Minneapolis Institute of Arts

67–69–6
Study for Nude Figure of Pierre de Wiessant
1885, plaster, height 26 inches
Musée Rodin, Paris

67–69–7
Study for Figure of Jacques de Wiessant
1885, plaster, height 27½ inches
Musée Rodin, Paris

67–69–8
Study for Figure of Jean de Fiennes
1885, plaster, height 28 inches
Musée Rodin, Paris

used for the figures of Jean d'Aire, Andrieu d'Andres, and Jacques de Wiessant. As the spectator moves around the group, the fact is registered that identical or closely related parts are being used, although there is sufficient variation for this not to strike one as a merely artificial unifying device.

In September 1893 the subscription was taken up again on the initiative of M. Dewavrin. At the end of April 1894, Rodin went to Calais to study the placing of his monument, while at the same time negotiations went on with several founders. The firm of Griffoul et Lorge was approached, but Rodin, who was anxious that each figure should be cast in a single piece, rejected their offer as they were of the opinion that each figure would have to be cast in two pieces. Thiébaut had made an offer of 18,000 francs, but the well-known firm of Le Blanc-Barbédienne offered to do the job for 12,000 francs and was finally given the contract.

The public subscription was still making very slow progress. In March 1894 the Minister of the Interior authorized a lottery consisting of 45,000 tickets of one franc each. This too went very slowly, so that the Ministry of Fine Arts was finally forced to accord a subvention of 5,350 francs.

On June 3, 1895, the monument was unveiled in the place Richelieu, on a pedestal just over five feet high and surrounded by an ornate iron grille. Rodin was not alone in his dissatisfaction with the final disposition of the monument. A correspondent in *Le Petit Dauphinois* of June 1, 1896, pointed out that according to plans and guides the group was placed in a garden, while in reality it was right in front of a public lavatory.[24] It was not until 1924 that the monument was placed on a very low pedestal, as Rodin had desired, and moved in front of the rebuilt Hôtel de Ville.

In one of the most farsighted tributes to Rodin, Octave Mirbeau said of *The Burghers* in 1889: "I do not know, in any art, of an evocation of souls so splendidly compelling. Only perhaps Michelet, that great reviver of the past, sometimes had those visions which light up the depths where the dead centuries sleep."[25] In his monument Rodin tried to visualize the burghers as they actually must have been, refusing to submit them to any abstract notion of patriotism or heroism. He wanted the spectator to differentiate between them according to the single-mindedness with which they made their sacrifice. He wanted his monument to inspire the citizens of Calais by virtue of its humanity, not by its rhetorical assertion of abstract values:

I did not hesitate to make them as thin and as weak as possible. If, in order to respect some academic convention or other, I had tried to show bodies that were still agreeable to look at, I would have betrayed my subject. These people, having passed through the privations of a long siege, no longer have anything but skin on their bones. The more frightful my representation of them, the more people should praise me for knowing how to show the truth of history.

I have not shown them grouped in a triumphant apotheosis; such a glorification of their heroism would not have corresponded to anything real. On the contrary, I have, as it were, threaded them

67–69–9 *Study for Figure of Jean d'Aire*
 1885, plaster, height 27½ inches
 Musée Rodin, Paris

67–69–10 *Study for Figure of Andrieu d'Andres*
 1885, plaster, height 25⅝ inches
 Musée Rodin, Paris

67–69–11 *Study for Figure of Pierre de Wiessant*
 1885, plaster, height 27½ inches
 Musée Rodin, Paris

67–69–12 *Study for Figure of Eustache de Saint-Pierre*
 1885, plaster, height 27½ inches
 Musée Rodin, Paris

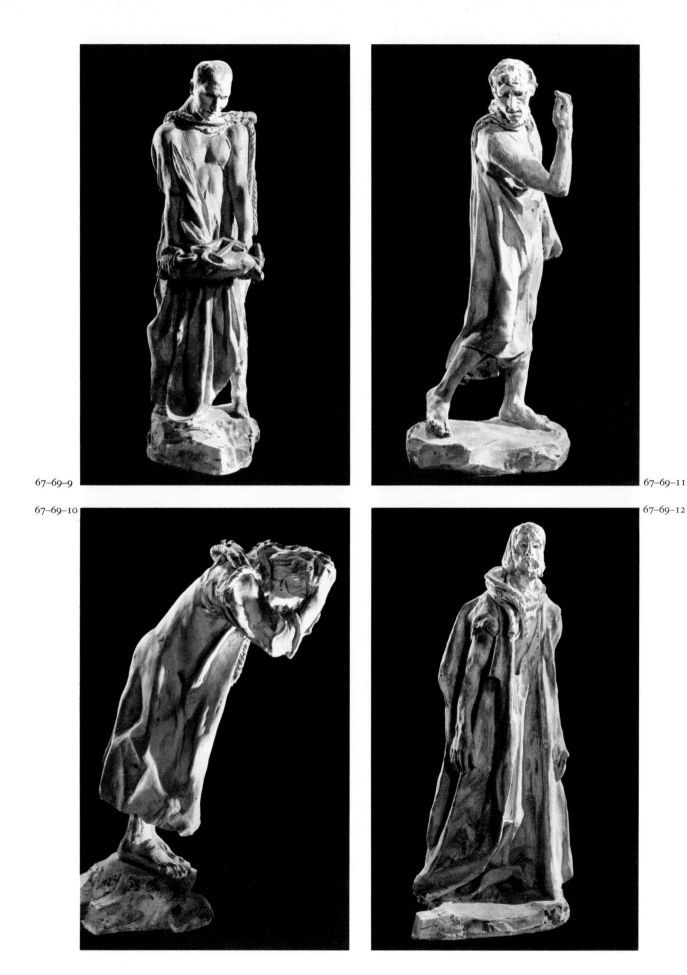

67–69–9

67–69–10

67–69–11

67–69–12

one behind the other, because in the indecision of the last inner combat which ensues, between their devotion to their cause and their fear of dying, each of them is isolated in front of his conscience. They are still questioning themselves to know if they have the strength to accomplish the supreme sacrifice—their soul pushes them onward, but their feet refuse to walk. They drag themselves along painfully, as much because of the feebleness to which famine has reduced them as because of the terrifying nature of the sacrifice . . . And certainly, if I have succeeded in showing how much the body, weakened by the most cruel sufferings, still holds on to life, how much power it still has over the spirit that is consumed with bravery, I can congratulate myself on not having remained beneath the noble theme I dealt with.[26]

The Burghers of Calais requires more empathy than any previous monument destined for public display and edification. It is public only in its scale and in the scope of its gestures, which are almost operatic; in all other respects it is intensely personal and private.

The first *maquette* for *The Burghers of Calais* dates from 1884. The studies of single burghers, nude and clothed *(see* figs. 67–69–7 through 12), date from 1885. The single figures were enlarged during the course of 1885 and 1886 and were seen by Edmond de Goncourt in the latter year. Reductions of five of the six burghers (the one exception being Jacques de Wiessant) were then made (fig. 67–69–13), probably toward the end of the 1890s, as the reduced figure of Jean d'Aire, from the collection of Johanny Peytel, was exhibited at the Exposition Rodin in 1900.

It is not known when the *Assemblage of Heads of "The Burghers of Calais"* (no. 69) was made nor for what purpose. It consists of three pairs of heads—two casts of the head of Jean d'Aire, two casts of the head of Pierre de Wiessant *(see* no. 68), and two casts of the head of Jean de Fiennes—and a number of hands placed protectively over them. Above there hovers the figure of one of the damned from *The Gates of Hell* (fig. 67–69–15), to which wings have been added.

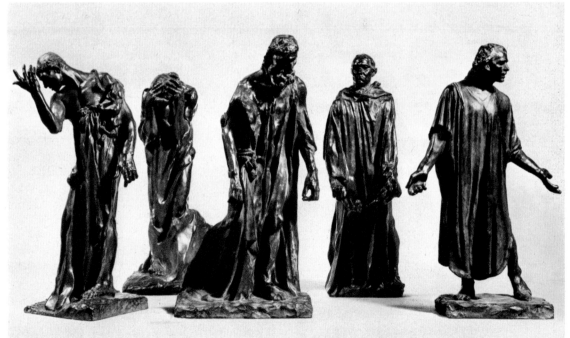

67–69–13

390

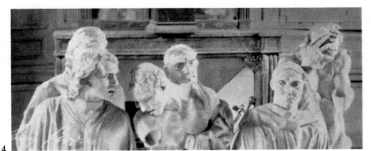

67–69–14

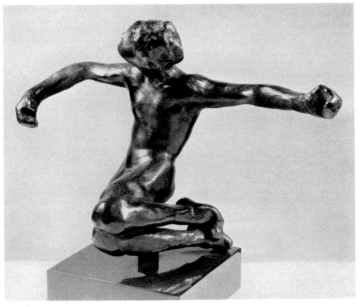

671–69–15

67–69–13
Reductions of five of the figures in
The Burghers of Calais
Late 1890s, bronze, height of each 18⅛ inches
Fine Arts Museums of San Francisco
Spreckels' Collection

67–69–14
Plaster casts of *The Burghers of Calais* in
Rodin's studio

67–69–15
A Damned Soul
Mid 1880?, bronze, height 6 inches
Location unknown

1. *See* Marcel Denquin, "A propos d'Eustache de Saint-Pierre," *Le Phare,* Calais, June 30, 1935. *See also* "Les Bourgeois de Calais," *Le Pays,* April 1895.

2. Quoted in *Le Moniteur des Arts,* an undated press clipping in the archives of the Musée Rodin. "Comment Eustache de Saint-Pierre, cet homme qu'on nous peint s'immolant avec tant de générosité aux devoirs de sujet et de citoyen, put-il consentir à reconnaître comme souverain l'ennemi de sa patrie; à s'engager solennellement de lui conserver cette même place qu'il avait si longtemps défendue contre lui; enfin, à se lier à lui par le nœud le plus fort, l'acceptation du bienfait? C'est ce qui me paraît s'accorder mal avec la haute idée donnée jusqu'ici de son héroïsme patriotique."

3. Voltaire, *Essai sur les mœurs,* vol. 1 (Paris: Editions Garnier Frères, 1963), pp. 719–20.

4. *See* n. 1 above, Denquin. "Ce ne fut qu'en octobre 1347 qu'Eustache de Saint-Pierre s'attacha au roi d'Angleterre; la trêve qui avait suspendu la guerre entre les deux nations fut tellement prolongée que, tant qu'il vécut, il ne vit plus de guerre ouverte entre l'Angleterre et la France. Cependant, on ne peut s'empêcher de regretter, pour sa plus grande gloire, qu'il n'ait pas imité ses compagnons Wiessant et d'Aire qui laissèrent confisquer leurs biens sans les réclamer, mais la belle action qu'il avait faite pour sauver ses concitoyens ne mérite pas moins le monument que vous lui destinez. J'en puis faire parler à M. Caffieri par un de mes amis qui croit qu'il s'en chargerait volontiers de l'exécution."

5. Ibid. "Il sera décerné une médaille d'or du prix de 150 francs à la meilleure dissertation sur "Le Dévouement d'Eustache de Saint-Pierre et de ses compagnons au siège de Calais en 1347, fait historique que plusieurs auteurs ont paru révoquer en doute."

6. Ibid. "Nous avons dit notre dernier mot, nous doutons … Qu'on n'aille pas croire que nous ayons nié le dévouement d'Eustache comme insensé. Nous eussions aimé le proclamer vainqueur de la patrie … mais nous l'avons dit, nous doutons."

7. Ibid. "Cette dissertation, tout en contenant le panégyrique de l'action héroïque des grands citoyens de Calais, aura pour but principal de combattre les doutes historiques qui ont jetés sur elle, entre autres par M. de Bréquigny, membre

de l'Académie des Inscriptions et par l'un des derniers lauréats de la Société des Antiquaires de Morinie."

8. The controversy was revived in 1895 at the time of the unveiling of Rodin's monument. A statement was published in *Le Pays,* April 1895, in answer to the charges leveled at Eustache de Saint-Pierre:

"Eustache de Saint-Pierre n'a pas été, comme beaucoup l'ont voulu dire, un homme ménageant les deux partis, et tâchant toujours d'être avec le plus fort. Il avait l'amour de sa patrie, mais cette patrie ne dépassait guère les murs de Calais. N'avait-il pas fait suffisamment son devoir envers le roi de France, en contribuant de toute son énergie à la résistance de la ville contre les conquérants?

"Quand elle eut changé de maître, il ne crut pas devoir se désintéresser de sa propriété parce qu'elle était anglaise.

"C'est pourquoi Edward III, ayant besoin de personnes expérimentées capables de le renseigner sur les coutumes et les richesses de la ville, voulut faire choix d'Eustache de Saint-Pierre; et c'est pourquoi celui-ci, dans l'intérêt de ses concitoyens, accepta....

"Tel est le sens que les derniers historiens donnent au rôle joué par celui dont on va inaugurer la statue."

In "Une Réhabilitation qui s'impose" by Jean Drault, *La Libre Parole,* January 7, 1904, it is recounted how a former mayor of Calais, inspecting the archives of that city in the company of M. Jules Chavannes, ex-archivist of the city of Arras, said: "To think that they are glorifying in bronze scum like that who sold their country."

On reexamining documents "D'autres savants... ne tardèrent pas à se rendre compte que pas un mot ne s'y trouvait qui put infirmer le récit de Froissard [sic]. Ce qu'on avait pris pour une donation d'Edward III à des français ayant trahi leur pays, n'était qu'une restitution de leurs biens confisqués qu'imposait, aux termes des traités, la paix ayant été signée."

Drault blamed "Judeo-Protestant free-masonry" for this distortion of history! "C'est en empoisonnant les sources de notre histoire que les judéo-protestants alliés à l'étranger sont parvenus à nous dominer. Ils sèment de crimes le passé de la France et ils nous disent:—Voilà vos aïeux! Des bandits et des traîtres!... Comment osez-vous les défendre?"

9. These are the facts as recorded by Cladel [26], p. 152. Frisch and Shipley [42], pp. 136–41, give a different version of the events leading to Rodin's being commissioned to execute the monument. According to their account, in 1883 Baron Alphonse de Rothschild, founder of the weekly journal *L'Art* (later *La Revue des Deux Mondes de l'Art),* hearing that Rodin was in a difficult financial position and having just returned from his estate near Calais, instructed Léon Gaucher, editor of the magazine, to inform Rodin that the magazine wished to present Calais with a statue of Eustache de Saint-Pierre, for which Rodin would be paid 15,000 francs. Upon Rodin's informing Gaucher that he wanted to do six figures, Gaucher communicated with the Municipal Council of Calais, which declared itself ready to add 20,000 francs to the sum the baron was offering.

Frisch and Shipley must have derived their version of the facts from the apparently verbatim account given by Rodin, contained in Coquiot [31], pp. 104–5. "Un jour, je reçois une lettre d'un sieur Léon Gauchez [sic], aux gages de feu le baron Alphonse de Rothschild, qui me mande à son bureau. Ce Gauchez, belge d'origine, marchand de tableaux, commanditaire du journal *L'Art,* en était aussi le critique d'art le plus médiocre et le plus encombrant sous divers pseudonymes: Paul Leroi, Noël Gehuzac, etc. Il faisait, je le savais, beaucoup de commandes au nom de son riche patron; et cela, à cette époque, était bien pour me tenter. Je vais donc chez l'homme en question; et, de haut, voici qu'il me commande un *Eustache de Saint-Pierre,* pour une somme de quinze mille francs."

Although asked for one figure, Rodin decided to do the group of six burghers. "Le lendemain, j'avertis de ma résolution le sieur Gauchez. Il ricane, et me jure qu'il ne 's'occupera plus de me tirer de la misère!'" (p. 105).

10. For a full account of other versions of the theme, *see* Peumery [85]. Among the foremost depictions of the theme may be mentioned the miniature in the manuscript of Froissart's *Chronicles* preserved in the Municipal Library of Breslau; the painting *Eustache de Saint-Pierre at the Siege of Calais* by Jean-Simon Berthelémy, offered to Louis XVI in 1779 and now at Versailles, and the engraving of the above-mentioned painting by Jean-Louis Anselin. Anselin dedicated this engraving to l'Assemblée Constituante in 1790 and, upon offering a proof to the city of Calais in

that year, was made a citizen of the city. Mention should also be made of *The Surrender of Calais* by H.-C. Salons, engraved by the English engraver John Henry Robinson.

The subject became extremely popular in the nineteenth century. In 1819 Ary Scheffer exhibited a painting by the name of *The Burghers of Calais* at the Salon. Christian Beutler believes this to have been the most important influence. "Ni le renvoi à l'emplacement, devant les murs de la ville, indiqué dans la première lettre de Rodin—(il quitte la ville et descend vers le camp)—, ni l'allusion à la population affamée et en pleurs, ne sont compréhensibles sans la connaissance du tableau d'Ary Scheffer" ("Les Bourgeois de Calais de Rodin et d'Ary Scheffer," *Gazette des Beaux-Arts,* Paris, 79 [January 1972], p.44). Two other versions of the theme—Alexandre-Evariste Fragonard's *The Burghers of Calais in the Tent of Edward III,* exhibited at the Salon of 1882, and one by Henri Génois—were delegated to the Musée d'Arras but were destroyed in World War I. *See also* E. Coulon, "Mon vieux Calais," *Le Petit Calaisien,* Calais, July 29, 1929.

11. John Jolliffe, ed. and trans., *Froissart's Chronicles* (London: Harvill Press, 1967), p.155.

12. This and the following quotations from Rodin's correspondence with Omer Dewavrin, Mayor of Calais, are taken from the typescript of the correspondence in the library of the Philadelphia Museum of Art.

"L'Idée me semble complètement originale, au point de vue de l'architecture et de la sculpture. Du reste, c'est le sujet lui même qui l'est, et qui impose une conception héroïque; et l'ensemble des six figures se sacrifiant à une expression et une émotion communicative. Le piédestal est triomphal, et a les rudiments d'un arc de triomphe, pour porter, non un quadrige, mais le patriotisme humain, l'abnégation, la vertu....

"Rarement j'ai réussi une esquisse avec autant d'élan et de sobriété. Eustache de St-Pierre, seul, par son mouvement digne, détermine et entraîne ses parents et amis....

"Je dois aussi vous envoyer aujourd'hui un dessin, une autre idée *(mais c'est l'esquisse en plâtre)* que je préfère."

13. Ibid. By November 1884 Rodin's ideas were already well known in Calais. *See Le Guetteur de Saint-Quentin,* Calais, November 28, 1884. "Le projet qui nous paraît le plus original est celui de M. Rodin, sculpteur à Paris, dont la maquette groupe sur le même socle dans des attitudes diverses, les six bourgeois de Calais."

14. *See* P. A. Isaac, "Le Monument d'Eustache de Saint-Pierre," *Journal de Calais,* Calais, January 14, 1885.

"Dans sa séance de lundi dernier, dont nous parlions samedi, la commission chargée de l'érection du monument d'Eustache de Saint-Pierre et de ses compagnons, a pris a l'unanimité une décision en faveur du groupe de M. Rodin dont on a pu voir un projet au Grand Salon de la Mairie.

"L'éminent artiste enverra prochainement une nouvelle maquette montrant le groupe au tiers de l'exécution définitive; d'après ce travail très poussé, on pourra juger des nuances et apprécier la puissance de son talent."

15. Cladel [26], p.155.

16. Letter of February 12, 1885, from the typescript in the library of the Philadelphia Museum of Art. "Dans les premiers mois de 86 l'œuvre sera terminée, mais non la fonte."

17. Letter of July 14, 1885, from the typescript in the library of the Philadelphia Museum of Art.

"Il est fait dans le but de l'exécution, aussi il y a des négligences de détail qui n'ont pas lieu d'étonner, car en général toutes les draperies seront recommencées en grand; le modèle de plis variant, le mannequin sur lequel on jette la draperie ne donne pas deux fois la même chose.

"J'ai mes nus, c'est-à-dire le dessous qui est fait, et que je fais mettre au point pour ne pas perdre de temps. Vous voyiez que c'est ce que l'on ne voit pas, et qui est le principal, qui est terminé....

"Autrement je pourrais faire un travail inutile au but, mais simplement pour charmer l'œil des Calaisiens, il faudrait que je fasse une dépense de 300 frs en pure perte pour nettoyer par ci par là et pour abatardir le travail, ce qui ne serait que pour le public, car l'esquisse au point de vue de l'artiste est mieux ainsi."

18. Quoted in Cladel [26], p.157. "Ce n'est pas ainsi que nous nous représentions nos glorieux concitoyens se rendant au camp du Roi d'Angleterre. Leur attitude affaissée heurte notre religion.... La silhouette du groupe laisse à désirer sous le rapport de l'élégance. L'auteur pourrait mouvementer davantage le sol qui porte ses personnages et même rompre la monotonie et la sécheresse des lignes extérieures en variant les tailles des six sujets.... Nous remarquons qu'Eustache de Saint-Pierre est couvert d'une étoffe aux plis trop épais pour représenter le costume léger que lui accorde l'histoire.... Nous croyons devoir

insister auprès de M. Rodin pour l'engager à modifier les attitudes de ses personnages et la silhouette de son groupe."

19. Ibid., pp. 158, 159. "Je relis à l'instant une note du *Patriote de Calais* qui relève à peu près les critiques déjà entendues, mais qui châtreraient mon œuvre; *les têtes devant faire pyramide (méthode Louis David) au lieu du cube, de la ligne droite;* c'est tout simplement l'Ecole qui me donne des lois; *je suis directement opposé à ce principe,* qui a prévalu dans notre époque depuis le commencement du siècle qui est directement opposé aux grandes époques d'art précédentes, et qui donne aux œuvres conçues sous cet esprit froideur et manque de mouvement, convention.

"2e Eustache de Saint-Pierre semble au critique devant le roi; que feraient ceux qui sont derrière, donc? Non, il quitte la ville et descend vers le camp; c'est ce qui donne au groupe cet aspect de marche, de mouvement. Eustache est le premier qui descend et pour mes lignes il a besoin d'être ainsi.

"3e Le monument doit être dans un jardin ou dans un monument d'architecte. *Il doit être au milieu d'une place.*

"Celui qui désespère et plonge seul peut être modifié; si vous obtenez cela seulement, mon groupe est sauvé. Ces Messieurs ne savent pas que c'est une exécution au tiers et non pas une consultation pour refaire un nouveau travail qu'il s'agit.

"Je suis à Paris l'antagoniste de cet art théâtral et d'Ecole. C'est vouloir me faire le suiveur de gens dont je méprise l'art conventionnel.

"…Le cube donne l'expression; le cône est le cheval, le dada des élèves concourant au prix de Rome."

20. Goncourt [53], vol. 3, p. 563. "Samedi 17 avril.— …Rodin fait tourner sur leurs selles les *terres* grandeur nature de ses six *Otages de Calais,* modelés avec une puissante accusation réaliste et ces beaux trous dans la chair humaine que Barye mettait dans les flancs de ses animaux."

21. *See L'Avenir de Calais,* Calais, June 9, 1887.

22. Letter of October 18, 1890, from the typescript in the library of the Philadelphia Museum of Art. "Je me suis remis à espérer bien que je vous dirai que je n'ai aucunement désespéré. les affaires même les meilleures ont toujours besoin de temps et elles sont mieux par cette raison. ainsi je regarde souvent mon groupe et y réfléchit à de petites choses de fesant gagner."

At one point Léon Maillard, visiting Rodin's studio in the boulevard d'Italie, saw only the upper sections of the bodies lined up on the modeling stand. An early Druet photograph, signed by Rodin, shows the burghers lined up in two rows (fig. 67–69–14). First row from left to right: Jean de Fiennes, Pierre de Wiessant, Jean d'Aire; second row from left to right: Eustache de Saint-Pierre, Jacques de Wiessant, and Andrieu d'Andres. This photograph reveals particularly clearly the very close relationship between the heads of Jean d'Aire and Jacques de Wiessant.

23. Quoted in *L'Art et les Artistes* [330], pp. 67–68. "Je ne voulais aucun piédestal à ces statues. Je souhaitais qu'elles fussent posées, scellées à même les dalles de la place publique, devant l'hôtel de ville de Calais, et qu'elles eussent l'air de partir de là pour se rendre au camp des ennemis. Elles se seraient ainsi trouvées comme mêlées à l'existence quotidienne de la ville: les passants les eussent coudoyées et ils eussent ressenti à ce contact l'émotion du passé vivant au milieu d'eux; ils se fussent dit: 'Nos ancêtres sont nos voisins et nos modèles, et le jour où il nous sera donné d'imiter leur exemple, nous devrons montrer que nous n'avons pas dégénéré de leur vertu!' …Mais la commission officielle ne comprit rien aux désirs que j'exprimai. Elle me crut fou… Des statues sans piédestal! Où donc cela s'était-il jamais vu. Il fallait un piédestal: il n'y avait pas moyen de s'en passer."

Compare the letter of December 8, 1893, from the typescript in the library of the Philadelphia Museum of Art.

"Cependant j'avais pensé primitivement que les bourgeois quittant la place du marché, dans la confusion des adieux, seul de St.-Pierre (Etienne) commençant à marcher pour couper court à cette scène pénible; j'avais pensé que placé très bas le groupe devenait plus familier, et faisait entrer le public mieux dans l'aspect de la misère et du sacrifice, du drame dis-je. Il serait bon peut-être d'avoir un deuxième projet d'architecte très bas mais assez important tout de même d'aspect.

"Il peut se faire que je me trompe, car je ne juge jamais que lorsque mon œil a vu les choses en place dans l'incertitude, je m'en rapporte à la Commission dont vous êtes président.

"Tel que votre croquis me montre le monument, il me semble qu'il se découpera sur le ciel, ayant à sa droite l'hôtel des postes, et à sa gauche le square, ce serait bien; beaucoup mieux que s'il se trouvait devant les arbres du jardin; dans ce cas, il ne se profilerait pas, et je retour-

nerais à mon idée de l'avoir très bas pour laisser au public pénétrer le cœur du sujet, comme dans les mises au tombeau d'églises, où le groupe est presque par terre."

24. Singulus, "Bruits et rumeurs," *Le Petit Dauphinois,* Calais, June 1, 1896. "On a dressé ce merveilleux monument, que les gens d'ici trouvent fort laid, devant un jardin disent les guides et les plans, devant un petit chalet de nécessité, dit la réalité désolante. Comme l'argent manquait, selon toute apparence, pour leur offrir un piédestal convenable, les cinq [*sic*] Bourgeois ont été juchés sur une sorte de billard à bandes vertes, ou mieux de pierre tombale qui met leurs têtes à peine à la hauteur du toit de l'édicule voisin."

25. Mirbeau [254], p.80. "Je ne connais, dans aucun art, une évocation d'âmes aussi splendidement étreignante. Seul peut-être, Michelet, ce grand ressusciteur du passé, eut-il parfois de ces visions qui éclairent la profondeur où dorment les siècles morts."

26. Quoted in *L'Art et les Artistes* [330], pp.66–67. "Je n'ai pas hésité à les faire aussi maigres, aussi décharnés que possible. Si, pour respecter je ne sais quelle convention académique, j'avais cherché à montrer des musculatures encore agréables à voir, j'aurais trahi mon sujet. Ces gens-là ayant passé par les privations d'un long siège, ne doivent plus avoir que la peau sur les os. Et plus je les ai représentés effrayants d'aspect, plus l'on doit me louer d'avoir su rendre la vérité de l'Histoire.

"Je ne les ai pas groupés en une apothéose triomphante: car une telle glorification de leur héroïsme n'aurait correspondu à rien de réel. Au contraire, je les ai comme égrenés les uns derrière les autres, parce que, dans l'indécision du dernier combat intérieur qui se livre entre leur dévouement à leur cité et leur peur de mourir, chacun d'eux est comme isolé en face de sa conscience. Ils s'interrogent encore pour savoir s'ils auront la force d'accomplir le suprême sacrifice... Leur âme les pousse en avant et leurs pieds refusent de marcher. Ils se traînent péniblement, autant à cause de la faiblesse à laquelle les a réduits la famine, qu'à cause de l'épouvante du supplice...Et certainement, si j'ai réussi à montrer combien le corps, même exténué par les plus cruelles souffrances, tient encore à la vie, combien il a encore d'empire sur l'âme éprise de vaillance, je ne puis me féliciter de n'être pas resté au-dessous du noble thème que j'avais à traiter."

REFERENCES

The Burghers of Calais
Phillips [275], p.143; Bartlett [125], pp.198, 250; Geffroy [199a], p.19; *L'Art Français,* Paris, July 6, 1889, repr.; Roger Marx, "Les Salons de 1895," *Gazette des Beaux-Arts,* Paris, 37ᵉ année, 14 (1895), pp.114–15; Claude Phillips, "Sculpture of the Year," *Magazine of Art,* London, 18 (1895), p.446, repr. p.436; Marx [243], pp.195–96; Maillard [71], pp.63–66; Mauclair [77a], pp.34–39, repr. opp. pp.36, 38; Lawton [67], pp.145–54, repr. opp. pp.145, 151; Ciolkowska [23], pp.42–49, 78, repr. opp. p.44; Coquiot [29], pp.131–40, repr. opp. p.132; Rilke [87], pp.59–66, repr. pls. 7, 8; *L'Art et les Artistes* [330], pp.66–68; Cladel [25a], pp.290–96; Lami [4], p.167; Bénédite [10a], pp.15–16, 27–28, repr. pls. XXII–XXIV; Grappe [338], no.110; Watkins [342], p.8, repr. p.8; Grappe [338a], no.132; Grappe [338b], no.188 bis; Cladel [26], pp.152–66; Grappe [338c], no.149; Frisch and Shipley [42], pp.136–50; Story [103], pp.19–21, 146, nos. 52, 59, 60; repr. pls. 52, 59, 60; Grappe [338d], no.167; Grappe [54], p.142, repr. p.76; Waldmann [109], pp.28–32, 74, nos. 10–20, repr. pls. 10, 13, 18; Bünemann [16]; Rilke [87a], pp.48–55, repr. pl.x; Cladel [27], pp.XXIV–XXV, repr. pl. 38; Georg Schmidt, "Die geheime Konstruktion in Rodins 'Bourgeois de Calais,'" *Musées Suisses,* Geneva, no.1 (November 1948), pp.11–16; "The Burghers of Calais," *Royal Society of British Sculptors, Annual Report,* London, 1955, p.23; Josef Adolf Schmoll gen. Eisenwerth, "Rodin's 'Bürger von Calais' und ihr Kompositionsproblem: Zur Neuerwerbung der Bronzestatue des 'Verzweifelnden' für das Saarländer Museum, Saarbrücken," *Saarbrücken Hefte,* Saarbrücken, 10 (1959), pp.59–70; Story [103a], nos. 36–45, repr. pls. 38, 42, 43; Goldscheider [49], pp.32, 34, repr. p. 82; Elsen [38], pp.70–87, repr. pp. 71, 84–85; Descharnes and Chabrun [32], pp.106–15, repr. p. 114; Spear [332], pp. 40–46, repr. pl. 58; Horst W. Janson, "Une Source négligée des Bourgeois de Calais," *La Revue de l'Art,* Paris, no. 5 (1969), pp.69–70; Tancock [341], no. 59, repr. p.58; E.H. Ramsden, "The Burghers of Calais: A New Interpretation," *Apollo,* London, n.s. 91 (March 1970), pp. 235–36; Goldscheider [205], pp. 165–74; Peumery [85]; Christian Beutler, "Les Bourgeois de Calais de Rodin et d'Ary Scheffer," *Gazette des Beaux-Arts,* Paris, 79 (January 1972), pp.39–50.

Small Head of Pierre de Wiessant
Cladel [25], opp. p. 18; Rilke [87], repr. pl. 80;

Grappe [338], no. 111; Watkins [342], no. 74; Grappe [338a], no. 133; Grappe [338b], no. 196; Grappe [338c], no. 151; Story [103], repr. pl. 57; Grappe [338d], no. 170; Lecomte [68], pl. 48; Charbonneaux [22], repr. pl. 27; Cladel [28], repr. pl. 34; Story [103a], repr. pl. 45; Goldscheider [49], p. 85; Elsen [38], p. 75; Tancock [341], no. 60.

Assemblage of Heads of "The Burghers of Calais"
Watkins [342], no. 92; Paris, 1962–63 [367], no. 57, repr. p. 24; Elsen [38], p. 82, repr. p. 81; Tancock [341], no. 61.

OTHER CASTS AND VERSIONS (No. 67)

Bronze

BELGIUM
Brussels, Mariemont Park. Commissioned in 1905–6 for the Warocqué Collection.

DENMARK
Copenhagen, Ny Carlsberg Glyptotek. Commissioned by Carl Jacobsen in 1903.

FRANCE
Calais, square of the Hôtel de Ville. Founder: Le-Blanc-Barbédienne.
Paris, Musée Rodin.

GREAT BRITAIN
London, gardens of the Houses of Parliament. Purchased by the British government in 1911.

JAPAN
Tokyo, National Museum of Western Art. Purchased by the Japanese government in 1959.

SWITZERLAND
Basel, Kunstmuseum Basel. Acquired in 1948.

UNITED STATES
Los Angeles, Norton Simon, Inc. Museum of Art. Founder: Georges Rudier. Cast no. 10/12.
Washington, D.C., Hirshhorn Museum and Sculpture Garden, Smithsonian Institution. Founder: Alexis Rudier.

Plaster

FRANCE
Meudon, Musée Rodin.

ITALY
Venice, Museo d'Arte Moderna. Acquired by Principe Giovanelli at the 1895 Biennale.

First Maquette for "The Burghers of Calais"
Plaster, height 23½ inches

FRANCE
Paris, Musée Rodin (fig. 67–69–1).

Bronze, height 13⅜ inches (without pedestal)

UNITED STATES
Beverly Hills and New York City, B. G. Cantor Collections (3 casts). Founder: Godard. Cast nos. 1/12, 5/12, 6/12.
Stanford, Stanford University Art Gallery and Museum. Gift of B. G. Cantor Art Foundation. Founder: Godard. Cast no. 2/12.

OTHER CASTS AND VERSIONS (No. 68)

Bronze

AUSTRALIA
Sydney, private collection.

FRANCE
Paris, Musée Rodin.

Bronze, height 3⅛ inches

ALGERIA
Algiers, Musée National des Beaux-Arts. Purchased by the state in 1949.

FRANCE
Paris, Musée Rodin.

UNITED STATES
Mount Kisco, N.Y., Collection Mr. and Mrs. Leon L. Gildesgame.
Philadelphia, Collection Mrs. Charles J. Solomon. Signed: A. Rodin. Founder: Alexis Rudier.

Terra-cotta

ARGENTINA
Buenos Aires, Collection Antonio Santamarina.

Bronze, height 13 inches

ARGENTINA
Buenos Aires, Collection Antonio Santamarina.

FRANCE
Paris, Musée Rodin.

GREAT BRITAIN
Private collection.

UNITED STATES
Beverly Hills and New York City, B. G. Cantor Collections. Founder: Georges Rudier. Cast no. 6/12.

Plaster

FRANCE
Paris, Musée Rodin.

UNITED STATES
San Francisco, California Palace of the Legion of
Honor. Spreckels Collection.

Monumental Head of Pierre de Wiessant

Bronze, height 34 inches

BELGIUM
Ghent, Museum voor Schone Kunsten. Cast from
a plaster in the same collection.

FRANCE
Paris, Musée Rodin.

SWITZERLAND
Basel, Kunstmuseum Basel.

UNITED STATES
Cleveland, Cleveland Museum of Art. Purchased by
Mrs. Emery May Holden Norweb in Paris in
1917 before Rodin's death. Signed: A.Rodin.
Founder: Alexis Rudier.
Los Angeles, Los Angeles County Museum of Art.
Gift of B.G. Cantor Art Foundation. Founder:
Susse. Cast no. 3/12.

Plaster

BELGIUM
Ghent, Museum voor Schone Kunsten. Purchased at
the Salon of Ghent, 1909.

FRANCE
Meudon, Musée Rodin.

UNITED STATES
Cleveland, Cleveland Museum of Art. Gift of Loïe
Fuller, 1917.

OTHER CAST (No. 69)

FRANCE
Paris, Musée Rodin.

STUDIES FOR INDIVIDUAL FIGURES

Study for Figure of Jacques de Wiessant

Plaster, height 27½ inches

FRANCE
Paris, Musée Rodin (fig.67–69–7).

Bronze

UNITED STATES
Beverly Hills and New York City, B.G.Cantor Col-
lections. Founder: Susse. Cast no. 1/12.
Stanford, Stanford University Art Gallery and Mu-
seum. Gift of B.G. Cantor Art Foundation.
Founder: Susse. Cast no.3/12.

Study for Figure of Jean de Fiennes

Plaster, height 28 inches

FRANCE
Paris, Musée Rodin (fig.67–69–8).

Bronze

UNITED STATES
Beverly Hills and New York City, B.G.Cantor Col-
lections. Founder: Susse. Cast no. 1/12.
Stanford, Stanford University Art Gallery and Mu-
seum. Gift of B.G. Cantor Art Foundation.
Founder: Susse. Cast no.3/12.

Study for Nude Figure of Jean de Fiennes

Plaster, height 75 inches

FRANCE
Paris, Musée Rodin.

Reduction of Final Figure of Jean de Fiennes

Bronze, height 18⅛ inches

AUSTRALIA
Collection Sir Warwick and Lady Fairfax.

FRANCE
Paris, Collection Mme J. Caudrelier-Benac. This is
the first cast of the reduced version, made
especially for J.Peytel.
— Musée Rodin.

GERMANY (WEST)
Bremen, Kunsthalle. Gift of Galerieverein, 1906.

NORWAY
Oslo, Nasjonalgalleriet. Purchased in Oslo in 1933.

UNITED STATES
Baltimore, Baltimore Museum of Art. Gift of Wilton
C.Dinges. Founder: Alexis Rudier.
Beverly Hills and New York City, B.G. Cantor Col-
lections. Founder: Georges Rudier. Cast no.6/12.
Cambridge, Fogg Art Museum, Harvard University.
Grenville L.Winthrop Bequest, 1943. Purchased
between 1923 and 1925. Founder: Alexis Rudier.

Madison, N.J., Estate of Geraldine R. Dodge. Founder: Alexis Rudier.

New York City, Collection William S. Paley.

St. Louis, Collection Morton J. May.

San Antonio, Marion Koogler McNay Art Institute. Founder: Alexis Rudier.

San Francisco, California Palace of the Legion of Honor. Gift of Alma de Bretteville Spreckels. Founder: Alexis Rudier (fig. 67–69–13).

Small Head of Jean de Fiennes

Bronze, height 3½ inches

AUSTRALIA
Adelaide, private collection.

FRANCE
Paris, Musée Rodin.

Study for Figure of Jean d'Aire

Plaster, height 27½ inches

FRANCE
Paris, Musée Rodin (fig. 67–69–9).

Bronze

UNITED STATES
Beverly Hills and New York City, B. G. Cantor Collections. Founder: Susse. Cast no. 1/12.

Stanford, Stanford University Art Gallery and Museum. Gift of B. G. Cantor Art Foundation. Founder: Susse. Cast no. 3/12.

Study for Nude Figure of Jean d'Aire

Plaster, height 33½ inches

FRANCE
Paris, Musée Rodin.

Bronze, height 42 inches

UNITED STATES
Los Angeles, Los Angeles County Museum of Art. Gift of B. G. Cantor Art Foundation. Founder: Georges Rudier. Cast no. 2.

Stanford, Stanford University Art Gallery and Museum. Gift of B. G. Cantor Art Foundation. Founder: Georges Rudier. Cast no. 2/12.

Bronze, height 80¾ inches

FRANCE
Paris, Musée Rodin.

SWITZERLAND
Lausanne, Collection Samuel Josefowitz. Founder: Georges Rudier.

Zurich, Kunsthaus Zurich (fig. 67–69–2).

Plaster

FRANCE
Meudon, Musée Rodin.

Study for Clothed Figure of Jean d'Aire

Bronze, height 80¾ inches

BELGIUM
Brussels, Musées Royaux des Beaux-Arts de Belgique. Signed: A. Rodin. Founder: Alexis Rudier.

GERMANY (WEST)
Dortmund, Museum am Ostwall. Signed: A. Rodin. Founder: Georges Rudier.

THE NETHERLANDS
Amsterdam, Stedelijk Museum. Signed: A. Rodin. Founder: Alexis Rudier.

NORWAY
Oslo, Oslo Kommunes Kunstsamlinger. Gift of the painter Fritz Thaulow. Erected in Solliparken at Drammensveien, 1902.

PORTUGAL
Lisbon, Calouste Gulbenkian Foundation. Purchased in 1918.

UNITED STATES
Los Angeles, Los Angeles County Museum of Art. Gift of B. G. Cantor Art Foundation. Founder: Susse. Cast no. 6/12.

Plaster

GERMANY (EAST)
Dresden, Staatliche Kunstsammlungen. Purchased in 1902 from the Internationale Kunstausstellung, Dresden, 1901.

UNITED STATES
Chicago, Art Institute of Chicago. Gift of Mrs. A. H. H. Ellis, 1893. Made for the museum and sent to the World's Columbian Exposition, 1893. Signed: A. Rodin.

U.S.S.R.
Moscow, State Pushkin Museum of Fine Arts.

Stoneware, height 75 inches

FRANCE
Meudon, Musée Rodin. Signed on front: A. Rodin. Signed on back: Jeanneney 1900.

Reduction of Final Figure of Jean d'Aire

Bronze, height 18⅛ inches

ARGENTINA
Buenos Aires, Collection Mercedes Santamarina.

FRANCE
Paris, Collection Mme J. Caudrelier-Benac. This is the first cast of the reduced version, made especially for J. Peytel.
— Musée Rodin.

GERMANY (EAST)
Dresden, Staatliche Kunstsammlungen. Purchased from Rodin in 1901. Signed: A. Rodin.
Leipzig, Museum der Bildenden Künste.

GERMANY (WEST)
Bremen, Kunsthalle. Gift of Galerieverein, 1906.

GREAT BRITAIN
Glasgow, Glasgow Art Gallery and Museum. Burrell Collection. Founder: Alexis Rudier.

UNITED STATES
Cambridge, Fogg Art Museum, Harvard University. Grenville L. Winthrop Bequest, 1943. Signed: A. Rodin. Founder: Alexis Rudier.
Cleveland, Cleveland Museum of Art. Gift of Loïe Fuller, 1917. Signed: A. Rodin. Founder: Alexis Rudier.
Los Angeles, Los Angeles County Museum of Art. Gift of B. G. Cantor Art Foundation. Founder: Georges Rudier. Cast no. 6/12.
Madison, N. J., Estate of Geraldine R. Dodge. Founder: Alexis Rudier.
New York City, Collection William S. Paley.
St. Louis, City Art Museum. Signed. Founder: Alexis Rudier.
— Collection Morton J. May.
San Antonio, Marion Koogler McNay Art Institute. Founder: Alexis Rudier.
San Francisco, California Palace of the Legion of Honor. Gift of Alma de Bretteville Spreckels. Signed: A. Rodin. Founder: Alexis Rudier (fig. 67–69–13).
Shreveport, R. W. Norton Art Gallery.
Washington, D. C., National Gallery of Art. Gift of Mrs. John W. Simpson, 1942. Signed: A. Rodin.

Study for Head of Jean d'Aire

Terra-cotta, height 7½ inches

FRANCE
Paris, Musée Rodin.

Terra-cotta, height 8 inches

UNITED STATES
Maryhill, Wash., Maryhill Museum of Fine Arts.

Bronze, height 2⅜ inches

FRANCE
Paris, Musée Rodin.

Bronze, height 5¾ inches

FRANCE
Paris, Musée Rodin.

ISRAEL
Jerusalem, Israel Museum. On loan from the Billy Rose Foundation.

SWITZERLAND
Lausanne, Collection Samuel Josefowitz.

Bronze, height 10¼ inches

UNITED STATES
Chicago, Art Institute of Chicago. Robert Allerton Collection.
Santa Barbara, Collection Wright Ludington.
Shawnee Mission, Kan., Collection Mr. and Mrs. Louis Sosland. Founder: Georges Rudier. Cast no. 6/12.

Plaster

FRANCE
Paris, Musée Rodin.

Colossal Head of Jean d'Aire

Plaster, height 26¾ inches

FRANCE
Meudon, Musée Rodin.

Bronze

UNITED STATES
Beverly Hills and New York City, B. G. Cantor Collections. Founder: Georges Rudier.
Los Angeles, Los Angeles County Museum of Art. Gift of B. G. Cantor Art Foundation. Founder: Georges Rudier. Cast no. 2/12.

Bust of Jean d'Aire

Bronze, height 15⅜ inches

FRANCE
Paris, Musée Rodin.

Bronze, height 18¾ inches

BELGIUM
Brussels, Musées Royaux des Beaux-Arts de Belgique. Signed: A. Rodin.

CANADA
Toronto, Collection Mr. and Mrs. Donald B. Sterling.

Colored plaster, height 12 inches

UNITED STATES
Hagerstown, Md., Washington County Museum of Fine Arts.

Terra-cotta, height 15½ inches

CANADA
Toronto, Art Gallery of Ontario. Purchased in 1928. Not signed or dated.

Stoneware, height 17¼ inches

FRANCE
Meudon, Musée Rodin. Signed. Inscribed: Jeanneney.

UNITED STATES
Phoenix, Phoenix Art Museum. On loan from Orme Lewis. Signed.
Stanford, Stanford University Art Gallery and Museum. Gift of B. G. Cantor Art Foundation. No. 4.

Study for Figure of Eustache de Saint-Pierre

Plaster, height 27½ inches

FRANCE
Paris, Musée Rodin (fig. 67–69–12).

Bronze

UNITED STATES
Beverly Hills and New York City, B. G. Cantor Collections. Founder: Susse. Cast no. 1/12.
Stanford, Stanford University Art Gallery and Museum. Gift of B. G. Cantor Art Foundation. Founder: Susse. Cast no. 3/12.

Study for Nude Figure of Eustache de Saint-Pierre

Bronze, height 26¼ inches

FRANCE
Paris, Musée Rodin.

THE NETHERLANDS
Otterloo, Rijksmuseum Kröller-Müller. Signed: A. Rodin.

UNITED STATES
Beverly Hills and New York City, B. G. Cantor Collections. Founder: Georges Rudier. Cast no. 4/12.
Stanford, Stanford University Art Gallery and Museum. Gift of B. G. Cantor Art Foundation. Founder: Georges Rudier. Cast no. 3/12.

Plaster

FRANCE
Paris, Musée Rodin (fig. 67–69–3).

Bronze, height 38½ inches

Location unknown (fig. 67–69–4).

CANADA
Montreal, Collection Bram Garber. Founder: Georges Rudier. Cast no. 1/12.

FRANCE
Paris, Musée Rodin.

UNITED STATES
San Francisco, California Palace of the Legion of Honor. Gift of B. G. Cantor Art Foundation. Founder: Georges Rudier. Cast no. 4/12.

Reduction of Final Figure of Eustache de Saint-Pierre

Bronze, height 18⅛ inches

FRANCE
Paris, Collection Mme J. Caudrelier-Benac. This is the first cast of the reduced version, made especially for J. Peytel.
— Musée Rodin.

ITALY
Milan, Galleria d'Arte Moderna. Gift of Emilia Cimino Folliero, 1935. Purchased from Rodin.

UNION OF SOUTH AFRICA
Stellenbosch, Peter Stuyvesant Foundation.

UNITED STATES
Cambridge, Fogg Art Museum, Harvard University. Grenville L. Winthrop Bequest, 1943. Inscribed: à M. Emile Chovanard. Founder: Alexis Rudier.
Madison, N. J., Estate of Geraldine R. Dodge. Founder: Alexis Rudier.
New York City, Collection William S. Paley.
St. Louis, City Art Museum. Acquired in 1953. Founder: Alexis Rudier.
— Collection Morton J. May.
San Antonio, Marion Koogler McNay Art Institute. Founder: Alexis Rudier.
San Francisco, California Palace of the Legion of Honor. Gift of Alma de Bretteville Spreckels. Founder: Alexis Rudier (fig. 67–69–13).

Washington, D.C., Collection Mr. and Mrs. David Lloyd Kreeger. Founder: Alexis Rudier.

Head of Eustache de Saint-Pierre

Bronze, height 13 inches

FRANCE
Paris, Musée Rodin.

UNITED STATES
Beverly Hills and New York City, B.G. Cantor Collections. Founder: Georges Rudier. Cast no. 6/12.
Stanford, Stanford University Art Gallery and Museum. Gift of B.G. Cantor Art Foundation. Founder: Georges Rudier. Cast no. 3/12.

Terra-cotta

FRANCE
Paris, Musée Rodin.

Bronze, height 2¾ inches

FRANCE
Paris, Musée Rodin.

Study for Figure of Pierre de Wiessant

Plaster, height 27½ inches

FRANCE
Paris, Musée Rodin (fig. 67–69–11).

Bronze

UNITED STATES
Beverly Hills and New York City, B.G. Cantor Collections. Founder: Susse. Cast no. 1/12.
Stanford, Stanford University Art Gallery and Museum. Gift of B.G. Cantor Art Foundation. Founder: Susse. Cast no. 3/12.

Study for Nude Figure of Pierre de Wiessant

Terra-cotta, height 12¼ inches

FRANCE
Paris, Musée Rodin.

Bronze, height 26 inches

CANADA
Montreal, Collection Bram Garber.

FRANCE
Paris, Musée Rodin.

GREAT BRITAIN
London, trustees of Sir Colin and Lady Anderson. Founder: Alexis Rudier.

UNION OF SOUTH AFRICA
Stellenbosch, Peter Stuyvesant Foundation.

UNITED STATES
Whitestone, N.Y., Collection Samuel Karlan. Founder: Georges Rudier.

Plaster

FRANCE
Paris, Musée Rodin (fig. 67–69–6).

Bronze, height 78 inches

BELGIUM
Antwerp, Koninklijk Museum voor Schone Kunsten. Purchased at the Triennial Exhibition, Antwerp, 1908. Signed: A. Rodin. Founder: J. Petermann.

GERMANY (WEST)
Hamburg, Hamburger Kunsthalle. Cast in 1942.

THE NETHERLANDS
Rotterdam, Museum Boymans–van Beuningen. Acquired in 1939.

SWITZERLAND
Winterthur, Kunstverein. Acquired in 1948.

UNITED STATES
Des Moines, Des Moines Art Center. Founder: Alexis Rudier.

Plaster, height 75 inches

FRANCE
Paris, Musée Rodin.

Bronze (without hands or head), height 75 inches

FRANCE
Paris, Musée Rodin.

UNITED STATES
Minneapolis, Minneapolis Institute of Arts. Founder: Alexis Rudier (fig. 67–69–5).

Plaster

FRANCE
Paris, Musée Rodin.

Reduction of Final Figure of Pierre de Wiessant

Bronze, height 18⅛ inches

FRANCE
Paris, Collection Mme J. Caudrelier-Benac. This is the first cast of the reduced version, made especially for J. Peytel.
— Musée Rodin.

GERMANY (WEST)
Bremen, Kunsthalle. Gift of Galerieverein, 1906.

GREAT BRITAIN
Collection Benjamin Britten and Peter Pears. Signed:
 A.Rodin. Inscribed: A mon ami B. Founder:
 Alexis Rudier.

NORWAY
Oslo, Nasjonalgalleriet. Purchased in 1933.

UNION OF SOUTH AFRICA
Stellenbosch, Peter Stuyvesant Foundation.

UNITED STATES
Cambridge, Fogg Art Museum, Harvard University.
 Grenville L.Winthrop Bequest, 1943. Signed:
 A.Rodin. Founder: Alexis Rudier.
Louisville, J.B. Speed Art Museum.
Madison, N.J., Estate of Geraldine R.Dodge. Foun-
 der: Alexis Rudier.
New York City, Collection William S.Paley.
Notre Dame, Ind., Art Gallery, University of Notre
 Dame.
St. Louis, Collection Morton J. May.
San Antonio, Marion Koogler McNay Art Institute.
 Founder: Alexis Rudier.
San Francisco, California Palace of the Legion of
 Honor. Gift of Alma de Bretteville Spreckels.
 Founder: Alexis Rudier (fig.67–69–13).

UNITED STATES
Cambridge, Fogg Art Museum, Harvard University.
 Grenville L.Winthrop Bequest, 1943. Founder:
 Alexis Rudier.
Madison, N.J., Estate of Geraldine R.Dodge. Foun-
 der: Alexis Rudier.
New York City, Metropolitan Museum of Art. Gift
 of G.Louise Robinson, 1940.
— Collection William S. Paley.
St.Louis, Collection Morton J.May.
San Antonio, Marion Koogler McNay Art Institute.
 Founder: Alexis Rudier.
San Francisco, California Palace of the Legion of
 Honor. Gift of Alma de Bretteville Spreckels.
 Founder: Alexis Rudier (fig.67–69–13).

UNION OF SOUTH AFRICA
Stellenbosch, Peter Stuyvesant Foundation. Foun-
 der: Georges Rudier. Cast no.10/12.

Study for Figure of Andrieu d'Andres

Plaster, height 25⅝ inches

FRANCE
Paris, Musée Rodin (fig.67–69–10).

Bronze

UNITED STATES
Beverly Hills and New York City, B.G.Cantor Col-
 lections. Founder: Susse. Cast no.1/12.
Stanford, Stanford University Art Gallery and Mu-
 seum. Gift of B.G. Cantor Art Foundation.
 Founder: Susse. Cast no.3/12.

Reduction of Final Figure of Andrieu d'Andres

Bronze, height 18⅛ inches

FRANCE
Paris, Collection Mme J.Caudrelier-Benac. This is
 the first cast of the reduced version, made
 especially for J.Peytel.
— Musée Rodin.

70 Project for the "Monument to Claude Lorrain"
1889

Bronze, 48½ × 17 × 20¾ inches
Signed side of base to right: A. Rodin
Foundry mark back of base to left:
Alexis Rudier M R/Fondeur Paris N.º 1

As early as November 26, 1877, a group of subscribers to a proposed monument to Claude Lorrain met in the Hôtel de Ville in Nancy to elect a committee.[1] Eventually in 1883 two committees were formed, one in Nancy, presided over by Léon Mougenot, and one in Paris, led by the landscape painter François-Louis Français.[2] Rodin's friend and admirer, the critic Roger Marx, became the secretary of the Parisian committee and undoubtedly kept Rodin fully informed of the committee's decisions, but it was not until December 1888 that the rules of the competition were published and that projects were invited.

Rodin was evidently excited by the prospect of raising a memorial to the great French painter of light, as Judith Cladel relates that he completed the first sketch in three-quarters of an hour in the studio of Jules Desbois, whom he was visiting on the way home from an official function.[3] In what must be the first study (fig. 70–1), the figure of the painter is already placed on a pedestal from which emerges the group of Apollo and the Chariot of the Sun. The forms, however, are very generalized, only the basic poses being indicated. The relationship between the scale of the figure of Claude and the chariot of Apollo is already established, but the conflicting rhythms of the monument, with the horses bounding to the left and the painter looking to the right, have not yet been worked out.

On April 9, 1889, the twelve projects submitted were exhibited together at the Galerie Durand-Ruel and Rodin's project was chosen.[4] He received six votes, while Falguière, whose project represented a draped figure seated on top of a column with allegorical figures at the base, gained four. It was "the fine idea of putting, on the pedestal itself, the motif to which Claude consecrated his life, light, that won him the majority of the votes,"[5] according to M. Français, president of the committee.

It is this stage in the development of the monument that is represented in the Philadelphia bronze. "The preoccupation in this project," Rodin wrote in the explanation that accompanied his project, "has been to personify, in the most tangible manner possible, the genius of the painter of light, by means of a composition in harmony with the Louis XV style of the capital of Lorraine. In 'Claude Lorrain's' face, surrounded with air and light, it is proposed to express the painter's attentive admiration for the scenery amidst which he stands. The idea is that the statue itself should be in bronze, the socle, with its decorative group, in stone."[6] In an interview published while the work was still in his studio, he further elaborated his idea:

My Claude Lorrain has found, and he is admiring what he always found, what he always admired, and what we find and admire in his pictures—a splendid sunrise. The broad orange light bathes his face, intoxicates his heart, provokes his hand armed with a palette. I have put him a palette [*sic*] so that the good workman may be recognised in him. The resemblance I caught in this way. The best and only likeness we have of him is just Marchal's face, the painter Marchal. That is a happy chance for me and flattering to Marchal. So I have a living Claude Lorrain, instead of a sheet of paper more or less covered with black strokes. As regards the soul, the thought, the genius of Claude, I had his pictures, in which he has put the sun and himself.[7]

Thus, in keeping with his normal practice, Rodin chose to work from a man who physically resembled the historical personality whom he had to represent. Nevertheless, he was almost certainly familiar with the iconography of Claude, scarce as this is.[8] He may well have known the portrait by an unknown artist in the Musée des Beaux-Arts in Tours which was exhibited at the Exposition Universelle in 1878 (fig. 70–3). He may also have known the bust by François Masson (1745–1807), dated 1806, and the portrait by Charles-Adolphe Bonnegrace (1808–1882), both at Versailles. Moreover, the rather unkempt appearance of his Claude and the frown suggest that he may have been familiar with Joachim von Sandrart's engraving,[9] which differs considerably from the bland appearance of the portraits in the Accademia di San Luca in Rome and the museum in Tours.

Rodin clearly remembered his own *Monument to Bastien-Lepage,* unveiled in 1887 (fig. 70–4), when he selected a pose for his Claude that is totally unrelated to the accepted rhetoric for such monuments.[10] He chose to represent him at the very moment when, precariously balanced on his right leg, and with his left leg bent and resting on a hillock, the painter compares the brilliance of the sun with his own depiction of it. Rodin's insight into the psychological makeup of the painter *sur-le-motif,* his sense of desperate urgency, reminds one that 1889 was the year of his joint exhibition with Claude Monet at the Galerie Georges Petit. A contemporary of the Naturalist writers, Rodin was also anxious that Claude should be shown wearing the type of clothes he might actually have worn when out painting in the countryside.

After the acceptance of the *maquette* enabled Rodin to proceed with the enlargement of his group, he again must have had recourse to the model, since there are considerable differences between the sprightly, elegant little figure of the *maquette* and the clumsy although intense figure of the final monument. It may indeed have been at this point that he turned to the features of the painter Charles François Marchal for inspiration. As he had done with the individual figures of *The Burghers of Calais (see* no. 67), Rodin studied the figure of Claude in the nude before proceeding to the clothed figure. Although no small nude study of the painter is known to exist, some idea of its appearance may be formed from the work generally known as *Aesculapius* (fig. 70–5).[11] In this the standing figure, the head of which is taken from the row of heads above the tympanum of *The Gates of Hell,* is closely related in pose to the body of Claude Lorrain. Enlarged studies of the nude and the clothed figure were then made before the work was finally cast in bronze *(see* figs. 70–6, 70–7).

Rodin, however, completed the pedestal long before he was satisfied with the figure of the painter. Thus on July 3, 1890, he wrote to the mayor of Nancy that "the pedestal could be regarded as finished... although the statue of Claude Lorrain is still far from being finished."[12] Writing from L'Islette Azay-le-Rideau on May 29, 1891, he reported, "It is finished, except for the figure of Claude, whose pose is established although he has not yet

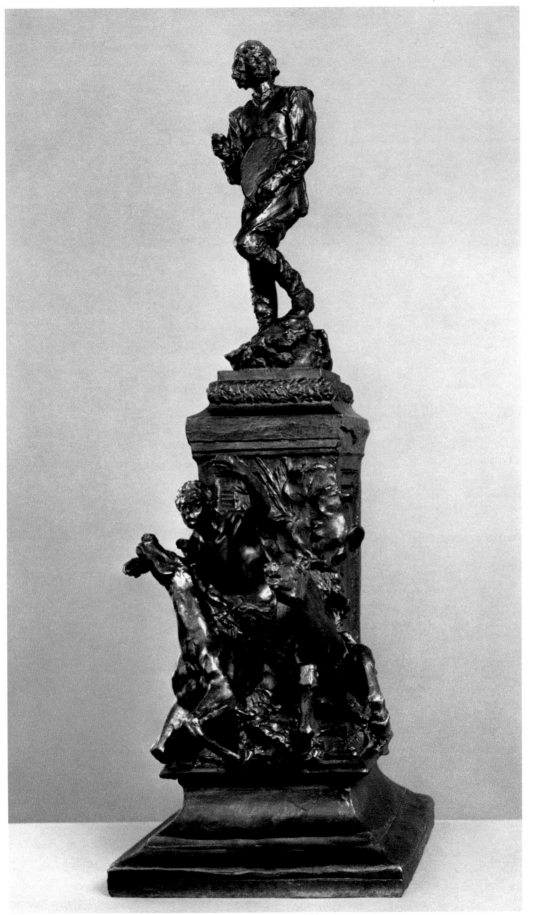

70

been clothed. While I clothe the Claude Lorrain, they [the stonecutters] will work on the stone part of the monument, Apollo and the horses and the pedestal."[13]

The monument was finally unveiled in the Pépinière Gardens in Nancy on June 6, 1892 (fig. 70-8), in the presence of M. Sadi Carnot, President of the Republic, and M. Léon Bourgeois, Minister of Public Instruction and Fine Arts. Immediately after the unveiling the monument met with a great deal of hostile criticism in the press. It was generally thought that the figure of Apollo was too important and that the horses were not finished because their hindquarters remained concealed in a mass of stone representing clouds. In addition, the public objected to the realism of the figure, the ungainly pose, and the unidealized physique. To these charges, Emile Gallé, the well-known glassmaker, replied:

> As for the historical inaccuracies, they are puerile. Rodin's symbolism is better than the rigidly historical—even if the rigidly historical were known, which is by no means proved. If the elegantly plastic had been the sculptor's chief aim, his central idea would be absent, which has conceived mind in a timid body, urged forward to the attainment of a radiant idea. People would like an Adonis, and Rodin has given them, together with the rupture of the line that pleases the crowd, a physical tension of the body opposed to the ecstatic vision of the mind. Fable, legend would fain have some decorative Thiers, with a Gambettian breast, developed on a tiny historical ground; the sculptor, instead, has hoisted up on his vast imaginative conception the gaunt Chamagne peasant.[14]

In spite of the able defenses of Emile Gallé and Roger Marx, however, Rodin was eventually forced to make some changes in the group of Apollo and his horses. He made the bodies of the horses emerge more distinctly from the rocks, an act he later bitterly resented. "I consented to retouch my horses. I was wrong," he later said to Judith Cladel.[15]

70-1
First Study for the "Monument to Claude Lorrain"
1889, plaster, height 14⅛ inches
Musée Rodin, Paris

70-2
Honoré-Jean-Aristide Husson
Eustache Le Sueur
1858
Luxembourg Gardens, Paris

70-3
Anonymous
Portrait of Claude Lorrain
Mid 17th century, oil on canvas, 24⅜ × 18⅞ inches
Musée des Beaux-Arts, Tours

70-4
Study for the "Monument to Bastien-Lepage"
1887, bronze, height 14¼ inches
Baltimore Museum of Art. Gift of Wilton C. Dinges

70–1

70–2

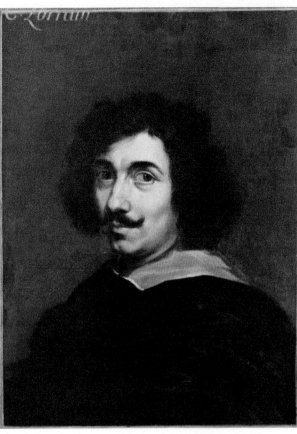

70–3

70–4

70–6

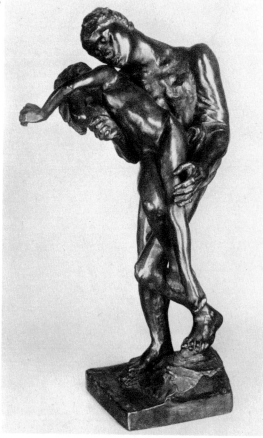

70–5

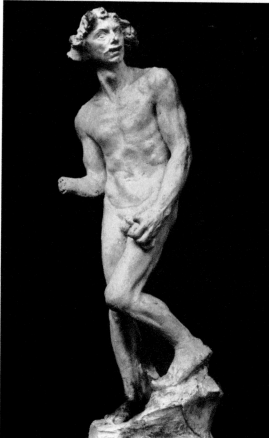

70–7

1. *See* "Statue à élever à Claude Gellée, le Lorrain, dans l'ancienne capitale de la Lorraine," *Journal de la Meurthe et des Vosges,* Nancy, November 26, 1877.

2. Lawton [67], p. 138, states that the committee was formed in 1883 while Cladel [26], p. 167, says it was formed in 1889. Jianou and Goldscheider [65], pp. 47–48, state that twelve sculptors, including Rodin, were invited to submit projects in 1883, and that his project was accepted by a majority of one vote on April 8, 1884.

3. Cladel [26], p. 168.

4. *See Le Temps,* Paris, April 10, 1889.
 "Le concours pour le monument qui sera érigé à Nancy à la mémoire de Claude Lorrain a été jugé hier…
 "Douze projets avaient été exposés dans la galerie Durand-Ruel… Une prime de 1500 francs a été attribuée à M. Falguière.
 "D'autre primes, l'une de 1,000 fr. a été attribuée à M. Gautherin, les autres, de 500 fr., à MM. Delaplanche, Marqueste, Peynot."

5. M. Français, *Discours prononcé à l'inauguration du monument élevé à la mémoire de Claude Gellée dit le Lorrain à Nancy, le lundi 6 juin 1892* (Paris: Institut de France, 1892), p. 2. "La belle idée de mettre, dans le piédestal même, le motif auquel Claude a consacré sa vie, la Lumière, lui valut la majorité des suffrages."

6. Quoted in Lawton [67], p. 140.

7. Ibid., p. 142.

8. *See* Marcel Röthlisberger, *Claude Lorrain, the Paintings,* vol. 1 (New Haven: Yale University Press, 1961), pp. 84–86.

9. An engraving, drawn by Sandrart and engraved by Collin, was published in Sandrart's *Teutsche Academie,* vol. 1, pt. 2 (Nuremberg: Jacob von Sandrart, 1675). It is surrounded by the inscription: CLAUDIUS GILLI alias LORENOIS MAHL. In the 1774 edition of Sandrart, by J. Volkmann, the last two words were changed to LORRAINES DICTUS.

10. Speaking of the *Monument to Bastien-Lepage,* Rodin said: "I have represented Bastien Lepage starting in the morning through the dewy grass in search of landscapes. With his trained eye he espies around him the effects of light or the groups of peasants" *(see* Lawton [67], p. 78).
 It is instructive to compare Rodin's statue of *Claude Lorrain* with figures of painters as represented by other sculptors. The statue of *Eustache Le Sueur* by Honoré-Jean-Aristide Husson in the Luxembourg Gardens in Paris (fig. 70–2), erected in 1858 from a subscription collected by the Société Libre des Beaux-Arts, is, for example, the essence of decorum beside Rodin's animated figure. Husson has made no attempt to understand the psychology of the painter with the result that the sculpture is singularly lacking in life. Compare also the statue of *Vélazquez* by Antonio Susillo y Fernandez, erected in the Plaza del Duque de la Victoria in Seville in 1892.

11. On the front of the base of *Aesculapius* is the following inscription: "ex voto dédié." To the left is inscribed "La Goulotte" and on the back "Esculape." This cast in the Musée Rodin is by Alexis Rudier. The foundry mark reads: Alexis Rudier/Fondeur Paris. Marked: M. R. No. 1.

12. *See* Thérèse Charpentier, "Notes sur le Claude Gellée de Rodin, à Nancy," *Bulletin de la Société de l'Histoire de l'Art Français,* Paris, November 9, 1968, p. 156. The letter of July 3, 1890, states: "Le modèle du piédestal avec les chevaux et la figure d'Apollon peut être tenu pour terminé, et comme il a reçu l'approbation du Président et du secrétaire du Comité de Paris, Monsieur Français et Monsieur Roger Marx, je me prépare à moins que vous n'y voyez d'inconvénient, à la faire mouler, afin de pouvoir procéder à la mise au point du modèle en pierre, que je voudrais terminer au commencement de l'année prochaine. Le bronze coulé entendu pour cette époque, quoique la statue de Claude Lorrain est encore loin d'être finie."

70–5
Aesculapius
c. 1903, bronze, height 26¾ inches
Musée Rodin, Paris

70–6
Study for Clothed Figure of Claude Lorrain
1889–92, plaster, height 90¾ inches
Musée Rodin, Meudon

70–7
Study for Nude Figure of Claude Lorrain
1889–92, plaster, height 90¾ inches
Musée Rodin, Paris

13. Ibid., p. 157.

"Le monument est, je crois, réussi. Il est fini sauf la figure de Claude qui a ses lignes mais à qui il manque d'être habillé.

"Pendant que j'habillerai le Claude Lorrain, on exécutera la pierre du monument, l'Apollon et les chevaux et le piédestal."

14. Gallé's defense appeared in *Le Progrès de l'Est,* Nancy, August 7, 1892, and is quoted in Lawton [67], p. 144.

15. Cladel [26], p. 169. "'J'ai consenti à retoucher mes chevaux, j'ai eu tort,' me disait-il avec contrition."

REFERENCES

M. Français, *Discours prononcé à l'inauguration du monument élevé à la mémoire de Claude Gellée dit le Lorrain à Nancy, le lundi 6 juin 1892,* Paris: Institut de France, 1892, pp. 1–4; "L'Inauguration de la statue de Claude Gellée," *Le Voltaire,* Paris, June 8, 1892, p. 2; Marx [243], p. 195; Maillard [71], pp. 57–62, repr. opp. p. 60; Mauclair [77a], pp. 32–33; Lawton [67], pp. 138–45, repr. opp. p. 139; Ciolkowska [23], pp. 52–53, repr. opp. p. 52; Lami [4], p. 167; Benedite [10a], pp. 16, 29, repr. pls. 34, 35; Grappe [338], no. 138; Watkins [342], no. 45; Grappe [338a], no. 162; Grappe [338b], no. 255; Grappe [338c], no. 198; Grappe [338d], no. 228; Grappe [54], p. 143, repr. p. 89; Goldscheider and Aubert [339], repr. p. 41; Goldscheider [49], pp. 34, 37; Elsen [38], p. 210; Descharnes and Chabrun [32], pp. 139, 142, 150–51; Thérèse Charpentier, "Notes sur le Claude Gellée de Rodin, à Nancy," *Bulletin de la Société de l'Histoire de l'Art Français,* Paris, November 9, 1968, pp. 149–58; Tancock [341], no. 62.

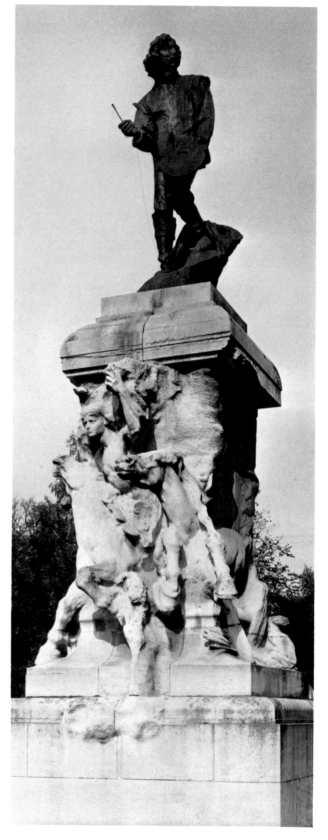

70–8
Monument to Claude Lorrain
1889–92, bronze figure, height 90½ inches
Pépinière Gardens, Nancy

OTHER CAST

FRANCE
Paris, Musée Rodin. Signed: A.Rodin. Founder: Alexis Rudier.

Monument to Claude Lorrain

Bronze figure, height 90½ inches (on stone pedestal)

FRANCE
Nancy, Pépinière Gardens (fig. 70–8).

STUDIES FOR THE MONUMENT

First Study for the "Monument to Claude Lorrain"

Plaster, height 14⅛ inches

FRANCE
Paris, Musée Rodin (fig. 70–1).

Bronze

UNITED STATES
Stanford, Stanford University Art Gallery and Museum. Gift of B.G. Cantor Art Foundation. Founder: Godard. Cast no. 1.

Study for Clothed Figure of Claude Lorrain

Plaster, height 14⅛ inches

UNITED STATES
Stanford, Stanford University Art Gallery and Museum. Gift of B.G. Cantor Art Foundation.

FRANCE
Paris, Musée Rodin.

Plaster, height 90¾ inches

FRANCE
Paris, Musée Rodin (fig. 70–6).

Study for Nude Figure of Claude Lorrain

Plaster, height 90¾ inches

FRANCE
Paris, Musée Rodin (fig. 70–7).

RELATED WORKS

Study for the "Monument to Bastien-Lepage"

Bronze, height 14¼ inches

FRANCE
Paris, Musée Rodin.

UNITED STATES
Baltimore, Baltimore Museum of Art. Gift of Wilton C.Dinges. Signed: A.Rodin (fig. 70–4).
Hartford, Wadsworth Atheneum.
Stanford, Stanford University Art Gallery and Museum. Gift of B.G. Cantor Art Foundation. Founder: Godard. Cast no. 3/12.

Monument to Bastien-Lepage

Bronze, height 69 inches

FRANCE
Damvillers, cemetery.

Plaster

FRANCE
Paris, Musée Rodin.

71 Apotheosis of Victor Hugo
1890–91

Bronze, 44 × 20¼ × 24 inches
Signed right side of base: A. Rodin
Foundry mark lower back of base to left:
ALEXIS RUDIER M R / Fondeur. PARIS. N° 1

In 1885 the Church of Ste.-Geneviève was deconsecrated and once again established as the Panthéon. On February 10, 1889, Gustave Larroumet, newly appointed Director of the Ministry of Fine Arts, submitted a report proposing a scheme of sculptural decoration for Soufflot's building. Alexandre Falguière was to execute a colossal group of *The Spirit of the Revolution,* Jules Dalou a group of *The Orators of 1830,* and Antonin Mercié a group of *The Generals of the Revolution.* Jean-Antoine Injalbert was to create a *Monument to Honoré Gabriel Mirabeau* for the right transept, and Rodin a *Monument to Victor Hugo,* to be erected in the left transept.[1]

Hugo's position among living writers had been quite exceptional. "For the men of that generation," wrote Judith Cladel, "Hugo was the bard of the nineteenth century, a legend during his lifetime. He was the inheritor of the verbal power of the prophets of the Bible, the superman of Guernsey who conversed familiarly with the sea and the stars."[2]

Shortly after Hugo's death on May 22, 1885, Jules Dalou had designed a complicated allegorical memorial to the poet which was exhibited at the Salon of 1886, although it was not accepted by the Fine Arts Commission.[3] The newly established rivalry between Dalou and Rodin may well have led the latter to start working out ideas for a monument to the poet who had so impressed him by his quasi-divine appearance when he had occasion to observe him in 1883 *(see* no. 87). He had evidently discussed the matter of a monument with Gustave Larroumet before 1889 since, writing to Rodin shortly before the opening of the Exposition Universelle, Larroumet said: "I have the project at heart; if I have allowed it to remain in abeyance, necessity has been the reason; but it will soon be revived."[4]

Even though Rodin did not receive official notification of the commission until September 16, 1889, it is certain that by September 10 he had devoted a great deal of attention to the project because on that date Armand Fallières, the newly appointed Minister of Fine Arts, approved a report in which it was stated that "M. Rodin has chosen for his monument the exiled Victor Hugo, who had the constancy to protest for eighteen years against the despotism that had chased him from his country.... He has thus shown him seated on the rock of Guernsey, behind him, in the volute of a wave, the three muses of Youth, Maturity, and Old Age breathing inspiration into him."[5] Rodin agreed to execute the monument for the sum of 75,000 francs; however, it was not until eight months later, on April 18, 1890, that he received the first installment of 5,000 francs.[6]

412

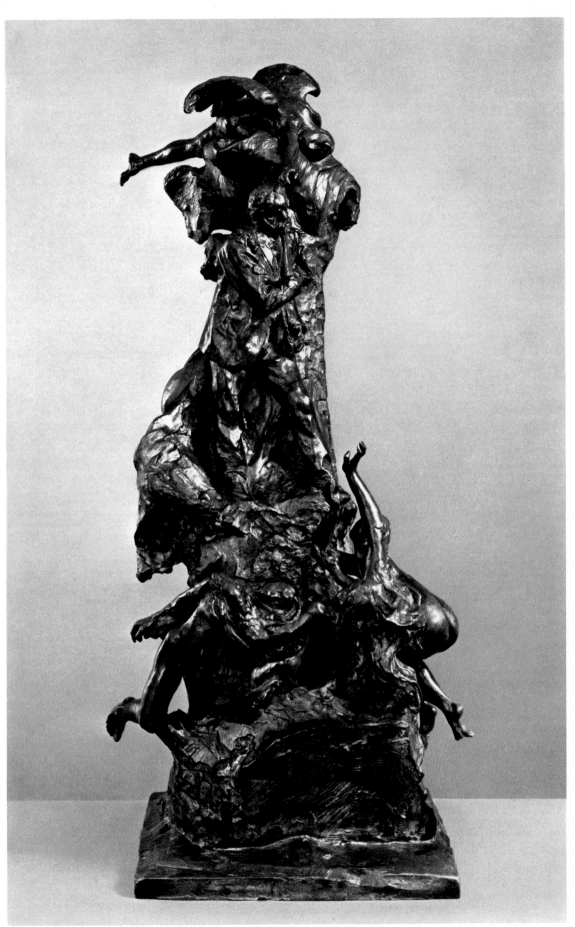

The Hugo monument posed problems of a completely different order from those occasioned by the Balzac monument (no. 75), on which Rodin later worked simultaneously. The difficulties experienced by Rodin in securing an adequate physical likeness of Balzac, who had died in 1850, did not arise in the Hugo monument because he had seen and studied the poet in his own surroundings while working on a bust in 1883. Hugo reminded Rodin of Hercules (see no. 87), and from the very beginning, with the exception of two studies (figs. 71-2, 71-3), he represented him as a naked, semi-divine prophetic figure surrounded by allegorical figures, although these were gradually eliminated as time went on.

The program of reading and the study of the iconography which preceded work on the *Balzac* seem not to have accompanied work on the *Hugo* because the poet had already imposed himself on Rodin's imagination. He did, however, make a trip in 1891 to Jersey and Guernsey with Eugène Carrière and Gustave Geffroy, the purpose of which, as in the case of the trips to Touraine while working on the Balzac monument, must have been to obtain first-hand impressions of the background against which the poet had spent so much of his time.

In what is probably the first and certainly the least successful of the projects for the monument (fig. 71-1), Victor Hugo was shown nude, seated on a rock, his left arm touching the ground, his right hand raised to his mouth in a curiously childish gesture. Behind him hover three muses, either those cited by Larroumet, Youth, Maturity, and Old Age, or representatives of Hugo's major poems—*La Légende des Siècles, Les Châtiments,* and *Les Voix Intérieures.*[7] The head of Hugo, as in all the other projects, is based on the portrait of 1883, but here it is very clumsily attached to the body.

In what is presumably the second project (fig. 71-2), the poet is clothed and his knees are covered with a rug, but the pose is much closer to that finally adopted in the definitive monument. His head leans on his right hand while his left arm is outstretched, and three muses still hover over his head. A reduced variant was made of this second project (fig. 71-3).

In mid 1890 disagreements arose between Rodin and the commissioning body. As reported in *Le Temps* of July 21, 1890, the committee "was unanimous in acknowledging that M. Rodin's work, almost 2.5 meters [approximately 98 inches] in height, would not harmonize with what surrounded it. However admirable the three women who dominate the head of the poet might be when they are finished, they form a confused mass when seen from a distance and the monument, in the words of one of the most distinguished members of the commission, would not 'silhouette' well." Rodin was then asked to prepare another *maquette,* which he apparently did with good grace: "They have asked me for another project conceived in a more decorative fashion: I am going to try to do it."[8]

71-1
Monument to Victor Hugo (first project)
1889–90, plaster, height 39 inches
Musée Rodin, Paris

71-2
Monument to Victor Hugo (second project)
1890, plaster, height 33 inches
Musée Rodin, Paris

71-3
Monument to Victor Hugo
(reduced variant of second project)
1890, terra-cotta, height 28⅜ inches
Kunsthistorisches Museum, Vienna

71-4
Louis-Ernest Barrias
Monument to Victor Hugo
1900–1902, bronze and marble
Place Victor Hugo, Paris

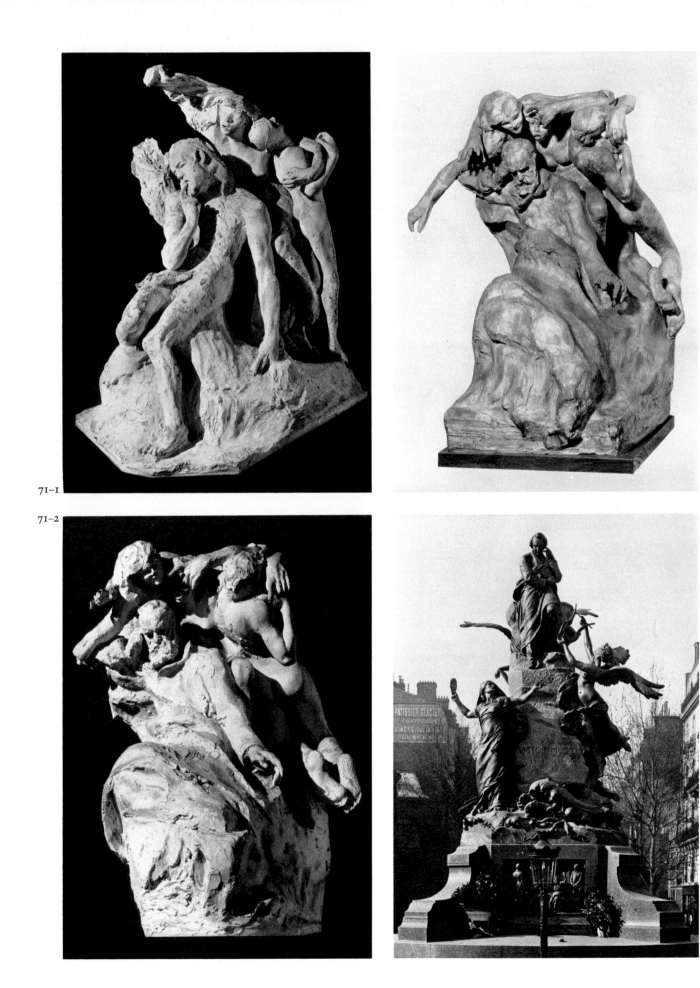

By the end of 1890 and evidently in response to the committee's observations, Rodin had started work on a wholly new monument, in which the figure of Hugo was represented standing. Late in the year he wrote to Rose Beuret from Touraine: "I must work hard this winter for I am frightened when I think of my works that are not finished and of the Victor Hugo which I must start again after having worked on it all last winter."[9] In a letter of December 28, 1890, to Gustave Larroumet, Rodin referred to a new composition "on which I am making great progress. I am making the Apotheosis because that is what is written on the pediment 'Aux grands hommes la Patrie Reconnaissante.' Victor Hugo is crowned by the Genius of the Nineteenth Century, a descending figure of Iris resting on a cloud crowns him too or rather their hands unite and hold flowers, some laurels, above him. Lower down I am making a powerful figure which is raising its head and contemplating him in his apotheosis; that is the crowd that gave him an unforgettable funeral, it is all of us, Vox Populi.... Victor Hugo is on a rock, waves beat the rock and a nereid or the water itself takes the form of the body of a woman and brings him a lyre; behind the monument Envy flees into a cavity."[10]

It is to this stage in the development of the second monument that the Philadelphia bronze belongs, although it differs in certain details from the description in Rodin's letter to Larroumet. Hugo is crowned by one figure, not by two, the "powerful figure which is raising its head and contemplating him" is not immediately identifiable, nor does a nereid present the poet with a lyre. Finally, the figure of Envy fleeing into a cavity behind the monument has been suppressed.[11]

In the *Monument to Victor Hugo* the element of self-identification on Rodin's part, so strongly present in the *Balzac,* was much less pronounced, with the result that the various projects rely much more heavily on conventional allegories to convey the essence of Hugo's epic character than is the case in the *Balzac.* In this connection it is instructive to compare Rodin's monuments with Louis-Ernest Barrias's *Monument to Victor Hugo* (fig. 71–4), erected in the place Victor Hugo in 1902. In this version a youthful Hugo stands pensively on the rock around which billow highly stylized waves, while figures of Satire, Lyric Poetry, and Fame offer their various tributes. In the *Balzac* Rodin's feelings were concentrated with great intensity in the one figure (although he did at the last moment consider incorporating an allegorical figure; *see* nos. 72–76), while in the *Victor Hugo* his attention seems to have been much more dispersed. The compactness of the *Balzac* contrasts with the sprawl of the *Hugo.* Rodin evidently recognized this, as in each successive stage of the two monuments to Victor Hugo he made an effort to prune the complex forms and simplify the iconography of his work. Thus in the Philadelphia bronze *maquette* as it exists today, he seems to have tried to simplify the allegorical framework of his first conception as outlined in the letter to Larroumet. In view of the fact that his ideas for the second monument were so advanced by the end of 1890, a date of 1890–91 should be assigned to this first project for the second monument rather than that of 1893 assigned to it by Grappe.[12]

71–5
Monument to Victor Hugo (third project)
1891–97?, plaster, height 44⅛ inches
Musée Rodin, Paris

71–6
Monument to Victor Hugo (fourth project)
1891–97?, plaster, height 36¼ inches
Musée Rodin, Paris

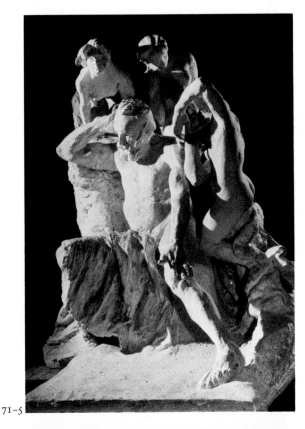

71-5

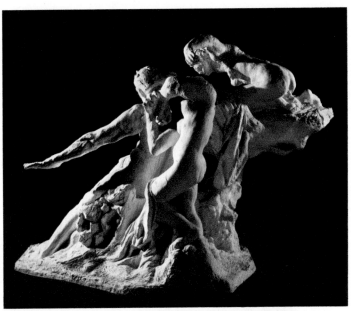

71-7
Monument to Victor Hugo (variant of fourth project)
1891–97?, plaster, height 36¼ inches
Musée Rodin, Paris

71-8
Monument to Victor Hugo
Plaster
As exhibited at the Salon de la Société
Nationale, 1897

71-6

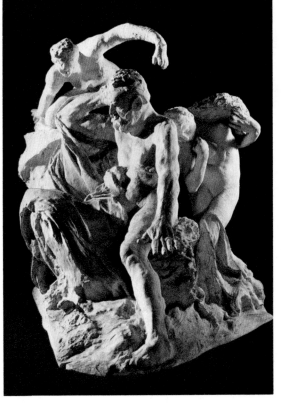

71-7

71-8

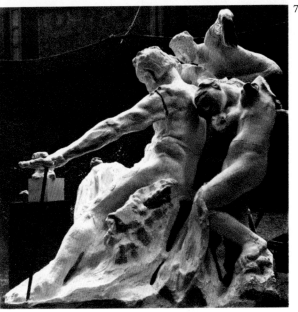

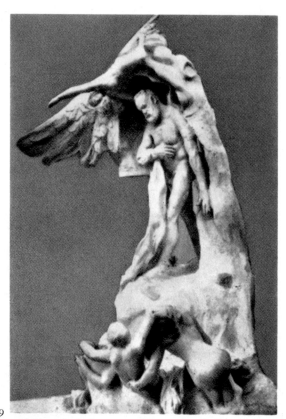

71–9

71–9
Apotheosis of Victor Hugo
(second project)
1891–94, plaster, height 88⅞ inches
Musée Rodin, Paris

71–10
Monument to Victor Hugo
Photographed in the gardens of
the Palais Royal, Paris

71–10

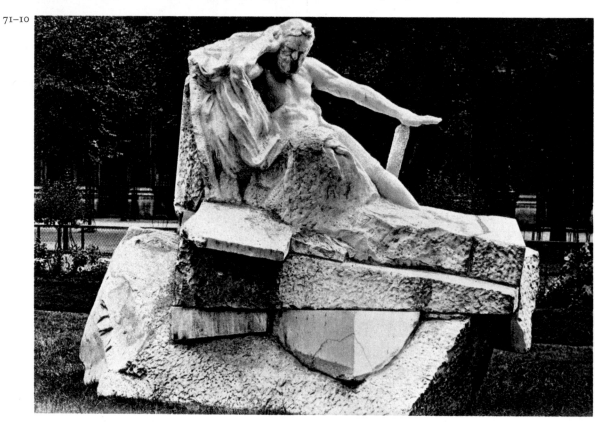

418

It is probable that Rodin temporarily abandoned work on his first monument after the decision of the committee in July 1890. On January 20, 1891, however, it was suggested in a report from Inspector Lefort that the group deemed unsuitable for erection in the Panthéon could be appropriately placed in the Luxembourg Gardens.[13] This suggestion evidently found favor with the Ministry of Fine Arts, as on June 19, 1891, Rodin received a new commission for a monument, incorporating four figures (that is to say, the group originally destined for the Panthéon), to be erected in the Luxembourg Gardens. For this the sum of 40,000 francs was allotted. The first payment of 5,000 francs was made on December 30, 1893, on the strength of a report from Armand Sylvestre, and the second of 6,000 francs on December 29, 1894, leaving 29,000 francs untouched on December 26, 1903.[14]

Now that an open-air site had been proposed, it was even more necessary to modify the complex initial monument. In the third project (fig. 71–5)[15] the poet is nude, the greater particularity of the anatomy suggesting that Rodin had studied the body of a middle-aged man since working on the first two studies. Two muses now kneel on the rock above him, while a third, based on a figure from the tympanum of *The Gates of Hell—The Inner Voice,* or *Meditation (see* no. 19)—stands to one side. In the fourth project (fig. 71–6) considerable modifications have been made. The drapery covering Hugo's right side is much more developed than in the third project, giving a greater sense of unity to the whole. The figure of *The Inner Voice* now stands farther apart from the poet and bears a load on her shoulders, while a single figure, *The Tragic Muse,* kneels behind him. In a variant of this fourth project, the figure of *The Inner Voice* has been altered, both arms now being raised as if sheltering the face *(see* fig. 71–7).

At this point in its development the monument was exhibited at the Salon de la Société Nationale in 1897 as *Victor Hugo. Plaster group. The arm of the woman is incomplete* (fig. 71–8). Rodin clearly took delight in the ruined aspect of his monument, which bore all the traces of his decisions, his second thoughts, his impatience, and the technical processes involved (the seams left by the piece molds are very prominent). The arm of the poet, supported by an iron bar, is attached to the body by a metal bracket. The projecting arm of *The Tragic Muse* is very crudely attached, while the figure of *The Inner Voice* has been deprived of her arms altogether. It is hardly surprising that one contemporary critic referred to it as "a dislocated and incoherent *maquette* on which it would be premature to pronounce a judgment."[16]

The carving of the group in marble was now undertaken by Rodin's assistants in his cavernous studio in the rue de l'Université, "the very one where the artist worked, as he was having the enormous block carved under his eyes, indicating day by day and almost hour by hour, with decisive pencil marks, the contours to maintain, the hollows to make deeper, the passages to be most clearly modeled in the light."[17] The marble figure of the poet alone was exhibited at the Salon in 1901 as *Victor Hugo. Marble.* In a report of February 9, 1904, from Eugène Morand, representative of the Ministry of Fine Arts, to the director, it was stated that the figure of the poet was complete, having been exhibited at the Salon of 1901, but that the figure of *The Tragic Muse,* on which the *praticiens* had started working, was in parts not even roughed out, and that work on the third figure, *The Inner Voice,* had not even been begun.[18]

Late in 1909 Rodin was still hesitating over the placing of the two muses in relation to the figure of Victor Hugo. Judith Cladel relates how, on the occasion of a visit to Rodin

when he was working on this problem, she expressed the view that the *"Victor Hugo* is complete in himself, his attitude, his gesture say everything so well, that the muses... add nothing to it."[19] Rodin evidently accepted Judith Cladel's opinion, as he immediately announced the completion of the work to Dujardin-Beaumetz, and the figure of Victor Hugo alone, mounted on a very unusual plinth consisting of large angular blocks, was unveiled in the gardens of the Palais Royal on September 30, 1909 (fig. 71–10).[20] It remained there until 1933, when it was removed to the Musée Rodin. In 1964 the city of Paris commissioned a bronze cast of the monument, including the two muses, which is now situated at the corner of the avenues Henri Martin and Victor Hugo.[21]

Meanwhile Rodin had been working on the second monument for the Panthéon. On February 20, 1891, Larroumet wrote to Rodin asking him when the monument for the Panthéon would be finished so that he could see it before bringing the committee.[22] On June 14, 1891, it was announced in the press that "M. Rodin has almost finished his second monument to Victor Hugo."[23] In the third week of June, Larroumet and the members of the committee went to Rodin's studio to inspect the progress being made on the monument.[24] "The commission," it was announced, "only had observations to make about details, from the point of view of execution."[25]

It was decided that a canvas version of this project should be constructed in the Panthéon so as to judge the final effect. Once again and, one might add, true to form the committee had numerous suggestions as to the improvements Rodin might make to his monument. In the words of Charles Yriarte, Inspector General in the Ministry of Fine Arts:

> The base was felt to be too narrow and the overall form too pyramidal; the result being a certain meagreness and emptiness.
>
> The main figure, poorly put together, does not go well with the imaginary figures carried on the waves; it would be easy to give him more amplitude by means of drapery of a sculptural character which would have the advantage of linking him with the waves which beat against the rock.
>
> The ideal figure, which closes off the composition and crowns it, seemed to crush itself against the rock instead of dominating it and triumphing.
>
> Finally, and most seriously, the rear of the monument seemed to be devoid of interest and to present little of substance to the public which must walk around the group to see it from all sides, as it will do with the *Mirabeau* which is located in the opposite arm of the crossing.[26]

Rodin seems to have satisfied the committee on at least some of these points as a payment of 6,000 francs was made on January 28, 1892, and another of 14,000 francs on December 29, 1894, leaving 50,000 francs untouched in February 1904, when Eugène Morand made his report.

In view of its degree of completion by the latter part of 1891 it seems imperative to assign a date of 1891–94 to the second project for the second monument (fig. 71–9) rather than that of 1897 assigned to it by Grappe.[27] In this version the naked walking figure of Hugo, clearly inspired by *The Walking Man* (fig. 65–1), is crowned by the two figures mentioned in the letter of December 28, 1890—Iris and the Genius of the Nineteenth Century. The flailing limbs of the nereids in the first project, however, have been replaced by the more compact group of *The Sirens* from the left-hand side of the left leaf of *The Gates of Hell* (see fig. 24–4). It is known, however, that Rodin envisaged a colossal monument (23 feet in height), and so it seems possible, as suggested by Grappe,[28] that the enlargement of the

standing figure of Hugo and of the head (fig. 87–4) took place in 1897. In February 1904 Eugène Morand announced that the figure of the poet and the winged figure were ready for carving in marble, but that Rodin wanted to modify the group of *Nereids*.[29] As late as 1914, Rodin promised to deliver the monument in two years, but the war and his declining health prevented this from happening.

The history of the two monuments to Victor Hugo makes rather unsatisfying reading since, unlike the *Balzac*, there is no culminating point to which all the preliminary studies lead. The monuments are remembered not as entities but as a series of fragments, some of which are very fine—for example, *The Tragic Muse; The Inner Voice,* or *Meditation; Iris, Messenger of the Gods;* and the *Bust of Victor Hugo* himself. It is not possible to blame this situation entirely on the commissioning body, although admittedly they were very demanding at times. Rather, it is due to the fact that at no point during the development of the two monuments did Rodin have a clear vision either of what he wanted his monuments to look like or to convey. This inability or refusal to think in monumental terms became more pronounced after 1900, the most conspicuous example being the ill-fated *Monument to Whistler.*

NOTES

1. *See* Cécile Goldscheider, "Rodin et le monument de Victor Hugo," *La Revue des Arts,* Paris, no. 3 (October 1956), pp. 179–84. This article is the main source of information on the development of the Victor Hugo monument. However, I differ considerably from Mme Goldscheider in the interpretation of certain facts and in what I take to be the chronology of the work, as the discussion reveals.

2. Cladel [26], p. 174. "Pour les hommes de cette génération, Hugo c'était le barde du XIXᵉ siècle, entré vivant dans la légende. C'était l'héritier en puissance verbale des prophètes de la Bible, le surhomme de Guernesey qui s'entretenait familièrement avec la mer et les astres."

3. It was exhibited as no. 3743. For description *see* no. 86.

4. Lawton [67], p. 259. *See also* n. 1 above, Goldscheider, p. 179. "Le projet que vous savez me tient à cœur, si je l'ai laissé dormir, c'est qu'il y avait nécessité, mais il se réveillera bientôt."

5. *See* n. 1 above, p. 179. "M. Rodin a choisi, pour son monument, le Victor Hugo de l'exil, celui qui eut la constance de protester pendant dix-huit ans contre le despotisme qui l'avait chassé de la patrie.... Il l'a donc représenté assis sur le rocher de Guernesey, derrière lui dans la volute d'une vague, les trois muses de la Jeunesse, de l'Age mûr et de la Vieillesse, lui soufflent l'inspiration."

6. The payments are listed in a letter from Eugène Morand, a member of the Commission on Works of Art, to the Director of the Ministry of Fine Arts, February 9, 1904, and in a memorandum dated December 26, 1903, entitled "Note relative aux acomptes payés à Monsieur Rodin sur ses commandes en cours." Both documents are in the Archives Nationales, Paris.

7. *See* n. 1 above, p. 181.

8. "Monsieur Rodin et la commission des travaux d'art," *Le Temps,* Paris, July 21, 1890. "Elle [the committee] a été unanime à reconnaître que l'œuvre de Monsieur Rodin, haute d'à peine 2 m. 50, sous la haute coupole de l'édifice, ne s'harmonisait pas avec ce qui l'entourait. Si admirables que puissent être, lorsqu'elles seraient terminées, les trois femmes qui dominent la tête du poète, leur groupe, vu du loin, formait un confus enchevêtrement, et le monument, selon le mot d'un des membres les plus distingués de la commission, ne se 'silhouettait' pas. Il a donc été décidé, à l'unanimité, qu'on prierait Monsieur Rodin de préparer une autre maquette en tenant compte des observations qui étaient faites à son premier projet.... Monsieur Rodin a désavoué d'ailleurs ses zélateurs intempestifs, en acceptant le verdict de ses aînés et de ses amis de la commission des travaux d'art. Comme il nous a déclaré lui-même modestement: 'On me demande un autre projet, conçu d'une façon plus décorative; je vais essayer de la faire.'"

9. Cladel [26], p. 175. "Il faut que je travaille dur

cet hiver, car je suis épouvanté en pensant à mes travaux qui ne sont pas finis, à ce Victor Hugo qu'il faut que je recommence après y avoir travaillé tout l'hiver dernier."

10. *See* n.1 above, p.183.

"Je fais l'Apothéose, puisque c'est ce qui est écrit au fronton 'Aux grands hommes la Patrie Reconnaissante,' Victor Hugo est couronné par le génie du XIXe siècle, une Iris descendue appuyée sur un nuage le couronne aussi ou plutôt leurs mains s'unissent et tiennent des fleurs, des lauriers au-dessus de lui. Plus bas je fais une figure puissante qui lève la tête et le contemple dans son apothéose, c'est la foule qui lui a fait des obsèques inoubliables, c'est nous tous, Vox Populi.

"Enfin je vous demanderai des conseils là-dessus.

"Victor Hugo est sur le rocher, des vagues battent le rocher et une néréide ou la vague elle-même prend corps de femme et lui apporte une lyre; derrière le monument l'envi *(sic)* s'enfuit en bas dans une anfractuosité."

11. According to Grappe [338d], no.268, this project, entitled *Apotheosis of Victor Hugo,* decorated the table of honor at a banquet given in 1893 on the occasion of the publication of *Toute la Lyre,* a posthumous work of the poet. The bronze was cast by the Musée Rodin in 1927.

12. Ibid.

13. *See* n.1 above, p.182.

14. *See* n.6 above.

15. According to Goldscheider, n.1 above, p.182, the third project for the first monument was represented to the committee in the last months of 1890. She states that a *trompe l'œil* version of it was painted on canvas in order to judge the effect the monument might make when erected in the Panthéon. However, it was a canvas version of the second monument *(see* n.25 below) that was presented to the committee in this manner, an event which took place in December 1891. There may be documentary evidence with which I am not familiar that led Mme Goldscheider to place these events in the latter part of 1890, although newspaper references would seem to support my interpretation of the facts.

16. Georges Lafenestre, quoted in Cladel [26], p.177. "Nous ne parlerons que pour mémoire du groupe en plâtre, *Victor Hugo,* par M. Rodin. Cet ouvrage, en l'état actuel, n'est qu'une maquette disloquée et incohérente sur laquelle il serait prématuré de porter un jugement. Le catalogue veut bien nous prévenir que dans cette colossale ébauche, il y a un bras de femme incomplet; c'est un catalogue optimiste. En réalité, une seule figure, celle du poète, nu, assis au bord de la mer, est assez poussée pour qu'on puisse y reconnaître dans le pétrissage sommaire, mais vigoureux, passionné, expressif des formes, les qualités puissantes que M. Rodin a déjà fait applaudir dans quelques morceaux isolés."

17. Cladel [26], pp.177–78. "Celui-là même où l'artiste travaillait, car il faisait exécuter sous ses yeux la pratique de l'énorme bloc, en indiquant, jour par jour et presque heure par heure, à coups de crayon impérieux, les contours à soutenir, les creux à approfondir, les passages à modeler savamment dans la lumière."

18. *See* n.6 above. "Ce monument comporte trois figures: celle du poète, exécutée en marbre, a été exposée au Salon de 1901. Pour la seconde, celle de 'La Muse Tragique,' la mise au point est faite dans une certaine partie et le travail du praticien commencé mais une grande part n'est même pas dégrossi. La troisième 'La Voix Intérieure,' n'est pas commencée."

19. Cladel [26], p.178. "*Victor Hugo* est si complet par lui-même, son attitude, son geste disent si bien *tout,* que les Muses… ne lui ajoutent rien."

20. *See* n.1 above, p.183. Goldscheider states that the monument was unveiled on September 30, 1909, while Descharnes and Chabrun [32], p.182, give the date as November 30.

21. The advisability of casting this work in bronze is open to serious question. The detached figures of *Meditation* and *The Tragic Muse* had both been cast in bronze before Rodin's death. There is no doubt, however, that the group as a whole was conceived in marble. Rodin's reaction to this decision may be judged from his comments on the Michelangelo monument in Florence. According to Cladel [26], pp.307–8, he regretted that *bronze* replicas of the Medici tombs had been placed on the square of the Signoria, because as they were "made in marble, their technique was not the one required by metal." It is more than probable that he would have felt the same way about his own work.

22. Letter of Feb.20, 1891, in Lawton [67], p.259.

23. *Le Temps,* Paris, June 14, 1891. "Monsieur Rodin a presque terminé son second monument de Victor Hugo."

24. *L'Eclair,* Paris, June 21, 1891. The author of this article confused the two monuments in his account of this visit. He described the poet seated on the rock, with sirens at his feet and Inspiration

hovering above him, combining the seated figure of the first monument with the allegorical figures of the second.

25. *La Paix*, Paris, June 21, 1891.

"La commission des Beaux Arts a examiné hier matin, en l'atelier du statuaire Auguste Rodin, la maquette du monument à Victor Hugo, que l'artiste doit exécuter pour la décoration du Panthéon.

"Dans le projet rectifié, les *Voix* qu'avait imaginées Auguste Rodin ne murmurent plus à l'oreille du poète; elles lui sont apportées par le souffle immense de la mer. Ces trois figures souples, balancées par le flot, suprêmement harmonieuses, s'enlacent en bas, au pied du rocher où rêve le poète, debout, dans une attitude qui lui était familière, et que nous ont conservée quelques portraits de lui. Couronnant le monument, une autre figure de femme est venue se poser sur le faîte du rocher, et semble envelopper le poète d'une caressante bénédiction.

"La commission n'a eu à faire cette fois que des observations de détail au point de vue de l'exécution. M. Yriarte, l'inspecteur des Beaux Arts, et M. le Deschault, architecte du Panthéon, ont été chargés de s'entendre à ce sujet avec l'artiste. La maquette va être développée à grandeur d'exécution au moyen d'un décor peint, qui sera élevé dans le Panthéon, sur l'emplacement réservé au monument, et l'on pourra se rendre compte ainsi de l'effet décoratif."

26. Excerpt from letter of December 29, 1891, in the Archives Nationales, Paris, from Charles Yriarte to the Minister of Fine Arts.

"La Base a été trouvée trop étroite et la forme générale trop pyramidale; il en résultait de la Maigreur et du 'Vide.'

"La Figure Principale, mal étoffée, se reliait peu aux figures imaginaires portée sur des vagues; il serait facile de lui donner de l'ampleur par une draperie d'un caractère sculptural qui aurait l'avantage de la relier aux vagues qui viennent battre le Rocher.

"La Figure idéale qui ferme la Composition et la couronne, a paru s'écraser sur le rocher au lieu de le dominer et d'y triompher.

"Enfin, circonstance très grave, la partie postérieure du monument a paru dénuée d'intérêt et présenter peu d'aliment au Public qui doit tourner autour du groupe, le voir sur toutes ses faces, comme il verra dans les mêmes conditions le *Mirabeau* qui s'élève dans le bras de la croix opposé."

27. In Grappe [338] and [338a], nos. 199 and 230 respectively, a date of 1897 was assigned to the first project for the second monument. In subsequent editions, however, Grappe revised the dating to 1893. He dated the standing figure of Victor Hugo 1902 in the 1927 and 1929 editions of the catalogue ([338], no. 246 and [338a], no. 280). In later editions this was revised to 1897.

28. Grappe [338d], no. 286.

29. *See* n. 6 above. "Le personnage principal, celui du poète, est prêt pour la traduction en marbre; il en est de même de la figure ailée qui l'accompagne. Les effigies des Néréides sont, dans la pensée de l'auteur, appelées à être modifiées. Monsieur Rodin compte achever ce modèle sans demander de nouvel acompte; mais il estime son travail assez avancé pour qu'il commence de se préoccuper de la traduction en marbre."

REFERENCES

Gustave Geffroy, "Le Monument de Victor Hugo," in *La Vie artistique*, vol. 1, 1ᵉ série, Paris: H. Floury, 1892, pp. 67–73; Lawton [67], pp. 258–63; Bénédite [10a], p. 16; Grappe [338], no. 199; Watkins [342], no. 44; Grappe [338a], no. 230; Grappe [338b], no. 296; Cladel [26], pp. 174–80; Grappe [338c], no. 233; Grappe [338d], no. 268; Cladel [27], pp. XXV–XXVI; Cécile Goldscheider, "Rodin et le monument de Victor Hugo," *Bulletin de la Société de l'Histoire de l'Art Français*, Paris, January 5, 1956, pp. 9–12; Cécile Goldscheider, "Rodin et le monument de Victor Hugo," *La Revue des Arts*, Paris, no. 3 (October 1956), pp. 179–84; Goldscheider [49], pp. 37–38; Descharnes and Chabrun [32], pp. 176–83; Tancock [341], no. 63.

OTHER CASTS AND VERSIONS

Bronze (first project)

FRANCE

Paris, Musée Rodin. Cast by the Musée Rodin in 1927. Founder: Alexis Rudier.

Plaster, height 88⅞ inches (second project)

FRANCE

Paris, Musée Rodin (fig. 71–9).

Victor Hugo Walking

Plaster, height 88⅞ inches

FRANCE
Paris, Musée Rodin.

STUDIES FOR THE FIRST "MONUMENT TO VICTOR HUGO"

First Project

Plaster, height 39 inches

FRANCE
Paris, Musée Rodin (fig. 71–1).

Second Project

Plaster, height 33 inches

FRANCE
Paris, Musée Rodin (fig. 71–2).

Reduced Variant of Second Project

Terra-cotta, height 15⅜ inches

FRANCE
Paris, Musée Rodin.

Bronze

FRANCE
Paris, Musée Rodin.

UNITED STATES
New York City, Collection Mr. and Mrs. Harold B. Weinstein. Founder: Persinka.

Terra-cotta, height 28⅜ inches

AUSTRIA
Vienna, Kunsthistorisches Museum. Purchased in 1961 (fig. 71–3).

Third project

Plaster, height 44⅛ inches

FRANCE
Paris, Musée Rodin (fig. 71–5).

Fourth Project

Plaster, height 36¼ inches

FRANCE
Paris, Musée Rodin (fig. 71–6).

Variant of Fourth Project

Plaster, height 36¼ inches

FRANCE
Paris, Musée Rodin (fig. 71–7).

Monument to Victor Hugo (including the figures of the two muses)

Bronze

FRANCE
Paris, corner of the avenues Henri Martin and Victor Hugo. Inaugurated in 1964.

Plaster (minus the figure of "The Inner Voice")

DENMARK
Copenhagen, Ny Carlsberg Glyptotek. Purchased by Carl Jacobsen in 1903.

Victor Hugo on the Rock (minus the figures of the two muses)

Marble, height 61⅞ inches

FRANCE
Paris, Musée Rodin.

DETACHED FIGURES FROM THE MONUMENT

The Inner Voice (Meditation)

See no. 5, Other Casts and Versions.

The Tragic Muse

Bronze, height 30¾ inches

SWITZERLAND
Geneva, Musée d'Art et d'Histoire. Gift of Rodin, 1896. Signed: Rodin.

Marble (unfinished), height 35 inches

FRANCE
Paris, Musée Rodin.

72 Balzac in a Frock Coat, Leaning Against a Pile of Books
1891–92

Plaster, 23⅝ × 9½ × 11¾ inches
Not signed or inscribed

73 Naked Balzac
1892

Plaster, painted with brown varnish,
29¾ × 13¾ × 15⅜ inches
Signed front, near right foot: Rodin[1]

74 Head of Balzac
1892

Plaster, 6¼ × 8¼ (shoulders) × 4½ inches
Signed on right shoulder to rear: A Rodin

75 Balzac
1897

Bronze, 41¾ × 15¾ × 13¾ inches
Signed top of base, lower right: A. Rodin
Foundry mark rear of base to right:
Alexis Rudier/Fondeur. Paris

76 Colossal Head of Balzac
1897

Bronze, 20 × 16½ × 15¼ inches
Signed on base to right: A. Rodin
Foundry mark center rear of base:
ALEXIS RUDIER/Fondeur. PARIS.

Long before Rodin received the commission for a monument to Balzac from the Société des Gens de Lettres in 1891, attempts had been made in Paris to erect a monument to the great writer, but they had all ended in failure.[2] In 1851, one year after Balzac's death, the sculptor Antoine Etex advertised in the Parisian newspapers for the opening of a public subscription to raise a monument, but nothing materialized. In December 1853 Alexandre Dumas took up the same idea. He organized a gala performance of *Les Trois Mousquetaires* at the Théâtre de la Porte St.-Martin to assist the project and planned a second gala concert, but Mme Balzac, who resented the lead taken in the affair by Dumas, had recourse to legal proceedings. Although Dumas won his case before the Tribunal de la Seine, the momentum of the subscription fell off after this unhappy affair.

In 1880 Emile Zola again proposed the erection of a monument to Balzac,[3] but it was not until November 1883 that the Société des Gens de Lettres at last decided to open a subscription for a monument to the second president of their society.[4] The state made a

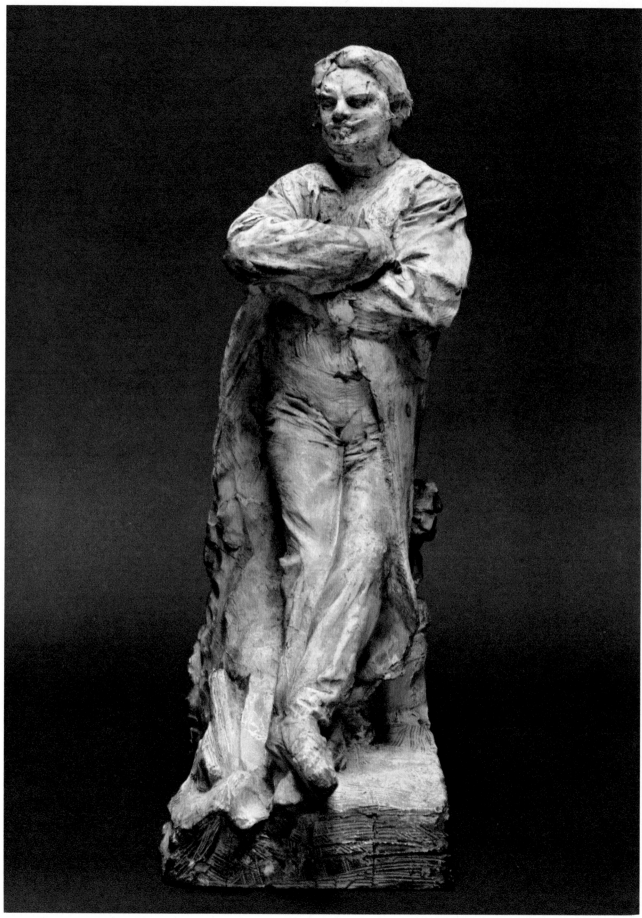

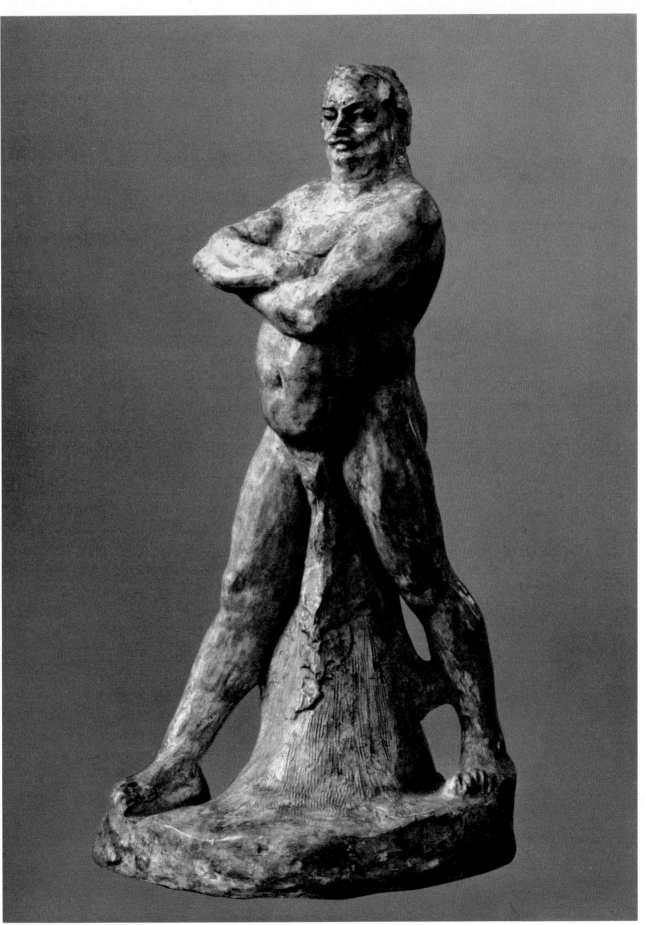

gift of money and the city of Paris promised a site, but there was a further delay of five years until the sculptor Henri Chapu was finally chosen for the task.[5] Chapu's projected monument represented Balzac seated in an attitude of meditation, pen in hand. To the left, a youthful figure wrote the name of the author on the base, while to the right and slightly in front stood the figure of Truth, veiled from the eyes of the public but revealing herself to Balzac.[6]

In 1891, however, before the completion of the monument, Chapu died, having drawn 6,000 francs from the 36,000 raised by the committee. The sculptors Falguière, Mercié, and Dubois were of the opinion that the *maquette* was sufficiently far advanced to be enlarged and given definitive form by *praticiens,* but this advice was not accepted by Emile Zola, who had become President of the Société in 1891.

Although Rodin had not as yet been officially approached by the Société, he had already devoted considerable thought to the project. Among his friends were a number of ardent Balzacians, especially Léon Cladel and Gustave Geffroy. In an interview published in 1888 he stated that he had no intention of presenting a *maquette* to the Société but that he had no doubt that the sculptor finally chosen for the task would not be able to depart very far from the well-known bust by David d'Angers (fig. 72–76–1). "Whatever the sculptor who receives the commission does, he will not be able to neglect this bust. In fact he will be obliged to copy it more or less exactly. Consequently, in my opinion, the very important question of Balzac's head is decided: it is David d'Angers's bust that will represent it. The only place where the artist will intervene is in the choice of symbolic figures that will decorate the monument and their disposition."[7]

In July 1891, however, Rodin was officially chosen to execute the monument, much to the disgust of certain coteries within the Société. Most vociferous in their complaints were the followers of Comte Anatole Marquet de Vasselot, the sculptor and art historian, and a member of the Rose-Croix Société whose cult of Balzac dated back to at least 1868, when he first exhibited a bust of the writer at the Salon. Thus it was reported in *La France* on July 11, 1891,[8] that Rodin had been awarded the commission because the jury had been rigged. Although Zola had promised Marquet de Vasselot "to be impartial and not cut his throat without listening to him," only Zola's friends had been informed of the meeting at which the decision was to be made. The others, believing that the question of the Balzac monument would not be discussed until the following November, did not attend the meeting, at which Marquet de Vasselot was defeated.

Rodin offered to complete a bronze figure of Balzac, 3 meters (118⅛ inches) in height, within a period of eighteen months, for the sum remaining from the subscription, that is to say, 30,000 francs. "I have always been interested in this great literary figure," he wrote in 1891, "and have often studied him, not only in his works but in his native province (vallée d'Indres)."[9] Rodin, who had indeed been to Touraine in 1890, returned to the area in August 1891.

Like the Naturalist writers, he proceeded to make an intense study of the extensive Balzacian iconography and literature before commencing work. In 1893 Gustave Geffroy was able to write that "Rodin had read and reread not only all the works of Balzac, but also all that has been written about Balzac: Mme Surville, Gozlan, Werdet, Gautier, Lamartine, d'Aurevilly, Bourget, Lovenjoul, Cerfberr, Christophe, Paul Flat, and many others."[10] Copies of Edmond Werdet's *Portrait intime de Balzac: Sa vie, son humeur et son caractère,*

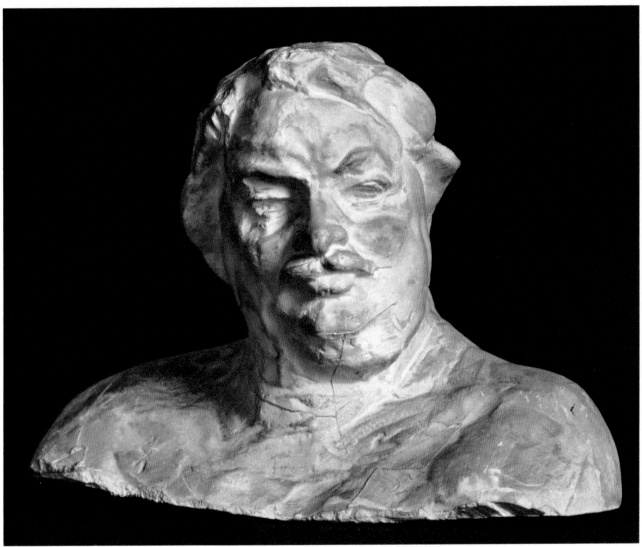

74

429

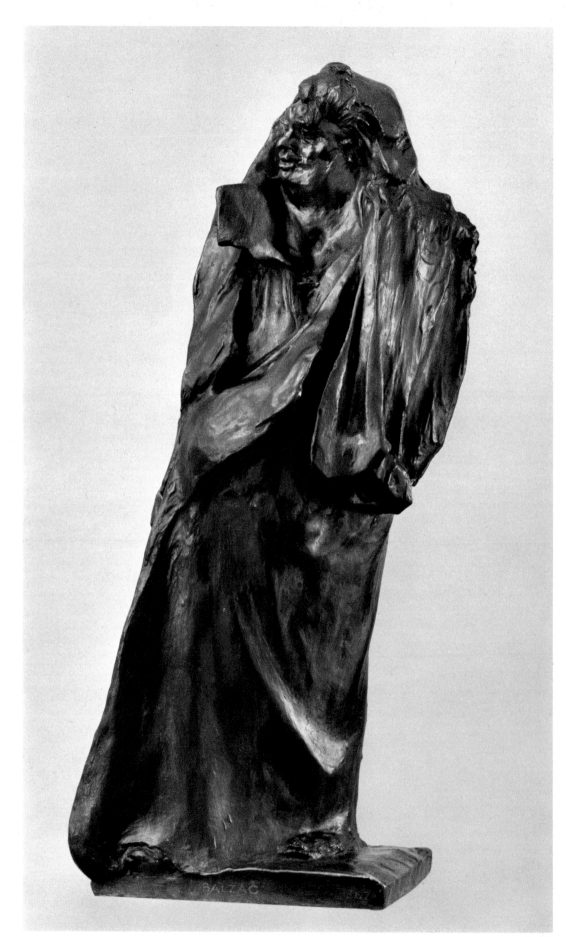

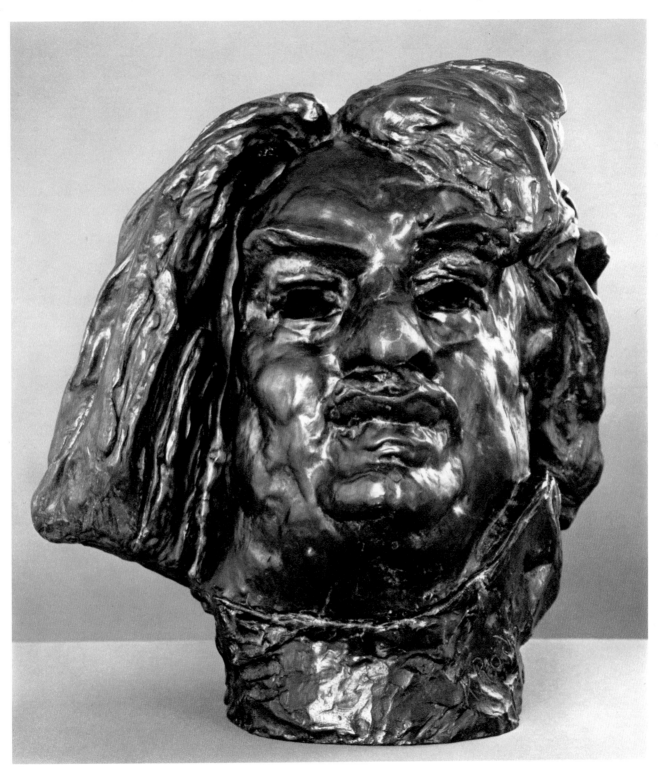

published in Paris in 1859, and Alphonse de Lamartine's *Balzac et ses œuvres,* of 1866, in which Rodin marked the passages he found particularly revealing, are known to have been in his library.[11]

Many of the studies of Balzac's head are closely related to earlier portraits of the artist, as has been convincingly pointed out by Mme Goldscheider,[12] and must have been executed in the very first months after the commission, when Rodin was still exploring the field. But far more important to Rodin was the work he did from various living models. Speaking of the head of Baudelaire,[13] on which he was working at the same time, Rodin said that he had a large number of documents, portraits, and photographs of the poet but that "what was of most use to me was a living model, a young draftsman who bore an astonishing resemblance to the poet."

"It is from this living head," he continued, "that I constructed my bust, that is to say, that I established the general lines, the character or, if you prefer it, the type. It was only afterward that I applied myself to producing the special character of the individual.... It is in this way that I work, since even immersing oneself in all the documents, one never imitates nature.... And nature is the only object of my efforts."

He followed the same procedure with his *Balzac.* Writing from Touraine on September 6, 1891, he stated: "I am making as many models as possible for the construction of the head, with types in the country; and, with the abundant information I have secured, and am still procuring, I have good hope of the Balzac."[14]

Various attempts have been made to arrange the sequence of over fifty studies for the monument chronologically, by far the most convincing being that adopted by Athena Spear. According to her cataloguing system,[15] heads *A* (fig. 72–76–2), *B, C,* and *D* (fig. 72–76–3), in which Balzac is portrayed young and with short hair, are among the earliest studies of the head. It seems probable that these were done from the living model, although to varying degrees they were modified to resemble already existing portraits *(see* Other Casts and Versions). In the next group of heads proposed by Spear, *E, F, H, I,* and *J,* to which she assigns the date of 1892, Balzac is fatter and long-haired. Once again the reference to well-known portraits of Balzac is unmistakable.

At this early stage in the development of the monument, Rodin considered clothing Balzac in contemporary costume. In three small studies *(a, b,* and *c)* the lack of detail places all the emphasis on the misshapen form of the writer, while in a fourth *(d)* a less grotesque Balzac leans back nonchalantly against a pile of books. It is this stage in the development of the figure that is represented by the plaster study in the Rodin Museum (no. 72). It was undoubtedly at this point that Rodin commissioned *le père* Bion, Balzac's former tailor, to make a suit of clothes to the measurements of his deceased client so as to form a more accurate idea of his size.[16]

In two other studies *(e* and *f),* the latter more highly finished than the former, Balzac is represented in the monk's robe which was his favorite working attire. Inspired by the written descriptions and perhaps by such visual records as the etching of Balzac in a monk's robe by Gavarni, Rodin here discovered the solution for the clothing of the figure that he was to use in the final version. Writing in 1892, Roger Marx referred to "a very advanced and very precise *maquette.* Balzac is represented standing, draped in the Dominican's frock.... An indefinable smile showing at once kindness, mockery, and challenge slightly opens the sinuous mouth."[17] This description could very well refer to study *f* (fig. 72–76–8).

432

It was a closely related work[18] that Rodin presented to the committee on January 10, 1892, and which was described in the following terms in *Le Temps* of January 11, 1892: "Balzac is standing, arms crossed, head upward, and dressed in his legendary monk's robe, fastened at the waist by a cord. The committee congratulated M. Rodin on his project and asked him to start working on the marble immediately."[19]

There is considerable disagreement among scholars as to the nature of the next group of studies for the head, in which once again Balzac is represented with short hair *(K and L; fig. 72–76–4). K,* the version in the Philadelphia collection (no. 74), was used in the nude study *h.* Mme Goldscheider and Jacques de Caso both subscribe to the view that in this head Rodin relied exclusively on the celebrated daguerreotype by Bisson of the dying Balzac.[20] Athena Spear proposes two further sources, a caricature of Balzac by Nadar and the portrait of Balzac by Louis Boulanger.[21]

To support their claim, these authorities point to Rodin's statement that "I have seen and studied all the possible portraits of this author of the *Comédie Humaine;* after a laborious examination, I decided to take my inspiration from a daguerreotype plate of Balzac executed in 1842; in my opinion, it is the only faithful likeness and true resemblance of the illustrious writer. The plate is the property of Nadar, who has made a photograph from it; I have studied this document at great length. Today I have captured Balzac. I know him as if I had lived with him for years."[22]

Albert Elsen, on the other hand, believes that this head was made directly from the living model, although he concedes that "the photograph could have inspired the choice of a living model."[23] Undoubtedly the vitality of the face and the individual structure of the head point to study from a living model, although, with certain differences, it must be admitted that it does bear a striking resemblance to the photograph. The most satisfying solution to this dilemma, perhaps, is that working from a living model, Rodin subsequently consulted the photograph to produce "the special character of the individual."

It is this head (no. 74) that was used in the remarkable studies of Balzac in the nude *(h,* no. 73; and *i),* most probably completed in 1892 and described by Charles Chincholle in 1894: "During the year 1892...the artist...conceived a strange Balzac in the attitude of a wrestler, seeming to defy the world. He had placed over very widespread legs an enormous belly. More concerned with a perfect resemblance than with the usual conception of Balzac, he made him shocking, deformed, his head sunk into his shoulders."[24]

Here again there is a wide divergence in the interpretations given to this figure. To Jacques de Caso, "the portrait conforms to the idea that the Naturalists had of Balzac, a Balzac facing the variety of the world around him, analyzing it."[25] He sees it as the culmination of what he refers to as "the first campaign [a period of eighteen months immediately following the commissioning of the statue in the spring of 1891], which was dominated by Rodin's main concern to established the veracity of Balzac's appearance, and to ensure correct proportions, volume and weight and the feeling of physical existence, by means of a live model who he felt resembled Balzac."[26] Albert Elsen, on the other hand, pointing to the discrepancy between the historical Balzac and Rodin's noble image of him, sees the naked Balzac as "a convincing metaphor of Balzac's spirit as a creative artist,"[27] and believes that "because of sculpture like his naked Balzac, Rodin should today be reconsidered as a *visionary.*[28] There is no better example of the divergent responses provoked among scholars and critics by one and the same work.

The period from 1893 to 1895 seems to have been a bad one for Rodin. He was in poor health, as both his own letters and the *Journal* of Edmond de Goncourt testify. "He has worked," de Goncourt wrote on April 16, 1893, "but he has only executed things of no importance."[29] Work on the *Balzac* of necessity slowed down, although at no point did it cease altogether. Athena Spear suggests that heads *O, P, Q,* and *R,* in which Balzac is again represented at a mature age, date from the mid 1890s. In this group of heads the modeling is much more emphatic than previously. The vast mane of hair, the projecting eyebrows and mustache, the deeply recessed eyes show Rodin beginning to attempt to capture Balzac's genius through exaggeration rather than through an interpretation of his actual appearance. Through the emphasis in each head on certain features, he brings out particular aspects of Balzac's multi-faceted personality, but he had clearly not yet found the synthesis for which he was looking, the adequate embodiment of Balzac's soul.

Connected with these heads are the figures *j* (fig. 72–76–5) and *k,* the latter a clothed version of the former, to which Athena Spear assigns the date of 1893–95. These are a development of nudes *h* and *i,* in the direction of a much greater grotesqueness. The legs are even more widely spread apart than in the earlier work and consequently throw the stomach into even greater prominence. The writer Séverine published a description of a "*bonhomme* in clay, furiously hammered with thumb marks," which she saw in the studio in 1894 and which may very well refer to this figure.[30] Certainly the grotesqueness of her description is more in keeping with this figure than with nudes *h* and *i,* which have considerable majesty. She wrote:

> Close up, it was very ugly, the skin as if flayed, the face barely indicated—quite naked, what a horror! But the arms were folded in such a manner over the powerful pectoral muscles, and the space between the legs, as if in the process of walking, with the conquering advance of the step, suggested so magnificently taking possession of the ground, the feet as if attached to the mother earth by roots. And from that formless face, full of holes, with a grin like a scar, a nose like a bird's beak, cannibal-like jaws, a rugged forehead beneath a mass of hair like a clump of weeds, there emanated such an imperious sovereignty, almost superhuman, that an austere shiver, known by intellectuals, passed down my spine.

The Société des Gens de Lettres continued to press Rodin to deliver the statue,[31] but still the work was nowhere near completion. "It appears that the statue of Balzac will not be erected in Paris for about another year," it was announced in the press on June 29, 1893,[32] but in requesting delays Rodin always underestimated the strength of his unrelenting determination to create a sculpture that was fully the equal in complexity of its outstanding subject.

> He is dreaming of a grandiose Balzac and, in order to arrive at the realization of his dream, the master has already made and remade his monument several times.
>
> One day even, when the clay statue was finished, Rodin, who was almost satisfied, resolved to call the committee.
>
> But in the night he changed his mind and the next morning ordered his stupefied *praticiens* to destroy the clay.
>
> But what about the committee?
>
> "When I am happy with it, the committee will be too," replied the master.[33]

434

Unfortunately this was not the case. The Société des Gens de Lettres cannot perhaps be blamed for feeling impatient, although no exoneration can be found for some of their actions in the ensuing months. Toward the end of 1894 their demands reached the height of absurdity when they ordered Rodin to deliver his statue within twenty-four hours, on pain of forfeiting the 10,000 francs he had already received. In order to resolve the issue, Rodin offered to put the money in the Caisse des Dépôts et Consignation until the day he delivered the statue, but they refused, on legal grounds, to receive it. Rodin then offered to leave the funds with the Société's own lawyer, whereupon it was agreed that the Société would omit the time clause from their agreement with him. This affair led to the resignation of Jean Aicard, who had succeeded Zola to the presidency in March 1894, and to the election of Aurélien Scholl as president in October of that year.[34]

Freed from the threat of legal action, Rodin was nonetheless still acutely conscious of the moral pressure being exerted on him to finish the *Balzac* as quickly as possible. "I beg you," Zola wrote from Venice on December 9, 1894, "in the name of genius, in the name of French literature, do not make Balzac wait any longer."[35]

Rodin continued to be in low spirits throughout 1895, although it is wrong to assume, on the strength of the entries in de Goncourt's *Journal,* that it was a completely fallow year. The Sarmiento monument (no. 77), the Victor Hugo monument (fig. 71–9), and the monument to Labor (fig. 47–1) occupied a great deal of his time, but he undoubtedly devoted much thought to the *Balzac.* Not yet satisfied with any of his own solutions, he cannot but have been aware of Marquet de Vasselot's machinations and of his concept of Balzac as the great seer and initiate.

Balzac, as understood by Rodin, was as far removed as possible from the Balzac of Marquet de Vasselot and his followers, Papus, Sar Péladan, and Maurice Barrès, but it is distinctly probable that the form of the debate led him to revise his attitude to the task before him. Marquet de Vasselot's *Balzac Sphinx* was exhibited at the Salon de la Société Nationale in May 1896. He then published two long articles in defense of his work,[36] which reveal that, in spite of their differences, Marquet de Vasselot and Rodin held in common certain approaches to the problems involved in representing the creator of the *Comédie Humaine* in the ungainly body described by so many commentators.

In the second of the articles he quotes a letter from Lamandie, Vice President of the Société in 1896, in which the view is stated that the representation of Balzac as a sphinx had avoided the difficulty "arising from the unaesthetic forms of the great man....the only thing that can validly interest us is the representation of his thought by the general lines of his posture, the accentuation of his face, the deep and striking flash of his glance. Physical difficulties are passing contingencies that should not be fixed in marble and bronze; these noble materials can only transmit to the future the imperishable, the permanent, the immanent, the silhouette of the spirit which endures, without the fleeting forms that time carries away to eternal oblivion."[37]

Rodin had come to a similar conclusion when he accepted the commission for a monument to Baudelaire four years previously: "I cannot see a statue of Baudelaire," he stated. "What is a statue after all; a body, arms, legs, covered with banal clothing. What do these have to do with Baudelaire, who lived only by his brain? With him, the head is everything."[38] For the cerebral and precious poet the head alone might suffice, whereas for the immensely fertile, prodigal author of the *Comédie Humaine* such a solution must have seemed inadequate.

72–76–1 David d'Angers (1788–1856)
Tomb of Honoré de Balzac
Père Lachaise Cemetery, Paris

72–76–2 *Bust of Balzac*
1891, plaster, height 17 inches
Musée Rodin, Paris

72–76–3 *Mask of Balzac*
1891, terra-cotta, height 9½ inches
Metropolitan Museum of Art, New York

72–76–4 *Bust of Balzac*
1892, wax, height 8¼ inches
Collection Mme Marcel Pollak, Paris

72–76–5 *Naked Balzac*
1894, plaster, height 50⅜ inches
Musée Rodin, Meudon

72–76–6 *Head of Balzac*
1897, bronze, height 7 inches
Ashmolean Museum, Oxford

72–76–7 *Naked Balzac*
1896?, bronze, height 37¾ inches
Museum of Modern Art, New York
Gift of B.G. Cantor Art Foundation

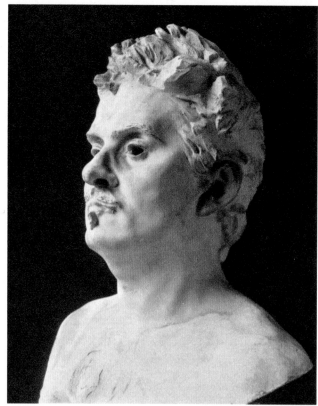

72–76–2

72–76–1

72–76–3

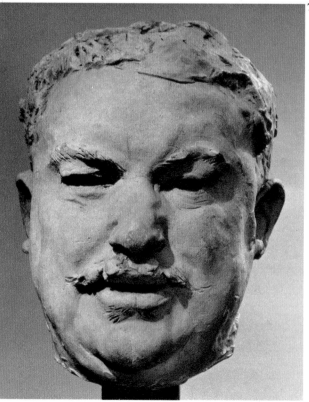

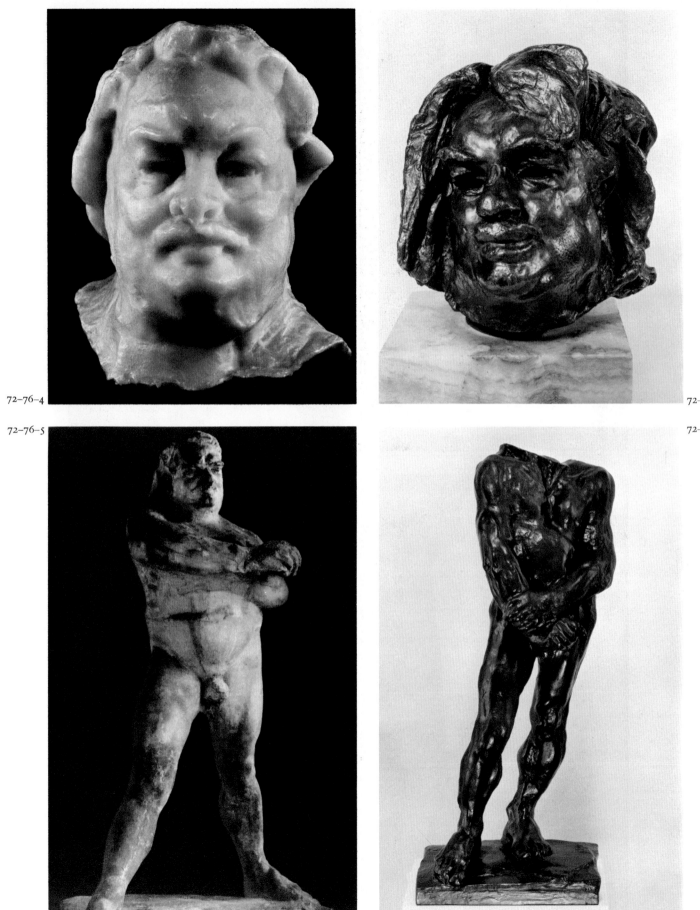

72-76-4

72-76-6

72-76-5

72-76-7

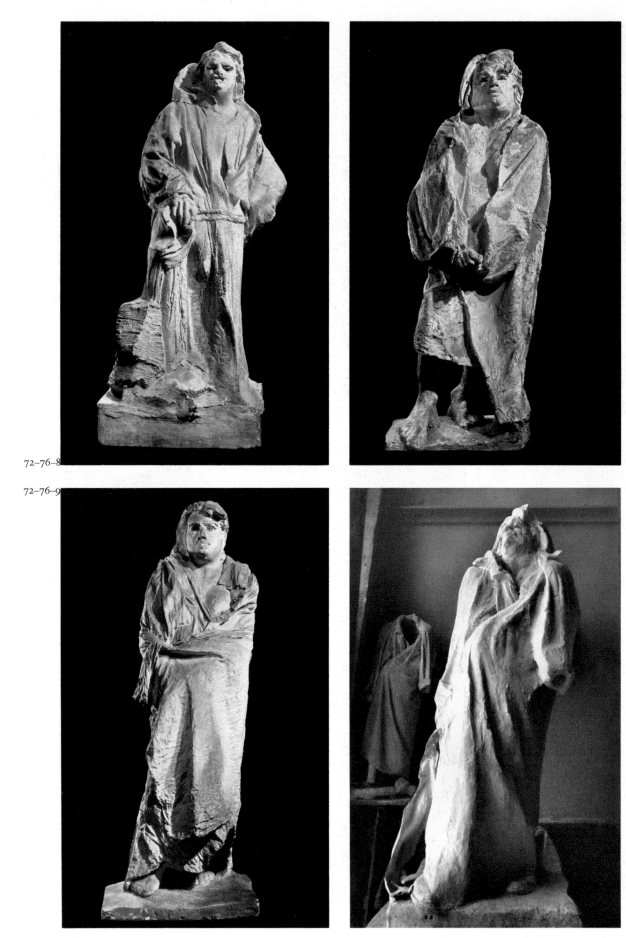

72–76–8

72–76–10

72–76–9

72–76–11

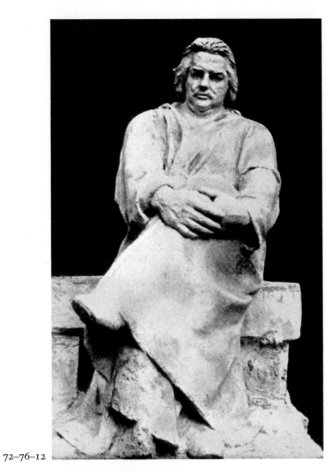

72–76–12

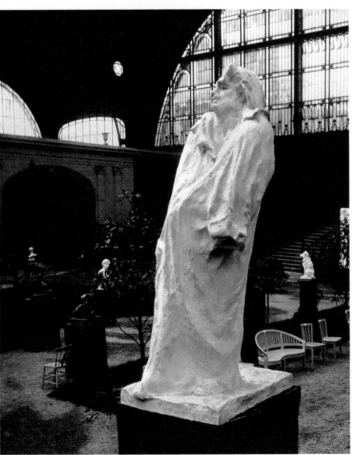

72–76–13

72–76–8
Study for Clothed Balzac
1891–92, plaster, height 42½ inches
Musée Rodin, Paris

72–76–9
Study for Clothed Balzac
1896–97, plaster, height 40½ inches
Musée Rodin, Paris

72–76–10
Study for Clothed Balzac
1896–97, plaster, height 41 inches
Musée Rodin, Paris

72–76–11
Balzac in Rodin's studio, showing
another cast of drapery at the left

72–76–12
Alexandre Falguière (1831–1900)
Monument to Balzac
Avenue de Friedland, Paris

72–76–13
Balzac at the Salon of 1898

439

Yet there is evidence that Rodin began to feel dissatisfied with the nude studies of 1892–95 for the very reason that they were too realistic, too corporeal. François Pompon, who was then working as a *praticien,* later reported that when visitors congratulated him on the realism of his work, Rodin would throw his dressing gown over it to hide it.[39] Certainly from 1896 on, Rodin seems to have approached the *Balzac* from a completely different point of view. He started working with renewed vigor, as several commentators testify.[40] He was also using a new model. In the words of Mathias Morhardt,[41] who, probably mistakenly, places these events toward the end of 1897,[42] this was "a sturdy, squat, powerfully muscled model.... He posed in the nude, of course. He was standing, the left foot forward by half a step."

The fact that the model used in studies *l* and *m* (fig. 72–76–7) bears no relationship to the physical form of Balzac, as had the model for the nudes of 1892–95, marks an important stage in the development of Rodin's thoughts about the monument. All ideas of verisimilitude have evidently been abandoned in favor of the creation of a figure that symbolizes the nature of Balzac's genius. Propriety demanded that the grasping of the penis,[43] a powerful symbol of virility, be concealed, but Rodin would not now have disputed Lamandie's statement to Marquet de Vasselot that "the only thing that can validly interest us is the representation of his thought by the general lines of his posture, the accentuation of his face, the deep and striking flash of his glance."[44]

Once this decision was made, it remained for Rodin to establish the nature of the clothing for the figure and to choose an appropriate head. By August 1896 these decisions seem to have been made, as evidenced from a journalist's report in the press: "One or two months ago, M. Rodin finished a *maquette* which gives him the satisfaction he searched for so untiringly. Balzac will be represented standing, in a strong, simple posture, his legs slightly apart, his arms crossed. He will be dressed in a sort of long robe without a belt, which will fall down to his feet."[45]

Various theories have been proposed as to the probable influences on Rodin's decision to clothe Balzac in the long shapeless garment that he wears in the final version. It has been suggested that he was influenced by a small Japanese figurine of a man in a long robe that he had in his possession,[46] that he looked long and searchingly at Medardo Rosso's *Book-maker,*[47] and that he recalled the figures of mourners by Claus Sluter for the Tomb of Philippe le Hardi,[48] of which he had made drawings on a trip to Burgundy in 1894–95. Plausible or not, these suggestions ignore the fact that the decision was inevitable within the context both of this particular work and of Rodin's art in general. In many of the earlier representations of Balzac which Rodin consulted in preparation for his work, the writer is clothed in the Dominican's robe that was his favorite working attire. Once the decision was made to represent Balzac the worker and creator, it followed naturally that he should be clothed in this manner. Moreover, such drapery had the timeless quality that he admired so much in the costume of the Greeks and Romans.[49]

During the last months of 1896 and the early part of 1897 he tried many different arrangements of the drapery, some much more successful than others. Morhardt later related that on one of his visits to the studio he saw "six similar examples of the plaster cast that Rodin had had made of the half life-size figure that he had just modeled. In a corner lay a roll of cloth. This cloth was then cut in six approximately equal pieces, and soon each one was wrapped around one of the models according to Rodin's instructions. Thus was born the

Balzac. With wet plaster thrown on the cloth, the latter was made rigid."[50] Studies *o* and *p* (figs. 72–76–9, 10), with their clumsy draperies, are two of the less successful experiments in this vein. In *q* the drapery is still somewhat shapeless, and the head is turned to the right instead of to the left. In study *r,* a sketch for the robe, Rodin has retained the motif of the robe held across the body, but the hanging sleeves give a stability and monumentality to the form that was lacking in earlier versions *(see* fig. 72–76–11). Study *s* is a full-scale model of the robe alone.

The final series of head and figure studies *(U, V, W, X; fig.* 72–76–6, and *Y* and *t, u, v),* which are close to the final version and differ from one another only in detail, bear out the report of the journalist who wrote in July 1897 that "Rodin is working constantly with love, retouching a detail, stressing a feature of the physiognomy, without changing the pose of the thinker who looks with arms crossed upon the passing human crowd."[51] The colossal head in the Rodin Museum (no. 76) is an enlargement of head *W.* Study *t,* the Philadelphia version (no. 75), differs from the final work only in the fact that the head is turned more sharply to the left and in the disposition of the draperies, which are more deeply hollowed out and angular.

It was announced in April 1897 at the general assembly of the Société des Gens de Lettres that the *maquette* was finished.[52] Its enlargement was then undertaken, although it is probable that even at this stage Rodin made adjustments to it, since he was still far from satisfied that the figure could stand on its own. "He wants to make Balzac's robe suppler, and to make the smile of the *Comédie* more profound," it was announced in *Le Journal des Débats* of March 20, 1898.[53] Evidently the angle of the figure also worried him, as Charles Chincholle wrote on March 19, 1898:

> The *praticiens* will install the pieces of the definitive modeling on the scaffolding. Only then will he judge with certainty the effect produced. If the statue leans too much to one side, he will modify the movement with the aid of wedges, either adding or subtracting, then he will deliver it to the founder.
>
> And so it is only in the open air that he will come to a decision as to the interest of a symbolic figure that he wants to make emerge from the plinth, to the statue's right. It is his fancy to imagine that there was in Balzac's study a small column supporting a figure of Fame brandishing a crown.
>
> You see, he said, this statue which he touches with his foot without seeing it represents belated fame which today tries to raise itself to him without being able to. It is not in plaster yet, but it will be in gilded bronze and will break the monotony of the black robe.
>
> The base, which is the work of M. Frantz Jourdain, is like those Assyrian capitals, consisting of unequal tiers, which are very swollen in the middle. A long time ago Rodin had a reduction made in wood. On the principal surface he modeled a naked, grimacing woman in plaster who has just removed a mask. For him it is the *Comédie Humaine.*[54]

It is revealing that even as late as March 1898, two months before the work was due to be exhibited, Rodin had still not abandoned the idea of the allegorical figure that he had first referred to in 1888.[55]

The exhibition of the *Balzac* at the Salon de la Société Nationale in May 1898 (fig. 72–76–13) gave rise to a scandal. In a century accustomed to scandals over artistic matters, it was unparalleled in its violence and in the breadth of its implications. The Société, rejecting a motion that merely expressed the desire that Rodin should *finish* his work,[56] adopted another which stated: "The Committee of the Société des Gens de Lettres has the

duty and the regret to protest against the sketch which M. Rodin is exhibiting at the Salon and in which it refuses to recognize the statue of Balzac."[57] Rodin then withdrew the work from the Salon and installed it at Meudon.

A meeting of protest was immediately called by Mathias Morhardt in one of the studios in the rue de l'Université, and a statement of condolence and encouragement was issued to the artist. A circular was sent out on May 13, requesting financial assistance from those who had already written to the committee in Rodin's support, and the sum of money necessary for the purchase of the sculpture was rapidly collected, the contributors including the outstanding names of the time in painting, sculpture, music, literature, and politics.[58] Rodin also received independent offers of purchase from Auguste Pellerin, the distinguished collector, who was prepared to pay 20,000 francs, and from Edmond Picard on behalf of the Maison d'Art in Brussels, but none of the offers proved to be acceptable. To the committee that organized the subscription he wrote: "It is my formal wish to remain the sole owner of my work. My interrupted labor and my own thoughts leave me no alternative now. I ask from the subscription only the generous names which are on it, in witness of and in recompense for my efforts."[59]

Despite the barrage of hostile and mostly ignorant criticism which greeted the work and the sale of small plaster figures of *Balzac in the Form of a Seal* (inscribed: "one step forward"), which were sold widely at the time, Rodin did not lose confidence in his work. When asked if he intended to retouch it, he replied: "It is possible; but for the moment I have no intention of doing so because I cannot see what retouches I could make. I don't even want to look at it. I will look at it again only in a few months' time when I no longer feel as affectionately toward it as artists always do at first for each new work. In any case, I like the statue as it is at the moment and I have no intention of retouching it."[60] To another reporter he said that he thought the neck was too thick,[61] but elsewhere he stated that such apparent exaggerations as there were in the form of the work were intentional and an integral part of his sculptural concept:

> I tried in the Balzac, as in the Victor Hugo, to find an art that is not photography in sculpture. There are errors in my Balzac; one cannot always realize one's dream; but I believe in the truth of my principle, and Balzac, rejected or not, is none the less a line of demarcation between commercial sculpture and the sculpture that is art that we no longer have in Europe....
>
> My principle is to imitate not only form but life. I look for that life in nature, but in amplifying it, exaggerating the holes and the bumps so as to give them more light; then I look for a synthesis of the whole.[62]

He had nothing but scorn for criticism of details:

> What right have they to reproach me for that dressing gown with floating sleeves? Would an inspired writer who walks feverishly up and down in his apartment at night in the pursuit of his inner visions dress any other way? It has never been done before! A statue for a public place must represent a great man in theatrical attitude, capable of making him admired by posterity. But such reasons are absurd! I claim that there was only one way of evoking my character; I had to show Balzac laboring in his study, his hair in disorder, his eyes lost in a dream, a genius who, in his small room, reconstructs piece by piece a whole society to make it vibrate tumultuously in front of his contemporaries and of generations to come, a really heroic Balzac who does not take one moment of rest, who works day and night, who makes vain efforts to fill the hole hollowed out by his debts,

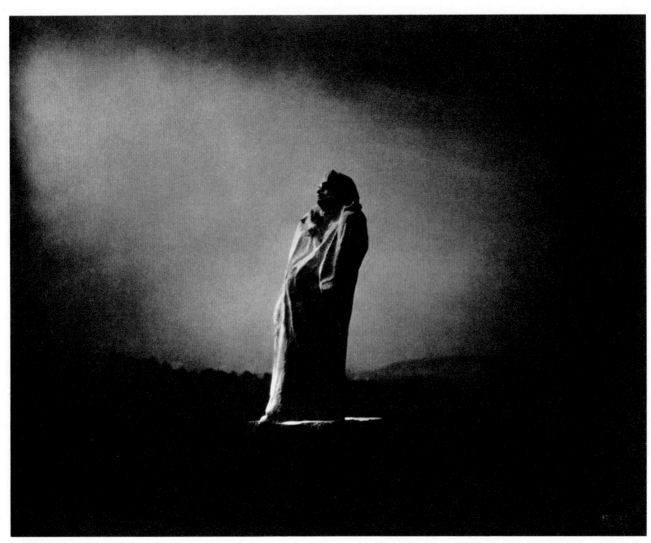

72–76–14
Edward Steichen
Monument to Balzac in the Moonlight
1908, photograph
Rodin Museum, Philadelphia

443

who above all is set upon the building of an immortal monument, who boils over with passion, who frenetically maltreats his body and takes no notice of the warnings of the heart disease from which he was shortly to die.[63]

But the critical reception accorded to the *Balzac* was not simply that of an uncomprehending and unappreciative public toward a work of art of advanced tendencies. The journalist who reported that "France was almost divided between Rodinists and anti-Rodinists, as between Dreyfusards and anti-Dreyfusards,"[64] pointed to the fact that the *Balzac* was thought of as being a political gesture and not just a statue of a great writer. The very complexity of Balzac's personality was in part responsible for this, and the conflict between the Naturalists and the Rose-Croix within the Société des Gens de Lettres as to the most appropriate form of the monument to be erected to Balzac, and as to the nature of Balzac's genius itself, was also a political conflict between the left and the right wing, republicanism and royalism, anti-clericalism and clericalism.

Thus to Marquet de Vasselot, Rodin's *Balzac* was unpatriotic: "No," he wrote, "the French spirit will never exist in this German larva, in this thing filled with beer which is at the Salon.

"And it is so-called French artists, but who think like Germans or Belgians, who have the audacity to want to import into a country like ours an art of an altogether different kind from that given to us by Ste.-Chapelle, the cathedrals of Reims, Amiens, Chartres, Paris, Beauvais, and Strasbourg."[65]

It is indeed ironic that Rodin, an impassioned admirer of the French Gothic, should have been criticized for his insufficient rapport with *le génie français*. To another right-wing critic, the *Balzac* was "Zola's revenge."[66] On the other hand, the socialist Municipal Council of Tours refused to allow M. Brunetière to lecture on Balzac in the local theater because "they declared that they could do nothing for Balzac who was clerical."[67]

Rodin seems to have been the only admirer of Balzac who remained unperturbed by, and uninterested in, Balzac's political and religious views, although this detachment in itself gave rise to a great deal of misunderstanding. On the grounds of his association with Zola, and of the names on the list of subscribers for the purchase of the *Balzac,* Rodin was reputed to be an active Dreyfusard.[68] To Georges Clemenceau and Raymond Poincaré, however, Rodin did not have the strength of his convictions. When they heard that Rodin was alarmed at the number of supporters of Zola among the subscribers for the monument, they requested Morhardt to remove their names from the list forthwith. In fact he remained sublimely indifferent to the political debate aroused by his work, believing in its exclusive value as a work of art and not as a manifesto.

"In my own eyes," he later said, "I have made my most serious progress since my first sketch. Nothing I have ever done satisfied me so much, because nothing cost me so much, nothing sums up so profoundly what I believe to be the secret law of my art."[69]

The following year Rodin had his own revenge, although in fact he bore no animosity toward Falguière, who had received the commission for the *Balzac* from the Société des Gens de Lettres after Rodin's figure had been rejected *(see* fig. 72–76–12*).* Exhibited in November at the Nouveau Cirque, Falguière's seated figure aroused a great deal of savage criticism, for the most part on the grounds that it was too close to Rodin's but not as good. To Gustave Geffroy it was "a *maquette* which reveals very clearly a preoccupation with

Rodin's statue, more than a preoccupation even, an embarrassment, which makes this seated Balzac, as if tired at the memory of the *other one,* which looked so well standing, rather funny."[70]

Charles Chincholle reported rather maliciously that Falguière, "not being able to escape the imperious influence of Rodin, ingenuously asked him if he could borrow 'the powerful neck, the sturdy form, the drapery, the hair, the chin, and the pupils of his Balzac.' And the chronicler reports that, impassive behind his pince-nez, Rodin replied without getting agitated: 'But go ahead, my dear colleague.' Falguière then went to work; and the whole operation consisted in seating the figure on a garden bench."[71]

Falguière's monument was finally inaugurated on the avenue Friedland in 1902. Rodin's *Balzac,* however, remained in seclusion at Meudon, where in 1908 it was photographed in the moonlight by Edward Steichen (fig. 72–76–14). Some of the studies, notably of the head, were cast before Rodin's death,[72] but it was not until 1930 that the full-scale figure was cast in bronze and purchased by the Koninklijk Museum voor Schone Kunsten in Antwerp.[73] Finally, in 1939 the Société des Gens de Lettres relented. On July 2 of that year, in the presence of all the surviving former presidents of the Société, the *Balzac* was inaugurated at the junction of the boulevards Raspail and Montparnasse (fig. 72–76–15). The covering drapery was removed by two of the greatest French sculptors of the time, Aristide Maillol and Charles Despiau.

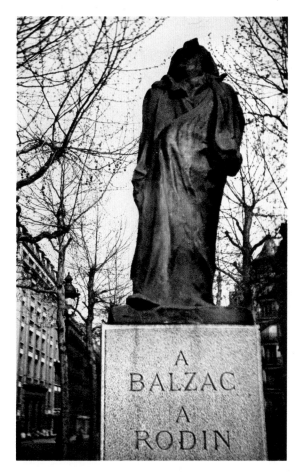

72–76–15
Monument to Balzac
1891–98, bronze, height 118⅛ inches
Boulevards Raspail
and Montparnasse, Paris

1. This work was given to the Rodin Museum in Philadelphia in 1971 by Mr. and Mrs. Sheldon M. Gordon, Mr. Gerson Bakar, and Mr. and Mrs. Norman Perlmutter.

2. In 1889, however, a statue of *Balzac* by Paul Fournier was unveiled at Tours.

3. "Une Statue pour Balzac," *Le Figaro,* Paris, December 6, 1880.

4. The president of the committee at this time was Henri Houssaye. Subscribers included Alexandre Dumas, Ludovic Halévy, Ferdinand de Lesseps, Guy de Maupassant, the Princess Mathilde, and the Vicomte Spoelberck de Lovenjoul. On April 25, Zola sent 1,000 francs. For the full list of subscribers, *see* Mathias Morhardt, "La Bataille du Balzac," *Mercure de France,* Paris, December 15, 1934.

5. The other contestants in 1888 were Jules-Félix Coutan, Aimé Millet, and Marquet de Vasselot.

6. *See* description in *Le Havre,* Le Havre, May 17, 1898. "Il avait fait un Balzac assis, la plume à la main, dans l'attitude de la méditation. Devant lui, pendant qu'à gauche du monument un génie enfant écrivait sur le socle le nom du grand romancier, à droite, les pieds à terre, se dressait la Vérité, voilée du côté du public, mais se révélant à Balzac seul." Two drawings of the Chapu statue were published by Charles du Bousquet in *La Revue de l'Art,* Paris, 30 (July–December 1911), p. 112.

7. "Au Jour le jour: La statue de Balzac," *Le Temps,* Paris, September 12, 1888.

 "Le sentiment de M. Rodin est fort simple. Il pense que c'est un grand honneur que celui d'exécuter le monument de Balzac et que, pour s'en charger, il faut de vigoureuses épaules. Son nom, nous a-t-il dit, n'a pas été pris en avant par lui-même. D'ailleurs, il ne se propose pas de présenter une maquette au comité de la Société des Gens de Lettres. Ce n'est que dans la cas où le monument lui serait confié qu'il s'en occupera sérieusement et qu'il exécutera un projet. Comme nous lui demandions de quelle nature il voyait le monument à edifier, M. Rodin nous rappela le buste de Balzac dû à David d'Angers.

 "Quoi que fasse le sculpteur chargé de cette statue, nous a-t-il dit, il ne pourra négliger ce buste. Bien mieux il sera obligé de le copier plus ou moins exactement. Par conséquent, selon moi, la question très importante de la tête de Balzac est réglée: c'est le buste de David d'Angers qui

la représentera. Là seulement où interviendra l'artiste, c'est dans le choix des figures symboliques qui décoreront le monument et dans la disposition même de celui-ci. Quant à moi, je n'ai pas encore songé à cela."

8. "La Statue de Balzac: La vérité sur le monument," *La France,* Paris, July 11, 1891.

 "Il y a deux jours, le vote de la Société des Gens de Lettres attribuait à M. Rodin, contre M. de Vasselot, le monument de Balzac qui doit décorer la place du Palais-Royal....

 "Voila l'homme [Marquet de Vasselot] que M. Zola s'est appliqué à renverser, après lui avoir promis d'être impartial et de ne pas *l'égorger sans l'entendre* à la séance de lundi dernier, la séance du vote, il ne fallait avoir que des *amis.* Ces *amis* seuls ont été prévenus et les autres membres du comité, croyant, d'après ce qu'avait dit M. Zola, que la question Balzac ne reparaîtrait qu'en novembre, ne se sont pas présentés à la séance en question."

9. Extract from a letter dated July 3, 1891, quoted in *L'Echo de Paris,* Paris, August 29, 1896.

 "J'offre de me charger d'exécuter un Balzac en bronze, haut d'environ 3 mètres avec piédestal en rapport, et cela dans un délai maximum de 18 mois à partir du jour de la commande, pour la somme restant de la souscription ouverte dans ce but.

 "Je me suis toujours beaucoup préoccupé de cette grande figure littéraire, je l'ai souvent étudiée dans ses œuvres, mais aussi dans son pays natal (vallée de l'Indres)."

10. "L'Imaginaire," *Le Figaro,* Paris, August 29, 1893, p. 1. "Rodin a lu et relu non seulement toutes les œuvres de Balzac, mais encore tous les écrits publiés sur Balzac... Mme Surville, Gozlan, Werdet, Gautier, Lamartine, d'Aurevilly, Bourget, Lovenjoul, Cerfberr, Christophe, Paul Flat, et combien d'autres."

11. *See* Cécile Goldscheider, "La Genèse d'une œuvre: Le Balzac de Rodin," *La Revue des Arts,* Paris, no. 1 (March 1952), pp. 37–44.

12. Ibid.

13. Jean Caujolle, "Chez Rodin: Balzac et Baudelaire," *La Lanterne,* November 7, 1898.

 "Je vous ai dit que j'avais beaucoup étudié ma figure de Baudelaire—j'ai, en effet, sur lui des quantités de documents, des portraits, d'excéllentes photographies. Mais ce qui m'a le plus servi, c'est un model naturel, un jeune dessinateur qui avait, avec le poète, une étonnante ressemblance.

"C'est d'après ce buste vivant que j'ai *construit* mon buste, c'est-à-dire que j'en ai établi la donnée générale, l'allure, ou, si vous aimez mieux, *l'air de race*. Je ne me suis attaché qu'après à produire le caractère spécial de l'individu....C'est ainsi que je travaille, ajoute Rodin, avec simplicité, car, même en m'entrant de tous les documents, on n'imite jamais la nature....Et la nature est le seul objet de mes efforts."

14. Lawton [67], p.205.

15. Spear [332], p.11. In order to facilitate a discussion of the studies for *Balzac,* I have decided to adopt Athena Spear's cataloguing system rather than create a new one. In attempting to relate the studies to the copious literary evidence, she established a sequence that has only been slightly modified by subsequent writers, most notably by Albert Elsen [398]. Professor Elsen believes that the "wrestler" nudes *h* and *i* and the related busts —*K, KK, L,* and *M*—postdate the figure studies *j* and *k* and the related heads *O, P, Q,* and *R,* which would mean that they are datable no later than 1892–93. Athena Spear [332a], p.116s, believes that *j* and *k* are more daring than the "wrestler" nudes, which she regards as "the culmination of the relatively traditional and serious renderings of the subject," and thus datable 1893–95. It is certainly true that figure studies *j* and *k* are much less successful and coherent than figure studies *h* and *i* but it seems to the present author that the degree of exaggeration found in *j* and *k* represents Rodin's faltering attempts to move away from the naturalistic approach of *h* and *i.* For additional studies, *see* Spear [332a], p.125s.

16. In *Le Petit Journal,* May 9, 1899, there is a description of a dinner given at the Château de Sache. One of the guests was *le père* Bion, "qui passe pour avoir été le tailleur de Balzac et à qui Rodin vint demander quelques mensurations exactes de son ancien client.

"Bion, très fier d'occuper ainsi l'attention, ne manque pas du reste de rappeler que Balzac est resté son débiteur pour une culotte de drap fin et quelques réparations."

17. "Balzac et Rodin," *Le Voltaire,* Paris, February 23, 1892, p.1. "De l'œuvre future, une maquette existe, très poussée, très précise. Balzac est figuré debout, drapé dans le froc de dominicain....Un indéfinissable sourire fait à la fois de bonté, de raillerie et de défi entr'ouvre la bouche aux contours sinueux."

18. Spear [332a], pp.112s, 114s, and 115s, supports this interpretation of the facts with further evidence.

19. *Le Temps,* Paris, January 11, 1892. "Balzac est debout, bras croisés, tête haute et drapé dans sa légendaire robe de moine serrée par une cordelière à la taille. La commission a félicité M. Rodin de son œuvre et l'a prié de se mettre immédiatement au travail du marbre."

20. *See* n.11 above, Goldscheider, p.42, and Jacques de Caso, "Balzac and Rodin in Rhode Island," *Rhode Island School of Design Bulletin,* Providence, 52, no.4 (May 1966), p.9.

21. Spear [332], p.20.

22. Gabriel Ferry, "La Statue de Balzac," *Le Monde Moderne,* 10 (1899), p.653. "J'ai vu, consulté tous les portraits possibles de l'auteur de *La Comédie Humaine;* après un laborieux examen, je me suis décidé à m'inspirer d'une plaque de daguerréotype de Balzac, exécutée en 1842; selon moi, c'est la seule effigie fidèle et vraiment ressemblante de l'illustre écrivain. Cette plaque est la propriété de Nadar, il en a fait une photographie; longuement j'ai étudié ce document. Aujourd'hui je tiens, je connais Balzac comme si j'avais vécu des années avec lui."

23. Albert Elsen, "Rodin's 'Naked Balzac,'" *Burlington Magazine,* London, 109 (November 1967), p.612, n.15. Jacques de Caso points out, in the article cited in n.20 above, p.9, that the daguerreotype wrongly attributed to Nadar was published in 1891. Professor Elsen, p.612, believes that a statement by Judith Cladel casts doubt on Rodin's having seen the published version of the photograph when it first appeared. Cladel [26], p.187, says that one day, to Rodin's profound joy, his friend Mathias Morhardt brought him a reproduction of this daguerreotype. In the opinion of the present author, there is little doubt that Rodin, an impassioned admirer of Balzac and known by all his friends to be working on a monument to the writer, would have seen the photograph when it first appeared. It is also known that Mallarmé, whose "Tuesdays" Rodin frequented, was the owner of a print of this photograph.

24. "Balzac et Rodin," *Le Figaro,* Paris, November 25, 1894, p.3. "Dans le courant de 1892... il lui soumit une maquette qu'il faut bien le dire, dérouta tous ceux qui la virent. Un des meilleurs amis du sculpteur s'était écrié en entrant dans l'atelier: 'Tiens, vous faites un Triboulet.' L'artiste, après avoir étudié son modèle, et sur tous les dessins faits d'après lui, et dans ses livres et

dans son pays même, avait conçu un Balzac étrange, ayant l'attitude d'un lutteur, semblant défier le monde. Il lui avait mis sur des jambes très écartées, un ventre énorme. S'inquiétant plus de la ressemblance parfaite que de la conception qu'on a de Balzac, il l'avait fait choquant, difforme, la tête enfoncée dans les épaules."

25. *See* n.20 above, p.12.
26. Ibid., p.6.
27. *See* n.23 above, p.615.
28. Ibid., p.616.
29. Goncourt [53], vol.4, p.384. "Dimanche 16 avril. Rodin se plaint près de moi de se trouver cette année sans entrain, de se sentir *veule*, d'être comme sous le coup d'une *influenza* non déclarée; il a travaillé cependant, mais il n'a exécuté que des choses sans importance."
30. "Les Dix Mille Francs de Rodin," *Le Journal,* Paris, November 27, 1894.

 "Une fois, chez le maître-sculpteur dont s'enorgueillait l'art français,—et que la postérité mettra au rang des plus illustres—je dénichai derrière un paravent, dans l'angle, un 'bonhomme' en glaise, furieusement martelé de coups de pouce, et campé de si glorieuse manière que mon admiration tomba en arrêt.

 "A cela près, il était fort vilain, la peau comme excoriée, le masque à peine indiqué—tout nu, l'horreur! Mais les bras se croisant de telle sorte sur les pectoraux puissants; mais l'espacement des jambes, dans le sens de la marche, l'avancée conquérante du pas, indiquaient si magnifiquement la prise de possession de sol, les pieds comme soudés de racines à la terre natale; mais, de cette face informe, trouée d'orbites, au rictus pareil à une balafre, le nez en 'chose' d'oiseau, les maxillaires anthropophagesques, le front bossué sous l'hirsutisme d'une tignasse d'oseraie, une telle souveraineté se dégageait, impérieuse, quasi surhumaine, que l'austère frisson, connu des intellectuels, vous passait sur la nuque.

 "... 'C'est mon Balzac,' fit doucement Rodin. Puis, avec une timidité dans la voix, se reprenait: 'Je veux dire la maquette—une des maquettes qui me serviront.'

 "... 'C'est rudement beau!'

 "'Non, non! seulement pas mal; assez dans le mouvement. Mais le sentiment, l'intimité de l'homme, voilà ce qu'il faudrait rendre—Et là, pensez si c'est commode; l'âme de Balzac.'"

 Jacques de Caso *(see* n.20 above, pp.11–12) assigns a date of 1897–98 to this figure and the related draped studies, apparently on stylistic grounds. He refers to its "hasty execution of modeling, attentive only to expressing the essential planes, and very different from the careful, analytical, almost chiseled modeling of the study in Rhode Island" (that is, nudes *h* and *i*). The present author cannot agree with the late dating of this figure, which is certainly much closer to the naked *Balzac* of 1892 than to the draped, anguished figure as exhibited in 1898. Séverine's description of the hair of the naked figure that she saw as "a mass of hair like a clump of weeds" is much closer to that of the figure under discussion than to that of nudes *h* and *i,* which is relatively short.
31. The Société delivered ultimatums on December 6, 1892, and June 15, 1893.
32. *Le Journal,* Paris, June 29, 1893. "Il paraît que la statue de Balzac ne pourra pas se dresser, en plein Paris, avant un an environ. Le renseignement émane du grand sculpteur et principal intéressé, Auguste Rodin."
33. *L'Echo de Paris,* Paris, October 10, 1894.

 "Il rêve un Balzac grandiose et, pour arriver à réaliser son rêve, le maître a déjà fait et défait plusieurs fois son monument.

 "Un jour même, la statue en terre achevée, Rodin, presque satisfait, résolut de convoquer le comité.

 "Mais, dans la nuit, il changea d'avis et, le lendemain matin, commanda à ses praticiens stupéfiés d'abattre la glaise.

 "Mais, et le comité?

 "'Quand je serai content, le comité le sera bien aussi,' réplique le maître."
34. Contrary to the impression given by most chronicles of these events, it seems that Rodin's relationship with the committee was still not irretrievably damaged at this point. The following account of the aftermath was given in *Le Temps,* Paris, December 6, 1894. "Le jour où la maquette sera terminée, Monsieur Rodin reprendra possession de la somme déposée chez le notaire de la société. Il ne cessera d'ailleurs pas d'en toucher les intérêts. 'La réconciliation,' nous a dit Monsieur Scholl, le nouveau Président de la Société des Gens de Lettres, 'est cordiale et complète. Elle a été scellée, hier soir, par un dîner amical au restaurant Durard.'"
35. Emile Zola, *Correspondance, 1872–1902* (Paris: F. Bernouard, 1929), pp.769–70. "Je vous en supplie, au nom du génie, au nom des lettres françaises, ne faîtes pas attendre Balzac davantage. Il est le votre dieu comme il est le mien.... Balzac

attend, et il ne faudrait pas que sa gloire souffrit trop longtemps encore du légitime souci que vous avez de la vôtre."

36. "Libres Critiques: A propos du 'Monument de Balzac,'" *Nouvelle Revue Internationale: Matinées Espagnoles,* Paris and Madrid, June 1, 1896, pp. 511–17; "A propos du 'Monument de Balzac,'" July 15, 1896, pp. 58–66.

37. Ibid., July 15, 1896, p. 62. "Bien que vous soyez avant tout un artiste, vous ne devez pas davantage vous arrêter à cette considération qu'en modelant Balzac en sphinx, vous avez tourné la difficulté naissant des formes inesthétiques du grand homme. Cette difficulté n'existe pas, pour un statuaire digne de ce nom, expressif d'idées sous couvert de la plastique; la corpulence, la taille rabougrie, la vilain profil du génial écrivain ne sauraient être des réalités observables et reproductibles; la seule chose qui puisse valablement nous intéresser est la représentation de sa pensée par le dessin général de son attitude, l'accentuation de sa physionomie, l'éclair profond et saisissant de son regard. Les difficultés physiques sont de passagères contingences qui ne doivent pas fixer le marbre et l'airain; ces nobles matières ne peuvent transmettre à l'avenir que l'impérissable, le permanent et l'immanent, la silhouette de l'esprit qui demeure, sans les modalités fugitives que le temps emporte à l'éternel oubli."

38. Quoted in Elsen [38], p. 125.

39. Paris, 1950 [359], p. 2. "Comme on le complimentait du réalisme du torse, des membres, rapporte Pompon qui était alors son praticien, il jeta son peignoir dessus pour les cacher."

40. Goncourt [53], vol. 4, p. 916. "Mardi 4 février.... Mirbeau parle de Rodin, qui aurait triomphé de la défaillance physique et morale de ces dernières années et se serait remis au travail et ferait des choses tout à fait extraordinaires. Et il nous montre le sculpteur lui montrant des sculptures anciennes et, sur son silence, lui disant: 'Vous trouvez cela pas bon, n'est-ce pas? Eh bien, moi, je le trouve détestable!' Et dans le moment, il inaugurerait une nouvelle sculpture, à la recherche d'un modelage fait par le jeu des lumières et des ombres."

41. *See* n. 4 above, Morhardt, p. 467. "Un modèle solide, trapu, aux muscles puissants, vint poser chez Rodin. Il posait nu, naturellement. Il se tenait debout, le pied gauche en avant d'un demi-pas."

42. Spear [332], p. 23, throws doubt on these events having taken place in 1897, giving as her reason:

"There is too great a distance between this nude and the final enlarged *Balzac* which was shown a few months later; and Rodin was not a man to hurry and exhibit the last minute's work." Her argument is convincing.

43. Elsen [38], p. 96, drew attention to the significance of this gesture.

44. *See* n. 37 above.

45. *Le Temps,* Paris, August 19, 1896. "Depuis ce moment, c'est-à dire depuis un an et demi ou deux ans, Monsieur Rodin, qui n'a cessé de s'occuper de ce monument et qui, d'ailleurs, est justement soucieux de faire une œuvre digne de l'illustre écrivain auquel elle doit être consacrée, a exécuté un grand nombre de maquettes. Dans les unes, Balzac est montré nu; dans les autres, il est habillé. Mais ces tâtonnements sont finis. Il y a déjà un ou deux mois que Monsieur Rodin a terminé une maquette qui lui donne la satisfaction qu'il a si infatigablement cherchée. Balzac sera représenté debout, dans une attitude forte et simple, les jambes un peu écartées, les bras croisés. Il sera revêtu d'une sorte de longue robe de chambre sans ceinture, qui descend jusque sur les pieds."

46. Paris, 1950 [359], p. 10. "Dans la collection d'objets d'Extrême-Orient réunie par Rodin, il existe une figure en céramique d'origine japonaise. On y retrouve certains traits du *Balzac,* la ressemblance est troublante; Rodin l'a-t-il connue avant ou après la réalisation de son œuvre?"

This was pointed out as early as 1909. *See L'Illustration,* Paris, no. 3464 (July 1909). "Une statuette, œuvre d'un artiste japonais qui faisait du 'Rodin' il y a quatre cents ans."

47. For full account of the relationship between Rosso and Rodin, *see* Margaret Scolari Barr, *Medardo Rosso* (New York: Museum of Modern Art, 1963), pp. 53–54.

48. Jacques de Caso, "Rodin and the Cult of Balzac," *Burlington Magazine,* London, 106 (June 1964), p. 282. "On a trip to Burgundy in 1894 or 1895, however, Rodin may have found the stimulus that led to his final solution of a *drapé* for his model. In an unpublished sketch-book, drawings of Balzac from the 'wrestler' period are associated with copies of mourners by Claus Sluter for the tomb of Philippe le Hardi then (as now) in the Dijon Museum. As had been the case with the *Bourgeois de Calais,* medieval sculpture, and not the influence of Medardo Rosso, must have provided Rodin from the beginning with stylistic sources for the conception of the *Balzac.*"

49. *See* Ludovici [70], p.112. "The dress of the Roman was universal and for all time, in this sense, that it did not mar the beauty of the human body. This is also true of much of the clothing of the Middle Ages. That is why I did not strip Balzac; because, as you know, his habit of working in a sort of dressing-gown *(houppe-lande)* gave me the opportunity of putting him into a loose flowing robe that supplied me with good lines and profiles without dating the statue."

50. *See* n.4 above, Morhardt, p.467. "Nous trouvâmes dans l'un des ateliers de la rue de l'Université six exemplaires semblables du plâtre que Rodin avait fait tirer du personnage demi-grandeur naturelle qu'il venait de modeler. Dans un coin se trouvait un rouleau de toile. Cette toile fut découpée en six lés d'une longueur à peu près égale et chacun d'eux, bientôt, enveloppa l'une des maquettes selon les indications que donnait Rodin. Ainsi naquit le *Balzac*. Au moyen de plâtre humide jeté sur l'étoffe, on a donné de la rigidité à celle-ci."

51. "Petite Chronique," *Art Moderne,* Brussels, July 25, 1897, quoted in Spear [332], p.24.

52. *Le Journal,* Paris, April 6, 1897. "Au commencement de la séance à l'assemblée générale de la Société des Gens de Lettres, un membre a annoncé que la maquette de la statue de Balzac, par Rodin, est terminée."

53. M. Demaison, "La Statue de Balzac," *Le Journal des Débats,* Paris, March 20, 1898. "Il [Charles Chincolle] confesse, à la fin, qu'elle ne sera peut-être pas prête pour le prochain Salon, que M.Rodin, jamais satisfait et toujours indécis, rêve d'une perfection plus parfaite encore. Il veut assouplir la robe de Balzac et creuser le sourire de la Comédie!"

54. "La Statue de Balzac," *Le Figaro,* Paris, March 19, 1898.

"En plâtre massif, elle est trop lourde pour être juchée sur un piédestal provisoire de pareille hauteur, qui placera dans l'allée où s'ouvre son atelier.

"Les praticiens installeront sur cet échafaudage les morceaux du modèle définitif. Alors seulement il jugera avec certitude de l'effet produit. Si la statue penche trop d'un côté, il modifiera le mouvement à l'aide de cales, ajoutera ou retirera, puis livrera au fondeur.

"Ainsi c'est en plein air seulement qu'il sera à même de se rendre compte de l'intérêt d'une figurine synthétique qu'il voudrait faire partir du socle, à droite de sa statue. Il lui plaît de supposer qu'il y avait, dans le bureau de Balzac, une colonnette surmontée d'une Renommée brandissant une couronne.

"Vous comprenez, dit-il. Cette statue qu'il rencontre du pied sans la voir, représente la renommée tardive qui, aujourd'hui, essaye de se hausser jusqu'à lui sans pouvoir l'atteindre. Elle n'est encore en plâtre, mais elle sera en bronze doré et rompra la monotonie du noir de la robe.

"Le socle, qui est l'œuvre de M. Frantz Jourdain, rappelle des chapiteaux assyriens qui, se composant d'étages inégaux, sont très enflés au centre. Rodin, il y a longtemps, en a fait une réduction en bois. Sur la face principale il a moulé en plâtre une femme nue qui, grimaçante, vient de retirer son masque. C'est, pour lui, 'La Comédie Humaine.'"

55. *See* n.7 above.

56. *See* n.4 above, Morhardt, p.471. "Le Comité, après examen du profil de la statue de Balzac exposé au Salon par Monsieur Rodin, exprime l'espoir que l'artiste achèvera son œuvre, réserve en conséquence son opinion jusqu'à l'entière exécution du travail et passe à l'ordre du jour."

57. Ibid. "Le Comité de la Société des Gens de Lettres a le devoir et le regret de protester contre l'ébauche que Monsieur Rodin expose au Salon, et dans laquelle il se refuse à reconnaître la statue de Balzac."

58. Among the subscribers were Monet (500 francs), Cézanne (40 francs), Sisley (5 francs), Pissarro (10 francs), Renoir (110 francs), Legros, Catulle Mendès, Verhaeren, Mallarmé, Lugné-Poë, Pierre Louys, Clemenceau, Mme A. Carpeaux. For full list of subscribers, *see* n.4 above, Morhardt.

59. Quoted in *Le Journal,* Paris, June 10, 1898.

Mes chers amis,

J'ai le désir formel de rester seul possesseur de mon œuvre.

Mon travail interrompu, mes réflexions, tout l'exige maintenant. Je ne demande à la souscription que les nons généreux qui y sont, en témoignage et récompense de mes efforts.

Et vous, plus enthousiastes encore, amis, amis, amis de tout temps à qui je dois peut-être la possibilité de faire de la sculpture, plein d'émotion, je vous dis merci.

Auguste Rodin

60. "La Vie de Paris: Le Balzac de Rodin," *Le Salut Public,* Lyons, October 19, 1898. "Le retoucherai-je? C'est possible; mais pour le moment, je n'ai pas à le faire, parce que je ne vois pas quelle

retouche je pourrai y apporter. Je ne veux même pas le regarder. Je le decouvrirai dans quelques mois seulement, lorsque je ne serai plus autant sous le coup de l'affection qu'un artiste ressent, les premiers temps, pour son œuvre. En tout cas, actuellement, la statue me plaît telle qu'elle est et je ne songe nullement à le retoucher."

61. *New York Evening Sun,* May 28, 1898. "But have I succeeded in expressing what I wished to express? The truth is that I am too intimate with my work to judge of it impartially. If I could go a year without seeing it, I might be freed from my personality and then I could judge of it as a stranger. The only thing that strikes me today is that the neck is too thick. It seemed to me that I ought to make it thick, for, in my opinion, modern sculpture should exaggerate forms for abstract reasons. By this exaggerated neck I would represent strength. I recognize now that I exceeded my idea. But, after all, have you viewed my statue from a distance of about twenty paces to the right?"

62. *Le Journal,* Paris, May 12, 1898.

"Sans doute, la décision de la Société des Gens de Lettres est pour moi un désastre matériel, mais mon travail d'artiste reste pour moi une suprême satisfaction. Aussi ai-je hâte de retrouver la paix et la tranquillité dont j'ai besoin.

"J'ai cherché dans Balzac, comme dans Victor Hugo, à rendre un art qui n'est pas de la photographie en sculpture. On peut trouver des erreurs dans mon Balzac; on ne réalise pas toujours son rêve; mais je crois à la vérité de mon principe, et Balzac, rejeté ou non, n'en est pas moins une ligne de démarcation entre la sculpture commerciale et la sculpture d'art que nous n'avons plus en Europe. J'ai, d'ailleurs, la satisfaction de voir que plusieurs jeunes artistes se sont groupés autour de moi et cherchent maintenant à suivre mes conseils.

"Mon principe, ce n'est pas d'imiter seulement la forme; mais d'imiter la vie. Cette vie, je la cherche dans la nature, mais en l'amplifiant, en exagérant les trous et les bosses, afin de donner plus de lumière; puis, je cherche dans l'ensemble une synthèse."

63. *L'Art et les Artistes* [330], pp. 70–71. "Eh bien! oui, fait-il, de quel droit m'a-t-on reproché cette robe de chambre aux manches flottantes? Est-ce autrement que s'habille un littérateur inspiré qui, la nuit, se promène fiévreux dans son appartement, à la poursuite de ses visions intérieures? Cela ne s'était jamais fait! Une statue sur une place publique doit représenter un grand homme dans une attitude théâtrale et capable de le faire admirer par la postérité! Mais de telles raisons sont absurdes! Je prétends, moi, qu'il n'y avait qu'une manière d'évoquer mon personnage: je devais montrer un Balzac haletant dans son cabinet de travail, les cheveux en désordre, les yeux perdus dans le rêve, un génie qui, dans sa petite chambre, reconstruit pièce à pièce toute une société pour la faire vivre tumultueuse devant ses contemporains et devant les générations à venir, un Balzac vraiment héroïque qui ne prend pas un moment de repos, qui fait de la nuit le jour, qui s'efforce en vain de combler le trou creusé par ses dettes, qui surtout s'acharne à l'édification d'un monument immortel, qui bouillonne de passion, qui, frénétique, violente son corps et méprise les avertissements de la maladie de cœur dont il doit bientôt mourir."

64. *La Croix,* May 5, 1899. "La France faillit de se partager en rodinistes et en anti-rodinistes comme en dreyfusards et anti-dreyfusards."

65. "L'Art nouveau: La Statue de Balzac," *Revue du Monde Catholique,* p. 135 (undated clipping in the archives of the Musée Rodin). "Non, jamais l'esprit français n'existera dans cette larve *allemande,* dans cet être rempli de bière qui est au salon.

"Et ce sont ces artistes soi-disant français, mais pensant en Allemands ou en Belges, qui ont l'audace de vouloir importer dans un pays comme le nôtre un autre art que celui qui nous a donné la Sainte-Chapelle, les Cathédrales de Reims, d'Amiens, de Chartres, de Paris, de Beauvais, de Strasbourg!"

66. *Indépendance Belge,* May 18, 1898. "Ça, dit un monsieur, c'est encore une vengeance de Zola!"

67. "Balzac à Tours," *Messager de Valence,* April 20, 1899. "Le conseil municipal de Tours a refusé toute subvention pour l'érection, dans sa ville natale, d'une statue de Balzac!

"Bien mieux encore, M. Brunetière ayant annoncé qu'il viendrait à Tours faire une conférence en faveur de l'immortel auteur de la *Peau de Chagrin,* le conseil lui a refusé la salle du Théâtre.

"Ils sont socialistes. Et ils sont déclaré qu'ils ne pouvaient rien faire pour Balzac qui, ont-ils déclaré, était clérical."

68. "Le Vernissage," *Le Cri de Paris,* Paris, May 7, 1899. Recounting the talk at a dinner party: "Parfaitement! Et savez-vous le plus dreyfusard de tous les peintres, l'apôtre? C'est M. Jean-Paul

Laurens. Puis, c'est M. Albert Maignan; puis le grand Rodin, qui est bien vengé de l'anti-dreyfusard Falguière; on regrette son Balzac aujourd'hui."

69. Mauclair [246], p.592. "J'ai fait à mes propres yeux mon plus sérieux progrès depuis ma première ébauche. Rien de ce que je fis ne me satisfait tant, parce que rien ne m'a tant coûté, rien ne résume si profondément ce que je crois être la loi secrète de mon art."

70. *Le Journal,* Paris, November 20, 1898. "C'est une maquette où se manifeste avec évidence la préoccupation de la statue de Rodin, et même plus que la préoccupation, une gêne qui fait paraître un peu comique ce Balzac assis, comme fatigué au souvenir de *l'autre,* qui était si bien debout. Donc je conclus que si l'œuvre a été proscrite, son influence reste, et je gagerais bien que Monsieur Falguière n'y échappera pas."

71. *La Petite République,* November 15, 1898.
"Ne pouvant échapper à l'influence impérieuse de Rodin, il a ingénument demandé à celui-ci la permission de lui emprunter 'le cou puissant, la carrure, la draperie, la chevelure, le menton, les prunelles de son Balzac.' Et la chronique rapporte que Rodin, impassible derrière son binocle, répondit sans s'émouvoir: 'Mais, faîtes donc, mon chère confrère.' Sur quoi Falguière opéra; et toute l'opération consista à asseoir le personnage ainsi amenuisé sur un banc de square.
"On conçoit l'indifférence dédaigneuse de Rodin devant ce tripatouillage naïf; plus que jamais, Balzac lui reste."

72. A *Study for the Head of Balzac,* in bronze, was exhibited at the Carfax Gallery in London, midsummer, 1899, no.55. Another bronze head was sold by 1901 to an American *(see New York Herald,* December 23, 1901).

73. *See* Other Casts and Versions. This cast is now in the Middelheim Museum in Antwerp.

REFERENCES

Roger Marx, "Balzac et Rodin," *Le Voltaire,* Paris, February 23, 1892, p.1; Gustave Geffroy, "L'Imaginaire," *Le Figaro,* Paris, August 29, 1893, p.1; Caliban [Emile Bergerat], "L'Avance à valoir," *L'Echo de Paris,* Paris, September 25, 1894; Séverine, "Les Dix Mille Francs de Rodin," *Le Journal,* Paris, November 27, 1894; Gaston Stiegler, "Rodin et Balzac," *L'Echo de Paris,* Paris, November 12, 1894;

Charles Chincholle, "Balzac et Rodin," *Le Figaro,* Paris, November 25, 1894, p.3; Jean Aicard, "L'Art au-dessus de l'argent," *Le Figaro,* Paris, December 3, 1894, pp.1–2; Roger Marx, "Balzac et Rodin," *Le Voltaire,* Paris, February 5, 1896, p.1; Félicien Champsaur, "Un Raté de génie," *Gil Blas,* Paris, September 30, 1896; Henri Frantz, "Rodin's Statue of Balzac," *Magazine of Art,* London and New York, 22 (March 1898), pp.617–18; M. Demaison, "La Statue de Balzac," *Le Journal des Débats,* Paris, March 20, 1898; Marie Louise Néron, "Autour de la statue de Balzac chez Rodin," *La Fronde,* Paris, May 1, 1898; Charles Chincholle, "La Vente de la statue de Balzac," *Le Figaro,* Paris, May 12, 1898, pp.2–3; Charles Chincholle, "L'Incident Rodin—Balzac," *Le Figaro,* Paris, May 17, 1898, p.3; Georges Rodenbach, "Une Statue," *Le Figaro,* Paris, May 17, 1898, p.1; Philippe Gille, "Balzac et M.Rodin," *Le Figaro,* Paris, May 18, 1898, p.1; Camille Mauclair, "L'Art de Monsieur Rodin," *La Revue des Revues,* Paris, June 15, 1898; Henry Jouin, "Balzac et son sculpteur," *La Nouvelle Revue,* Paris, 112 (June 1898), pp.589–94; Quentin [278], pp.193–96, 321–24; Alexandre [6]; Eugène Plouchart, *Psychologiquement sur le Balzac de M.Rodin,* Paris: Chamuel, 1898; Gabriel Ferry, "La Statue de Balzac," *Le Monde Moderne,* 10 (1899), pp.641 ff.; Maillard [71], pp.14–16, 71, 74, repr. opp. p.74; *La Plume* [327], pp.10–16, 54–56; Mauclair [77a], pp.43–51, repr. opp. pp.46, 48; Lawton [67], pp.174–90, repr. opp. pp.178, 191; Ciolkowska [23], pp.81–97, repr. opp. p.4; Coquiot [29], pp.143–52, repr. opp. p.144; *L'Art et les Artistes* [330], pp.70–71; Cladel [25a], pp.312–14, 317–20, 323–25, repr. p.315; Arsène Alexandre, "Balzac dans un fauteuil," *La Renaissance de l'Art Français et des Industries de Luxe,* Paris, 4, no.2 (February 1921), pp.53–56; Bénédite [10a], pp.17–18, 30, pls. XLIII–XLIV; Grappe [338], nos.188, 189, 205; Rilke [88], pp.66–69; Watkins [342], nos.1, 67, 84, 111, repr. p.9; Grappe [338a], nos.218–20, 236; Grappe [338b], nos.293–95, 316; Mathias Morhardt, "La Bataille du Balzac," *Mercure de France,* Paris, December 15, 1934, pp.463–89; Judith Cladel, "Rodin: L'Affaire du 'Balzac,'" *Revue de France,* Paris, June 1, 1935, pp.509–37; June 15, 1935, pp.697–722; Magdeleine A.Dayot, "Le Balzac de Rodin sur une place de Paris," *L'Art et les Artistes,* Paris, 33, no.172 (December 1936), p.107; Cladel [26], pp.182–224; Louis Vauxcelles, "Le 'Balzac' de Rodin," *Le Monde Illustré,* Paris, October 23, 1937, p.738; André Fontainas, "Le Balzac de Rodin est offert à Paris," *Mercure de France,* Paris, 285 (December 15, 1938), pp.286–97; Grappe [338c], nos.231, 232, 232 bis, 244, 254;

Frisch and Shipley [42], pp. 211–20, 234, 239, repr. pp. 256, 257; Story [103], pp. 21–22, 25, 147, no. 82, repr. pls. 78–80; Grappe [338d], nos. 265–67, 279, 289; Grappe [54], p. 143, nos. 101–3; Waldmann [109], pp. 68–71, 79, nos. 75–80, repr. pls. 75, 77, 78; Lecomte [68], pp. 17–29, repr. pls. 63, 64; Cladel [27], pp. XXIX–XXX, repr. pls. 71, 72; Cécile Goldscheider, "La Genèse d'une œuvre: Le Balzac de Rodin," *La Revue des Arts,* Paris, no. 1 (March 1952), pp. 37–44; Josef Adolf Schmoll gen. Eisenwerth, "Rodins Balzac," *Kunstgeschichte Gesellschaft zu Berlin,* Sitzungs-bericht, Berlin, n. s., 1955–56, pp. 8–10; Story [103a], repr. pls. 64, 66, 67; Goldscheider [49], pp. 38–42, repr. p. 100; Elsen [38], pp. 89–105, repr. pp. 88, 98–100; Jacques de Caso, "Rodin and the Cult of Balzac," *Burlington Magazine,* London, 106 (June 1964), pp. 279–84; Jacques de Caso, "Balzac and Rodin in Rhode Island," *Rhode Island School of Design Bulletin,* Providence, 52, no. 4 (May 1966), pp. 1–22; Descharnes and Chabrun [32], pp. 164–75; Schlumberger [297], pp. 56–65; Albert E. Elsen, "Rodin's 'Naked Balzac,'" *Burlington Magazine,* London, 109, (November 1967), pp. 606–17; Tancock [341], nos. 64–67, repr. p. 63; Edward Steichen, "Rodin's Balzac," *Art in America,* New York, 57, no. 5 (September 1969), pp. 26–27.

OTHER CASTS AND VERSIONS (No. 72)

Plaster (B. 28; S. d.)

FRANCE
Paris, Musée Rodin.

Bronze

UNITED STATES
Beverly Hills and New York City, B. G. Cantor Collections. Founder: Susse. Cast no. 1/12.
New York City, Museum of Modern Art. Gift of B. G. Cantor Art Foundation. Founder: Susse. Cast no. 3/12.
Stanford, Stanford University Art Gallery and Museum. Gift of B. G. Cantor Art Foundation. Founder: Georges Rudier. Cast no. 4/12.

OTHER VERSIONS (No. 73)

Bronze, height 28¾ inches (B. 26; S. h.)

FRANCE
Paris, Musée Rodin.

ISRAEL
Jerusalem, Israel Museum. Billy Rose Collection. Signed. Founder: Alexis Rudier. Cast no. 1.

UNITED STATES
Beverly Hills and New York City, B. G. Cantor Collections. Founder: Georges Rudier. Cast no. 10/12.
Des Moines, Des Moines Art Center. Signed: A. Rodin. Founder: Alexis Rudier. Cast no. 3.
New York City, Museum of Modern Art. Gift of B. G. Cantor Art Foundation. Founder: Georges Rudier. Cast no. 1/12.

Bronze, height 51¼ inches (B. 27; S. i.)

FRANCE
Paris, Musée Rodin.

UNITED STATES
Baltimore, Baltimore Museum of Art (ex. Collection Alan and Janet Wurtzburger). Signed: A. Rodin. Founder: Georges Rudier.
Chicago, Art Institute of Chicago. Signed: Rodin. Inscribed: Original.
Los Angeles, Los Angeles County Museum of Art. Gift of B. G. Cantor Art Foundation. Founder: Georges Rudier. Cast no. 4/12.
Providence, Museum of Art, Rhode Island School of Design. Signed: Rodin. Inscribed: original. Founder: Alexis Rudier.
Stanford, Stanford University Art Gallery and Museum. Gift of B. G. Cantor Art Foundation. Founder: Georges Rudier. Cast no. 5/12.

Plaster

FRANCE
Meudon, Musée Rodin. Signed: Rodin. Inscribed: Original.

OTHER CASTS AND VERSIONS (No. 75)

Bronze (B. 36; S. t.)

GERMANY (WEST)
Cologne, Wallraf-Richartz Museum. Signed: A. Rodin. Founder: Georges Rudier. Cast no. 11/12.

JAPAN
Tokyo, National Museum of Western Art. Founder: Alexis Rudier.

SWEDEN
Göteborg, Göteborgs Konstmuseum. Signed: A. Rodin. Founder: Georges Rudier.

SWITZERLAND
Zurich, Kunsthaus. Gift of Werner and Nelly Bär. Signed: A. Rodin.

UNION OF SOUTH AFRICA
Stellenbosch, Peter Stuyvesant Foundation. Founder: Georges Rudier. Cast no. 5/12.

UNITED STATES
Beverly Hills and New York City, B.G. Cantor Collections. Founder: Georges Rudier. Cast no. 1/12.

Plaster

FRANCE
Paris, Musée Rodin.
— Société des Gens de Lettres, Hôtel de Massa. Gift of Musée Rodin, 1950, on the centenary of Balzac's death.

OTHER CASTS (No. 76)

Bronze (S. W.)

ARGENTINA
Buenos Aires, Museo Nacional de Bellas Artes. Gift of Mercedes Santamarina.

UNITED STATES
Beverly Hills and New York City, B.G. Cantor Collections. Founder: Georges Rudier. Cast no. 1/12.
Stanford, Stanford University Art Gallery and Museum. Gift of B.G. Cantor Art Foundation. Founder: Georges Rudier. Cast no. 2/12.

STUDIES FOR THE "MONUMENT TO BALZAC"

In order to avoid confusion in identifying the studies, the system used by Athena Spear in the Cleveland Museum catalogue [332] has been adopted in this list (S. followed by a capital letter for the heads and a small letter for the figures). References to the original listing in the Balzac exhibition at the Musée Rodin [359] are also given in parentheses (B. followed by a numeral).

Bust of Balzac as a young man (inspired by the portrait of Achille Devéria)

Plaster, height 17 inches (B. 1; S. A.)

FRANCE
Paris, Musée Rodin, (fig. 72–76–2).

Bronze, height 16⅜ inches

GREAT BRITAIN
London, Bethnal Green Museum. Gift of Rodin to the Victoria and Albert Museum, 1914. Signed: A. Rodin. Founder: Alexis Rudier.

UNITED STATES
Beverly Hills and New York City, B.G. Cantor Collections. Founder: Georges Rudier. Cast no. 3/12.
New York City, Museum of Modern Art. Gift of B.G. Cantor Art Foundation. Founder: Georges Rudier. Cast no. 2/12.

Mask (inspired by the drawing of Louis Boulanger)

Terra-cotta, height 7⅛ inches (B. 2; S. B.)

FRANCE
Paris, Musée Rodin.

Bronze, height 12½ inches

UNITED STATES
New York City, Museum of Modern Art. Gift of B.G. Cantor Art Foundation. Founder: Georges Rudier. Cast no. 1/12.
Stanford, Stanford University Art Gallery and Museum. Gift of B.G. Cantor Art Foundation. Founder: Georges Rudier. Cast no. 3/12.

Mask (variant of the preceding one)

Plaster, height 9⅞ inches (B. 3; S. C.)

FRANCE
Paris, Musée Rodin.

Mask (inspired by the pastel attributed to either Court or Séguin)

Terra-cotta, height 9½ inches (B. 4; S. D.)

UNITED STATES
New York City, Metropolitan Museum of Art. Acquired in 1910 (fig. 72–76–3).

Plaster

FRANCE
Paris, Musée Rodin.

Smiling Head (inspired by the caricature by B. Roubaud published in Le Charivari *in 1838)*

Terra-cotta, height 10¼ inches (B. 5; S. E.)

FRANCE
Paris, Musée Rodin.

Head (variant of the preceding one)

Terra-cotta, height 11 inches (B. 6; S. F.)

FRANCE
Paris, Musée Rodin.

Head

Terra-cotta, height 11 inches (B. 7; S. G.)

FRANCE
Paris, Musée Rodin.

Head (inspired by the lithograph of Emile Lassalle published in "Galeria des contemporains illustrés," 1841)

Plaster, height 6¾ inches (B. 8; S. H.)

FRANCE
Paris, Musée Rodin.

Bronze

UNITED STATES
New York City, Museum of Modern Art. Gift of B. G. Cantor Art Foundation. Founder: Georges Rudier. Cast no. 1/12.
Stanford, Stanford University Art Gallery and Museum. Gift of B. G. Cantor Art Foundation. Founder: Georges Rudier.

Bust (based on the preceding head)

Plaster, height 29⅛ inches (B. 9; S. I.)

FRANCE
Paris, Musée Rodin.

Half-length portrait (using head H)

Plaster, height 22 inches (B. 10; S. J.)

FRANCE
Paris, Musée Rodin.

Bust (inspired by the daguerreotype of Bisson-Nadar; used in figure study i)

Bronze, height 10⅝ inches (B. 11, 12; S. L.)

FRANCE
Albi, Musée Toulouse-Lautrec. Gift of Eugène Rudier, 1939 (height 12½ inches).
Paris, Musée Rodin.

GREAT BRITAIN
Glasgow, Glasgow Art Gallery and Museum. Burrell Collection.

London, Bethnal Green Museum. Signed: A. Rodin. Founder: Alexis Rudier (height 12½ inches).

UNITED STATES
Baltimore, Baltimore Museum of Art. Signed: A. Rodin. Founder: Alexis Rudier.
Montclair, N. J., Kasser Foundation.
New Orleans, Collection Mrs. Hunt Henderson. Founder: Alexis Rudier.
New York City, Collection Bella and Sol Fishko. Founder: Alexis Rudier.
Williamstown, Mass., Williams College Museum of Art. Signed: A. Rodin. Founder: Alexis Rudier (height 11½ inches).

U.S.S.R.
Kiev, State Museum of Western and Oriental Art.

Wax, height 8¼ inches

FRANCE
Paris, Collection Mme Marcel Pollak (fig. 72–76-4).

Plaster, height 12¼ inches

FRANCE
Paris, Musée Rodin.

Bronze, height 7 inches

FRANCE
Paris, Musée Rodin.

UNITED STATES
Atlanta, High Museum of Art. Founder: Georges Rudier.
New York City, Collection Mr. and Mrs. Ralph F. Colin. Signed: A. Rodin. Founder: Alexis Rudier.
Philadelphia, Collection Mrs. Charles J. Solomon. Signed: A. Rodin. Founder: Alexis Rudier.

Half-length portrait (after figure study i)

Bronze, height 18½ inches (S. M.)

SWITZERLAND
Zurich, Collection Werner and Nelly Bär. Acquired in 1936. Signed: A. Rodin.

UNITED STATES
Cleveland, Cleveland Museum of Art. Signed: A. Rodin. Founder: Alexis Rudier.
Washington, D. C., Hirshhorn Museum and Sculpture Garden, Smithsonian Institution. Founder: Alexis Rudier.

Head (possibly inspired by the drawing by Gavarni)

Terra-cotta, height 11 inches (S. N.)

FRANCE
Paris, Musée Rodin.

Plaster and terra-cotta, height 8¼ inches
(B.13; S.NN.)

FRANCE
Paris, Musée Rodin.

Head (inspired by the portrait by Bertall, 1847)

Plaster, height 9⅞ inches (B.14; S.O.)

FRANCE
Paris, Musée Rodin.

Head (inspired by a portrait published in "L'Illustration," August 1850)

Terra-cotta, height 7½ inches (B.16; S.P.)

FRANCE
Paris, Musée Rodin.

Head (variant of the preceding one; used in figure study j or k)

Terra-cotta, height 7⅞ inches (B.17; S.Q.)

FRANCE
Paris, Musée Rodin.

Bust (variant of the two preceding works)

Plaster, height 17 inches (S.R.)

FRANCE
Paris, Musée Rodin.

Bronze, height 12 inches

UNITED STATES
New York City, Museum of Modern Art. Gift of B.G. Cantor Art Foundation. Founder: Georges Rudier. Cast no. 1/12.

Mask (without hair)

Plaster, height about 6 inches (S.S.)

FRANCE
Paris, Musée Rodin.

Head (for figure study p?)

Terra-cotta, height 5⅞ inches (B.15?; S.T.)

FRANCE
Paris, Musée Rodin.

Head

Terra-cotta, height about 4 or 5 inches (S.U.)

FRANCE
Paris, Musée Rodin.

Head (similar to the preceding one)

Terra-cotta and plaster, height 8¼ inches (S.V.)

FRANCE
Paris, Musée Rodin.

Head

Bronze, height 7⅜ inches (B.18?; S.W.)

FINLAND
Helsinki, Kunstmuseum Athenaeum. Antell Collection. Purchased in 1901 from an exhibition of French art at the museum. Signed: A.Rodin.

FRANCE
Tours, Musée des Beaux-Arts. Signed: A. Rodin. Founder: Alexis Rudier.

GREAT BRITAIN
Private collection.

NORWAY
Oslo, Nasjonalgalleriet. Gift of Nasjonalgalleriet's Venner, 1918. Signed: A.Rodin. Founder: Alexis Rudier.

SWITZERLAND
Lausanne, Collection Samuel Josefowitz. Founder: Alexis Rudier.

UNITED STATES
Baltimore, Baltimore Museum of Art. Gift of Wilton C.Dinges.
Cleveland, Cleveland Museum of Art (ex. Collection John K.Sanders). Bought by Mr. Sanders from Rodin in 1901. Signed: A.Rodin.
Maryhill, Wash., Maryhill Museum of Fine Arts.
New Haven, Collection George Heard Hamilton.
New York City, Museum of Modern Art. Gift of B.G.Cantor Art Foundation. No foundry mark.
— Collection Thomas J.Rosenberg.
San Francisco, California Palace of the Legion of Honor. Signed: A.Rodin. No foundry mark.
Springfield, Mass., Collection Dr. Malcolm W.Bick.
Washington, D.C., National Gallery of Art. Gift of Mrs. John W.Simpson, 1942.

Head (based on No. 76)

Stoneware, height 17⅜ inches

FRANCE
Paris, Musée du Conservatoire des Arts et Métiers.
Paul Jeanneney Bequest, 1921.
— Musée du Petit Palais. Signed. Inscribed: Jeanneney.
— Musée Rodin.

UNION OF SOUTH AFRICA
Stellenbosch, Peter Stuyvesant Foundation.

UNITED STATES
New York City, American-Israel Cultural Foundation. Gift of B.G. Cantor Art Foundation.

Head (variant of the preceding one)

Bronze, height 7 inches (S. X.)

GREAT BRITAIN
Oxford, Ashmolean Museum. No foundry mark (fig. 72–76–6).

SWEDEN
Stockholm, Collection of H.M. the King of Sweden.

UNITED STATES
Brooklyn, Brooklyn Museum. Gift of the Brooklyn *Daily Eagle*, 1948.
Chapel Hill, William Hayes Ackland Memorial Art Center, University of North Carolina (ex. Collection Henri Duhem, purchased from Rodin).
Washington, D.C., Hirshhorn Museum and Sculpture Garden, Smithsonian Institution. Founder: Alexis Rudier. Cast no. 2.

Plaster

UNITED STATES
San Francisco, California Palace of the Legion of Honor.

Head (variant of T, W, and XX)

Bronze, height 7½ inches

UNITED STATES
St. Louis, Collection Joseph Pulitzer, Jr. Founder: Alexis Rudier.

Head (based on the engraving by Edmond Hédouin)

Terra-cotta and plaster, height 7½ inches (B. 19; S. Y.)

FRANCE
Paris, Musée Rodin.

Head (definitive study)

Wax, height 5⅛ inches (B. 20; S. Z.)

FRANCE
Paris, Musée Rodin.

Clothed figure (dressed in period clothes, standing with right arm forward leaning on a support, left arm behind back)

Terra-cotta, height 7⅛ inches (B. 21; S. a.)

FRANCE
Paris, Musée Rodin.

Clothed figure (dressed in period clothes, standing, arms behind back)

Terra-cotta, height 7⅞ inches (B. 22; S. b.)

FRANCE
Paris, Musée Rodin.

Clothed figure (variant of the preceding one)

Terra-cotta, height about 8½ inches (S. c.)

FRANCE
Meudon, Musée Rodin.

Clothed figure (dressed in robe, standing with left leg advancing, holding manuscript, head slightly turned to left)

Plaster, height 38¼ inches (B. 30; S. e.)

FRANCE
Meudon, Musée Rodin. Signed: A. Rodin.

Clothed figure (dressed in robe, standing, hands at waist, a pile of manuscripts at his feet)

Plaster, height 42½ inches (B. 32; S. f.)

FRANCE
Paris, Musée Rodin (fig. 72–76–8).

Bronze

UNITED STATES
Beverly Hills and New York City, B.G. Cantor Collections. Founder: Georges Rudier. Cast no. 1/12.

Headless standing nude (right leg stepping on a mound, left arm behind back, right arm incomplete)

Plaster, height 33½ inches (S. g.)

FRANCE
Meudon, Musée Rodin.

Bronze

UNITED STATES
Beverly Hills and New York City, B.G.Cantor Collections. Founder: Georges Rudier. Cast no. 1/12.

Standing nude (legs apart, right arm stretched forward, left arm behind back)

Plaster, height 16⅛ inches (B.23; S. gg.)

FRANCE
Meudon, Musée Rodin.

Bronze

FRANCE
Paris, Musée Rodin.

GREAT BRITAIN
Leicester, Leicester Museum and Art Gallery. Signed: A.Rodin. Founder: Georges Rudier. Cast no. 2/12.

SWITZERLAND
Lausanne, Collection Samuel Josefowitz. Founder: Georges Rudier.

UNITED STATES
Beverly Hills and New York City, B.G.Cantor Collections. Founder: Georges Rudier. Cast no.11/12.
New York City, Collection Helen Frankenthaler. Founder: Georges Rudier.
Rochester, Memorial Art Gallery of the University of Rochester. Signed: A.Rodin.

Standing nude (legs widely spread, arms folded over bulging abdomen)

Plaster, height 50⅜ inches (B.24; S. j.)

FRANCE
Meudon, Musée Rodin (fig.72–76–5).

Standing nude (similar to the preceding one, covered with robe open in front)

Plaster, height 54¼ inches (B.25; S. k.)

FRANCE
Meudon, Musée Rodin.

Sketch for the definitive nude

Bronze, height 11½ inches (S. l.)

FRANCE
Paris, Musée Rodin.

UNITED STATES
Baltimore, Collection Jules Horelick. Founder: Georges Rudier. Cast no. 8/12.
New York City, Museum of Modern Art. Gift of B.G.Cantor Art Foundation. Founder: Georges Rudier. Cast no. 12/12.
Santa Barbara, Collection Wright Ludington.

Sketch for the definitive nude (with legs broken off)

Terra-cotta, height about 7 inches (S.ll.)

FRANCE
Meudon, Musée Rodin.

Headless standing nude in the definitive attitude (right foot forward, hands crossed over genitals)

Plaster, height 37¾ inches (B.29; S. m.)

FRANCE
Paris, Musée Rodin.

Bronze

SWITZERLAND
Lausanne, Collection Samuel Josefowitz. Founder: Georges Rudier.

UNITED STATES
New York City, Museum of Modern Art. Gift of B.G.Cantor Art Foundation. Founder: Georges Rudier. Cast no. 2/12. (fig.72–76–7).
Stanford, Stanford University Art Gallery and Museum. Gift of B.G. Cantor Art Foundation. Founder: Georges Rudier. Cast no. 1/12.

Sketch in the definitive attitude (covered with long drapery)

Terra-cotta, height 12 inches (S. n.)

FRANCE
Meudon, Musée Rodin.

Figure in the definitive attitude (covered with long drapery)

Plaster, height 40½ inches (B.31; S. o.)

FRANCE
Paris, Musée Rodin (fig.72–76–9).

Figure in the definitive attitude (covered with short drapery made of cloth dipped in plaster)

Plaster, height 41 inches (B.34; S. p.)

FRANCE
Paris, Musée Rodin (fig. 72–76–10).

Figure dressed in robe, standing in the definitive attitude (head is turned to the right, left hand comes out of drapery and holds part of it)

Plaster, height 45⅝ inches (B.33; S. q.)

FRANCE
Paris, Musée Rodin.

Robe in the definitive position

Terra-cotta, height 13¾ inches (S.r.)

FRANCE
Meudon, Musée Rodin.

Robe in the definitive position

Plaster, height 59 inches (B.35; S. s.)

FRANCE
Paris, Musée Rodin.

Figure dressed in robe, standing in the definitive attitude (neck and chest covered with drapery)

Plaster, height 45¼ inches (B.37; S. u.)

FRANCE
Paris, Musée Rodin.

Final model

Plaster, height 41¾ inches (B.38; S.v.)

FRANCE
Paris, Musée Rodin.

Monument to Balzac

Plaster, height 118⅛ inches (B.39)

CZECHOSLAVAKIA
Prague, Národní Galerie. Acquired in 1935.

FRANCE
Meudon, Musée Rodin.

Bronze

AUSTRALIA
Melbourne, National Gallery of Victoria.

BELGIUM
Antwerp, Koninklijk Museum voor Schone Kunsten. On loan to the Openluchtmuseum voor Beeld-houwkunst, Middleheim. Signed: A. Rodin. Founder: Alexis Rudier. Acquired in 1931.

FRANCE
Paris, Musée Rodin.
— boulevards Raspail and Montparnasse. Erected on July 2, 1939 (fig. 72–76–15).

GREAT BRITAIN
Hemel-Hemstead, Shell Offices.

THE NETHERLANDS
Eindhoven, municipality of Eindhoven.

UNITED STATES
Beverly Hills and New York City, B.G. Cantor Collections. Founder: Susse. Cast no. 9/12.
Fort Worth, Fort Worth Art Center Museum. Founder: Susse.
Houston, Museum of Fine Arts.
Los Angeles, Norton Simon, Inc. Museum of Art. Founder: Georges Rudier. Cast no. 8/12.
New York City, Museum of Modern Art. Presented in memory of Curt Valentin by a group of his friends. Cast in 1954.
Washington, D.C., Hirshhorn Museum and Sculpture Garden, Smithsonian Institution. Founder: Georges Rudier. Cast no. 6/12.

459

77 President Sarmiento
1894–96

Bronze, 43 × 23 × 18 inches
Signed low down on base to right: A. Rodin
Foundry mark back of base to left:
Alexis. Rudier./Fondeur. Paris.

Rodin's name was already so well known in Latin America in 1894 that he was chosen by the city of Buenos Aires, in preference to a native sculptor, to make a monument in honor of Domingo Faustino Sarmiento (1811–1888; fig. 77-1). Sarmiento was one of the most remarkable figures in the history of nineteenth-century Argentina. Because of his political opinions and his opposition to the dictator Juan Manuel de Rosas, he spent much of his early life in Chile, where he founded the first public school and campaigned for liberal causes and public education. This latter interest took him to Europe, Africa, and the United States, where he made a thorough study of educational methods.

From 1856 on, Sarmiento conducted his campaign for public education in Argentina. For a time he represented Buenos Aires in the national Senate, but relinquished this position in 1864 to accept the appointment as Minister to Chile and Peru and, in 1865, to the United States. He was President of Argentina from 1868 to 1874, during which time he completely reorganized the system of public education. After his retirement from the presidency, he continued to be active in public life and in 1879 became Minister of the Interior in President Nicolas Avellaneda's government and two years later national superintendent of schools. Sarmiento was equally well known as an author, his book *Facundo, civilización i barbarie* (1845) being one of the most renowned works in Argentinian literature.

Toward the end of 1894, Rodin received a letter from Señor del Valle,[1] chairman of the committee in Buenos Aires, in which definite proposals were made as to the type of monument to be constructed. Señor del Valle wrote:

> To my mind, the figure on the pedestal ought to be the expression of intelligent force. Sometimes, Sarmiento himself said that his book, "El Facundo," was like a rock of the Andes with which he had destroyed barbarism in the Argentine Republic; and, as his whole career was spent in this struggle for civilisation, I think we might give material form to the idea by representing a Titan boldly hurling a huge piece of rock. In order that the allegory may not be taken as the expression of mere physical force, it would suffice for the artist to put into the features an expression of high intelligence. I think also that the statue should be represented standing in an attitude and gesture that would convey the impression of strength in repose, the concentration of the intimate thought of a man of action who was also a thinker. The bas-relief might have as its subject Sarmiento as an educator with young children around him.[2]

Rodin did not observe del Valle's instructions, but an agreement was signed on November 30, 1894, in which he consented to have the monument finished within three and a half years. He was to be paid the sum of 75,000 francs, an amount thus far only equaled by the sum

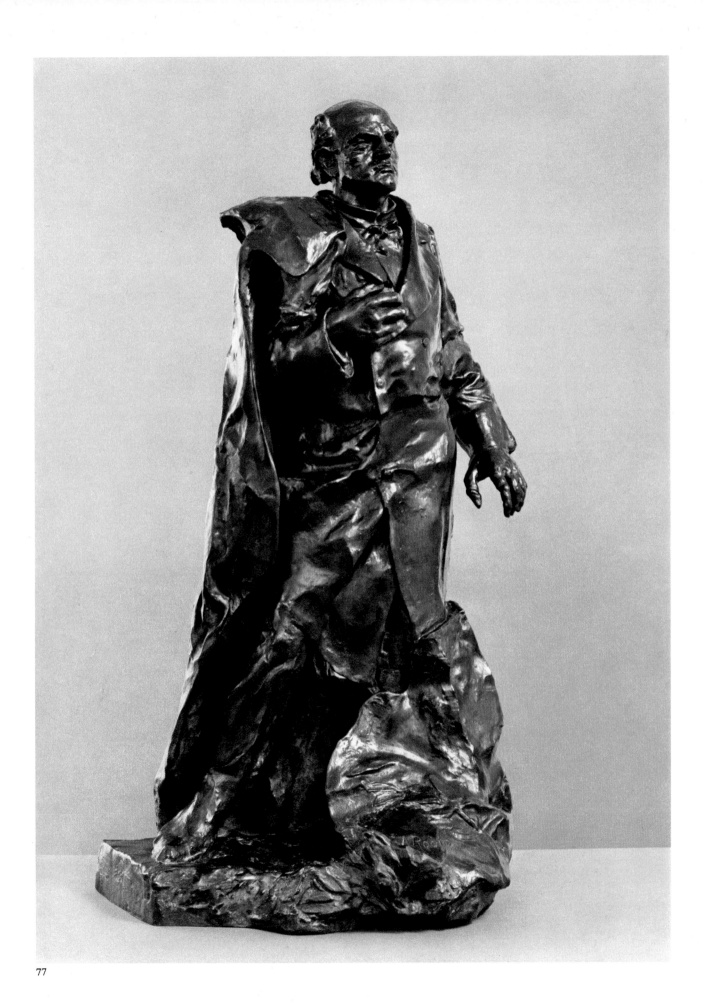

allotted for the second Victor Hugo monument *(see* no. 71). However, out of this sum Rodin had to pay for his materials and expenses, with the exception of the cost of transportation to Argentina.

Rodin started work on this monument while in poor health and deeply involved with the monument to Balzac. When the two monuments are compared, it is clear that the former did not engage his interest in the same way as the latter. He returned to a compositional scheme for a public monument which he had evolved in the *Monument to Claude Lorrain (see* fig. 70–8), where the standing figure of the person to be commemorated is placed on a pedestal on which there is a symbolic representation of his achievements. Claude, the painter of light, stands on a pedestal from which emerges Apollo, driver of the Chariot of the Sun, while for Sarmiento, the great educator, a different Apollo was chosen—Apollo, vanquisher of the snake of error and ignorance (in fact, a combination of the Apollo and Hercules myths).

From the beginning, in order to secure a physical likeness, Rodin relied on two photographs of Sarmiento in particular, one taken in the United States at the time of his candidacy for the presidency and the other taken in Chile.[3] So far as is known, however, the definitive figure does not seem to have been preceded by studies of the nude that it was Rodin's normal practice to make when working on a monumental scale. The first study for the fully clad Sarmiento (fig. 77–2), in which he is shown walking forward at a rather leisurely pace, dates from 1895. In 1896, an old friend of the president in London sent Rodin two additional photographs,[4] and by October of that year the figure of Sarmiento was practically finished. On October 16 Señor Miguel Cané, the Argentinian minister in Paris, wrote to Rodin: "You tell me that Sarmiento's figure is practically finished. I hope that you have paid attention to the observations I made you on the subject of the physical type of the personage, and that now I shall see the true Sarmiento."[5]

Like Señor Cané, Rodin seems to have been dissatisfied with the lack of dynamism of his first plaster study, as in the medium-sized study (the version in Philadelphia) the pose is rather more energetic. In the words of Eduardo Schiaffino, a former pupil of Puvis de Chavannes and Director of the Museo Nacional de Bellas Artes in Buenos Aires, and Rodin's defender after the unveiling of the monument, Sarmiento is in the "attitude of a walking man who is preparing to turn around on the spot, as if to embrace with a single glance the multitudes gathered to listen to his speech."[6] The head is now thrust forward in a more determined fashion, a capacious cloak is slipping off the right shoulder, and a mass of drapery conceals the left foot. An early Druet photograph shows Rodin trying to give more weight to his figure and covering the left leg with wrapping paper.[7] At this stage in its development before enlargement, however, the president's left hand was still empty. According to Grappe, the figure of Sarmiento was already at the foundry in 1895, although it seems more probable that the casting did not start until 1896.[8]

At the same time, Rodin was working on the pedestal. For the figure of Apollo he used the *Mercury Standing,* to which Grappe assigned a date of 1888.[9] This figure can be seen falling backward at the top left-hand corner of the right-hand leaf of *The Gates of Hell (see* no. 1, detail M). The original *maquette,* height 25⅝ inches, in which Apollo emerges in very high relief from a rocky background, was then enlarged to 98½ inches and carved in marble over the next two years. Also in existence is a freestanding life-size plaster study for Apollo (fig. 77–3).

77-1

77-3

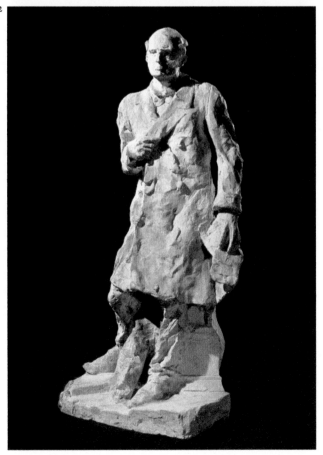

77-2

77-1
President Sarmiento
Photograph

77-2
First Study for Figure of
"President Sarmiento"
1895, plaster, height 25¼ inches
Musée Rodin, Paris

77-3
Study for Apollo, for the
"Monument to President Sarmiento"
1896, plaster, height 71 inches
Musée Rodin, Paris

The completed Sarmiento monument (figs. 77–4a–c) was shipped at the end of 1899 and inaugurated on May 25, 1900, in the Park of the 3rd of February by the President of the Republic, Julio Argentino Roca. As Rodin must have expected by now, the reception was, with few exceptions, extremely unfavorable. Criticism centered on the head of Sarmiento, which was felt to be too small and brutish, and the size of the marble pedestal. One of the adverse critics wrote that Rodin had not known Sarmiento "and it is for this reason that he has disfigured him... and has produced a strange head unknown to us, a head the skull of which is midway between that of a gorilla and that of a niams-niams from the center of equatorial Africa; and we find it very strange that Sarmiento, whose forehead was high, broad, and powerful and whose jaw was square and energetic, has been transformed in passing through the mind of a talented sculptor into a veritable psychological phenomenon.... It is difficult to imagine anything more hideous, vulgar, almost repulsive, and so unlike Sarmiento, than the profile of his statue seen from the right-hand side."[10] In some quarters it was even suggested that a committee should be formed to ask the governor, as an act of homage to Sarmiento, to remove the monument from the park and withdraw it altogether from public sight.[11] In Eduardo Schiaffino, however, Rodin did find a sensitive critic who stated: "Nobody who knew Sarmiento or examined during his life any photographs of him will hesitate in recognizing our great man at first sight."[12]

NOTES

1. The fullest account of the development of the Sarmiento monument is given in Lawton [67], pp. 209–18.
2. Ibid., p. 210.
3. *See* Eduardo Schiaffino, "El Monumento de Sarmiento y la representación individual en la estatuaria monumental: El Balzac y el Sarmiento de Rodin," *La Nación,* Buenos Aires, May 25, 1900. "Así lo comprendió artista y consultando la serie variadísima de sus retratos, detuvo la atención en dos de ellos: una magnífica cabeza fotografiada en Estados Unidos, en el momento de su candidatura presidencial, la única quizás que denuncie ampliamente al pensador; los ojos son espléndidos de nobleza y revelan junto con la familiaridad de la reflexion, la recondita tristeza común á todos los espíritus para quienes la solidaridad humana no es una vana palabra. El otro es un retrato de pie ejecutado en Chile; forma parte de un grupo en el que se halla la señora de Toro; en esta imagen está contenido el movimiento y el gesto familiar del hombre, utilizados por Rodin."
4. Lawton [67], p. 214.
5. Ibid., p. 212.

6. *See* n. 3 above. "Un hombre en marcha, que se dispone á girar sobre si mismo, cual si quisiera abarcar de una sola ojeada à la multitudes congregadas para escuchar su arenga."
7. Reproduced in Descharnes and Chabrun [32], p. 154.
8. Grappe [338d], no. 274. Señor Miguel Cané's letter to Rodin of October 16, 1896 (quoted in Lawton [67], p. 212), makes it seem unlikely that Rodin had sent it to the foundry by this date.
9. Grappe [338d], no. 204.
10. Enrique Chanourdie, "Sarmiento y su estatua: Rodin y sus críticos," *Revista Técnica,* Buenos Aires, June 1900. "Sarmiento, el nuestro, el Sarmiento Argentino, Rodin no lo ha conocido tampoco; y es por este motivo que lo ha desfigurado, y por una rara sugestión mental y visual ha producido una cabeza extraña y desconocida para nosotros, una cabeza cuyo cráneo es el intermediario entre la de un gorila y lo de un niams-niams del centro del Africa Ecuatorial; y tenemos este resultado singular, que la Sarmiento de frente alta, ancha, potente, de mandibula enérgica y cuadrada, se ha transformado al pasar por la mente de un escultor de talento en un verdadero fenomeno psicólogico.... Es difícil concebir algo más feo, vulgar, casi repulsivo, y por

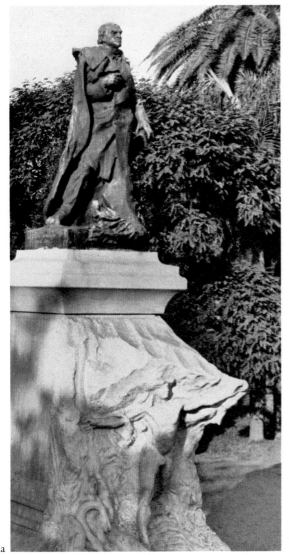

77-4a

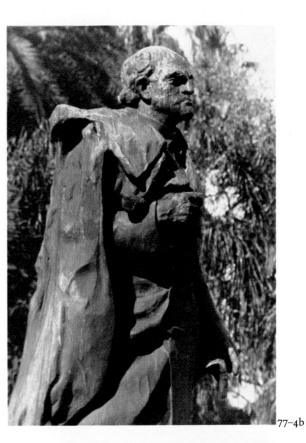

77-4b

77-4c

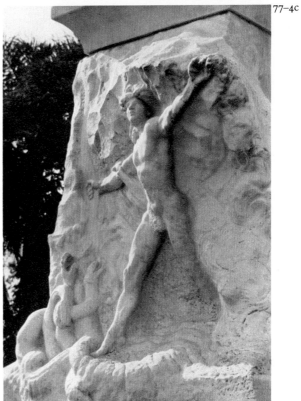

77-4a–c
Monument to President Sarmiento
1894–96, bronze and marble
Park of the 3rd of February,
Buenos Aires

77-4b
Detail of figure of Sarmiento

77-4c
Detail of pedestal

lo tanto menos parecido à Sarmiento, que el perfil de su estátua mirada por su costado derecho."

11. *See* "Absurda empresa contra la estatua de Sarmiento," *El Tiempo*, Buenos Aires, May 29, 1900.

12. *See* n.3 above. "Nadie de los que conocieron á Sarmiento ó examinaron en su vida algunas de sus fotografías, vacilará en reconocer á primera vista á nuestro grande hombre. ¿No es acaso bastante?"

REFERENCES

Eduardo Schiaffino, "Auguste Rodin, el hombre y la obra," *La Nación,* Buenos Aires, May 24, 1900; Eduardo Schiaffino, "El Monumento de Sarmiento y la representación individual en la estatuaria monumental: El Balzac y el Sarmiento de Rodin," *La Nación,* Buenos Aires, May 25, 1900; Enrique Chanourdie, "Sarmiento y su estatua: Rodin y sus críticos," *Revista Técnica,* Buenos Aires, June 1900; Lawton [67], pp.209–17, repr. opp. p. 210; Cladel [25], repr. opp. p. 80; Ciolkowska [23], p.98; Bénédite [10a], pp.16, 29, repr. pl. XXXVIII; Watkins [342], no.57; Cladel [26], pp.180–81; Descharnes and Chabrun [32], pp.154–55; Tancock [341], no.68.

OTHER CAST

FRANCE
Paris, Musée Rodin.

Monument to President Sarmiento

Bronze and marble

ARGENTINA
Buenos Aires, Park of the 3rd of February. Property of the municipality of Buenos Aires (figs. 77–4a–c).

STUDIES FOR THE MONUMENT

First Study for Figure of "President Sarmiento"

Plaster, height 25 ¼ inches

FRANCE
Paris, Musée Rodin (fig. 77–2).

Maquette for the Pedestal of the Monument

Plaster, height 25 ⅝ inches

FRANCE
Paris, Musée Rodin.

Study for Apollo

Plaster, height 71 inches

FRANCE
Paris, Musée Rodin (fig. 77–3).

Apollo Crushing the Python

Plaster, height 98 ½ inches

FRANCE
Paris, Musée Rodin. Rodin wanted to have a plaster cast made of the base of the monument in order to display it opposite the *Monument to Victor Hugo* in his museum. This was not realized during his lifetime, but in 1922 Carlo Madariaga presented this plaster cast to the Musée Rodin.

PORTRAITS

78 Father Pierre-Julien Eymard

a 1863

Bronze, 5 ½ × 4 × 4 ⅝ inches
Signed on right side of collar: A. Rodin
Foundry mark back of collar to left:
Alexis Rudier/Fondeur PARIS

b 1863

Bronze, 22 ¾ × 11 × 10 ½ inches
Signed on front of base to left: A. Rodin
Foundry mark rear of base to left:
Alexis RUDIER/Fondeur. PARIS.

St. Pierre-Julien Eymard (fig. 78–1)[1] was the founder of the Society of the Blessed Sacrament. He was born in 1811 at La Mure d'Isère and was ordained priest in July 1834, serving the church at Chatte and then at Monteynard. After his novitiate in the Oblates of Mary, he was appointed Director of the Little Seminary of Belley. While praying in the Church of Notre-Dame-de-Fourvières in January 1851, Father Eymard was inspired to found an order expressly to honor the Blessed Sacrament.

In August 1855, he presented a petition to the pope, but it was not until May 8, 1863, that the pope solemnly approved and confirmed the new order. At the first vespers of Corpus Christi on June 3, 1863, Father Eymard received a degree of approbation signed by Pius IX. The sole aim of the Society of the Blessed Sacrament was the glorification of the Eucharist. "Our Lord will be taken from His Tabernacle. He will be exposed. He will reign. He will be the Master; and He will have servants, whose sole occupation will be the care of His Divine Person, leaving all other work for the service of His Throne and for the needs of His Royal Presence. These religious will give Him *personal* service and not indirectly by their works."[2] Father Eymard was also instrumental in the founding of the Servants of the Blessed Sacrament, a society of women devoted to the perpetuation of the life of the Blessed Virgin after the Last Supper. Father Pierre-Julien Eymard died in 1868.

Rodin entered the newly founded order of the Society of the Blessed Sacrament upon the death of his sister in 1862, a loss which greatly affected him. "In my naked cell, with its bare walls, I thought of Fra Filippo and Fra Bartolomei. Their example spurred me on."[3] As Brother Augustin, Rodin modeled the bust of the founder of the order in 1863, and Father Eymard, seeing where Rodin's true vocation lay, persuaded him to return to secular life and become a sculptor.

There is some disagreement as to the nature of the relationship between Father Eymard and the young novice. Rodin was present at the priest's funeral in 1868.[4] Much later in life he kept a bronze cast of the bust in his bedroom at Meudon, together with a huge seventeenth-century cruxifix.[5] According to Father Romain Saint-Cyr, assistant general of the Society, Father Eymard made a gift of this bust to Sister Marguérite Guillot, founder of the Servants of the Blessed Sacrament, and it appears that this was taken to Angers by Rodin himself.[6]

According to Bartlett,[7] however, the understanding between Rodin and Father Eymard was far from perfect. The latter, he states, "had summed up the experiences of his

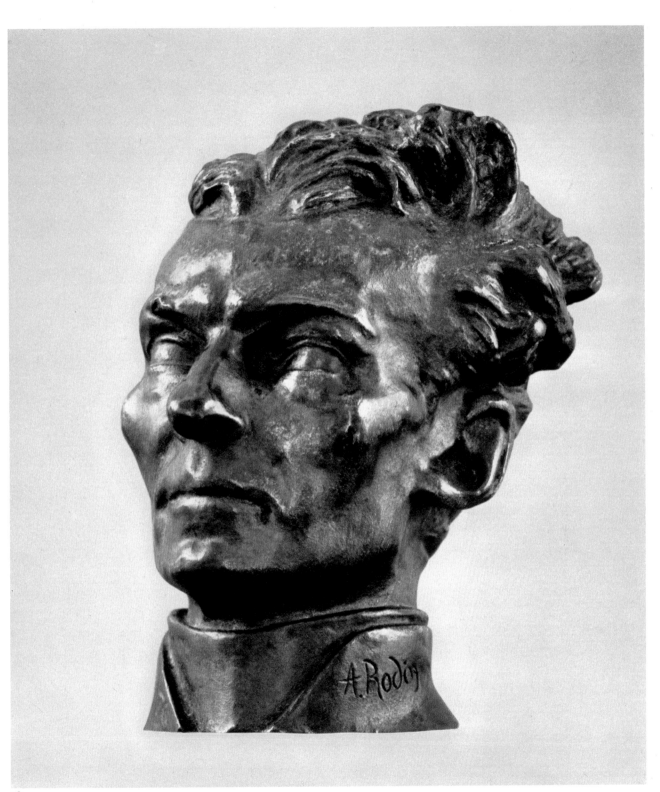

78a

life and observation in the expression—which he enjoyed repeating—that 'life was an organized lie,' and he wanted his bust made, in some respects, in accordance with this conclusion."[8]

In Bartlett's version, Father Eymard thought that Rodin had made the hair on the sides of his head look like the "horns of the devil," and he would not accept the bust until they were removed. When Rodin refused to make any alterations, the priest neither accepted the bust nor paid the sculptor.[9] Father R. Ullens of the Society of the Blessed Sacrament was also of the opinion that Father Eymard disapproved of the work.[10] He stated that Rodin himself gave the bust to the Servants of the Blessed Sacrament and that when Father Eymard heard of this, he strongly advised the nuns to conceal the work, which he found abominable. It was evidently so well hidden that it was not found again until 1925, at the instigation of Father Ullens.

Although he is generally very accurate, Bartlett seems to have allowed anticlerical feelings to overcome him when he wrote about St. Pierre-Julien Eymard. The sentiments he attributes to him are totally at variance with all his known published statements, and it is surely impossible that within the religious community the bust could have been subject to a financial transaction. He may not have liked the bust Rodin made of him and may even have advised the nuns of the Servants of the Blessed Sacrament to dispose of it, but this is unlikely to be for the reasons advanced by Bartlett.

Stylistically the severe forms and blank eyes of this bust are very close to the portraits of David d'Angers.[11] In his very earliest portraits—Jean-Baptiste Rodin (pl. 2) of 1860 and the work under discussion—Rodin preferred the austerity of the Davidian mode to the greater vivacity of Carpeaux's busts. Tucked into the soutane is a phylactery on which is inscribed the first strophe of the Eucharistic prayer composed by St. Pierre-Julien Eymard. The following syllables can be read: "AUDES AC GRATIA... MO DEVINISSIMO."[12] The substitution of an E for an I in the word "DIVINISSIMO," although hardly surprising in light of the highly eccentric spelling and grammar of many of Rodin's letters, adds an appealing note of youthful gaucherie to the high seriousness and accomplishment of this imposing work.

NOTES

1. Father Eymard was canonized on December 9, 1962.
2. Lady Herbert, *The Priest of the Eucharist: A Sketch of the Life of the Very Rev. Peter J. Eymard, Founder of the Society of the Most Blessed Sacrament* (New York: Fathers of the Blessed Sacrament, 1907), p. 34.
3. Frisch and Shipley [42], p. 56.
4. Ibid., p. 57.
5. Ibid., p. 53.
6. Personal communication from Father Saint-Cyr, who had access to a letter from St. Pierre-Julien Eymard and to another from Sister Guillot.
7. Bartlett in Elsen [39], pp. 21–22.
8. Ibid., p. 21.

9. Ibid., p. 22.
10. Sigogneau [102], p. 19. This information was contained in a letter from Father Ullens to Dr. Sigogneau.
11. Bartlett in Elsen [39], p. 22, states that the bust was made life-size (no. 78b) and that the smaller head is a mechanical reduction (no. 78a). On the other hand, Lami [4], p. 165, says that the life-size version is an enlargement of the small head. It seems more probable that Rodin took the opportunity to work on the bust life-size, and that the reductions were made at a later date.

Bénédite [10a], pl. 1(B), states that there are contemporary documents which suggest that Rodin made a marble version of this work, although no trace of it has so far been found. He also states that the bust was cast only in 1917

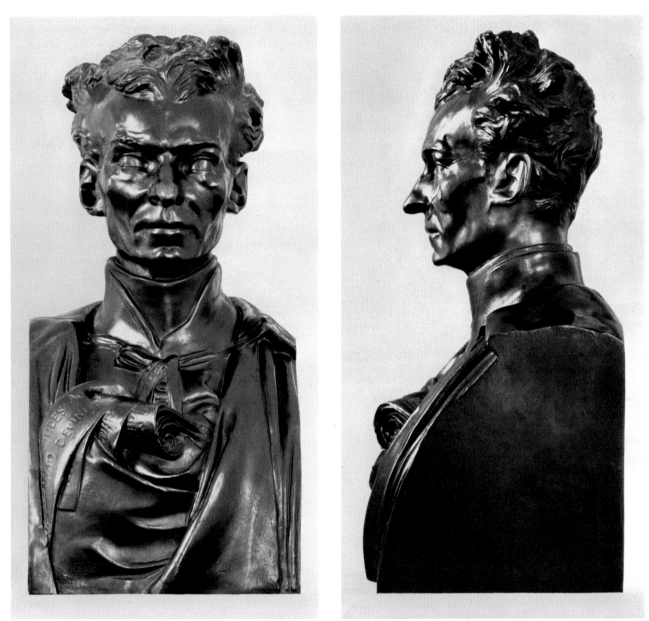

78b Front 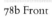 78b Side

78-1 Father Pierre-Julien Eymard
Photograph

(that is to say, at the same time as the bust of Jean-Baptiste Rodin) and that, in addition to the small version (no. 78a), there is another of enormous dimensions. It has not been possible to confirm any of this information, although it seems certain that the work was cast in bronze long before 1917.

12. The complete sentence of the prayer reads as follows: "LAUDES AC GRATIA OMNI MOMENTO SANCTISSIMO AC DIVINISSIMO SACRAMENTO." Many thanks are due to Father L. Saint-Pierre, of La Mure, France, for conveying this information to me.

REFERENCES

Bartlett [125], pp. 28–29; Lawton [67], pp. 23–24; Lami [4], p. 165; Bénédite [10a], pp. 7, 9, 25, repr. pl. 1(B); Grappe [338], no. 2; Grappe [338a], no. 2; Watkins [342], nos. 51, 76; Grappe [338b], no. 7; Sigogneau [102], p. 19; Cladel [26], p. 85; Grappe [338c], no. 7; Frisch and Shipley [42], p. 57, repr. opp. p. 48; Story [103], p. 143, no. 2, repr. pl. 2; Grappe [338d], no. 7; Grappe [54], p. 140; Waldmann [109], pp. 55, 77, no. 61, repr. pl. 61; Story [103a], no. 2, repr. pl. 2; Goldscheider [49], p. 14, repr. p. 13; Elsen [38], p. 109, repr. p. 108; Sutton [104], pp. 20–21, repr. pl. 2; Mirolli [81], pp. 99–100, repr. pl. 68; Descharnes and Chabrun [32], p. 29, repr. pp. 22–23; Tancock [341], no. 70, repr. p. 67.

OTHER CASTS AND VERSIONS

a

FRANCE
Paris, Musée Rodin.

IRELAND
Dublin, Municipal Gallery of Modern Art. On loan from the National Gallery of Ireland. Signed: Rodin.

UNITED STATES
Cleveland, Cleveland Museum of Art. Signed: Rodin.

Madison, N. J., Estate of Geraldine R. Dodge. Founder: Alexis Rudier.

New York City, Collection Willard B. Golovin.

Philadelphia, Collection Mrs. Charles J. Solomon (ex. Collection Jules Mastbaum). Signed: A. Rodin. Founder: Alexis Rudier.

Stanford, Stanford University Art Gallery and Museum. Gift of B. G. Cantor Art Foundation. Founder: Susse. Cast no. 3/12.

b

Bronze

FRANCE
Paris, Musée Rodin. Signed: A. Rodin. Founder: Alexis Rudier.

ITALY
Rome, Curie Générale des Pères du Très Saint-Sacrament.

JAPAN
Tokyo, National Museum of Western Art (ex. Collection Matsukata). Signed: A. Rodin.

Plaster

FRANCE
Grenoble, Musée de Peinture et de Sculpture. Gift of the Musée Rodin, 1931.

79 Mask of the Man with the Broken Nose
1863–64

Bronze, 10¼ × 6⅞ × 9¾ inches
Signed right side of neck and on stamp inside: A. Rodin.
Foundry mark back of neck to left:
Alexis RUDIER/Fondeur. PARIS.

Rodin recognized the *Man with the Broken Nose* to be his first major work. "That mask," he said, "determined all my future work. It is the first good piece of modeling I ever did. From that time I sought to look all around my work, to draw it well in every respect. I have kept that mask before my mind in everything I have done."[1] It was made in 1863 and 1864 in his first studio in the rue Lebrun, shortly after he decided to abandon the religious life in the Society of the Blessed Sacrament. He was desperately poor, as was his model, Bibi, an odd-job man well known in the St.-Marcel quarter. Rodin described to Dujardin-Beaumetz the conditions in which he worked:

> The air sifted in everywhere, through ill-shut windows, through the warped door; the slates of the roof, worn out by old age or skewed by the wind, established a permanent draft. It was glacially cold. A well was hollowed in one corner of the wall; the water was near the curb and kept up a penetrating dampness in all seasons....
>
> It was there that I made the "Man with the Broken Nose." For tenacity in study, for sincerity in execution of form, I have never done more or better....
>
> The winter that year was especially rude, and I couldn't have a fire at night. "The Man with the Broken Nose" froze. The back of his head split off and fell.[2]

Referring to this work in later years, Rodin said he chose Bibi because "he had a fine head; belonged to a fine race—in form—no matter if he was brutalized. It was made as a piece of sculpture, solely, and without reference to the character of the model, as such. I called it 'The Broken Nose,' because the nose of the model was broken."[3]

It is undoubtedly true that it was Bibi's striking appearance that first gave Rodin the idea of making a study of his head. On the other hand, the classical references in the work are unmistakable. Judith Cladel said that it was the model's resemblance to an ancient Greek shepherd that tempted Rodin to model his head.[4] Elsewhere she wrote that he "strove to portray the energy and imposing simplicity that had astonished him in the antique busts and the statue of 'The Knife-Grinder' that he had seen in the galleries of the Louvre."[5]

At this time Rodin greatly admired classical sculpture. He made frequent visits to the Louvre, spending most of his time in the antique galleries, and he owned plaster casts of the *Venus de Milo* and the *Dying Gladiator,* as well as some others.[6] From the very beginning, Rodin bound the hair of the *Man with the Broken Nose* in a fillet, as if he felt that a classical attribute was necessary to give to his life study a certain classical dignity. It differs considerably, however, from the two earlier male portraits, *Jean-Baptiste Rodin* of 1860 (pl. 2)

and *Father Pierre-Julien Eymard* executed in 1863 (no. 78), in both of which, to varying degrees, classical prototypes had been referred to. In the latter two busts the inner life is as restrained as the outer form. The blank eyes, the smooth surfaces, and the geometrical forms place the emphasis on the solid mass existing in space. In the *Man with the Broken Nose,* however, the more dedicated observation of the profiles has resulted in a much greater fluidity of form and a far more eventful surface, as well as a vast increase in pathetic power, to which the fragmentary form and the sideways tilt contribute a great deal.

A terra-cotta version (fig. 79-1) may show the head immediately as it looked after the accident in the rue Lebrun studio. The hair is extended beyond the fillet, while in the more familiar bronze version this extension is missing. In deciding to exhibit the work in later years in spite of the damage it had undergone, Rodin probably concluded that he should trim the back and rough edges of the mask so as to make the break look less arbitrary.[7]

Rodin returned to the mask again in Belgium in 1872. A second version was prepared in which the shoulders and the upper part of the chest are represented (fig. 79-3). This was exhibited in plaster at the Brussels Salon in 1872 as *Bust of M.B....,*[8] but in spite of the campaign of Rodin's friends, no buyers were found for it. In changing the format as well as the material, when it was carved in marble in 1875, the character of the work was completely changed.[9] The intense pathos disappeared and was replaced by the sober dignity of a Greek philosopher. The marble was exhibited at the Salon of 1875, but once again it excited little comment.

The *Man with the Broken Nose* eventually became one of Rodin's most popular works, although its fame spread more rapidly in England than in France. A bronze was exhibited at the Grosvenor Gallery in London in 1882 as *Study of a Head,* and by 1889 ten casts had been sold in England, one of them entering the collection of Sir Frederick Leighton, P. R. A., although none had yet been sold in France.[10]

When Rodin started working on *The Gates of Hell,* he modeled another head of an old man with a broken nose (c. 1880–82), which was inserted into the row of heads above *The Thinker* in the tympanum of *The Gates (see* no. 1). Considerably smaller than the head of 1864, the *Small Head of the Man with the Broken Nose* (fig. 79-4) presents an even more tragic aspect than its predecessor. The flesh has sagged, while the modeling has become more animated, submerging details, the locks of hair and the fillet, in a more expressive total activity. It was this head that was later incorporated into a number of other works. At some late date, for example, the *Small Head of the Man with the Broken Nose* was added to *Earth* in a very strange assemblage to be found at Meudon. In *The Sculptor and His Muse* of 1895, this head is used for the seated figure of the sculptor who stifles a cry while a female figure hovers over him and holds his penis.[11] Finally, in the marble *Jardiniere* executed about 1905 (fig. 79-5), a reduced version of the head was attached to the side of the bowl.

NOTES

1. Bartlett in Elsen [39]. p. 21.
2. Dujardin-Beaumetz in Elsen [39], p. 148.
3. Bartlett in Elsen [39], pp. 20–21.
4. Cladel [26], p. 91. "Son air misérable et résigné, sa face au nez écrasé comme d'un coup de talon, son apparence de vieux pâtre thessalien, toute cette curieuse physionomie, tenta Rodin qui fit le buste du bonhomme, après lui avoir ceint la tête d'un étroit bandeau."
5. Cladel [25a], p. 54.
6. Bartlett in Elsen [39], p. 26.
7. The *Man with the Broken Nose* is a particularly problematic work to catalogue. Slight differences

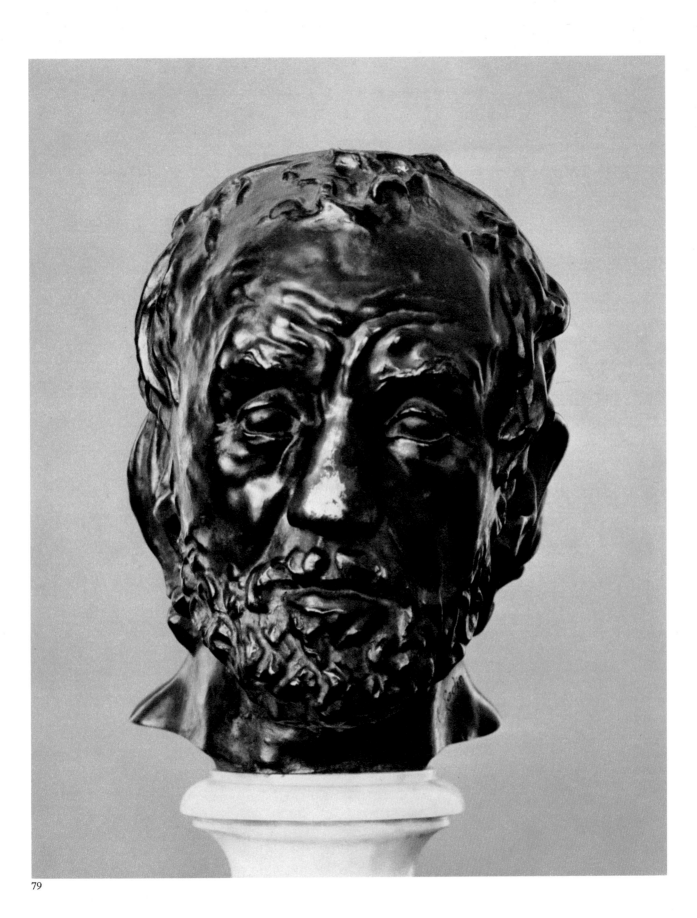

in the mounting and the angle at which the head is displayed are cause for the wide diversity of measurements given in the catalogues of museums and private collections. As far it has been possible to discover, there are three basic ways of mounting the head: 1) the neck is cut in a straight line where it joins the shoulders, but the head is titled forward and, at the point of contact, the head is attached to the base with a screw; 2) the neck is cut in a straight line where it joins the shoulders, but the head sits squarely on a base; 3) the neck is extended to include the collar bones (fig.79-2). It seems probable that in the third way of mounting the head, a bronze must have been cast from a plaster made after the 1864 mask had been refurbished in 1872. In the most recent posthumous casts the complete head, and not the mask, has been used, thus indicating that a plaster made after 1872 is being utilized in the casting.

8. It is always said that a marble was exhibited at the Brussels Salon in 1872. However, Ruth Mirolli [81], p.135, n.1, points out that the *Livret de Salon de Bruxelles,* Brussels, 1872, p.130, indicates that a plaster was submitted.

9. The date 1875 is carved into the base of the Musée Rodin marble.

10. Bartlett in Elsen [39], pp.87–88. Other casts were owned by W.E.Henly in 1881 and Robert Browning in 1882.

11. A possible explanation of the iconography of this work is to be found in Rodin's observations on voluptuousness published in a little-known conversation with Paul Gsell, *Twelve Aquarelles by Auguste Rodin,* intro. Paul Gsell (Geneva, Paris: Georg Editions, 1920), p.9. "'Art,' Rodin said, 'is nothing else but a sensual voluptuousness. It is only a derivative of the power of loving.' Rodin indicated without possible contestation from where, according to him, all inspiration came. 'Why,' he often said to me, 'leave out in art half the human being. Man is a composition of two natures. If you suppress one, you lie.'"

79-1 *Mask of the Man with the Broken Nose*
 1863–64, terra-cotta, height 9½ inches
 Koninklijk Museum voor Schone Kunsten, Antwerp

79-2 *Mask of the Man with the Broken Nose*
 1863–64, bronze, height 12 inches
 Fogg Art Museum, Harvard University, Cambridge, Mass. Grenville L.Winthrop Bequest, 1943

REFERENCES

Bartlett [125], pp.28,99; Geffroy [199a], p.9; Maillard [71], pp.32–34, 108; Mauclair [77a], pp.3–4, 6–7; Lawton [67], pp.24–26, repr. opp.p.26; Ciolkowska [23], pp.26–27; Rilke [87], pp.22–25, repr. p.2; Cladel [25a], pp.53–54, repr. p.56; Lami [4], p.165; Bénédite [10a], pp.9, 25, repr. p. 11; Grappe [338], nos.3, 9; Watkins [342], no.55, repr. p.17; Grappe [338a], nos.3, 16; Grappe [338b], nos.8, 19; Cladel [26], pp.90–92; Grappe [338c], nos.8, 19; Frisch and Shipley [42], pp.66, 95–96; Story [103], pp.16, 143, no.3, repr. pl.3; Grappe [338d], nos.8, 21; Waldmann [109], pp.21–22, 73, no.1, repr. pl.1; Rilke [87a], pp.15–18, repr. pl.IV; Cladel [27], p.x, repr. pl.4; Story [103a], no.3, repr. pl.3; Elsen [38], pp.109–11, repr. p.106; Goldscheider [50], p.16, repr. pl.50; Sutton [104], pp.21–25, 28, repr. pl.3; Mirolli [81], pp.102–8, 135–36; Descharnes and Chabrun [32], pp.34–35, repr. p.28; Tancock [341], no.71, repr. p.68; *Metamorphoses in Nineteenth Century Sculpture,* Fogg Art Museum, Harvard University, Cambridge, Mass., November 19, 1975–January 7, 1976.

OTHER CASTS AND VERSIONS

Bronze

ARGENTINA
Buenos Aires, Collection Antonio Santamarina.

CZECHOSLOVAKIA
Prague, Národní Galerie. Acquired in 1925. Founder: Alexis Rudier.

DENMARK
Copenhagen, Ny Carlsberg Glyptotek. Gift of Ny Carlsbergfondet, 1919. Signed: A.Rodin.

FRANCE
Paris, Musée Rodin.

GREAT BRITAIN
Glasgow, Glasgow Art Gallery and Museum. Burrell Collection.

79-3 *Man with the Broken Nose*
 1872, plaster, height 18 inches
 Location unknown

79-4 *Small Head of the Man with the Broken Nose*
 1882, bronze, height 4⅞ inches
 Národní Galerie, Prague

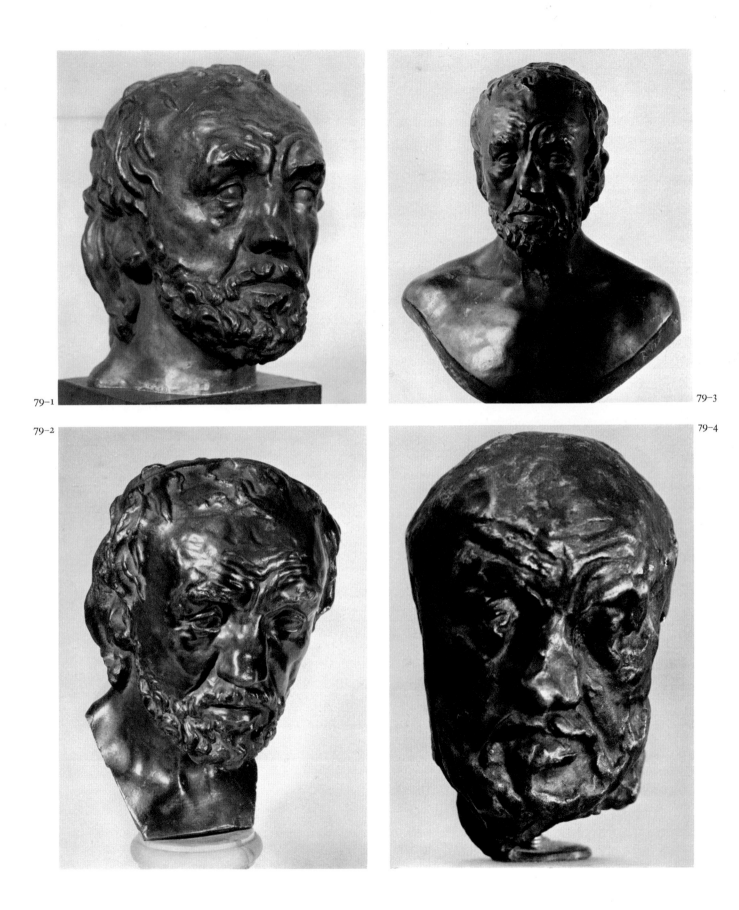

79-1

79-2

79-3

79-4

477

ITALY

Rome, Galleria Communale d'Arte Moderna. Acquired in 1913.

JAPAN

Tokyo, National Museum of Western Art (ex. Collection Matsukata). Signed: A.Rodin.

UNITED STATES

Montclair, N.J., Kasser Foundation.

Pittsburgh, Museum of Art, Carnegie Institute. Purchased in 1920 from the Musée Rodin. Signed: A.Rodin. Founder: Alexis Rudier.

79–5
Jardiniere
c. 1905, marble, height 6¼ inches
Museum of Fine Arts, Boston

Plaster

CZECHOSLOVAKIA

Prague, Národní Galerie.

FRANCE

Belfort, Musée de Belfort. Given to the sculptor Camille Lefèvre by Rodin.

Béziers, city of Béziers.

Bronze, height 9½ inches

FRANCE

Paris, Musée Rodin. Signed: A.Rodin.

UNITED STATES

Hagerstown, Md., Washington County Museum of Fine Arts. Signed: A.Rodin. Founder: Alexis Rudier.

Williamstown, Sterling and Francine Clark Art Institute. Acquired by Mr.Clark in 1916. Signed: A.Rodin. Founder: Alexis Rudier.

Terra-cotta

BELGIUM

Antwerp, Koninklijk Museum voor Schone Kunsten. Gift of the Musée Rodin, 1924. Signed: Rodin. Cast no. 5 (fig. 79–1).

Ceramic

FRANCE

Sèvres, Estate of M.Mayadon. Executed in 1916 by M.Mayadon.

Bronze, height 12 inches

AUSTRALIA

Melbourne, National Gallery of Victoria. Unsigned.

DENMARK

Copenhagen, Ordrupgaardsamlingen. Signed.

GERMANY (EAST)

Dresden, Staatliche Kunstsammlungen. Purchased from Rodin in 1894. Signed: Rodin.

GREAT BRITAIN

Cambridge, Fitzwilliam Museum. Not signed. No foundry mark.

Oxford, Ashmolean Museum (ex. Collection Alphonse Legros).

IRELAND

Dublin, Municipal Gallery of Modern Art. On loan from the National Gallery of Ireland. Signed: Rodin.

SWITZERLAND

Geneva, Musée d'Art et d'Histoire. Gift of Rodin, 1896.

UNITED STATES

Amherst, Amherst College (ex. Collection Gustave Biot). Presented to Biot.

Boston, Museum of Fine Arts. Gift of Benjamin Kulp, 1951. Executed c. 1901–1903.

Cambridge, Fogg Art Museum, Harvard University. Grenville L.Winthrop Bequest, 1943. Not signed. No foundry mark (fig. 79–2).

Chicago, Art Institute of Chicago. Arthur Jerome Eddy Memorial Collection. Signed: Rodin.

Northampton, Smith College Museum of Art. Purchased from Rodin in 1909 by Emily Hesslein.

Providence, Museum of Art, Rhode Island School of Design. Gift of Mrs. Gustave Radeke, 1921 (ex. Collection Ionides).

Washington, D.C., Hirshhorn Museum and Sculpture Garden, Smithsonian Institution. Founder: Alexis Rudier.

Plaster

FRANCE

Paris, Musée Rodin. Gift of B. G. Cantor Art Foundation (ex. Collection Antony Roux).

Bronze, height 11 inches (complete head)

UNITED STATES

Beverly Hills and New York City, B. G. Cantor Collections. Founder: Georges Rudier. Cast no. 8/12.

Montgomery, Ala. Collection Adolph Weil, Jr.

New York City, Collection Bella and Sol Fishko. Founder: Georges Rudier.

Northampton, Collection Leonard Baskin. Founder: Georges Rudier.

Plaster, height 18 inches

Location unknown (fig. 79–3).

Marble, height 22⅞ inches

FRANCE

Paris, Musée Rodin.

Terra-cotta

FRANCE

Paris, Musée Rodin.

Bronze, height 3½ inches

FRANCE

Paris, Musée Rodin.

UNITED STATES

Beverly Hills and New York City, B. G. Cantor Collections. Founder: Georges Rudier. Cast no. 10/12.

Los Angeles, Los Angeles County Museum of Art. Gift of Leona Cantor. Founder: Georges Rudier. Cast no. 6/12.

RELATED WORKS

Small Head of the Man with the Broken Nose

Bronze, height 4⅞ inches

CZECHOSLOVAKIA

Prague, Národní Galerie (fig. 79–4).

UNITED STATES

Baltimore, Baltimore Museum of Art. Cone Collection. Signed: A. Rodin. Founder: Alexis Rudier.

Beverly Hills, Collection Leona Cantor. Founder: Georges Rudier. Cast no. 12/12.

New York City, Estate of Alexander Dobkin.

New York City, Collection Dr. Gerald L. Feinberg. Founder: Georges Rudier. Cast no. 10/12.

San Francisco, California Palace of the Legion of Honor. Spreckels Collection. Founder: Alexis Rudier.

Shreveport, R. W. Norton Art Gallery. Signed. Founder: Alexis Rudier.

Stanford, Stanford University Art Gallery and Museum. Gift of B. G. Cantor Art Foundation. Founder: Georges Rudier.

Plaster

UNITED STATES

Maryhill, Wash., Maryhill Museum of Fine Arts.

The Sculptor and His Muse

Bronze, height 26⅜ inches

UNITED STATES

Madison, N. J., Estate of Geraldine R. Dodge. Signed. Founder: Alexis Rudier.

San Francisco, California Palace of the Legion of Honor. Gift of Alma de Bretteville Spreckels. Founder: Alexis Rudier.

Wayzata, Minn., Collection Mr. and Mrs. Maurice L. Melamed.

The Earth (with the head of the "Man with the Broken Nose")

Plaster, height 12 inches

FRANCE

Meudon, Musée Rodin.

Jardiniere (incorporating the head of the "Man with the Broken Nose")

Marble, height 6¼ inches

UNITED STATES

Boston, Museum of Fine Arts. Gift of Julia Isham Taylor from the estate of Samuel Isham, 1917 (fig. 79–5).

80 Mignon
1867–68

Bronze, 15½ × 12 × 9½ inches
Signed left shoulder and
inside in relief: A. Rodin
Foundry mark rear of base to left:
Alexis. Rudier./Fondeur Paris

81 Mask of Mme Rodin
1880–82 (executed 1911)

Pâte de verre, 9½ × 6¼ × 7⅛ inches
Not signed or inscribed[1]

A great deal of controversy surrounds the dating of the various portraits of Rose Beuret, or Mme Auguste Rodin, as she became on January 29, 1917. Born in 1844,[2] she met Rodin in 1864 and lived with him until her death on February 14, 1917. Simple, illiterate, and, with good cause, insanely jealous, she was nevertheless the woman to whom Rodin always returned after his numerous liaisons.

The chief cause of the dispute is the improbability of the dating adopted by Grappe. He assigns a date of 1870 to *Mignon* (no. 80).[3] However, his dating of 1871 for what is assumed to be the next portrait of Rose Beuret, the terra-cotta bust known as *The Alsatian Woman* (fig. 80, 81–3),[4] casts doubt on his dating of *Mignon,* for while the latter represents a young girl, the former is the portrait of a mature woman. It is inconceivable that they were executed within one year of each other.

Grappe further confuses matters when he assigns a date of 1890 to the marble portrait (fig. 80, 81–2)[5] and the bronze mask (fig. 80, 81–1),[6] which are closely related to one another and to *The Alsatian Woman.* He states that these works of 1890 represent Mme Rodin when she was over forty (in fact, forty-six), that is to say that she had matured beyond measure in the years 1870–71, but that her features changed hardly at all in the next nineteen years, the period between *The Alsatian Woman* and the two portraits, the marble and the bronze mask.

Later commentators have sought various ways out of this confusing situation. Ruth Mirolli accepts the date 1870 for *The Alsatian Woman*[7] and concludes that "the undated *Mignon* must be put as early as possible in order to allow for the physical changes seen in Rose's face in the interval between the two works,"[8] that is to say, 1867. She attributes the solemnity of *The Alsatian Woman* to the fact that it was probably executed in the autumn and winter of 1870, when Paris was besieged by the Germans, and the choice of costume to the fact that Alsace was the first French territory to be lost to Prussia.[9] She observes that the portraits dated 1890 by Grappe and assumed by him to represent Mme Rodin in that year are in fact reworkings of *The Alsatian Woman.*[10] It should still be asked, however, if even a period of three years is enough to account for the great physical changes observable in the two portraits.

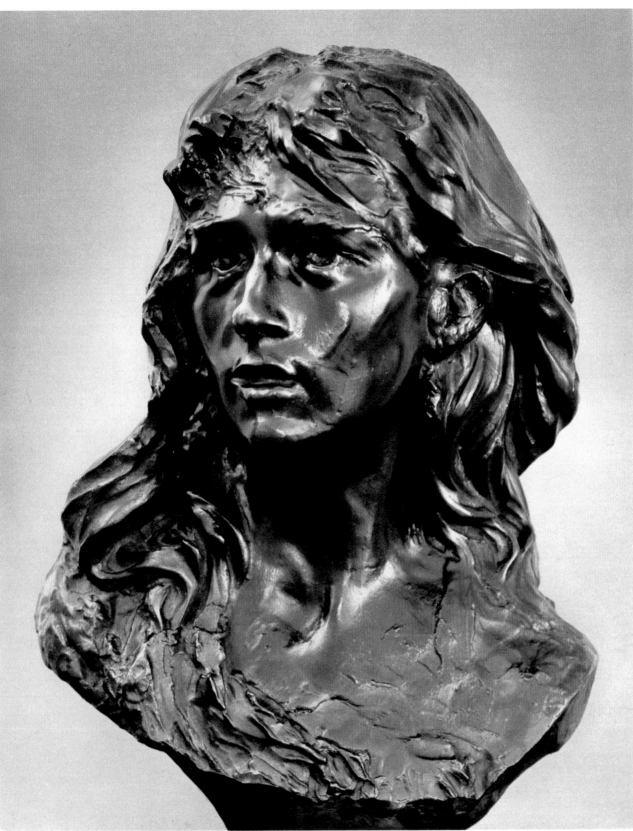

Athena Tacha Spear[11] is also suspicious of Grappe's chronology. She assigns a date of 1870–71 to *Mignon,* believing it to have been executed during the siege of Paris by the Germans, thereby accounting for what she refers to as "the haggard face of *Mignon.*"[12] She rejects an earlier dating because she does not believe that Rodin would have made such a direct portrait while working for Carrier-Belleuse.[13] She too believes that *The Alsatian Woman* could not have been done right after *Mignon,* but she shifts the dating of the former work to the early 1890s, thereby forming a group with the marble and the bronze mask.[14] She suggests, however, that all three works were done in 1891 or 1892 rather than 1890 and that they mark Rodin's return to Rose Beuret after the end of his relationship with Camille Claudel.[15] It is questionable, however, if works should be redated on such subjective grounds.

Neither of these attempts to establish a convincing sequence for these portraits is entirely satisfactory. A newly discovered photograph of Rose Beuret provides a more satisfying, although admittedly conjectural, solution. Judith Cladel formerly owned a photograph of Rose Beuret (fig. 80, 81–4) on the back of which Mme Cladel, who knew Rose as well as she knew Rodin, works out that it must have been taken between 1880 and 1882, when Rose was thirty-six or thirty-eight years old.[16] This photograph resembles so closely the bust known as *The Alsatian Woman* and the portraits generally dated 1890 that a revised dating of 1880–82 for all of them seems to be obligatory.

The following sequence for the portraits of Rose Beuret is therefore suggested. The first portrait, *Mignon* of 1867–68 (no. 80),[17] is wonderfully vivacious and almost baroque in its rhythms. It is in strong contrast to the work he was doing for Carrier-Belleuse at this time, but the nature of his relationship to the model and his extraordinary technical diversity and precocity make this not at all surprising.

The next portraits of Rose Beuret, *The Alsatian Woman* and the bronze *Mask of Mme Rodin,* were executed in 1880–82, when she was thirty-six or thirty-eight years old. The choice of costume in the more developed bust may appear to be rather surprising, but Rodin had used his mistress's strong features in a number of different guises in the late 1870s *(see* nos. 66 and 107), and the decision to clothe her in a rather generalized version of a folk costume that appealed to him is not inconsistent with this practice.[18]

The next portrait is the marble *Mme Rodin,* executed in 1898. Grappe gave no reasons for dating the execution of this marble 1890, although it seems that the date was based on what he took to be the apparent age of the model.[19] From the letters of Rodin to Bourdelle and Bourdelle's own notes preserved in the Musée Bourdelle, however, it is clear that Bourdelle carved the marble portrait of Mme Rodin in 1898,[20] working from the bronze portrait here dated 1880–82.

The *Mask of Mme Rodin* (no. 81) is a *pâte de verre* version of the 1880–82 portrait of Rose Beuret and was prepared by Jean Cros in 1911.[21] It is extremely curious that Rodin made no portraits of his mistress after she had reached early middle age. Instead, in the marble and in the *pâte de verre* mask, he returned to the noble image he had made of her in happier times.

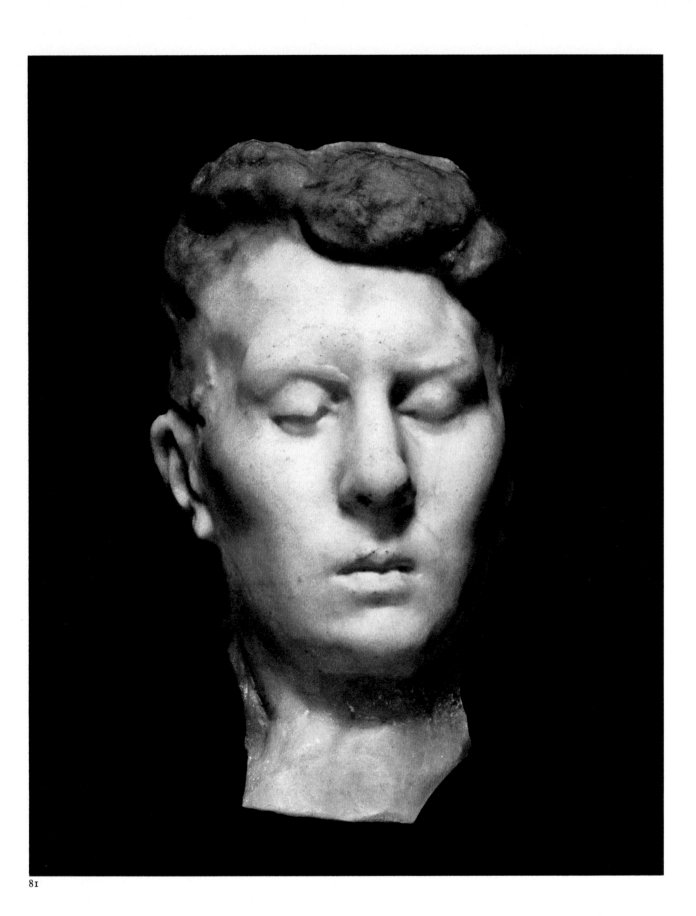

1. According to information provided by the Musée Rodin at the time of purchase, this cast was retouched by Rodin.

2. Grappe [338d], no. 14, gives 1845 as the year of Mme Rodin's birth, but, as pointed out by Spear [332], p. 1, Judith Cladel's date of 1844 agrees with the inscription on Rose's tombstone at Meudon (Cladel [26], p. 87).

3. Grappe [338d], nos. 14, 15.

4. Ibid., no. 16.

5. Ibid., no. 249.

6. Ibid., no. 250. "Ce buste représente la femme du sculpteur, à une époque plus proche de nous, quand Mme Rodin avait dépassé la quarantaine. Le modèle a conservé toute la pureté de ses traits."

7. Mirolli, [81], p. 121, n. 1. "The portrayal of Rose in *Alsacienne* seems almost closer to the mature, serious and full face of *Bellone* of 1878 than to the pretty girl of *Mignon*. But if the dating of the *Alsacienne* is moved into the Brussels period, not only does it contradict the little evidence that exists about the piece and make the idea of doing the portrait as an Alsatian woman less meaningful, but it would put the bust into a period when it seems that Rodin was not doing anything in a very personal manner. So it appears that the date of *Alsacienne* cannot be altered."

8. Ibid.

9. Ibid., p. 122.

10. Ibid., p. 123, n. 1. "Grappe dated them in 1890, mentioning how well preserved Rose was when in her forties.... However, they are not portraits of that late period, but reworkings of *Alsacienne*."

11. Spear [332], p. 2.

12. Ibid.

13. Ibid., p. 1. "It is doubtful that Rodin made such a direct portrait while working under Carrier-Belleuse in Paris (1863 to 1870)." In opposition to this view, I would point out that Rodin's work was never, at any one moment, stylistically consistent. He worked in the mode that seemed most appropriate to the work in hand. Thus the *Man with the Broken Nose (see* no. 79) dates from this very period.

14. Ibid., p. 2.

15. Ibid., p. 5. "According to Rodin's most reliable biographer, J. Cladel, in 1891, Camille Claudel, his disciple and assistant with whom he had had a passionate relation since the mid-1880's, abandoned him. It is likely that after this rupture which terminated a period of extreme tension and heart-breaking scenes on the part of both Rose and Camille, Rodin recorded his return to Rose by this series of portraits of her in a grave, calm, and contained mood. Therefore, I suggest as a date for the mature portraits of Madame Rodin (including the *Alsacienne)* 1891 or 1892, rather than 1890."

16. The inscription in pencil written on the back of the photograph reads as follows:

$$\begin{array}{r} 1844 \\ \underline{38} \\ 1882 \end{array} \quad \text{vers 1880 ou 82}$$

17. Cladel [26], p. 87. Cladel states that Rose posed for *Mignon* three or four years after she first met Rodin, which was in 1864.

18. While in Strasbourg in 1863, Rodin modeled a work called *The Little Alsatian Girl. See* Bartlett in Elsen [39], p. 24. Cladel [26], p. 52, also mentions "un petit buste d'Alsacienne" made by Rodin when he was doing commercial sculpture in Belgium. Rodin refused to visit the Hôtel de Ville because this "*péché de jeunesse*" was to be seen there.

19. *See* n. 6 above.

20. Personal communication from M. Michel Dufet, Conservateur du Musée Bourdelle, Paris.

21. Jean Cros was the son of Henry Cros (1840–1907), who had studied sculpture under Antoine Etex and François Jouffroy. With a thorough grounding in ancient languages, Cros's reading of Greek and Latin authors in the original enabled him to reconstruct processes that were thought to have

80, 81–1
Mask of Mme Rodin
1880–82, bronze, height 10⅝ inches
Musée des Beaux-Arts, Pau

80, 81–2
Mme Rodin
1898, marble, height 18½ inches
Musée Rodin, Paris

80, 81–3
The Alsatian Woman
1880–82, terra-cotta, height 20⅞ inches
Musée Rodin, Paris

80, 81–4
Rose Beuret, c. 1880–82
Photograph

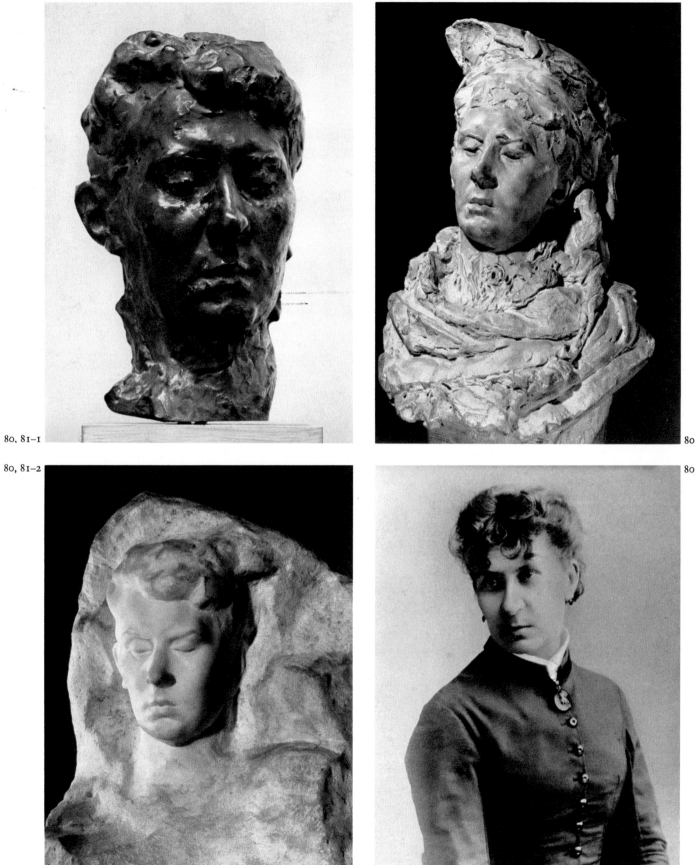

80, 81-1

80, 81-3

80, 81-2

80, 81-4

been lost forever. Thus he rediscovered the technique of *pâte de verre* as well as that of painting in wax and encaustic, publishing his discoveries together with Charles Henry in 1884—*L'Encaustique et les autres procédés de peinture chez les anciens: Histoire et technique.* *Pâte de verre* involves working in colored powders obtained from grinding blocks of glass.

In 1908 there was a retrospective exhibition of the work of Henry Cros at the Galerie M. A. Hébrard, and it may have been there that Rodin decided to see how his own works would look if executed in *pâte de verre*. After Cros's death in 1907, his work was carried on by his son Jean, and in 1911 he transferred four earlier works by Rodin into *pâte de verre*—*Camille Claudel* (see no.108), *Countess Hélène von Nostitz Hindenburg* (no.92), *Hanako* (no.98), and the *Mask of Mme Rodin* under discussion. Only once did Rodin actually conceive a work in this material—*Mask of an Old Faun.*

REFERENCES

Mignon
Bénédite [10a], p.27, repr. pl. XVII (B); Grappe [338], nos.4, 5; Watkins [342], no.10, repr. p.10; Grappe [338a], nos.4, 5; Grappe [338b], nos.13, 14; Grappe [338c], nos.14, 14 bis; Frisch and Shipley [42], p.410; Grappe [338d], nos.14, 15; Waldmann [109], p. 73, no.2, repr. pl.2; Cladel [27], repr. pl.3; Elsen [38], p.111, repr. p.112 (plaster); Mirolli [81], pp. 118, 120–21; Sutton [104], p.22, repr. pl.5 (plaster); Spear [332], pp. 1–2, 5, repr. opp. p.1, no.1; Tancock [341], no.72, repr. p.71.

Mask of Mme Rodin
Grappe [338], no.161; Watkins [342], no.43; Grappe [338a], no.186; Grappe [338b], no.437; Grappe [338c], no.359; Grappe [338d], no.421; Martinie [73], pl.12; Jourdain [66], pl.50; Tancock [341], no.73.

OTHER CASTS AND VERSIONS (No. 80)

Bronze

FRANCE
Paris, Musée Rodin. Signed: A. Rodin. Founder: Georges Rudier.

SWITZERLAND
Lausanne, Collection Samuel Josefowitz. Founder: Alexis Rudier.

UNITED STATES
Beverly Hills and New York City, B. G. Cantor Collections (2 casts). Founder: Georges Rudier. Cast nos.4/12 and 12/12.
Cambridge, Collection Mr. and Mrs. John Coolidge. Founder: Alexis Rudier.
Cleveland, Cleveland Museum of Art (ex. Collection Ralph King, Cleveland). Purchased from the Carnegie International Exhibition, Pittsburgh, 1920. Signed: A. Rodin. Founder: Alexis Rudier.
Los Angeles, Collection Mr. and Mrs. Henry Mancini.
Madison, N. J., Estate of Geraldine R. Dodge. Founder: Alexis Rudier.
San Francisco, California Palace of the Legion of Honor. Spreckels Collection. Signed: A. Rodin. Founder: Alexis Rudier.
— M. H. de Young Memorial Museum. Signed: A. Rodin. Founder: Alexis Rudier.

Plaster

FRANCE
Paris, Musée Rodin. Gift of Alexis Rudier, 1927.

OTHER CASTS AND VERSION (No. 81)

Pâte de verre

BELGIUM
Antwerp, Koninklijk Museum voor Schone Kunsten. Purchased at the exhibition Art Contemporain, Antwerp, 1924.

FRANCE
Paris, Musée Rodin.

Ceramic

FRANCE
Sèvres, Estate of M. Mayadon.

The Alsatian Woman

Terra-cotta, height 20⅞ inches

FRANCE
Paris, Musée Rodin (fig. 80, 81–3).

Mask of Mme Rodin

Bronze, height 10⅝ inches

FRANCE
Lyons, Musée des Beaux-Arts (2 casts). Tripier
 Bequest, 1917 and Claudius Cote Bequest, 1961.
Paris, Musée Rodin.
Pau, Musée des Beaux-Arts (fig. 80, 81–1).

ITALY
Faenza, Pinacoteca Communale e Museo Civico.
 Acquired in 1908.

SWITZERLAND
Geneva, Collection M. Lucien Archinard. Signed:
 A. Rodin.

UNION OF SOUTH AFRICA
Stellenbosch, Peter Stuyvesant Foundation.

UNITED STATES
Cambridge, Fogg Art Museum, Harvard University.
 Grenville L. Winthrop Bequest, 1943.
Detroit, Detroit Institute of Arts. Gift of Dr. and
 Mrs. G. Kamperman (ex. Collections Sir William
 Rothenstein; Sir John Rothenstein).
Stanford, Stanford University Art Gallery and
 Museum. Gift of B. G. Cantor Art Foundation.
 Founder: Georges Rudier. Cast no. 6/12.

Plaster

UNITED STATES
Maryhill, Wash., Maryhill Museum of Fine Arts.

Mme Rodin

Marble, height 18½ inches

FRANCE
Paris, Musée Rodin. Executed by Antoine Bourdelle
 (fig. 80, 81–2).

82 Bust of an Unknown Man
1880

Terra-cotta, 20½ × 8½ × 8½ inches
Inscribed right side of supporting member: N<u>o</u>. 1 Rodin
[cursive script]./A Rodin/80

In the first edition of the catalogue of the Musée Rodin,[1] this bust was said to represent Dr. Thiriar, a well-known figure in the Belgian medical world, who was physician to Leopold II and who became a close personal friend of Rodin. In subsequent editions,[2] however, the sitter was identified as Henry Thorion, a prominent Nancy personality in the period 1885–95. Born at Fresnes-en-Woëwre, Thorion was a doctor, chemist, and journalist. With Maurice Barrès and Stanislas de Guaïta, he became interested in Cabalism. Grappe assumed that Rodin must have met Thorion during the course of his work on the *Monument to Claude Lorrain (see* no. 70).

However, the inscription on the base of the Philadelphia terra-cotta is dated 1880. From this, two conclusions can be drawn—either Rodin knew Thorion in Paris in 1880 and made the bust in that year, which seems unlikely, or the bust was made in 1880 and represents an unknown man. Until further evidence is forthcoming, the latter proposal must be accepted.

The redating of this little-known work makes it the first of the group of powerful portraits, including those of Jean-Paul Laurens and Alphonse Legros, both dated 1881 (nos. 83, 84), which greatly enhanced Rodin's reputation. In its incisive realism and inner concentration it differs considerably from the majority of Rodin's male portraits of the 1870s, for example, those of M. Garnier of 1870 and M. Saffrey of 1871 (pl. 1), in which the detailed treatment of physiognomy and costume is related to the Second Empire mode of Carpeaux.[3]

NOTES

1. Grappe [338], no. 8.
2. Grappe [338a], no. 107; [338b], no. 150; [338c], no. 112; [338d], no. 126.
3. Mirolli [81], p. 169, points out that the bust of Paul de Vigne of 1876 (Grappe [338d], no. 33) "is decisively different from other busts which Rodin did in Brussels such as the *Docteur Thiriar,* for here he omitted all details and created something looser and broader than any portrait he had yet done including the *Mignon."*

REFERENCES

Grappe [338], no. 8; Watkins [342], no. 122; Grappe [338a], no. 107; Grappe [338b], no. 150; Grappe [338c], no. 112; Grappe [338d], no. 126; Tancock [341], no. 74.

488

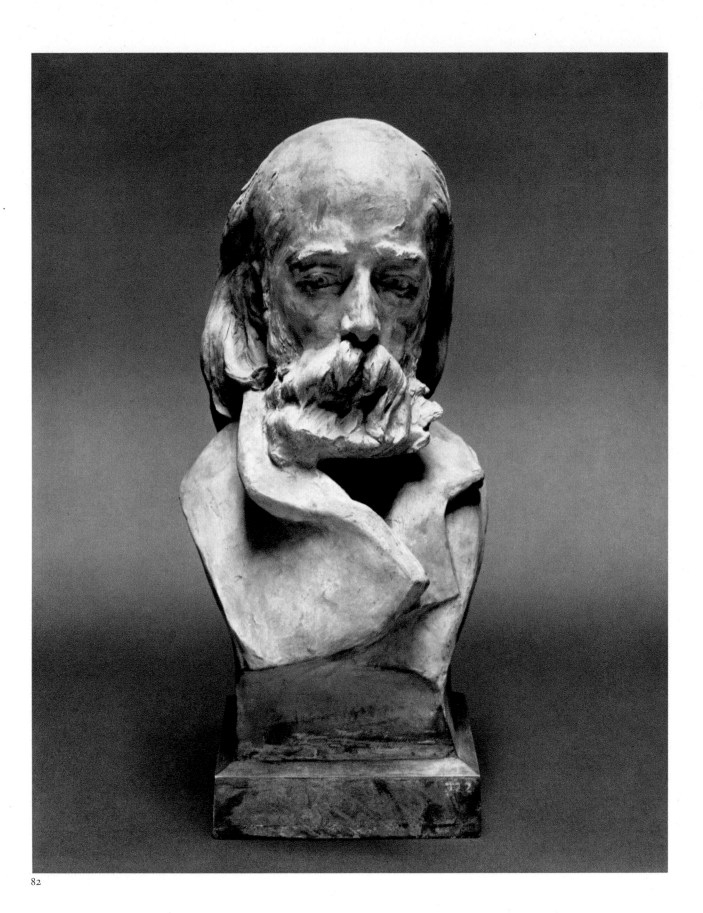

83 Jean-Paul Laurens
1881

Bronze, 22¾ × 14¾ × 13 inches
Signed top of base to right: A. Rodin
Foundry mark back of base to right:
Alexis RUDIER/Fondeur PARIS

Jean-Paul Laurens (fig. 83-1) was born in 1838 at Fourquevaux (Haute-Garonne). He first attended courses at the Ecole des Beaux-Arts in Toulouse and then went to Paris on a scholarship from the department of Haute-Garonne. In Paris he became the pupil of Léon Cogniet and of Alexandre Bida and in 1863 made his debut at the Salon, later gaining considerable popularity as a painter of historical subjects.

Among his most important works are the decorations in the Hôtel de Ville in Paris, the fresco of the *Death of Ste.-Geneviève* in the Panthéon, and the *Lauraguais* in the Capitole in Toulouse. He was a member of the Académie des Beaux-Arts, Director of the Académie de Toulouse, and a professor at the Académie Julian. He later filled the place left vacant by Ernest Meissonier at the Institut. He died in Paris in 1921.

Despite the considerable differences in their attitudes toward art, Rodin and Laurens retained the highest regard for one another. Rodin's spirited bust of the painter was executed in 1881 and exhibited at the Salon of 1882,[1] where it gained very favorable notices. Paul Leroi, in the revue *L'Art* of July 1882, referred to it as "a bust that does honor to the greatest masters of all times. There is but one name to give to it, that of masterpiece. Look out for Rodin. He is going a long way."[2]

By way of return for Rodin's portrait of him,[3] Laurens painted Rodin wearing a turban in the guise of a Merovingian warrior. This was then incorporated into the Panthéon frescos. He acted as Rodin's spokesman in certain dealings with the Municipal Council of Calais (*see* nos. 67–69) and contributed a eulogy for the catalogue of the 1900 Rodin exhibition: "April 19, 1900. What can I add to what I have already said about Rodin before you. You know my admiration for the great sculptor. He is of the race of those who walk alone, of those who are unceasingly attacked but whom nothing can hurt. His procession of marble and bronze creations will always suffice to defend him. He may rely on that. That is my feeling."[4]

A comparison of this bust with that of Carrier-Belleuse, also seen at the Salon of 1882 (*see* no. 85), shows how careful Rodin was to adapt the style of his busts to the character of his sitter. For the bust of his former employer, Rodin worked in an intimate style that looks back to the eighteenth century through Carpeaux, while that of Laurens is conceived in a much more classical and stately manner, in keeping with the more public stance of the history painter.[5]

490

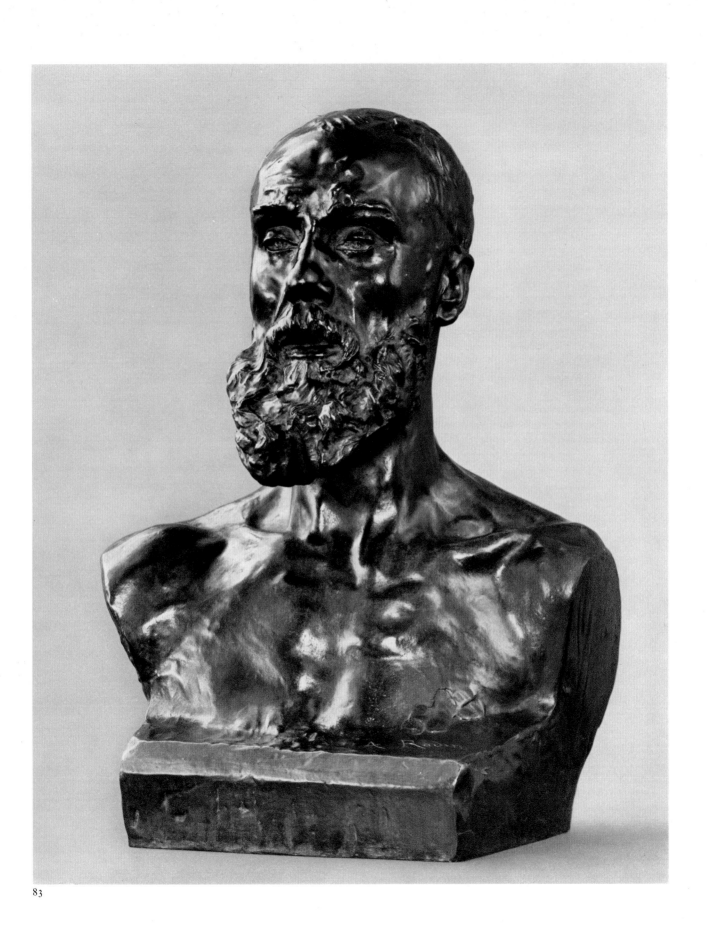

NOTES

1. In the 1927 and 1929 editions of the Musée Rodin catalogue (*see* [338], no. 58 and [338a], no. 75 respectively), Grappe gave a date of 1882 for this bust, although in subsequent editions it was revised to 1881.
2. Quoted in Bartlett in Elsen [39], p. 53.
3. Unlike many of Rodin's sitters, Laurens seems to have thought highly of his bust. In the painting entitled *Portrait* (a full-length standing woman) reproduced in *L'Art Français* of October 18, 1890, Laurens depicted Rodin's bust of him in a niche in the background.
4. Paris, 1900 [349], p. iii.

 "19 avril 1900.
 Que pourrais-je ajouter à ce que j'ai déjà dit devant vous de Rodin?
 Vous connaissez mon admiration pour le grand sculpteur.
 Il est de la race de ceux qui *marchent seuls,* de ceux que sans cesse on attaque, mais que rien ne peut entamer.
 Son cortège de marbres et de bronzes suffira toujours à le défendre.
 Il peut compter dessus.
 Voilà mon sentiment."
5. This has also been pointed out by Mirolli [81], p. 239.

REFERENCES

Bartlett [125], p. 113; Mirbeau [254], repr. p. 80; E. Montrosier, "Jean-Paul Laurens," *Gazette des Beaux-Arts,* Paris, 40ᵉ année, 20 (December 1898), p. 446, repr. opp. p. 446; Maillard [71], pp. 110–11, repr. p. 113; Lawton [67], p. 92, repr. opp. p. 93; Rilke [87], p. 56, repr. pl. 52; Lami [4], p. 166; Bénédite [10a], p. 28, repr. pl. xxv (B); Grappe [338], no. 58; Watkins [342], no. 61; Grappe [338a], no. 75; Grappe [338b], no. 80; Grappe [338c], no. 62; Story [103], pp. 16, 144, no. 25, repr. pl. 25; Grappe [338d], no. 70; Rilke [87a], p. 45; Story [103a], no. 18, repr. pl. 18; Mirolli [81], pp. 239–40; Tancock [341], no. 75.

OTHER CASTS

Location unknown. Formerly in the collection of Jean-Paul Laurens, this was a *cire-perdue* cast by Gonon. *See Gazette des Beaux-Arts,* December 1898, p. 446.

CZECHOSLOVAKIA
Prague, Národní Galerie. Acquired in 1925.

DENMARK
Copenhagen, Ny Carlsberg Glyptotek. Purchased by Carl Jacobsen in 1906. Signed: A. Rodin. Cast in 1905.

FRANCE
Nantes, Musée des Beaux-Arts. Gift of Musée Rodin, 1917.
Paris, Musée Rodin.

GERMANY (EAST)
Dresden, Staatliche Kunstsammlungen. Purchased from Rodin in 1901. Signed: A. Rodin.

HUNGARY
Budapest, Szépmüvészeti Múzeum. Purchased from Rodin in 1901. Signed.

JAPAN
Tokyo, National Museum of Western Art (ex. Collection Matsukata). Signed: A. Rodin.

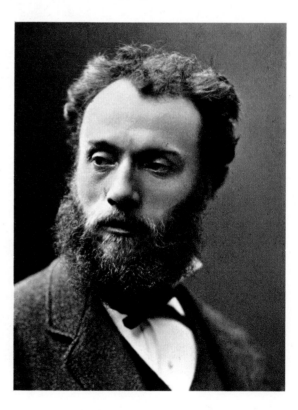

83–1
Jean-Paul Laurens
Photograph

84 Alphonse Legros
1881–82

Bronze, 12¼ × 7¾ × 9 inches
Signed right side of neck and inside in relief: A. Rodin
Foundry mark back of neck, center: Alexis RUDIER/Fondeur PARIS.

Alphonse Legros was born in Dijon on May 8, 1837. After apprenticeship to a house painter, Nicolardot, he enrolled in courses at the Ecole des Beaux-Arts in Dijon for a short time and, when the family moved to Lyons in 1851, entered the studio of Charles-Antoine Cambon, chief decorator at the Opéra. As a student at the Petite Ecole about 1854 and a pupil of Lecoq de Boisbaudran, Legros first met Rodin. Thereafter the ties of friendship were very close. Sir William Rothenstein described Rodin as Legros's "closest friend."[1] Legros was already a remarkable draftsman. Rodin later told M. Clement-Janin that his own drawings at Lecoq's were absolutely impersonal, while those of Legros were already those of a master.[2] Both Rodin and Legros were permanently influenced by the training of the memory they received from Lecoq de Boisbaudran. Legros's *Portrait of His Father* in the Musée des Beaux-Arts in Tours is very close to Holbein's *Portrait of His Father,* which he had formerly learned by heart.[3]

Legros and Rodin were both great admirers of Baudelaire. Legros's painting *The Angelus,* exhibited at the Salon of 1859, was favorably noticed by Baudelaire, and in 1861 Legros dedicated to the poet his series of engravings, *Esquisses à l'eau-forte.* In 1861 he composed a series of illustrations for Edgar Allan Poe's *Tales of Mystery and Imagination,* intended to be published as a series with an introduction by Baudelaire, but the project fell through. At the end of 1860 Whistler invited him to London, where he stayed at the house of the painter's sister, Lady Haden.

Returning to London in 1863, he established himself in Chelsea and made the acquaintance of Dante Gabriel Rossetti and Edward Burne-Jones. Before long his reputation had spread to official circles. A portrait of Léon Gambetta was commissioned by Sir Charles Dilke, and he was visited in his studio by Prince Leopold, son of Queen Victoria. At the end of 1875 Sir E. J. Poynter nominated him Professor of Engraving at the South Kensington School. A year later, with the support of Sir Frederick Leighton and G. F. Watts, he became Director of the Slade School of Art, a post which he retained until 1893. As Director of the Slade, he was a very active teacher, although he never learned to speak English. His remarks were translated by assistants or pupils.

In later years he returned increasingly to the graphic arts, but he did experiment with sculpture. In 1897 he was commissioned to design decorations for the Bank of England on the occasion of the jubilee of Queen Victoria; then, through the agency of Sir William Rothenstein, he received a commission for two monumental fountains for Welbeck Abbey in Nottinghamshire, home of the Duke of Portland. After his death, these were finished by Edouard Lantéri. Legros died at Watford, England, in 1911.

In 1881 Rodin made his first visit to England at the invitation of Legros. This visit was important for a number of reasons. It was through Legros that Rodin met a group of men

who later became his active supporters, furthering his reputation in the Anglo-Saxon world. Among them were William Ernest Henley, Director of the *Magazine of Art;* Robert Louis Stevenson, who defended him in a letter in the London *Times* dated September 6, 1886 *(see* no. 32); John Singer Sargent; Robert Browning; and Gustave Natorp. In addition, Legros's heavy teaching commitments left Rodin, who did not speak English, with a lot of spare time on his hands. It was during one such absence that Rodin experimented with a copperplate already used by Legros and executed his first etching in drypoint, *Cupids Leading the World.* "I understood immediately," he told Judith Cladel.[4] According to Grappe, the first sketch of Rodin's portrait of Legros was made in 1881.[5] However, between November 1881 and May 1882, Rodin used to visit the former businessman Natorp in his studio on the boulevard Montparnasse, and it was in Natorp's studio that Legros sat for his bust.[6] It is thus datable 1881–82, rather than 1881.

It was largely through Rodin that Legros's reputation was rescued from oblivion in France. On Rodin's recommendation, Arsène Alexandre went to visit him, then Albert Besnard, who did a watercolor of Legros at his engraving desk. They were followed by Etienne Moreau-Nélaton and Léonce Bénédite, who organized an exhibition of his work in the Musée du Luxembourg in 1900, at the same time as Rodin's exhibition in the Pavillon d'Alma. Legros was relatively unusual among Rodin's sitters in that his bust gave him great satisfaction. "I wish I were as intelligent as your bust," he is reported to have told Rodin.[7] In return, Legros painted Rodin's portrait and also made an engraving of him.

NOTES

1. William Rothenstein, *Men and Memories,* vol. 1 (New York: Coward-McCann, 1931), p.319.
2. Harold J. Wright, *The Etchings, Drypoints and Lithographs of Alphonse Legros, 1837–1911* (London: Print Collectors' Club, 1934).
3. Reproduced in Horace Lecoq de Boisbaudran, *The Training of the Memory in Art and the Education of the Artist,* trans. L.D. Luard (London: Macmillan, 1911), pls. 5, 6.
4. Cladel [26], p. 148. "J'ai compris tout de suite."
5. In the 1927 and 1929 editions of the catalogue of the Musée Rodin *(see* [338], no. 57 and [338a], no. 74 respectively), Grappe dated the bronze of the Legros bust 1882. In subsequent editions, however, he revised the dating of the bronze to 1881.
6. Lawton [67], p.242. Statement by Gustave Natorp: "In the winter 1881–2, Professor Legros came to Paris on a visit to me, and sat to Rodin for his bust in my studio."
7. Frisch and Shipley [42], p.266.

REFERENCES

Phillips [275], repr. p.143; Bartlett [125], p. 261; Mirbeau [254], repr. p.79; Arsène Alexandre, "Rodin et Legros," *Le Figaro,* Paris, June 1, 1900, p.1; Bénédite [10a], p.29, repr. pl. XXIX (B); Grappe [338], no. 57; Watkins [342], no. 53; Grappe [338a], no. 74; Grappe [338b], no. 79; Grappe [338c], no. 61; Story [103], pp. 16, 144, no. 26, repr. pl. 26; Grappe [338d], no. 69; Grappe [54], p.141, repr. p. 45; Waldmann [109], pp. 55, 78, no. 62, repr. pl. 62; Story [103a], no. 17, repr. pl. 17; Tancock [341], no. 76.

OTHER CASTS

FRANCE
Dijon, Musée de Dijon. Acquired in 1918. Signed. Founder: Alexis Rudier.
Paris, Musée du Petit Palais. Deposited by the state in 1912.
— Musée Rodin. Signed: A. Rodin. Founder: Alexis Rudier.

GREAT BRITAIN
Manchester, City Art Gallery. Inscribed on original, marble pedestal: a mon ami A Legros A Rodin.

PORTUGAL
Lisbon, Calouste Gulbenkian Foundation. Purchased by C. S. Gulbenkian from Rodin in 1910.

UNITED STATES
Cambridge, Fogg Art Museum, Harvard University Grenville L. Winthrop Bequest, 1943.
Elkhart, Ind., Collection Walter R. Beardsley.

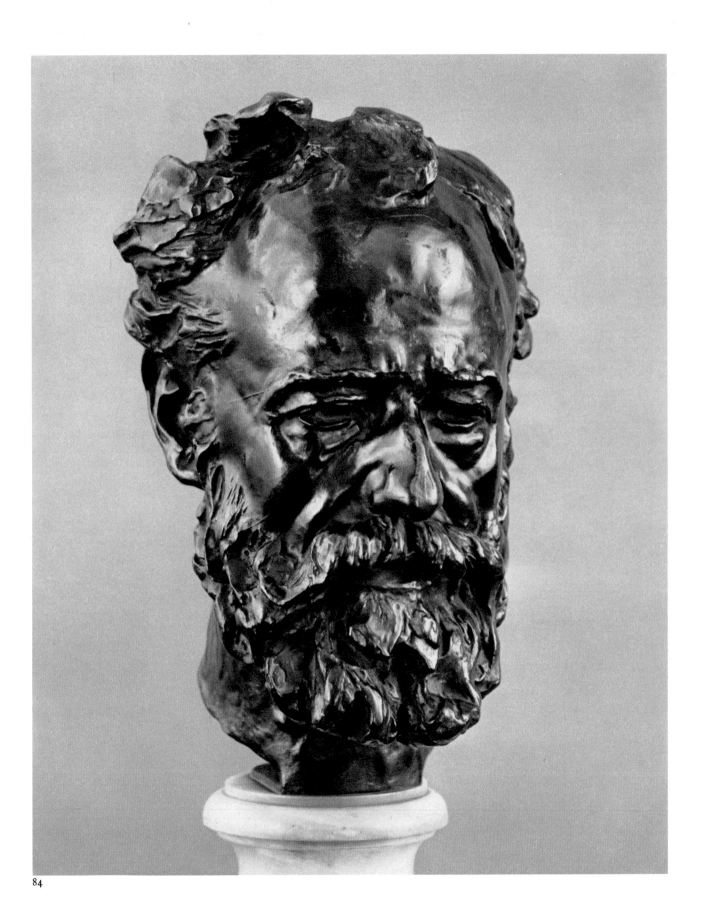

495

85 Albert-Ernest Carrier-Belleuse
1882 (executed 1907)

Biscuit de Sèvres, 14½ × 9½ × 5½ inches
Signed left-hand side, beneath shoulder: A. Rodin
On front of supporting member: CB
On back of supporting member: Sevres DE

s
1907[1]

Albert-Ernest Carrier-Belleuse (fig. 85–1) was born in 1824 at Anisy-le-Château (Aisne). It was through David d'Angers that he gained admission to the Ecole des Beaux-Arts in 1840, but he showed no taste for the reigning academic style, his preferences going to the art of the eighteenth century and to Pierre Prud'hon. Obliged to work for commercial sculptors, he was prevented from following the courses with any regularity. In 1851 he exhibited some medallions at the Salon and in the same year became Director of the Drawing School at the Minton porcelain factory in Stoke-on-Trent, England.

On his return to Paris in 1855, Carrier-Belleuse rapidly became one of the most productive and fashionable sculptors of the Second Empire. He was active in all fields of sculpture, producing everything from models of dolls' heads for the Limoges factory, *bustes de fantaisie* for commercial reproduction (for example, *Diana, Leda, Autumn, Spring, Innocence*), portraits of the most famous people of his time (Napoleon III, Jules Grévy, Jules Simon, Louis Thiers, Honoré Daumier, François Arago, George Sand, Joseph-Ernest Renan, Eugène Delacroix, Théophile Gautier, Camille Corot, Gustave Doré, Alexandre-Gabriel Decamps, and Hendrik Leys), to decorative work on public buildings. In Paris he worked on the Church of St. Augustin, the Palais des Tuileries, the Tribunal de Commerce, the Musée du Louvre, the Hôtel de Païva, the Théâtre de la Renaissance, the Théâtre Français, the Opéra, and the Hôtel de Ville. He also did monumental marble sculpture *(Hebe Sleeping)* and monuments *(Tomb of General San Martino,* Buenos Aires; *Michael the Brave,* Bucharest; *Alexandre Dumas,* Villers-Cotterets; *J.-J. Rousseau,* Montmorency; and *André Masséna,* Nice).

"He is almost a sculpture factory," wrote one critic in 1865. "Each day busts, ornaments, statuettes, candelabras, caryatids come out of his studio; bronze, marble, plaster, alabaster, he works in everything; he models everything; but how much spirit, imagination, verve the machine has! At times one might almost say he was a genius."[2] In December 1875 he became Director of the Manufacture de Sèvres and played an important part in the reorganization of the factory. He concentrated on the sculptural decoration of vases and was also responsible for the revival of sculpture in *biscuit,* which was almost extinct on his arrival. It was his intention to collect drawings in order to form a repertory of ornament comparable to the repertory of architectural forms of Viollet-le-Duc. However, he died in 1887 before this was possible.

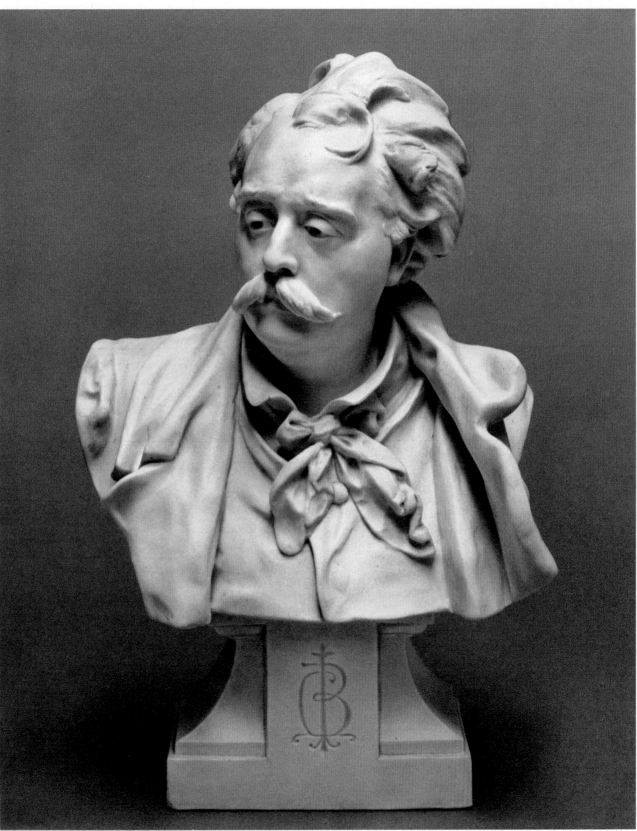

Rodin began to work for Carrier-Belleuse in 1864, an important event in his life. "I was very happy to go to Belleuse, because it took me away from an ornament-maker to one that made figures."[3] Rodin said of Carrier-Belleuse that "he was a man of his day in sculpture. Nothing that I ever did for him interested me."[4] However, he later revised his opinion, saying "Carrier-Belleuse had something of the beautiful blood of the eighteenth century in him; something of Clodion; his sketches were admirable, in execution they became chilled; but the artist had a great true value; *he* didn't use casts from nature!"[5]

Rodin made models for Carrier-Belleuse and worked for him on decorative projects (Salle de Rubens, Musée du Louvre; decorative work in the Church of St. Vincent de Paul; the modeling of parts of the arms and feet of the *Hebe*)[6] until the outbreak of the Franco-Prussian War in 1870. Rodin then followed his employer to Brussels in 1871 and, despite a disagreement that arose between them when Carrier saw models in a shop window made by Rodin on his own behalf, worked for him again from 1879 to 1882 as part of the "personnel extraordinaire non-permanent de la manufacture de Sèvres."

The fashionable and sometimes superficial sculptor thus played a role of considerable importance in Rodin's life. Although never strictly a pupil of the older artist, Rodin nevertheless signed himself "Pupil of Barye and Carrier-Belleuse" at the first Salons in which he exhibited.[7] Not only was Rodin relieved of more menial tasks when he started working for Carrier-Belleuse but he saw how a large and important *atelier* was organized. In order to produce the quantity of works that came out of the studio, it was necessary to employ a large number of assistants, each of them a specialist in one part of the sculptural process. Thus Rodin did not think, as had Barye, that the artist himself should be responsible for the execution of the work from beginning to end. During the years he worked for Carrier-Belleuse much of Rodin's own work was also in a decorative, feminine, eighteenth-century mode,[8] and this style did not cease with the end of his final period of association with Carrier in 1882 (*see The Minotaur, no. 41*).

One negative influence of this association was that Rodin concentrated almost exclusively on the modeling of the nude when he started working for himself. Gustave Coquiot asked Rodin why he had modeled only one religious group, *Christ and the Magdalen (see* fig. 19-5). Rodin replied that religious sculpture had tempted him, but that it could not be done without a lot of draperies, and he had done so much of that with Carrier that the nude imposed itself immediately on him.[9]

Rodin's bust of Carrier-Belleuse was made in 1882 and exhibited in terra-cotta at the Salon of that year (fig. 85–2). In reduced size the bust was then edited in an unlimited edition in *biscuit de Sèvres* by the Manufacture Nationale. The *biscuit* bust differs from the bronze in the treatment of the loosely knotted cravat around the neck, which is much more prominent than in the bronze, and in the addition of the pedestal on which the initials C. B. are engraved. The Philadelphia version was executed in 1907, the work being undertaken by Edouard Du Fossé, who worked at the Manufacture from 1901 until 1922.[10]

NOTES

1. Purchased from F. and J. Tempelaere, Paris.
2. Edouard Lockroy, "Le Monde des arts," *L'Artiste,* January 15, 1865, p. 40. "M. Carrier-Belleuse sait donner plus de vie, de mouvement, de grâce, de

dignité à ce qu'il compose; les vingt-quatre figures du Palais de Justice sont pleines de brillantes qualités. C'est presque une machine à sculpter ce M. Carrier-Belleuse. Chaque jour sortent de son atelier des bustes, des ornements, des statues,

85-1 Albert-Ernest Carrier-Belleuse
Photograph

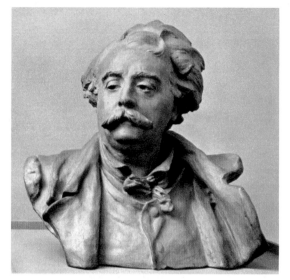

85-2 *Albert-Ernest Carrier-Belleuse*
1882, terra-cotta, height 18½ inches
Stanford University Art Gallery and
Museum, Stanford, Calif.
Gift of B.G. Cantor Art Foundation

des statuettes, des candélabres, des cariatides: bronze, marbre, plâtre, albâtre; il taille tout, il façonne tout, il creuse tout; mais que cette machine a d'esprit, d'imagination, de verve! Parfois on lui croirait du génie."

3. Bartlett in Elsen [39], p. 25.
4. Ibid., p. 26.
5. Dujardin-Beaumetz in Elsen [39], pp. 177-78.
6. Lawton [67], p. 30.
7. This formula was finally abandoned in 1885.
8. Even before his association with Carrier-Belleuse, Rodin had shown a pronounced enthusiasm for the art of the eighteenth century. It was because of the eighteenth-century character of his style, which his training at the Petite Ecole had encouraged, that he was refused entry to the Ecole des Beaux-Arts in 1857.
9. Coquiot [30], pp. 35-36. For the revelant quote, *see* no. 19, n. 7.
10. My thanks are due to Mlle M. Brunet, Bibliothécaire-archiviste at the Manufacture de Sèvres, for conveying this information.

REFERENCES

Bartlett [125], p. 113; Lawton [67], p. 92; Marx [75], p. 47; Watkins [342], no. 83; Grappe [338a], nos. 76, 77; Grappe [338b], nos. 99, 100; Grappe [338c], nos. 76, 77 bis; Grappe [338d], nos. 86, 87; Grappe [54], p. 141, repr. p. 52 (bronze); Elsen [38], repr. p. 208 (bronze); Tancock [341], no. 77; Tancock [315], p. 47, repr. p. 47.

OTHER CASTS AND VERSIONS

Biscuit de Sèvres

FRANCE
Paris, Musée Rodin. Purchased in 1927 from the Manufacture de Sèvres.

UNITED STATES
Indianapolis, Indianapolis Museum of Art.

Terra-cotta, height 18½ inches

UNITED STATES
Stanford, Stanford University Art Gallery and Museum. Gift of B.G. Cantor Art Foundation (ex. Collection Mme A.M. Morin, granddaughter of Carrier-Belleuse) (fig. 85-2).

Plaster

FRANCE
Paris, Musée du Petit Palais. Carrier-Belleuse Donation, 1905.

Bronze, height 23¼ inches

FRANCE
Paris, Musée Rodin. Founder: Montagutelli.

86 Jules Dalou
1883

Bronze, 20¾ × 16 × 7 inches
Signed front of figure's left shoulder and on stamp inside: A. Rodin
Foundry mark rear of right shoulder:
ALEXIS RUDIER/Fondeur. PARIS.

Aimé-Jules Dalou (fig. 86–1) was born of working-class parents in Paris in 1838. In 1851 his sister showed examples of his modeled work to Carpeaux, then an assistant master in the sculpture and modeling class at the Petite Ecole. Dalou subsequently studied there from 1852 to 1854, just preceding Rodin. He then enrolled at the Ecole des Beaux-Arts, although he spent very little time there, preferring to study the seventeenth- and eighteenth-century sculpture at Versailles.

Although Dalou exhibited *Roman Woman Playing with Knucklebones* at the Salon of 1861, real success came in 1870 when *The Embroiderer* was shown at the Salon. This work was bought by the state and commissioned in marble. During the war of 1870–71 he supported the Commune and became a member of Courbet's Commission de Surveillance des Musées Nationaux, but he soon had to flee the country for London, where he was assisted by Alphonse Legros *(see* no. 84). Taken up by the aristocracy, he exhibited at the Royal Academy and in 1877 became second teacher in the modeling class at the National Art Training School, now the Royal College of Art.

In 1879 the amnesty enabled Dalou to return to France, where he entered the competition organized by the city of Paris for a monument to the triumph of the Republic. His group was finally inaugurated in November 1899 at the place de la Nation. A strong believer in the theories of Prud'hon, Dalou devoted his last years to the development of a monument to Labor, for which over a hundred sketches survive. He died in 1902.

"My first friend," Rodin said, "was Dalou—a great artist who was in the tradition of the masters of the eighteenth century. He was a born decorator. We got to know each other while very young at a decorator's, who often forgot to pay us, with the result that Dalou and I were obliged to separate, he going to a taxidermist and I to another employer, more reliable than the first. Later I saw Dalou after the amnesty [1879]; yes, politics had taken him a long way; but he knew how to profit from it and immediately got an important position at the Hôtel de Ville. Dalou was a fine speaker! Ah! on that score he was easily the winner. He spoke with an extraordinary eloquence, which certainly was not without its use in getting councillors to understand something of artistic questions. He dreamed of being the great Minister of Fine Arts; but he died before being able to realize this fine dream."[1]

Rodin's bust of Dalou was completed in 1883, and it is certainly one of his finest. Rodin has captured Dalou's combative spirit in an altogether remarkable way. But the

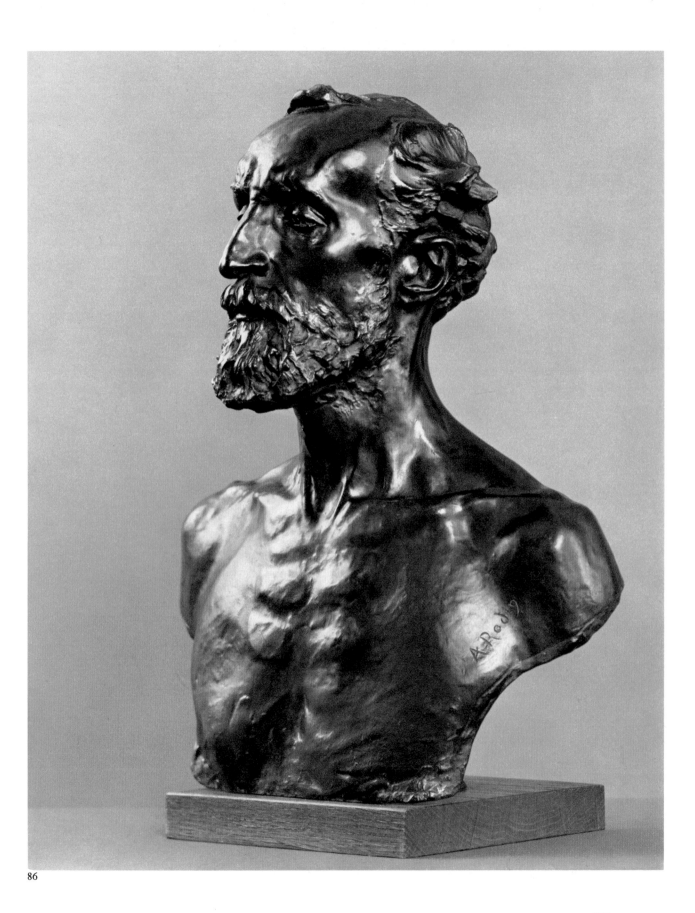

friendship which grew between them when they were both employed by the decorator was soon marred by a series of misunderstandings. Dalou was very enthusiastic about Rodin's bust of Victor Hugo *(see* no. 87), whereupon Rodin introduced him to the aged poet. Hugo, who had just finished sitting for Rodin, agreed to sit for Dalou, but he fell gravely ill immediately afterward. As there was no hope of Hugo's recovery, the poet's family, who had not liked Rodin's bust, asked Dalou to do a posthumous portrait *(see* fig. 87-7). He did this without informing Rodin, much to the latter's annoyance.[2]

In 1886 Dalou submitted an extremely complicated project for the monument to Victor Hugo to be erected in the Panthéon. Inspired by the sight of a catafalque beneath the Arc de Triomphe, he represented Victor Hugo on a bier, covered with drapery and flowers and framed by a triumphal arch which enclosed a bas-relief representing scenes from Hugo's major works. This project was never realized, however, and the commission finally went to Rodin in 1889 *(see* no. 71). The final rupture between the two men was due to Dalou's displacing of Camille Claudel's bust of Rodin at an exhibition.[3] Léon Cladel's attempt to reconcile the two former friends was not successful,[4] although according to Grappe, friendly relations were eventually reestablished.[5]

From being one of Rodin's greatest admirers, Dalou became a bitter critic. "He's put the Muse's buttocks right under the poet's nose!"[6] he said of one of the projects for the monument to Victor Hugo. He joined the ranks of Rodin's opponents during the *Balzac* affair, saying, "The pleasant memory of the friendly ties that once bound Rodin and myself, forbids me to have any part in this new blunder into which maladroit friends are tumbling him."[7]

But Dalou's admiration for Rodin seems always to have been tempered with a touch of envy. "Rodin," he said, "had the luck not to have been at the Ecole des Beaux-Arts!"[8] The widening gulf between the two artists was as much artistic as personal, the underlying classicism of Dalou's temperament accounting for his resolute opposition to the Balzac monument.

NOTES

1. Coquiot [31], pp. 109–10. "Mon premier ami, me dit-il, ce fut Dalou. Un grand artiste qui avait la belle tradition des maîtres du XVIIIe. Il était né décorateur. Nous nous connûmes très jeunes chez un ornemaniste, qui oubliait souvent de nous payer, de sorte que nous fûmes obligés de nous séparer, Dalou et moi; lui, pour entrer chez un empailleur-naturaliste, et moi chez un autre patron, plus ponctuel que le premier. Plus tard, je revis Dalou, après l'amnistie; oui, la Politique l'avait entraîné loin; mais il sut en profiter et prendre tout de suite une place prépondérante à l'Hôtel de Ville. C'était un beau parleur que Dalou! Ah! là-dessus, il me rendait aisément des points. Il parlait avec une éloquence entraînante, et qui, certes, n'était pas inutile pour amener les conseillers à comprendre quelques bribes des questions artistiques. Il rêvait d'être le grand surintendant des Beaux-Arts; il est mort avant d'avoir pu réaliser ce beau rêve."

2. *See* Maurice Dreyfous, *Dalou: Sa vie et son œuvre* (Paris: Librairie Renouard, 1903), pp. 213–14.

3. Lawton [67], p. 88.

4. Cladel [26], p. 37.

5. Grappe [338d], no. 92. "Quand Dalou rentra à Paris, les deux artistes se virent de plus en plus fréquemment; mais il semble que tardivement des ombres fâcheuses s'étendirent sur leurs relations; on les réconcilia enfin. Les deux artistes, en fait, n'avaient jamais cessé de correspondre, de se fréquenter, et de s'obliger mutuellement." Grappe's account of their relationship does not correspond with any of the other sources, although there may be documentary evidence in the form of letters in the Musée Rodin that supports his case.

6. Frisch and Shipley [42], p. 237.

7. Ibid.

8. Cladel [25a], p. 36.

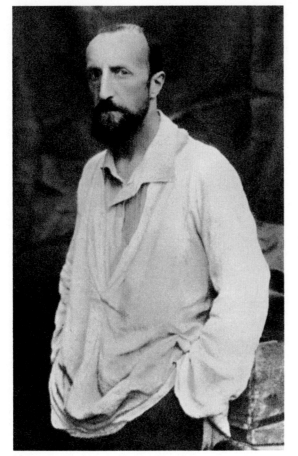

86-1
Jules Dalou, c. 1880
Photograph

REFERENCES

Phillips [275], repr. p. 142; Mirbeau [254], p. 77, repr.
p. 78; Geffroy [199a], p. 17; Maillard [71], p. 110;
Lawton [67], pp. 88–89, repr. opp. p. 89; Ciolkowska
[23], p. 41, repr. opp. p. 108; Bénédite [10a], p. 27, repr.
pl. XXI; Grappe [338], no. 66; Watkins [342], no. 63;
Grappe [338a], nos. 83 bis, 84; Grappe [338b], nos. 104,
105; Cladel [26], pp. 36–37; Grappe [338c], nos. 81,
81 bis; Frisch and Shipley [42], p. 264; Story [103],
pp. 16, 145, no. 35, repr. pl. 35; Grappe [338d], nos. 92,
93; Waldmann [109], pp. 57, 78, no. 64, repr. pl. 64;
Story [103a], no. 25, repr. pl. 25; Elizabeth H. Payne,
"Jules Dalou, Friend of Rodin," *Detroit Institute
Bulletin*, Detroit, 41, no. 3 (Spring 1962), pp. 46–47;
Elsen [38], p. 122, repr. p. 120; Descharnes and
Chabrun [32], p. 121; Tancock [341], no. 78.

OTHER CASTS AND VERSIONS

Bronze

CZECHOSLOVAKIA
Prague, Národní Galerie. Acquired in 1925.

DENMARK
Copenhagen, Ny Carlsberg Glyptotek. Gift of Ny
Carlsbergfondet, 1909. Signed: A. Rodin. Cast in
1909.

FRANCE
Nantes, Musée des Beaux-Arts. Gift of the Musée
Rodin, 1917.
Paris, Musée Rodin. Founder: Alexis Rudier.
— Université de Paris, Bibliothèque Jacques Doucet.

GERMANY (WEST)
Bremen, Kunsthalle. Gift of the Vereinigung von
Freunden der Kunsthalle, 1909. Signed: A. Rodin.
Hamburg, Hamburger Kunsthalle. On permanent
loan from the Museum für Kunst und Gewerbe.

ITALY
Rome, Galleria Nazionale d'Arte Moderna.

SWITZERLAND
Zurich, Collection Werner and Nelly Bär. Signed:
A. Rodin. Founder: Alexis Rudier.

UNITED STATES
Boston, Museum of Fine Arts. Acquired in 1912.
Signed: A. Rodin.
Detroit, Detroit Institute of Arts (ex. Collection
Johanny Peytel). Signed: A. Rodin. Founder:
Alexis Rudier.
New York City, Metropolitan Museum of Art. Gift
of Thomas F. Ryan, 1910. Founder: Alexis Rudier.
Cast in 1910.
Stanford, Stanford University Art Gallery and
Museum. Gift of B. G. Cantor Art Foundation.
Founder: Georges Rudier. Cast no. 9/12.

Plaster

FRANCE
Avignon, Musée Calvet. Gift of the Musée Rodin,
1926.
Bagnols-sur-Cèze (Gard), Musée de Bagnols-sur-
Cèze. Gift of Léonce Bénédite.
Nice, Musée des Beaux-Arts (Jules Chéret). Gift of
Georges Grappe.
Paris, Musée Rodin. Gift of Mme Pierre Roche, 1929.
Given to Pierre Roche by Rodin.

87 Victor Hugo

a 1883

Plaster, 22¼ × 10 × 11½ inches
Inscribed right side of supporting member:
A. MONSIEUR FANTIN-LATOUR/
Hommage d'admiration et de/
sympathie. Rodin[1]

b 1883

Bronze, 17 × 10¼ × 10¾ inches
Signed on base to right: A. Rodin
Foundry mark behind right shoulder:
Alexis RUDIER/Fondeur.
PARIS.

In 1883 Edmond Bazire, one of the editors of the newspaper *L'Intransigeant,* who had organized the celebrations in honor of Victor Hugo's eightieth birthday, introduced Rodin to the great poet. Bazire was eager for Rodin to make a bust of Hugo, but Hugo himself (fig. 87–1), who believed that David d'Angers's bust of him could not be bettered and who had, moreover, just given over thirty sittings to a mediocre sculptor by the name of Vilain, was completely opposed to the idea.[2] It must have taken a considerable amount of persuading to get him to change his mind, as sometime in 1883 Rodin wrote to Hugo: "Dear and Illustrious Master,—I apologise for my insisting, but the ambition to be the one who shall have made the Victor Hugo bust of my generation is so natural that you will not reproach me. Moreover, my desire, as I have already told you, is to be ready for Mademoiselle Jeanne's birthday. By beginning now, I shall manage it. Allow me, therefore, to count on a moment you will grant me from time to time. I shall not abuse your kindness or cause you any fatigue, and the bust will get finished without your perceiving it."[3]

Finally, in order to express his gratitude to Bazire, Hugo agreed to permit Rodin to model his bust, on the condition that he did not have to pose. Rodin gave several accounts of his first impressions upon meeting the poet: "The first time I saw Victor Hugo, he made a profound impression on me; his eye was magnificent; he seemed terrible to me; he was probably under the influence of anger or a quarrel, for his natural expression was much more that of a good man.

"I thought I had seen a French Jupiter; when I knew him better he seemed more like Hercules than Jupiter."[4] To Bartlett, Rodin said that Hugo "always had twelve or fourteen guests at his table, and being somewhat deaf he heard little of the conversation, but often in the very midst of it he would break out with some astonishing observation. It was not until two or three years after his death that I really saw the man, the amplitude of his character, and felt the force of his private work and impersonal nature."[5]

In order not to disturb Hugo, Rodin installed his modeling equipment on the balcony: "I would study the great poet attentively, and endeavor to impress his image on my memory; then suddenly with a run I would reach the veranda to fix in clay the memory of what I had just seen. But often, on the way, my impression had weakened, so that when I arrived before my stand I dared not touch the clay, and I had to resolve to return to my model again."[6] Rodin later told Dujardin-Beaumetz that Lecoq de Boisbaudran's emphasis on the training of the memory had been especially useful to him when working on this bust: "You know that I hold as a principle the comparison of all the contours of a work with those

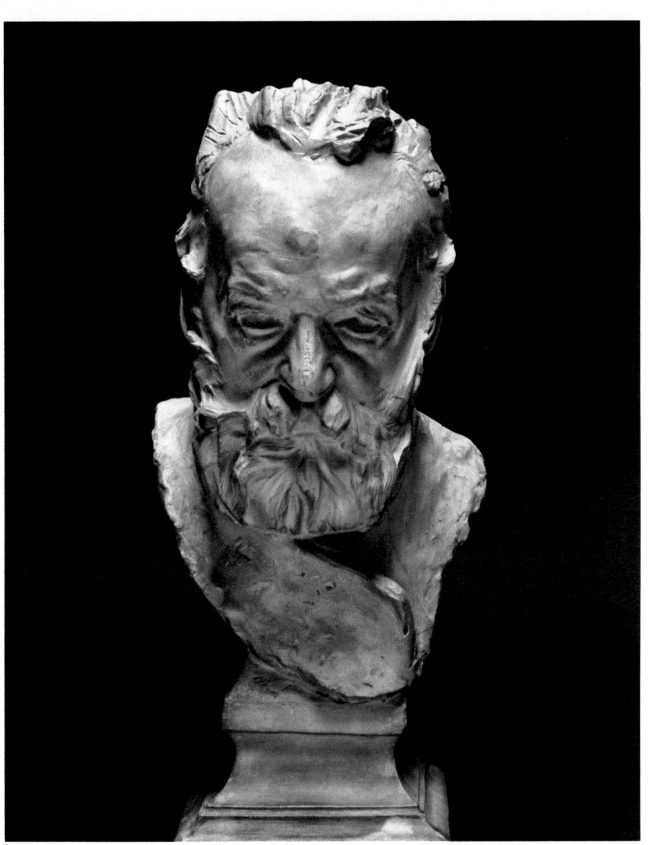

of nature. Being unable to follow my habitual procedure, I placed myself beside or behind him, following him with my eye, making quick sketches of him, drawing as many profiles as I could on little squares of paper; he didn't look at me, but had the goodness not to dismiss me; he tolerated me. I made many drawings of the skull; I then compared those contours with those of the bust; thus I managed to execute it, but with such difficulties. I extricated myself from them as best I could."[7]

Using a cigarette paper book, Rodin made some eighty drawings, which range from extremely rudimentary studies of the basic structure of the head (fig. 87-3) to more developed portraits.[8] These were used in two drypoints (see fig. 87-2) and the engraving Rodin made of Victor Hugo in 1884. The bust was finished six months before Hugo's death and was exhibited at the Salon of 1884, but it proved to be displeasing to the poet's family. "You would think you were looking at the portrait of an old sculptor," they said.[9] It was so little appreciated by the family, in fact, that Jules Dalou was invited to make the death mask (fig. 87-7), and it was his failure to inform Rodin of this that led to the rupture of their friendship.[10]

In the first bronze cast [11] the head is supported by a solid base, while in what is probably a later edition[12] a small pedestal has been added, thereby making the bust slightly taller. At a later date a reduced version (height 7 inches) of this head was made for sale to Hugo's admirers. A second, heroic bust of Hugo (fig. 87-4) dates from 1897 and is taken from the over life-size standing figure of Hugo executed for the second monument (see no. 71). Although the features are based on the bust of 1883, the later work is a much more impressive interpretation of the poet's character. The head is bent forward as if in deep concentration, and the tight surface of the earlier bust has been replaced by a rugged, sketchy handling which recalls that Rodin was working concurrently on the Balzac (see no. 75).

There are also various marble versions of the busts of Victor Hugo. In 1888 the Petit Palais acquired a marble version of the first bust, which had been commissioned by the city of Paris.[13] A marble was also carved after the variant of this first bust (fig. 87-5), as well as after the heroic bust of 1897. Finally, a marble in which the head emerges from an uncut matrix (fig. 87-6) was carved about 1910 and belongs to the group that includes the Puvis de Chavannes[14] and the Mozart (fig. 99-2).

The Philadelphia bronze and plaster belong to the later edition of the first bust, although in the bronze the pedestal, cast in one piece in the plaster, has been omitted. The plaster is dedicated to Henri Fantin-Latour, who, like Rodin, was a pupil of Lecoq de Boisbaudran at the Petit Ecole. Fantin had seen this plaster about 1890 at a dealer's on the rue Guénégaud and had greatly admired it. Shortly afterward, and greatly to his surprise, Rodin sent the plaster to him as a gift.[15]

NOTES

1. Purchased from F. and J. Tempelaere, Paris.
2. See Marcel Adam, "Victor Hugo et Auguste Rodin," Le Figaro, Supplément, Paris, December 28, 1907.
3. Letter quoted in Lawton [67], p. 83.
4. Dujardin-Beaumetz in Elsen [39], p. 169.
5. Bartlett in Elsen [39], p. 56. In their conversations the poet and the sculptor often seem to have turned to the subject of the Gothic. See Auguste Rodin, "The Gothic in the Cathedrals and Churches of France," North American Review, New York, 180 (1905), p. 219.
"One of the first among foreigners to understand the ancient cathedrals and churches of France

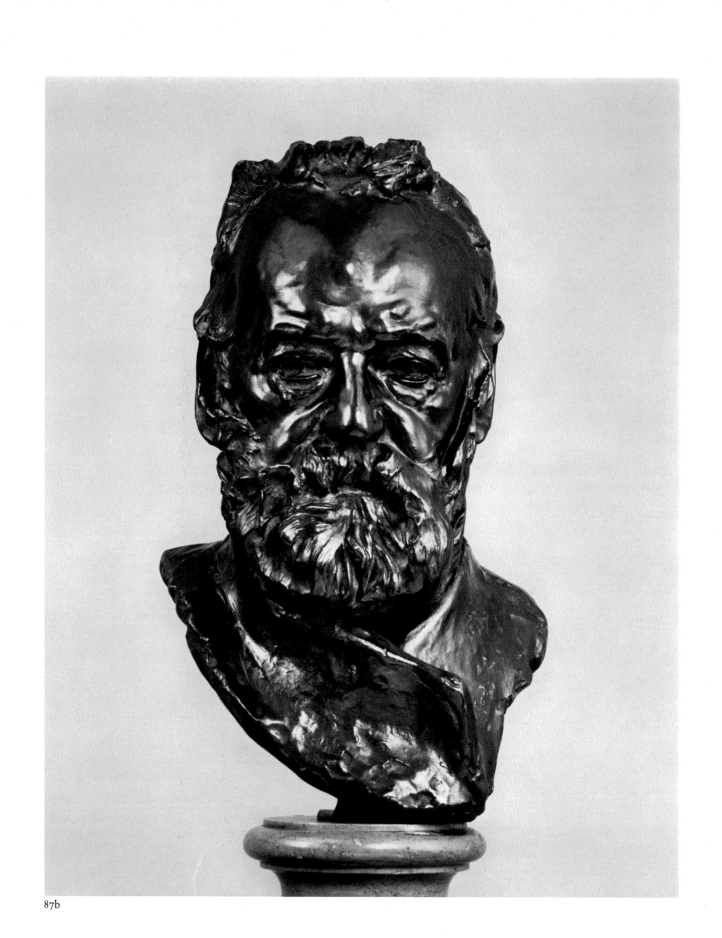

87–1

87–3

87–2

87–1 Victor Hugo, c. 1883
Photograph

87–2 *Victor Hugo* (three-quarter view)
1884, drypoint, 8¾ × 6^{15}/₁₆ inches

87–3 *Victor Hugo*
1883, pencil, pen, ink, and gouache
Location unknown

87–4 *Heroic Bust of Victor Hugo*
1897, bronze, height 27⅝ inches
Kunstmuseum Basel, Basel

87–5 *Victor Hugo*
1883, marble, height 21¾ inches
Fogg Art Museum, Harvard University,
Cambridge, Mass. Grenville L. Winthrop
Bequest, 1943

87–6 *Victor Hugo* (unfinished)
1910, marble, height 26⅜ inches
Musée Rodin, Paris

87–7 Jules Dalou
Death Mask of Victor Hugo
1885, terra-cotta, height 15 inches
Maison de Victor Hugo, Paris

508

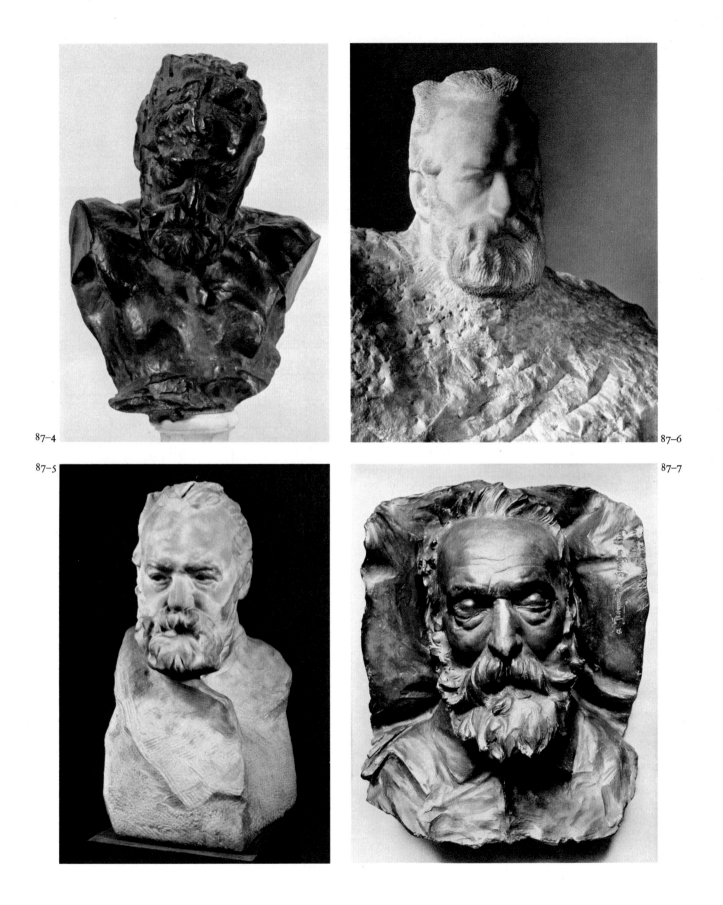

87–4

87–6

87–7

was Ruskin, as was Victor Hugo among his fellow-countrymen. Hugo had made no special study of the subject; but he understood through his great genius: he understood as a poet; for cathedrals are vast poems.

"...Victor Hugo related to me that, when the Rue de Rivoli was being cut, that part of it which is beyond the arcades, between the Louvre and the Rue Saint-Antoine, had been originally designed to have another course, commencing opposite the colonnade of the Louvre and running from there in a straight line as far as the Place du Trône. Had this plan been carried out, the Tour Saint-Jacques, a fine specimen of Gothic sculpture, would have been demolished. Victor Hugo protested with such good effect that the original plan was modified, and the Tower was preserved."

6. Gsell [57c], p. 148. It is generally believed that Hugo gave Rodin no formal sittings for his bust. However, according to Marcel Adam, *see* n. 2 above, Rodin came to an understanding with Hugo's nurse, who had great influence over him. She persuaded Hugo to pose for Rodin, although only on one occasion.

7. Dujardin-Beaumetz in Elsen [39], p. 170.

8. Mauclair [77], p. 17, stated that Rodin had used cigarette papers for his drawings of Hugo. Unfortunately it seems that many of the drawings had already disappeared by 1889 when Bartlett wrote his articles in the *American Architect and Building News* [15]. Through the agency of M. Sagot, a Parisian dealer in art and rare books, a cast of the bust and the eighty preliminary drawings entered the collection of an iron merchant from Besançon, who was very interested in Hugo. The iron dealer was forced to sell the bust at a sale in Lyons sometime before 1889. It was bought by M. Sagot for a nominal sum, but he was unable to discover the fate of the drawings (*see* Bartlett in Elsen [39], p. 56). However, a number of these drawings were published in Maillard [71], pp. 87, 97, 99–102, and photographs of others survive in the Cabinet des Estampes, Bibliothèque Nationale, Paris. Marcel Adam, n. 2 above, states that several of these drawings had been found at a *bouquiniste's* by M. Georges Hugo.

9. *See* n. 2 above. "On croirait voir le portrait d'un vieux ciseleur."

10. Dalou's *Death Mask of Victor Hugo* is signed: A Jeanne et Georges Hugo. J. Dalou, mai, 1885.

11. This cast, with the dedication "A L'ILLUSTRE MAITRE" inscribed on the front, is now in the Musée Rodin. It was presented to the museum in 1928.

12. Spear [332], p. 7, makes this suggestion, which is very plausible.

13. Bartlett in Elsen [39], p. 56.

14. Grappe [338d], no. 413.

15. Information contained in a letter from Mme V. Fantin-Latour to M. Tempelaere, January 31, 1926 (in the Philadelphia Museum of Art files).

REFERENCES

W. E. H[enley], "Two Busts of Victor Hugo," *Magazine of Art,* London and New York, 7 (1884), pp. 127–32; Bartlett [125], p. 114; Mirbeau [254], pp. 76–77; Dujardin-Beaumetz [35], pp. 108–9; Geffroy [199a], p. 17; Maillard [71], p. 109, repr. p. 108; Mauclair [77a], pp. 18–19; Marcel Adam, "Victor Hugo et Auguste Rodin," *Le Figaro,* Supplément, Paris, December 28, 1907; Lawton [67], pp. 82–85; Ciolkowska [23], pp. 40–41; Bénédite [10a], p. 30, repr. pl. XXXV (B); Grappe [338], nos. 63, 245; Watkins [342], nos. 65, 85; Grappe [338a], nos. 80, 81, 279; Grappe [338b], nos. 107, 315, 430; Grappe [338c], nos. 83, 144, 252, 356; Frisch and Shipley [42], pp. 173–74; Grappe [338d], nos. 95, 162, 287, 418; Grappe [54], p. 141, repr. p. 54; Descharnes and Chabrun [32], p. 176, repr. p. 177; Spear [332], pp. 5, 7–8, repr. pls. 6–10, no. III; Tancock [341], no. 79.

OTHER CASTS AND VERSIONS

Plaster

DENMARK
Copenhagen, Ny Carlsberg Glyptotek. Gift of Carl Jacobsen, 1903 (height 18⅞ inches).

FRANCE
Avignon, Musée Calvet. Gift of the Musée Rodin, 1926 (height 24 inches).
Cambrai, Musée de Cambrai. Gift of Rodin, 1885 (height 24 inches).
Meudon, Musée Rodin. Cast from the marble in Moscow.
Paris, Maison de Victor Hugo (2 casts). One painted green and signed: A. Rodin.

Bronze

DENMARK
Copenhagen, Ny Carlsberg Glyptotek. Purchased in
1901 by Carl Jacobsen. Signed: A.Rodin. Cast
in 1901.

FRANCE
Auteuil, Jardin des Poètes.
Paris, Musée Rodin. This cast was offered to Hugo by
Rodin and was presented to the museum in 1928.
Signed and dated: A.Rodin/1883. Inscribed: a
l'illustre maitre. No foundry mark.

JAPAN
Tokyo, National Museum of Western Art. On loan
to the museum in 1960. Purchased in 1966.
Signed: A.Rodin.

SWEDEN
Stockholm, Nationalmuseum. Acquired in 1903
through Carl Milles. Signed: A.Rodin.
— Prins Eugens Waldemarsudde. Gift of the French
state to Prins Eugen.

UNION OF SOUTH AFRICA
Durban, Durban Museum and Art Gallery.

UNITED STATES
Cleveland, Cleveland Museum of Art. On loan from
the estate of Constance Mather Bishop.
New York City, Metropolitan Museum of Art.
Acquired in 1966.
St.Louis, City Art Museum. Signed: A.Rodin.
Founder: Bingen.
San Francisco, California Palace of the Legion of
Honor. Spreckels Collection. No foundry mark.
Stanford, Stanford University Art Gallery and
Museum. Founder: J.Petermann.

Terra-cotta (with plaster base), height 15⅞ inches

SWEDEN
Göteborg, Göteborgs Konstmuseum. Gift of Friends
of the Museum, 1946. Signed: Rodin. Inscribed: 1.

Bronze, height about 22 inches (including base)

ALGERIA
Oran, Musée Municipal. Acquired in 1929.

FRANCE
Lyons, Musée des Beaux-Arts. Acquired in 1927.

UNITED STATES
Berea, Ohio, Baldwin-Wallace College. Founder:
Alexis Rudier.

Cleveland, Cleveland Museum of Art (ex. Collection
James Parmelee, Washington). Signed: A.Rodin.
Purchased in 1916.

Bronze, height 11½ inches

FRANCE
Besançon, Musée des Beaux-Arts et d'Archéologie.
Given in 1934. Signed: Rodin. Founder: Griffoul
et Lorge.

Bronze, height 7¾ inches

UNITED STATES
Beverly Hills and New York City, B.G.Cantor Col-
lections. Founder: Alexis Rudier.

Plaster

UNITED STATES
Stanford, Collection Mr. and Mrs. Albert Elsen.

Terra-cotta mask, height 15⅜ inches

FRANCE
Nice, Bibliothèque Municipale.

Bronze mask, height 12½ inches

GREAT BRITAIN
Cardiff, National Museum of Wales. Acquired in
1934.

Marble

FRANCE
Paris, Musée du Petit Palais (ex. Hôtel de Ville).
Purchased in 1888 by the city of Paris (height
22¼ inches).
— Musée Rodin (ex. Musée du Luxembourg).
— Musée Rodin. Left unfinished in 1910 (height
26⅜ inches) (fig. 87–6).

PORTUGAL
Lisbon, Calouste Gulbenkian Foundation (ex. Col-
lection James Horsfall).

UNITED STATES
Cambridge, Fogg Art Museum, Harvard University.
Grenville L.Winthrop Bequest, 1943 (ex. Col-
lection Henri Rochefort) (height 21¾ inches)
(fig. 87–5).

U.S.S.R.
Moscow, State Pushkin Museum of Fine Arts
(height 21⅝ inches).

OTHER PORTRAITS OF
VICTOR HUGO

Heroic Bust of Victor Hugo

Bronze, height 27⅝ inches

FRANCE

Nantes, Musée des Beaux-Arts. Gift of the Musée
 Rodin, 1923.
Paris, Maison de Victor Hugo.
— Musée Rodin. Signed: A. Rodin. No foundry
 mark.

GREAT BRITAIN

Manchester, City Art Gallery. Gift of Rodin, 1911.
 Signed: A.Rodin. Founder: Alexis Rudier.
Montgomery, University of Wales, Gregynog Hall.
 Bought by Margaret S. Davies before 1918.
 Signed: A.Rodin.

SWITZERLAND

Basel, Kunstmuseum Basel. Acquired in 1906 (fig.
 87–4).
Lausanne, Collection Samuel Josefowitz. Founder:
 Alexis Rudier.

UNITED STATES

Beverly Hills and New York City, B.G.Cantor Col-
 lections. Founder: Georges Rudier. Cast no.6/12.
Los Angeles, Los Angeles County Museum of Art.
 Gift of B. G. Cantor Art Foundation. Founder:
 Georges Rudier. Cast no.5/12.

Marble, height 41½ inches

UNITED STATES

San Francisco, California Palace of the Legion of
 Honor. Spreckels Collection.

Plaster, height 29⅛ inches

GERMANY (EAST)

Dresden, Staatliche Kunstsammlungen.

88 Henri Becque

1883 (reduced 1907?)

Bronze, $6 \times 3\frac{1}{4} \times 2\frac{5}{8}$ inches
Signed right side of supporting member: A. Rodin
Foundry mark back of supporting member, lower left:
ALEXIS RUDIER/Fondeur. Paris

Henri Becque (fig. 88–2), the playwright, was born in Paris in 1837. His first work to be performed was *Michel Pauper* in June 1870, but he did not reappear in the theater again until 1879 with *La Navette,* a one-act play. His best-known plays were written and performed in the early 1880s: *Les Honnêtes Femmes* of 1880; *Les Corbeaux,* a play in four acts (Théâtre Français, 1882); and *La Parisienne,* a play in three acts, of 1885. He received the Legion of Honor in 1887 and died in 1899.

As a dramatist, Becque abandoned the complicated plots and artificiality of Scribe and Labiche for a much more naturalistic study of the world. "He rid the dramatic formulas of all the complications which had been added since the time of Molière. In this way he rejoined the most illustrious representative of the Comédie-Française and led the theater back to the healthy traditions of classicism. He willingly named Molière his master, and he boasted of having imitated the immortal author of *L'Avare.*"[1]

Rodin and Henri Becque were close friends and used to meet at Le Bon Cosaque Club, which numbered among its members Guy de Maupassant, Bourget, Mallarmé, and Richepin. Apart from the personal sympathy existing between them—signed copies of *Les Corbeaux* and *Les Honnêtes Femmes* exist in the library of the Musée Rodin[2]—Rodin must have approved of Becque's literary aims. "He was a rough man," Rodin said, "incisive and proud of his poverty. He wore it like a plume. He was full of bitterness, no doubt, but he reserved his gall for the mediocre people and things of his period. Nobody admired with more enthusiasm what was admirable! When I engraved his portrait, I took great pleasure in trying to convey that resolute, stubborn expression, deeply imbued with a passionate candor."[3]

Becque first sat for Rodin in 1883, at which time and probably from the bust, Rodin made a drypoint showing Becque from three different angles, two profiles and a three-quarter view (fig. 88–1). In the 1927 edition of the catalogue of the Musée Rodin,[4] Grappe assigns a date of 1886 to the plaster (height $25\frac{5}{8}$ inches), as he does in the 1929 edition.[5] He gives the same date for the terra-cotta (height $11\frac{1}{4}$ inches).[6] However, in the 1931 edition[7] and in subsequent editions he dates the terra-cotta 1883 and the plaster 1907. He moves the date of the terra-cotta back three years on the grounds that in none of the portraits did the engraving precede the bust.

After Becque's death in 1899, it was decided on the initiative of Emile Bergerat to erect a monument to him, and after Rodin received the commission he asked the family for the loan of the original terra-cotta, from which the plaster enlargement was made in 1907.[8]

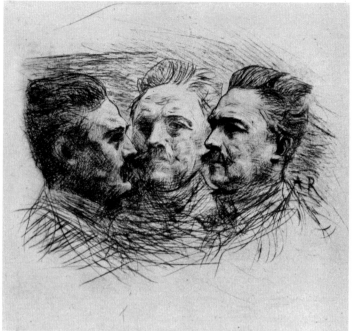

88–1

88–2

88–3

88–1
Henri Becque
1883, drypoint, 6¼ × 8 inches

88–2
Henri Becque, c. 1883
Photograph

88–3
Monument to Henri Becque
1908, marble, height 25⅝ inches
Place Prosper Goubeaux, Paris

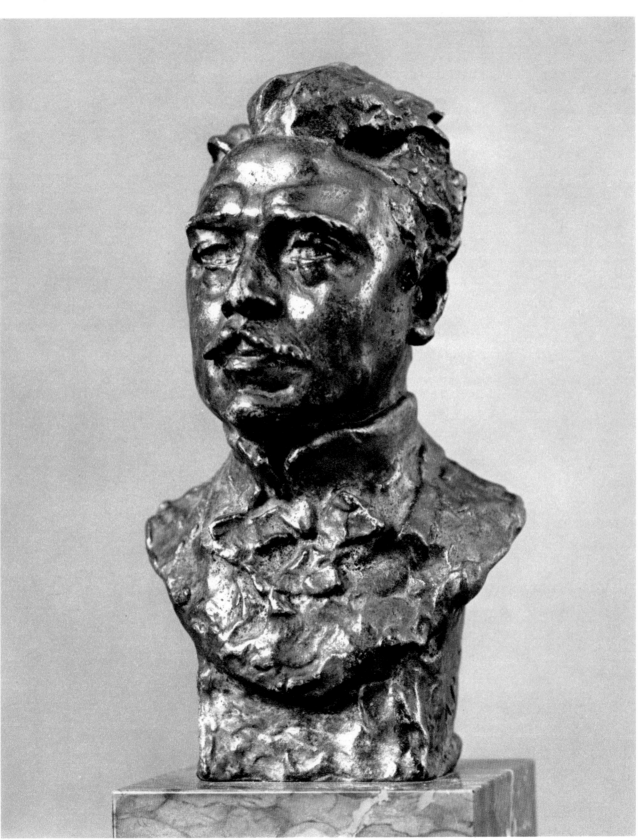

515

This then served for the execution of the marble monument, unveiled on June 1, 1908, in the place Prosper Goubeaux, at the crossing of the boulevard de Courcelles and the avenue de Villiers (fig. 88–3). It seems most probable that the Philadelphia bronze is a reduction of the original terra-cotta made for the dramatist's admirers and executed at the same time as the plaster enlargement in 1907.

NOTES

1. Eric Dawson, *Henri Becque: Sa vie et son théâtre* (Paris: Payot, 1923), p. 230. "Il débarrassa les formules dramatiques de toutes les complications qui s'y étaient ajoutées depuis le temps de Molière. Par là il rejoint le plus illustre représentant de la comédie française, et il ramena le théâtre aux saines traditions du classicisme. Il nommait volontiers Molière son 'maître', et il vantait d'avoir imité l'immortel auteur de *L'Avare*." The author further describes Becque, p. 231, as "l'un des points culminants de l'évolution du théâtre français."
2. Grappe [338d], no. 100.
3. Coquiot [31], p. 113. "Ah! celui-là était un rude homme, incisif et orgueilleux de sa pauvreté. Il la portait comme un panache. Il était plein d'amertume, sans doute, mais il réservait son fiel pour les gens et les choses médiocres de son époque. Nul n'admirait avec plus d'enthousiasme ce qui était admirable! Quand j'ai gravé son portrait, j'ai eu une joie profonde en cherchant à rendre ce masque résolu, entêté et tout empreint d'une coléreuse franchise!"
4. Grappe [338], no. 89.
5. Grappe [338a], no. 112.
6. Ibid., no. 111.
7. Grappe [338b], no. 114.
8. Grappe [338d], no. 368.

REFERENCES

Pierre Mortier, "Feuillets d'Almanach: Le 'Becque de Rodin,'" *Gil Blas,* Paris, April 2, 1908; Ciolkowska [23], pp. 41, 103; Lami [4], p. 167; Grappe [338], no. 89; Watkins [342], no. 75; Grappe [338a], no. 112; Grappe [338b], nos. 114, 393; Cladel [26], p. 254; Grappe [338c], nos. 88, 323; Grappe [338d], nos. 100, 368; Martinie [73], repr. pl. 47; Tancock [341], no. 80.

OTHER CASTS AND VERSIONS

Bronze

FRANCE
Paris, Musée Rodin.

UNITED STATES
New York City, Collection Mrs. Patrick Dinehart (ex. Collection Jules Mastbaum).
Stanford, Stanford University Art Gallery and Museum. Gift of B. G. Cantor Art Foundation. Founder: Georges Rudier. Cast no. 6/12.

Terra-cotta, height 11¼ inches

FRANCE
Paris, Musée Rodin (ex. Collection Henri Becque). Gift of Becque's nephews, 1928.

Plaster, height 25⅝ inches

FRANCE
Paris, Musée Rodin.

Bronze

FRANCE
Paris, Musée Rodin.

Marble

FRANCE
Paris, place Prosper Goubeaux. Placed on a pedestal, this bust was erected as a monument to the writer in 1908 (fig. 88–3).

89 Mme Vicuña
1884

Bronze, 14¼ × 14 × 10 inches
Signed back of shoulders to right and inside in relief: A Rodin
Foundry mark back of shoulders to left:
Alexis. RUDIER./Fondeur. PARIS.

Mme Luisa Lynch de Morla Vicuña was the wife of the Chilean Ambassador to Paris. Rodin, who began to mix in much more fashionable society in the 1880s, probably met Mme Vicuña at the embassy as well as in the salons he frequented.[1] It appears that the bust (fig. 89-1) was executed about 1884, although it was not exhibited at the Salon until 1888. It is the first and one of the best of the society portraits that became one of Rodin's main sources of income after 1900. No work of Rodin's gained more immediate popularity than this bust, which has also been known as *The Charmer* and *Girlhood*.

"With an easy decisiveness," Gustave Geffroy wrote, "he evokes the woman of today, the reserved face of the fashionable woman, the physical suppleness of a lively, high-strung creature. The shoulders and the breasts rise from an ample fur, the head is leaning to the right, but this simple attitude is also brand new through the inimitable bending of the neck and the thrusting forward of the face. The roundness and firmness of those shoulders are, naturally, perceptible, but it seems that through some unparalleled delicacy of touch, the artist has made apparent the warmth of the breasts, the delicate swelling of the moist lips, the flow of the glance through the long narrow eyes, the well-groomed hair caught up by the silky material wound round the head, the rebelliousness of a twisted strand at the nape of the neck."[2]

The work was so popular, in fact, that the French government asked M. Vicuña if he would be willing to part with it. Flattered, no doubt, by the proposal made to him, he raised no objections, and the marble bust was purchased for 3,000 francs by the French government on July 20, 1888.[3] To express his gratitude and to compensate M. Vicuña for the loss of the portrait of his wife, Rodin presented him with two other original works, a marble of *Andromeda (see no. 35)* and the original *maquette* of the *Monument to General Lynch*.[4]

In 1914 Roger Marx referred to "three totally dissimilar interpretations that one would not attribute to the same artist,"[5] although as far as is known these have never been exhibited. The carving of the marble, which is of an extremely high quality, was done by Jean Escoula, although the posy of flowers at Mme Vicuña's breast was carved by a sculptor named Cornu.[6] In fact, Rodin felt that the execution of the marble was almost too perfect. "Exquisitely charming as it is," remarked T.H. Bartlett, "the sculptor does not regard it as a fully satisfactory reproduction of his model, because it bears too much the impress of the character of the superior marblecutter who executed it."[7] A tightly worked drawing, signed and dated 1888 and executed after the sculpture for purposes of reproduction, exists in the Cabinet des Dessins of the Musée du Louvre (fig. 89-2).

Since no other bronzes of the bust of Mme Vicuña are known to have existed before the recent cast in Stanford, the Philadelphia bronze, which omits the drapery and flowers of the marble, was presumably specially commissioned by Jules Mastbaum. In the process of transference from marble to bronze, however, the bust has lost a good deal of the cool sensuousness of the marble that makes its enormous popularity perfectly understandable.

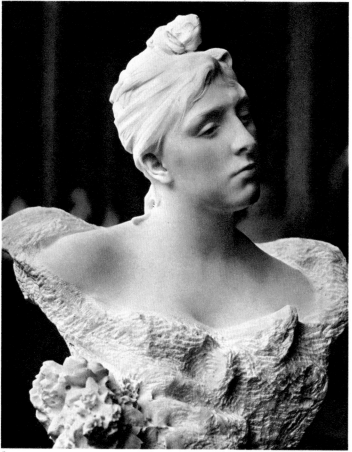

89-1

89-2

89-1
Mme Vicuña
1884, marble, height 22 ½ inches
Musée Rodin, Paris

89-2
Mme Vicuña
1888, pen and ink, 6⁵/₁₆ × 4 ¼ inches
Cabinet des Dessins, Musée du
Louvre, Paris

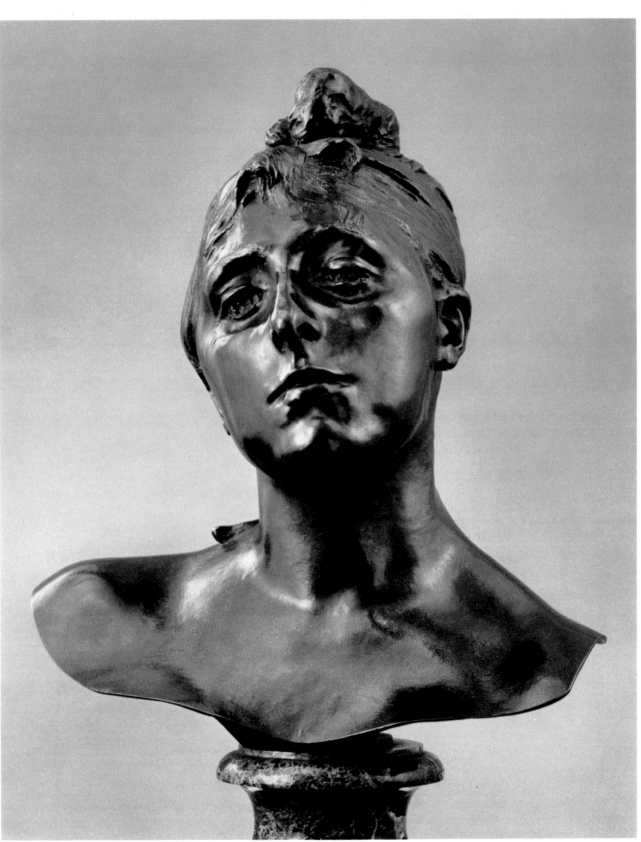

NOTES

1. Letter from M. Carlos Morla Lynch, May 10, 1967.
2. Geffroy [199b], p.101. "Avec une décision facile, il évoque la femme d'aujourd'hui, la discrétion de visage d'une mondaine, la souplesse physique d'une créature vivante et nerveuse. Les épaules et les seins surgissent d'une ample fourrure, la tête est penchée à droite, et cette attitude de simplicité est aussi une attitude neuve par l'intraduisible flexion du cou, par l'en-avant du visage. La rondeur et la fermeté de ces épaules sont, naturellement, perceptibles, mais il semble, par on ne sait quelle délicatesse de toucher, que l'artiste ait rendu évidente la tiédeur des seins, la légère enflure humide de la bouche, la coulée du regard entre les yeux minces et longs, l'application serrée des cheveux, leur enroulement d'étoffe soyeuse autour du crâne, la rébellion d'une mèche tordue sur la nuque."
3. Document in the Archives Nationales, Paris.
4. These works now belong to M. Carlos Morla Lynch, Madrid. It must have been through his friendship with the Chilean Ambassador and his wife that Rodin secured two commissions in 1886 for monuments to be erected in Chile, one for a *Monument to Benjamin Vicuña-Mackenna* and the other for a *Monument to General Lynch*. Vicuña-Mackenna, a statesman and writer on Chilean history, who was a liberal candidate for the presidency in 1875, was depicted standing on a plinth on which were bas-reliefs representing sittings of Parliament and an allegory of the mother country reaching up in gratitude to the principal personage. For General Lynch, who was active in the deposing of the Calderon government in Peru in 1881 and appointed Chilean Minister to Spain in 1884, Rodin designed his only equestrian monument. *See* fig. 20-1 and Lawton [67], pp. 69-71.
5. Marx [245], p.205. "Du buste de jeune femme, conservé au musée du Luxembourg, je sais trois interprétations sans analogue et qu'on n'attribuerait pas au même artiste, si un sens exceptionnel de la forme ne perçait pas sous le contraste des apparences."
6. Lami [4], p.167, and Bénédite [10a], pl.28. Lami states incorrectly that there is a version of this bust in the Musée de Peinture et de Sculpture in Grenoble given by the Baronne de Rothschild. In fact, the work in question is the early marble called *Young Girl Listening (see* Chronology).
7. Bartlett in Elsen [39], p.84.

REFERENCES

Javel [226], repr.; Geffroy [199a], p.17; Bartlett [125], p.250; Lawton [67], p.85, repr. opp. p.85; Cladel [25a], pp.137-41, repr. p.139; Lami [4], p.167; Bénédite [10a], p.28, repr. pl. XXVIII; Grappe [338], no.72; Watkins [342], no.59; Grappe [338a], no.90; Grappe [338b], no.140; Grappe [338c], no.103; Story [103], pp.15-16, 145, no.37, repr. pl.37; Grappe [338d], no.116; Grappe [54], p.141, repr. p.57; Waldmann [109], pp.58-59, 78, no.65, repr. p.65; Story [103a], no.28, repr. pl.28 (marble); Descharnes and Chabrun [32], p.122, repr. p.122; Tancock [341], no.81.

OTHER CASTS AND VERSIONS

Bronze

UNITED STATES
Stanford, Stanford University Art Gallery and Museum. Gift of B.G. Cantor Art Foundation. Founder: Georges Rudier. Cast no. 1.

Marble, height 22½ inches

FRANCE
Paris, Musée Rodin (fig. 89-1).

Plasters

FRANCE
Paris, Musée Rodin.

90 Pierre Puvis de Chavannes
1890

Bronze, 16¼ × 6¾ × 9 inches
Signed right side of base and on stamp inside: A. Rodin
Foundry mark rear of base to left:
ALEXIS RUDIER/Fondeur. PARIS.

No painter had a greater reputation at the end of the nineteenth century than Pierre Puvis de Chavannes (1824–1898; fig. 90–1). He studied painting under Henri Scheffer and Thomas Couture and made his first appearance at the Salon in 1850 with a *Pietà*. Although he did a number of easel paintings, he was principally active as a painter of large-scale decorative works, among the most important of them being the series of paintings at Amiens; decorative work for the Palais de Longchamps at Marseilles and for the Hôtel de Ville at Poitiers; the frescoes of *The Life of St. Genevieve* in the Panthéon in Paris; the staircase at the Musée des Beaux-Arts in Lyons; the Hemicycle at the Sorbonne; a staircase and reception room in the Hôtel de Ville in Paris; and finally, the frescoes in the Boston Public Library.

Although Rodin owned paintings by Renoir, Monet, and Van Gogh, his preferences among modern painters were for the independent artists of a more conservative tendency, notably Eugène Carrière *(see no. 63)* and Puvis de Chavannes, for whom he had the greatest admiration.

"I love his serenity, his meditative tranquility before life. He has turned away from the anguish of mystery, and all his figures are animated by a great interior happiness which never reveals itself through cries or violent gestures. And how well he knew how to transform his surroundings! Many green backgrounds in the Bois de Boulogne have become landscapes appropriate to his grave figures."[1]

Grappe assigned a date of 1891 to Rodin's portrait of Puvis de Chavannes.[2] However, on July 18, 1890, the Ministry of Fine Arts commissioned a marble portrait of Puvis, for which the sum of 3,000 francs was to be paid.[3] It seems most probable then that the bronze bust of Puvis, which was exhibited in plaster at the Salon de la Société Nationale in 1891, was begun in 1890 as a preparatory study for the execution of the marble. Rodin showed Puvis in the antique style, with bare shoulders and chest, as he had done in the busts of Jules Dalou (no. 86) and Jean-Paul Laurens (no. 83). Puvis, however, who attached great importance to his official glories *(see his Self-Portrait, fig. 90–2),*[4] insisted that the bust should be attired. The rapidity with which the frock coat, wing collar, and rosette of the Legion of Honor were indicated contrasts strongly with the high degree of finish of the face (fig. 90–3).

In spite of the friendship that united them, Puvis de Chavannes did not like Rodin's portrait of him. "I was really upset," Rodin said, "when he didn't like the bust I had made of him. If, since then, I no longer regret it so much, it is because I was very much of the opinion that the Princess Cantacuzène [Puvis's wife] had influenced him."[5]

The critics, however, reacted very favorably to the portrait. "Here, as in all the busts modeled by the artist," wrote Gustave Geffroy, "the preoccupation with the whole and with the dominant expression affirms itself and triumphs. One can walk around the plinth, look at the work from ten different points of view, always a profile of significant lines will be inscribed in the field of vision, always the attitude will be physiologically and intellectually informative. It is thus that M. Puvis de Chavannes appears robust and calm, proud and reserved, the jaw and the neck solid, the crease of attention between the eyes, the look fixed, the rugged receding forehead of a Lyons mystic." But Geffroy went on to ask why the model had "to demand of his portraitist so much precision in the costume, and why did Rodin, at the last moment, have to indicate the frock coat, the wing collar, the rosette of the Legion of Honor? It is only the evocation of the poet of *The Sacred Wood* and of *Summer* who is important to us, and not that of the great, complicated artist, head of an art concern, president of a society, speechmaker, and successor to Meissonier."[6]

In the version of this portrait in Philadelphia, however, the head is not supported by fully clad shoulders, but by a curiously shaped squarish base on which the line of the collar is barely indicated. In 1892 the marble commissioned in 1890 was exhibited at the Salon de la Société Nationale (fig. 90–4), and on January 16, 1895, at a banquet in honor of Puvis de Chavannes over which Rodin presided, each guest was presented with a plaquette on which appeared the head of the painter in profile.

In 1911 the Ministry of Fine Arts commissioned another marble bust of Puvis de Chavannes for the Panthéon.[7] This work, in which the head emerges from a large mass of uncut marble, belongs to the group which includes the *Mozart (see* fig. 99–2) and the *Victor Hugo* (fig. 87–6). According to Bénédite, this was exhibited in 1913, although another, the same size as the original, was finished only in 1916.[8]

NOTES

1. Coquiot [31], p. 37. "J'aime sa sérénité, sa tranquillité méditative devant la vie. Il a repoussé l'angoisse du mystère et toutes ses figures sont animées d'un grand bonheur intérieur, qui ne se trahit jamais par des cris et des gestes violents. Et comme il savait transposer tous les décors! Bien des fonds de verdure du Bois de Boulogne sont devenus des paysages appropriés à ses graves figures."

2. Grappe [338d], no. 257.

3. Document in the Archives Nationales, Paris. According to Lami [4], p. 168, the marble entered the collection of the Musée de Picardie in Amiens in 1894.

4. This work is signed and dated at top right: P. Puvis de Chavannes 1887.

5. Coquiot [31], p. 37. "J'ai eu un chagrin véritable le jour qu'il n'accorda point son estime à son propre buste que j'avais exécuté. Si, depuis, ce chagrin s'est adouci, c'est que j'ai fortement pensé que la princesse Cantacuzène avait pesé sur son opinion."

6. Gustave Geffroy, "La Sculpture," in *La Vie artistique,* vol. 1, 1e série (Paris: H. Floury, 1892), pp. 286–87. "Ici, comme dans tous les bustes modelés par l'artiste, la préoccupation de l'ensemble et de l'expression dominante s'affirme et triomphe. On peut tourner autour de ce socle, regarder l'œuvre de dix points de vue différents, toujours s'inscrira dans le champ de la vision un profilement de lignes significatives, toujours l'attitude sera physiologiquement et intellectuellement renseignante. C'est ainsi que M. Puvis de Chavannes apparaît robuste et calme, fier et réservé, la mâchoire et la nuque solides, le pli de l'attention entre les yeux, le regard fixe, le front bossué et fuyant d'un mystique lyonnais. Pourquoi faut-il que le modèle ait demandé à son portraitiste tant de précision dans le costume et que Rodin, au dernier jour, ait dû indiquer cette redingote, ce col droit, cette rosette de Légion d'honneur? C'est seulement l'évocation du poète du *Bois Sacré* et de l'*Eté* qui nous importait, et non celle du grand artiste compliqué d'un chef de bureau de

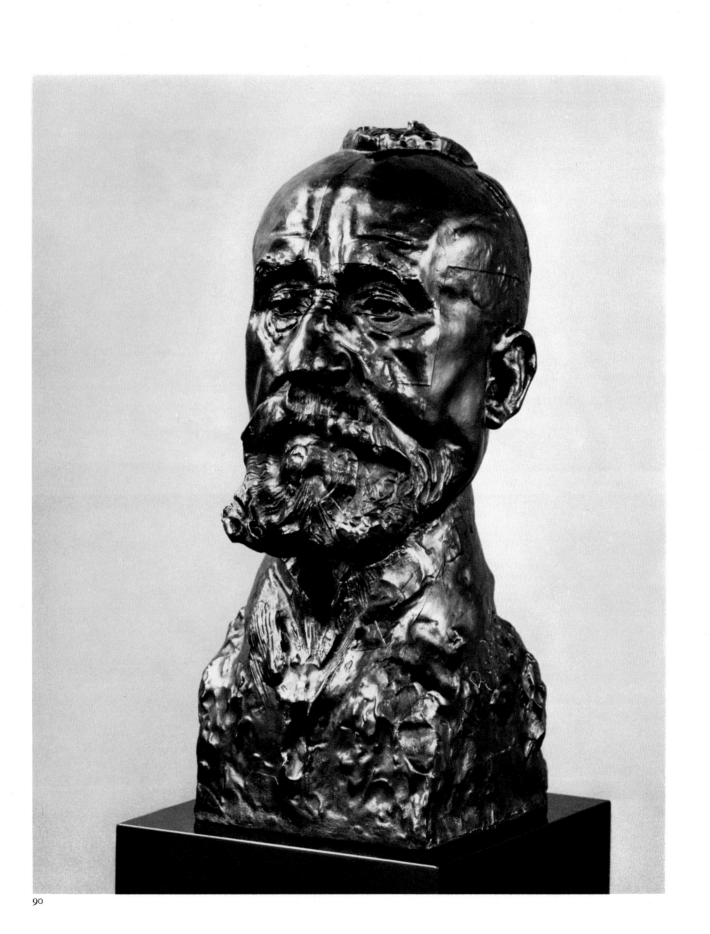

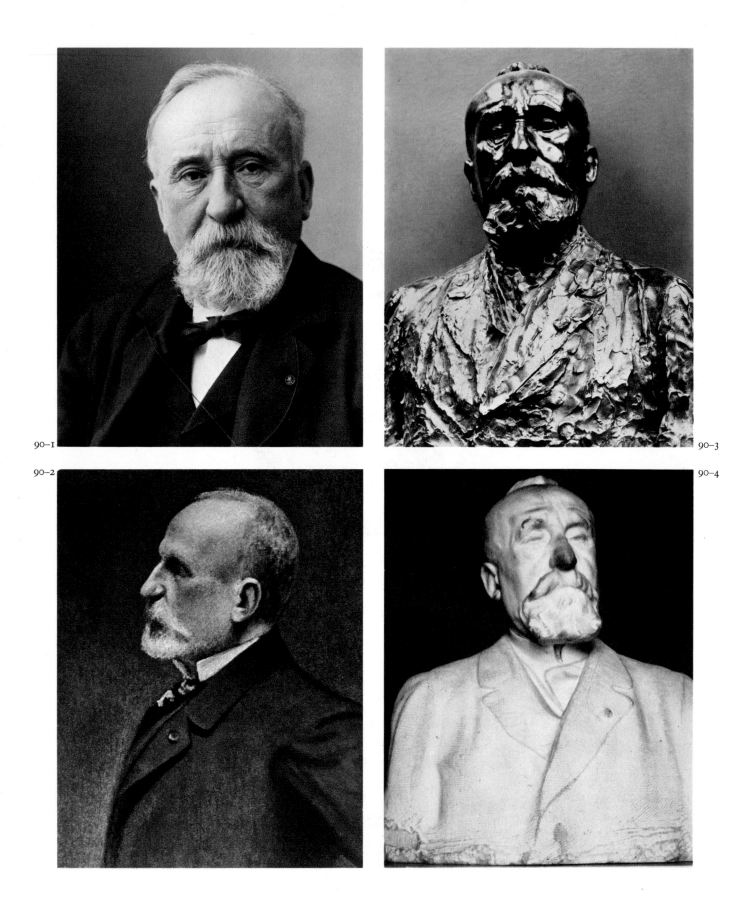

l'art, président de société, faiseur de discours, fonctionnaire successeur de Miessonier [*sic*]."

7. Grappe [338d], nos. 412, 413, assigns a date of 1910 to both marbles. A marble bust of Puvis was, however, commissioned by the Ministry of Fine Arts on February 26, 1911, with Rodin to receive the sum of 6,000 francs (document in the Archives Nationales, Paris). It seems unlikely that Rodin would have started work on the marble before that date.

8. Bénédite [10a], pl. xxv (A), p. 28.

REFERENCES

Edouard Rod, "Les Salons de 1891 au Champ-de-Mars et aux Champs-Elysées," *Gazette des Beaux-Arts,* Paris, 33e année, 6 (July 1891), pp. 31–32; Gustave Geffroy, "La Sculpture," in *La Vie artistique,* vol. 1, 1e série, Paris: H. Floury, 1892, pp. 285–87; Maillard [71], pp. 111–12; Lawton [67], pp. 91–92, repr. opp. p. 39; "A la Mémoire de Puvis de Chavannes," *Le Journal des Débats,* Paris, October 26, 1910, p. 2; Coquiot [31], p. 37; Lami [4], p. 168; Bénédite [10a], p. 28, repr. pl. xxv (A); Grappe [338], no. 174; Watkins [342], no. 12; Grappe [338a], no. 202; Grappe [338b], no. 286; Grappe [338c], no. 223; Frisch and Shipley [42], p. 264; Grappe [338d], no. 257; Grappe [54], p. 143, repr. p. 99; Elsen [38], pp. 122–23, repr. p. 123; Descharnes and Chabrun [32], p. 148, repr. p. 148; Tancock [341], no. 82.

OTHER CASTS AND VERSIONS

Bronze, height 19¾ inches

DENMARK
Copenhagen, Ny Carlsberg Glyptotek. Gift of Carl Jacobsen, 1901. Cast in 1901.

90–1 Pierre Puvis de Chavannes
Photograph

90–2 Pierre Puvis de Chavannes
Self-Portrait
1887, oil on panel, 25⅝ × 21¼ inches
Galleria degli Uffizi, Florence

90–3 *Pierre Puvis de Chavannes*
1891, bronze, height 19¾ inches
Musée Rodin, Paris

90–4 *Pierre Puvis de Chavannes*
1890–92, marble, height 22⅞ inches
Musée de Picardie, Amiens

FRANCE
Paris, Musée Rodin (fig. 90–3).

GERMANY (WEST)
Krefeld, Kaiser Wilhelm Museum. Signed: A. Rodin. Founder: Alexis Rudier.

JAPAN
Tokyo, Bridgestone Museum of Art.
— National Museum of Western Art (ex. Collection Matsukata). Signed: A. Rodin.

UNITED STATES
New York City, Metropolitan Museum of Art. Gift of Thomas F. Ryan, 1910. Purchased from Rodin.

Plaster, height 18⅞ inches

FRANCE
Lyons, Musée des Beaux-Arts. Gift of the state, 1896.

Plaster, height 21⅝ inches

GERMANY (EAST)
Dresden, Staatliche Kunstsammlungen. Purchased in 1902 from the Internationale Kunstausstellung, Dresden, 1901.

Terra-cotta (head only), height 7⅞ inches

Location unknown. Charles Pacquemont Sale, Galerie Georges Petit, December 12, 1932.

Wax, height 7 inches

UNITED STATES
Cambridge, Fogg Art Museum, Harvard University. Grenville L. Winthrop Bequest, 1943. Preparation for a *cire-perdue* cast; no bronzes known. Inscribed: Donné à L. Bénédite par Rodin le 10 novembre 1916.

Marble, height 22⅞ inches

FRANCE
Amiens, Musée de Picardie. Commissioned by the Ministry of Fine Arts on July 18, 1890. Entered museum in 1894. Signed: A. Rodin (fig. 90–4).

Marble, height 24⅜ inches

FRANCE
Paris, Musée Rodin.

Marble, height 29½ inches

FRANCE
Paris, Musée Rodin.

91 Séverine

1893

Bronze, 6⅜ × 4¾ × 5 inches
Signed on neck to right and on stamp inside: A. Rodin
Foundry mark underneath hair to left:
.Alexis. RUDIER./.Fondeur. PARIS.

Séverine (figs.91–1, 91–2) was the *nom de plume* of Caroline Rémy (1855–1929), a novelist, journalist, and lecturer. Of advanced political opinions, she was a disciple of Jules Vallès, acting for a time as his secretary and editing his novels, *Le Bachelier* and *L'Insurgé*. She joined the Socialist party in 1918 and then became affiliated with the Communists. From 1886 to 1888 she directed the newspaper *Le Cri du Peuple* and during the 1890s was one of Rodin's most spirited defenders in the press. She was among those who made orations at Rodin's funeral on November 24, 1917.

In 1893, the year of publication of her first book, *Pages Rouges,* and possibly on the occasion of this event, Rodin made several drawings of Séverine *(see* fig.91–3), which are evidently preparatory studies for the small mask under discussion. Rodin must have been greatly impressed by her features, as studies of the human head on this scale are extremely rare in his graphic *œuvre*. Athena Tacha Spear suggests that the pencil drawing of a head in the collection of the Rodin Museum (fig.91–4) is also a portrait of Séverine.[1] Rodin was not the first artist to have depicted this formidable writer. About 1885 Renoir executed the pastel portrait now in the National Gallery of Art in Washington, D.C. (fig.91–5). Although superficially like so many other portraits by Renoir of physically attractive young women, that of Séverine is marked by the brooding intensity of its expression.

This mask is sometimes called *The Mulatto*. It seems very probable that it was exhibited at the Exposition Rodin in 1900: "Small bust, bronze. Small mask of a woman with prominent cheeks, thick lips, the eyes wide open but somewhat pensive."[2]

NOTES

1. Spear [332], p.32. She makes this suggestion "on the basis of resemblance alone."
2. *See* Paris, 1900 [349], no.22. "Petit buste, bronze. Petit masque d'une femme aux pommettes saillantes, à bouche lippue, les yeux largement ouverts mais un peu dans le rêve."

REFERENCES

Watkins [342], no.72; Grappe [338b], no.292; Grappe [338c], nos.229, 230; Grappe [338d], nos.263, 264; Spear [332], p.32, no.v, repr. p.31; Tancock [341], no.83.

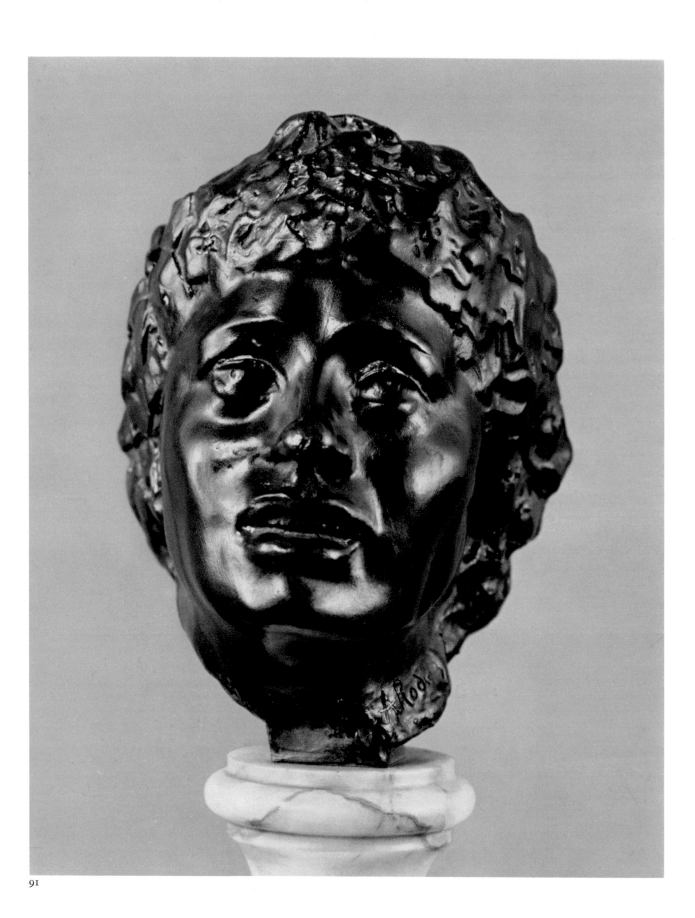

OTHER CASTS AND VERSIONS

Bronze

FRANCE
Paris, Musée Rodin.

SWITZERLAND
Zurich, Kunsthaus Zurich.

UNITED STATES
Cambridge, Fogg Art Museum, Harvard University.
Grenville L. Winthrop Bequest, 1943.
Cleveland, Cleveland Museum of Art (ex. Collection
Salmon Portland Halle. Purchased before Rodin's
death). Signed: A. Rodin. Founder: Alexis Rudier.
San Francisco, California Palace of the Legion of
Honor. Spreckels Collection. No foundry mark.

Plaster

FRANCE
Paris, Musée Rodin.

DRAWINGS

FRANCE
Paris, Musée Rodin. Charcoal, 12⅝ × 10¼ inches.
Signed: A.R.
— Musée Rodin. Charcoal, 12¼ × 9½ inches. Signed:
A.R.

HUNGARY
Budapest, Szépmüvészeti Múzeum. Charcoal,
12⅝ × 10⅝ inches. Signed: A.R. (fig. 91-3).

UNITED STATES
Philadelphia, Rodin Museum. Pencil, 6⅛ × 4⅛ inches.
Signed: A.R. (fig. 91-4).

91-1

91-2

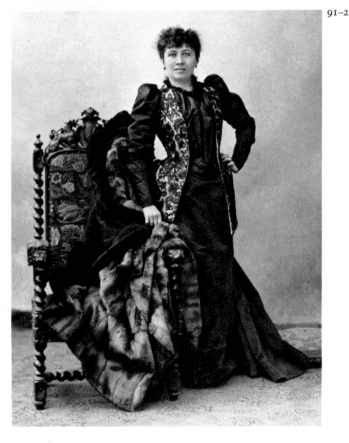

91-3

91-4

91-5

91-1
Séverine
Photograph

91-2
Séverine
Photograph

91-3
Séverine
c. 1893, charcoal, 12⅝ × 10⅝ inches
Szépmüvészeti Múzeum, Budapest

91-4
Séverine
c. 1893, pencil, 6⅛ × 4⅛ inches
Rodin Museum, Philadelphia

91-5
Pierre-Auguste Renoir
Séverine
c. 1885, pastel, 24½ × 20 inches
National Gallery of Art,
Washington, D.C.
Chester Dale Collection

92 Countess Hélène von Nostitz Hindenburg

1902 (executed 1911)

Pâte de verre, 9 × 8¼ × 2⅝ inches
Not signed or inscribed

Hélène von Hindenburg, later Countess Hélène von Nostitz Hindenburg (1878–1944), who lived in Paris with her grandfather, the German ambassador, met Auguste Rodin for the first time at the Exposition of 1900. Overwhelmed by his work, she introduced herself to him, and a close friendship ensued. Profoundly interested in music, literature, and the visual arts, the countess provided Rodin with the type of companionship that he came increasingly to value in his old age. The elevated tone of their relationship is admirably conveyed in the countess's memoirs[1] and in the letters Rodin wrote to her.

After her first protracted stay in Paris, the countess was visited by Rodin while she was staying at her mother's house, the Villa Margherita in Ardenza, near Leghorn. She used to read to Rodin—Lamartine, Baudelaire (especially *L'Invitation au Voyage*), Maeterlinck, and Goethe—and play music by his favorite composers, Gluck and Beethoven. Together they visited Lucca and Pisa and went for long walks, during which Rodin gave frequent expression to his almost mystical feeling for the correspondences between all created forms.

"Rodin," she wrote, "seemed to see figures everywhere. At first in the gnarled trees that fought for their very existence with the elements, on the shore. There were some which lay along the earth and then rose into the air. Another clung to a rock; like a flame, the green grew out of its tortured stem. Then the rocks became alive. In Rodin's eyes Grecian gods suddenly appeared; there in the cave Andromeda was freed by Perseus; the waves of the sea became monsters; horses champing at their bits stood on the shore, the foam covered them and they were afraid."[2]

After a year of separation, they met again in Florence. Rodin, in his growing serenity and detachment, was finding a satisfaction in Perugino that he could no longer find in more agitated masters. "In a masterpiece of Perugino," Rodin wrote to her, "and in this little flower, there is the same movement, for both lead us to the quietude of peace."[3] They returned to Ardenza together, and it was on this occasion, in 1902, that Rodin modeled the first small bust of the countess, a bronze cast of which is in the Musée Rodin.

In 1905 the countess went to Paris to make possible the modeling of the large bust.[4] At first, sittings took place in the rue de l'Université, but then she moved into La Houlette, a small studio in the lower part of the garden at Meudon. The marble version was executed in 1908, but it was not until 1911 that Rodin returned to the 1902 study and had it cast in *pâte de verre,* at the same time as the masks of *Mme Rodin* (no. 81) and *Hanako* (no. 98).[5]

NOTES

1. Nostitz [83b] and [84].
2. Nostitz [83b], p. 42.
3. Ibid., p. 48.
4. *See* Munich, 1955 [362], no. 15.

5. In the first two editions of the catalogue of the Musée Rodin, Grappe assigned a date of 1901 to both the small bronze and the *pâte de verre (see* [338], nos. 242, 243, and [338a], nos. 276, 277), but in subsequent editions he revised the date of the *pâte de verre* to 1911.

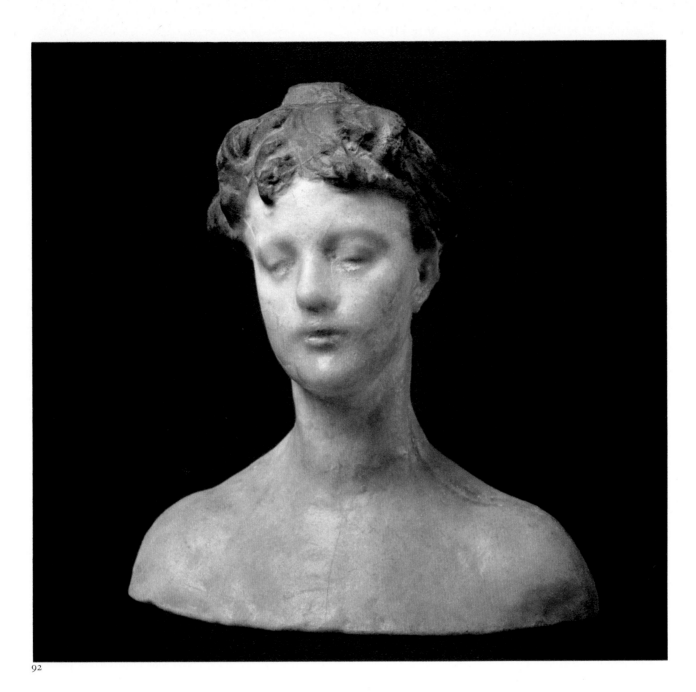

92

REFERENCES

Grappe [338], nos. 242, 243; Watkins [342], no. 43; Grappe [338a], nos. 276, 277; Grappe [338b], nos. 351, 438; Nostitz [83b], pp. 55, 67, 68; Grappe [338c], nos. 288, 360; Grappe [338d], nos. 324, 422; Waldmann [109], pp. 62, 79, no. 70, repr. pl. 70; Tancock [341], no. 84.

OTHER VERSIONS

Bronze
FRANCE
Paris, Musée Rodin.

Marble
Location unknown.

93 Eugène Guillaume

1903

Bronze, 13 × 7 × 10 inches
Signed front of base to right and on stamp inside: A. Rodin
Foundry mark back of neck to left: Alexis RUDIER/Fondeur. PARIS

Eugène Guillaume (1822–1905; fig. 93-1) first studied at the Ecole de Dessin in Dijon and learned the first principles of sculpture from Pierre Darbois. In 1841 he entered the Ecole des Beaux-Arts as a pupil of Pradier and won the Prix de Rome in 1845 with *Theseus Finding His Father's Sword Under a Rock*. From 1846 to 1850 he lived in Italy, and the works he sent home—*Anacreon, The Reaper,* and *The Gracchi*—soon attracted attention to him. He rapidly obtained a number of important commissions, including figures and bas-reliefs for the Church of Ste.-Clothilde, stone figures for the façade of the Church of the Trinity, the group of *Instrumental Music* for the Opéra, monuments to Ingres and Duban for the Ecole des Beaux-Arts, as well as decorative work in the Louvre and the Palais de Justice in Marseilles.[1]

Guillaume, an exponent of the most austere Neoclassicism, was the most successful sculptor in the second half of the nineteenth century. The orthodoxy of his style put no obstacles in the way of his dazzlingly successful official career. In 1863 he became a professor at the Ecole des Beaux-Arts and in 1864 director of that institution. From 1878 to 1879 he was Director of the Ministry of Fine Arts; in 1882 he became professor of aesthetics at the Collège de France and in 1887 professor of drawing at the Ecole Polytechnique. In 1891 he replaced the painter Hébert as head of the Ecole de Rome and in 1898 was offered the chair at the Institut left vacant by the Duc d'Aumale. He died in Rome in 1905.

No two artists were more different than Rodin and Guillaume; yet toward the end of the latter's life they were united by ties of the closest friendship. "At first," Rodin said, "this sculptor was far from having friendly feelings toward me. One day, finding my *Mask of the Man with the Broken Nose* at the house of one of my friends, he insisted that it should be thrown away on the rubbish heap, no less! And the entire time he presided over the destinies of the Ecole des Beaux-Arts, then over the Académie de France in Rome, I can assure you our relationship did not improve. In fact, I had no worse enemy! Then time passed; and if one gets older, there are at least some consolations! For me one was to see this same Guillaume greet me one day and even visit me in Paris and at Meudon. By that time I had become a great artist for him; I really don't know how to tell you the truth; and God only knows all the praises he heaped on me and all the disclosures he made to me."[2]

Rodin's affection for the aged sculptor is admirably conveyed in this moving bust, in which the handling is much freer than in many of the busts of society figures made at the same time. It may even be that Rodin thought of it as unfinished, as Georges Grappe states that he refused to touch the bust after Guillaume's death.[3] However, a plaster version was exhibited at the Grosse Kunstausstellung in Dresden in 1904, which indicates his general satisfaction with the bust, although certain areas, notably the extension of the neck and shoulders in the larger version, were left in an unmodeled state.[4]

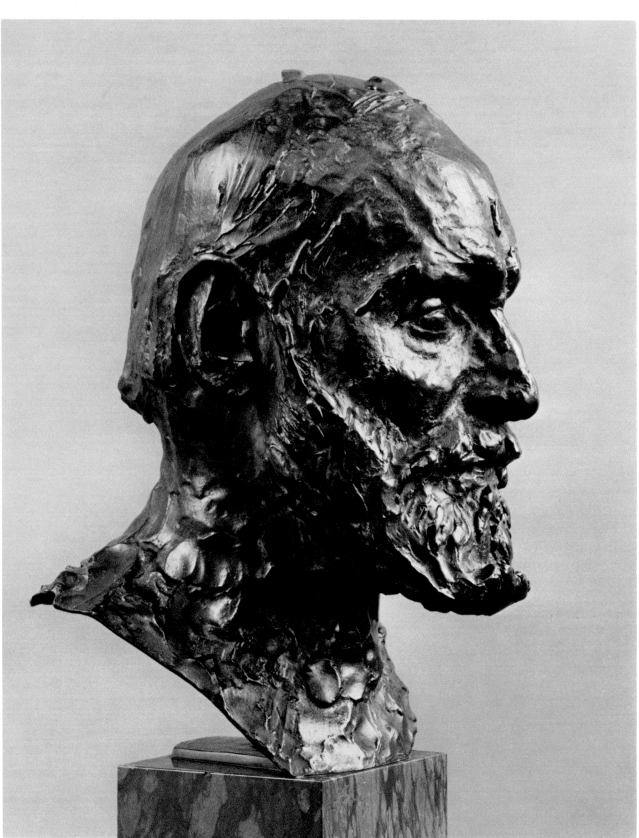

NOTES

1. See article on Guillaume in *Les Arts,* Paris, no.41 (May 1905), pp.2–5.
2. Coquiot [31], p.112. "Oui! tout d'abord ce sculpteur ne fut point tendre pour moi. Trouvant un jour chez un de ses amis mon masque de *l'Homme au nez cassé,* il exigea que cette œuvre fût jetée aux gravats, simplement! Et pendant tout le temps qu'il présida aux destinées de l'école des Beaux Arts, puis de l'Académie de France à Rome, je vous assure que nos rapports ne s'améliorèrent pas. Certainement, je n'avais pas un pire ennemi! Puis le temps passa; et si l'on peut vieillir, on a bien des consolations! car, pour moi, j'eus celle de voir ce même Guillaume me faire un beau jour des avances, et même me visiter à Paris et à Meudon. Alors, j'étais devenu un noble artiste pour lui; je ne sais pas trop pourquoi, à bien dire; et Dieu sait tous les éloges dont il me gratifia, et toutes les confidences qu'il me fit."
3. Grappe [338d], no.331. "Quand il fut présenté au public, le buste était tel qu'il était sorti des mains du sculpteur après la dernière séance de pose, antérieure à la mort d'Eugène Guillaume. Rodin se refusa à y apporter la moindre retouche."
4. In the 1929 edition of the catalogue of the Musée Rodin, Grappe gave the height of the bust as 21¼ inches, presumably the height of the version just described *(see* [338a], no.292).

REFERENCES

Bénédite [10a], p.30, repr. pl.XLV (A); Grappe [338], no.256; Watkins [342], no.14; Grappe [338a], no.292; Grappe [338b], no.358; Grappe [338c], no.295; Story [103], p.149, no.113, repr. pl.113; Grappe [338d], no.331; Grappe [54], p.144, repr. pl.123; Story [103a], no.76, repr. pl.76; Tancock [341], no.85.

OTHER CASTS AND VERSIONS

Bronze

ALGERIA
Algiers, Musée National des Beaux-Arts. Purchased by the state in 1929.

BELGIUM
Brussels, Musées Royaux des Beaux-Arts de Belgique. Signed: A.Rodin.

FRANCE
Dijon, Musée de Dijon. Deposited by the state in 1928.
Paris, Musée Rodin.

UNITED STATES
Madison, N.J., Estate of Geraldine R. Dodge. Founder: Alexis Rudier.
Stanford, Stanford University Art Gallery and Museum. Gift of B.G. Cantor Art Foundation. Founder: Georges Rudier. Cast no. 6/12.

Plaster

FRANCE
Roanne, Musée et Bibliothèque Joseph Déchelette. Gift of Georges Grappe. Acquired in 1931.

GERMANY (EAST)
Dresden, Staatliche Kunstsammlungen. Gift of Rodin, 1904.

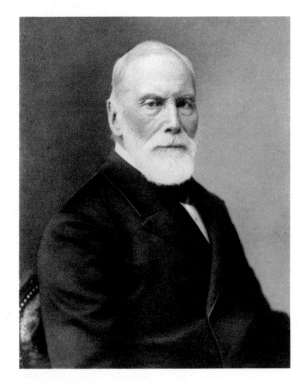

93–1
Eugène Guillaume, c. 1905
Photograph from *Les Arts,* May 1905

94 George Bernard Shaw
1906

Bronze, $15 \times 7\frac{1}{4} \times 8\frac{1}{2}$ inches
Signed right side of neck to front and on stamp inside: A. Rodin
Foundry mark back of neck to left: Alexis RUDIER/Fondeur. PARIS.

George Bernard Shaw (1856–1950; fig. 94–1), the playwright and polemicist, was apparently opposed in principle to the idea of sitting for his portrait, although he made an exception for Rodin. "In the year 1906," he wrote, "it was proposed to furnish the world with an authentic portrait bust of me before I had left the prime of life too far behind. The question then arose: Could Rodin be induced to undertake the work? On no other condition would I sit, because it was clear to me that Rodin was not only the greatest sculptor then living, but the greatest sculptor of his epoch: one of those extraordinary person [sic] who, like Michael Angelo, or Phidias, or Praxiteles, dominate whole ages as fashionable favorites dominate a single London season. I saw, therefore, that any man who, being a contemporary of Rodin, deliberately allowed his bust to be made by anybody else, must go down to posterity (if he went down at all) as a stupendous nincompoop."[1]

"Please have as many replicas cast as you want," Shaw wrote to Rodin on April 22, 1914, "the work is yours; the honor is mine; I am still proud of being known as your model; you are the only man beside whom I feel really humble."[2]

Rodin's reputation in the Anglo-Saxon world had been growing steadily ever since his first visit to England in 1881, and after 1900, in fact, he made almost as many busts of Englishmen and Americans as he did of Frenchmen. Shaw posed for Rodin in the early months of 1906, going out to Meudon every day with his wife. By April 1906, the bust was already well advanced.[3] Writing to Clara Westhoff on April 16, 1906, Rainer Maria Rilke, at that time Rodin's secretary, has left a particularly interesting account of Rodin's procedure when making a bust.

> I was present at the first sittings and saw for the first time how Rodin tackles his work. First there is a firmly shaped clay dummy, consisting of nothing but a ball set on something that supports it like a shoulder. This dummy is prepared for him and contains *no* armature *at all;* it only holds together by firm kneading. He begins his work by first placing his model at a very short distance, about half a step from the stand. With a big iron compass he took the measurement from the top of the head to the tip of the beard, and immediately established this proportion on the clay dummy by lumps of clay. Then in the course of the work he took measurements twice more; nose to back of head, and ear to ear from behind. After he had further cut out the eye sockets very quickly, so that something like a nose was formed, and had marked the place for the mouth with an indentation such as children make on a snowman, he began, with his model standing very close, to make first four profiles, then eight, then sixteen, having his model turn after about three minutes. He began with the front and back views and the two full side profiles, as though he were fitting four different drawings vertically against the clay ball, then fitted half profiles, etc., between these contours.

Yesterday, at the third seance, he seated Shaw in a cunning little child's armchair (that ironic and by no means uncongenial scoffer was greatly entertained by all this) and cut off the head of the bust with a wire (Shaw, whom the bust was already remarkably like, in a superior sort of way, watched his decapitation with indescribable joy) and worked on the recumbent head, partially supported by two wedges, seeing it from above, at about the same time as the model sitting low down a step away. Then the head was set on again and the work is now going along in the same fashion.... At some distance away a dark cloth has been hung up, so that the profiles stand out clearly. The Master works very rapidly, ... executing stroke after stroke at very short intervals, during which he absorbs indescribably, fills himself with form. One seems to feel how his quick, bird-of-prey-like clutch is always carrying out only one of these faces that are streaming into him and one comprehends his working from memory after the sitting is over.[4]

Rodin was evidently impressed by Shaw's head, although opinions differ as to the nature of his reaction to the writer's appearance. According to Anthony Ludovici, who worked for Rodin for six months in 1906, Rodin described Shaw's head as "une vraie tête de Christ."[5] René Chéruy, who worked for Rodin for six years, beginning in December 1902, and who was present when Shaw sat for Rodin, related, on the contrary, that Rodin responded to the author's diabolic potentialities.

"The sculptor was impressed by the peculiar features of the great writer's face—the hair parted in two standing locks, the forked beard, the sneering mouth, the inquisitive nose. 'Suddenly,' as Chéruy remembered it, 'Rodin interrupted his work and said, "Do you know, you look like—like the devil!" And Bernard Shaw, with a smile, replied, 'But I *am* the devil'!'"[6]

To Mrs. Shaw, however, the bust simply reminded her of her husband. "The bust has arrived," she wrote to Rodin, "it is looking at me now while I am writing. The resemblance to my husband is so striking that sometimes it really frightens me. When I enter the room I am quite startled."[7]

NOTES

1. George Bernard Shaw, "When Rodin 'sculped' me," *American Art Student,* New York, 2, no.7 (March 1918) p.4 (partial reprint from *Gil Blas,* Paris, May 24, 1912). A translation of the *Gil Blas* article is published in Elsen [38], pp.126–28.

2. Letter from Shaw to Rodin, April 22, 1914, in the Musée Rodin. "Je vous en prie, faîtes mouler aussi de répliques que vous voulez; l'œuvre est à vous: l'honneur est à moi: je suis toujours fier d'être connu comme votre modèle; vous êtes le seul homme auprès de qui je me sens vraiment humble."

3. Letter from Rilke to Sir William Rothenstein dated April 26, 1906. Quoted in William Rothenstein, *Men and Memories,* vol.2 (New York: Coward-McCann, 1931), pp.108–9. "Rodin aurait été ravi de pouvoir vous montrer le buste de Shaw qui s'avance merveilleusement déjà, vibrant de vie et de caractère; ce que ne serait point accessible, si Mr Shaw n'était pas ce modèle extraordinaire qui pose avec la même énergie et sincérité qui font sa gloire d'écrivain."

4. *Letters of Rainer Maria Rilke,* trans. Jane B. Greene and M.D. Herter (New York: W.W. Norton, 1945), pp.206–7. Quoted in Elsen [39], pp.8–9.

5. Ludovici [70], p.121.

6. Rice [283], p.34.

7. Grappe [338d], no.353. "Le buste est arrivé: il me regarde maintenant, pendant que j'écris. La ressemblance avec mon mari est tellement frappante que quelquefois absolument elle m'effraie. Quand j'entre dans la chambre, parfois je reste toute saisie."

REFERENCES

George Bernard Shaw, "When Rodin 'sculped' me," *American Art Student,* New York, 2, no.7 (March 1918), pp.4–5; Lami [4], p.168; Bénédite [10a], p.29,

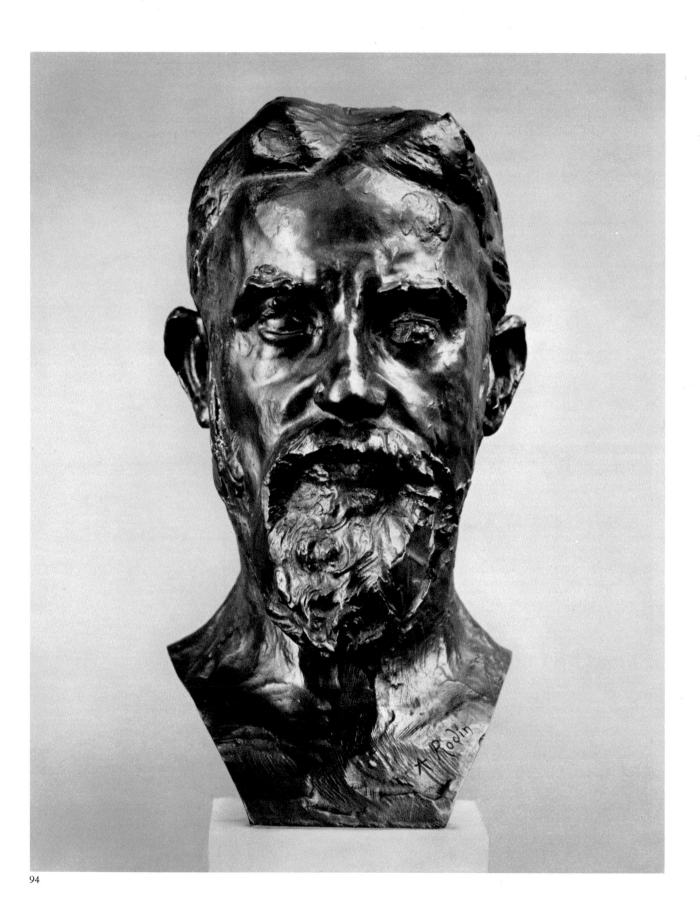

537

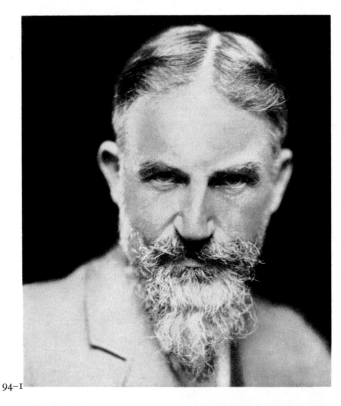

94-1

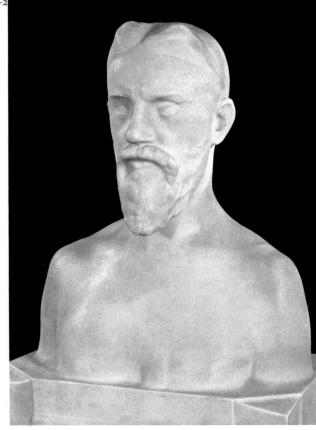

94-2

repr. pl. XXXIX (A) (without neck); Grappe [338], nos. 271–73; Watkins [342], no. 19; Grappe [338a], nos. 307–9; Grappe [338b], nos. 377–79; Grappe [338c], nos. 312, 312 bis, 312 ter; Story [103], p. 148, nos. 93–95, repr. pls. 93, 94 (marble); Grappe [338d], nos. 353–55; Grappe [54], p. 144, repr. p. 129 (marble); *Letters of Rainer Maria Rilke,* trans. Jane B. Greene and M. D. Herter (New York: W. W. Norton, 1945), pp. 206–7; Story [103a], nos. 78–80, repr. pls. 78, 79 (marble), 80 (bronze); Elsen [38], pp. 125–28, repr. p. 124; Descharnes and Chabrun [32], pp. 200–201, repr. p. 200 (marble); Tancock [341], no. 86.

OTHER CASTS AND VERSIONS

Bronze

FRANCE
Paris, Musée Rodin. Signed: A. Rodin. Founder: Alexis Rudier.

UNITED STATES
Beverly Hills, Collection Julie Andrews.
Madison, N. J., Estate of Geraldine R. Dodge. Signed: A. Rodin. Founder: Alexis Rudier.

Bronze, height 11⅜ inches

FRANCE
Paris, Musée Rodin.

Terra-cotta, height 10⅝ inches

FRANCE
Paris, Musée Rodin.

Marble, height 23⅝ inches

FRANCE
Paris, Musée Rodin.

IRELAND
Dublin, Municipal Gallery of Modern Art. Gift of George Bernard Shaw. Signed: A. Rodin. Inscribed: Bernard Shaw (fig. 94–2).

94–1
George Bernard Shaw, 1911
Photograph

94–2
George Bernard Shaw
1906, marble, height 23⅝ inches
Municipal Gallery of Modern Art,
Dublin

95 Marcelin Berthelot
1906

Plaster, with traces of ochre paint, 18 × 11 × 9 inches
Inscribed right side of base: A M. Jules E. Mastbaum

Pierre-Eugène-Marcelin Berthelot (fig. 95–1), noted scientist and statesman, was born in Paris in 1827, the son of a doctor, and became one of the outstanding men of his time. Having extremely diverse cultural interests, he nevertheless concentrated on the sciences and became assistant to A. J. Balard at the Collège de France in 1851. He retained this post until he became professor of organic chemistry at the Ecole Supérieure de Pharmacie in 1859. In 1865 a chair of organic chemistry was created for him at the Collège de France to enable him to continue his studies. His discoveries were published in some five to six hundred articles in the *Comptes rendus de l'Académie des Sciences* and in the *Annales de physique et de chimie*. They were grouped around two fundamental ideas, the synthesis of organic compounds[1] and the study of the general laws of mechanics which govern such chemical phenomena.[2] But he was equally interested in the history of science, publishing *Les Origines de l'alchimie* in 1885 and other works on the science of the ancient and medieval worlds.[3]

Berthelot was equally active in the field of public affairs. His scientific knowledge was put to practical use during the Franco-Prussian War when he directed the Comité Scientifique de Défense, which organized the manufacture of nitroglycerine, dynamite, and cannons. Then in 1876 he became Inspector General of Public Education and played an important role in the reorganization of higher education in France. In 1881 he was elected a life senator and presided over the commission which drafted laws concerning the reorganization and the laicity of primary education. From 1886 to 1887 he was Minister of Public Instruction in the Goblet ministry and from 1895 to 1896 held the portfolio for foreign affairs in the Bourgeois cabinet. Berthelot died in 1907 and was buried in the Panthéon.

Rodin formed a close relationship with Berthelot long before the execution of the bust in 1906. He visited the scientist in his studio and showed deep interest in his researches.[4] The latter presented signed copies of his books to Rodin.[5] The portrait Rodin made of Berthelot exists in three known versions, one of the head alone (height 11¾ inches), a second (the Philadelphia version) in which the chest and shoulders are more developed, and a third, which Grappe mentions.[6] Comparison of the first two versions makes it seem probable that the smaller work is a preliminary study for the larger. The modeling of the head is much freer and less developed than that of the bust, the sobriety of which recalls some of Rodin's earliest works in this genre, for example, *Jean-Baptiste Rodin* of 1860 *(see* pl. 2) and *Father Pierre-Julien Eymard* of 1863 (no. 78), in which the influence of David d'Angers was strongly present. Rodin's feeling for nuances of style may have suggested to him that the seriousness of this mode was more suitable for conveying Berthelot's greatness as a thinker than the more spirited style of many of his later busts.

Over the decades the Musée Rodin has changed its listings of the various versions of the bust of Berthelot. In the 1927 edition of the catalogue of the Musée Rodin,[7] Grappe listed two bronzes and, although no dimensions are given in this catalogue, it is to be presumed that one of them is the head alone and the other is the bust. The 1929 edition[8] records three versions: bronze, height 11¾ inches; bronze, height 17¼ inches; and plaster, height 21⅝ inches. In the 1931 edition[9] the same three works are listed, while in the 1938 edition the 21⅝-inch plaster has been omitted. In the definitive edition of 1944,[10] reference is made only to the 11¾-inch bronze. Jianou and Goldscheider also list only the bronze.[11]

NOTES

1. His principal works on this theme are *Chimie organique fondée sur la synthèse* (1860) and *Les Carbures d'hydrogène* (1901).
2. *Mécanique chimique* was published in 1879 and *Thermochimie* in 1897.
3. Other works on this subject are *Introduction à l'étude de la chimie des anciens et du moyen âge* (1889); *Collection des anciens alchimistes grecs* (1887–88); *La Chimie au moyen âge* (1893).
4. Frisch and Shipley [42], p. 436.
5. Story [103], p. 97.
6. This third version measures 21⅝ inches in height (Grappe [338a], no. 326 and [338b], no. 385).
7. Grappe [338], nos. 288, 289.
8. Grappe [338a], nos. 324–26.
9. Grappe [338b], nos. 383–85.
10. Grappe [338d], no. 360.
11. Jianou and Goldscheider [65], p. 110.

REFERENCES

Grappe [338], nos. 288, 289; Watkins [342], no. 104; Grappe [338a], nos. 324–26; Grappe [338b], nos. 383–85; Grappe [338c], nos. 316, 316 bis; Story [103], p. 148, no. 97; Grappe [338d], no. 360; Grappe [54], pp. 128, 144; Lecomte [68], repr. pl. 71; Cladel [27], repr. pl. 93; Herriot [61], repr. pl. 68; Cladel [28], repr. pl. 79; Descharnes and Chabrun [32], repr. p. 214; Tancock [341], no. 87.

OTHER CASTS AND VERSIONS

Plaster, height 21⅝ inches

FRANCE
Paris, Musée Rodin.

Bronze, height 11¾ inches

FRANCE
Paris, Musée Rodin. Signed: A. Rodin. Founder: Alexis Rudier.

Bronze, height 17¼ inches

DENMARK
Copenhagen, Ny Carlsberg Glyptotek. Gift of Ny Carlsbergfondet, 1932. Signed: A. Rodin. Cast in 1930.

FRANCE
Paris, Musée Rodin.

95–1 Marcelin Berthelot executing an experiment in his laboratory at the Collège de France
Engraving

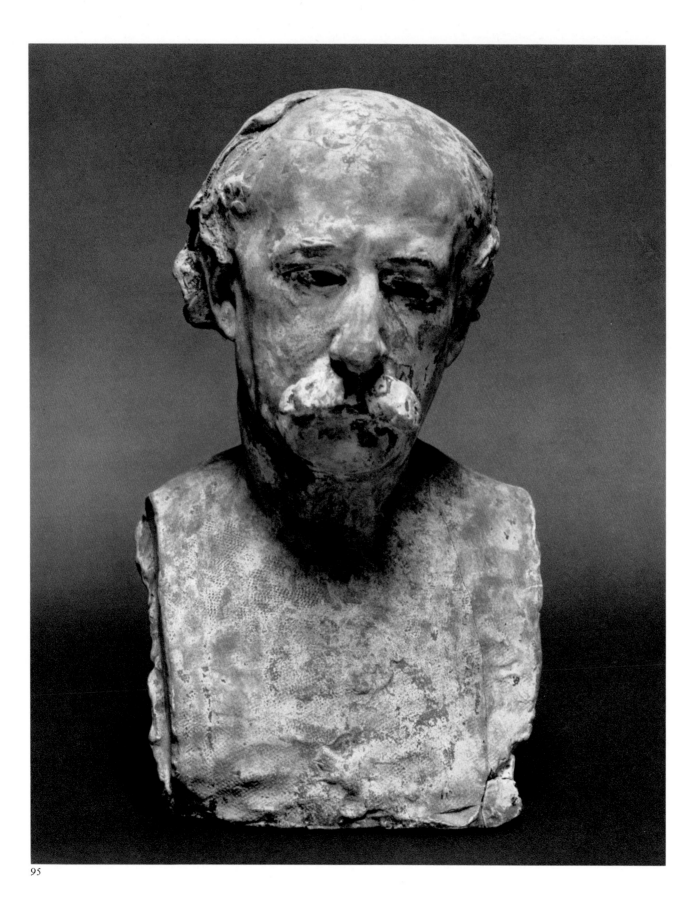

96 Joseph Pulitzer

1907

Bronze, 19 × 18½ × 10 inches
Signed on left shoulder: A. Rodin
Foundry mark rear of right shoulder:
.Alexis RUDIER./Fondeur. PARIS.

Joseph Pulitzer (1847–1911; fig. 96–1), newspaper editor and publisher, was born in Mako, Hungary, and brought up in Budapest. Emigrating to the United States in 1864, he moved a year later to St. Louis, where he studied for the bar, became a newspaper reporter, and dabbled in local politics. His influence grew, as did his fortune when he pulled off a clever financial maneuver by buying the bankrupt German newspaper *Staats-Zeitung* for practically nothing and selling its franchise in the Associated Press to the *St. Louis Daily Globe* for $20,000. Pulitzer continued to devote time to politics while at the same time building his newspaper empire. In 1878 he bought the dying *St. Louis Dispatch,* which was immediately merged with the *Post* and became the highly successful *St. Louis Post-Dispatch.*

In 1883 Pulitzer moved east and bought the New York *World* for $346,000 and in 1887 founded the *Evening World.* By the 1890s, Pulitzer had established a dominant position for the *World* in the competitive New York newspaper field. As one of the leading liberal newspapers of its time, the *World* supported the labor movement in such controversies as the Homestead strike of 1892 and took a stand against William Jennings Bryan for the presidency in 1896. In his last years Pulitzer became totally blind, but although his health was failing he kept in close contact with the *World* until the time of his death in 1911.

Rodin received a commission for the bust of Pulitzer in 1907. Room was cleared for a studio on the top floor of the Villa Cynthia at Cap Martin.

> Rodin insisted that Mr. Pulitzer in posing should lay bare his shoulders in order that he might correctly visualize the poise of the head. To this Mr. Pulitzer objected strenuously. Rodin was obdurate but it was not until he threatened to throw up the commission and return to Paris that his subject surrendered, and then under conditions that none but his immediate attendants should be admitted to the studio. This was agreed to and the work went on, the model proving very petulant and unruly and refusing to talk to Rodin, who naturally wished to relax his sitter and get some glimpse of his mentality. The contract was for a bronze and a marble bust.[1]

Rodin was not accustomed to sitters who resented having their portraits made. By the time he worked on the portrait of Joseph Pulitzer the wealthy and famous on both sides of the Atlantic were queuing up to be immortalized by the greatest sculptor of the time. Nonetheless, Pulitzer's truculence did not prevent Rodin from creating one of the most moving of his later portraits, in its sympathetic understanding of the state of blindness being rivaled, perhaps, only by Degas's portraits of his cousin and sister-in-law, Estelle Musson de Gas.[2]

542

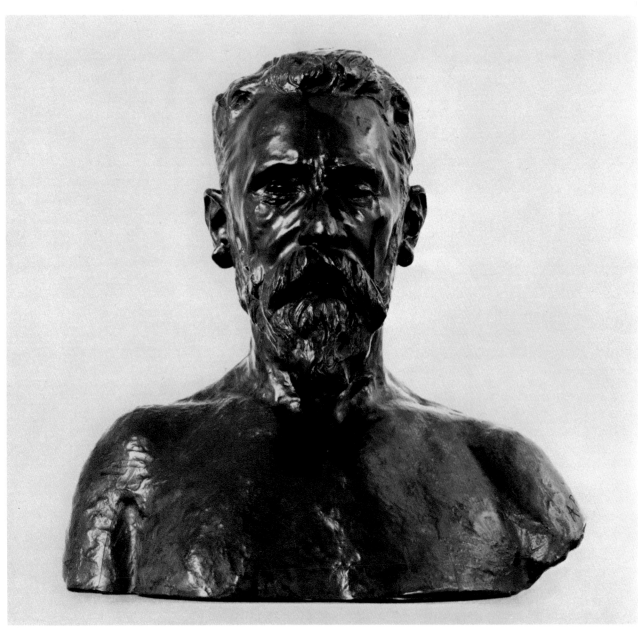

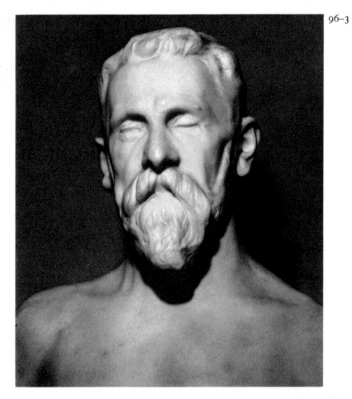

96–1
Joseph Pulitzer
Photograph

96–2
Rodin at work on the bust
of Joseph Pulitzer, 1907

96–3
Joseph Pulitzer
1907, marble, height 19 ½ inches
Missouri Historical Society,
St. Louis

Rodin's penetrating insight into the plight of a man struck by blindness is particularly apparent when compared with another portrait of Pulitzer by John Singer Sargent, painted in 1905.[3] Sargent's painting has a curious psychological ambivalence but, in its masterful portrayal of what is readily apparent, does not penetrate very far. Rodin's bust, on the other hand, is deprived of any details or accessories that might suggest a particular time or place, all the stress being placed on the spiritual condition of the sitter as this is revealed in the painstaking recording of his physiognomy.

Mrs. Pulitzer described the bust to her blind husband in a letter. "Rodin has seen you a thoughtful and mature man, an expression of mental introspection. It was as I have seen you in your study when everything around was quiet and peaceful and you were thinking and planning those things that made history and success."[4]

A cast of the bronze later went to the School of Journalism at Columbia University in New York, which Pulitzer endowed in 1903. The Musée Rodin plaster and the Philadelphia bronze differ from that in the Pulitzer Collection only in the shape of the base.

NOTES

1. Don C. Seitz, *Joseph Pulitzer: His Life and Letters* (New York: Simon and Schuster, 1924), p. 38.
2. *Woman with a Vase*, 1872, Musée du Louvre; *Estelle Musson de Gas*, 1872–73, private collection, Switzerland; *Estelle Musson de Gas*, 1872–73, National Gallery of Art, Washington, D.C., Chester Dale Collection.
3. *See Modern Painting, Drawing and Sculpture Collected by Louise and Joseph Pulitzer, Jr.,* vol. 2 (Cambridge, Mass.: Fogg Art Museum, 1957), pp. 250–51, illus. 79.
4. Quoted in *St. Louis Post-Dispatch*, April 6, 1947, p. 10.

REFERENCES

Watkins [342], no. 2; Grappe [338a], no. 334 bis; Grappe [338b], no. 395; Grappe [338c], no. 325; Grappe [338d], no. 370; *Modern Painting, Drawing and Sculpture Collected by Louise and Joseph Pulitzer, Jr.,* vol. 1 (Cambridge, Mass.: Fogg Art Museum, 1957), p. 85, no. 60, illus. 57; Goldscheider [49], p. 44; Descharnes and Chabrun [32], repr. p. 205 (plaster); Tancock [341], no. 88.

OTHER CASTS AND VERSIONS

Bronze

UNITED STATES

New York City, Columbia University, School of Journalism. Presented by the staff of New York *World*. Founder: Henry Bonnard Bronze Company.

St. Louis, Collection Joseph Pulitzer, Jr. Signed: A. Rodin.

Plaster, height 20⅛ inches

FRANCE

Paris, Musée Rodin.

Marble, height 19½ inches

UNITED STATES

St. Louis, Missouri Historical Society. Signed (fig. 96-3).

97 Hanako
1908

Plaster, 6¾ × 4¾ × 4⅝ inches
Signed front of neck to right: A. Rodin

98 Hanako
1908 (executed 1911)

Pâte de verre, 8⅝ × 4¾ × 3½ inches
Not signed or inscribed[1]

In 1908 Loïe Fuller, the celebrated American dancer, introduced Rodin to the Japanese dancer, Ohta Hisa (1868–1945; fig. 97, 98–5), better known as Hanako. Rodin's interest in the dance and dancers of the East probably began as early as 1889 when a troop of Javanese dancers performed at the Exposition Universelle. He returned to this subject in 1896 on the occasion of the visit to Paris of a troup of Javanese dancers and in 1906, when King Sisowath of Cambodia brought the royal ballet of Cambodia to Paris.

Rodin was greatly impressed by Hanako's strength and self-control. "She has no fat at all," he said. "Her muscles are clean-cut and prominent like those of a fox-terrier. She is so strong that she can stand for a long time on one leg with the other lifted at right angles straight in front of her. When like that, she looks as firm as a tree rooted in the ground. Her anatomy is quite different from that of Europeans, but is very beautiful, and has extraordinary power."[2]

As is the case with many of the later portraits, the head of Hanako exists in a number of different versions *(see* figs. 97, 98–2, 3, 4), recording both different expressions and different stages in the development of the same head. A number of these were recorded by Edward Steichen during his stay at Meudon in 1908, when he photographed the statue of *Balzac* by moonlight *(see* Chronology). Grappe, who dates the studies 1908 or slightly later, lists four heads of the dancer, only one of which was cast in bronze.[3] He does not list the head under discussion, nor the two studies which were photographed by Steichen. There are also several drawings of Hanako, one of which is in the Metropolitan Museum of Art.[4] It seems likely that a drawing of a female nude in the Rodin Museum also represents Hanako. Certainly the well-rounded yet muscular forms of the body could well be those of an oriental woman (fig. 97, 98–1).

Judith Cladel watched Rodin model the head of Hanako and it seems that she was referring to number 97 when she said that "Hanako did not pose like other people. Her features were contracted in an expression of cold, terrible rage. She had the look of a tiger, an expression thoroughly foreign to our Occidental countenances. With the force of will which the Japanese display in the face of death, Hanako was enabled to hold this look for hours."[5] It was this intensity of emotion expressed in the features, and no direct physical resemblance, that led Rodin to consider using one of the heads of Hanako as the basis for a portrait of Beethoven.[6]

In a discussion with the English writer Muriel Ciolkowska on the theme of the artist's duty to study nature, Rodin indicated that he intended to represent Hanako in a dying attitude.[7] Whether or not it was his intention, this was the effect achieved when he had one of the studies transposed into *pâte de verre* (no. 98).

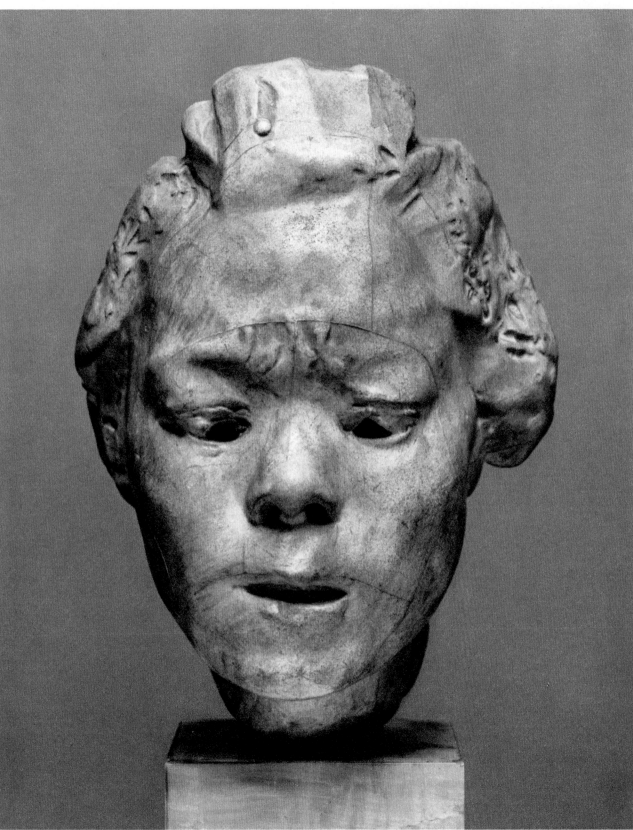

NOTES

1. According to information provided by the Musée Rodin at the time of purchase, this is a unique cast retouched by Rodin.
2. Leslie [69], p.273.
3. Grappe [338d], no.371, bronze (fig.97, 98-2); no.372, plaster, height 18⅛ inches; no.373, terracotta, height 5⅞ inches; and no.423, *pâte de verre*, height 8⅝ inches.
4. For a similar drawing in the Musée Rodin, *see* Descharnes and Chabrun [32], p.254.
5. Cladel [25a], p.162.
6. Grappe [338d], no.372. "Quand Rodin voulut faire un *Beethoven*, il songea à s'inspirer de ces différentes études, mais le projet n'eut pas de suite."
7. Ciolkowska [154], p.267. "Under every expression or gesture lies an invariable principle,—this must be sought, rendered and preserved throughout the work. Thus, while modelling this little head of the Japanese actress, Hanako, I am seeking that essential condition which must be maintained under, for instance, the dying attitude in which I intend to represent her later."

REFERENCES

Hanako (no.97)
Cladel [25a], pp.161-62; Watkins [342], no.87; Leslie [69], pp.272-73; Cladel [27], repr. pl.96 (bronze); Elsen [38], pp.119-20, repr. p.119 (gilded bronze); Tancock [341], no.89.

Hanako (no.98)
Cladel [25a], pp.161-62; Grappe [338], no.279; Watkins [342], no.43; Grappe [338a], no.315; Grappe [338b], no.439; Grappe [338c], no.361; Grappe [338d], no.423; Elsen [38], pp.119-20; Tancock [341], no.90; Tancock [315], p.48, repr. p.48.

OTHER CASTS AND VERSIONS (No.97)

Plaster

FRANCE
Nice, Collection Dr. Barney Kochin. Gift of Rodin to John Marshall.

UNITED STATES
Maryhill, Wash., Maryhill Museum of Fine Arts.

Bronze

FRANCE
Paris, Musée Rodin.

JAPAN
Tokyo, National Museum of Western Art (ex. Collection Matsukata). Signed: A. Rodin.

UNITED STATES
Beverly Hills, Collection Mrs. Jefferson Dickson (ex. Collection Jules Mastbaum). Founder: Alexis Rudier.
Boston, Collection Manuel K. Berman (3 casts). Founder: Georges Rudier. Cast nos. 5, 9, 10.
Cambridge, Fogg Art Museum, Harvard University. Grenville L. Winthrop Bequest, 1943. Purchased in 1926. Unsigned.
New York City, Collection Mrs. Bertram Smith. Founder: Alexis Rudier.
Philadelphia, Collection Mrs. Charles J. Solomon (ex. Collection Jules Mastbaum). Signed: A. Rodin. Founder: Alexis Rudier.
San Francisco, California Palace of the Legion of Honor. Gilded. Inscribed: A l'admirable et géniale artiste, Loïe Fuller. No foundry mark.

OTHER CAST (No.98)

FRANCE
Paris, Musée Rodin.

OTHER PORTRAITS OF HANAKO

Bronze mask, height 6⅞ inches

FRANCE
Paris, Musée Rodin.

GREAT BRITAIN
11 casts in private collections *(see fig.97, 98-2).*

JAPAN
Tokyo, National Museum of Western Art (ex Collection Matsukata). Signed: A. Rodin.

THE NETHERLANDS
Otterloo, Rijksmuseum Kröller-Müller. Purchased from the Musée Rodin in 1950. Signed: A. Rodin.

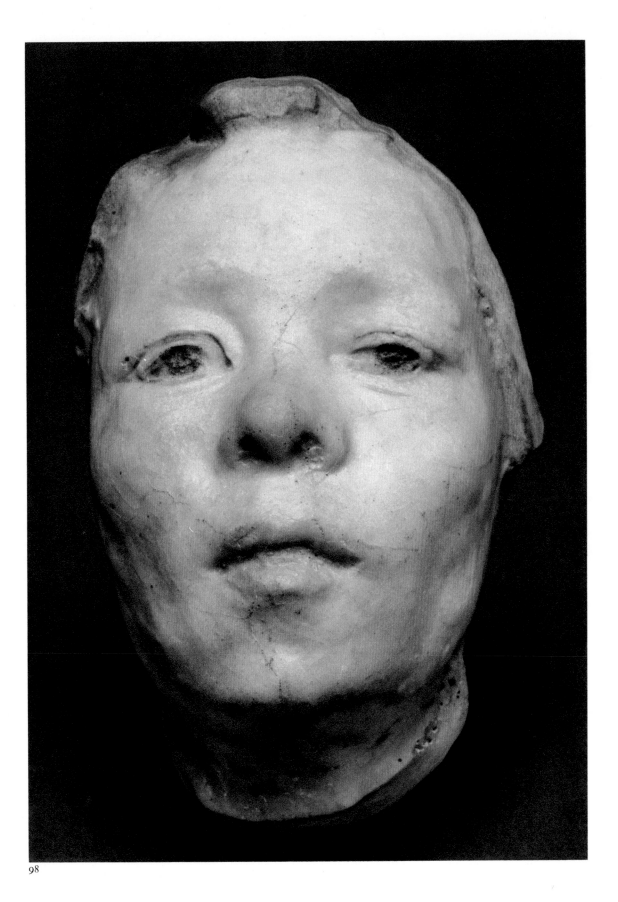

97, 98–1

97, 98–1
Hanako
c. 1908, pencil, 14¼ × 8¾ inches
Rodin Museum, Philadelphia

97, 98–2
Mask of Hanako
c. 1908, bronze, height 6⅞ inches
Private collection

97, 98–3
Head of Hanako
1908, bronze, height 12⅛ inches
Location unknown

97, 98–4
Mask of Hanako
1908, bronze, height 5⅞ inches
Location unknown

97, 98–5
Hanako, c. 1908
Photograph

SWEDEN
Stockholm, Collection of H.M. the King of Sweden. Gift of Rodin to Princess Margaretha, 1912.

UNITED STATES
Cleveland, Cleveland Museum of Art (ex. Collection Salmon Portland Halle. Purchased before Rodin's death). Signed: A. Rodin. Founder: Alexis Rudier.
New York City, Collection Mr. and Mrs. Richard Rodgers (ex. Collection Eugène Rudier).

Terra-cotta

FRANCE
Meudon, Musée Rodin.

Plaster head, height 18⅛ inches

FRANCE
Meudon, Musée Rodin.

Bronze, height 12⅛ inches
Location unknown (fig. 97, 98–3).

UNION OF SOUTH AFRICA
Stellenbosch, Peter Stuyvesant Foundation. Founder: Georges Rudier. Cast no. 8/12.

UNITED STATES
New York City, Collection Daisy V. Shapiro. Founder: Georges Rudier. Cast no. 2/12.
Stanford, Stanford University Art Gallery and Museum. Gift of B.G. Cantor Art Foundation. Founder: Georges Rudier. Cast no. 7/12.

Terra-cotta mask, height 5⅞ inches

FRANCE
Paris, Musée Rodin.

Bronze mask
Location unknown (fig. 97, 98–4).

Bronze mask, height 21 inches

UNITED STATES
Los Angeles, Los Angeles County Museum of Art. Gift of B.G. Cantor Art Foundation. Founder: Godard. Cast no. 2/12.

Plaster

FRANCE
Paris, Musée Rodin.

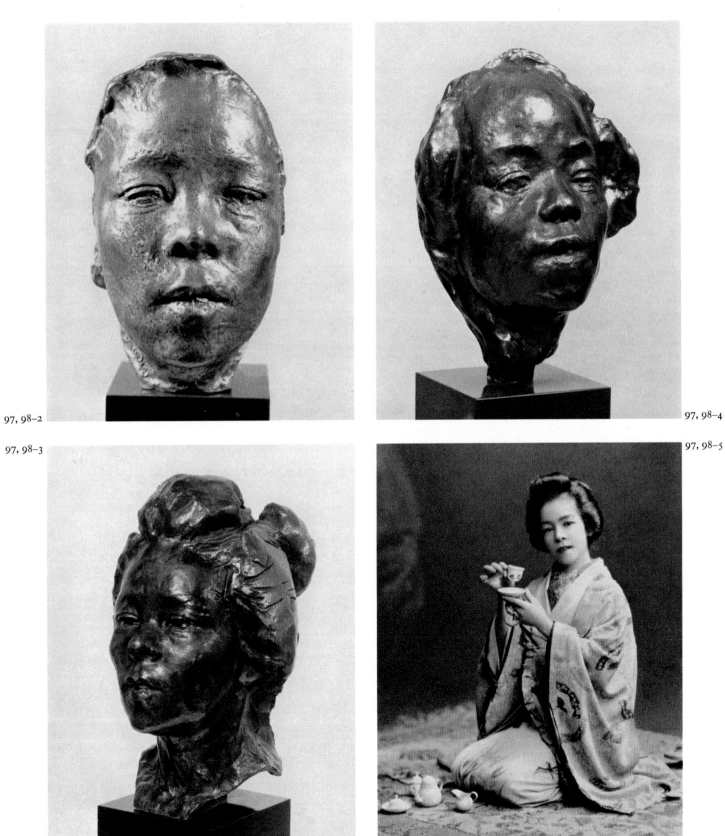

97, 98–2

97, 98–4

97, 98–3

97, 98–5

99 Gustav Mahler

1909

Bronze, 13 ½ × 9 × 8 ¾ inches
Signed center front of neck and on stamp inside: A. Rodin
Foundry mark back of neck to left:
Alexis Rudier/Fondeur. Paris

Gustav Mahler (1860–1911; fig. 99–1), the great Austrian composer and conductor, had already gained a considerable reputation in Paris when Rodin made his bust in 1909. In 1900 he had conducted concerts with the Vienna Philharmonic Orchestra at the Théâtre du Châtelet and at the Trocadéro. In 1905 three of the *Lieder eines fahrenden Gesellen* were sung at the Concerts Lamoureux by Mme Faliero-Dalcroze, and in 1909 his Symphony no. 1 was given at the Salle Gaveau by a visiting orchestra from Munich.

Victor Frisch stated that he introduced Rodin to Mahler during the interval on the occasion of the first performance of Mahler's *Das Lied von der Erde*.[1] However, this is clearly not the case, since although this work was finished in 1908, it did not receive its first performance in Munich until 1911, when the conductor was Bruno Walter. It seems probable, though, that it was Frisch who introduced Rodin to the composer in 1909, although the work they heard was the Symphony no. 1, not *Das Lied von der Erde*.

Rodin was greatly impressed by the appearance of the dying man. To Alma Mahler he said that Mahler's head was a mixture of Frederick the Great's, Franklin's, and Mozart's.[2] Elsewhere the reverberations that Mahler's appearance awoke in him were carried back even further: "I find his features remarkable. There is a suggestion not only of the Eastern origin, but of something even more remote, of a race now lost to us—the Egyptians in the days of Rameses."[3]

It is extremely doubtful that Rodin would have appreciated Mahler's music—his own taste ran to Beethoven, Mozart, and Gluck and not to the music of his contemporaries—but the blend of idealism and pessimism in Mahler's character spoke very directly to him, resulting in one of the finest of his late portrait busts.

The bust of Mahler, emerging from an uncut matrix, was then carved in marble (fig. 99–2), forming a group with the *Victor Hugo* and the *Puvis de Chavannes (see* nos. 87, 90).[4] The radiance of the new material made even closer the kinship that Rodin saw between Mahler and Mozart. It is under the latter name that the portrait of Mahler in marble has always been known.

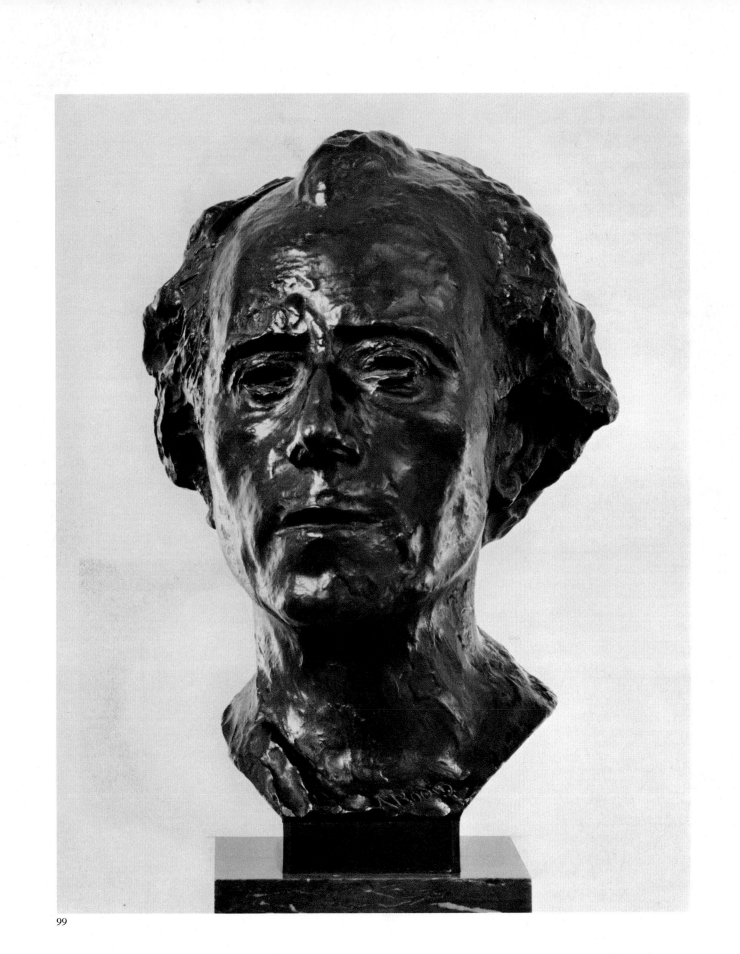

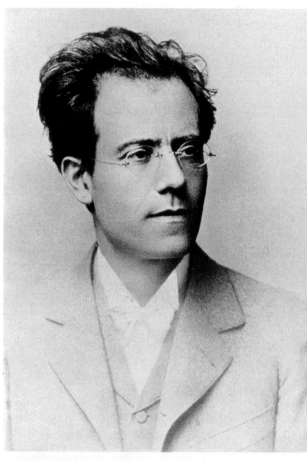

99–1

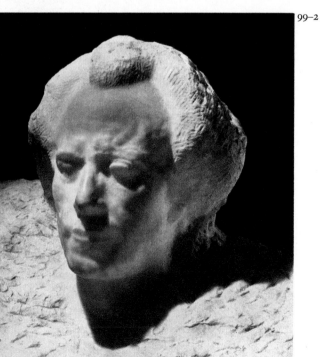

99–2

99–1
Gustav Mahler
Photograph

99–2
Mozart
1910–11, marble, height 12⅝ inches
Musée Rodin, Paris

NOTES

1. Frisch and Shipley [42], p. 438.
2. Statement by Alma Mahler reported by Edward Lockspeiser in *Debussy: His Life and Mind,* vol. 2 (New York: Macmillan, 1965), p. 107, n. 2.
3. Robert MacCameron, "Auguste Rodin: His Life and Work, with a Consideration of the Proposed Rodin Room in the Metropolitan Museum of Art," *Town and Country,* New York, no. 3377 (February 4, 1911), p. 19.
4. In the 1927 and 1929 editions of the catalogue of the Musée Rodin, Grappe assigned a date of 1909 to the marble *(see* [338], no. 312 and [338a], no. 349). In subsequent editions the date was revised to 1910. However, the inscription on the marble in the Musée Rodin reads: "A Rodin. 1911." The work should probably be dated 1910–11.

REFERENCES

Lami [4], p. 169; Grappe [338], nos. 310–12; Watkins [342], no. 27; Grappe [338a], nos. 347–49; Grappe [338b], nos. 416, 417, 432; Grappe [338c], nos. 339, 339 bis, 352; Grappe [338d], nos. 397, 398, 414; Tancock [341], no. 91.

OTHER CASTS AND VERSIONS

Bronze

AUSTRIA
Vienna, Kunsthistorisches Museum, Neue Galerie. Acquired in 1911. Signed: A. Rodin.
— Opera. Gift of Alma Mahler.

CZECHOSLOVAKIA
Prague, Národní Galerie. Acquired in 1935. Signed A. Rodin.

FRANCE
Paris, Musée Rodin. Signed: A. Rodin. Founder: Alexis Rudier.

GERMANY (EAST)
Dresden, Staatliche Kunstsammlungen. Purchased from Rodin in 1912. Signed: A. Rodin.
Mannheim, Städtische Kunsthalle. Acquired in 1929. Founder: Alexis Rudier.

GREAT BRITAIN
London, Collection George Solti.
Montgomery, University of Wales, Gregynog Hall. Bought by Margaret S. Davies before 1918.

SWITZERLAND
Winterthur, Kunstverein. Presented in 1935. Signed: Rodin.

UNITED STATES
Brooklyn, Brooklyn Museum. Acquired in 1922. Signed: A. Rodin.
Cambridge, Fogg Art Museum, Harvard University. Grenville L. Winthrop Bequest, 1943. Signed: A. Rodin. Founder: Alexis Rudier.
New York City, Collection Erich Cohn. Purchased from the Musée Rodin in 1935.
— Collection Bella and Sol Fishko. Founder: Georges Rudier.
— Collection Joseph H. Hirshhorn. Founder: Alexis Rudier.
— Philharmonic Hall. Gift of Erich Cohn.
Washington, D. C., National Gallery of Art. Bequest of Charlotte Walter Lindt in memory of her father, Bruno Walter, 1970. Signed: A. Rodin.

U.S.S.R.
Moscow, State Pushkin Museum of Fine Arts.

Terra-cotta, height 12⅛ inches

FRANCE
Paris, Musée Rodin.

RELATED WORK

Mozart

Marble, height 12⅝ inches

FRANCE
Paris, Musée Rodin. Signed: A. Rodin. 1911 (fig. 99-2).

100 Edward H. Harriman

1909

Bronze, 19¼ × 12 × 7¾ inches
Signed underneath left shoulder: A. Rodin.
Foundry mark rear of base to left:
ALEXIS. RUDIER/Fondeur. Paris

Edward Henry Harriman (1848–1909; fig. 100-1), the railroad executive, began his career as a rebuilder of bankrupt railroads in 1881 with the purchase of the Lake Ontario Southern Railway, which he renamed the Sodus Bay and Southern and sold at considerable profit to the Pennsylvania Railway. In 1883 he entered the Illinois Central directorate, later becoming its vice-president. In 1897 he became a director of the Union Pacific, assuming the presidency in 1903. Harriman pursued a policy of purchasing stocks in railway companies in different sections of the country. It was this policy that led to an investigation of the Harriman lines in 1906–7 by the Interstate Commerce Commission. Also the owner of a steamship line to the Orient and a director of the Equitable Life Assurance Society, Harriman aroused a great deal of hostility because of his pervasive influence. He died in 1909.

In persuading Rodin to make the bust of Mr. Harriman, his family was following a tradition that was already well-established in America. Arthur Jerome Eddy, author of *Cubists and Post-Impressionism,* sat for his portrait in 1898, establishing a precedent that was followed by a number of Americans prominent in business and the world of the arts in the following decade. Mrs. John W. Simpson, one of Rodin's keenest supporters on this side of the Atlantic and the owner of a choice collection of Rodin's work, which is now in the National Gallery of Art in Washington, D. C., sat in 1902; Mrs. Potter Palmer, the Chicago patron of the arts, in 1903; Joseph Pulitzer, in 1907 (*see* no. 96), and Thomas F. Ryan, in 1909. Ryan in particular played an important role in furthering Rodin's reputation in America by donating sculptures to the Metropolitan Museum of Art in New York in 1910 and providing funds for the purchase of other sculptures by Rodin.

There is some doubt as to whether or not Mr. Harriman actually sat for Rodin. Grappe states that the marble was made in 1909 and executed posthumously from photographs.[1] However, W. Averell Harriman, in a communication of June 29, 1967, stated that the bust was made during the last summer of Edward Harriman's life, when he went to Europe for treatment. It was apparently through his wife Mary, who knew Rodin, that the sittings were arranged. Averell Harriman remarks that the bust does not remind him of any photographs in the possession of the family, and he is convinced that the bust was done from life "with photographs, if at all, playing only a minor role."[2]

An unusual feature of this work is the classical drapery which shrouds the sitter's shoulders. This was abandoned, however, in the two marble versions, one of which is in the Musée Rodin in Paris and the other, formerly in the collection of the Harriman family, which is now in the Fine Arts Museums of San Francisco (fig. 100-2).

556

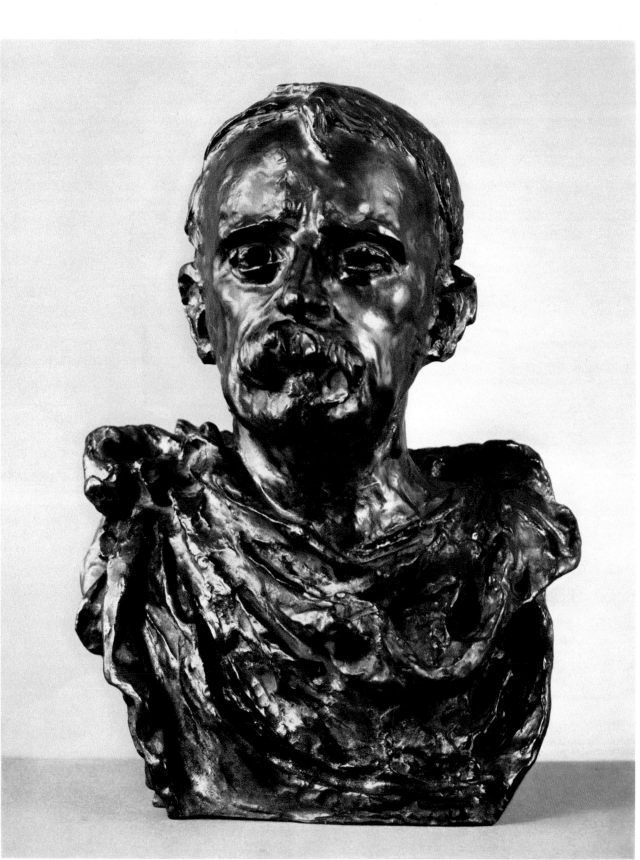

557

NOTES

1. Grappe [338d], no. 394.
2. Personal communication from W. Averell Harriman, June 29, 1967.

REFERENCES

Lami [4], p. 168; Grappe [338], nos. 313–15; Watkins [342], no. 41; Grappe [338a], nos. 350–52; Grappe [338b], nos. 413–15; Grappe [338c], nos. 338, 338 bis, 338 ter; Frisch and Shipley [42], p. 438; Grappe [338d], nos. 394–96; Descharnes and Chabrun [32], repr. p. 204 (plaster); Tancock [341], no. 92.

OTHER CASTS AND VERSIONS

Plaster

FRANCE
Paris, Musée Rodin.

Bronze, height 12⅝ inches

FRANCE
Paris, Musée Rodin.

Terra-cotta, height 10⅝ inches

FRANCE
Paris, Musée Rodin.

Marble, height 15¾ inches

FRANCE
Paris, Musée Rodin.

Marble, height 20¾ inches

UNITED STATES
San Francisco, M. H. de Young Memorial Museum. Gift of W. A. and E. Roland Harriman. Signed: Rodin (fig. 100–2).

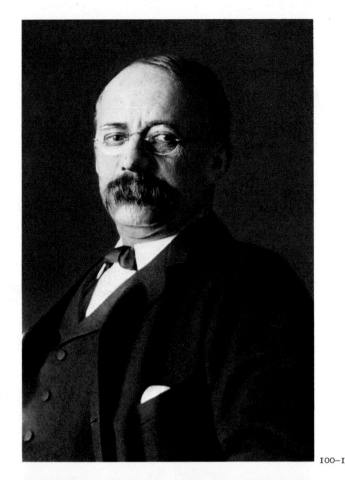

100–1

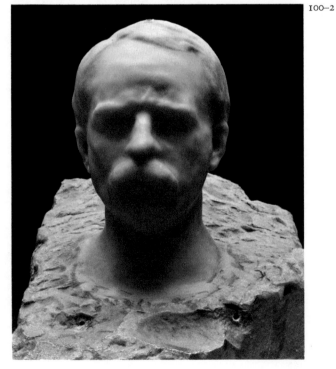

100–2

100–1
Edward H. Harriman, 1907
Photograph

100–2
Edward H. Harriman
1909, marble, height 20¾ inches
Fine Arts Museums of San Francisco
Gift of W. A. and E. Roland Harriman

101 Barbey d'Aurevilly

1909–12

Bronze, 33 ½ × 27 ½ × 22 ¼ inches
Not signed
Foundry mark back of base to left:
Alexis. Rudier. Fondeur. Paris

Jules-Amédée Barbey d'Aurevilly (1808–1889), French novelist and critic, was born at Saint-Sauveur-le-Vicomte in Normandy. As soon as he had taken his university degree, he went to Paris, becoming one of the celebrated dandies of his day. As a youth, Barbey once caught a glimpse of George Brummell when he was British consul at Caen. The sight of this paragon of elegance so impressed him that for the rest of his life he devoted a great deal of attention to his appearance. In the 1830s he crystallized his manner of dressing—a tight-fitting frock coat, a lace jabot and cuffs, tight-fitting white trousers with a stripe of blue, pink, or yellow, a flowing cloak, and a large-brimmed black hat. He continued to dress in the same style until the day he died. His ideas on dandyism were summarized in *Du Dandysme et de G.Brummell,* published in 1845.

It was not only in his clothes, however, that Barbey spoke out against the growing industrialization of society and its attendant blight of conformism. Although the diabolism of certain of his novels—*Une Vieille Maîtresse* (1851) and *L'Ensorcelée* (1854)—brought him into conflict with the Church, Barbey returned to Roman Catholicism in 1855 after a period of decadence. In his later years a fervent monarchist, traditionalist, and devout Catholic, he was greatly admired by authors such as Paul Bourget, Sar Péladan, François Coppée, and Léon Bloy. Bloy referred to Barbey in 1892 as "the greatest of our Catholic writers." It was through the influence of Barbey, in fact, that Bloy was converted to Catholicism.

In 1909 Rodin was asked to make a monument to Barbey d'Aurevilly to be erected at Saint-Sauveur-le-Vicomte, the writer's birthplace. In principle Rodin was averse to making posthumous portraits. No amount of iconographical data could give him full knowledge of all the profiles, so essential to his concept of the portrait. With rare exceptions, in the portraits Rodin made of historical figures—for example, Claude Lorrain and Balzac—his familiarity with the documentary material was secondary to the work done from a living model who closely resembled the person in question. Thus Rodin did not make a portrait of Rembrandt because he could not find a man who resembled him.[1]

In the case of Barbey d'Aurevilly, it is not known that Rodin worked in his customary manner. Given the extravagant nature of Barbey's appearance, it is indeed hardly likely that he would have found anybody who resembled him. But Louise Read, Barbey's secretary

101-1

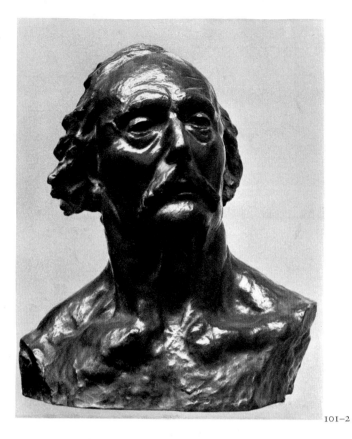

101-2

101-3

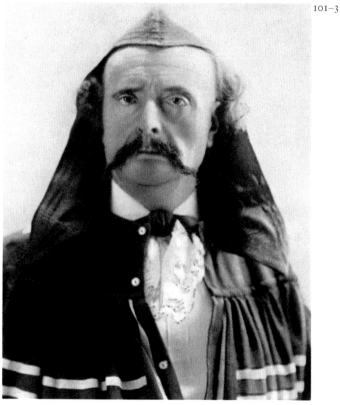

101-1 *Monument to Barbey d'Aurevilly*
1909–12, bronze, height 33½ inches
In front of château, Saint-Sauveur-le-Vicomte

101-2 *Barbey d'Aurevilly*
1909–12, bronze, height 18½ inches
Musées Royaux des Beaux-Arts de Belgique,
Brussels

101-3 Barbey d'Aurevilly in working clothes
Photograph

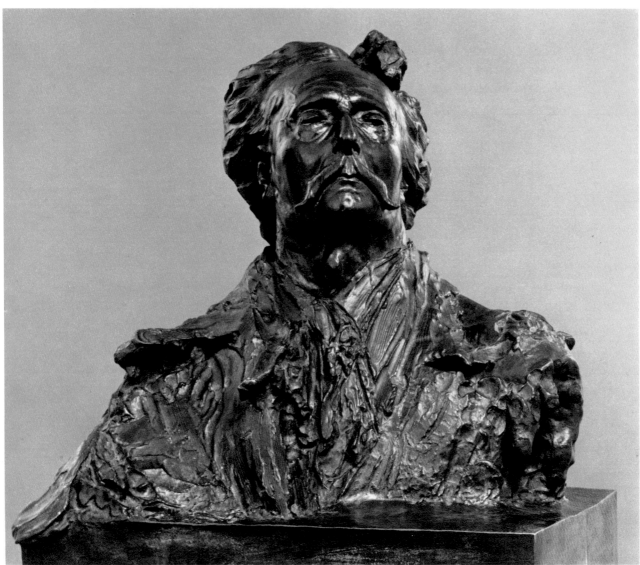

101

and helper from 1879 until his death in 1889 and protector of his estate after he died, loaned Rodin a cast of Barbey's death mask. Using this, together with photographs *(see* fig. 101–3), Rodin was able to create an astonishing image of the arrogant and aging dandy.

In addition to the wax study, height 11 inches, to which Grappe assigns a date of 1909,[2] there is a life-size bronze study (fig. 101–2), in which the poet is shown with bare shoulders, and a life-size plaster study of the head alone, in which the treatment of certain details, notably the hair and the mustache, is more subdued. The enlarged bronze bust, identical with the Philadelphia bronze, was not inaugurated at Saint-Sauveur-le-Vicomte until 1912 *(see* fig. 101–1).

NOTES

1. *See* Werth [111], p. 22.
2. Grappe [338d], no. 392. Descharnes and Chabrun [32], p. 214, assign a date of 1901 to the wax study, although they give no reason for this earlier dating.

REFERENCES

L'Art et les Artistes [330], p. 58; Jean de Bonnefon, "L'Ame de Rodin (La matière animée)" in *Triptyque d'âmes: Chopin, Rodin, Barbey d'Aurevilly,* Paris: Picard, 1926, pp. 23–46; Grappe [338], nos. 316, 317; Watkins [342], no. 42; Grappe [338a], nos. 353, 354; Grappe [338b], nos. 411, 412; Grappe [338c], nos. 337, 337 bis; Grappe [338d], nos. 392, 393; Grappe [54], no. 144, repr. p. 133; Tancock [341], no. 93.

Plaster (head alone), height 15 inches

FRANCE
Paris, Musée Rodin.

Plaster, height 18½ inches

CZECHOSLOVAKIA
Prague, Národní Galerie. Acquired in 1935.

Bronze

BELGIUM
Brussels, Musées Royaux des Beaux-Arts de Belgique (fig. 101–2).

OTHER CASTS AND VERSIONS

Bronze

FRANCE
Saint-Sauveur-le-Vicomte, in front of château. Erected as a monument in 1912 (fig. 101–1).

Wax, height 11 inches

FRANCE
Paris, Musée Rodin.

102 Georges Clemenceau
1911

Bronze, 18½ × 13 × 10 inches
Not signed
Foundry mark rear of base to right:
MONTAGUTELLI Fres / CIRE PERDUE / .PARIS.[1]

Georges Clemenceau (1841–1929; fig. 102–1) was born at Mouilleron-en-Pareds (Vendée). He began his career in medicine, but his interest in radical politics soon became a full-time occupation. After the revolution of 1870, he became Mayor of the eighteenth *arrondissement* in the Montmartre section of Paris. He was elected to the Paris Municipal Council on July 23, 1871, for the Clignancourt *quartier,* a position he held until 1876, when he was elected to the Chamber of Deputies for the eighteenth *arrondissement.*

Clemenceau aligned himself with the extreme left of the Chamber, and in 1880 started the newspaper *La Justice,* which became the voice of the radical movement in Parisian politics. Defeated in the election of 1893, he devoted himself to journalism, becoming an active supporter of Zola in the Dreyfus affair. In 1903 he assumed the directorship of the journal *L'Aurore,* launching a campaign for the revision of the Dreyfus affair and for the separation of church and state.

In 1911 Clemenceau became a member of the Senate and joined its commission for foreign affairs and the army. In the face of the threat from Germany, he became alarmed at the state of French armaments and in 1913 started a new newspaper, *L'Homme Libre,* which conducted an active campaign for greater efficiency in war preparations and, once hostilities had started, in the conduct of the war. In November 1917 Clemenceau was appointed Minister of War in the Poincaré government and from November 1918 to June 1919 was absorbed in the postwar international settlement. In 1920, distrusted by both the right-wing clerical party and by the extreme left, Clemenceau's cabinet fell. He died in 1929.

Rodin's relationship with Clemenceau was rather an uneasy one. Although not, like Degas, actively anti-Dreyfusard, Rodin would not sign the petition on his behalf. After the rejection of the *Balzac* by the Société des Gens de Lettres, a group of Rodin's admirers opened a public subscription for the purchase of the work *(see* nos. 72–76), but he rejected their offer. On hearing of Rodin's attitude, Clemenceau, whose name had been on the list of subscribers, wrote to Mathias Morhardt, organizer of the subscription: "M. Rodin told a member of the staff of *L'Aurore* he was afraid of having too many of Zola's friends among the contributors to the *Balzac* fund. Kindly remove my name from your list."[2]

Clemenceau later told Victor Frisch that through this incident his respect for Rodin the man—although not Rodin the artist—had suffered.[3] In 1911, at any rate, he agreed to sit for his bust, although the encounter was not a happy one. "At every touch of my thumb on the clay," Rodin said, "I could feel that he was displeased; he had a pitying smile on his face.... His sneering expression worried, almost paralysed me."[4]

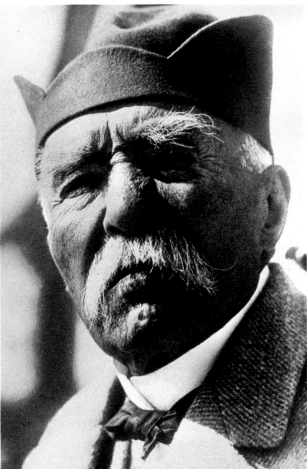

102–1
Georges Clemenceau
Photograph

102–2
Several versions of the bust of Georges Clemenceau
in Rodin's studio (at left is a plaster cast of *Mignon;* no. 80)

102–2

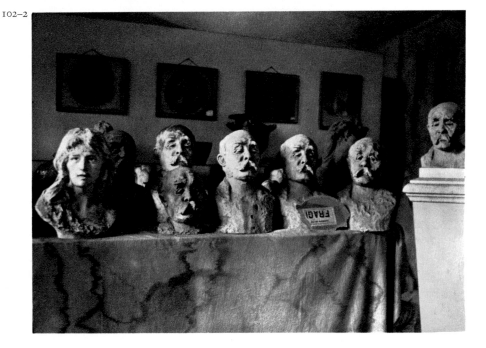

564

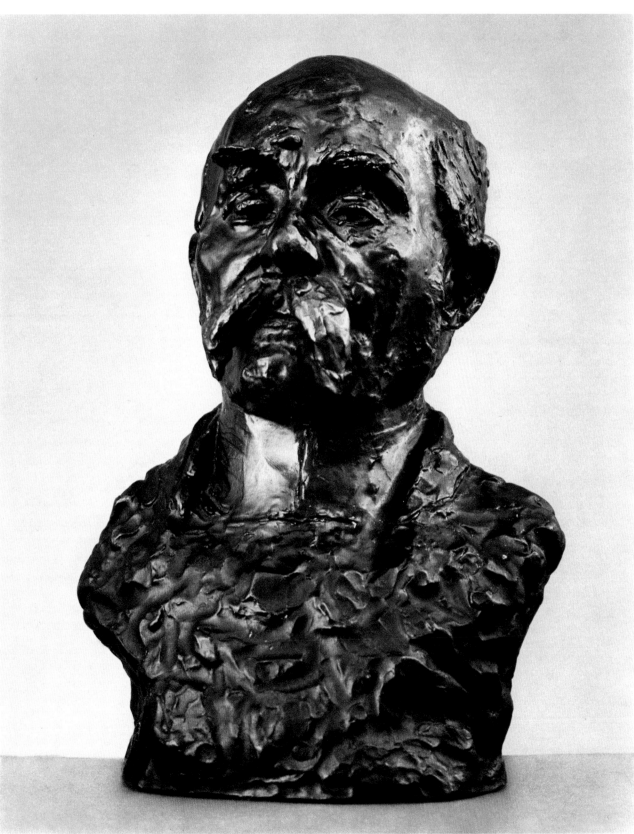

565

Over a period of eighteen sittings, Rodin made some twenty-three studies, each one differing slightly in expression *(see* fig. 102–2). It became increasingly important to Rodin not to obliterate the heightened expressivity achieved through the ever-increasing spontaneity and audacity of his touch. But Clemenceau was no more satisfied with the final version than he was with any of the preceding studies, accusing Rodin of having made an Oriental of him: "Clemenceau is Tamburlaine, Genghis Khan."[5]

Although this work was executed three years before the outbreak of World War I, Rodin perhaps saw in the militant stance of the old statesman the great war leader he was soon to become. It may have been this foresight that distressed him.

NOTES

1. According to information provided by the Musée Rodin at the time of purchase, this is the third cast.
2. Frisch and Shipley [42], p. 241.
3. Ibid., pp. 241–42.
4. Tirel [106a], p. 78.
5. Cladel [26], p. 271. "Clemenceau, c'est Tamerlan, c'est Gengis Khan!"

REFERENCES

Bénédite [130], repr. pp. 14, 15; Bénédite [10a], p. 31, repr. pl. LIX (B); Tirel [106a], p. 78; Grappe [338], no. 346; Watkins [342], no. 56, repr. p. 18; Grappe [338a], no. 384; Grappe [338b], no. 441; Cladel [26], p. 271; Grappe [338c], no. 363; Frisch and Shipley [42], pp. 240–41, repr. opp. p. 225; Story [103], pp. 149–50, no. 114, repr. pl. 114; Grappe [338d], no. 425; Grappe [54], p. 144, repr. p. 135; Story [103a], no. 91, repr. pl. 91; Elsen [38], pp. 128–31, repr. p. 129; Descharnes and Chabrun [32], p. 215, repr. p. 215; Tancock [341], no. 94.

OTHER CASTS AND VERSIONS

At least two versions seem to have been cast in bronze. The one reproduced in Grappe [338d], no. 425, is ⅜ inch higher than the bronze cast in Philadelphia and the base is somewhat smoother. There is also a large egg-shaped indentation toward the right-hand side. This version can be seen at the center of the row of heads on the table in fig. 102–2.

Bronze

CZECHOSLOVAKIA
Prague, Národní Galerie. Acquired in 1936. Signed: A. Rodin.

FRANCE
Paris, Hôtel Matignon.
— Musée Rodin. Founder: Alexis Rudier.
— State War Department.

UNITED STATES
Greenwich, Collection Herbert Mayer. Founder: Georges Rudier. Cast no. 7/12.
New Orleans, Isaac Delgado Museum of Art. On loan from Pierre B. Clemenceau.
Stanford, Stanford University Art Gallery and Museum. Gift of B. G. Cantor Art Foundation. Founder: Georges Rudier. Cast no. 12/12.

Plaster

FRANCE
Colmar, Musée d'Unterlinden. Société Schongauer.
Paris, Musée Rodin (23 preliminary studies).

103 Pope Benedict XV
1915

Bronze, 9½ × 6¾ × 9¾ inches
Signed base of neck to right: A. Rodin
Foundry mark rear of base to left:
Alexis. Rudier/Fondeur. Paris

Giacomo della Chiesa (1854–1922; fig. 103–1) was appointed Archbishop of Bologna by Pius X in December 1907. In May 1914 he became a cardinal and on September 3 of the same year was elected Pope, assuming the name of Benedict XV.

A group of Francophiles in the Vatican made arrangements for Albert Besnard, then Director of the French Academy in Rome, to paint a portrait of the Pope and for Rodin to make a bust. Late in 1914 Rodin left for Italy in the expectation of making a bust of the Pontiff, although it proved to be impossible to arrange sittings on this first visit. He returned to Rome on April 8, 1915, and commenced work, but problems soon arose.

Albert Besnard, to whom the Pope gave only four sittings, related that it was the Pope's dream to restore to the papacy the position of supremacy it once held in the arts.[1] He expected portraits of him to be suitably flamboyant, imparting nobility in the manner of the great Baroque artists, Hyacinthe Rigaud, Antoine Coysevox, and Giovanni Lorenzo Bernini. It is hardly surprising that he soon became alarmed at the intense physical and psychological scrutiny to which Rodin was subjecting him. To Rodin's annoyance, the Pope would not sit still, but turned around as Rodin moved about him to observe the profiles. Nor would the Pope permit himself to be observed from above. He soon grew tired of the immobility that the sculptor imposed on him, and Albert Besnard reports that the Pope was heard saying to a member of his entourage: "I will not, absolutely not, pose any longer." "'Why don't you copy the bust of Count Lipaï (the Austrian sculptor)?' the Pope asked our national figure. 'It would be much quicker.'"[2]

Needless to say Rodin did not respond favorably to this idea, and at the end of the third sitting the Pope indicated that the next sitting would be the last. The portrait of Pope Benedict XV is thus a long way from being finished, but few papal portraits compare with it in the intimacy of the approach and the ruthless portrayal of physical infirmities.

As far as the work in hand was concerned, this was a frustrating trip for Rodin, but the visits to Rome in the last years of his life were marked by pleasures that perhaps compensated for his professional disappointments. He was able to revisit the sites and the works of art that had meant so much to him as a youth and to make new discoveries as well. Albert Besnard tells how Rodin went to the courtyard of the Palazzo Farnese to see the bronze cast of *The Walking Man* that had been installed there in 1912 and how he spent hours caressing the antique sculptures in the French Academy. The painter accompanied Rodin on some of his walks, and he noted the enthusiasm with which he now greeted the work of Bernini: "A walk in Rome with Rodin. He never tires of admiring the busts of

Bernini. I can see very clearly what it is that impresses him; it is the science of arrangement. He walks around them like a man looking for the answer to a secret."[3]

With increasing age Rodin's taste became catholic in the extreme, and he responded with equal delight to a broad range of sculpture, from that of Southeast Asia to the major accomplishments of the European Baroque. Concerning the latter, an anonymous author stated:

> He could assure himself once again that he was not mistaken in forcing himself to reinstate the "Rococo" style (sometimes known as Jesuit), and that masterpieces of an incontestable beauty remain to us from the seventeenth and even parts of the sixteenth and eighteenth centuries. It is only in the last eight or ten years that justice has been done to this period. For a long time it was said that anything from this period was ugly. No doubt fashion will change, and perhaps the "Rococo" and "Jesuit" styles will regain their prestige at the expense of another period which will not deserve such disfavor.
>
> And yet, where Bernini is concerned, how can one doubt the beauty of this art? asked Rodin. Bernini—architect, painter, and sculptor—was a great artist. I was most impressed by his Fontana di Trevi; surrounded by tritons, Neptune allows a mass of bubbling water to flow over and around him, and its passionate and majestic life animates and makes the little Roman square where it is found seem much bigger. Bernini can also be seen in the Piazza Navona, where the water passes through rocks, tritons, and obelisks. This is also very beautiful.[4]

Somewhat surprisingly Rodin even had something to say in favor of the Victor Emmanuel monument, declaring it to be a "praiseworthy work of modern art that does not dishonor at all the magnificent city in which it is located."[5]

In spite of Rodin's enthusiasm for the Baroque and the Neo-Baroque, however, the bust of Pope Benedict XV does not depart in spirit from the principle that governed his entire *œuvre*, that of slavish devotion to nature. It was a portrait of Giacomo della Chiesa that Rodin executed and not one of the Supreme Pontiff.

103–1
Pope Benedict XV
Photograph

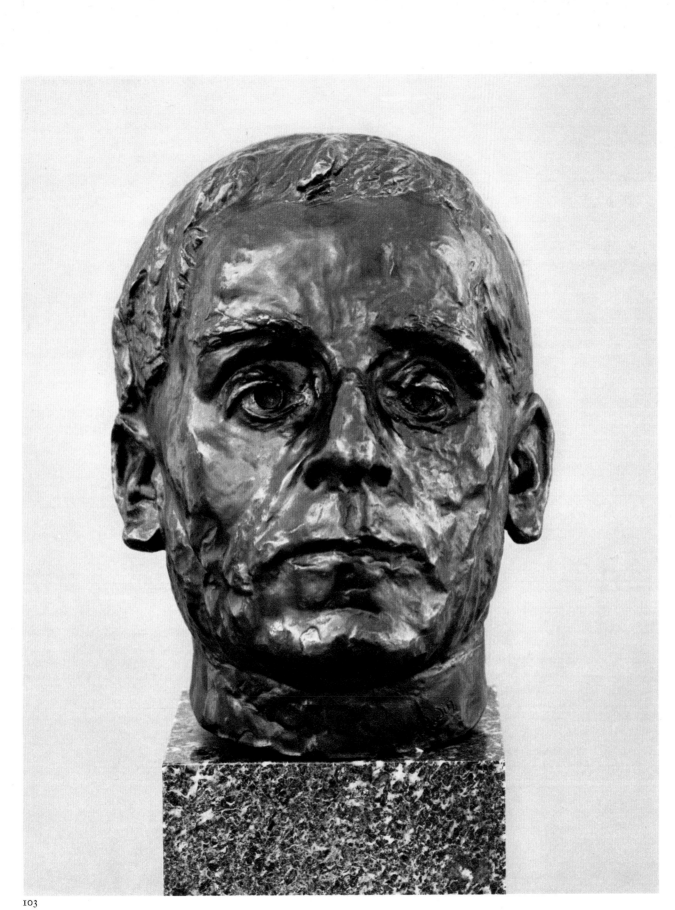

NOTES

1. Cladel [26], pp.306–7. "Il s'agissait, ... d'une grande toile à la Rigaud. Le pape, homme minuscule, a des idées de grandeur et même de luxe. Il veut rétablir l'esthétique papale et se prêterait par conséquent à un grand effet de mise en scène."

2. Albert Besnard, *Sous le ciel de Rome* (Paris: Les Editions de France, 1925), p.236. "Rodin, qui était venu à Rome une seconde fois pour le buste du pape, en est reparti, il y a huit jours, découragé par son modèle qui ne voulait plus lui accorder de séance, se disant fatigué de l'immobilité que lui imposait le sculpteur. 'Je ne veux plus, je ne veux plus poser,' disait-il à quelqu'un de son entourage.... Ce pape est encore jeune, et l'immobilité le fatigue. 'Pourquoi ne copiez-vous pas le buste du comte Lipaï (le sculpteur autrichien),' disait Benoît XV à notre Rodin national, 'cela irait plus vite?'"

3. Ibid., p.199. "23 novembre 1914... Promenade dans Rome avec Rodin. Il ne se lasse pas d'admirer les bustes du Bernin. Je vois bien ce qui le touche là-dedans, c'est la science de l'arrangement. Il tourne autour en homme qui cherche un secret."

4. *Le Temps*, Paris, February 20, 1912. "Il a constaté que de la Porte Saint-Jean à la porte de la voie Appienne toutes les fortifications romaines étaient demeurées intactes. Il a admiré le monument formidable élevé à Victor Emmanuel et par lequel les Italians ont voulu exprimer l'ardeur, l'élan de leur patriotisme. L'architecture en est diverse; elle commémore la gloire de Rome et elle évoque ses principales époques artistiques. 'L'ensemble est une louable œuvre d'art moderne qui ne déshonore point la cité magnifique.'

"Il a pu s'assurer une fois de plus qu'il ne s'était pas trompé en s'efforçant de réhabiliter le style 'rococo', dit jésuite, et qu'il nous reste de ce dix-septième siècle—il faut même y comprendre une partie du seizième et une partie du dix-huitième—des chefs-d'œuvre d'une incontestable beauté. Il n'y a guère que dix ou huit ans qu'on rend justice à cette époque. Il fut longtemps admis que ce qui nous venait d'elle était laid. La mode va changer sans doute, et peut-être sera-ce au détriment d'une autre époque—qui ne méritera point non plus de défaveur—que le 'rococo' et le 'jésuite' regagneront leur prestige.

"Et pourtant, dit Rodin, quand on a le Bernin, comment peut on douter de la beauté de cet art? le Bernin, architecte, sculpteur, et peintre, était un très grand artiste! On a de lui cette *Fontaine Trévi* qui m'a profondément impressionné: Neptune, entouré de tritons, laisse s'écrouler sur lui, autour de lui, une masse d'eau bruyante, et cela vit d'une vie puissante et majestueuse qui anime et rend plus vaste la petite place romaine où se trouve le monument. Le Bernin est encore sur cette place Navone où l'eau passe parmi les rochers, des tritons, des obélisques. Et c'est aussi très beau."

5. Ibid.

REFERENCES

Bénédite [10a], p.31, repr. pl.59a; Grappe [338], no.355; Watkins [342], no.25; Grappe [338a], no.396; Grappe [338b], no.449; Cladel [26], pp.306–10; Grappe [338c], no.371; Grappe [338d], no.434; Grappe [54], p.144, repr. p.136; Descharnes and Chabrun [32], pp.260, 264, repr. p.262; Tancock [341], no.95, repr. p.82.

OTHER CASTS

FRANCE
Paris, Musée Rodin. Signed: A. Rodin. Founder: Alexis Rudier.

JAPAN
Tokyo, National Museum of Western Art (ex. Collection Matsukata). Signed: A. Rodin.

SWITZERLAND
Geneva, Musée d'Art et d'Histoire.

UNITED STATES
Los Angeles, Los Angeles County Museum of Art. Gift of B. G. Cantor Art Foundation. Founder: Georges Rudier. Cast no. 7/12.

VATICAN CITY
Istituto per le Opere di Religione. Gift of B. G. Cantor Art Foundation. Founder: Georges Rudier. Cast no. 5/12.

104 Etienne Clémentel
1916

Bronze, $20\frac{3}{8} \times 21\frac{5}{8} \times 11$ inches
Signed on left shoulder: A.Rodin
Foundry mark rear of right shoulder:
Alexis RUDIER/Fondeur. PARIS.[1]

Etienne Clémentel (1864–1936; fig.104–2) was born and educated at Riom. As a young man he took painting and modeling lessons with the intention of entering the Ecole des Beaux-Arts, but family pressures forced him to follow a different profession. In 1889 he purchased a notary's office at Riom, pursuing a political career in that town which finally led to his becoming mayor. In 1900 he became deputy for the Puy-de-Dôme and in January 1905 entered the Rouvier cabinet as Minister for the Colonies.

Subsequently Clémentel became Minister of Agriculture in the Barthon cabinet, and for four years, 1915–19, in the cabinets of Briand, Ribot, Painlevé, and Clemenceau, he held the post of Minister of Commerce, becoming the founding President of the International Chamber of Commerce. He occupied various political positions during the next decade, but in 1930 ill health forced him to retire. He returned to painting and died at Prompsat (Puy-de-Dôme) on December 25, 1936.

Clémentel became close to Rodin in the last years of the sculptor's life. On April 1, 1916, Clémentel went to Meudon to obtain Rodin's signature on the provisional contract for the bequest of Rodin's works and property to the state. It was Clémentel, in his capacity as Minister of Commerce, whom Judith Cladel approached when, due to the rapid decline in Rodin's health and the unscrupulous behavior of some of his associates, the situation at Meudon seemed to be getting out of control.[2] He arranged for the studios at Meudon to be guarded by officials from the Ministry of Fine Arts and drew up the will, duly signed by Rodin, in which it was stated that all prior wills were null and void and that the part of his estate not left to the French government was to go to Rose Beuret. He was again present at the signing of the second donation of September 13, 1916, and was one of the witnesses at Rodin's marriage to Rose Beuret on January 29, 1917. He ultimately became one of the three executors of Rodin's will.

Clémentel informed Judith Cladel[3] that the bust Rodin had made of him was done shortly before the master fell ill. Since Rodin's health began to decline seriously about March 1916, it seems probable that he worked on the bust in the early months of that year. Following his normal procedure (see Introduction), Rodin made plaster casts of the bust at various stages of its development, thereby retaining the freshness of the modeling and obviating the risk of overworking the clay. Thus this bust exists in at least two versions, that in the Rodin Museum being one of the first studies for the bust. In the second slightly more developed version (fig.104–1), the base is shaped differently.

Clémentel affirmed that the bust was left unfinished by Rodin. He asked Judith Cladel if her brother Marius would be prepared to finish it, but she was of the opinion that only someone thoroughly familiar with the master's work should be permitted to complete it.[4] Jules Desbois, Rodin's most faithful assistant, was approached, but he declared that it should not be touched, even though the back of the head was unfinished.[5] Fortunately his advice was followed and it was decided not to complete it.

By the time he worked on the portrait, Rodin's health and mental equilibrium had been sadly impaired, but the brilliant spontaneity and sureness of the modeling of this bust confirm that there had been no decline in his sculptural ability. Rodin's last bust—and last work—compares favorably with the best of the busts produced in the 1880s.

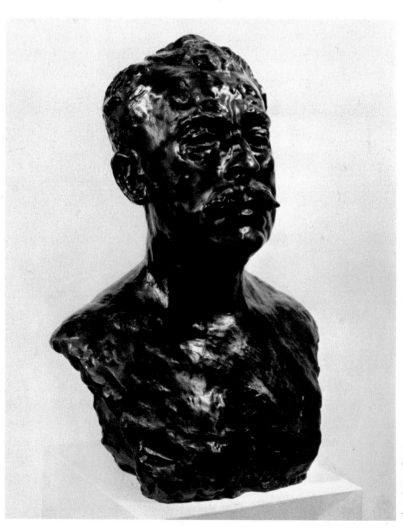

104–1
Etienne Clémentel
1916, bronze, height 21⅝ inches
Hirshhorn Museum and Sculpture
Garden, Smithsonian Institution,
Washington, D.C.

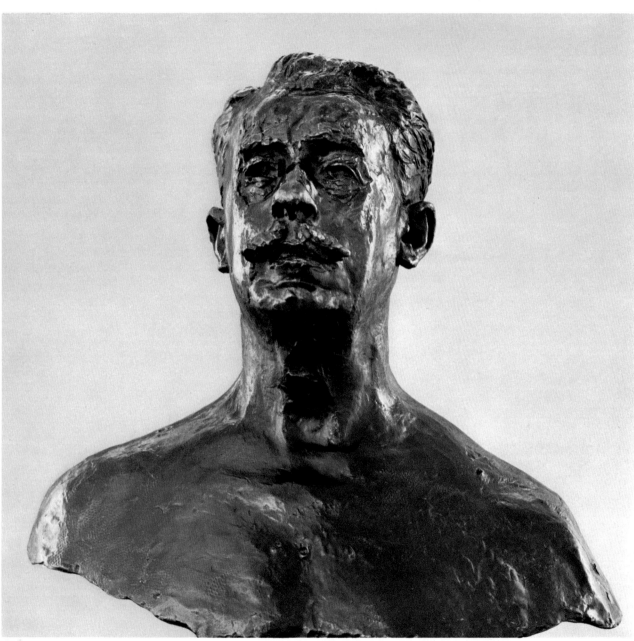

104

573

104–2

NOTES

1. This work was acquired for the Rodin Museum in 1968 with W. P. Wilstach funds.
2. Cladel [26], p. 331.
3. Ibid., p. 335.
4. Ibid.
5. Ibid., p. 366.

REFERENCES

Grappe [338], nos. 358, 359; Grappe [338a], nos. 399, 400; Grappe [338b], nos. 451, 452; Cladel [26], pp. 334, 335, 339, 341, 350, 351, 358–59, 361, 366, 388, 392–93; Grappe [338c], nos. 373, 373 bis; Grappe [338d], nos. 435, 436; Elsen [38], p. 213; Descharnes and Chabrun [32], pp. 262, 265, repr. p. 262; Tancock [341], no. 96.

104–2
Etienne Clémentel reading a eulogy
at Rodin's funeral

OTHER CASTS

Bronze

ALGERIA
Algiers, Musée National des Beaux-Arts. Acquired in 1931.

FRANCE
Paris, Musée Rodin. Signed: A. Rodin. Founder: Alexis Rudier.
Riom, Musée Municipal F. Mandet.

JAPAN
Tokyo, National Museum of Western Art (ex. Collection Matsukata). Signed: A. Rodin.

Bronze, height 21⅝ inches

FRANCE
Paris, Musée Rodin. Signed: Rodin. Founder: Alexis Rudier.

UNITED STATES
Washington, D.C., Hirshhorn Museum and Sculpture Garden, Smithsonian Institution. Founder: Alexis Rudier (fig. 104–1).

ALLEGORICAL PORTRAITS

105 Flora

1865–70

Terra-cotta, painted brown,
13¾ (excluding base) × 8 × 7¾ inches
Signed right side of shoulder: A. RODIN
Inscribed in pen and ink on back of base:
Certifié par Rodin/le 16 Juillet 1910/à son atelier
182 rue/de l'Université.

As a young man, Rodin's taste was in no way opposed to that of his contemporaries. He admired Carrier-Belleuse and Carpeaux and shared their admiration for French sculpture of the eighteenth century. "In my youth," he said, "I thought for a long time like the others that the Gothic was bad; I only understood it through traveling."[1] "There is no such thing as ugliness," he said on another occasion. "When I was young, I committed that error, like the others; for me to make the bust of a woman she had to seem pretty, according to my own particular idea of Beauty; today [1908] I would make the bust of any woman and it would be as beautiful."[2]

Auguste Rodin's earliest portraits—*Jean-Baptiste Rodin* of 1860 *(see pl. 2)* and *Father Pierre-Julien Eymard* of 1863 *(see no. 78)*—were of male subjects and were strongly influenced by the austere classicism of the busts of David d'Angers. In the latter part of the 1860s, however, portraits of females predominate, Rodin choosing the sitters not for strength of character or facial distinction but for girlish charm. Not surprisingly, it is no longer the influence of d'Angers that is felt but that of Carrier-Belleuse and especially Carpeaux, for whom Rodin had had the greatest admiration ever since he first encountered him at the Petite Ecole.

These works are remarkable for their elegance, charm, and the brio of their execution. They are also a signal proof of the young Rodin's astonishing facility, his ability to express himself with felicity in any number of styles. Dating from the same period as the *Flora* are the following works: *Young Girl with Disheveled Hair;*[3] *Young Girl with Flowers in Her Hair* (fig. 105-1); *Mme Cruchet;*[4] *Young Girl with Roses on Her Hat* (fig. 105-2); *Woman with Daisies in Her Hat* in the Musée Rodin; *Bust of a Young Girl* in the National Gallery of Art in Washington, D.C. (fig. 105-3); *Bust of a Young Woman* in the collection of Ernestina Llobet de Lavallo in Buenos Aires; *Head of a Bacchante* in the Musée Rodin at Meudon; *Head of a Bacchante* (fig. 105-4); and *Bust of a Smiling Woman* in the Musée Rodin.[5]

According to an oral tradition recorded by Grappe,[6] *Flora* was executed in the years 1865–66, but since there was no proof of this he dated it 1865–70. Until further evidence is forthcoming, this last date must be accepted.[7]

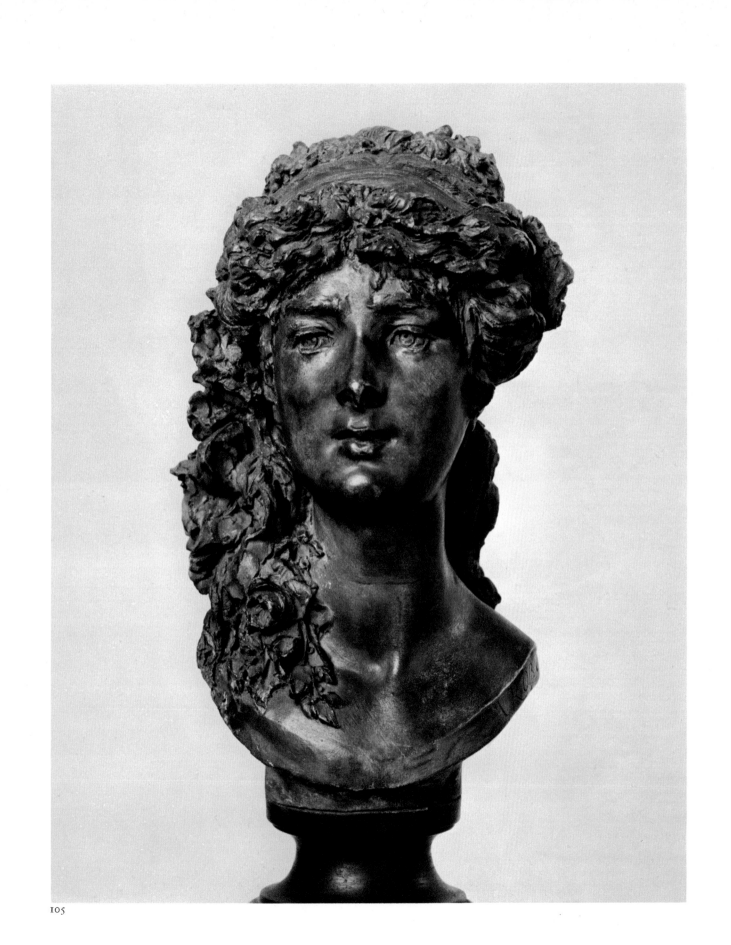

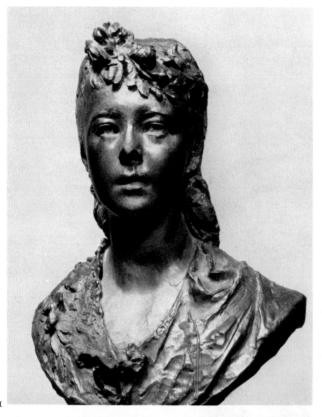

105-1

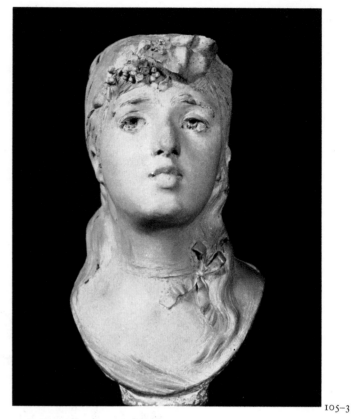

105-3

105-2

105–1
Young Girl with Flowers in Her Hair
1865–70, bronze, height 20½ inches
National Museum of Western
Art, Tokyo

105–2
Young Girl with Roses on Her Hat
1865–70, terra-cotta, height 21 inches
Musée Rodin, Paris

105–3
Bust of a Young Girl (Mme Cruchet?)
c. 1868, terra-cotta, height 12¼ inches
National Gallery of Art, Washington, D.C.
Gift of Mrs. John W. Simpson, 1942

105–4
Head of a Bacchante
1865–70, terra-cotta, height 15⅜ inches
Location unknown

105–5
Bust of a Woman
1875?, terra-cotta, height 19¼ inches
National Gallery of Art, Washington, D.C.
Gift of Mrs. John W. Simpson, 1942

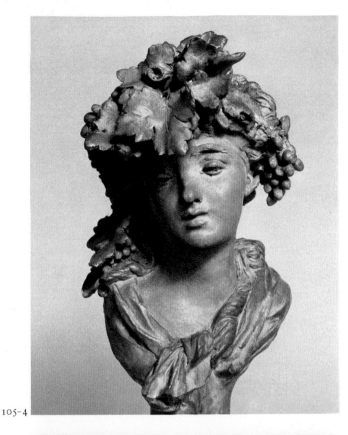

105-4

105-5

NOTES

1. Judith Cladel, "Rodin et l'art gothique," *La Revue Hebdomadaire*, Paris, no. 45 (November 7, 1908). "Dans ma jeunesse, j'ai cru longtemps comme les autres, que le gothique était mauvais; je ne l'ai compris qu'en voyageant."
2. Cladel [25], p. 116. "Il n'y a pas de laideur. Quand j'étais jeune, je commettais cette erreur, comme les autres; pour que je fisse le buste d'une femme, il fallait qu'elle me parût jolie, selon mon idée particulière de la Beauté; aujourd'hui, je ferai le buste de n'importe quelle femme, et ce sera aussi beau."
3. Grappe [338d], no. 9.
4. Ibid., no. 13.
5. The *Bust of a Woman* in the National Gallery of Art in Washington, D.C. (fig. 105–5) bears the following inscription: "offert à madame &/monsieur J. W. Simpson/ A Rodin/1908/terre-cuite originale faite/en 1875." Mirolli [81], p. 120, n. 1, points out that stylistically this piece belongs to the group of portraits of the 1860s. If it does date from 1875, it does not resemble any other work made in that period.
6. Grappe [338d], no. 10.
7. Jianou and Goldscheider [65], p. 84, date *Flora* 1866–70.

REFERENCES

Watkins [342], no. 36; Grappe [338a], no. 3 bis; Grappe [338b], no. 10; Grappe [338c], no. 10; Grappe [338d], no. 10; Grappe [54], p. 140, repr. p. 28; Cladel [27], repr. pl. 2; Goldscheider and Aubert [339], repr. p. 26; Tancock [341], no. 97.

OTHER CAST

Tinted plaster, height 18½ inches

FRANCE
Paris, Musée Rodin.

RELATED WORKS

Young Girl with Disheveled Hair

Terra-cotta, height 14½ inches

FRANCE
Paris, Musée Rodin.

Young Girl with Flowers in Her Hair

Plaster, height 20½ inches

FRANCE
Paris, Musée Rodin.

Bronze

FRANCE
Paris, Musée Rodin.

JAPAN
Tokyo, National Museum of Western Art (ex. Collection Matsukata). Signed: A. Rodin (fig. 105–1).

Head of a Bacchante

Tinted plaster, height 19 inches

FRANCE
Meudon, Musée Rodin.

Terra-cotta, height 15⅜ inches

Location unknown (fig. 105–4).

Bust of a Smiling Woman

Plaster, height 16½ inches

FRANCE
Paris, Musée Rodin.

Mme Cruchet

Terra-cotta, height 10⅝ inches

BELGIUM
Brussels, Musée d'Ixelles.

FRANCE
Paris, Musée Rodin. Cast from the example in Brussels.

UNITED STATES
San Francisco, California Palace of the Legion of Honor. Spreckels Collection.

Bust of a Young Girl (Mme Cruchet?)

Terra-cotta, height 12¼ inches

UNITED STATES
Washington, D.C., National Gallery of Art. Gift of Mrs. John W. Simpson, 1942. Inscribed: Buste. fait. en. 1868/retrouvé. offert. A. Mme K. Simpson/en 1908/A. Rodin (fig. 105–3).

Young Girl with Roses on Her Hat

Terra-cotta, height 21 inches

FRANCE
Paris, Musée Rodin (fig. 105–2).

Woman with Daisies in Her Hat

Terra-cotta, height 23 inches

FRANCE
Paris, Musée Rodin.

106 La Lorraine
1872–75

Terra-cotta, painted red, 15¼ × 10½ × 8 inches
Signed back of base in center: A Rodin[1]

Like so many works in Rodin's *œuvre,* the dating of *La Lorraine* must remain speculative. In the first two editions of the catalogue of the Musée Rodin,[2] Grappe dated the work under discussion 1880, while admitting that stylistically it was altogether out of keeping with Rodin's work of the late 1870s. In subsequent editions,[3] he revised the dating to 1877 because an example of the bust bearing that date had been discovered, although he did not state where it was found. In all five editions, he suggested that a bust dating from about 1872 and bearing the title *The Daughter of Mme Angot* might be identical with *La Lorraine.*[4]

This may or may not be the case, but certainly a dating of about 1872 is more acceptable on stylistic grounds than one of 1877. With its smooth surfaces, the detailed treatment of the accessories, and its rather superficial charm, it is particularly close to the frankly decorative sculpture of Carrier-Belleuse. In Rodin's own *œuvre* it is closer to the *Suzon* and *Dosia* (figs. 106–1, 106–2), which were purchased by the Compagnie des Bronzes in Brussels in 1872 and cast commercially on a large scale, than to any of the portraits done after 1877.[5] It cannot, however, be dogmatically stated that Rodin ceased working in this style after 1876, the year of his return from Italy and of his revulsion against his *péchés de jeunesse,* as he was never consistent stylistically. As late as 1914, for example, he produced a bust in his youthful style at the request of Lady Sackville.[6]

Without knowledge of the particular circumstances surrounding the origins of *La Lorraine,* it seems most reasonable to assign to it a date of 1872–75, placing its production in the period of Rodin's life when the need to sell resulted in the creation of a group of works in which his particular qualities are the least evident.[7]

NOTES

1. The unusual form of the signature, more flamboyant than that later adopted by Rodin, may eventually enable a more precise dating to be made. This piece was at one time in the collection of Omer Dewavrin. It was purchased from Mme Dewavrin by F. and J. Tempelaere, from whom it was acquired by Mr. Mastbaum.
2. Grappe [338], no. 22; [338a], no. 34.
3. Grappe [338b], no. 40; [338c], no. 35; [338d], no. 37.
4. Grappe [338d], no. 37.
 "Vers 1872, un buste portant le titre de *La Fille de Mme Angot* peut faire penser qu'il s'agit de la *Lorraine.* De même vers 1882, le *Courrier de l'Art* signalait que Rodin travaillait à un buste de *Manon Lescaut.* On parlait déjà à cette époque de la mise prochaine à la scène, par Massenet de l'héroïne de l'abbé Prévost. Exhumée alors du fonds ancien pour lui donner quelque actualité, c'est probablement la *Lorraine* qui se trouve accommodée aux nécessités du jour.
 "Il exista aussi une *Modestie* qui parut entre 1880 et 1886 à diverses petites expositions; appelée la *Fiancée* ou l'*Accordée de village* avec une coiffe différente, elle fut aussi la *Paysanne* et la *Jeune fille à la croix.*"
5. This information is contained in Christiane de Boelpaepe, *Le Séjour de Rodin en Belgique,* Brussels, 1958, and is quoted in Mirolli [81], p. 131, n. 1. A photograph preserved in the archives of the Rodin Museum depicts a terra-cotta(?) head of a

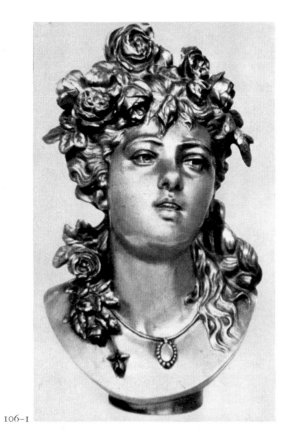

106-1

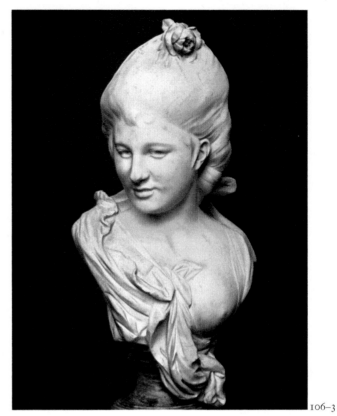

106-3

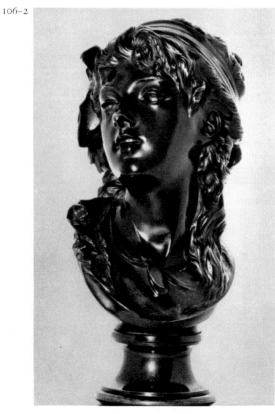

106-2

106-1
Dosia
1872, bronze, height 16½ inches
Collection Mrs. R. Fischer, Buenos Aires

106-2
Suzon
1872, bronze, height 17⅜ inches
R.W. Norton Art Gallery, Shreveport, La.

106-3
Bust of a Woman
1878, marble
Musée des Beaux-Arts, Rennes

582

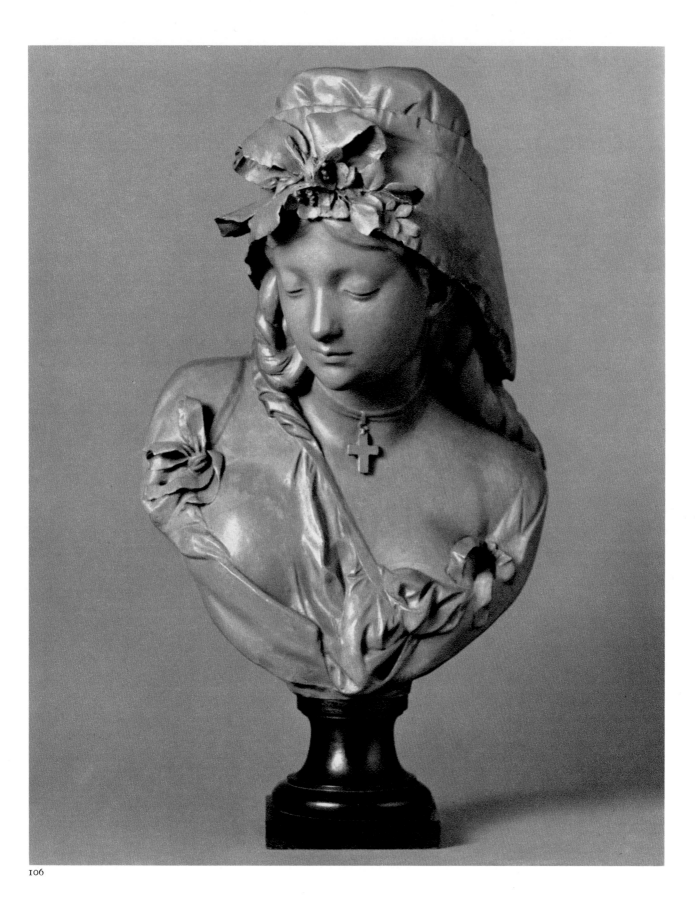

583

young girl which is remarkably close to the *Dosia* in conception. The latter differs from the lost work only in the treatment of the hair and in the addition of a necklace. The lost work is also very close to the plaster(?) bust which Rodin gave to Lady Sackville in 1913 (repr. in Nicholson [269], pl. 49).

6. *See* Nicholson [269], pp. 37–43. While she was sitting for her portrait, a marble version of which is now in the Musée Rodin, Lady Sackville challenged Rodin to produce a bust in the style of the eighteenth century. Rodin agreed to model her in this style in the summer of 1913 and within a few weeks, according to Mr. Nicholson, he produced a bronze statuette on the basis of one of his early works. By June 1914 he had executed a further portrait of her in blue-glazed terra-cotta at the age of eighteen. This is now in the possession of Benedict Nicholson.

7. Mirolli [81], p. 132, groups two other works dated 1877 and 1878 by Grappe—*Young Girl Listening (see* Chronology) and *Bust of a Woman* (fig. 106–3)—with *La Lorraine* and describes them as "the most truly Second Empire works Rodin ever did."

REFERENCES

Grappe [338], no. 22; Watkins [342], no. 34; Grappe [338a], no. 34; Grappe [338b], no. 40; Grappe [338c] no. 35; Grappe [338d], no. 37; Mirolli [81], pp. 131–32; Tancock [341], no. 98.

OTHER CAST

Plaster, height 19¼ inches

FRANCE
Paris, Musée Rodin.

RELATED WORKS

Young Girl Listening

Plaster, height 25⅝ inches

FRANCE
Paris, Musée Rodin. Cast from marble in Grenoble.

Marble, height 24¾ inches

FRANCE
Grenoble, Musée de Peinture et de Sculpture. Gift of la Baronne Nathaniel de Rothschild, 1887.

Bust of a Woman

Marble

FRANCE
Rennes, Musée des Beaux-Arts (fig. 106–3).

Suzon

Bronze, height 17⅜ inches

UNITED STATES
Beverly Hills, Collection Leona Cantor.
New York City, Shepherd Gallery Associates, Inc.
Shreveport, R. W. Norton Art Gallery (fig. 106–2).
Stanford, Stanford University Art Gallery and Museum. Gift of B. G. Cantor Art Foundation.

Bronze, height 9 inches

UNITED STATES
Los Angeles, Charles Feingarten Gallery.

Plaster

FRANCE
Paris, Musée Rodin.

Porcelain, height 15½ inches (including pedestal)

UNITED STATES
Shreveport, R. W. Norton Art Gallery.

Dosia

Bronze, height 16½ inches

ARGENTINA
Buenos Aires, Collection Mrs. R. Fischer (fig. 106–1).

Terra-cotta

FRANCE
Paris, Musée Rodin. Gift of César Wynrocx, 1929.

Plaster

FRANCE
Paris, Musée Rodin.

107 Bellona

1879

Bronze, 30½ × 22¾ × 14½ inches
Signed lower right side of base: A. RODIN
Foundry mark back center of base
ALEXIS RUDIER/FONDEUR PARIS.[1]

In the first two editions of the catalogue of the Musée Rodin,[2] Grappe assigned a date of 1881 to *Bellona*. In subsequent editions, however, he dated the terra-cotta 1878 and the bronze 1881, basing the dating of the former on the fact that it appeared in an exhibition of decorative art early in 1879.[3] Other commentators state that Rodin submitted the work known as *Bellona* in a competition for a bust of *The Republic,* which was announced only in 1879.[4] Since it seems unlikely that Rodin would have tackled this subject and on such a grand scale, solely for his own pleasure, Grappe's dating of 1878 is here rejected and a date of 1879 proposed instead.

The origin of *Bellona*'s baleful glance is well known. Like the screaming countenance of the Genius of War in *The Call to Arms* (no. 66), it was inspired by the appearance of Rose Beuret during one of the violent arguments between Rodin and his mistress that became increasingly frequent as time went on.[5]

The subject of the Republic was extremely popular among sculptors in this politically self-conscious age. Jean Gautherin's *The French Republic* was exhibited at the Salon of 1879, a contemporary critic writing that "the Salon of this year abounds in very unsuccessful statues and busts of the Republic."[6] The *Gallia Victrix* (fig. 107–2) of Augustin-Jean Moreau-Vauthier (1831–1893),[7] a slightly later work, is typical of the helmeted Amazons that were used to symbolize the nation, the Republic, or the various civic virtues. Rodin's work, however, has a fierce vitality that none of the other contemporary personifications has, due in part, no doubt, to its origins in Rodin's stormy personal life. The swelling draperies, the straining tendons of the neck, and the volutes of the superb helmet have a baroque vitality that look back to the *Bellona* of Jan Cosyns of 1697 on the Maison de Bellone in Brussels.[8]

Although the bust of *Bellona* was originally intended to represent the Republic, Rodin himself was fully aware of the difficulties inherent in the personification of such an abstract idea. "When a modern sculptor makes a Republic," he said, "he always makes an ugly slut."[9]

When a cast finally entered the Hôtel de Ville, it was known as *The Republic,*[10] but it was evidently soon recognized that the belligerence of the bust made the title of *Bellona* much more appropriate, and it has been known by this title ever since. Other titles by which *Bellona* has been known are: *Clorinde* (from Tasso's *Jerusalem Delivered); Hippolytus* (the beloved of Phaedra); and *Walkyrie* when a cast was given to Edouard Colonne, leader of the Colonne orchestra.[11]

Rodin returned to the subject of *Bellona* in 1883 when he used it as the subject of a drypoint (fig. 107–1).

NOTES

1. According to information provided by the Musée Rodin at the time of purchase, this is the third cast.
2. Grappe [338], nos. 42, 43; [338a], nos. 59, 60.
3. Grappe [338d], no. 44. "Conçue décorativement, elle était certainement terminée en 1878, puisqu'au début de l'année suivante elle figura à un concours d'art décoratif; mais elle ne connut aucun succès."
4. *See* Bartlett in Elsen [39], p. 46. "In 1879, Rodin entered two competitions, one for a monument to commemorate the defense of Paris, and the other for a bust of the Republic. Neither was successful.... For the latter he made a large head wearing a helmet. Of it, the journal *La France* said: 'A work of singular originality, but which the jury could not accept. Instead of a Republic, it represents a sullen Bellona with a physiognomy very dramatic.' On another occasion the same paper referred to the bust as 'a sculpturesque fantasy, a bedevilled fervor that makes one dream of Carpeaux when in his most audacious moments of imaginative composition."

 See also Ciolkowska [23], p. 42, and Lawton [67], p. 87. The composition was announced in the following words in *L'Art,* Paris, 4 (1879), p. 119. "La Ville de Paris ouvre deux concours: le premier, pour le buste de la République destiné à être placé dans la mairie du XIIᵉ arrondissement et à servir de type pour les autres établissements municipaux. Ce buste aura un mètre de hauteur non compris le piédouche."
5. Cladel [26], p. 237. "Rodin ne cachait pas qu'il l'avait saisie sur le vif, pendant les scènes que sa femme lui prodiguait."
6. Eugène Véron, "La Sculpture au Salon de Paris, 1879," *L'Art,* Paris, 3 (1879), p. 10. "Le Salon de cette année abonde en statues et en bustes de la République fort peu réussis. La seule œuvre de cette catégorie à laquelle nous puissions nous arrêter est le buste de M. Gautherin qui a de la largeur et de la puissance, mais dont l'expression est malheureusement un peu indécise." This work is reproduced opposite p. 10.
7. This bust, formerly in the Musée du Luxembourg, was executed with the aid of the goldsmith Augustin Falize.
8. Descharnes and Chabrun [32], p. 59.
9. "Quand un sculpteur moderne fait une république, il fait toujours une maritonne." This statement was found in one of Judith Cladel's notes contained in the Judith Cladel archives, Lilly Library, Indiana University, Bloomington.
10. Grappe [338d], no. 45. According to an unpublished note in the Cladel archives and to Ciolkowska [23], p. 42, this head was placed in the Ministry of Commerce.
11. Grappe [338d], no. 45.

REFERENCES

Bartlett [125], pp. 100–101; Geffroy [199a], repr. opp. p. 12 (marble); Maillard [71], p. 142; Lawton [67], p. 87, repr. opp. p. 170; Bénédite [10a], p. 27, repr. pl. XIX; Grappe [338], nos. 42, 43; Watkins [342], no. 71; Grappe [338a], nos. 59, 60; Grappe [338b], nos. 50, 51; Grappe [338c], nos. 42, 42 bis; Frisch and Shipley [42], p. 118; Grappe [338], nos. 44, 45; Grappe [54], p. 140, repr. p. 39; Tancock [341], no. 99.

OTHER CASTS AND VERSIONS

Bronze

FRANCE
Paris, Musée Rodin.

JAPAN
Tokyo, National Museum of Western Art (ex. Collection Matsukata). Signed: A. Rodin.

SWEDEN
Stockholm, Nationalmuseum. Acquired in 1907 through Carl Milles. Signed: A. Rodin.

UNITED STATES
Stanford, Stanford University Art Gallery and Museum. Gift of B. G. Cantor Art Foundation (ex. Collection Hugh V. Warrender, who bequeathed it to the Garrick Club, London). Signed. Founder: A. Gruet.

Terra-cotta, height 31 inches

FRANCE
Paris, Musée Rodin.

Marble, height 26 inches

UNITED STATES
Location unknown. Sold Parke Bernet, February 26, 1970, no. 21 (fig. 107–3). (A marble was exhibited at the Monet-Rodin exhibition in 1889 [347], as no. 13. It was also reproduced in *L'Art Français,* July 6, 1889, and in Geffroy [199a], opp. p. 12. Presumably this is to be identified with the marble sold in 1970.)

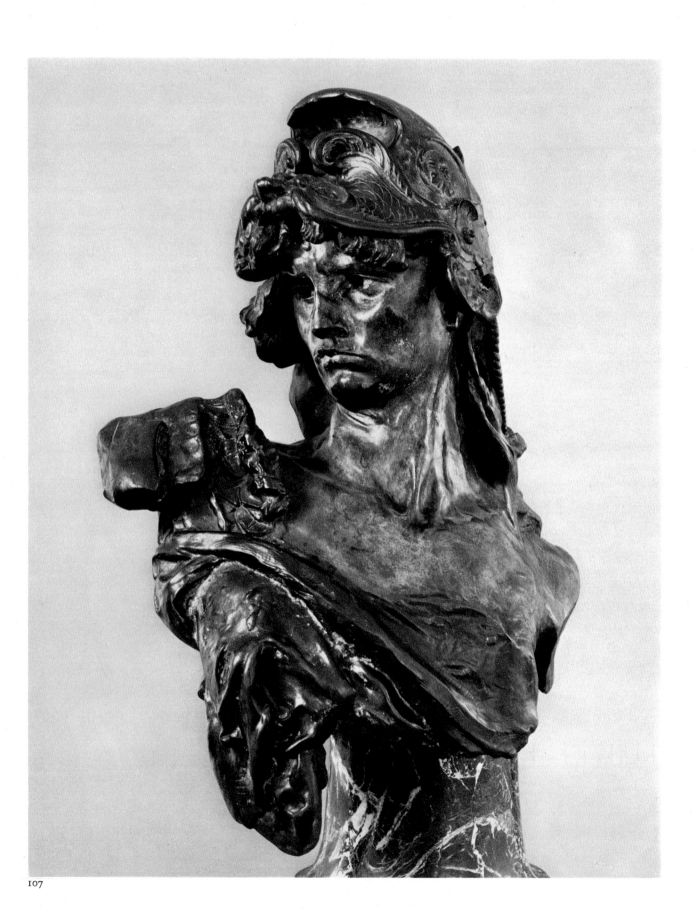

107

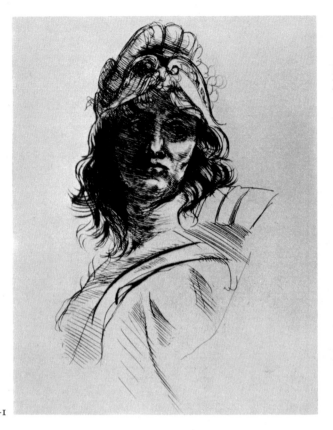

107–1

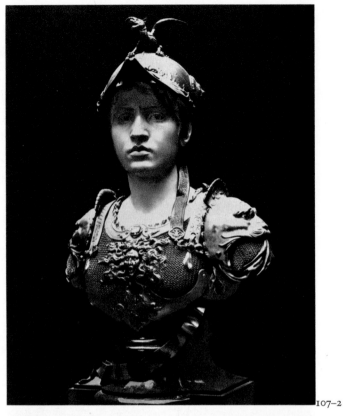

107–2

107–3

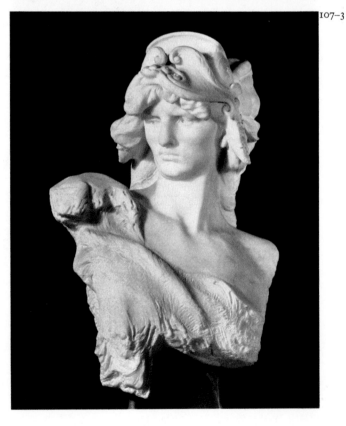

107–1
Bust of Bellona
1883, drypoint, 5⅞ × 3¹⁵/₁₆ inches

107–2
Augustin-Jean Moreau-Vauthier
(1831–1893)
Gallia Victrix
Location unknown

107–3
Bellona
1879, marble, height 26 inches
Location unknown

588

108 Thought
1886–89

Bronze, 17¾ × 15⅝ × 16½ inches
Signed top of base to left: A. Rodin
Foundry mark back of base to left:
Alexis RUDIER./Fondeur. PARIS.

Rodin met Camille Claudel (1864–1943; fig. 108-1), sister of the poet Paul Claudel, in 1883. Recently arrived in Paris, she shared a studio in the rue Notre-Dame-des-Champs with several friends who were also students. From time to time the sculptor Alfred Boucher inspected their work, and it was during one of his absences, when Rodin agreed to stand in for him, that he first met Camille Claudel. She became his constant companion for the next four or five years, the closeness of their relationship leading Edmond de Goncourt to compare the couple with Prud'hon and Mlle Mayer.[1]

None of Rodin's other liaisons caused so much anxiety to Rose Beuret because in Camille, Rodin had found a woman who was not only extremely beautiful but also a sculptor of considerable talent. In the studio she was less an assistant than a collaborator. With her knowledge of anatomy—she had at one time modeled all the bones of the body in clay[2]—Rodin entrusted her with the modeling of the hands and feet of many of his most important works. In the early 1890s the quarrels became fiercer and the breaks more protracted until finally the inevitable and irrevocable break occurred.[3] For Rodin this was shattering, but for Camille, in the words of Paul Claudel, it was "the total, profound and final catastrophe."[4] She withdrew completely from society, living a life of total seclusion until finally, in July 1913, she was removed forcibly to an asylum.

Rodin had the highest opinion of Camille Claudel's merits as a sculptor. "I have shown her where to find the gold," he said, "but the gold she has found is her own."[5] He made every effort to find prospective buyers for her work and to arouse interest in it. In May 1894, for example, he wrote to the critic Raymond Bouyer asking him if he would devote a study to the works of Camille Claudel exhibited at the Salon de la Société Nationale des Beaux-Arts.[6] When the plans for the Musée Rodin were being discussed, it was even proposed that a room be devoted to her work, but Rodin died before this could be arranged. She survived Rodin by twenty-six years, apparently holding him responsible for her mental derangement. "Everything that has happened to me," she wrote to Eugène Blot in 1934, "is more than a novel, it is an epic, *The Iliad* or *The Odyssey*. It would need Homer to relate it, I won't undertake it today, and I do not want to make you sad. I have fallen into the abyss. I live in such a curious, strange world. Of the dream that my life was, this is the nightmare."[7]

Rodin was the subject of several works by Camille Claudel. A number of drypoints date from about 1886,[8] and a fine portrait dates from about 1888.[9] She in turn posed for a number of works by Rodin and probably for many of the figures on *The Gates of Hell* that are no longer identifiable. The first portraits of her date from 1884. In one, her hair

is cut short and worn in a fringe (fig. 108–3), while in the other she wears a Phrygian bonnet (fig. 108–2).[10] About 1885 her features, emerging from a rough-hewn base, were used in the marble *Dawn* (fig. 108–5). Her features were also used in the work entitled *Thought*.

Dated 1888 by Georges Grappe in the first two editions of the catalogue of the Musée Rodin,[11] *Thought* had its dating revised to 1886 in subsequent editions, although on what grounds it is not known. Other commentators, however, state that the work was executed in 1889, and Lami gives the name of the *praticien* as Victor Peter. Grappe refers to a terra-cotta study for this work, known as *The Little Breton* because the headdress used is a Breton marriage cap.[12] It seems possible, therefore, that this first study dates from 1886 and that the marble enlargement was made by Victor Peter in 1889, although in the absence of documentary evidence this dating must remain speculative.

Rodin discussed this work with Anthony Ludovici in 1906.[13] "He said it was an experiment," Ludovici recalled. "He wished to see whether he could make the head so exuberantly alive, so thoroughly pulsating with life, that it imparted vitality even to the inert mass of marble beneath it. 'I wanted the marble below to look as if the blood from that head were circulated through it.'" The experiment cannot be described as particularly successful nor the ambition an elevated one, although the work has since gained considerable popularity. The Philadelphia bronze, which was cast directly from the marble (fig. 108–4), as is evidenced by a comparison of the chisel marks on the marble with the indentations on the bronze, is unique and was presumably specially commissioned by Jules Mastbaum for his museum.

But *Thought* was not the last work in which Rodin used the features of his mistress. From 1892 date two particularly plaintive works, *The Convalescent,* a marble in which the head and hands barely emerge from the rock, and *Farewell* (fig. 108–6), a modified version of the former in plaster in which the forms are more fully delineated. In using the beautiful features of his tormented mistress for these works it seems as though Rodin foresaw the inevitable and rapidly approaching collapse of their liaison.

NOTES

1. Goncourt [53], vol. 4, p. 571.

 "Jeudi 10 mai.

 Marx me parle, ce matin, de la sculpteuse Claudel, de son collage un moment avec Rodin, collage pendant lequel il les a vus travailler ensemble, amoureusement, tout comme devaient travailler Prud'hon et Mlle Mayer.

 "Puis un jour, pourquoi, on ne le sait, elle a quelque temps échappé à cette relation, puis l'a reprise, puis l'a brisée complètement. Et quand c'est arrivé, Marx voyait entrer chez lui Rodin tout bouleversé, qui lui disait en pleurant qu'il n'avait plus aucune autorité sur elle."

2. *See* Marcel Aubert and Paul Claudel, *Camille Claudel,* Musée Rodin, Paris, November-December 1951, p. 5.

3. One can only speculate as to the chain of circumstances that led to the termination of their affair. An interesting sidelight is provided by the statement of Robert Godet that Camille was the object of rivalry between Rodin and Debussy. *See* Edward Lockspeiser, *Debussy: His Life and Mind,* vol. 1 (London: Cassell, 1962), p. 183.

4. *See* n. 2 above, p. 7. "Le divorce était pour l'homme une nécessité, il fut pour ma sœur la catastrophe totale, profonde, définitive."

5. Cladel [26], p. 227. "Je lui ai montré où trouver de l'or, mais l'or qu'elle trouve est bien à elle."

6. Letter reproduced in Descharnes and Chabrun [32], p. 126.

7. Copy of a letter in the Judith Cladel archives, Lilly Library, Indiana University, Bloomington. Letter to Eugène Blot, May 24, 1934. "Tout ce qui m'est arrivé est plus qu'un roman, c'est même une épopée, l'Iliade ou l'Odyssée. Il faudrait bien Homère pour la raconter, je ne l'entreprendrai pas aujourd'hui et je ne veux pas vous attrister. Je suis tombé dans le gouffre. Je vis dans un

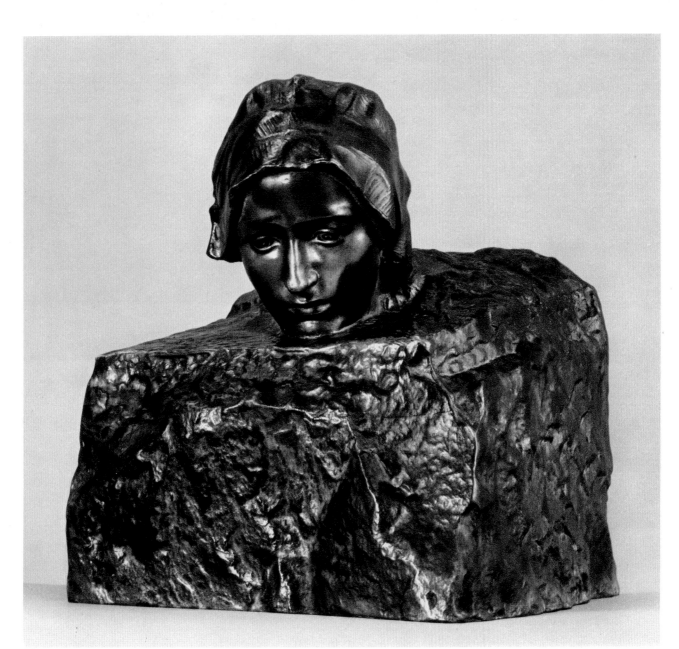

591

monde si curieux, si étrange. Du rêve que fut ma vie, ceci est le cauchemar."

8. Reproduced in Maillard [71], between pp. 20–21.

9. Tinted plaster, 24 × 10 × 12 inches, in the Musée Rodin, Paris. An engraving of it was used as the frontispiece in Maillard [71]. Another bronze cast is in the California Palace of the Legion of Honor, San Francisco.

10. This was cast in *pâte de verre* by Jean Cros in 1911 (*see* nos. 80, 81).

11. Grappe [338], no. 127; [338a], no. 150.

12. There is also a terra-cotta in the Museum der Bildenden Künste in Leipzig which is said to be by Rodin. Not having seen the work, the present writer is not in a position to give an opinion as to its authenticity, although the handling of the clay, applied as if with a spatula, would be most unusual if by Rodin.

13. Ludovici [70], p. 71.

REFERENCES

Maillard [71], p. 134 (repr. on cover); Lawton [67], pp. 86–87, repr. opp. p. 86; Cladel [25a], p. 141, repr. p. 146; Lami [4], p. 167; Bénédite [10a], p. 28, pl. XXIX; Grappe [338], no. 127; Watkins [342], no. 47; Grappe [338a], no. 150; Grappe [338b], no. 187; Grappe [338c], no. 147; Story [103], pp. 18, 145, no. 47, repr. pl. 47; Grappe [338d], no. 165; Grappe [54], p. 142, repr. p. 70; Waldmann [109], pp. 47, 76, nos. 47, 48, repr. pls. 47, 48; Story [103a], no. 47, repr. pl. 47; Elsen [38], p. 116, repr. p. 115; Descharnes and Chabrun [32], p. 127, repr. p. 127; Tancock [341], no. 100.

OTHER VERSIONS

Marble, height 29⅛ inches

FRANCE
Paris, Musée Rodin.

UNITED STATES
Philadelphia, John G. Johnson Collection (fig. 108–4).

OTHER WORKS BASED ON THE FEATURES OF CAMILLE CLAUDEL

Bust of Camille Claudel

Bronze, height 10½ inches
Location unknown (fig. 108–3).

FRANCE
Paris, Musée Rodin.

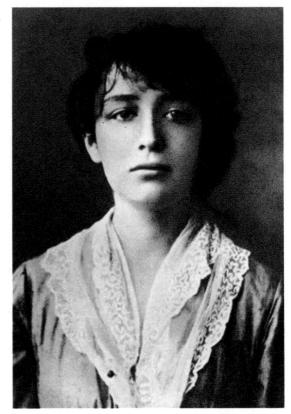

108–1 Camille Claudel
Photograph from *L'Art décoratif,* July 1913

SWITZERLAND
Zurich, Collection Werner and Nelly Bär. Purchased in 1955. Signed: A. Rodin.

UNITED STATES
Beverly Hills, Cantor, Fitzgerald Art Foundation. Founder: Georges Rudier. Cast no. 7/12.
Greenwich, Collection Herbert Mayer. Founder: Georges Rudier. Cast no. 2/12.

Camille Claudel in a Phrygian Cap

Bronze, height 9½ inches

FRANCE
Paris, Musée Rodin.

GREAT BRITAIN
London, Victoria and Albert Museum. Gift of Rodin, 1914 (fig. 108–2).

ISRAEL
Tel Aviv, Tel Aviv Museum. Gift of B. G. Cantor Art Foundation.

JAPAN
Tokyo, Bridgestone Museum of Art.

SWITZERLAND
Lausanne, Collection Samuel Josefowitz. Founder: Georges Rudier.

UNITED STATES
Stanford, Stanford University Art Gallery and Museum. Gift of B.G. Cantor Art Foundation. Founder: Georges Rudier. Cast no. 8/12.

Terra-cotta
FRANCE
Paris, Musée Rodin.

Plaster
UNITED STATES
San Francisco, California Palace of the Legion of Honor. Spreckels Collection.

Pâte de verre
FRANCE
Paris, Musée Rodin.

UNITED STATES
New York City, Collection Mr. and Mrs. Peter Ausnit.

Dawn
Marble, height 22⅛ inches
FRANCE
Paris, Musée Rodin (fig. 108–5).

St. George
Plaster, height 18½ inches
FRANCE
Paris, Musée Rodin (fig. 110–2).

The Convalescent
Marble, height 19⅜ inches
FRANCE
Paris, Musée Rodin.

Farewell
Plaster, height 17¾ inches
FRANCE
Paris, Musée Rodin (fig. 108–6).

108–2 *Camille Claudel in a Phrygian Cap*
1884, bronze, height 9½ inches
Victoria and Albert Museum, London
Gift of Rodin, 1914

108–3 *Bust of Camille Claudel*
1884, bronze, height 10½ inches
Location unknown

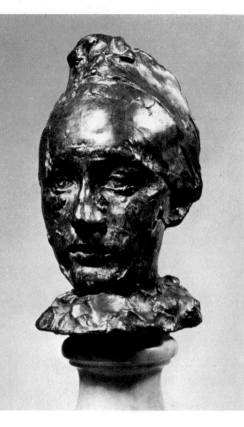

108–2

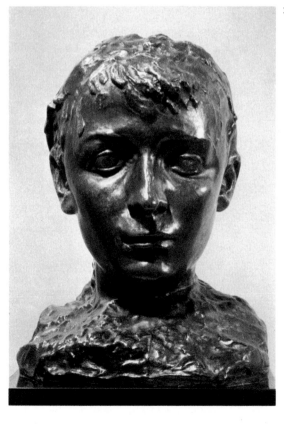

108–3

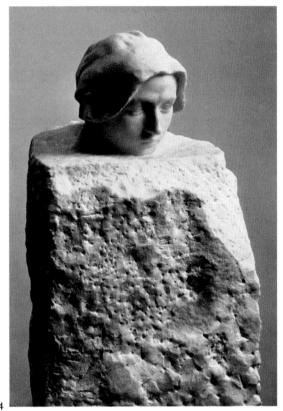

108–4

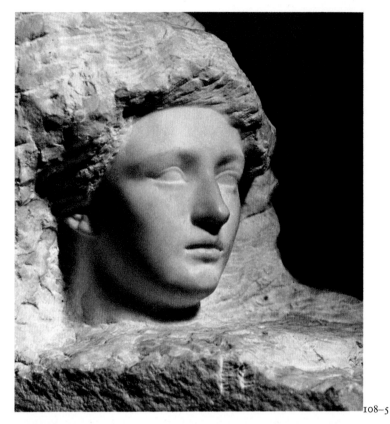

108–5

108–6

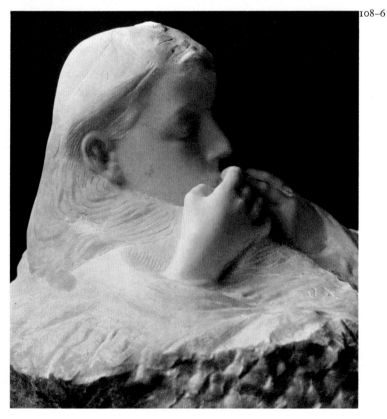

108–4
Thought
1886–89, marble, height 29⅛ inches
John G. Johnson Collection, Philadelphia

108–5
Dawn
1885, marble, height 22⅛ inches
Musée Rodin, Paris

108–6
Farewell
1892, plaster, height 17¾ inches
Musée Rodin, Paris

594

109 Minerva
1896?

Marble, 22½ × 12¼ × 11½ inches
Signed back of work to left: A. Rodin[1]

Sometime before 1888[2] Rodin met Mrs. Mariana Russell, wife of the Australian painter John P. Russell, who lived in the Château de l'Anglais at Belle-Ile. He may even have met her at a considerably earlier period, as Grappe refers to a bust done a long time before the 1888 wax portrait (fig. 109–1),[3] but it has been impossible to identify this bust. (It appears that she read to him from Dante's *Inferno* while he was working on *The Gates.*) The classical purity of Mrs. Russell's features evidently appealed to Rodin, as the 1888 wax portrait was used as the basis for a number of representations of classical deities done during the next decade *(see* fig. 109–2).

The even absorption of light that one finds in a wax, so different from the total absorption of a plaster (fig. 109–3) or the vivacity of the highlights of a bronze, contributes immeasurably to the effect of classical repose. In 1889 the wax bust was cast in silver, and with a somewhat smaller base, the head was then cast in bronze. In a bronze version in the Fogg Art Museum in Cambridge, Massachusetts, the head is mounted on a square base to which is attached the small plaque of *Protection (see* nos. 27, 28).

According to Grappe,[4] a *Study of a Woman* (fig. 109–4), using the features of Mrs. Russell and with classical drapery around the shoulders, was carved in 1890. A second group of works—*Minerva Wearing a Helmet* (fig. 109–7), *Pallas with the Parthenon* (fig. 109–5), and *Pallas Wearing a Helmet* (fig. 109–6)—was executed about 1896. According to Frisch and Shipley, they were done during a second visit to Paris on the part of Mrs. Russell,[5] although there is no reason to suppose that her physical presence was necessary for the execution of these works.

Rodin evidently relished this opportunity to pay homage to the antique world, although some of his experiments are far from successful. The figure of Pallas balancing the Parthenon on her head verges on the ridiculous, while others, such as the marble head wearing a bronze helmet in the Walker Art Gallery in Liverpool, are more bizarre than pleasing. The marble *Minerva Without a Helmet* (fig. 109–8) in the National Gallery of Victoria in Melbourne was also obviously intended to wear a bronze helmet, although for some reason this was never added.

Unlike the majority of Rodin's marbles, the Philadelphia *Minerva,* carved in yellowish marble, is very highly finished. An owl and classical horses and riders are engraved on the helmet, while on the breastplate is what appears to be a head of Medusa. The high degree of finish and the empty nameplate at the base of the work suggest that this marble may have been commissioned to perform a specific decorative function, although thus far it has not been possible to ascertain what this might have been. Until further evidence is forthcoming, a date of 1896 must be assigned to it, this being Grappe's dating for the group of related works.

NOTES

1. This piece was purchased from F. and J. Templaere, Paris.
2. In the 1927 and 1929 editions of the catalogue of the Musée Rodin, Grappe dated the original wax portrait of Mrs. Russell 1889, but in subsequent editions he revised the dating to before 1888, as it was exhibited in silver at the Exposition Monet-Rodin [347], no. 30.
3. Grappe [338d], no. 188. "Il existe un autre buste, mais bien antérieur à celui-ci et qui n'a pas le même caractère. Les deux versions ont été exposées ensemble au Pavillon de l'Alma en 1900 avec la simple mention: Mme R. qui lui avait été précédemment aussi donnée." It is described in the following terms: "Tête modelée avec une simplicité, mais aussi une subtilité extrême, du caractère le plus grave, le plus affectueusement attendri, et quasi religieux."
4. Ibid., no. 247.
5. Frisch and Shipley [42], p. 423.

REFERENCES

Watkins [342], no. 54; Tancock [341], no. 101.

RELATED WORKS

Mrs. Russell

Wax, height 18½ inches

FRANCE
Paris, Musée Rodin.

UNITED STATES
Hamilton, N. Y., Colgate University, Picker Gallery. Purchased in 1955 from the Musée Rodin by Herbert Mayer. Said to be an edition of four. Signed. Inscribed: o.
Stanford, Stanford University Art Gallery and Museum. Signed: Rodin. Inscribed: 1 (fig. 109-1).

Bronze, height 17 inches

FRANCE
Paris, Musée Rodin.

JAPAN
Tokyo, National Museum of Western Art (ex. Collection Matsukata). Signed: A. Rodin.

UNITED STATES
Los Angeles, Los Angeles County Museum of Art. Gift of B. G. Cantor Art Foundation. Founder: Georges Rudier. Cast no. 5/12.

Bronze, height 18¼ inches (mounted on square base with relief of "Protection")

UNITED STATES
Cambridge, Fogg Art Museum, Harvard University. Grenville L. Winthrop Bequest, 1943. Inscribed: a Rosa Bénédite. A. Rodin.

Silver, height 18½ inches

FRANCE
Paris, Musée Rodin.

Plaster, height 13¾ inches

POLAND
Warsaw, Muzeum Narodowe.

UNITED STATES
New York City, Metropolitan Museum of Art. Gift of Rodin, 1912 (fig. 109-3).

Study of a Woman

Marble, height 22½ inches

FRANCE
Paris, Musée Rodin (fig. 109-4).

Pallas Wearing a Helmet

Plaster, height 23⅝ inches

FRANCE
Paris, Musée Rodin.

Marble, height 21¼ inches

FRANCE
Lyons, Musée des Beaux-Arts (as *Tête d'Athéna*). Acquired from Rodin in 1906. Signed: A. Rodin 1905 (fig. 109-6).

Pallas with the Parthenon

Marble and plaster, height 18½ inches

FRANCE
Paris, Musée Rodin (fig. 109-5).

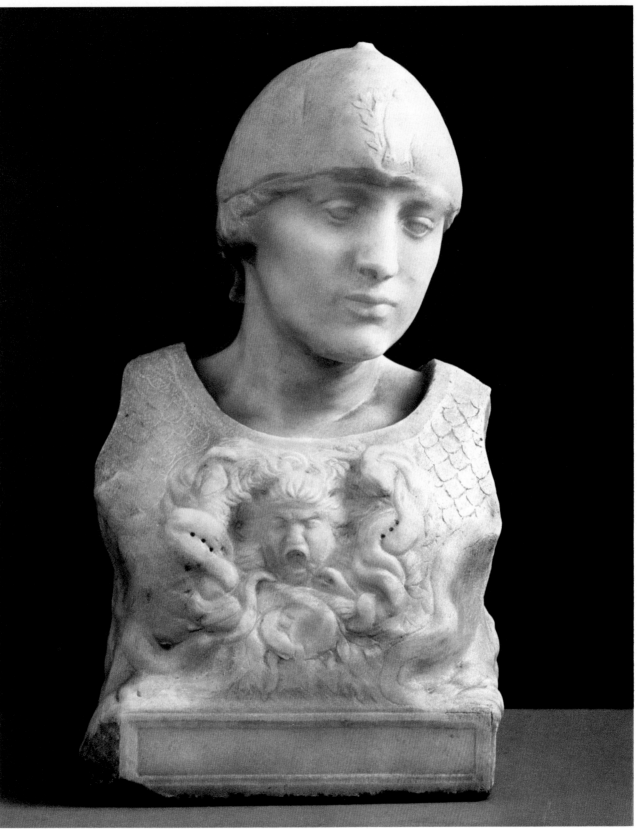

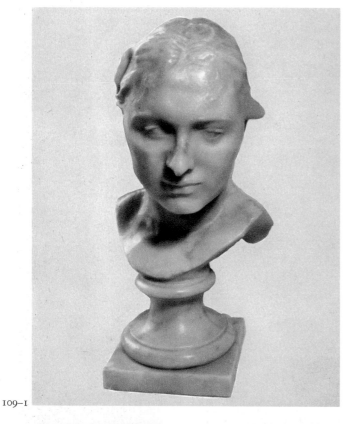

109–1

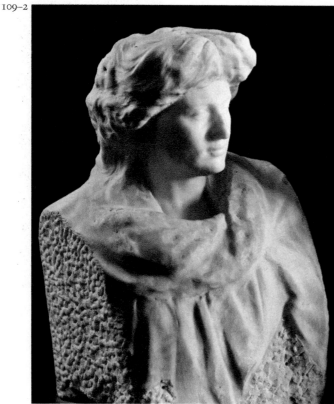

109–2

Minerva Wearing a Helmet

Plaster, height 19¾ inches

FRANCE
Paris, Musée Rodin.

Marble and bronze, height 19 inches

GREAT BRITAIN
Liverpool, Walker Art Gallery (fig. 109–7).

Minerva Without a Helmet

Marble, height 12 inches

AUSTRALIA
Melbourne, National Gallery of Victoria (fig. 109–8).

Ceres

Marble, height 27 inches

UNITED STATES
Boston, Museum of Fine Arts. Acquired in 1910.
 Signed: A. Rodin (fig. 109–2).

109–1 *Mrs. Russell*
 1888, wax, height 18½ inches
 Stanford University Art Gallery
 and Museum, Stanford, Calif. Gift of
 Mr. and Mrs. William Janss

109–2 *Ceres*
 1896, marble, height 27 inches
 Museum of Fine Arts, Boston

109–3 *Mrs. Russell*
 1888, plaster, height 13¾ inches
 Metropolitan Museum of Art,
 New York. Gift of Rodin, 1912

109–4 *Study of a Woman*
 1890, marble, height 22½ inches
 Musée Rodin, Paris

109–5 *Pallas with the Parthenon*
 1896, marble and plaster, height 18½ inches
 Musée Rodin, Paris

109–6 *Pallas Wearing a Helmet*
 1896 (executed 1905)
 Marble, height 21¼ inches
 Musée des Beaux-Arts, Lyons

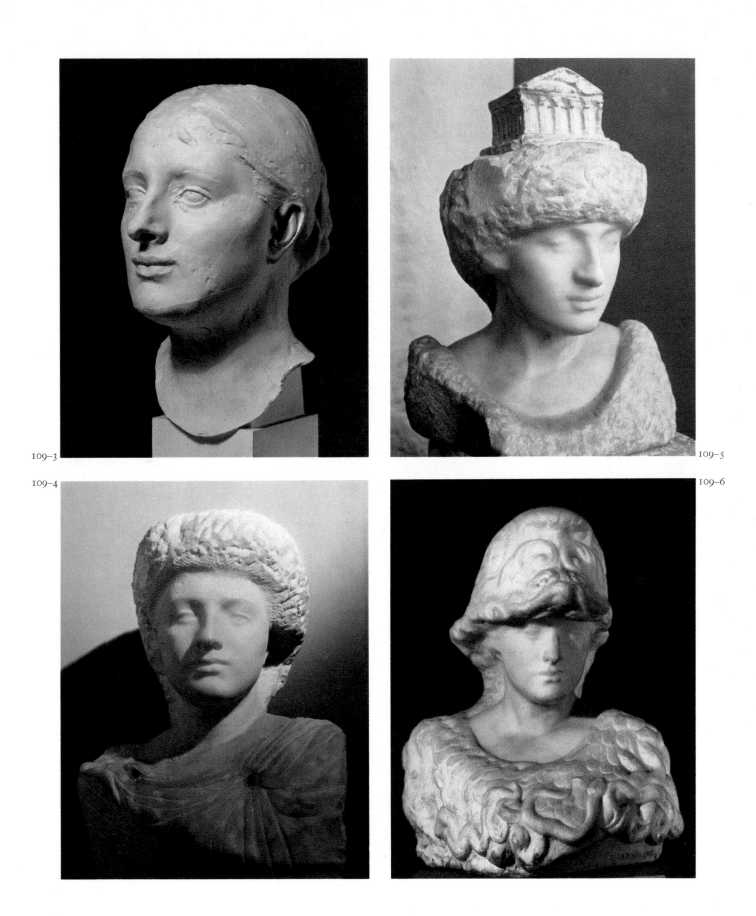

109–3

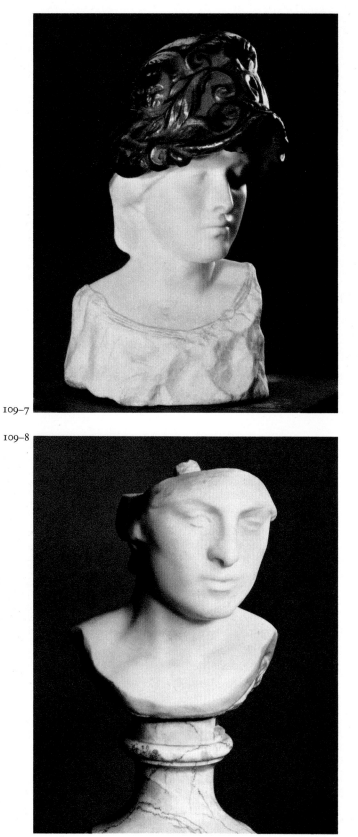

109–7

109–8

109–7
Minerva Wearing a Helmet
1896, marble and bronze, height 19 inches
Walker Art Gallery, Liverpool

109–8
Minerva Without a Helmet
c. 1896, marble, height 12 inches
National Gallery of Victoria, Melbourne

600

110 Study for "La France"
1904

Bronze, 18¾ × 17 × 13 ½ inches
Signed on right shoulder and on stamp inside: A. Rodin
No foundry mark

In the 1927 and 1929 editions of the catalogue of the Musée Rodin,[1] Georges Grappe assigned a date of 1911 to the plaster *Study for "La France"* and to the plaster of the definitive work, in which the head is placed in profile against a plaque (fig. 110–1). In subsequent editions he revised the dating of both works to 1904 (the former in plaster and the latter in bronze), since it appears that a work by the name of *La France* was exhibited at the Salon d'Automne in 1905 and at Versailles in 1907, although it was not listed in the catalogues.

For this personification of France, which is strongly reminiscent of the *St. George* of 1889 (fig. 110–2), Rodin returned to the classically regular features of Camille Claudel, despite the fact that his relations with her had ceased at least ten years before *(see* no. 108). In his discussion of the Rodin sculptures in the Tate Gallery in London,[2] Ronald Alley, ignoring Grappe's reasons for assigning a date of 1904 to both works, redated the definitive version about 1907–8. He based his decision on information obtained from René Chéruy, who had worked as Rodin's secretary from 1902 until 1908 and had seen Rodin making *La France* at the end of 1907 or 1908, shortly before the visit of Edward VII to Meudon. Chéruy described Rodin adding the shoulders and the sketchy helmet, placing the head in relief against a plaster plaque, on which there is the indication of a vault, and calling the work *La France.* Apparently, the following day Rodin took a second cast, repeating the same process, but turned the profile to the left and called it *St. George.*

Writing fifty years after the events described, M. Chéruy may well have forgotten exactly when the events took place, for in 1906 Rodin presented a cast of this work, with the head in profile to the right and called *St. George,* to the University of Glasgow, from which he had recently received an honorary degree. This cast bears a plaque with the inscription: "En déférence à/L'Université de Glasgow/le SAINT-GEORGES/par le docteur/Auguste Rodin." It must have been this work that Chéruy saw Rodin making and in 1906, not 1907 or 1908, the explanation of the change in title being due to the fact that it was being presented to the University of Glasgow and not so as to flatter Edward VII, as surmised by Chéruy. For the reasons outlined, Grappe's date of 1904 for the *Study for "La France"* is retained, while a date of 1906 is proposed for the definitive version.

In 1907 Rodin made a reduction of *La France.* A small plaster of this, with the inscription: "A Julia, Hommage, Rodin," is now in the collection of Violet Hood in London, who modeled for Rodin from 1907 until 1913. Another cast is in the Fine Arts Museums of San Francisco.

In 1912 Rodin used this work again. With a new inscription a cast was presented by the French people to the citizens of the United States to commemorate the tercentenary of Samuel de Champlain, discoverer of the lake which bears his name. The bronze was added to the Champlain monument, a lighthouse on the shores of the lake, and the presentation ceremony took place at Fort Ticonderoga on Lake Champlain on May 3, 1912. An early photograph (fig. 110–3) shows a cast with the following inscription written in chalk: "LE 20 JUILLET 1609 LE FRANCAIS S. CHAMPLAIN/A DÉCOUVERT LE LAC QUI PORTE SON NOM./LE 3 MAI 1912/LES ÉTATS-UNIS/D'AMÉRIQUE/ÉLEVANT/CE MONU-/MENT,/UNE DÉ-/LÉGATION/FRANCAISE/A SCELLÉ/CETTE FIGURE/DE/LA FRANCE."

NOTES

1. Grappe [338], nos. 347, 348; [338a], nos. 385, 386.
2. Alley [334], no. 6052, pp. 215–16. René Chéruy's remembrances were conveyed to Mr. Alley in letters of June 20, 1957, and August 18, 1957.

REFERENCES

Lami [4], p. 167; Grappe [338], no. 347; Watkins [342], no. 38; Grappe [338a], no. 385; Grappe [338b], no. 363; Grappe [338c], no. 299; Grappe [338d], no. 337; Elsen [38], p. 195, repr. p. 194; Tancock [341], no. 102, repr. p. 86.

OTHER CASTS AND VERSIONS

Bronze

ARGENTINA
Buenos Aires, Museo Nacional de Bellas Artes. Acquired at the Alvear Collection Sale.

FRANCE
Paris, Musée Rodin.

ISRAEL
Tel Aviv, Tel Aviv Museum. Gift of B. G. Cantor Art Foundation. Founder: Georges Rudier. Cast no. 6/12.

UNITED STATES
Stanford, Stanford University Art Gallery and Museum. Gift of B. G. Cantor Art Foundation. Founder: Georges Rudier. Cast no. 4/12.
Washington, D.C., National Gallery of Art. Gift of Mrs. John W. Simpson, 1942. Signed: A. Rodin.

Plaster

FRANCE
Paris, Musée Rodin.

Bronze (bust in profile against plaque), height 25¼ inches

FRANCE
Riom, Hôtel de Ville (as *Gallia Victrix*). Signed: A. Rodin. Founder: Alexis Rudier.

GREAT BRITAIN
London, Bethnal Green Museum. Gift of Rodin to the Victoria and Albert Museum, 1914. Signed: A. Rodin. Founder: Alexis Rudier (fig. 110–1).
Glasgow, University of Glasgow. Gift of Rodin, 1906. Inscribed: En déférence à/L'Université de Glasgow/le Saint-Georges/par le docteur/Auguste Rodin.

UNITED STATES
Crown Point, N.Y., Lake Champlain, Champlain Monument. Inaugurated in 1912.
Elkhart, Ind., Collection Walter R. Beardsley. Founder: Montagutelli.

Bronze, height 3⅜ inches

UNITED STATES
New York City, Collection Mrs. Patrick Dinehart (ex. Collection Jules Mastbaum).

Plaster

GREAT BRITAIN
London, Collection Violet Hood. Inscribed: A Julia, Hommage, Rodin, 1907.

UNITED STATES
San Francisco, California Palace of the Legion of Honor. Gift of Alma de Bretteville Spreckels.

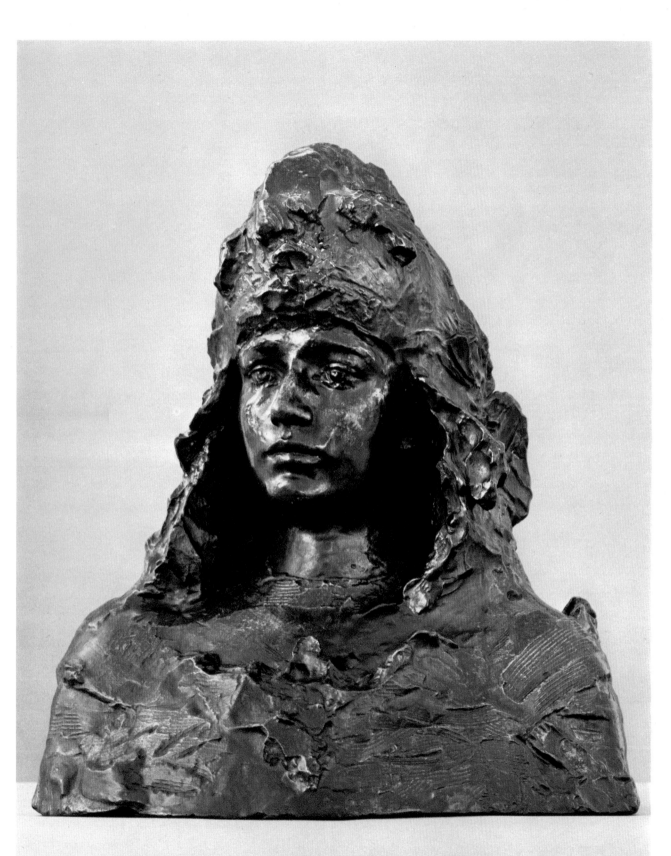

603

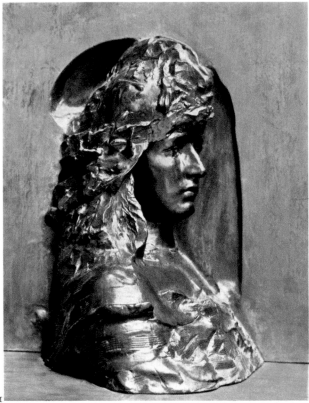

110–1

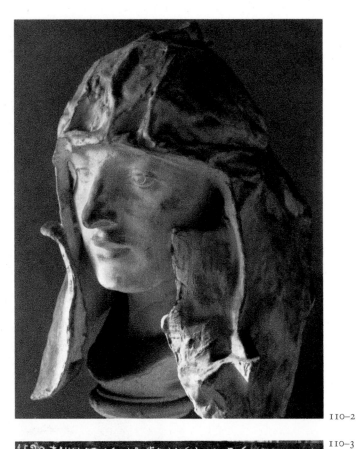

110–2

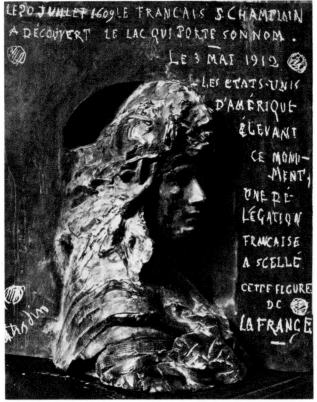

110–3

110–1
La France
1904, bronze, height 25¼ inches
Bethnal Green Museum, London

110–2
St. George
c. 1889, plaster, height 18½ inches
Musée Rodin, Paris

110–3
La France (in course of execution,
showing text of inscription in chalk)

FRAGMENTS
AND ASSEMBLAGES

111 Small Head
c. 1882

Plaster, $2\frac{3}{8} \times 1\frac{5}{8} \times 2\frac{1}{2}$ inches
Not signed or inscribed

112 Head of a Young Girl with Closed Eyes
c. 1885

Plaster, $9\frac{1}{4}$ (including base) $\times 5 \times 5$ inches
Not signed or inscribed

113 Mask of an Old Man
c. 1885

Bronze, $7\frac{1}{2} \times 5 \times 5$ inches
Signed front of neck to left
and on stamp inside: A. Rodin
Foundry mark front of neck to right:
Alexis. Rudier/Fondeur. Paris

114 Head of a Laughing Boy
before 1889

Bronze, $6\frac{3}{8} \times 4\frac{3}{8} \times 5\frac{1}{2}$ inches
Signed on neck to right: A Rodin
Foundry mark back of neck to left:
ALEXIS RUDIER/FONDEUR PARIS

115 Tragic Head
mid 1890s

Bronze, $6\frac{5}{8} \times 4\frac{1}{2} \times 5$ inches
Signed center back of head: A Rodin
Foundry mark back of head to left:
Alexis RUDIER/Fondeur. PARIS.

116 Study of Two Heads and a Hand
mid 1890s?

Plaster, $4\frac{1}{2} \times 4 \times 2\frac{3}{8}$ inches
Not signed or inscribed

117 Head of a Slave
c. 1898

Bronze, $5 \times 3\frac{5}{8} \times 4\frac{1}{4}$ inches
Signed on neck to right: A. Rodin
Foundry mark back of neck to left:
Alexis. RUDIER./.Fondeur. PARIS.

Rodin's working methods *(see* Introduction) left him with an abundance of "spare parts" —entire figures and parts of figures—that were stored on shelves and in drawers at the Villa des Brillants in Meudon and utilized when the need arose *(see* pls. 17–19). Comte Robert de Montesquiou left a vivid account of the sight that met his eyes when he visited Rodin in his studio: "Vast vitrines are full of fragments; clenched hands, convulsive gestures, masks, torsos; I say again, a whole valley of Jehoshaphat of limbs ready to join together again into anatomies full of thought and life when the god of the region, Auguste Rodin, signals the resurrection with his mighty clarion."[1] In addition to the astonishing range of portraits of known individuals *(see* nos. 78–104), there exist a large number of smaller anonymous heads, some of which were doubtless conceived in connection with *The Gates of Hell,* while others are independent studies.

Just above the tomb on the right-hand leaf of *The Gates of Hell* can be seen the kneeling figure of *The Despairing Youth.* Grappe observed that this figure, with his arms raised over his head, seems to be a study for one of the sons in the group of *Ugolino (see* no. 1, detail B) and that is closely related in feeling to *Paolo and Francesca (see* no. 1, detail A) and *The Prodigal Son* (pl. 5). In comparison with the latter work, however, the treatment of the anatomy is much more detailed.

The *Small Head* (no. 111) is a study for the head of *The Despairing Youth,* although it can hardly be seen in the figure on *The Gates of Hell* as it is concealed by a projecting ledge on which the figure of an old man is seated. It is related in feeling to the *Head of Sorrow* (no. 9), but the facial structure is more pronounced, masculine rather than feminine.

According to Grappe,[2] the *Head of a Laughing Boy* (no. 114), to which he assigns a date of before 1889, at one time formed part of the frieze of *The Gates of Hell* and was known as *Infant Faun.* The degree of hilarity which, apart from the manic mirth of the *Duchesse de Choiseul,* is unique in Rodin's œuvre must have led him to decide not to include it in *The Gates.*

The majority of these heads have no pedigree at all, however, and seem to have been occasioned by Rodin's interest in the features of individual although anonymous models. The *Head of a Young Girl with Closed Eyes* (no. 112), with its mocking smile and aquiline nose, seems almost certainly to be a portrait, although there is no means of knowing who it is. It may be dated about 1885, together with heads like *Closed Eyes* and the *Small Head with Turned-Up Nose* (fig. 111–117–1).

Like Géricault, although without his morbid interest in amputated limbs, Rodin used to frequent hospitals, among them the Hôpital Laennec, and many of his studies of deformed limbs must have been inspired by what he saw there. The *Mask of an Old Man* (no. 113) may have been inspired by a hospital inmate, although no references to this work have so far been found. Its contorted features, close to the grimacing masks of Franz Xaver Messerschmidt, are decidedly unusual in Rodin's œuvre. It is suggested that this head was done in the mid 1880s, at the time when Rodin was studying the features of old men for *The Burghers of Calais* (no. 67).

The *Tragic Head* (no. 115),[3] one of the most moving of all these heads, is not connected with any known project, although the rough and powerful modeling, which preserves the imprint of the artist's fingers, makes it seem probable that it was created toward the middle of the next decade, at the time when Rodin was working on the *Balzac* (no. 75).

Head of a Slave (no. 117), sometimes called *Head of a Blind Slave,* is closely related to *The Cry* of 1898,[4] which is a study for the marble entitled *The Tempest* (also called *Terror*

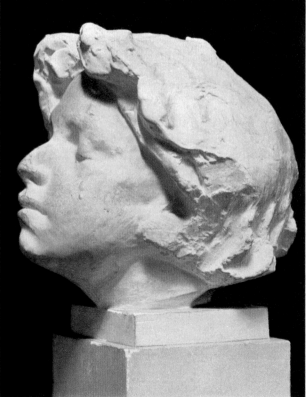

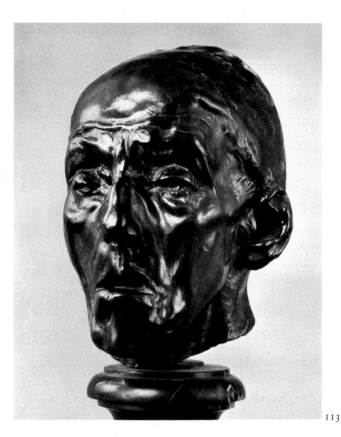

111

112

113

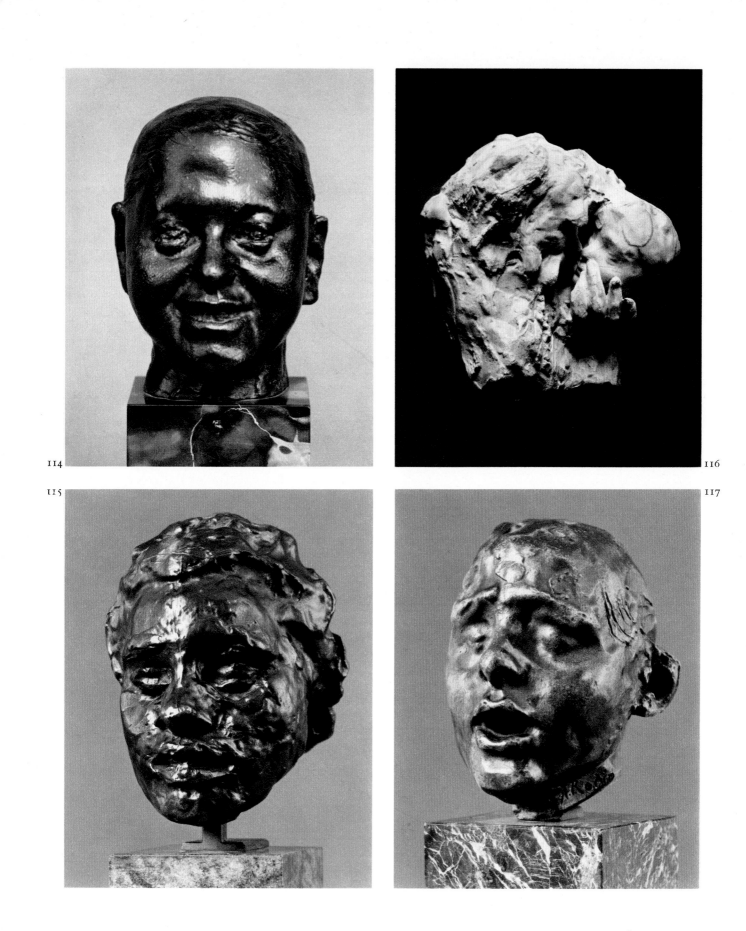

114

115

116

117

and *Marathon Runner;* fig. 111–117–3). Although the eyes of the detached head are closed, there is little doubt that both works were done from the same model and with the same expressive purpose. In both there is a strong sensation of forward movement and of extreme stress, both physical and emotional. It is this, rather than physical blindness, that seems to account for the closed eyes of the head. For this reason, it is here called *Head of a Slave* rather than *Head of a Blind Slave.*

In several other works—*The Shade: The Head and the Left Hand (see* no. 5), *Head of a Bishop* (fig. 111–117–2), and *Assemblage of Heads of "The Burghers of Calais"* (no. 69)—Rodin experimented with the juxtaposition of detached heads and hands. The *Study of Two Heads and a Hand* (no. 116) belongs to this group. In this an appealing snub-nosed head, modeled after the heads of the three sirens at the feet of Victor Hugo in the first project for the second monument to Victor Hugo *(see* no. 71), is enclosed in the embrace of a vaguely sketched older male figure.

NOTES

1. Montesquiou [258], p. 122. "De vastes vitrines sont pleines de fragments; des mains crispées, des gestes convulsés, des masques, des torses; je le répète, toute une vallée de Josaphat de membres prêts à se rejoindre en des anatomies pleines de pensée et de vie, quand le dieu de céans, Auguste Rodin, leur sonnera le réveil, de son clairon formidable."

2. In the first two editions of the catalogue of the Musée Rodin *(see* [338], no. 235, and [338a], no. 269), Grappe assigned a date of before 1900 to this work, although in subsequent editions the date was revised to before 1889.

3. In New York, 1963 [369], no. 84, Cécile Goldscheider assigned a date of about 1896 to this head. In Jianou and Goldscheider [65], p. 99, however, the head is dated toward 1885. On stylistic grounds the later date seems to be more probable.

4. In New York, 1963 [369], no. 78, Cécile Goldscheider assigned a date of about 1895 to *The Cry.* In Jianou and Goldscheider [65], p. 107, however, the work is dated 1898. No reason is given for this change.

REFERENCES

Small Head
Watkins [342], no. 95; Tancock [341], no. 11.

Head of a Young Girl with Closed Eyes
Watkins [342], no. 88; Tancock [341], no. 103.

Mask of an Old Man
Watkins [342], no. 39; Tancock [341], no. 104.

Head of a Laughing Boy
Cladel [25], repr. p. 40; Grappe [338], no. 235; Watkins [342], no. 5; Grappe [338a], no. 269; Grappe [338b], no. 242; Grappe [338c], no. 183; Grappe [338d], no. 212; Tancock [341], no. 105.

Tragic Head
Watkins [342], no. 72; Tancock [341], no. 106.

Study of Two Heads and a Hand
Watkins [342], no. 98; Tancock [341], no. 107.

Head of a Slave
Watkins [342], no. 78; Tancock [341], no. 108.

RELATED WORKS (No. 112)

Closed Eyes

Bronze, height 4⅜ inches

AUSTRALIA
Collection Sir Warwick and Lady Fairfax.

FRANCE
Paris, Musée Rodin.

GREAT BRITAIN
London, Collection Sir Anthony Blunt.

Small Head with Turned-Up Nose

Bronze, height 4⅜ inches

FRANCE
Paris, Musée Rodin.

GREAT BRITAIN
London, Private collection (fig. 111–117–1).

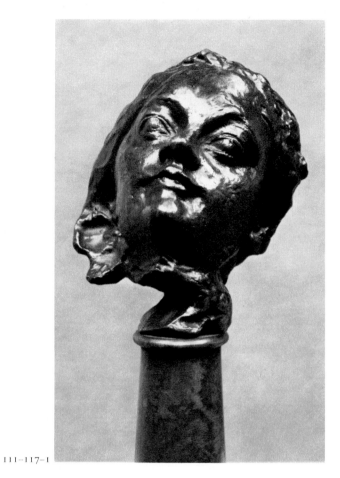

111-117-1

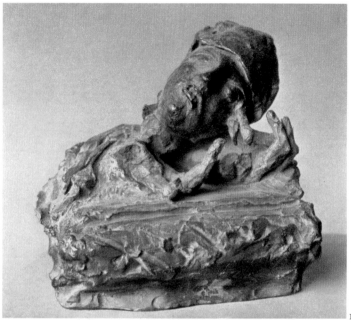

111-117-2

111-117-3

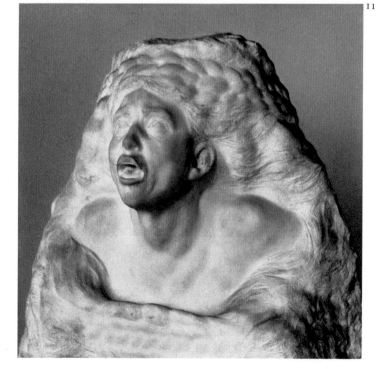

111-117-1
Small Head with Turned-Up Nose
c. 1885, bronze, height 4⅜ inches
Private collection, London

111-117-2
Head of a Bishop
1895, wax, height 7⅞ inches
Musée Rodin, Paris

111-117-3
The Tempest
1898?, marble, height 18⅛ inches
Musée Rodin, Paris

SWEDEN
Stockholm, Prins Eugens Waldemarsudde. Gift of Rodin, 1912. Inscribed: A S. A. R. le Prince Eugène de Suède. En hommage sympathique. A. Rodin.

SWITZERLAND
Lausanne, Collection Samuel Josefowitz. Founder: Alexis Rudier.

OTHER CASTS (No. 113)

THE NETHERLANDS
The Hague, Haags Gemeentemuseum. Signed: A. Rodin. Founder: Alexis Rudier.

UNITED STATES
Miami Shores, Fla., Collection Emeterio Zorrilla. Signed: A. Rodin. Founder: Alexis Rudier.
Philadelphia, Collection Mrs. Larry Ash (ex. Collection Jules Mastbaum). Signed: A. Rodin. Founder: Alexis Rudier.

OTHER CASTS (No. 114)

FRANCE
Paris, Musée Rodin.

UNITED STATES
Philadelphia, Collection Mrs. Charles J. Solomon. Signed: A. Rodin. Founder: Alexis Rudier.

OTHER CASTS (No. 115)

AUSTRALIA
Sydney, private collection. Founder: Georges Rudier. Cast no. 7/12.

UNITED STATES
New York City, Collection Mr. and Mrs. Arthur J. Barsky. Founder: Georges Rudier.
Philadelphia, Collection Mrs. Charles J. Solomon. Signed: A. Rodin. Founder: Alexis Rudier.

OTHER CASTS (No. 117)

UNITED STATES
Beverly Hills, Collection Mrs. Jefferson Dickson (ex. Collection Jules Mastbaum). Founder: Alexis Rudier.
Los Angeles, Los Angeles County Museum of Art. Gift of Leona Cantor. Founder: Georges Rudier. Cast no. 11/12.

RELATED WORKS

The Cry

Bronze, height 10¼ inches

FRANCE
Paris, Musée Rodin.

GREAT BRITAIN
Munlucky, Rosshire, Collection Mrs. Allan Cameron. Founder: Georges Rudier.

UNION OF SOUTH AFRICA
Stellenbosch, Peter Stuyvesant Foundation. Founder: Georges Rudier. Cast no. 8/12.

UNITED STATES
Los Angeles, Los Angeles County Museum of Art. Gift of B. G. Cantor Art Foundation. Founder: Georges Rudier. Cast no. 12/12.

Plaster

FRANCE
Paris, Musée Rodin.

The Tempest

Marble, height 13⅜ inches

UNITED STATES
New York City, Metropolitan Museum of Art. Gift of Thomas F. Ryan, 1910.

Bronze

UNITED STATES
Stanford, Stanford University Art Gallery and Museum. Gift of B. G. Cantor Art Foundation.

Marble, height 18⅛ inches

FRANCE
Paris, Musée Rodin (fig. 111–117–3).

118 Head of a Funerary Spirit
1899

Bronze, 6 × 4¾ × 5¼ inches
Signed on neck to right and on stamp inside: A. Rodin
Foundry mark rear center of neck:
.Alexis RUDIER./.Fondeur. PARIS.

On March 27, 1899, Rodin received the commission for a monument to Puvis de Chavannes from the Société Nationale des Beaux-Arts. On the following day it was announced in *L'Echo de Paris* that he was going to start work immediately, but that before doing anything he had to ask the Musée de Picardie in Amiens for a plaster cast of the bust of Puvis de Chavannes which he had executed in 1890 (*see* no. 90).[1] According to the newspaper, Rodin intended "placing a retouched reproduction of this bust on a stele which will be decorated by a woman symbolizing Painting.

"The creator of *The Kiss* is going to treat his subject largely and seriously, in the style of Puvis de Chavannes's own work.

"M. Rodin does not know yet where the monument to the painter of the Panthéon frescoes will be placed; that is why he cannot yet make any decisions on the general appearance of this work which he wants to adapt perfectly to the milieu where it will be installed.

"The committee is hesitating between two positions: one at Neuilly, the other in the Latin Quarter in the new square of the Sorbonne."

From the beginning Rodin seems to have been less worried about the portrait of Puvis de Chavannes than about the allegorical framework supporting it. He soon abandoned this first idea for one that was described in 1905 by Camille Mauclair. "The bust of the great painter is placed on a plain table, as the ancients placed those of their dead upon little domestic altars. A fine tree loaded with fruit bends over and shades the head. Leaning on the table behind the bust is a beautiful naked youth, who sits dreaming in a well-chosen supple attitude. The whole design is intimate, gentle, and pure. Placed on the ground in a garden this votive monument would show how much delicacy and caressing lightness sometimes lies in Rodin's sombre and pathetic thoughts."[2]

The head under discussion is that of "the beautiful naked youth, who sits dreaming," a figure generally referred to as *The Spirit of Eternal Repose*, while the head is known as *Head of a Funerary Spirit*. Grappe assigned a date of 1898 to the head and the full-length plaster figure,[3] but unless Rodin decided to use a preexisting figure in his monument both works must date from 1899 rather than 1898. The full-length plaster of *The Spirit of Eternal Repose*, minus arms, was exhibited at the Exposition Rodin in 1900 and described in the

following terms: "One of the most recent works, of an intense melancholy, of a penetrating and funereal grace."[4] It was also exhibited as *The Spirit of Repose,* "in greatly reduced dimensions."[5]

Thus the *Head of a Funerary Spirit* seems to have been taken from the reduced version of *The Spirit of Eternal Repose.* Rodin returned to the entire figure again in 1914, when it was carved in marble, the carving for the most part having been done by Charles Despiau.

NOTES

1. *L'Echo de Paris,* Paris, March 28, 1899.
 "Il va se mettre au travail, mais auparavant, il devra demander au musée d'Amiens un moulage du buste de Puvis de Chavannes, qu'il exécuta voici quelques années.
 "Monsieur Rodin a, en effet, l'intention de placer une reproduction retouchée de ce buste sur une stèle qu'ornera une femme symbolisant la Peinture.
 "L'auteur du Baiser veut traiter son sujet largement et sobrement, dans le style même de l'œuvre de Puvis de Chavannes.
 "Monsieur Rodin ne sait encore où sera placé le monument du peintre des fresques du Panthéon; c'est pourquoi il ne pourra pas encore prendre de décision au sujet de l'allure générale de cette œuvre qu'il désire adapter parfaitement au milieu où elle sera installée.
 "Le comité hésite entre deux placements: l'un à Neuilly, l'autre au quartier Latin, dans le nouveau square de la Sorbonne. Mais ce square est déjà demandé pour Pasteur, pour l'empereur Julien, pour le maréchal Catinat, pour P. Verlaine."
2. Mauclair [77a], pp. 89–90.
3. Grappe [338d], nos. 292 bis, 293. In the first two editions *(see* [338], nos. 240, 241, and [338a], nos. 274, 275), he dated the *Head of a Funerary Spirit* toward 1900 and *The Spirit of Eternal Repose* in marble 1900. In the 1931 edition [338b], nos. 323, 324, he dated the head toward 1898 and the full-length marble figure 1898. He retained the date of toward 1898 for the head in subsequent editions *(see* [338c], no. 259, and [338d], no. 292 bis) but dated the plaster of *The Spirit of Eternal Repose* toward 1898 *(see* [338c], no. 260, and [338d], no. 293) and assigned a date of 1914 to the marble version *(see* [338c], no. 369, and [338d], no. 431).

4. Paris, 1900 [349], no. 65. "Une des plus récentes œuvres, d'une intense mélancolie, d'une grâce pénétrante et funèbre; destinée à un monument commémoratif."
5. Ibid., no. 116. "*Le Génie du Repos.* Variante de la grande figure, dans des dimensions beaucoup plus réduites."

REFERENCES

Marx [243], p. 196; Grappe [338], no. 240; Watkins [342], no. 73; Grappe [338a], no. 274; Grappe [338b], no. 323; Grappe [338c], no. 259; Grappe [338d], no. 292 bis; Tancock [341], no. 109.

OTHER CASTS

FRANCE
Paris, Musée Rodin.

JAPAN
Tokyo, National Museum of Western Art (ex. Collection Matsukata). Signed: A. Rodin.

UNITED STATES
Beverly Hills, Collection Mrs. Jefferson Dickson (ex. Collection Jules Mastbaum). Founder: Alexis Rudier.
Washington, D.C., Hirshhorn Museum and Sculpture Garden, Smithsonian Institution. Founder: Alexis Rudier.

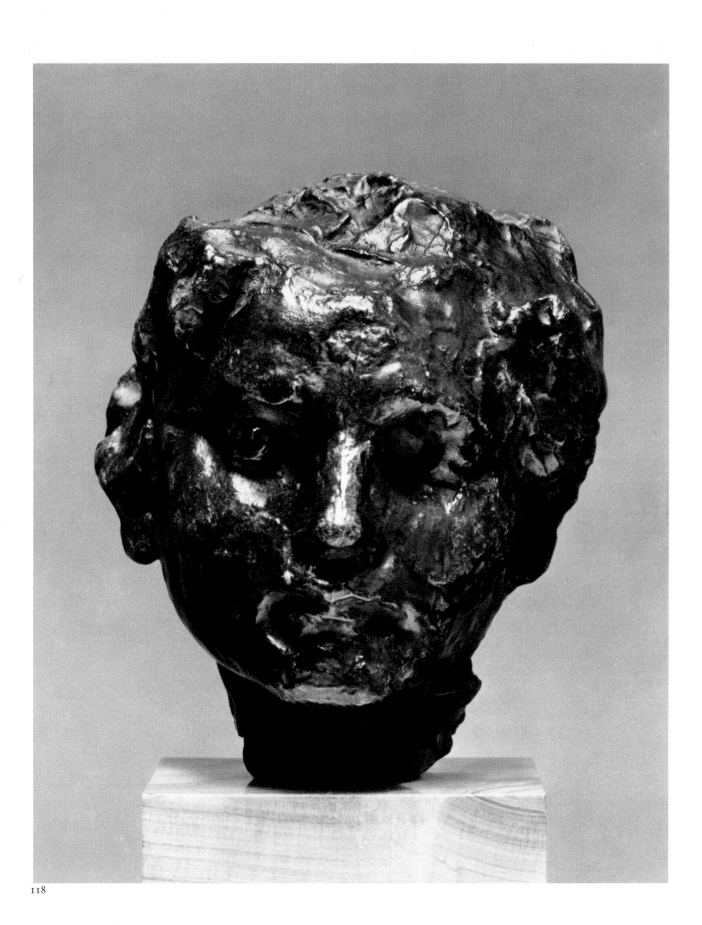

615

c. 1885

c. 1885

Bronze, 18½ × 11¾ × 8 inches
Signed front center of base: A. Rodin
Foundry mark rear center of base:
Alexis RUDIER./Fondeur. PARIS.[1]

Bronze, 18 × 10⅝ × 6½ inches
Signed front of base to right: A Rodin
Foundry mark back of base to left:
Alexis Rudier Fondeur Paris

To Gustave Kahn, one of Rodin's contemporaries and admirers, Rodin was "the sculptor of hands, of furious, clenched, angered, damned hands."[2] He continued: "The hands of the great sculptor are present and living, like the hands of the poet Verlaine; there are sad hands, furious and tired, full of energy or huddled together in fatigue, hands of seekers after chimeras or passions, heroic or vicious hands."[3]

Certainly Rodin devoted more attention to this immensely flexible part of the human body than he did to any other part. Not content simply with commemorating a particular movement of the hand in each small sculpture, he would sometimes group these little studies to create strange new dialogues (*see* fig. 119, 120–4) and, when the time came to incorporate them in a sculpture, he would experiment tirelessly with their relationship to the arm and the entire body until the axis embodied the particular mingling of emotions he wished to convey in his figure. The model Pignatelli, who posed for *St. John the Baptist Preaching* (no. 65), described to Henri Matisse Rodin's habit of walking around his figure with the hand on a peg, working out the most effective way of attaching it to the body.[4] This synthetic approach to the construction of the human figure became even more pronounced in the 1880s when of necessity he was working in a typically piecemeal fashion on *The Gates of Hell* (no. 1).

A particular impetus to his fascination with the expressive power of hands may well have been given in 1887, however, when he received his copy of Eadweard Muybridge's *Animal Locomotion,* to which he was one of the original subscribers.[5] In volume 7 Muybridge reproduced photographs of hands that were dramatically illuminated and silhouetted against a dark background (*see* figs. 119, 120–1, 2). These photographs must surely have convinced Rodin of what he knew intuitively already, namely, that the hand in isolation was capable of expressing an infinite variety of emotions and could, moreover, in its own right, constitute a sculptural statement.

It is generally assumed that *The Clenched Hand* (no. 119), also known as *The Mighty Hand,* and the related work, *The Left Hand* (no. 120), are studies for *The Burghers of Calais* (no. 67). Comparison with the states of extreme tension represented by these hands, in which anger seems to play as important a part as anguish, with the more resigned and lyrical gestures of *The Burghers* makes it seem probable that Rodin rejected these hands at a certain stage in the development of the monument as being too fierce in their expressiveness.

Muybridge might have provided the general impetus toward the proliferation of detached hands, although a more specific one seems to have come from a drawing by Victor Hugo entitled *The Dream* (fig. 119, 120–3) in which a gesticulating hand, bathed in mysterious shadows, emerges from a flapping sleeve.[6] In view of Rodin's association with the poet in the 1880s, it is not unlikely that he would have seen this drawing and that he remembered it subconsciously when he decided to exhibit his own hands in an upright position. In the two works under discussion, the form of the base gives a rhetorical, almost melodramatic, aspect to the hands that can easily be modified. In early photographs they are often seen emerging from blankets as if they are the hands of invalids (fig. 119, 120–5). Their powerfully distended forms, however, stand in no need of dramatic props to make their full impact.

NOTES

1. According to information provided by the Musée Rodin at the time of purchase, this is the second cast.
2. *La Plume* [327], p. 28. "Rodin est le sculpteur des mains, des mains furieuses, crispées, cabrées, damnées."
3. Ibid., p. 29. "Les mains du grand sculpteur sont présentes et vivantes comme les mains du poète Verlaine; ce sont des mains tristes, furieuses et lasses, pleines d'énergie ou tassées de fatique, des mains d'étreigneur de chimères ou de passions, mains d'héroïsme ou mains de vice."
4. *See* Raymond Escholier, *Matisse: A Portrait of the Artist and the Man* (New York: Praeger Publishers, 1960), p. 138.
5. I am grateful to Dr. Aaron Scharf for drawing this reference to my attention.
6. *See Maison de Victor Hugo* (Paris: 6, Place des Vosges, 1934), no. 235. "Une main dressée semble écarter la vision d'un cauchemar."

REFERENCES

The Clenched Hand
Watkins [342], no. 29; Elsen [38], p. 80; Tancock [341], no. 116.

The Left Hand
Watkins [342], no. 32; Tancock [341], no. 117.

OTHER CASTS (No. 119)

CANADA
Montreal, Collection Bram Garber. Founder: Georges Rudier. Cast no. 8/12.

FRANCE
Paris, Musée Rodin.

GERMANY (WEST)
Hof sur Mühlen, Collection Mr. and Mrs. Willy Schniewind. Purchased by Otto Henkele from Rodin about 1910.

GREAT BRITAIN
London, Collection Benedict Nicholson. Signed: A. Rodin. Founder: Alexis Rudier.

INDIA
Bombay, Wadia Collection.

SWEDEN
Kungälv, Collection Bo Boustedt. Founder: Georges Rudier. Cast no. 11/12.

SWITZERLAND
Lausanne, Collection Samuel Josefowitz. Founder: Alexis Rudier.

UNION OF SOUTH AFRICA
Stellenbosch, Peter Stuyvesant Foundation. Founder: Georges Rudier.

UNITED STATES
Beverly Hills, Collection Mrs. Jefferson Dickson (ex. Collection Jules Mastbaum). On loan to the Museum of Modern Art, New York City. Founder: Alexis Rudier.

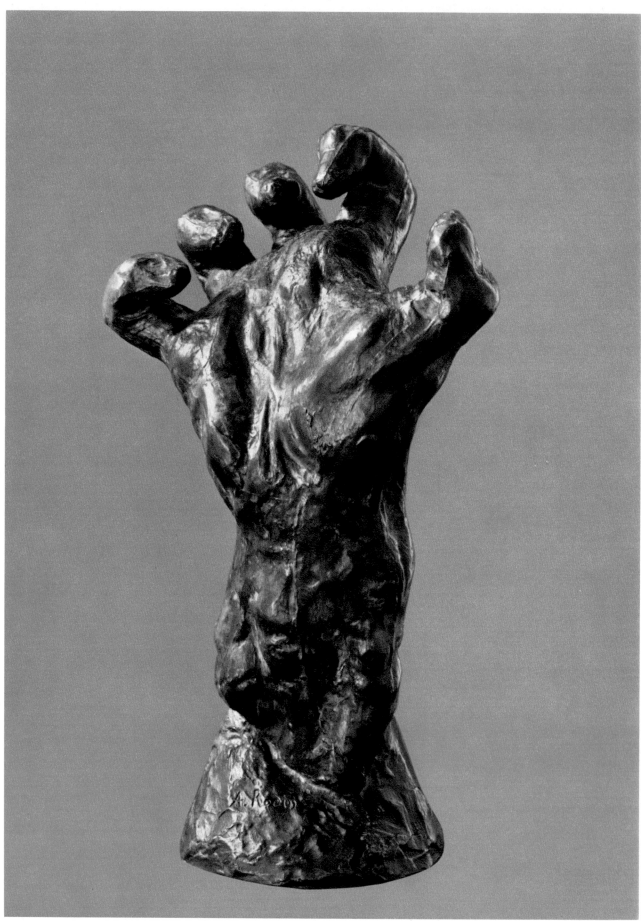

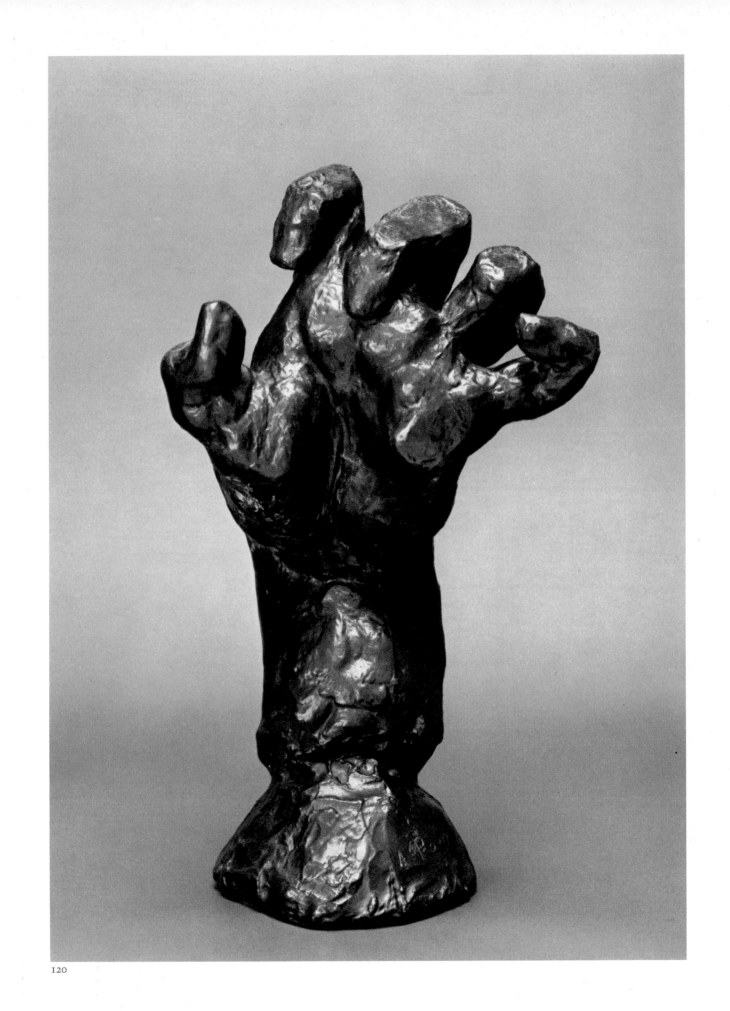

St. Louis, City Art Museum (ex. Collection André
Schoeller). Signed: Rodin. Founder: Alexis Rudier.

San Francisco, California Palace of the Legion of
Honor. Spreckels Collection. Signed: A. Rodin.
Founder: Alexis Rudier.

119, 120–1

119, 120–2

OTHER CASTS (No. 120)

FRANCE
Paris, Musée Rodin.

UNITED STATES
Beverly Hills and New York City, B. G. Cantor Collections (2 casts). Founder: Georges Rudier. Cast nos. 3/12 and 10/12.

Stanford, Stanford University Art Gallery and Museum. Gift of B. G. Cantor Art Foundation. Founder: Georges Rudier. Cast no. 7/12.

RELATED WORK

Supplication (torso of "The Centauress" in front of the left hand)

Plaster, height 18 inches

FRANCE
Meudon, Musée Rodin.

Bronze

SWITZERLAND
Lausanne, Collection Samuel Josefowitz. Founder: Susse.

UNITED STATES
Beverly Hills and New York City, B. G. Cantor Collections. Founder: Godard. Cast no. 1/12.

Chicago, Collection A. James Speyer. Founder: Georges Rudier.

Los Angeles, Los Angeles County Museum of Art. Gift of B. G. Cantor Art Foundation. Founder: Godard. Cast no. 8/12.

Stanford, Stanford University Art Gallery and Museum. Gift of B. G. Cantor Art Foundation. Founder: Godard. Cast no. 6/12.

119, 120–3

119, 120–1
Eadweard Muybridge
Photographs of hands, from
Animal Locomotion,
1887

119, 120–2
Eadweard Muybridge
Photographs of hands, from
Animal Locomotion,
1887

119, 120–3
Victor Hugo (1802–1885)
The Dream
Pen and wash, 9⅝ × 6⁷/₁₆ inches
Maison de Victor Hugo, Paris

119, 120–4
Hands
Bronze, height 6 inches
Collection Mr. and Mrs.
Stanley Marcus, Dallas

119, 120–5
Early photograph showing *Hand*
emerging from blanket

119, 120–4

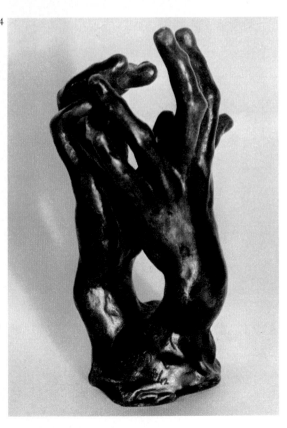

119, 120–5

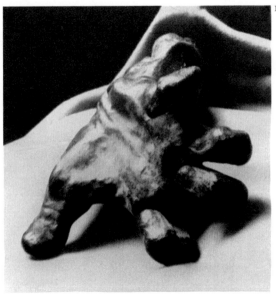

121 The Hand of God
1898

Bronze, 26¾ × 17½ × 21½ inches
Signed top of base to right: A. Rodin
Foundry mark rear of base at center:
ALEXIS RUDIER/Fondeur PARIS

With the exceptions of *The Clenched Hand* (no. 119) and *The Left Hand* (no. 120), it was not until the end of the nineteenth century that Rodin began to experiment with the expressive potentialities of making enlargements from his numerous studies of hands. The first and most ambitious of these is *The Hand of God*, which was seen in Rodin's studio in 1898 by Edouard Rod.[1]

Although deeply involved in questions of salvation and damnation in *The Gates of Hell* (no. 1), Rodin had accorded the Deity a very minor place in his scheme: a small crouching figure in low relief entitled *The Creator* is inserted in the lower left reveal.[2] Rodin sympathized with the sufferings of the souls in Hell more than he comprehended the Deity's reasons for putting them there. At the same time he felt very strongly the correspondence between the creativity of God and that of the artist, insofar as they both created form out of the formless. "What is modeling?" he asked. "When God created the world, it is of modeling He must have thought first of all."[3]

In choosing to represent God by His hand alone, it seems distinctly probable, in view of Rodin's wide knowledge of art history, that he may have turned deliberately to the medieval and Renaissance method of representing God as a hand emerging from a cloud. Widely distributed in the form of emblems,[4] the hand of God varied considerably in its significance, ranging from the punitive (God's hand letting a stone fall on the head of man) to the protecting and blessing (God's hand emerging from the clouds and holding a wreath).

Whether or not Rodin actually consulted a book of emblems, his sculpture of creation is very much in the spirit of such images. Aware of hands, his own and other people's, Rodin reveals a considerable element of self-aggrandizement in his decision to represent the hand of God. Recognizing the personal basis of the symbolism, Henri Bergson wrote of it: "It is the fleeting moment of creation, which never stops; it is in a sense the genius of Rodin himself in its eternal creative force. He that lives *in the intention,* lives free, lives creating, lives like a very god."[5]

It has been pointed out that God's hand is based on the hand used for Pierre and Jacques de Wiessant in *The Burghers of Calais* (no. 67).[6] The transformation of this gesture from one of despair and farewell to one of omnipotence in *The Hand of God* is a particularly interesting example of Rodin's ability to effect radical changes of meaning in his works simply by changing the terms of reference.

The Hand of God exists in three sizes: heights 6 inches, 12 inches, and 28 inches. Athena Spear suggests convincingly that the original model was 12 inches in height and that this was then subjected to both enlargement and reduction.[7]

NOTES

1. Rod [286], p. 427.
2. *See* Albert Alhadeff, "Rodin: A Self-Portrait in the *Gates of Hell*," *Art Bulletin*, New York, 48, nos. 3 and 4 (September-December 1966), pp. 393-95.
3. Cladel [25a], p. 222.
4. *See* Arthur Henkel and Albrecht Schöne, eds., *Emblemata: Handbuch zur Sinnbildkunst des XVI. und XVII. Jahrhunderts* (Stuttgart: J. B. Metzlersche Verlagsbuchhandlung, 1967).
5. Frisch and Shipley [42], p. 431.
6. Spear [332], p. 79.
7. Ibid.

REFERENCES

Rod [286], p. 427; *Les Maîtres Artistes* [328], p. 267; Cladel [25a], p. 222; Lami [4], p. 171; Bénédite [10a], p. 31, repr. pl. LVII (B) (marble); Grappe [338], no. 244; Watkins [342], no. 69; Grappe [338a], no. 278; Grappe [338b], no. 321; Cladel [26], p. 14; Grappe [338c], no. 257; Story [103], pp. 17, 148, no. 89, repr. pl. 89; Grappe [338d], no. 291; Waldmann [109], pp. 48, 77, no. 50, repr. pl. 50 (marble); Story [103a], no. 70, repr. pl. 70 (marble); Spear [332], pp. 79-82, no. XX; Tancock [341], no. 118.

OTHER CASTS AND VERSIONS

Bronze

UNITED STATES
New York City, Collection Mr. and Mrs. Harold B. Weinstein. Purchased from the Paley estate.
Pittsburgh, Museum of Art, Carnegie Institute. Purchased in 1920 from the Musée Rodin. This version, which is open in the back, must have been cast from a different marble from that in the Rodin Museum (height 28 inches).

Plaster, height 28¾ inches

UNITED STATES
Beverly Hills and New York City, B. G. Cantor Collections.

Bronze, height 12½ inches

FRANCE
Paris, Musée Rodin.

UNITED STATES
Beverly Hills, Collection Leona Cantor. Founder: Georges Rudier. Cast no. 9/12.
Madison, N. J., Estate of Geraldine R. Dodge. Founder: Alexis Rudier.

Plaster, height 14 inches

UNITED STATES
Maryhill, Wash., Maryhill Museum of Fine Arts. Signed. Inscribed: A l'admirable et géniale artiste.

Bronze, height 6 inches

FRANCE
Paris, Musée Rodin.

UNITED STATES
Beverly Hills and New York City, B. G. Cantor Collections. Founder: Alexis Rudier.
Cleveland, Cleveland Museum of Art. Signed: A. Rodin.
New York City, Collection Dr. and Mrs. Harry Bakwin. Signed. Founder: Alexis Rudier.
San Francisco, California Palace of the Legion of Honor. Spreckels Collection. Signed: A. Rodin. Founder: Alexis Rudier.

Plaster

UNITED STATES
San Francisco, California Palace of the Legion of Honor. Spreckels Collection.

Marble

FRANCE
Paris, Musée Rodin (height 36⅝ inches).

UNITED STATES
New York City, Metropolitan Museum of Art. Carved by Victor Frisch. Presented to the museum in 1908 by Edward D. Adams (height 29 inches).
Providence, Museum of Art, Rhode Island School of Design (ex. Collection Samuel P. Colt) (height 39½ inches).

Plaster, height 36⅝ inches

FRANCE
Meudon, Musée Rodin.

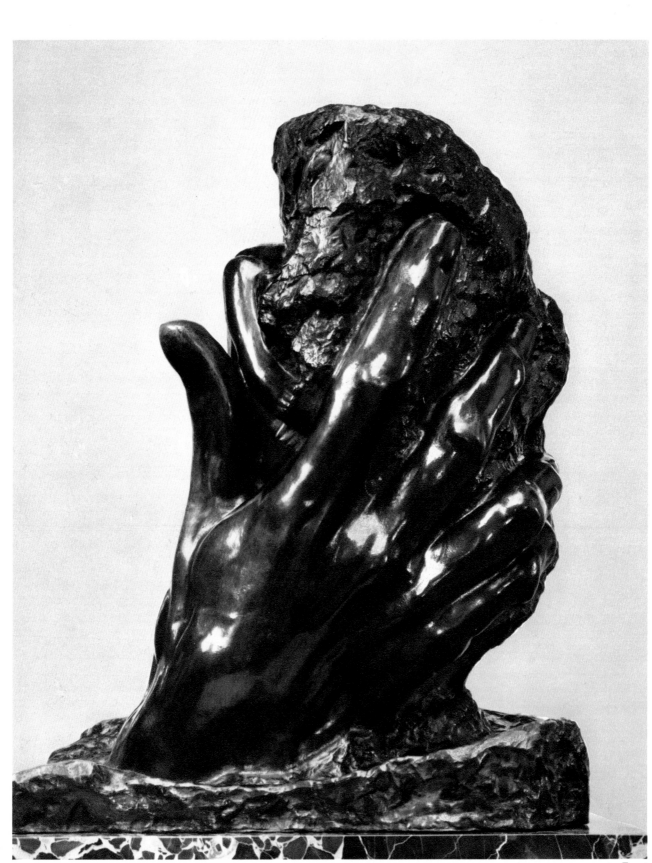

121 Front

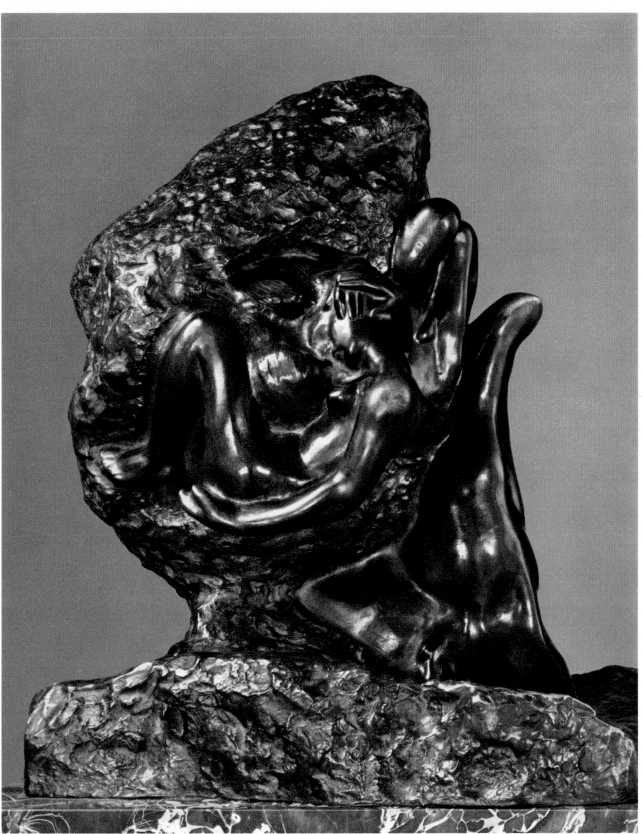

121 Back

122 The Hand of the Devil Holding Woman
1903

Bronze, 16 × 25¾ × 19 inches
Signed front of base to right: A. Rodin
Foundry mark center rear of base:
Alexis. Rudier/Fondeur. Paris.

Rodin's relationship to the opposite sex changed a great deal during the course of his long life. "I did not know that, distrusted at twenty, they would charm me at seventy," he said. "I distrusted them because I was timid."[1] There are signs, too, that this lack of self-confidence on his own part received outside confirmation from the equation, widely current in the late nineteenth century, between woman and the devil. Many of the female figures in *The Gates of Hell* are diabolical *(see* especially no. 11), and Rodin later told Arthur Symons that one of the inspirations for the work known as *The Eternal Idol (see* pls. 9, 10) was Alfred de Vigny's "La Colère de Samson": "In all times and in all places an eternal struggle takes place on earth in the presence of God between the goodness of man and the cunning of woman; for woman is an impure creature both in body and in soul."[2]

His first full-scale female figure after the encounter with Michelangelo's work in Florence was of Eve *(see* no. 8), the cause of man's downfall. He returned to this subject in 1885 in the work known as *Eve and the Serpent* (no. 37) and in the terra-cotta of *Eve Eating the Apple* in the National Gallery of Art in Washington, D.C. (fig. 37–1), which must date from the same time. Although unable to flank *The Gates* with figures of Adam and Eve as he desired, Rodin did succeed in incorporating the figure of Eve in the panels themselves. This figure, very similar to the Washington terra-cotta, may be seen, somewhat concealed, near the lower right-hand corner of the right-hand leaf. In view of his interest in the figure of Eve, it is not at all surprising that after the creation of *The Hand of God* (no. 121), he should have carved its diabolical counterpart, *The Hand of the Devil Holding Woman.*

Since no other bronze casts of this work are known, it seems probable that the Philadelphia bronze was specially cast for Mr. Mastbaum.

NOTES

1. Coquiot [31], p. 64.
 "Je ne savais pas que, méprisées à vingt ans,
 elles me charmeraient à soixante-dix ans.
 "Je méprisais parce que j'étais timide."
2. Symons [313], p. 96.
 Une lutte éternelle en tout temps, en tout lieu
 Se livre sur la terre, en présence de Dieu,
 Entre la bonté d'Homme et la ruse de Femme,
 Car la femme est un être impur de corps et d'âme.

REFERENCES

Lami [4], p. 171; Grappe [338], no. 254; Watkins [342], no. 50; Grappe [338a], no. 290; Grappe [338b], no. 353; Grappe [338c], no. 291; Grappe [338d], no. 327; Adams [5], repr. p. 39; Tancock [341], no. 119.

OTHER VERSION

Marble, height 15¾ inches

FRANCE
Paris, Musée Rodin.

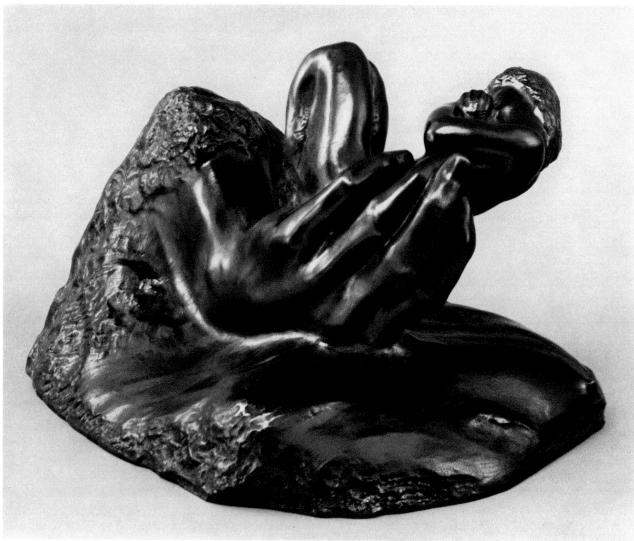

122

123 The Cathedral
1908

Bronze, 24½ × 10¾ × 11¾ inches
Signed top of base to left: A Rodin
Foundry mark right side of base:
Alexis RUDIER/FONDEUR PARIS

Dated 1910 by Grappe in the 1927 and 1929 editions of the catalogue of the Musée Rodin,[1] *The Cathedral* had its dating revised to 1908 in subsequent editions when it was discovered that in that year a prospective purchaser intended adapting these hands for a fountain.[2] Rodin also called it *The Arch of Alliance* on occasion, but it is under the name of *The Cathedral* that it is now universally known.

Constructed from two right hands, the work evidently owes its inspiration to an idea which came to Rodin during his ceaseless experimentation with the grouping of fragments of his major works. It was thus the sight of the work that gave him the idea for the title and not vice versa.

Rodin's great passion for Gothic architecture, which started with visits to the French cathedrals and Belgian churches in the 1870s and culminated in the publication *Cathedrals of France* in 1914, and his sensitivity to the expressiveness of hands are thus united in this work.

NOTES

1. Grappe [338], no. 340; [338a], no. 378.
2. Grappe [338c], no. 333.

REFERENCES

Grappe [338], no. 340; Watkins [342], no. 40; Grappe [338a], no. 378; Grappe [338b], no. 406; Grappe [338c], no. 333; Story [103], pp. 17–18, 149, no. 101, repr. pl. 101; Grappe [338d], no. 384; Waldmann [109], pp. 53, 77, no. 59, repr. pl. 59 (stone); Story [103a], no. 92, repr. pl. 92 (stone); Tancock [341], no. 120, repr. p. 93.

OTHER CASTS AND VERSIONS

Bronze

CANADA
Montreal, Collection Mr. and Mrs. Bernard Lande. Founder: Georges Rudier. Cast no. 12/12.

FRANCE
Paris, Musée Rodin.

SWITZERLAND
Lausanne, Collection Samuel Josefowitz. Founder: Alexis Rudier.

UNION OF SOUTH AFRICA
Stellenbosch, Peter Stuyvesant Foundation.

UNITED STATES
Madison, N.J., Estate of Geraldine R. Dodge. Founder: Georges Rudier.

Stone, height 25¼ inches

FRANCE
Paris, Musée Rodin.

Plaster, height 5¾ inches

FRANCE
Paris, Musée Rodin.

Bronze

FRANCE
Paris, Musée Rodin.

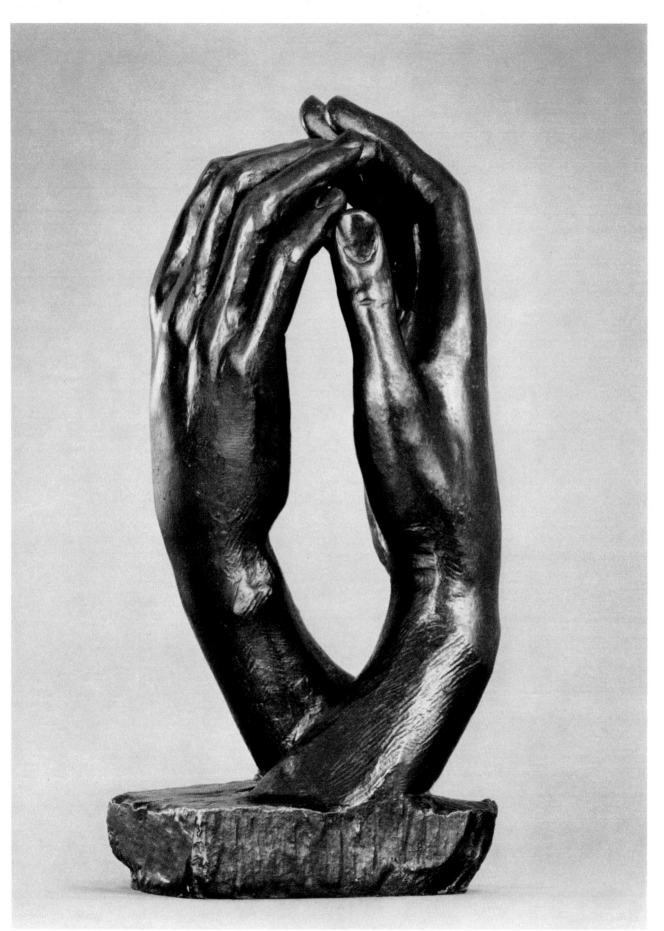

124 Two Hands
before 1909

Bronze, 18 × 20 ⅞ × 12 ¾ inches
Signed top of base by right hand: A. Rodin
Foundry mark rear of base to left:
Alexis. Rudier/Fondeur Paris

Late in life Rodin decided to give more permanent form to the fascination with hands that played such an important part in his art. *Two Hands,* which was carved in marble sometime before 1909,[1] belongs to this group of works. Inevitably some of the sensitivity that characterizes the innumerable smaller studies was lost in the process of enlargement.

In the Fine Arts Museums of San Francisco there are two plaster casts, height 6 ½ inches, representing a male hand clasping a female hand. On the base of one of them is the inscription: "Hands of Rodin and Rose Beuret. 1916. Paris." These casts were made by Guioché shortly before the cast of Rodin's hand holding a torso *(see* no. 127), and it would seem that he used *Two Hands* of 1909 as a model.

Like numbers 9, 108, 122, 125, and 126, the bronze cast of this work seems to have been specially commissioned by Mr. Mastbaum.

NOTES

1. Grappe [338d], no. 385. "Cette pièce, dite *Mains d'amants,* figura à l'Exposition de la Société des Peintres et des Sculpteurs en 1909. Elle semble n'avoir figuré nulle part ailleurs auparavant et elle ne fait l'objet d'aucune mention dans un catalogue permettant de la situer à une époque antérieure."

REFERENCES

Lawton [67], opp. p. 215; Grappe [338], no. 338; Watkins [342], no. 20; Grappe [338a], no. 376; Grappe [338b], no. 407; Grappe [338c], no. 333 bis; Grappe [338d], no. 385; Adams [5], repr. p. 39; Tancock [341], no. 121.

OTHER VERSION

Marble, height 18⅛ inches

FRANCE
Paris, Musée Rodin.

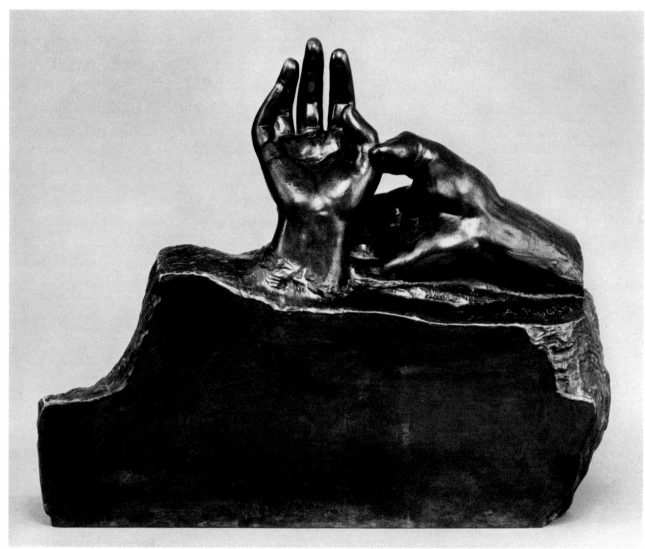

124

125 The Hand from the Tomb

1910

Bronze, 23 ⅝ × 21 ¾ × 17 inches
Signed top of base to right of hand: A. Rodin
Foundry mark left of base to rear:
Alexis.Rudier./Fondeur. Paris.

According to Grappe,[1] this work, representing a hand emerging from a tomb on which, as yet, no name has been inscribed, was made for a funerary monument, although the exact circumstances of its creation are not known. It has also been called *Punishment* and *Mene, Tekel, Peres,* the inscription which appeared on the wall of Belshazzar's palace when he ordered that the vessels taken from the temple by his father should be used as drinking vessels.

"They drank wine, and praised the gods of gold, and of silver, of brass, of iron, of wood, and of stone.

"In the same hour came forth fingers of a man's hand, and wrote over against the candlestick upon the plaister of the wall of the king's palace: and the king saw the part of the hand that wrote."[2]

When none of the king's councillors could interpret the message on the wall, Daniel was summoned to solve the riddle.

"And this is the writing that was written, MENE, MENE, TEKEL, UPHARSIN.

"This is the interpretation of the thing: MENE; God hath numbered thy kingdom, and finished it.

"TEKEL; Thou art weighed in the balances, and art found wanting.

"PERES; Thy kingdom is divided, and given to the Medes and Persians."[3]

Like numbers 9, 108, 122, 124, and 126, the bronze of this work is unique and seems to have been specially commissioned by Mr. Mastbaum.

NOTES

1. Grappe [338d], no. 417.
2. Dan. 5:4–5.
3. Dan. 5:26–28.

REFERENCES

Grappe [338], no. 339; Watkins [342], no. 7; Grappe [338a], no. 377; Grappe [338b], no. 434; Grappe [338c], no. 355; Grappe [338d], no. 417; Cladel [27], repr. pl. 103 (marble); Tancock [341], no. 122.

OTHER VERSION

Marble, height 23¼ inches

FRANCE
Paris, Musée Rodin.

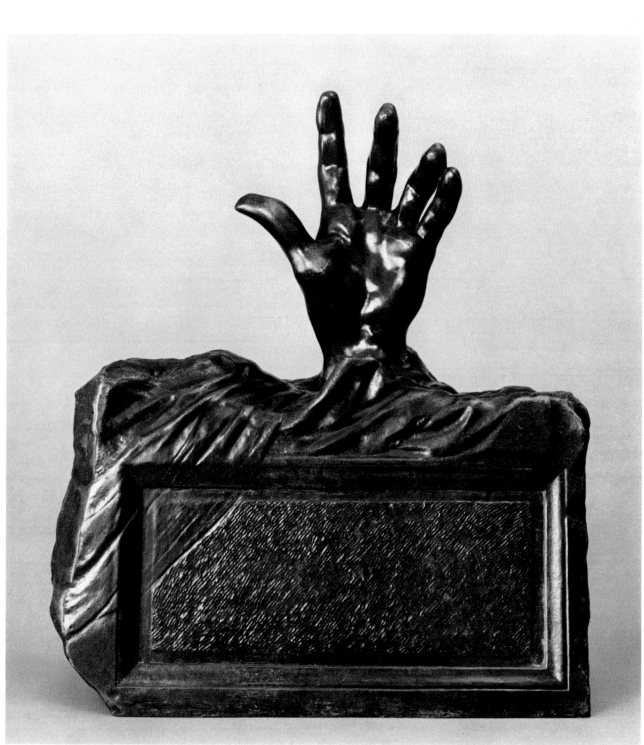

125

126 The Secret

1910

Bronze, 33 ½ × 19 × 15 ¼ inches
Signed top of base to right: A. Rodin
Foundry mark rear of base to left:
.Alexis RUDIER./.Fondeur. PARIS.

The Secret was perhaps exhibited in London in 1910 as *Hands Holding the Sacred Tablets*.[1] It has been suggested in connection with this work that Rodin may have derived the image from a Renaissance book of emblems.[2] It seems almost certain that the sculptor was familiar with such literature since, in his endeavors to educate himself, he had, as a young man, been an assiduous frequenter of the Cabinet des Dessins and the Cabinet des Estampes. At the same time it should be recognized that the striking image was arrived at through his creative process of forming unexpected assemblages from fragments of his own works.

In the Fine Arts Museums of San Francisco there is a small bronze study of the hand (fig. 126–1) that was used twice, slightly modified, and on a greatly enlarged scale in *The Secret*. There is a similar terra-cotta study of a hand in the National Gallery of Art in Washington, D.C., and a related study of two confronted hands in the Fogg Art Museum in Cambridge, Massachusetts (fig. 126–2). Like numbers 9, 108, 122, 124, and 125, the Philadelphia bronze seems to have been specially cast for Mr. Mastbaum.

NOTES

1. Grappe [338d], no. 415.
2. Story [103], p. 17. "I imagine the sculptor must at some time of his life have been interested in the old books of 'Emblems'—Alciatus's or others—which were so popular with the people in the epoch following the Renaissance in Northern Europe. In one or other of these books I remember seeing a picture of hands conveying the same symbolism as we find in 'The Secret.'"

REFERENCES

Lami [4], p. 171; Grappe [338], no. 337; Watkins [342], no. 52; Grappe [338a], no. 375; Grappe [338b], no. 433; Grappe [338c], no. 353; Story [103], p. 17; Grappe [338d], no. 415; Grappe [54], p. 144, repr. p. 134 (marble); Story [103a], no. 111, repr. pl. 111 (marble); Tancock [341], no. 123.

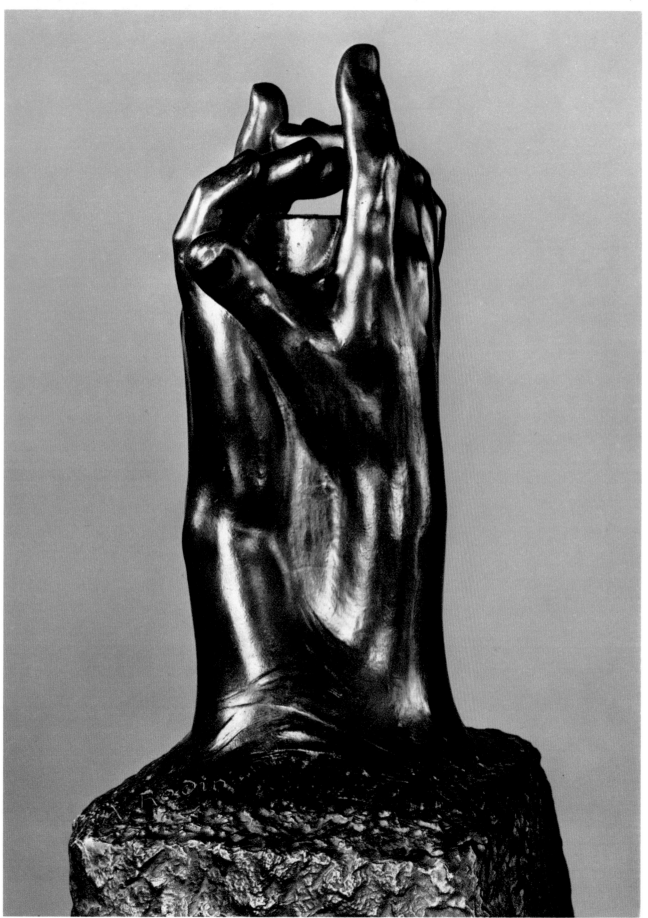

126

OTHER CASTS AND VERSIONS

Bronze study, height 5 inches

FRANCE
Paris, Musée Rodin.

SWITZERLAND
Lausanne, Collection Samuel Josefowitz. Founder:
　Alexis Rudier.

Marble, height 35 inches

FRANCE
Paris, Musée Rodin.

RELATED WORK

Hands

Bronze, height 6⅛ inches

UNITED STATES
Cambridge, Fogg Art Museum, Harvard University.
　Grenville L. Winthrop Bequest, 1943 (fig. 126–2).

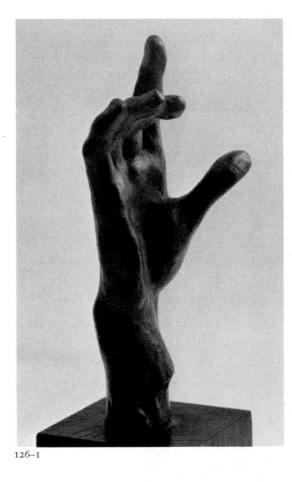

126–1

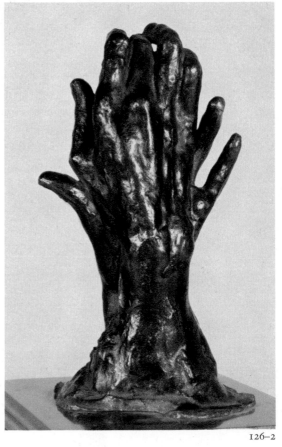

126–2

126–1　*Hand*
　　　Bronze, height 3⅞ inches
　　　Fine Arts Museums of San Francisco
　　　Spreckels' Collection

126–2　*Hands*
　　　c. 1910, bronze, height 6⅛ inches
　　　Fogg Art Museum, Harvard University,
　　　Cambridge, Mass.
　　　Grenville L. Winthrop Bequest, 1943

127 Hand of Rodin Holding a Torso
1917

Plaster, 6¼ × 9 × 3¾ inches
Not signed or inscribed

Three weeks before Rodin's death, Paul Cruet, who was largely responsible at that time for making Rodin's molds, took this cast of his right hand. Into it was inserted a cast of a small torso by Rodin, *Small Torso A,* one of the innumerable small fragments possibly connected with *The Gates of Hell* (no. 1). The torso has since been cast separately.

This composite work, made from a life cast and an original work, which pays homage to Rodin the sculptor, recalls his own emblem of creativity, *The Hand of God* (no. 121), and, even more closely, his diabolical commentary on it, *The Hand of the Devil Holding Woman* (no. 122).

REFERENCES

Grappe [338], repr. p. 119; Watkins [342], no. 109; Grappe [338a], repr. p. 141; Grappe [338b], repr. p. 162; Grappe [338c], repr. p. 139; Frisch and Shipley [42], repr. opp. p. 405; Grappe [338d], no. 438; Cladel [27], repr. p. xviii; Jourdain [66], repr. pl. 52; Goldscheider [50], repr. p. 124; Descharnes and Chabrun [32], repr. pp. 270, 271; Tancock [341], no. 124.

OTHER CASTS AND VERSIONS

Plaster

UNITED STATES
New York City, Metropolitan Museum of Art. Bequest of Malvina C. Hoffman, 1966.
Washington, D.C., National Gallery of Art. Gift of Mrs. John W. Simpson, 1942.

Bronze

FRANCE
Paris, Musée Rodin.

GREAT BRITAIN
London, Collection Mr. and Mrs. P. Hart.
— Collection Chester Beatty, Jr.

UNITED STATES
Beverly Hills, Collection Leona Cantor. Founder: Georges Rudier. Cast no. 3/12.
Beverly Hills and New York City, B. G. Cantor Collections (2 casts). Founder: Georges Rudier. Cast nos. 7/12 and 9/12.
Hagerstown, Md., Washington County Museum of Fine Arts. Founder: Alexis Rudier.
Stanford, Stanford University Art Gallery and Museum. Gift of B. G. Cantor Art Foundation. Founder: Georges Rudier. Cast no. 8/12.

RELATED WORK

Small Torso A

Bronze, height 4 inches

UNION OF SOUTH AFRICA
Stellenbosch, Peter Stuyvesant Foundation. Founder: Georges Rudier. Cast no. 6/12.

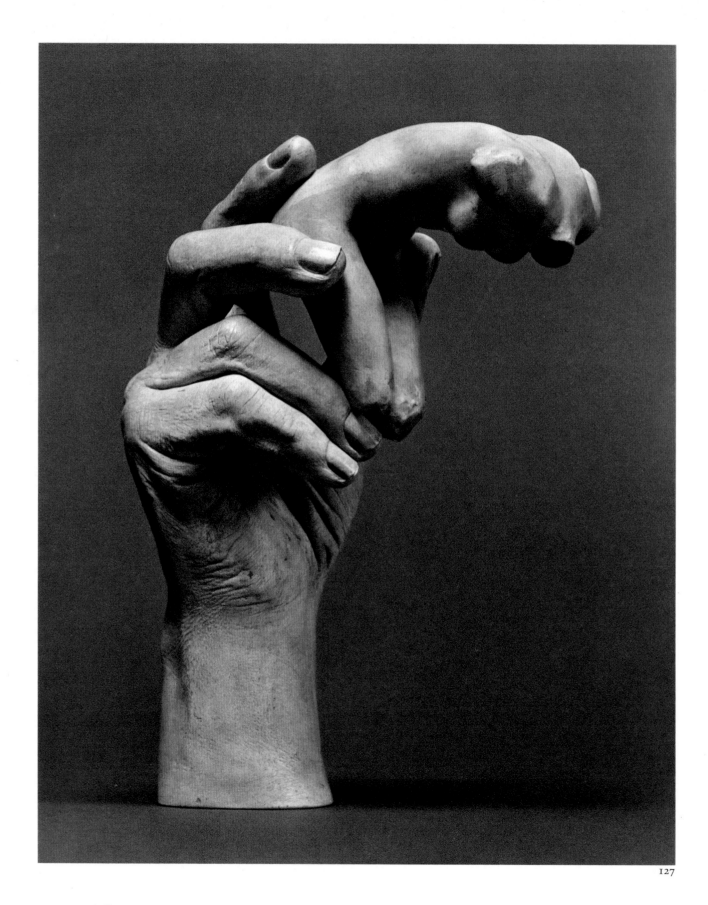

BIBLIOGRAPHY
AND
INDICES

This is a selected bibliography primarily devoted to Rodin's sculpture and therefore does not attempt to provide a comprehensive list of references to Rodin's work in other mediums—drawings, watercolors, prints, or book illustrations. For this the reader is referred to Elsen and Varnedoe [40]. Monographs or articles on only one work of art have, with few exceptions, been placed in the Reference sections of the catalogue entries to which they pertain. Unfortunately the literature is not nearly as informative as it is extensive, a limited amount of material having been diluted in an abundance of repetitious publications. The frequency with which certain books and articles have been referred to—notably those by Georges Grappe, Judith Cladel, Albert Elsen, and Athena Spear—gives the clearest indication as to which texts have been found most useful by the author. A complete Rodin bibliography is being prepared by Josef Adolf Schmoll gen. Eisenwerth.

WORKS OF REFERENCE

1 Bénézit, E. "Auguste Rodin." In *Dictionnaire critique et documentaire des peintres, sculpteurs, dessinateurs et graveurs,* vol. 7, pp. 299–303. New ed. Paris: Librairie Gründ, 1954.

2 Elgar, Frank. "Auguste Rodin." In *Encyclopedia of World Art,* vol. 12, pp. 274–75. New York, Toronto, London: McGraw-Hill Book Co., 1966.

3 Grohmann, W[ill]. "Auguste Rodin." In *Allgemeines Lexikon der Bildenden Künstler,* by Ulrich Thieme and Felix Becker, vol. 28, pp. 462–64. Leipzig: Verlag E. A. Seemann, 1934.

4 Lami, Stanislas. "Auguste Rodin." In *Dictionnaire des sculpteurs de l'école française au dix-neuvième siècle,* vol. 4, pp. 161–75. Paris: Librairie Ancienne Honoré Champion, 1921.

BOOKS ON RODIN

5 Adams, Philip R. *Auguste Rodin.* New York: Hyperion Press, 1945.

6 Alexandre, Arsène. *Le Balzac de Rodin.* Paris: H. Floury, 1898.

7 Alhadeff, Albert. "Academic and Italian Sources of the Early Work of Auguste Rodin." Unpublished Master's thesis, The Institute of Fine Arts, New York University, 1962.

Alley, Ronald. *See* no. 334.

Aubert, Marcel. *See* nos. 336, 339.

8 Aurel. *Rodin devant la femme: Fragments inédits de Rodin; sa technique par lui-même.* Paris: Maison du Livre, 1919.

9 Aveline, Claude. *Rodin: L'Homme et l'œuvre.* Paris: Les Ecrivains Réunis, 1927.

10 Bénédite, Léonce. *Rodin.* (Librairie Centrale des Beaux-Arts.) Paris: Editions Albert Lévy, 1923.
 10a Eng. trans. London: Ernest Benn, 1924.

11 ———. *Rodin.* (Maîtres de l'Art Moderne.) Paris: F. Rieder, 1926.
 11a Eng. trans. by Wilfrid Jackson. London: John Lane, the Bodley Head, 1926.

See also no. 340.

12 Bourdelle, Antoine. *La Sculpture et Rodin, avec 22 compositions, dont 19 inédites d'Antoine Bourdelle, et précédé de quatre pages de journal par Claude Aveline.* Paris: Editions Emile-Paul Frères, 1937.

13 Bovy, Adrien. *A. Rodin.* Geneva: Editions La Tribune, 1918.

14 Brasil, Jaime. *Rodin.* Portugal: Editions Lopes da Silva, 1944.

Breck, Joseph. *See* no. 337.

15 Briegel-Wasservogel, Lothar. *Auguste Rodin: Eine Studie.* (Über Kunst der Neuzeit, no. 9.) Strasbourg: J. H. Heitz, 1903.

16 Bünemann, Hermann. *Auguste Rodin: Die Bürger von Calais.* (Werkmonographien zur bildenden Kunst, no. 22.) Berlin: Gebrüder Mann, 1946..
 16a Rev. ed., Stuttgart: Reclam, 1957.

17 Burckhardt, Carl. *Rodin und das plastische Problem.* Basel: Benno Schwabe, 1921.

18 ———. *Rodin: Vortrag gehalten am 19. Mai 1948 im Basler Kunstverein.* Basel: Basler Kunstverein, 1950.

Butler, Ruth. *See* Mirolli, Ruth Butler.

19 Canudo, Ricciotto. *La Torre del Lavoro e della Volontà di Augusto Rodin.* Siena: Edizione Fratelli Bocca, 1908.

Caso, Jacques de. *See* no. 343.

20 Cassou, Jean. *Rodin.* Paris: Phaidon, 1949.

Chabrun, Jean-François. *See* no. 32.

21 Champigneulle, Bernard. *Rodin*. Paris: Editions Aimery Somogy, 1967.
 21a Eng. trans. by J. Maxwell Brownjohn. New York: Harry N. Abrams, 1967.

22 Charbonneaux, Jean. *Les Sculptures de Rodin*. (Bibliothèque Aldine des Arts, vol. 10.) Paris: Fernand Hazan, 1949.

23 Ciolkowska, Muriel. *Rodin*. Pref. by Roger Marx. (Little Books on Art.) London: Methuen, 1912.

24 Cladel, Judith. *Auguste Rodin: Pris sur la vie*. Paris: Editions de la Plume, 1903.

25 ———. *Auguste Rodin: L'Œuvre et l'homme*. Pref. by Camille Lemonnier. (Librairie Nationale d'Art et d'Histoire.) Brussels: G. Van Oest & Cie, 1908.
 25a *Rodin: The Man and His Art, with Leaves from His Note-book*. Eng. trans. by S. K. Star. Intro. by James Huneker. New York: Century Co., 1917.

26 ———. *Rodin: Sa vie glorieuse, sa vie inconnue*. Paris: Bernard Grasset, 1936.
 Reviewed by Louis Vauxcelles in *Le Monde Illustré*, Paris, August 29, 1936, p. 733.
 26a Definitive ed., 1950.
 26b *Rodin*. Eng. trans. by James Whitall. New York: Harcourt, Brace, 1937; London: Kegan Paul, 1938.

27 ———. *Rodin*. Paris: Editions Terra & Editions Aimery Somogy, 1948.

28 ———. *Rodin*. (Collection Ars Mundi.) Paris: Editions Aimery Somogy, 1952.
 28a Eng. trans. by Lucy Norton. London: William Heinemann, 1953.

 Claris, Edmond. *See* no. 165a.

29 Coquiot, Gustave. *Le Vrai Rodin*. Paris: Editions Jules Tallandier, 1913.
 Reviewed in *Le Temps*, Paris, July 31, 1913, p. 4.

30 ———. *Rodin*. Paris: Bernheim-Jeune, 1915.
 30a 2d ed., Paris: Albin Michel, 1925.

31 ———. *Rodin à l'hôtel de Biron et à Meudon*. Paris: Librairie Ollendorff, 1917.

32 Descharnes, Robert, and Chabrun, Jean-François. *Auguste Rodin*. Lausanne: Edita, 1967; Paris: La Bibliothèque des Arts, 1967.
 32a Eng. trans. New York: Viking Press, 1967; London: Macmillan, 1967.

Reviewed by Albert E. Elsen in *Burlington Magazine*, London, 110, no. 787 (October 1968), p. 585.

33 Dircks, Rudolf. *Auguste Rodin, with List of His Principal Works*. (Langham Series of Art Monographs, vol. 4.) London: Siegle, Hill and Co., 1904.

34 Duhem, Henri. *Rodin*. Paris: Bibliothèque de l'Association, 1901.

35 Dujardin-Beaumetz, Henri-Charles-Etienne. *Entretiens avec Rodin*. Paris: Paul Dupont, 1913.
 35a Eng. trans. in Elsen, no. 39.

36 Eckermann, A. *Auguste Rodin*. Munich, 1912.

37 Elsen, Albert E. *Rodin's Gates of Hell*. Minneapolis: University of Minnesota Press, 1960. Reviewed by Jacques de Caso in *Burlington Magazine*, London, 106, no. 731 (February 1964), pp. 79–82.

38 ———. *Rodin*. Homage by Jacques Lipchitz. Postscript by Peter Selz. New York: Museum of Modern Art, 1963.

39 ———, ed. *Auguste Rodin: Readings on His Life and Work*. Englewood Cliffs, N. J.: Prentice-Hall, 1965.
 Includes: Albert E. Elsen, "Introduction," pp. 1–12; Truman H. Bartlett, pp. 13–109 (reprinted from no. 125); Rainer Maria Rilke, pp. 110–44 (reprinted from no. 87a); Henri-Charles-Etienne Dujardin-Beaumetz, "Rodin's Reflections on Art," pp. 145–85 (Eng. trans. of no. 35 by Ann McGarrell and edited by Albert E. Elsen).

40 ———, and Varnedoe, J. Kirk T. *The Drawings of Rodin*. With additional contributions by Victoria Thorson and Elisabeth Chase Geissbuhler. New York: Praeger Publishers, 1971. Includes: Albert E. Elsen, "Rodin's Drawings and the Mastery of Abundance," pp. 17–24; J. Kirk T. Varnedoe, "Rodin as a Draftsman— A Chronological Perspective," pp. 25–120; Victoria Thorson, "Symbolism and Conservatism in Rodin's Late Drawings," pp. 121–40; Elisabeth Chase Geissbuhler, "Preliminary Notes on Rodin's Architectural Drawings," pp. 141–56; J. Kirk T. Varnedoe, "True and False," pp. 157–85.

41 Emde, Ursula. *Rilke und Rodin*. Marburg/Lahn: Verlag des Kunstgeschichtlichen Seminars, 1949.

42 Frisch, Victor, and Shipley, Joseph T. *Auguste Rodin: A Biography.* New York: Frederick A. Stokes and Co., 1939.

43 Gantner, Joseph. *Rodin und Michelangelo.* Vienna: A. Schroll, 1953.

44 Geffroy, Gustave. *A. Rodin.* Paris: Editions Dentu, 1892.

45 ———, and Saunier, Charles. *Rodin.* Paris, 1918.

 See also no. 199a.

46 Geissbuhler, Elisabeth Chase. *Rodin: Later Drawings, with Interpretations by Antoine Bourdelle.* Foreword by Herbert Read. Boston: Beacon Press, 1963; London: Peter Owen, 1963; Toronto: S. J. Reginald Saunders & Co., 1963.

47 Geyraud, Pierre. *Rodin devant la douleur et l'amour.* Paris: Editions Revue Moderne des Arts de la Vie, 1937.

48 ———, and Philippe, Y. *Le Pathétique de Rodin.* (Notre Temps.) Paris: Henri Lemoine, 1952.

49 Goldscheider, Cécile. *Rodin: Sa vie, son œuvre, son héritage.* Paris: Les Productions de Paris, 1962.

50 ———. *Rodin.* (Petite Encyclopédie de l'Art, nos. 63, 64.) Paris: Fernand Hazan, 1964. Vol. 1, *1840–1886.* Vol. 2, *1886–1917.*

 50a Eng. trans. by Bettina Wadia. 2 vols. New York: Tudor Publishing Co., 1964.

51 ———. *Rodin.* (I Maestri della Scultura, no. 29.) Milan: Fratelli Fabbri Editori, 1966.

 See also nos. 65, 339.

52 Goldscheider, Ludwig. *Rodin.* Paris: Phaidon, 1949.

53 Goncourt, Edmond de, and Goncourt, Jules de. *Journal: Mémoires de la vie littéraire.* 4 vols. Paris: Fasquelle, Flammarion, 1959.

 Goncourt, Jules de. *See* no. 53.

54 Grappe, Georges. *Le Musée Rodin.* (Collection Musées et Monuments.) Monaco: Les Documents d'Art, 1944.

55 ———. *Rodin.* Paris: Phaidon, 1955.

 See also no. 338.

56 Grautoff, Otto. *Auguste Rodin.* (Künstler Monographien, no. 93.) Bielefeld and Leipzig: Velhagen und Klasing, 1908.

57 Gsell, Paul. *L'Art: Entretiens réunis par Paul Gsell.* Paris: Bernard Grasset, 1911.

 57a New rev. ed., 1951.

 57b *Art.* Eng. trans. by Mrs. Romilly Fedden. Boston: Small, Maynard and Co., 1912; London: Hodder and Stoughton, 1912.

 57c Reissued as *On Art and Artists.* Intro. by Alfred Werner. New York: Philosophical Library, 1957.

 57d *Die Kunst.* Ger. trans. by Paul Prina. Munich: Kurt Wolff Verlag, 1920.

58 Hale, William Harlan, and the Editors of Time-Life Books. *The World of Rodin 1840–1917.* New York: Time-Life Books, 1969.

59 Havelaar, Just. *Auguste Rodin.* (Fransche Kunst, vol. 14.) Leiden: A. W. Sijthoff, 1920.

60 Henriquez Ureña, Max. *Whistler y Rodin.* Conferencia pronunciada la noche del 22 de Abril de 1906, en la Academia de Dibujo y Pintura "El Salvador." Havana: Imprenta de Esteban Fernandez, 1906.

61 Herriot, Edouard. *A la gloire de Rodin: Discours prononcé par M. Edouard Herriot… à l'occasion du dixième anniversaire de la mort de Rodin et de la restauration du parc de l'hôtel Biron.* Paris: Marcel Seheur, 1928.

62 ———. *Rodin.* (Merveilles des Beaux-Arts.) Lausanne: Editions Jean Marguerat, 1949.

63 Hover, Otto. *Auguste Rodin.* Emmendingen: Dehio Verlag, 1948.

64 Hubacher, Hermann. *Rodin.* Zurich: Rudolf Mühlemann, 1949.

65 Jianou, Ionel, and Goldscheider, C[écile]. *Rodin.* (Editions d'Art.) Paris: Arted, 1967. Reviewed by Albert E. Elsen in *Burlington Magazine,* London, 109, no. 776 (November 1967), pp. 649–50.

66 Jourdain, Frantz. *Rodin.* (Collection "Artistes de jadis et d'aujourd'hui.") Lausanne: Editions Jean Marguerat, 1949.

 Kahn, Gustave. *See* nos. 329a, 329b.

67 Lawton, Frederick. *The Life and Work of Auguste Rodin.* London: T. Fisher Unwin, 1906; New York: Charles Scribner's Sons, 1907.

68 Lecomte, Georges. *Chefs-d'œuvre de Rodin*. Paris: Les Publications Techniques et Artistiques, 1946.

Lerner, Abram. *See* no. 346.

69 Leslie, Anita. *Rodin: Immortal Peasant*. Intro. by Sir John Lavery. New York: Prentice-Hall, 1937; London: Herbert Joseph, 1939.

70 Ludovici, Anthony M. *Personal Reminiscences of Auguste Rodin*. Philadelphia: J. B. Lippincott Co., 1926; London: John Murray, 1926. Includes reprint of no. 236.

Maclagan, E. R. D. *See* no. 335.

71 Maillard, Léon. *Auguste Rodin, statuaire: Etudes sur quelques artistes originaux*. Paris: H. Floury, 1899.

72 Marquina, Rafael. *Augusto Rodin*. (Monografias de Arte.) Madrid: Estrella, 1934.

73 Martinie, A.-Henri. *Auguste Rodin, 1840–1917*. (Collection des Maîtres.) Paris: Les Editions Braun, 1947.

74 ———. *Rodin*. (Collection "Plastique.") Paris: Les Editions Braun, 1947.

75 Marx, Roger. *Auguste Rodin: Céramiste*. Paris: Société de Propagation des Livres d'Art, 1907.

76 Mauclair, Camille. *L'Œuvre de Rodin*. Conférence au Pavillon Rodin, 31 juillet 1900. Paris: Editions de la Plume, 1900.

77 ———. *Auguste Rodin: L'Homme et l'œuvre*. (Bibliothèque Internationale de Critique.) Paris: La Renaissance du Livre, 1918.

 77a *Auguste Rodin: The Man—His Ideas—His Works*. Eng. trans. by Clementina Black. London: Duckworth and Co., 1905.

78 Meier-Graefe, Julius. *Entwicklungsgeschichte der Modernen Kunst*. 3 vols. Stuttgart: Verlag Julius Hoffmann, 1904. Scattered references to Rodin in vols. 1 and 2.

 78a *Modern Art*. Eng. trans. 2 vols. New York: G. P. Putnam's Sons, 1908; New York: Arno Press, 1968. Scattered references to Rodin in both volumes.

79 Mendes, Manuel. *Rodin*. Lisbon: Ars Editorial, 1947.

80 [Mirolli] Butler, Ruth. "Literary Aspects in the Work of Auguste Rodin." Unpublished Master's thesis, The Institute of Fine Arts, New York University, 1957.

81 Mirolli, Ruth Butler. *The Early Work of Rodin and its Background*. Ann Arbor, Mich.: University Microfilms, 1966.

82 Morice, Charles. *Rodin*. Paris: H. Floury, 1900. Partially reprinted in no. 327.

83 Nostitz, Hélène von. *Rodin in Gesprächen und Briefen*. Dresden: Verlag Wolfgang Jess, 1927.
 83a 2d ed., 1949.
 83b *Dialogues with Rodin*. Eng. trans. by H. L. Ripperger. New York: Duffield and Green, 1931.

84 ———, ed. *Rodin: Briefe an zwei deutsche Frauen*. Intro. by Rudolf Alexander Schröder. Berlin: Holle Verlag, [191?].

85 Peumery, Gisèle. *Les Bourgeois de Calais: Leur histoire, leur monument*. Calais: E. Butez, 1971.

Philippe, Y. *See* no. 48.

86 Pierron, W. Sander. *Rude et Rodin à Bruxelles*. Brussels, 1903.

87 Rilke, Rainer Maria. *Auguste Rodin*. (Die Kunst, vol. 10.) Berlin: Julius Bard, 1903; Leipzig: Insel-Verlag, 1913.
 87a Eng. trans. by Jessie Lemont and Hans Trausil. New York: Sunwise Turn, 1919; New York: Fine Editions Press, 1945; London: Grey Walls Press, 1946. Reprinted in Elsen, no. 39.
 87b Fr. trans. by Henri Betz. Paris: Editions Emile-Paul Frères, 1928.

88 ———. *Lettres à Rodin*. Pref. by Georges Grappe. (Les Images du Temps, no. 7.) Paris: Editions Lapina, 1928; Paris: Editions Emile-Paul Frères, 1931.
 88a *Briefe an Auguste Rodin*. Ger. trans. Leipzig: Insel-Verlag, 1928.

89 Riotor, Léon. *Auguste Rodin, statuaire: L'Œuvre et ses aventures; Rodin dessinateur; caractères et projets; commentaires*. Paris: Anonay, 1900.
 89a New ed., Paris: Librairie Léon Vanier, 1903.

90 ———. *Rodin*. (Art et Esthétique.) Paris: Librairie Félix Alcan, 1927.

91 Ripley, Elizabeth. *Rodin: A Biography*. Philadelphia: J. B. Lippincott Co., 1966.

92 Rodin, Auguste. *Les Cathédrales de France*. Intro. by Charles Morice. Paris: Librairie Armand Colin, 1914. Reviewed by Paul Sauday in *Le Temps*, Paris,

April 22, 1914; Emile Mâle in *Gazette des Beaux-Arts,* Paris, 56ᵉ année, 11 (May 1914), pp. 372–78.

92a New ed., 1921.

92b *Cathedrals of France.* Eng. trans. by Elisabeth Chase Geissbuhler. Pref. by Herbert Read. Boston: Beacon Press, 1965.

See also nos. 288a, 288b.

93 *Rodin inconnu: Images de Rudomine.* Intro. by Marcel Aubert. Commentary by Roger Gabert. Paris: Editions de l'Archipel, 1950.

94 *Rodin Sculptures.* Pref. by Marcel Aubert. Eng. text trans. by R. Shedlin. Paris: Editions Tel, 1952.

95 Roh, Franz. *Rodin.* (Scherz Kunstbücher.) Bern: Alfred Scherz Verlag, 1949.

Rostrup, Haavard. *See* no. 333.

Sanders, Patricia B. *See* no. 343.

Saunier, Charles. *See* no. 45.

96 Sauve, Professor L. *Rodin et l'anatomie.* Paris, 1941.

Schaub-Koch, Emile. *See* no. 295a.

97 Schilling, Karl. *Auguste Rodins Vermächtnis in Gedanken und Gestaltung.* (Geistiges Europa.) Hamburg: Hoffmann und Campe Verlag, 1939.

98 Schmitz, Robert. *Rodin und die Fielder-Hilde-brandsche Kunsttheorie.* Bern: Lierow, 1929.

99 Schmoll gen. Eisenwerth, Josef Adolf. *Der Torso als Symbol und Form.* Baden-Baden: Bruno Grimm, 1954.

100 Shimbun, Yomiuri. *Auguste Rodin.* Tokyo: Orion Books, 1969.

Shipley, Joseph T. *See* no. 42.

101 Sigogneau, Albert. *A propos de Rodin: Quelques mécanismes psychologiques présidant à l'activité esthétique.* Bordeaux: Librairie de l'Université, 1932.

102 ———. *Le Tourment de Rodin: Mécanismes psychologiques présidant à l'activité esthétique.* Bordeaux: Librairie Delmas, 1933.

Spear, Athena Tacha. *See* no. 332.

103 Story, Sommerville. *Rodin.* Catalogue by Georges Grappe. (Phaidon edition.) London: George Allen and Unwin, 1939.

103a Rev. ed. without Grappe catalogue, London: Phaidon, 1961.

104 Sutton, Denys. *Triumphant Satyr: The World of Auguste Rodin.* London: Country Life, 1966. Reviewed by Albert E. Elsen in *Burlington Magazine,* London, 109, no. 767 (February 1967), pp. 105–6.

105 Taillandier, Yvon. *Rodin.* Paris: Flammarion, [1966].

105a Eng. trans. by Anne Ross. New York: Crown, [1967].

Tancock, John L. *See* no. 341.

106 Tirel, Marcelle. *Rodin intime, ou l'envers d'une gloire.* Pref. by A. Beuret. Paris: Aux Editions du Monde Nouveau, 1923.

106a *The Last Years of Rodin.* Eng. trans. by R. Francis. Pref. by Judith Cladel. New York: Robert M. McBride, 1925; London: A. M. Philpot, 1925.

Tominaga, Soichi. *See* no. 345.

107 Varende, Jean de la. *Rodin.* Paris: Editions Rombaldi, 1944.

Varnedoe, J. Kirk T. *See* no. 40.

108 Veidaux, André. *Auguste Rodin, statuaire.* Paris: V. Giard & E. Brière, 1900.

109 Waldmann, Emil. *Auguste Rodin.* Vienna: A. Schroll, 1945.

Watkins, Fridolyn G. *See* no. 342.

110 Weinberg, Louis. *The Art of Rodin.* New York: Modern Library, 1918.

111 Werth, Léon, et al. *Images de Rodin.* Paris: Les Publications Techniques et Artistiques, 1946. Includes: Léon Werth, "Rodin et son temps," pp. 3–10; Claude Roger-Marx, "Le Génie de Rodin," pp. 11–14; Judith Cladel, "Dans l'intimité du génie," pp. 15–29; Etienne Martin, "La Leçon de Rodin et la jeune sculpture," pp. 30–32; Marcel Aubert, "Le Musée Rodin," pp. 33–40; Raymond Martin, "Rodin et la tradition," pp. 41–42.

ARTICLES ON RODIN

Adams, Philip R. *See* no. 356.

112 Aitken, Charles. "The Rodin Gift." *Contemporary Review,* London, 107 (March 1915), pp. 346–54.

113 Alexandre, Arsène. "Croquis d'après Rodin." *Le Figaro,* Paris, July 21, 1899, p. 1.

114 ———. "Auguste Rodin." *Le Figaro,* Paris, November 18, 1917, p. 1.

115 ———. "Le Tombeau de Rodin." *Les Arts,* Paris, 14, no. 168 (1918), pp. 1–9.

See also nos. 349, 368.

116 Alhadeff, Albert. "Michelangelo and the Early Rodin." *Art Bulletin,* New York, 45, no. 4 (December 1963), pp. 363–67.

117 Amaya, Mario. "Rodin's Dancers." *Dance and Dancers,* London, 14, no. 3 (March 1963), pp. 24–26.

118 ———. "Unknown Rodin." *Apollo,* London, n.s. 78 (July 1963), p. 54.

119 Anderson, Alder. "Auguste Rodin at Home." *Pall Mall Magazine,* London, 27 (May–August 1902), pp. 325–38.

120 Anet, Claude, and Schopfer, Jean. "Auguste Rodin." *Craftsman,* New York, 5, no. 6 (March 1904), pp. 525–45.

Angelloz, J. F. *See* no. 362.

Armand-Blanc, May. *See* nos. 327, 328.

Arp, Jean. *See* no. 361.

121 Aubert, Marcel. "La Réouverture du Musée Rodin." *Pro Arte,* Geneva, no. 57 (January 1947), pp. 9–17.

See also nos. 93, 94, 111, 358, 359.

122 Aurel. "Rodin et la femme." *La Grande Revue,* Paris, 86 (July 1914–February 1915), pp. 206–19; 95 (November 1917–February 1918), pp. 238–53.

123 Austrian, Delia. "Rodin as I Knew Him." *International Studio,* New York, 68, no. 271 (September 1919), pp. xlvii–lii.

124 Avery, Charles. "From David d'Angers to Rodin—Britain's National Collection of French Nineteenth-Century Sculpture." *Connoisseur,* London, 179, no. 722 (April 1972), pp. 230–39.

125 Bartlett, Truman H. "Auguste Rodin, Sculptor." *American Architect and Building News,* Boston, 25, nos. 682–703 (January 19–June 15, 1889), pp. 27–29; 44–45; 65–66; 99–101; 112–14; 198–200; 223–25; 249–51; 260–63; 283–85. Reprinted in Elsen, no. 39.

126 Beach, Sylvia. "A Musée Rodin in Paris." *International Studio,* New York, 62, no. 246 (August 1917), pp. xlii–xliv.

127 Bénédite, Léonce. "Une Exposition d'œuvres de Auguste Rodin au Musée du Luxembourg." *Art et Décoration,* Paris, 17 (February 1905), pp. 48–51.

128 ———. "Rodin." In *Les Artistes: Les victoires de la volonté; biographies contemporaines,* pp. 99–112. Paris: Librairie Armand Colin, 1912.

129 ———. "Auguste Rodin (1840–1917)." *Gazette des Beaux-Arts,* Paris, 60e année, 14 (January–March 1918), pp. 5–34.

130 ———. "Le Musée Rodin." *Les Arts,* Paris, 14, no. 168 (1918), pp. 10–24.

131 ———. "Dante et Rodin." In *Dante: Mélanges de critiques et d'érudition française,* pp. 209–19. Paris: Librairie Française, 1921.

See also nos. 330, 351.

132 Berger, John. "Rodin." In *The Moment of Cubism and Other Essays,* pp. 132–39. New York: Pantheon Books, Random House, 1969.

133 Bergerat, Emile. "Les Débuts d'Auguste Rodin." *Le Figaro,* Supplément, Paris, March 31, 1906, p. 1.

Bernardini-Sjoestedt, Léonie. *See* no. 330.

134 Bernier, Rosamond. "Henry Moore parle de Rodin." *L'Œil,* Paris, no. 155 (November 1967), pp. 26–33.

135 Bernstein, Herman. "Auguste Rodin." In *Celebrities of Our Time: Interviews,* pp. 120–35. New York: Joseph Lawren Publisher, 1924.

136 Berthelot, René. "Auguste Rodin." *La Plume,* Paris, 12e année, no. 275 (1900), pp. 595–99.

Besnard, Albert. *See* no. 349.

137 Besson, George. "De Rodin à Maillol." *Le Point,* Colmar, 2, no. 6 (December 1937), pp. 235–41.

Beuret, A. *See* no. 106.

138 Boeck, Wilhelm. "Rodins 'Höllenpforte': Ihre Kunstgeschichtliche Bedeutung." *Wallraf-Richartz Jahrbuch,* Cologne, 16 (1954), pp. 161–95.

Boès, Karl. *See* no. 327.

Bornibus, Jacques. *See* no. 368.

139 Bouhelier, Saint Georges de. "Rodin." *L'Aurore,* Paris, April 19, 1908.

Bouyer, Raymond. *See* nos. 327, 328.

Bowness, Alan. *See* no. 389.

140 Breck, Joseph. "Auguste Rodin and His French Critics." *Edinburgh Review,* Edinburgh, 215 (January 1912), pp. 74–92.
 140a Reprinted in *Supplement to the Metropolitan Museum of Art Bulletin,* New York, May 1912, pp. 23–30. Reissued in 1913. *See* no. 337.

141 ———. "The Collection of Sculptures by Auguste Rodin in the Metropolitan Museum." *Supplement to the Metropolitan Museum of Art Bulletin,* New York, May 1912, pp. 9–20. Reissued in 1913. *See* no. 337.

142 Brisson, Adolphe. "L'Exposition d'Auguste Rodin." *La Revue Illustrée,* Paris, 30, no. 14 (July 1, 1900).

Brown, J. Carter. *See* no. 395.

143 Brownell, William C. "Auguste Rodin." *Scribner's Magazine,* New York, 29 (1900), pp. 88–101.

144 ———. "Rodin and the Institute." In *French Art: Classic and Contemporary Painting and Sculpture,* pp. 243–74. New and enl. ed. New York: Charles Scribner's Sons, 1912.

Browse, Lillian. *See* no. 376.

145 Brughetti, Romualdo. "Rodin and Bourdelle in Buenos Aires." *Sculpture International,* London, 3, no. 2–3 (1970), pp. 44–48.

Bucarelli, Palma. *See* no. 381.

146 Campagnac, Edmond. "Rodin et Bourdelle d'après des lettres inédites." *La Grande Revue,* Paris, 131 (November 1929), pp. 3–19.

147 Canudo, Ricciotto. "Notre Colonne Trajanne: La 'Tour de Travail' de Rodin." *Le Censeur Politique et Littéraire,* Paris, August 3, 1907, pp. 417–22.

148 Carl, J.-A. "Rodin." *L'Art,* Paris, 63 (February 1904), pp. 60–69.

Carrière, Eugène. *See* nos. 328, 349.

149 Caso, Jacques de. "Rodin's Mastbaum Album." *Master Drawings,* New York, 10, no. 2 (Summer 1972), pp. 155–61.

See also no. 37 [review].

150 Casseres, Benjamin de. "Rodin and the Eternality of the Pagan Soul!" *Camera Work,* New York, nos. 34–35 (April–July 1911), pp. 13–14.

151 Chaumeix, André. "Le Mouvement des idées: Les entretiens de Rodin sur l'art." *La Revue Hebdomadaire,* Paris, 20e année, no. 31 (August 5, 1911), pp. 109–28.

152 Chéruy, René. "Un Musée Rodin à Philadelphie." *L'Illustration,* Paris, 87, no. 4521 (October 26, 1929), pp. 466–67.

153 Christoffel, Ulrich. "Rodin und Hildebrand." *Die Kunst,* Munich, 71, no. 2 (November 1934), pp. 33–44.

154 Ciolkowska, Muriel. "Auguste Rodin on Prejudice in Art." *Englishwoman,* London, April 1910, pp. 263–69.

155 Cladel, Judith. "Le Sculpteur Auguste Rodin pris sur la vie." *La Plume,* Paris, 14e année, pt. 2 (1902), pp. 1393–1403; 15e année, pt. 1 (1903), pp. 85–96, 178–85, 238–45, 286–90, 341–51, 393–405, 450–61, 527–32, 571–78.

156 ———. "The Great Rodin. He Talks to 'The Lone Hand' of His Ideals and His Methods." *Lone Hand, The Australian Monthly,* Sydney, November 2, 1908, pp. 6–15.

157 ———. "L'Enseignement d'art de Rodin." *La Vie,* Paris, November 23, 1912.

158 ———. "Rodin's Note-Book." *Century Magazine,* New York, 88 (1914), pp. 38–44; 279–85; 513–21; 740–49.

159 ———. "Une Conscience française Auguste Rodin." *L'Homme Libre,* Paris, November 25, 1917, p. 1.

160 ———. "Rodin et l'Allemagne. Le maître refusa de faire le buste de Guillaume II." *L'Homme Libre,* Paris, November 30, 1917, p. 1.

161 ———. "La Mort d'Auguste Rodin." *Les Arts Français,* Paris, no. 11 (1917), pp. 195–97.

162 ———. "Le Cas Rodin—les volontés du grand sculpteur méconnus." *L'Homme Libre,* Paris, January 30, 1918, p. 1.

163 ———. "La Jeunesse de Rodin." *La Revue Universelle,* Paris, 59 (November 1, 1934), pp. 266–96; 59 (November 15, 1934), pp. 415–34; 61 (May 1, 1935), pp. 308–24; 61 (May 15, 1935), pp. 430–51.

164 ———. "Rodin et l'amitié." *La Revue Hebdomadaire,* Paris, 44ᵉ année, no. 10 (March 9, 1935), pp. 168–90; 44ᵉ année, no. 11 (March 16, 1935), pp. 340–60.

See also nos. 106a, 111, 330, 363.

165 Claris, Edmond. "L'Impressionnisme en sculpture: Auguste Rodin et Medardo Rosso." *La Nouvelle Revue,* Paris, n.s. 10 (June 1, 1901), pp. 321–36.

165a Reprinted in *De l'Impressionnisme en sculpture.* Paris: Editions de "La Nouvelle Revue," 1902.

166 Clark, Kenneth. "Rodin." In *The Romantic Rebellion: Romantic Versus Classic Art,* pp. 331–57. New York: Harper & Row, 1973.

167 Clemen, Paul. "Auguste Rodin." *Die Kunst für Alle,* Munich, 20, no. 3 (April 1, 1905), pp. 289–307; 321–335.

Clément-Janin. See no. 328.

Constant, Benjamin. See no. 331.

168 Coquiot, Gustave. "Le Musée Rodin." *Le Figaro,* Paris, June 19, 1914, p. 1.

See also nos. 327, 328.

169 Cox, Kenyon. "Rodin." *Architectural Record,* New York, 18, no. 5 (November 1905), pp. 327–46.

170 Daudet, Léon. "Le Génie de Rodin." *L'Action Française,* Paris, 10ᵉ année, no. 324 (November 20, 1917), p. 1.

See also no. 331.

171 Dayot, Armand. "Rodin au Panthéon: Quelques souvenirs." *L'Art et les Artistes,* Paris, 25, no. 131 (November 1932), pp. 37–42.

De Lamazelle. See no. 331.

172 Devigne, Marguerite. "Rodin (Palais des Beaux-Arts)." *Cahiers de Belgique,* Brussels, no. 4 (April 1930), p. 136.

173 Diolé, Philippe. "Despiau nous parle de Rodin qui fut 'son père spirituel.'" *Beaux-Arts,* Paris, no. 45 (November 10, 1933), p. 1.

Donohue, Kenneth. See no. 383.

Dorbec, Prosper. See no. 328.

174 Durbé, Dario. "Rodin, Rosso e l'ultima produzione impressionista." In *L'Arte Moderna,* vol. 1, pp. 121–60. Milan: Fratelli Fabbri Editori, 1967.

175 Elder, Marc. "Eugène Carrière et Auguste Rodin." *Les Arts,* Paris, 15, no. 180 (1919), pp. 19–23.

176 Elsen, Albert E. "The Humanism of Rodin and Lipchitz." *College Art Journal,* New York, 17, no. 3 (Spring 1958), pp. 247–65.

177 ———. "Rodin Recovered." *Art International,* Zurich, 7, no. 7 (September 1963), pp. 33–36.

178 ———. "Rodin's Modernity." *Artforum,* New York, 2, no. 6 (December 1963), pp. 23–26.

179 ———. "Rodin's 'La Ronde.'" *Burlington Magazine,* London, 107, no. 747 (June 1965), pp. 290–99.

180 ———. "Rodin's 'The Walking Man.'" *Massachusetts Review,* Amherst, 7, no. 2 (Spring 1966), pp. 289–320.

181 ———. "Rodin's Portrait of Baudelaire." In '*25,' A Tribute to Henry Radford Hope.* Bloomington: University of Indiana, 1966.

182 ———. "The Arts Council's Circulating Rodin Exhibition." *Burlington Magazine,* London, 109, no. 770 (May 1967), pp. 325–26.

183 ———, in collaboration with Henry Moore. "Rodin's 'Walking Man' as Seen by Henry Moore." *Studio International,* New York, 174 (July/August 1967), pp. 26–31.

184 ———. "Notes on the Partial Figure." *Artforum,* New York, 8, no. 3 (November 1969), p. 59.

185 ———. "Drawing and the True Rodin." *Artforum,* New York, 10, no. 6 (February 1972), pp. 64–69.

See also nos. 32 [review], 40, 65 [review], 104 [review], 388, 398.

186 Fagus, Félicien. "Discours sur la mission de Rodin." *La Revue Blanche,* Paris, 22 (1900), pp. 241–52.

187 Faure, Elie. "Auguste Rodin." *Les Ecrits Nouveaux,* Paris, 1 (April 1918), pp. 51–56.

188 Fitz-Gerald, William G. "A Personal Study of Rodin. The Home Life and Working Habits of the Great Sculptor." *World's Work,* New York, 11 (1905), pp. 6818–34.

189 Flax. "Auguste Rodin." *Les Hommes du Jour,* Paris, no. 38 (October 10, 1908), pp. 2–4.

Florisoone, Michel. *See* no. 355.

Fontainas, André. *See* no. 327.

190 Foratti, Aldo. "Le 'Michelangelisme' de Rodin." *La Revue des Nations Latines,* Florence, 3ᵉ année, no. 2 (May 16, 1918), pp. 93–103; 5ᵉ année, no. 5 (July 1, 1918), pp. 273–79.

Fouquet, Georges. *See* no. 364.

France, Anatole. *See* nos. 328, 331.

Frantz, Henri. *See* no. 327.

191 Frédéric, Louis. "I Rodin's ateljé, Meudon." *Konstrevy,* Stockholm, no. 4 (1953), pp. 118–21.

192 Fugl, Alexander. "Billedhuggeren Auguste Rodin, 1840–1917." *Samleren,* Uppsala, August 1935, pp. 129–44.

Gabert, Roger. *See* no. 93.

Gamzu, Dr. Haim. *See* no. 380.

193 Gantner, Joseph. "Rodin und der Impressionismus." *Universitas,* Stuttgart, 8, no. 4 (1953), pp. 365–73.

194 ———. "Il Problema del 'non Finito' in Leonardo, Michelangelo e Rodin." In *Atti del Seminario di Storia dell'Arte,* pp. 47–61. Studi di Storia dell'arte dell'Istituto di storia dell'arte medievale e moderna dell'Università di Pisa, July 1–15, 1953. Pisa: Annali della scuola normale superiore di Pisa, 1954.

195 Ganz, Hermann. "Rodin im Hôtel Biron." *Kunst und Künstler,* Berlin, 27 (1928), pp. 102–8.

196 Gardner, Albert Ten Eyck. "The Hand of Rodin." *Metropolitan Museum of Art Bulletin,* New York, 15, no. 9 (May 1957), pp. 200–204.

197 Garin, Pierre. "Le Vrai Rodin." *La Nouvelle Revue,* Paris, 4th ser., 8 (July 15, 1913), pp. 193–96.

198 Geffroy, Gustave. "Chronique—Rodin." *La Justice,* Paris, July 11, 1886.

199 ———. "Le Statuaire Rodin." *Les Lettres et les Arts,* Paris, 3 (September 1, 1889), pp. 289–304.
199a Extract published separately. Paris: Boussod, Valadon et Cie, 1889. Largely reprinted in no. 347.
199b Reprinted as "Auguste Rodin" in *La Vie artistique,* vol. 2, 2ᵉ série, pp. 62–115. Paris: H. Floury, 1893.

200 ———. "Rodin." In *La Vie artistique,* vol. 1, 1ᵉ série, pp. 225–29. Paris: H. Floury, 1892.

201 ———. "Rodin." *Art et Décoration,* Paris, 8 (October 1900), pp. 97–110.

See also nos. 327, 331, 347.

202 Geissbuhler, Elisabeth Chase. "Rodin's Abstractions: The Architectural Drawings." *Art Journal,* New York, 26, no. 1 (Fall 1966), pp. 22–29.

See also no. 40.

203 Goldscheider, Cécile. "Nouvelles Acquisitions (au Musée Rodin)." *Les Musées de France,* Paris, no. 9 (November 1950), pp. 201–2.

204 ———. "Rodin et la danse." *Art de France,* Paris, no. 3 (1963), pp. 321–35.

205 ———. "La Nouvelle Salle des Bourgeois de Calais au Musée Rodin." *La Revue du Louvre,* Paris, 21, no. 3 (1971), pp. 165–74.

See also nos. 358, 359, 360, 363, 366, 367, 369, 378, 379, 380, 381, 383, 384, 385, 389, 391, 392, 393, 394, 396.

206 Gourmont, Rémy de. "Le Marbre et la chair." *Le Journal,* Paris, March 11, 1893.

207 Grand, M. P. "Rodin: Genius with Giblets." *Art News,* New York, 62, no. 3 (May 1963), pp. 24–28.

208 Grappe, Georges. "Rodin collectionneur." *Le Cousin Pons,* Paris, n.s. 11, no. 1 (January 1–15, 1928), pp. 7–15.

209 ———. "Affinités électives—Ovide et Rodin." *L'Amour de l'Art,* Paris, 17, no. 6 (June 1936), pp. 203–8.

210 ———, with Gréber, Jacques, and White, Gilbert. "Musée Rodin de Philadelphie. Fondation Mastbaum." *La Renaissance de l'Art Français et des Industries de Luxe,* Paris, 9, no. 11 (November 1926), pp. 593–600.

See also nos. 88, 103.

211 Grautoff, Otto. "Auguste Rodin." *Die Kunst für Alle,* Munich, 26, no. 2 (October 15, 1910), pp. 25–47.

See also no. 330.

Gréber, Jacques. *See* no. 210.

212 Gsell, Paul. "Chez Rodin." *L'Art et les Artistes,* Paris, 4, no. 23 (February 1907), pp. 393–415.

213 ———. "Le Musée Rodin." *L'Art et les Artistes,* Paris, 19, no. 2 (June 1914), pp. 45–71.

214 ———. "Auguste Rodin." *La Revue de Paris,* Paris, 25 (January 15, 1918), pp. 400–417.

215 ———. "Le Musée Rodin à Meudon." *La Renaissance de l'Art Français et des Industries de Luxe,* Paris, 6, no. 8 (August 1923), pp. 457–65.

216 ———. "Deux Centenaires, Rodin et Claude Monet." *L'Illustration,* Paris, 207, no. 5096 (November 9, 1940), pp. 242–45.

217 ———. "Auguste Rodin et la guerre." *Pro Arte,* Geneva, no. 21 (January 1944), pp. 14–16.

See also no. 330.

218 Guillemot, Maurice. "Au Val-Meudon." *Le Journal,* Paris, August 17, 1898.

219 Hall, Douglas. "A Note on Rodin and the Bronzes in the Burrell Collection." *Scottish Art Review,* Glasgow, 11, no. 1 (1967), pp. 1–5.

Hamel, Maurice. *See* no. 331.

220 Harris, Frank. "Rodin." In *Contemporary Portraits,* pp. 314–28. New York: Mitchell Kennerley, 1915.

See also no. 327.

Hefting, J. V. C. *See* no. 360.

Henley, W. E. *See* no. 328.

221 Hess, John L. "'Original' Bronzes of Rodin Sculptures Being Cast 50 Years after His Death." *New York Times,* February 23, 1968, p. 42.

222 Hoffman, Malvina. "Rodin, and Paris." In *Heads and Tales,* pp. 33–55. New York: Charles Scribner's Sons, 1936.

223 Houston, G. Craig. "Rilke and Rodin." In *German Studies Presented to Professor H. G. Fiedler, M.V.O.,* pp. 244–65. Oxford: Clarendon Press, 1938.

Howe, Thomas C. *See* no. 370.

Huneker, James. *See* no. 25a.

224 Hunt, Clyde. "A Visit to Rodin." *American Architect,* New York, 105 (April 29, 1914), pp. 202–4.

225 Janson, H. W. "Rodin and Carrier-Belleuse: The Vase des Titans." *Art Bulletin,* New York, 50, no. 3 (September 1968), pp. 278–80.

Jarvis, Alan. *See* no. 390.

226 Javel, Firmin. "A. Rodin." *L'Art Français Revue Artistique Hebdomadaire,* Paris, 1e année, no. 41 (February 4, 1888).

227 ———. "Auguste Rodin." *L'Art Français Revue Artistique Hebdomadaire,* Paris, 3e année, no. 115 (July 6, 1889).

228 Jewell, Edward Alden. "Rodin, Who Stirred Tempests, Is Honoured with a Museum." *New York Times Magazine,* December 15, 1929, pp. 10–11.

Jianou, Ionel. *See* no. 391.

229 Kahn, Gustave. "Notes sur Rodin." *Mercure de France,* Paris, 172, no. 623, June 1, 1924, pp. 313–25.

See also nos. 327, 329.

Kalenberg, Angel. *See* no. 393.

230 Kohlschmidt, Werner. "Rilke und Rodin." In *Actes du Cinquième Congrès International des Langues et Littératures Modernes, Florence, 27–31 Mars 1951,* pp. 513–21. Florence: Valmartina, 1955.

231 Lancellotti, Arturo. "Necrologio: Auguste Rodin." *Emporium,* Bergamo, 46 (1917), pp. 332–36.

Landis, Ellen. *See* no. 387.

232 Larroumet, Gustave. "Rodin." *Le Figaro,* Supplément Littéraire, Paris, January 12, 1895.

Laurens, Jean-Paul. *See* no. 349.

Lavery, Sir John. *See* no. 69.

Leblond, Marius-Ary. *See* no. 328.

Lecomte, Georges. *See* no. 359.

Lee, Sherman E. *See* no. 332.

233 Le Franc, Jean. "Rome vue par Rodin." *Le Temps,* Paris, February 20, 1912, p. 4.

Lemonnier, Camille. *See* no. 25.

234 Lemont, Jessie. "Auguste Rodin: A Visit to Meudon." *Craftsman,* New York, 20, no. 3 (June 1911), pp. 289–93.

235 Lindsay, Jack. "Rodin." *Art and Artists,* London, 4, no. 11 (February 1970), pp. 12–15.

Lintilhac, Eugène. *See* no. 331.

Lipchitz, Jacques. *See* nos. 38, 361.

236 Ludovici, Anthony M. "Personal Reminiscences of Auguste Rodin." *Cornhill Magazine,* London, n.s. 55 (July 1923), pp. 1–13; n.s. 55 (August 1923), pp. 131–43; n.s. 59 (December 1925), pp. 754–66; n.s. 60 (January 1926), pp. 111–126; n.s. 60 (February 1926), pp. 213–26. Reprinted in no. 70.

Lumet, Louis. *See* no. 331.

237 MacColl, D. S. "Rodin." *Saturday Review,* London, 90, no. 2344 (September 29, 1900), pp. 392–93.

See also no. 328.

238 Macdonald, James S. "Visiting Rodin." *Art in Australia,* Sydney, 3d ser., no. 1 (August 1922), pp. 55–58.

Madl, Karel. *See* no. 328.

Mâle, Emile. *See* no. 92 [review].

239 Manson, Anne. "Cet intraitable Monsieur Rodin." *Paris-Presse-L'Intransigeant,* Paris, March 10–18, 1959.
 239a Reprinted in *Les Maudits de Cézanne à Utrillo,* by Gilbert Guilleminault, pp. 119–94. Paris: Editions Denoël, 1959.

240 ———. "Rodin." *Jardin des Arts,* Paris, no. 156 (1967), pp. 15–30.

241 Marguillier, Auguste. "Auguste Rodin." *Kunst und Kunsthandwerk,* Vienna, 3 (1900), pp. 237–62.

Martin, Etienne. *See* no. 111.

Martin, Raymond. *See* no. 111.

Martinie, A.-Henri. *See* no. 288b.

242 Marx, Roger. "Cartons d'artistes: Auguste Rodin." *L'Image,* Paris, no. 10 (September 1897), pp. 293–99.

243 ———. "Auguste Rodin." *Pan,* Berlin, 3 (1897), pp. 191–96.

244 ———. "Rodin céramiste." *Art et Décoration,* Paris, 17 (February 1905), pp. 117–28.

245 ———. "Trois Aspects du génie d'Auguste Rodin." In *Maîtres d'Hier et d'Aujourd'hui,* pp. 199–239. Paris: Calmann-Lévy, 1914.

See also nos. 23, 327.

Masson, André. *See* no. 361.

246 Mauclair, Camille. "L'Art de M. Auguste Rodin." *La Revue des Revues,* Paris, 25, no. 12 (June 15, 1898), pp. 591–610. Partially reprinted in no. 327.

247 ———. "The Decorative Sculpture of Auguste Rodin." *International Quarterly,* Burlington, Vt., 3 (1901), pp. 166–81.

248 ———. "Notes sur la technique et le symbolisme de M. Auguste Rodin." *La Renaissance Latine,* Paris, 4, pt. 2 (May 1905), pp. 200–220.

249 ———. "Les Dessins de Rodin sur un exemplaire des 'Fleurs du Mal.'" In *Les Fleurs du Mal,* by Charles Baudelaire, pp. i–xii. Paris: Limited Editions Club, 1940.

See also nos. 327, 328, 331.

250 Maus, Octave. "Rodin à Ixelles." *Art Moderne,* Brussels, no. 39 (1911), pp. 305–6.

McGough, Stephen C. *See* no. 398.

Mellerio, André. *See* nos. 327, 328.

Merrill, Stuart. *See* no. 327.

Merson, Olivier. *See* no. 331.

251 Meyer, Agnes Ernst. "Some Recollections of Rodin." *Camera Work,* New York, nos. 34–35 (April–July 1911), pp. 15–19.

Michel, André. *See* no. 331.

Miomandre, Francis de. *See* no. 330.

252 Mirbeau, Octave. "Auguste Rodin." *La France,* Paris, February 18, 1885.
 252a Reprinted in *Des Artistes, Première Série 1885–1896,* pp. 12–19. Paris: Ernest Flammarion, 1922.

253 ———. "Auguste Rodin." *L'Echo de Paris,* Paris, June 25, 1889.
 253a Reprinted in *Des Artistes, Première Série 1885–1896,* pp. 97–102. Paris: Ernest Flammarion, 1922.

254 ———. "Auguste Rodin." *La Revue Illustrée,* Paris, 8, no. 87 (July 15, 1889), pp. 75–80.

255 ———. "Auguste Rodin." *Le Journal,* Paris, June 4, 1895.
 255a Reprinted in *Des Artistes, Première Série 1885–1896,* pp. 234–43. Paris: Ernest Flammarion 1922.

256 ———. "Hommage à Auguste Rodin." In *Les Dessins de Auguste Rodin, 129 Planches comprenant 142 dessins, reproduits en facsimile par la*

Maison Goupil, pp. 9–14. Paris: Jean Boussod, Manzi, Joyant et Cie, 1897.

See also nos. 327, 330, 331.

Mockel, Albert. *See* no. 327.

Monet, Claude. *See* no. 349.

Mongan, Elizabeth. *See* no. 357.

257 Monkhouse, Cosmo. "Auguste Rodin." *Portfolio,* London, 18 (1887), pp. 7–12.

258 Montesquiou, Robert de. "Altesses Sérénissimes." In *L'Animateur,* pp. 117–22. Paris: Société d'Edition et de Publications, 1907.

See also no. 328.

259 Montorgueil, Georges. "L'Affaire des faux Rodins." *L'Illustration,* Paris, 153, no. 3962 (February 8, 1919), pp. 160–61.

Moore, Henry. *See* no. 183.

260 Moore, T. Sturge. "Rodin." *Monthly Review,* London, 9 (October 1902), pp. 96–107.

261 Moreau-Vauthier, Paul. "Le Maître fondeur Eugène Rudier." *L'Art et les Artistes,* Paris, 32, no. 165 (March 1936), pp. 203–9.

262 Morey, Charles Rufus. "The Art of Auguste Rodin." *Art Bulletin,* New York, 1, no. 4 (September 1918), pp. 145–54.

263 Morice, Charles. "Rodin." *L'Homme Libre,* Paris, November 18, 1917, p. 1.

264 ———. "Rodin." *Mercure de France,* Paris, 124, no. 468 (December 16, 1917), pp. 577–96.

See also nos. 92, 327.

265 Mourey, Gabriel. "The Work of Auguste Rodin." *International Studio,* New York, 4, no. 16 (June 1898), pp. 215–23.

266 ———. "Auguste Rodin." In *Des Hommes devant la nature et la vie,* pp. 9–34. (Société d'Editions Littéraires et Artistiques.) Paris: Librairie Ollendorff, 1902.

267 ———. "A Few Words on the Death of Rodin." *International Studio,* New York, 64, no. 254 (April 1918), pp. 57–62.

268 Natanson, Thadée. "Auguste Rodin." *Arts de France,* Paris, no. 7 (1946), pp. 24–34.

269 Nicholson, Benedict. "Rodin and Lady Sack-ville." *Burlington Magazine,* London, 112, no. 802 (January 1970), pp. 37–43.

Nordenfalk, Carl. *See* no. 377.

270 P. S. "Les Idées de Rodin." *Le Temps,* Paris, November 19, 1917, p. 1.

271 Paris, W. Francklyn. "Rodin as a Symbolist." *International Studio,* New York, 49, no. 194 (April 1913), pp. xliii–xlv.

Parkhurst, Charles. *See* no. 388.

Payro, Julio. *See* no. 371.

272 Pératé, André. "Rodin." *Le Correspondant,* Paris, December 10, 1917, pp. 874–82.

See also no. 331.

273 Peters, H. F. "Rilke-Rodin: A Correction." *Modern Language Notes,* Baltimore, 57, no. 1 (January 1942), pp. 9–10.

274 ———. "Rilke in His Letters to Rodin." *Modern Language Quarterly,* Seattle, 4, no. 1 (March 1943), pp. 3–12.

275 Phillips, Claude. "Auguste Rodin." *Magazine of Art,* London, 11 (1888), pp. 138–44.

Pica, Vittorio. *See* no. 328.

276 Picard, Edmond. "L'Exposition Rodin." *L'Echo de Paris,* Paris, July 19, 1900.

277 Pierron, W. Sander. "François Rude & Auguste Rodin à Bruxelles." *La Grande Revue,* 24 (October 1902), pp. 138–62.

278 Quentin, Charles. "Rodin." *Art Journal,* London, 50 (1898), pp. 193–96; 321–24.

279 ———. "Le Musée Rodin." *Art Journal,* London, 52 (1900), pp. 213–17.

280 ———. "New Work by Auguste Rodin." *Art Journal,* London, 54 (1902), pp. 121–23.

Rambosson, Yvanhoé. *See* no. 327.

281 Rameau, Jean. "La Victoire de M. Rodin." *Le Gaulois,* Paris, May 3, 1898, p. 1.

See also no. 331.

282 Rapin, René. "Rilke, Jacobson and Rodin." *Bibliothèque Universelle et Revue de Genève,* Geneva, October 1925, pp. 1734–43.

Read, Herbert. *See* nos. 46, 92b.

283 Rice, Howard C. "Glimpses of Rodin."

Princeton University Library Chronicle, Princeton, 27, no. 1 (Autumn 1965), pp. 33–44.

284 Rilke, Rainer Maria. "Sur des œuvres de Rodin." *Bibliothèque Universelle et Revue de Genève,* Geneva, May 1925, pp. 527–41.

See also no. 361.

Riotor, Léon. *See* nos. 327, 328.

Rochefort, Henri. *See* no. 331.

285 Roches, F. "Rodin et l'architecture." *L'Architecture Française,* Paris, no. 3 (January 1941), pp. 35–40.

286 Rod, Edouard. "L'Atelier de M. Rodin." *Gazette des Beaux-Arts,* Paris, 40ᵉ année, 19 (May 1898), pp. 419–30.

287 Rodenbach, Georges. "M. Rodin." In *L'Elite,* pp. 273–91. (Bibliothèque Charpentier.) Paris: Eugène Fasquelle, 1899.

See also no. 331.

288 Rodin, Auguste. "Vénus: A la Vénus de Milo." *L'Art et les Artistes,* Paris, 10 (March 1910), pp. 243–55. Reprinted in no. 330.
 288a Reprinted as *Venus. To the Venus of Melos.* Eng. trans. by Dorothy Dudley. New York: B. W. Huebsch, 1912.
 288b Reprinted as *A la Vénus de Milo.* Pref. by A.-H. Martinie. Paris: La Jeune Parque, 1945.

See also nos. 330, 331, 361, 368.

Roëll, D. C. *See* no. 355.

289 Roger-Marx, Claude. "Sur un groupe de Rodin." In *Les Premières Funérailles.* N. p., n. d.

See also no. 111.

290 Roger-Milès, L. "Rodin." *Le Figaro Illustré,* special number, Paris, no. 192 (March 1906), pp. 62–80.

291 ———. "Rodin." *Le Gaulois,* Paris, November 18, 1917, pp. 1–2.

Rosenthal, Albert. *See* no. 352.

292 Rostrup, Haavard. "Dessins de Rodin." *From the Collections of the Ny Carlsberg Glyptothek,* Copenhagen, 2 (1938), pp. 211–26.

Rouvier, Jean. *See* no. 362.

293 Russell, John. "Rodin's Adventures on Mt. Venus." *Art News,* New York, 69, no. 1 (March 1970), pp. 36–37.

294 Saarinen, Aline B. "Revival of Rodin—And of Sentiment." *New York Times Magazine,* March 20, 1955, p. 28.

Sauday, Paul. *See* no. 92 [review].

Saunier, Charles. *See* no. 331.

Sauty, Louis. *See* no. 327.

295 Schaub-Koch, Emile. "L'Esthétique et la technique de Rodin." *La Nouvelle Revue,* Paris, September 1, 1933.
 295a Extract published separately. Paris: Editions de "La Nouvelle Revue," 1933.

296 ———. "Quelques Notes sur le nu dans la sculpture de Rodin." *Pro Arte,* Geneva, no. 6 (October 1942), pp. 19–20.

297 Schlumberger, Eveline. "Rodin consciencieux, célèbre, discuté, opiniâtre, génial, bafoué. Rappelez-vous: L'Affaire Balzac." *Connaissance des Arts,* Paris, no. 182 (April 1967), pp. 57–65.

298 Schmoll gen. Eisenwerth, Josef Adolf. "Zur Genesis des Torso-Motivs und zur Deutung des fragmentarischen Stils bei Rodin." In *Das Unvollendete als Künstlerische Form; Ein Symposion,* pp. 117–40. Bern and Munich: Francke Verlag, 1959.

299 ———. "Auguste Rodin. Das heutige Bild seines Werkes und seiner Wirkung." *Universitas,* Stuttgart, 23, no. 4 (1968), pp. 393–409.

300 ———. "Der alte Pan—zum Spätwerk Rodins." In *Beiträge für Hans Gerhard Evers,* pp. 11–35. (Darmstädter Schriften, no. 22.) Darmstadt: Justus von Liebig Verlag, 1968.

Schopfer, Jean. *See* no. 120.

Schröder, Rudolf Alexander. *See* no. 84.

301 Seiberling, Dorothy. "The Great Rodin—His Flagrant Faker." *Life,* New York, 58, no. 22 (June 4, 1965), pp. 64–71.

302 Sells, A. Lytton. "Auguste Rodin and His English Friends, 1885–1889." *College Art Journal,* New York, 15, no. 2 (Winter 1955), pp. 143–45.

Selz, Peter. *See* no. 38.

303 Séverine. "Auguste Rodin." *Le Journal,* Paris, September 10, 1894.

See also no. 331.

Seymour, Charles. *See* no. 357.

Sickman, Laurence. *See* no. 392.

Silvestre, Armand. *See* no. 331.

304 Simmel, Georg. "L'Œuvre de Rodin comme expression de l'esprit moderne." In *Mélanges de Philosophie Relativiste,* pp. 126–38. Paris: Librairie Félix Alcan, 1912.

305 ———. "Auguste Rodin." In *Philosophische Kultur,* pp. 168–86. Leipzig, 1919.

Simoni, H.-Ernest. *See* no. 328.

306 Sizeranne, Robert de la. "L'Œuvre de Rodin." *La Revue des Deux Mondes,* Paris, 87e année, 42 (December 15, 1917), pp. 915–34.

See also no. 331.

307 Smiley, Charles Newton. "Rodin in the Metropolitan Museum." *Art and Archaeology,* New York, 3, no. 2 (February 1916), pp. 106–14; 3, no. 3 (March 1916), pp. 164–71.

308 [Spear] Tacha, Athena C. "The Prodigal Son: Some New Aspects of Rodin's Sculpture." *Allen Memorial Art Museum Bulletin,* Oberlin, 22, no. 1 (Fall 1964), pp. 23–39.

309 Spear, Athena T. "A Note on Rodin's Prodigal Son and on the Relationship of Rodin's Marbles and Bronzes." *Allen Memorial Art Museum Bulletin,* Oberlin, 27, no. 1 (Fall 1969), pp. 25–36.

310 Steinberg, Leo. "Rodin." In *Other Criteria: Confrontations with Twentieth-Century Art,* pp. 322–403. New York: Oxford University Press, 1972 (reprinted from no. 369).

Sucharda, Stanislaw. *See* no. 350.

311 Symons, Arthur. "Rodin." *Fortnightly Review,* London, 77 (1902), pp. 957–67.

312 ———. "Auguste Rodin." In *From Toulouse-Lautrec to Rodin, with some Personal Reminiscences,* pp. 219–42. London: John Lane, the Bodley Head, 1929.

313 ———. "Notes on Auguste Rodin." *Apollo,* London, 14, no. 80 (August 1931), pp. 93–97.

See also no. 327.

Tacha, Athena C. *See* Spear, Athena T.

314 Tancock, John L. "Rodin is a Rodin is a Rodin." *Art and Artists,* London, 2, no. 4 (July 1967), pp. 38–41.

315 ———. "Unfamiliar Aspects of Rodin." *Apollo,* London, 100, n.s. no. 149 (July 1974), pp. 46–51.

See also no. 376.

316 Taylor, Francis Henry. "Rodin." *Parnassus,* New York, 2, no. 11 (February 1930), p. 10.

317 Thiébault-Sisson. "Auguste Rodin." *Le Temps,* Paris, November 18, 1917, p. 3.

Thorson, Victoria. *See* no. 40.

318 Treu, Georg. "Auguste Rodin." *Jahrbuch der Bildenden Kunst,* Berlin, 2 (1903), pp. 81–86.

See also no. 328.

319 Tucker, W. "Rodin: The Language of Sculpture." *Studio International,* New York, 184 (December 1972), pp. 222–25; 185 (January 1973), pp. 38–40.

320 ———. "Gravity, Rodin, Degas." *Studio International,* New York, 186 (July 1973), pp. 25–29.

321 Tyler, Parker. "Rodin and Freud: Masters of Ambivalence." *Art News,* New York, 54, no. 1 (March 1955), pp. 38–41; 63–64.

322 Varenne, Gaston. "Bourdelle inconnu: Les rapports entre Bourdelle et Rodin (Documents inédits)." *La Revue de France,* Paris, October 1, 1934, pp. 444–60; October 15, 1934, pp. 618–31.

323 Varnedoe, J. Kirk T. "Early Drawings by Auguste Rodin." *Burlington Magazine,* London, 116, no. 853 (April 1974), pp. 197–202.

See also nos. 40, 395.

Vauxcelles, Louis. *See* no. 26 [review].

Veidaux, André. *See* no. 327.

Vitry, Paul. *See* no. 328.

324 Vollard, Ambroise. "Une Visite de Rodin." *Le Correspondant,* Paris, December 10, 1917, pp. 919–30.

325 Waldmann, Emil. "Rodin." *Kunst und Künstler,* Berlin, 16 (1918), pp. 190–91.

Wander, Steven H. *See* no. 398.

Welschinger, Henri. *See* no. 331.

326 Wennberg, Bo. "Auguste Rodin." In *Skulptörer,* pp. 113–37. (Arsbok för Svenska statens konstsamlingar, no. 12.) Stockholm: Rabén & Sjögren, 1964.

Werner, Alfred. *See* no. 57c.

Werth, Léon. *See* no. 111.

White, Gabriel. *See* no. 389.

White, Gilbert. *See* no. 210.

SPECIAL EDITIONS OF PERIODICALS DEVOTED TO RODIN

327 *Rodin et son œuvre. La Plume,* Paris, 1900. Published in fascicles, nos. 266–71 (May 15–August 1, 1900).
Includes: Octave Mirbeau, "Préface," pp. 1–4; Gustave Geffroy, "Renaissance par Rodin," p. 6; Gustave Coquiot, "Rodin: Ses dessins en couleurs," pp. 8–9; Albert Mockel, "Le 'Balzac' et le 'Baiser' de Rodin," pp. 10–16 (reprinted from *La Réforme,* Brussels, May 29, 1898); Stuart Merrill, "La Philosophie de Rodin," pp. 17–19; Camille Mauclair, "La Technique de Rodin," pp. 19–27 (extract from no. 246); Gustave Kahn, "Les Mains chez Rodin," pp. 28–29; Charles Morice, "Rodin," pp. 31–32 (extract from no. 82); Gustave Geffroy, "Auguste Rodin," pp. 33–46 (extract from no. 199b); Arthur Symons, "Les Dessins de Rodin," pp. 47–48; Roger Marx, "Auguste Rodin," pp. 49–52; Frank Harris, "Un Chef-d'œuvre de l'art moderne," pp. 54–56 (reprinted from *Saturday Review,* London, July 2, 1898); André Veidaux, "La Race de Rodin," pp. 56–64; André Fontainas, "La Vie selon Rodin," pp. 65–66; Léon Riotor, "Rodin en Suède," pp. 66–69; Yvanhoé Rambosson, "Le Modèle et le mouvement dans les œuvres de Rodin," pp. 70–73; Léon Riotor, "Caractères et projets," pp. 74–80 (extract from no. 89); Louis Sauty, "Le 'Victor Hugo' de Rodin," p. 80; André Mellerio, "Les Dessins de Rodin interprétés lithographiquement en couleurs par A. Clot," pp. 81–82; Raymond Bouyer, "Rodin méconnu," pp. 82–83; Henri Frantz, "Le Balzac de Rodin," pp. 83–84; May Armand-Blanc, "L'Exposition Rodin," pp. 84–87; "Le Banquet de la Plume en l'honneur d'Auguste Rodin," pp. 87–88; Karl Boès, "Toast à Rodin," p. 88.

328 *Les Maîtres Artistes,* Paris, no. 8 (October 15, 1903).
Includes: Anatole France, "La Porte de l'enfer," pp. 260–62; Comte Robert de Montesquiou, "Auguste Rodin," pp. 262–65; May Armand-Blanc, "Le Sensualisme chez Rodin," p. 265; H.-Ernest Simoni, "Poussières de marbre," pp. 265–68; Prosper Dorbec, "Rodin," pp. 268–69; Raymond Bouyer, "Rodin méconnu," pp. 269–70; Paul Vitry, "Le Victor Hugo de Rodin et le Beethoven de Max Klinger," p. 270; Camille Mauclair, "Auguste Rodin: Son œuvre, son milieu, son influence," pp. 271–78; Marius-Ary Leblond, "Rodin social," pp. 278–82; Eugène Carrière, "L'Art de Rodin," p. 282; André Mellerio, "Pointes sèches: Quelques réflexions devant une eau-forte de Rodin (Le Portrait de Victor Hugo)," p. 284; Clément-Janin, "Les Dessins de Rodin," pp. 285–87; Gustave Coquiot, "Rodin: Ses dessins en couleur," pp. 287–88; Léon Riotor, "Rodin, dessinateur," pp. 288–90; Vittorio Pica, "Rodin en Italie," pp. 293–95; Georg Treu, "Auguste Rodin," pp. 295–98; Karel B. Madl, "Auguste Rodin en Autriche," pp. 298–302; W. E. Henley, "Sur Auguste Rodin," pp. 302–4; D. S. MacColl, "Auguste Rodin," pp. 304–11.

329 *Auguste Rodin: L'Homme et l'œuvre. L'Art et le Beau,* Paris, no. 12 (December 1906), pp. 101–35.
Includes the following articles by Gustave Kahn: "Auguste Rodin," pp. 101–5; "Rodin chez lui," pp. 105–8; "Les Deux Manières de Rodin," pp. 108–19; "Les Bourgeois de Calais, Claude Lorrain, etc....," pp. 119–20; "La Porte de l'enfer—Le Balzac: La deuxième manière," pp. 120–35.

 329a Reprinted as *Auguste Rodin.* Berlin: Marquardt and Co., n.d.

 329b Reprinted in an Eng. trans. as *Auguste Rodin.* (The International Art Series.) London and Leipzig: T. Fisher Unwin, 1909.

330 *Rodin: L'Homme et l'œuvre. L'Art et les Artistes,* Paris, 19, no. 109 (April 1914), pp. 1–112.
Includes: Octave Mirbeau, "Auguste Rodin," pp. 3–6; "Essai biographique," pp. 7–11; Paul Gsell, "En haut de la colline," pp. 13–28; Léonie Bernardini-Sjoestedt, "L'Atelier de Rodin à Meudon," pp. 29–36; "Pensées inédites de Rodin," pp. 37–40; "Le Musée Rodin," pp. 41–44; Judith Cladel, "L'Hôtel Biron," pp. 45–48; Paul Gsell, "Chez Rodin," pp. 49–72; Francis de Miomandre, "Les Dessins de Rodin," pp. 73–84; Léonce Bénédite, "Propos sur Rodin," pp. 85–90; Auguste Rodin, "Vénus: A la Vénus de Milo," pp. 91–104 (reprinted from no. 288); Otto Grautoff, "Les Œuvres de Rodin en France et à l'étranger," pp. 105–7 (extract

654

from no. 56); "Essai bibliographique," pp. 109–11.

331 *Les Arts Français,* Paris, no. 14 (February 1918). Includes: Charles Saunier, "Auguste Rodin," pp. 17–23; Gustave Geffroy, "L'Œuvre de Rodin à l'Exposition de 1900," pp. 24–29 (extract from *La Vie artistique,* 7ᵉ série, Floury, 1901); Camille Mauclair, "L'Influence de Rodin," p. 30 (extract from no. 77); Louis Lumet, "Les Dessins d'Auguste Rodin," pp. 31–32; "Opinions sur Rodin," pp. 32–36, by Anatole France, Octave Mirbeau, Georges Rodenbach, Armand Silvestre, Séverine, Henri Welschinger, André Michel; "Le 'Balzac' de Rodin," pp. 36–41, by Henri Rochefort, André Pératé, Benjamin Constant, Olivier Merson, Jean Rameau, Octave Mirbeau, Léon Daudet, Robert de la Sizeranne, Maurice Hamel, Auguste Rodin; De Lamazelle and Eugène Lintilhac, "Rodin et l'Hôtel Biron: Deux conceptions d'art," pp. 41–42; Auguste Rodin, "L'Œuvre littéraire de Rodin: Aux jeunes artistes," pp. 42–44; "Bibliographie générale," pp. 45–48.

CATALOGUES OF PERMANENT COLLECTIONS

332 Cleveland, Cleveland Museum of Art. *Rodin Sculpture in the Cleveland Museum of Art,* by Athena Tacha Spear. Foreword by Sherman E. Lee. Cleveland: Cleveland Museum of Art, 1967.
 332a *A Supplement to Rodin Sculpture in the Cleveland Museum of Art,* by Athena Tacha Spear. Cleveland: Cleveland Museum of Art, 1974.

333 Copenhagen, Ny Carlsberg Glyptotek. *Moderne Skulptur,* by Haavard Rostrup. Copenhagen: Ny Carlsberg Glyptotek, 1964.

334 London, Tate Gallery. *The Foreign Paintings, Drawings and Sculpture,* by Ronald Alley. London: By Order of the Trustees, 1959.

335 London, Victoria and Albert Museum. *Catalogue of Sculpture by Auguste Rodin,* by E. R. D. Maclagan. London: H. M. Stationary Office, 1914.
 335a 2d ed., 1925.

336 Meudon, Villa des Brillants and Musée Rodin. *La Villa des Brillants à Meudon et le Musée Rodin: Catalogue-Sommaire.* Intro. by Marcel Aubert. Paris: 77, rue de Varenne, 1948.

337 New York, Metropolitan Museum of Art. *The Collection of Sculptures by Auguste Rodin,* by Joseph Breck. New York: Metropolitan Museum of Art, 1913. Reprint of nos. 140 and 141.

338 Paris, Musée Rodin. *Catalogue du Musée Rodin. I–Hôtel Biron,* by Georges Grappe. Paris: 77, rue de Varenne, 1927.
 338a 2d ed., 1929.
 338b 3d ed., 1931.
 338c 4th ed., 1938.
 338d 5th ed., 1944.

339 Paris, Musée Rodin. *Le Musée Rodin,* by Cécile Goldscheider and Marcel Aubert. Paris: Editions H. Laurens, 1948.

340 Paris, Musée Rodin. *Musée Rodin. Catalogue sommaire des œuvres d'Auguste Rodin,* by Léonce Bénédite. Paris: Imprimerie Frazier-Soye, 1919.
 340a 2d ed., 1924.

341 Philadelphia, Rodin Museum. *Rodin Museum Handbook,* by John L. Tancock. Philadelphia: Philadelphia Museum of Art, 1969.

342 Philadelphia, Rodin Museum. *Rodin Museum of Philadelphia,* by Fridolyn G. Watkins. Philadelphia: Press of Edward Stern, 1929.
 342a 2d ed., 1933.
 342b 3d ed., 1945.

343 San Francisco, Fine Arts Museums of San Francisco. *Rodin Sculpture: A Critical Study of the Spreckels' Collection,* by Jacques de Caso and Patricia B. Sanders. San Francisco: Fine Arts Museums of San Francisco, forthcoming.

344 Stellenbosch, Union of South Africa. *Rembrandt Art Foundation. Rodin Collection (Sculptures and Drawings).* Stellenbosch, 1967.

345 Tokyo, National Museum of Western Art. *Musée National d'Art Occidental: Catalogue Général.* Pref. by Soichi Tominaga. Tokyo: Musée National d'Art Occidental, 1961.

346 Washington, D. C., Joseph H. Hirshhorn Museum and Sculpture Garden. *The Hirshhorn Museum and Sculpture Garden,* edited and with an intro. by Abram Lerner. New York: Harry N. Abrams, 1974.

EXHIBITION CATALOGUES

347 Paris, Galerie Georges Petit. *Claude Monet, A. Rodin.* 1889. 90 pp. Intro. by Gustave Geffroy, pp.47–84 (largely reprinted from no.199).

348 Amsterdam, Arti et Amicitiae. *Tentoonstelling van Beeldhouwwerken door A. Rodin, Parijs.* August–September 1899. 6 pp. illus. Exhibition shown at: Haagsche Kunstkring, The Hague; Maison d'Art, Brussels.

349 Paris, Place de l'Alma. *Exposition de 1900: L'Œuvre de Rodin.* 1900. 86 pp. illus. Prefaces by Eugène Carrière, pp.i–ii; Jean-Paul Laurens, p.iii; Claude Monet, p.v; and Albert Besnard, pp.vii–ix; Intro. and Catalogue by Arsène Alexandre, pp.xi–xix.

350 Prague, Manes Society. *Auguste Rodin.* May 10–July 15, 1902. Pref. by Stanislaw Sucharda.

351 Basel, Kunsthalle, Société des Amis des Arts de Bâle. *Auguste Rodin 1840–1917: Exposition de Sculptures, Aquarelles, Dessins, et Estampes Originales du Maître.* April 1918. 36 pp. Intro. by Léonce Bénédite, pp.3–15.

352 Philadelphia, Rodin Museum of Philadelphia, Jules E. Mastbaum Foundation. *Exhibit of the Rodin Museum of Philadelphia. Gallery 25. Department of Fine Arts. Sesqui-Centennial Exposition.* 1926. 8 pp. illus. Pref. by Albert Rosenthal, pp.3–4.

353 Copenhagen, Palais de Charlottenborg. *Rodin-Udstillingen udlaan fra Rodin-Museet.* September 1930. 22 pp. illus.

354 Buenos Aires, Museo Nacional de Bellas Artes. *Exposicion Rodin.* October 1934. 28 pp. illus.

355 Amsterdam, Stedelijk Museum. *Rondom Rodin: Tentoonstelling Honderd Jaar Fransche Sculptuur.* July–September 1939. 200 pp. illus. Intro. by D. C. Roëll, pp.vii–viii; Essay in French and Dutch by Michel Florisoone, pp.ix–xxviii.

356 Columbus, Ohio, Columbus Gallery of Fine Arts. *A. Rodin.* October 1944. 16 pp. illus. Essay by Philip R. Adams, pp.1–4.

357 Washington, D.C., National Gallery of Art. *Rodin: Sculpture, Drawings, Prints.* October 6–December 12, 1946. 8 pp. illus. Foreword by Elizabeth Mongan and Charles Seymour, Jr., pp.2–3.

358 Basel, Offentliche Kunstsammlung. *Auguste Rodin, 1840–1917.* April 10–July 14, 1948. 128 pp. illus. Intro. by Marcel Aubert, pp.9–16; Extracts from no.57, pp.17–19; no.87, pp.20–25; Catalogue notes by Cécile Goldscheider, pp.31–54.

359 Paris, Musée Rodin. *Balzac et Rodin.* 1950. 24 pp. illus. Essays by Marcel Aubert, pp.1–3, and Georges Lecomte, pp.5–8; Catalogue by Cécile Goldscheider, pp.9–15.

360 The Hague, Haags Gemeentemuseum. *Rodin, Bourdelle, Maillol, Despiau.* June 30–September 4, 1950. 52 pp. illus. Foreword by J. V. C. Hefting, pp.6–7; Remarks by Cécile Goldscheider, p.8; Essays on Rodin, Bourdelle, Maillol, and Despiau, pp.9–14.

361 New York, Curt Valentin Gallery. *Auguste Rodin.* May 4–29, 1954. 42 pp. illus. Essays by Jacques Lipchitz, pp.6–13; Jean Arp, p.19; Auguste Rodin, pp.20–23; and André Masson, p.35; Letter of Rainer Maria Rilke, August 8, 1903, pp.26–34 (reprinted from *Letters of R. M. Rilke,* W. W. Norton and Co.). Exhibition shown at: Minneapolis Institute of Arts, June 15–August 1, 1954; Des Moines Art Center, August 12–September 19, 1954; Portland Art Museum, October 22–November 22, 1954; Santa Barbara Museum of Art, December 1954; City Art Museum, St. Louis, January 1955; Cincinnati Art Museum, March 1955.

362 Munich, Bayerische Akademie der Schönen Künste. *Rilke und Rodin.* June–July, 1955. 40 pp. illus. Foreword by Jean Rouvier, pp.5–6; Intro. by J. F. Angelloz, pp.7–10. Exhibition shown at: Kunsthalle, Bremen, July 24–August 28, 1955.

363 Paris, Musée Rodin. *Rodin: Ses collaborateurs et ses amis.* 1957. 28 pp. illus. Pref. by Judith Cladel, pp.3–4; Catalogue by Cécile Goldscheider, pp.5–28.

364 Metz, Musée de Metz. *A. Rodin et A. Bourdelle.* 1961. Pref. by Georges Fouquet.

365 Munich, Städtische Galerie. *Auguste Rodin.* May 10–August 13, 1961. 106 pp. illus. Intro. by H. K. R.

366 Nice, Palais de la Méditerranée. *Sculptures de Rodin.* December 1961–January 1962. 40 pp. illus. Intro. by Cécile Goldscheider, pp.3–5.

656

367 Paris, Musée du Louvre. *Rodin inconnu.* December 1962–January 1963. 116 pp. illus. Essay by Cécile Goldscheider, pp. 9–10.

368 Paris, Galerie Claude Bernard. *Auguste Rodin.* 1963. 50 pp. illus. Intro. by Jacques Bornibus, pp. 3–10; Extract from no. 87, pp. 27–31; Statements by Arsène Alexandre, p. 32, and Auguste Rodin, pp. 33–34.

New York, Museum of Modern Art. *Rodin.* May 1–September 8, 1963. *See no. 38.*

369 New York, Charles E. Slatkin Galleries. *Auguste Rodin 1840–1917, an Exhibition of Sculptures/Drawings.* May 6–June 26, 1963. 120 pp. illus. Intro. by Leo Steinberg, pp. 10–27 (reprinted in no. 310); Catalogue notes by Cécile Goldscheider, pp. 46–118.
Exhibition held under the auspices of the Musée Rodin, Paris, and shown at: Montreal Museum of Fine Arts, August 17–September 17, 1963; Art Gallery of Toronto, September 26–October 20, 1963; Winnipeg Art Gallery, November 1–December 1, 1963; William Rockhill Nelson Gallery, Kansas City, December 15–January 15, 1964; Cleveland Museum of Art, January 27–March 1, 1964; Baltimore Museum of Art, March 8–April 8, 1964; North Carolina Museum of Art, Raleigh, April 20–May 20, 1964; Dallas Museum of Fine Arts, June 1–July 1, 1964; Minneapolis Museum of Art, July 15–August 23, 1964; Seattle Art Museum, September 11–October 6, 1964; Fogg Art Museum, Cambridge, Mass., October 21–November 20, 1964; National Gallery of Canada, Ottawa, December 4–January 10, 1965.

370 San Francisco, California Palace of the Legion of Honor. *The Works of Auguste Rodin.* October 18–December 8, 1963. 22 pp. illus. Foreword by Thomas C. Howe, pp. 2–3.

371 Beirut, Musée Sursock. *Auguste Rodin.* April 13–June 15, 1964.

372 Buenos Aires, Museo Nacional de Arte Decorativo. *Rodin–Bourdelle.* October–November 1964. Pref. by Julio Payro.

373 Stellenbosch, Union of South Africa, Rembrandt Tobacco Corporation. *Rodin and His Contemporaries.* 1965? 18 pp. illus.

374 Helsinki, Kunstmuseum Athenaeum. *Auguste Rodin.* September 10–October 10, 1965. 18 pp. illus.

Exhibition shown at: Kunstmuseum, Turku, October 19–November 7, 1965; Kunstmuseum, Tampere, November 14–December 4, 1965.

375 Leningrad, Hermitage. *Rodin and His Time.* 1966. 60 pp. illus.

376 London, Arts Council of Great Britain. *Rodin: An Exhibition of Sculpture with Some Drawings and Prints Organized by the Arts Council 1966–7.* 1966. 40 pp. illus. Intro. by Lillian Browse, pp. 6–9; Catalogue by John Tancock, pp. 17–39.
Exhibition shown at: Hatton Gallery, University of Newcastle upon Tyne, November 5–December 31, 1966; Museum and Art Gallery, Leicester, January 7–February 18, 1967; City Art Gallery, Birmingham, February 25–April 1, 1967; City Art Gallery, Leeds, April 8–May 20, 1967; Royal Scottish Museum, Edinburgh, May 27–July 8, 1967; National Museum of Wales, Cardiff, July 15–August 26, 1967; Southampton Art Gallery, September 2–October 14, 1967; Reading Art Gallery, October 21–December 2, 1967.

377 Stockholm, Nationalmuseum. *Rodin: Levande form.* January 20–March 13, 1966. 64 pp. illus. Foreword by Carl Nordenfalk, pp. 7–8.

378 Marseilles, Musée Cantini. *Rodin.* March–April 1966. 24 pp. illus. Catalogue by Cécile Goldscheider.

379 Tokyo, National Museum of Western Art. *Rodin.* July 23–September 11, 1966. 160 pp. illus. Catalogue by Cécile Goldscheider.
Exhibition shown at: Kyoto National Museum of Modern Art, September 18–October 30, 1966; Fukuoka Cultural Center, November 9–December 11, 1966.

380 Tel Aviv, Tel Aviv Museum. Helena Rubinstein Pavilion. *Rodin.* February–March 1967. 46 pp. illus. Intro. by Dr. Haim Gamzu, pp. 9–10; Pref. by Cécile Goldscheider, pp. 17–20.

381 Rome, Accademia di Francia (Villa Medici). *Mostra di Auguste Rodin (1840–1917).* May 26–June 30, 1967. 84 pp. illus. Essays by Palma Bucarelli, pp. 5–7, and Cécile Goldscheider, pp. 9–13.

382 Prague, Národní Galerie. *Exposition Rodin.* July 13–September 15, 1967.

383 Los Angeles, Los Angeles County Museum of Art. *Homage to Rodin.* Collection of B. Gerald

Cantor. November 14, 1967–January 7, 1968. 108 pp. illus. Foreword by Kenneth Donohue, pp. 6–7; Intro. by Cécile Goldscheider, pp. 9–11. Exhibition shown at: Museum of Fine Arts, Houston, January 31–March 3, 1968; Brooklyn Museum, New York, May 13–August 25, 1968; Virginia Museum of Fine Arts, Richmond, September 16–October 20, 1968; California Palace of the Legion of Honor, San Francisco, November 21, 1968–January 5, 1969.

384 Paris, Musée Rodin. *Rodin collectionneur.* 1967–68. 126 pp. illus. Intro. by Cécile Goldscheider, pp. 5–7.

385 Zagreb, Galerija Suvremene Umjetnosti. *Auguste Rodin 1840–1917.* July 3–August 25, 1968. 36 pp. illus. Intro. by Cécile Goldscheider, p. 7.

386 Lisbon, Escola Superior de Belas-Artes de Lisboa. *Obras de Rodin existentes em Portugal.* October 1968. 24 pp. illus.

387 New York, American Federation of Arts. *Rodin Bronzes from the Collection of B. Gerald Cantor.* Circulating exhibition 1969–70. 36 pp. illus. Intro. by Ellen Landis, pp. 3–4.

388 Baltimore, Baltimore Museum of Art. *The Partial Figure in Modern Sculpture from Rodin to 1969.* December 2, 1969–February 1, 1970. 114 pp. illus. Foreword by Charles Parkhurst, p. 7; Essays on Rodin by Albert E. Elsen, pp. 16–28, 29–32.

389 London, Hayward Gallery. *Rodin: Sculpture and Drawings.* January 24–April 5, 1970. Exhibition organized by the Arts Council of Great Britain and the Association Française d'Action Artistique. 120 pp. illus. Supplement to the catalogue by Cécile Goldscheider; Foreword by Gabriel White, pp. 7–8; Essay by Alan Bowness, pp. 9–12.

390 Montreal, Montreal Museum of Fine Arts. *Rodin and His Contemporaries Presented in Canada by Rothmans of Pall Mall Canada Limited.* March 25–April 26, 1970. 52 pp. illus. Essay by Alan Jarvis, p. 6.

391 Rochechouart, France, Centre artistique et littéraire. *Rodin.* April 18–May 18, 1970. 44 pp. illus. Pref. by Cécile Goldscheider, p. 15; Essays by Ionel Jianou, pp. 22–31, and Cécile Goldscheider, pp. 34–38.

392 Kansas City, William Rockhill Nelson Gallery of Art–Atkins Museum of Fine Arts. *Auguste Rodin. From the B. Gerald Cantor Collection and the B. G. Cantor Art Foundation.* 1971. 70 pp. illus. Foreword by Laurence Sickman, p. 3; Intro. by Cécile Goldscheider, pp. 5–8.

393 Montevideo, Museo Nacional de Artes Plasticas. *Rodin.* June 1971. 30 pp. illus. Essays by Angel Kalenberg, pp. 2–5, and Cécile Goldscheider, pp. 6–7.

394 Caracas, Museo de Bellas Artes. *Rodin: Exposicion de 55 esculturas, 30 acuarelas y dibujos de Rodin.* September 1971. 40 pp. illus. Intro. by Cécile Goldscheider, pp. 6–7.

395 Washington, D.C., National Gallery of Art. *Rodin Drawings: True and False.* November 20, 1971–January 23, 1972. 16 pp. illus. folder. Intro. by J. Carter Brown, p. 2; Foreword by J. Kirk T. Varnedoe, p. 3.
Exhibition shown at: Solomon R. Guggenheim Museum, New York, March 9–May 14, 1972.

396 Tokyo, Contemporary Sculpture Center. *Rodin, Bourdelle, Maillol.* 1972–73. 164 pp. illus. Intro. note by Cécile Goldscheider p. 5.

397 Lisbon, Museu Calouste Gulbenkian. *Rodin 1840–1917.* 1973.

398 Stanford, California, Stanford University Art Gallery. *Rodin & Balzac: Rodin's Sculptural Studies for the Monument to Balzac from the Cantor, Fitzgerald Collection.* Spring 1973. 72 pp. illus. Compilation of quotes by Steven H. Wander, pp. 5–13; Essays by Albert Elsen, pp. 37–58, and Stephen C. McGough, pp. 60–66.

INDEX OF WORKS BY RODIN

Works in the collection of the Rodin Museum are indicated by catalogue numbers in parenthesis. Page references immediately following are those of the catalogue entries and precede other references to the works.